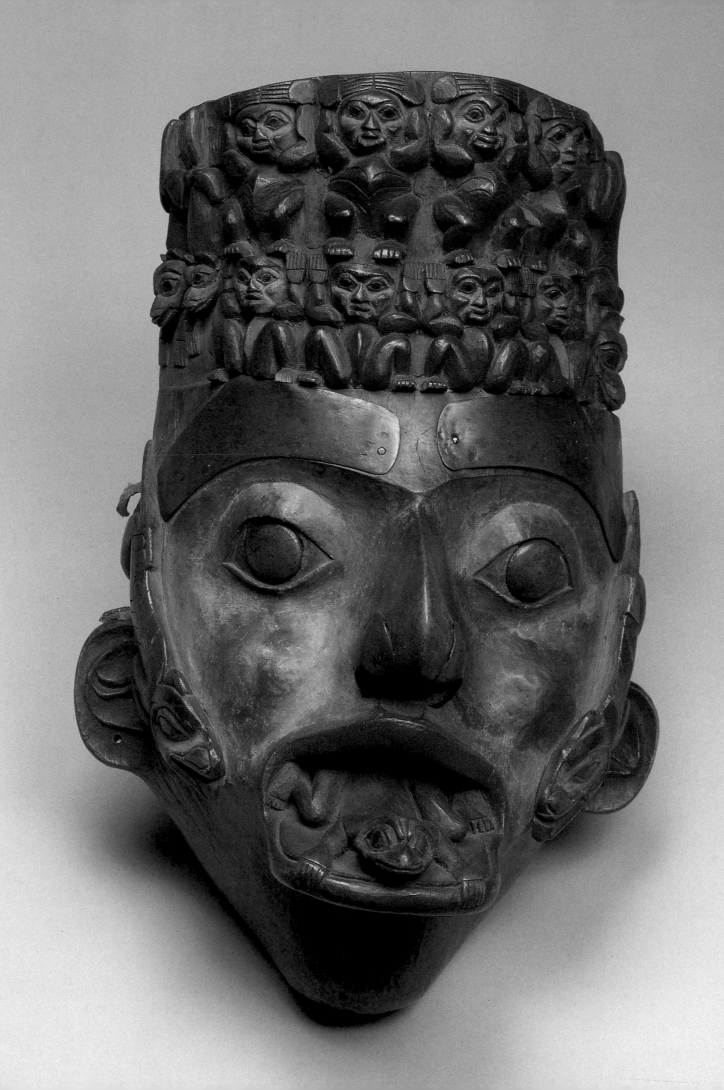

ALLEN WARDWELL

TANGIBLE VISIONS

NORTHWEST COAST INDIAN SHAMANISM AND ITS ART

THE MONACELLI PRESS

With The Corvus Press, New York

First published 1996
in the United States of America by
THE MONACELLI PRESS, INC.
10 East 92nd Street, New York, New York 10128

LIBRARY OF CONGRESS
CATALOGING-IN-PUBLICATION DATA
Wardwell, Allen.
p. cm.
Includes bibliographical references.
ISBN 1-885254-16-4
1. Indian art – Northwest Coast of North America.
2. Indians of North America – Northwest Coast
of North America – Material culture. 3. Indians
of North America – Northwest Coast of North
America – Religion. 4. Ceremonial objects – North-
west Coast of North America. 5. Shamanism –
Northwest Coast of North America. 6. Northwest
Coast of North America – Antiquities. 7. Title.
E78.N78W283 1995
704'.03972–dc20 95–24157

Designed by Eleanor Morris Caponigro
Printed and bound in Italy

FRONTISPIECE
No. 1. Tlingit Mask. Emmons (n.d., Notes, NMAI)
identifies this mask as representing the spirit of
an old woman. A frog emerges from her mouth,
and land otters are carved on her cheeks. On her
forehead are eight land spirits, with land otters on
each side. In 1878 Emmons attended the funeral
of Scan-hu-na, the shaman who owned this mask.
He apparently collected the mask from this shaman,
who belonged to the Kagwantan clan of Hoonah,
during the year of the latter's death. Emmons de-
scribes this as the most elaborate Tlingit mask he
ever saw and records that it was a celebrated object
among the people. Wood, copper, metal buttons,
and red, black, and blue-green pigment; height 13
inches; c. 1840–60. National Museum of the Ameri-
can Indian, Smithsonian Institution, Washington,
D.C., 9/7989. Purchased from Emmons, 1919

ACKNOWLEDGMENTS

I HAD MY FIRST real encounter with the powerful and graphic art of the Northwest Coast Indians thirty years ago. My exposure was brought about by research for the exhibition "Yakutat South: Indian Art of the Northwest Coast," which was held at the Art Institute of Chicago in 1964. Over the ensuing period, despite many distractions I maintained my interests in this art. I knew that there were large numbers of fine shamanic objects in various collections that had not even been photographed and that no study of this kind had ever been compiled.

As I visited the various museums and private collections whose holdings are represented here, I was struck again and again by my colleagues' wholehearted interest in the project. As a result, they all unstintingly shared their resources with me, and I profited greatly from my contacts and discussions with them. I began in New York, with the American Museum of Natural History, which houses one of the premier collections of this material. My relationships to its staff have always been close, as they once again proved to be. Stanley Freed, Chief Curator of Anthropology, opened the doors of his department without hesitation. As he has many times in the past, my friend Technician Anibal Roderiguez provided access to the storerooms and cut through the red tape to allow new photographs to be made. I was also efficiently assisted by Barbara Mathe and her staff in the photography archives.

Uptown, at the National Museum of the American Indian, Curator Mary Jane Lenz shared with me her enthusiasm over the treasures housed in the annex storage in the Bronx. She then worked closely with photographer Bobby Hansson after the objects had been selected. Roland Force, who was director during the time of my research, graciously permitted objects to be removed from display at the museum in Manhattan in order for them to be photographed. Dr. Force also made staff assistants Peter Brill and Kelton Bond available to open the cases and supervise the work. Archivist Nancy Rossoff led me to unexpected discoveries in her office, as did Registrar Lee Callender. Sharon Dean, Assistant Curator of the Photography Department, cheerfully supplied me with prints of existing photographs and additional information.

At the Field Museum of Natural History in Chicago, Curator James van Stone most helpfully took from exhibition every specimen I had requested for photography. The excellent color transparencies were then made by Ron Testa and Diane Alexander White. Janet Miller, Department of Anthropology Registrar, and her successor, Janice Klein; Photograph Researcher Nina Cummings; and Will Grewe, Assistant Collection Manager, Anthropology Department, also helped me find materials in the storerooms and archives there.

My guide to the collections of the National Museum of Natural History in Washington and frequent correspondent was Collections Manager Felicia Pickering, and curators George Ulrich and Nancy Lurie took care of my visit and requests at the Milwaukee Public Museum. Curator Michael Gramley helped me to track down the George T. Emmons material in the Buffalo Museum of Science.

At the Art Museum of Princeton University, Director Allen Rosenbaum and Registrar Maureen McCormick allowed the best of the William Libbey and Sheldon Jackson collections to be taken from display for photography.

Robin Wright, Director of the Thomas Burke Memorial, Washington State Museum in Seattle, happily tolerated my presence in her office while I pored over the incomparable slide collection of Bill Holm, Director Emeritus of the museum. Here, I found photographs of many little-known shamanic objects that Mr. Holm had recorded in collections throughout the world. Dr. Wright also saw through additional requests for materials. In Cambridge, at the Peabody Museum of Harvard University, Kathleen Skelly, Senior Collections Manager, provided me access to the Edward G. Fast collection. The new photographs I requested from Hillel Berger were provided with the help of Barbara Isaacs, Coordinator of the Photographic Archives. Martha Labell, Staff Assistant for Photographic Archives, followed through on subsequent requests.

The storage facilities of the Canadian Museum of Civilization in Hull outside Ottawa were made available to me by Chief Curator of Ethnological Services Andrea Lafôret. There, I was ably assisted by Leslie Tepper, Curator of Plateau Ethnology; Cataloguer Margo Reid; and Collections Manager Glen Forrester, who introduced me to the computer system and card files, and supervised my visits to the storerooms. I am also particularly grateful to Senior Registrar Kathleen Bishop-Glover for the time and assistance she provided to Mr. Hansson when he came to photograph the objects I had discovered there.

Curators Alan Hoover and Peter Macnair allowed me to study the Charles F. Newcombe collections at the Royal British Columbia Museum in Victoria. While I was there, Dan Savard provided access to his rich and beautifully kept photography archives, which are the source for many of the early images that appear in this volume. He also patiently responded to my many subsequent requests for prints and information.

Data on the specimens in the British Museum in London were provided by Curator Jonathan King, and Anjelica Deeprose and Sarah Posey supplied photographs, some newly made for this book. Also in London, photographer Werner Forman allowed the use of his prints of pieces from the Museum of Anthropology and Ethnography in Saint Petersburg, Russia. My friend Eberhard Fischer, Director of the Rietberg Museum in Zurich, and his curator Lorenz Holmberger provided photographs and material on the Tlingit masks there.

Much of my research was completed at the Robert Goldwater Library of the Metropolitan Museum of Art in New York. As always, I was welcomed there and provided with every title I requested by Librarian Allan Chapman; his successor, Ross Day; assistant Peter Blank; and other members of the staff.

I am especially indebted to Aldona Jonaitis, now Director of the University of Alaska Museum, Fairbanks, who has written extensively on Northwest Coast shamanism, and my old friend and mentor Bill Holm, who is a leading scholar in the field of Northwest Coast Indian art. Each of them read early drafts of the manuscript and made many helpful comments, which I have incorporated into the text. Any errors

are, of course, mine, but their guidance has immeasurably influenced the final form of this book.

Among many other colleagues who assisted me, Eugene Thaw gave photographs and documentation about objects in his collection and generously made a donation to help defray some of the costs of this publication. Adelaide de Menil and Ted Carpenter readily supplied photographs, as did George Terasaki, who shared books from his library as well.

I especially thank Dan Monroe, Director of the Peabody Essex Institute in Salem, who during the long process of finding a publisher, generously offered his institution as copublisher to assist in grant applications. He and his staff, especially Donald S. Marshall, Director of Publications, worked closely with me to bring outside funding to the book. The fact that we were unsuccessful in no way diminishes the great value of their vote of confidence and willingness to share the resources of their museum with me.

As to the actual publisher, I was gratified with the immediate interest of Gianfranco Monacelli and with his educated response to the text and illustrations as we went through the manuscript together. His readiness to see a work of this nature and complexity into print and international distribution has demonstrated his strong personal belief in its value. I am indebted to him for his faith and commitment.

It is also a pleasure for me to acknowledge the contributions of those who worked on the production of this volume. I thank Deborah Reade for her fine maps and drawings, Sherry Babbitt and Robin Jacobson for their patient and meticulous copyediting, and Bobby Hansson for his travels and excellent photographs, many taken in less than ideal situations. I also wish to point to the contributions of the designer Eleanor Caponigro and those assistants who worked with her during the project's long gestation: Arlyn Simon, Amelia Ranney, Georgia Smith, and Deborah Reade. Eleanor's role in the ultimate appearance and content of this book far exceeds that of a designer. Her genuine enthusiasm for the material combined with our friendship of twenty years engendered an easy give-and-take between us. This allowed me to share personal insights into some objects that would not have seen print without her encouragement. Combined with her taste, skill, and sensitivity, these factors are what have given this book its soul. The texts, photographs, and design reinforce one another in a manner that befits the work of such an award-winning artist. It has been an honor and a pleasure to have been associated with her.

Lastly, I am deeply grateful for the ongoing support of my parents, Lelia and Edward, to whom this book is dedicated, and that of my wife, Sally.

ALLEN WARDWELL, *New York*

To my parents
Lelia M. and Edward R. Wardwell

CONTENTS

NORTHWEST COAST

INDIAN PEOPLES

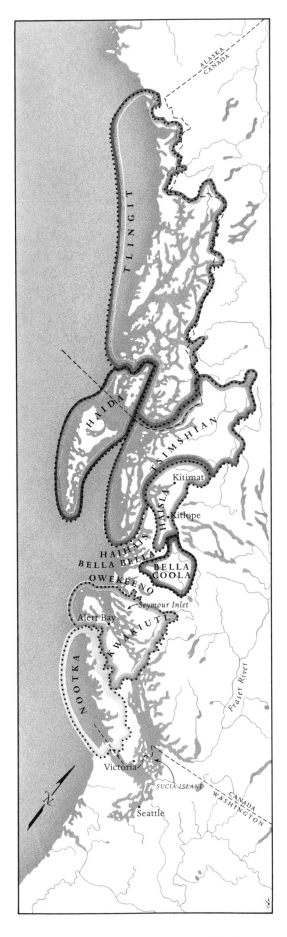

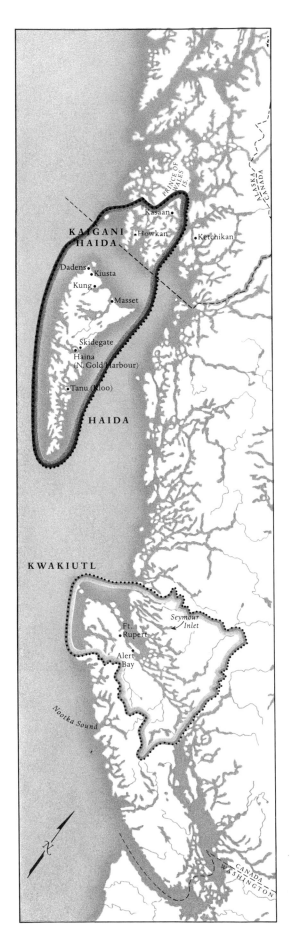

TERRITORIES AND VILLAGES

KWAKIUTL/HAIDA

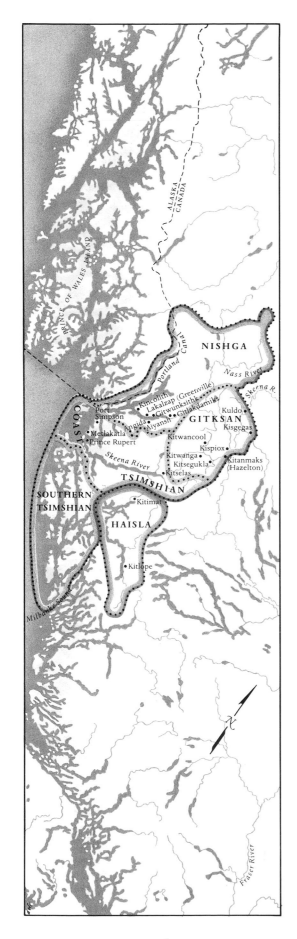

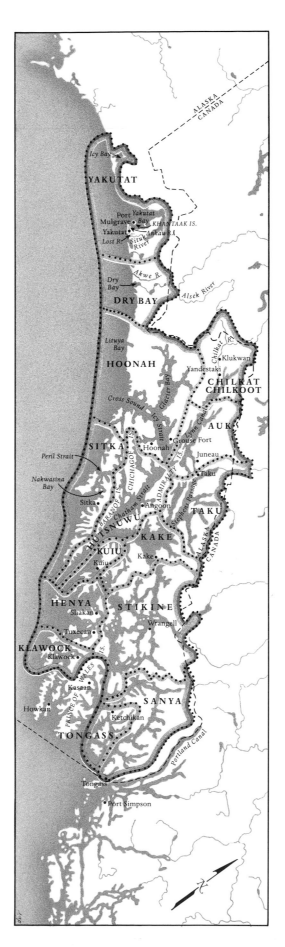

TSIMSHIAN / HAISLA

TLINGIT TRIBES

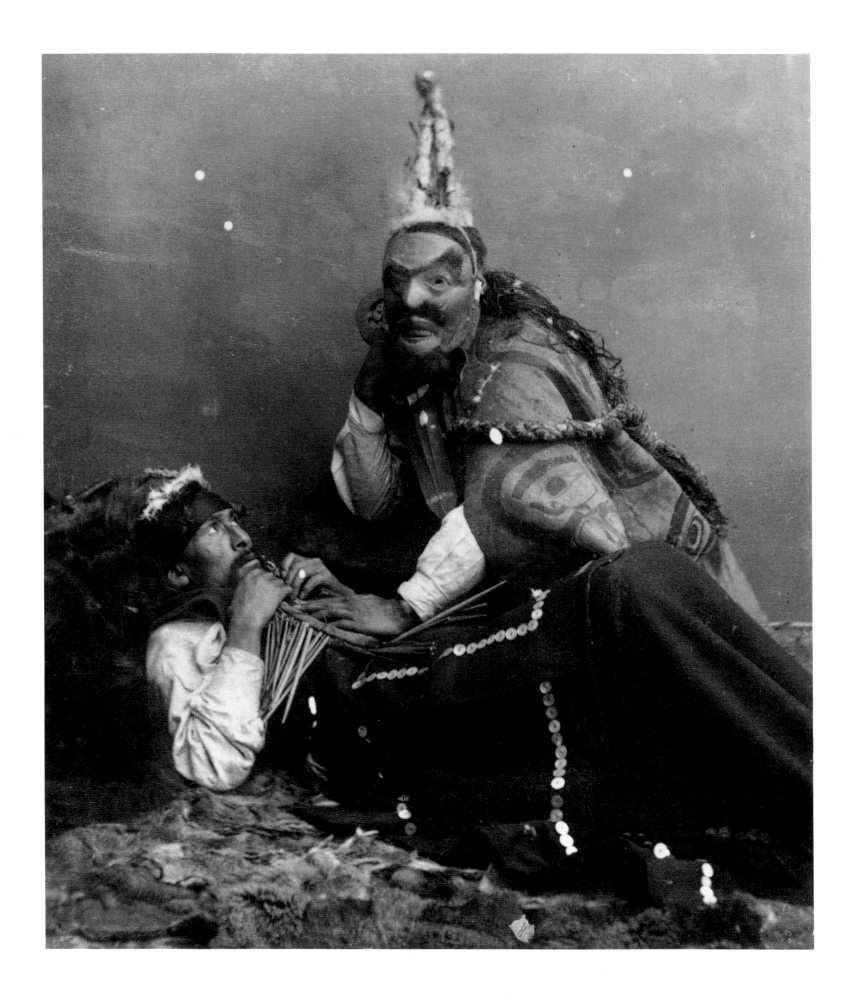

CHAPTER I

PROBLEMS AND PARAMETERS

WHAT IS SO MOVING, *so immensely reassuring about the shaman's attributes and roles is that he or she is the balancer, the bringer of equilibrium, the healer, the maker of words, songs, images, forms, expressive of the principle of the one in the many, of "Pan in Proteus." And so across time and cultures and vast geographical space those rooted and keenly honed concepts speak, concatenate, set up correspondences, transform with their transformations our own perception of history, of art, of artists. Of meaning.*

ANNE TRUEBLOOD BRODZKY

AT THE MENTION of the subject of Northwest Coast Indian art, the images most often brought to mind are those of objects associated with prestige and the display of important family crests in the form of zoomorphic images. Totem poles, large painted seagoing canoes, Chilkat blankets, painted house fronts, storage boxes, and the masks, rattles, and other paraphernalia made for long feast and ceremonial cycles have become the hallmarks of the art. Less well known but at least as important, however, are the art objects that were made to accompany the performances of the shamans, those individuals responsible for controlling events caused by supernaturals. It is the purpose of this volume to give proper emphasis and representation to these powerful expressions.

In doing so, we are aware of our presumption. This is not a book that could have been written by any of the people who used or believed in the objects that are shown and discussed. In their original context, these pieces inspired respect, awe, and sometimes even dread. By acting to connect the shaman with his spirit helpers, they were articles of great power that could not be looked at casually or even exposed unless under the proper controlled situations. Contact with the objects by those who did not know how to handle them was dangerous and to be avoided. When not in use, they were kept in boxes either in parts of the shaman's house that were sealed off from visitors or in caches deep in the forest so that the uninitiated would not encounter them.

The grave houses of Tlingit shamans, which contained the ritual paraphernalia they had used during their lifetimes, were shunned by members of the community, for they believed that if they were exposed to the spiritual power of the objects they might become ill or even die. In certain cases, it was thought that such contact could cause the exposed persons to acquire the traits that would compel them to become shamans themselves. The often raw and aggressive beauty modern viewers find in the art is therefore but a small part of the impact it had in its original settings, if indeed it was a part at all.

The dates that are given for the objects in this volume have been determined through the consideration of various factors, including information as to when and where they were collected, materials and pigments used, style, evidence of use and wear, and admittedly subjective but educated guesswork. Refinements will undoubtedly be forthcoming as more information becomes available. If anything, however, it may ultimately be found that some examples are of even earlier dates than those suggested here.

Fig. 1. Shaman Curing a Sick Man. In 1889, the photographer Edward de Groff took a series of posed pictures in Sitka showing a shaman treating an ill patient and torturing a witch (see also fig. 4). Two of them, of which this is one, were made into engravings for publication in a Sitka newspaper at the time (de Laguna in Emmons, 1991, p. 401). The shaman depicted has been identified as Dr. Pete of the Wolf 6 clan of the Sitka Tlingit. By the time this photograph was made, he had given up the practice (ibid.; Holm, 1987b, pp. 236, 238). The paraphernalia that appear in the de Groff pictures were all collected by Emmons from various sources, and he must have supplied de Groff with the objects to use as props. Although not all of them have been located, most are now in the American Museum of Natural History, New York. The mask is illustrated here as no. 56. Photograph by Edward de Groff, Sitka, 1889. American Museum of Natural History, New York, 335775

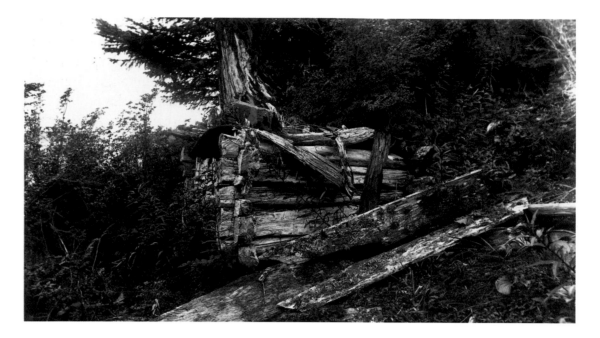

Fig. 2. Tlingit Grave House at Sitka. This grave house had obviously not been cared for over a period of years. By the time of the photograph, its contents had either decayed or been collected. Photograph by Winter and Pond, Juneau, c. 1900. Alaska State Library, Juneau, 87–110

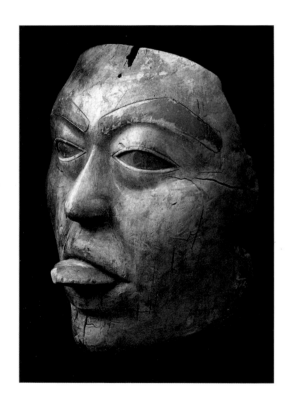

No. 2. Tlingit Mask. The mask was among the contents of the grave house of Setan, a Tlukwaxdi shaman, that were collected by Emmons in 1884–93. The house was on the Akwe River, a few miles west of Dry Bay near an old, deserted village. The protruding tongue indicates either incipient death, perhaps by drowning, or a trance state. The fine and realistic carving is diagnostic of Tlingit art of the first part of the nineteenth century, if not even earlier. Several other masks from this period are included in this volume, and this one appears to have been made by the same artist as nos. 98 and 102. Wood and traces of black and blue-green pigment; height 8½ inches; c. 1790–1820. American Museum of Natural History, New York, E 414. Purchased from Emmons, 1893

Especially ironic is the fact that the very subject of this publication – art made for use by shamans – was, to those who saw it in use, actually of secondary importance to the dramatic impact of the shamanic séances themselves. The songs, chants, stories, and dances of these performances were what most impressed those who were present. The tangible art objects only served to embellish in some way the more powerful intangible expressions of these theatrical events. It has been pointed out (Pasztory, 1981, p. 28) that objects are too static, for, unlike the dancing, singing, and chanting shaman, they do not change and are not able to transform themselves into other beings or states. These articles are therefore now removed not only from their cultures but also from the much more significant actions and dramas for which they were created.

Certain difficulties inherent in the examination of such art must be mentioned as well. Most Northwest Coast objects have come down to us without much documentation, and it is not always possible to tell simply by looking at a piece whether it was made for use by a shaman or for crest display. As will be seen, there are several well established groups of objects whose shamanic function and iconography are already clearly documented; these include amulets, crowns, and the oystercatcher and round rattles that are known to have been used exclusively by shamans. Often, however, when faced with certain undocumented masks, human and animal sculptures, storage boxes, and other objects, we can only make educated guesses as to whether they were made for use by shamans.

At times, the intended use of an object can be hypothesized with some certainty. For example, the appearance of specific motifs or animal forms often associated with shamans, such as the depiction of skeletal elements, the land or river otter, the bound witch, the devilfish, and the oystercatcher, can be a reliable indicator. Shamanic

connections are also clearly suggested by some odd facial expressions on anthropomorphic masks, including those that depict a trancelike state or represent incipient death, often by drowning. The eyes are shown half-closed and looking upward, with the irises partly concealed by the lids, the jaw is slack, and a swollen tongue protrudes from a partially open mouth. Another clue to shamanic function is the fact that the eye holes on many of the masks used by Tlingit shamans were not cut through. The shaman often did not actually have to see, as he relied on his assistants to guide him during some performances, while at others he danced within a small prescribed area (de Laguna, 1972, pt. 2, p. 692; Vaughan and Holm, 1982, p. 91, no. 55).

Nonetheless, it is particularly among the undocumented masks that the greatest problems in determining original use arise. One reason is that the human face and some of the animal forms, including the bear, the wolf, the mountain goat, the raven, and the killer whale, were employed in both shamanic and crest art. As Aldona Jonaitis (1986, pp. 96–97) has suggested, this was done to represent the shaman's ability to move in both the secular and supernatural spheres. In addition, certain powerful shamans were known to have incorporated clan emblems into their paraphernalia as a way of indicating their high social position in their community (Kaplan and Barsness, 1986, p. 198, no. 230). A few shamans were even chiefs as well, thereby providing another opportunity for the use of both crest and shamanic iconography in the art they employed. It is therefore often impossible to declare on the basis of its style and iconography that an undocumented mask was made specifically for shamanic use. The same may also be true for some staffs, storage boxes, and combs; those that are

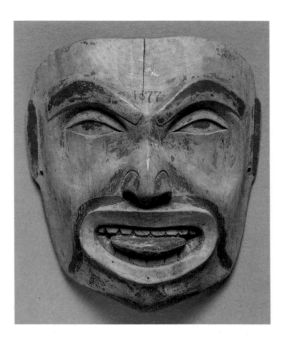

No. 3. Tlingit Maskette. As in no. 2, the protruding tongue indicates that the subject is either in the throes of death or experiencing a trance. Adding to the effect are the half-closed eyes. Such maskettes were attached to a hide band that was worn on the forehead of a practicing shaman. Collected by Captain Edward G. Fast at Sitka, 1867–68. Wood and black, red, and traces of blue-green pigment; height 4½ inches; c. 1820–40. Peabody Museum of Archaeology and Ethnology, Harvard University, Cambridge, 69–30–10/1677. Purchased from Fast, 1869

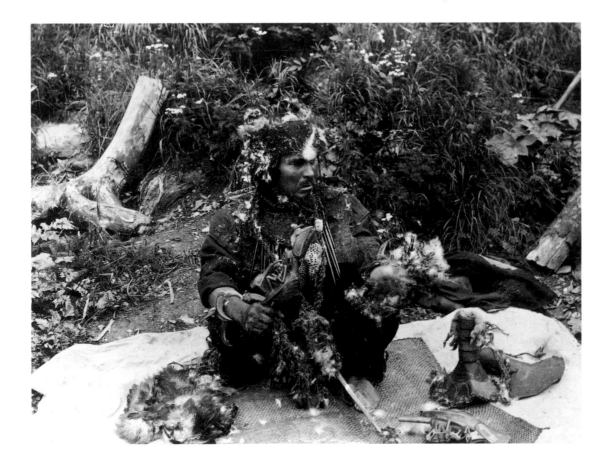

Fig. 3. Tlingit Shaman Dressed for Practice. De Laguna (in Emmons, 1991, p. 384) states that this photograph was taken at Gastineau Channel near Juneau, and writes that the shaman "wears a necklace of rattling bone or ivory pendants, and protective armbands; he grasps rattles in his hands, and has sprinkled himself with bird's down." A raven rattle is in his right hand and another on the mat in front of him. Such rattles were commonly used by chiefs. To his left is a clan hat with four potlatch rings on the top. These details may suggest that this shaman was also a chief. Photograph by George Emmons, c. 1887. American Museum of Natural History, New York, 336801

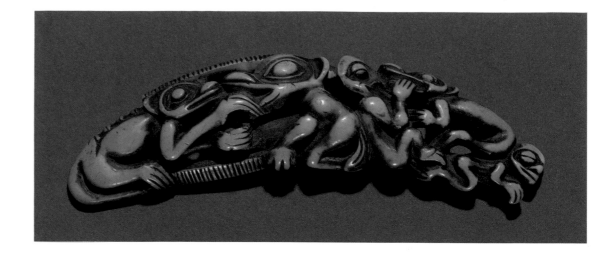

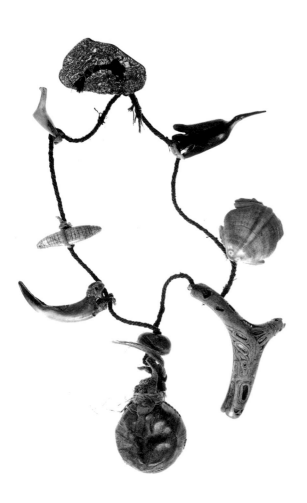

included in this book are accompanied by explanations as to why a shamanic function was attributed to them. We have not, however, intentionally shown pieces that were originally made for crest display and later came to be used by shamans.

Compounding these problems of identification is the fact that a vast amount of information concerning the original meaning and context of these objects will never be known. In many cases, the name of the shaman who owned them is now lost, and only in rare instances has the entire content of a shaman's kit been preserved so that we could study the articles as an interrelated unit.

It must also be remembered that much of the content of shamanic art was highly personal and dependent on the experiences and activities of the practitioner who used it. It might represent such esoteric ideas as the contents of dreams, visions induced by privation from water, food, and sleep during wilderness vigils, trance incidents, encounters with animal spirits, the actual acquisition of shamanic powers, or battles with witches and other evildoers. Carvings of these experiences appear on some of the more complex shamanic objects such as ivory amulets, staffs, and the figure groups on the backs of the oystercatcher rattles. They are also painted on shamans' aprons and box drums. Obviously, without communication with the shamans themselves, the specific interpretation of this imagery can never be known. Some iconographic meaning can be attached to certain of the figures and motifs found throughout much of the shamanic art. However, many objects also depict spirits that were the unique property of individual shamans. Here again, the powers and attributes of each would only have been known by the ritualist with whom they were allied, and such information is usually not available. To complicate the issue further, the practitioner's paraphernalia may include objects that were not made by artists known to the shaman who used them. Some of these elements originated in cultures far removed from the Northwest Coast and were undoubtedly incorporated into shamanic kits because they were thought to possess special powers that existed outside of the community (Jonaitis, 1986, p. 123). One Tlingit shaman's necklace at the University Museum in Philadelphia, for example, has among its amulets two Eskimo ivory carvings, a bird form of metal thought to be from Siberia, and a shell frog of Southwest Indian origin (no. 5). Athabaskan pieces are also often found in shamanic context. To such objects, the shaman could attach whatever meaning he wished.

It is also known that shamanic art was exchanged among the neighboring Tlingit, Haida, and Tsimshian. Bill Holm (1983, p. 119, no. 203) mentions the possibility that all of the so-called soul catcher amulets used by these three groups may have been made by the Tsimshian, and Frederica de Laguna notes (1972, pt. 2, p. 679) that "in many cases the masks, rattles, and other objects [used by the Tlingit shaman] may not have been made by the Tlingit, but have been imported from the Tsimshian, and there is no guarantee therefore that the animal which appears on such an object is interpreted in the same way by the Tlingit shaman as by the Tsimshian carver."

Certain of the objects illustrated here are accompanied by quite detailed descriptions of their iconography taken from notes that were made by their collectors, of whom George T. Emmons was the foremost. There is, however, no way of proving that such documentation is accurate, and this data should be approached with caution. While some of it may have been obtained from shamans who had renounced their practices and become Christianized, it is hard to believe that the objects themselves and the stories behind them could have quickly lost so much of their power and mystique that they might be casually discussed with the outsiders who collected them. The potent material that was gathered from grave houses would seem to be especially difficult to document, and yet much of it comes with considerable information. Frederica de Laguna (in Emmons, 1991, p. viii) has recently suggested a plausible explanation of this situation. She notes the great efforts that were being made at the turn of the century by missionaries and the U.S. Navy to eradicate shamanism. A number of ritualists were publicly disgraced or imprisoned, and many subsequently gave up the practice, leaving their paraphernalia to be taken by collectors. Under such circumstances, they may have been willing to talk about the meaning of the objects they had once used. Such defrocked practitioners might also have given information about objects that had belonged to other shamans.

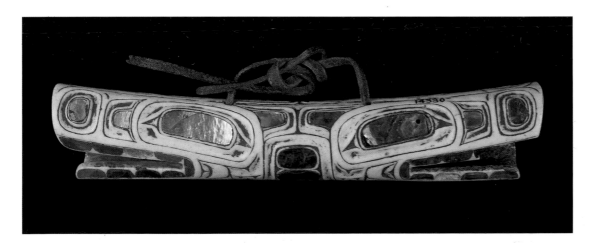

No. 6. *Tsimshian Soul Catcher*. Bone pendants of this nature, known as soul catchers, were worn by shamans. They were often used to hold the errant souls of ill individuals, which were captured and then returned to the patient to effect a cure. All of them have an open-mouthed animal head, here probably that of a bear, at each end. Although this one is traditionally said to be from the Haida, all bone soul catchers are now thought to have been made by the Tsimshian (see p. 197). Collected by Edward Ayer, probably from Carl Spuhn, 1892 (see Cole, 1985, p. 125). Bone, abalone, and rawhide; length 7⅞ inches; c. 1840–60. Field Museum of Natural History, Chicago, 14330. Given by Ayer, 1897

The considerable literature about Northwest Coast shamanism has been consulted to provide as much context for the illustrations as possible. More has been written about Tlingit shamanism than about that of any of the other groups. It has long been recognized that shamanism was a particularly strong element of this culture. John Swanton (1908c, p. 463) wrote in 1905, "It would appear that, taking the people of the North Pacific coast as a whole, shamanism reached its climax among the

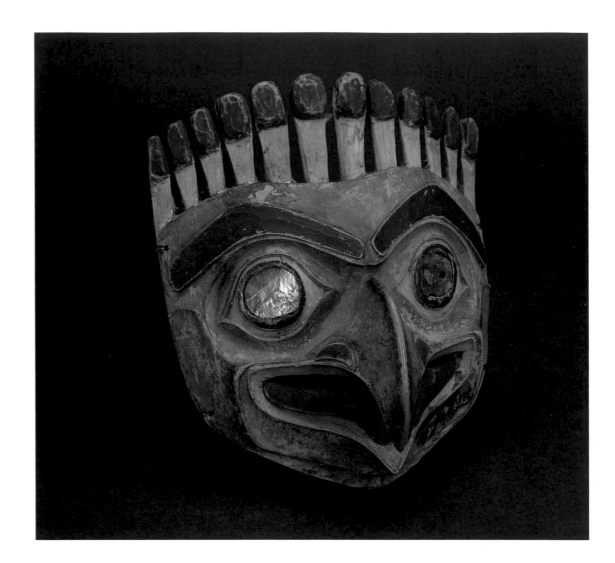

No. 7. Tlingit Maskette. According to Emmons (n.d., Notes), who collected it at Klukwan, this maskette was the property of a Chilkat shaman. The sharply downturned beak and prominent feathers over the head identify it as an eagle spirit helper. Wood and black, red, and blue pigment; height 5 inches; c. 1840–60. Field Museum of Natural History, Chicago, 79080. Purchased from Emmons, 1902

No. 8. Tlingit Mask (opposite). Because of the round and relatively flat features of the face and the way in which the "eyes, nose and mouth are formalized and reduced in prominence," King (1979, p. 84, pl. 82) has concluded that this mask represents the moon. Its light blue color and the fact that some shamans' spirits were celestial further support this theory. Collected by Sheldon Jackson in the area of Sitka, 1870–79. Wood and red, black, and blue pigment; height 8¾ inches; c. 1830–50. The Art Museum, Princeton University. On permanent loan from the Department of Geological and Geophysical Sciences, 3912. Given by Jackson, 1892

Tlingit." Many of the descriptions therefore apply directly to Tlingit practices and beliefs. It is far beyond the purposes of this book to differentiate between aspects of shamanism as it was observed by each separate Northwest Coast group.

The largest single category of objects represented is masks and maskettes, and it will be noted that every example is of Tlingit origin. In the general literature concerning mask use along the Northwest Coast, there are references that they were employed by shamans of other tribes. However, as research progressed, it became apparent that there were no documented non-Tlingit examples that could be shown to have been worn by or to have been the property of shamans. Regarding the Haida, it is known that masks were used by secret societies and for crest display, but we have yet to find a single example known to have been the property of a shaman and used in performances. Among the Tsimshian, as Marie-Françoise Guédon (1984b, p. 197) has written, "masks are not used during shamanic performances." She (1984a, p. 152) further states that "a Tsimshian shaman does not wear masks." Writing of shamanic practice among the Haida of Masset, Swanton (1905, p. 43) quotes Franz Boas as stating that "the shaman does not wear a mask." The same could be said for the Bella Bella, the Bella Coola, the Kwakiutl, and the Westcoast. We have therefore concluded that only Tlingit shamans used masks. Because of the relative proximity of the Tlingit to

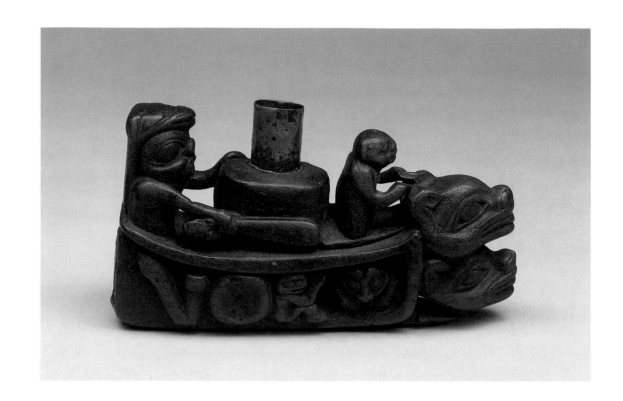

No. 9. *Tlingit Pipe*. A shaman in a frog headdress is singing and beating a drum in a spirit canoe. In the bow a human sits over the heads of two land otters; a bear and another seated human are below. Although Emmons (n.d., Notes, NMAI) refers to it as a shaman's pipe, this late-nineteenth-century example was made for trade, as were quite a number of wood and argillite pipes depicting shamanic activities. Collected by Emmons from the Hoonah on Chichagof Island. Wood and brass; length 6½ inches; c. 1880–1900. National Museum of the American Indian, Smithsonian Institution, Washington, D.C., 1/2910. Purchased from Emmons, 1907

the Eskimo, among whom masks were used extensively by shamans, influence from the north seems evident. Cultural exchange of other object types between the two peoples is well documented by Holm (1988).

For this and other reasons, the majority of the objects shown in this volume are also Tlingit, although as many examples of high quality from other peoples have been included as possible. The Haida and Tsimshian are fairly well represented, but the Bella Coola, the Bella Bella, the Kwakiutl, and the Westcoast are not. With the exception of the Coast Salish, who produced large quantities of art for shamans' use, it seems that the further south along the coast one proceeds, the rarer shamanic art becomes, a phenomenon that is difficult to explain. Perhaps among certain groups the intangibles, or the songs, dances, and performances that were the primary elements of the shamanic ceremonies, were so effective that the tangibles, or the supplementary art objects, were not thought to be necessary.

From one point of view, however, the Kwakiutl may be thought to have produced a vast amount of art that is connected in some way to shamanism. It has often been mentioned that the events accompanying the initiation of a novice into the *hamatsa* dancing society are closely related to those through which a shaman formed his spirit alliances (see, for example, Drucker, 1940, p. 230). The ceremonies included many feats that were similar to those practiced during shamanic performances such as transforming oneself into another type of being, sucking away diseases, displaying magic, and projecting diseases into the audience (Waite, 1966, p. 269). In addition, prior to his initiation, the novice also had spent time away from his community in the forest, where he was exposed to supernatural influences and formed an alliance with a guardian spirit. Every *hamatsa* member was thus regarded as a shaman of a sort.

The objects associated with the ceremony can therefore be regarded as at least related to shamanism. They comprise a wide array of large, spectacular masks,

including some of the transformation type, which can be opened to reveal a second and even a third face beneath the first; rattles; puppets; cedar bark head and neck rings; tunics; and aprons. However, such works form a distinctive expression of their own. They were used in a context quite different from a shamanic séance, and were thus not actually employed by practicing shamans such as those discussed in this volume. This accounts for their omission here.

Careful readers will also note another slight inconsistency: In the discussion of the antiquity of shamanism in Chapter II, attention is given to certain examples of the prehistoric art of the southern Northwest Coast, but in the discussion of the historic period, no mention is made of the shamanic art of the Coast Salish of the southern region, which also includes figures representing shaman helpers that were employed in dramatizations of the dangerous spirit canoe voyages to the underworld that were taken to rescue lost souls, and spirit rattles used as power figures (see, for example, Holm, 1983, p. 30, no. 23; 1987b, no. 11, p. 48). In style, Coast Salish art, being of a stark, minimal nature, stands completely apart from the expressions of the northern groups represented here and therefore has been omitted.

This volume thus concentrates on the shamanic art of northern Northwest Coast peoples, particularly the Tlingit, among whom shamanism had its strongest manifestation. Despite the many problems of interpretation and documentation, the amount of information that is available, combined with the large number of objects of high aesthetic quality, justifies its publication. Because of their artistic importance, a number of relatively well-known works are included among the illustrations. Efforts have also been made to locate exceptional examples that have not been previously published. A surprising number that had not yet been photographed have been discovered in museum storerooms and even on exhibition. The objects represent a significant but less known aspect of this vigorous Native American expression. It may never be possible to grasp fully the ceremonial context of these pieces, but by bringing them to light we hope to provide some insight into the beliefs and practices that brought about the creation of such powerful works.

No. 10. Tlingit Bowl. Emmons (n.d.) describes this object as a shaman's feast dish, claiming that it had been passed through a "long line of Doctors." The depth of the carving, however, would seem to render it impractical for the purpose of eating, and it may have been used to hold medicinal herbs or magical substances. A reclining shaman, probably in a trance, holds a staff in the right hand. Emmons identifies the animal figure below as a mouse although it could be a land otter. The head on the right may be that of a devilfish, as its tentacles are carved along both sides of the bowl. Collected by Emmons at Klukwan, 1884–93. Wood and traces of red and black pigment; length 28⅞ inches; c. 1790–1820. American Museum of Natural History, New York, E 1555. Purchased from Emmons, 1893

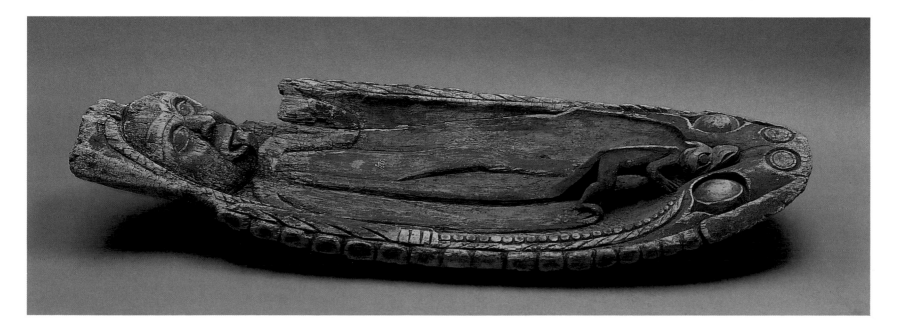

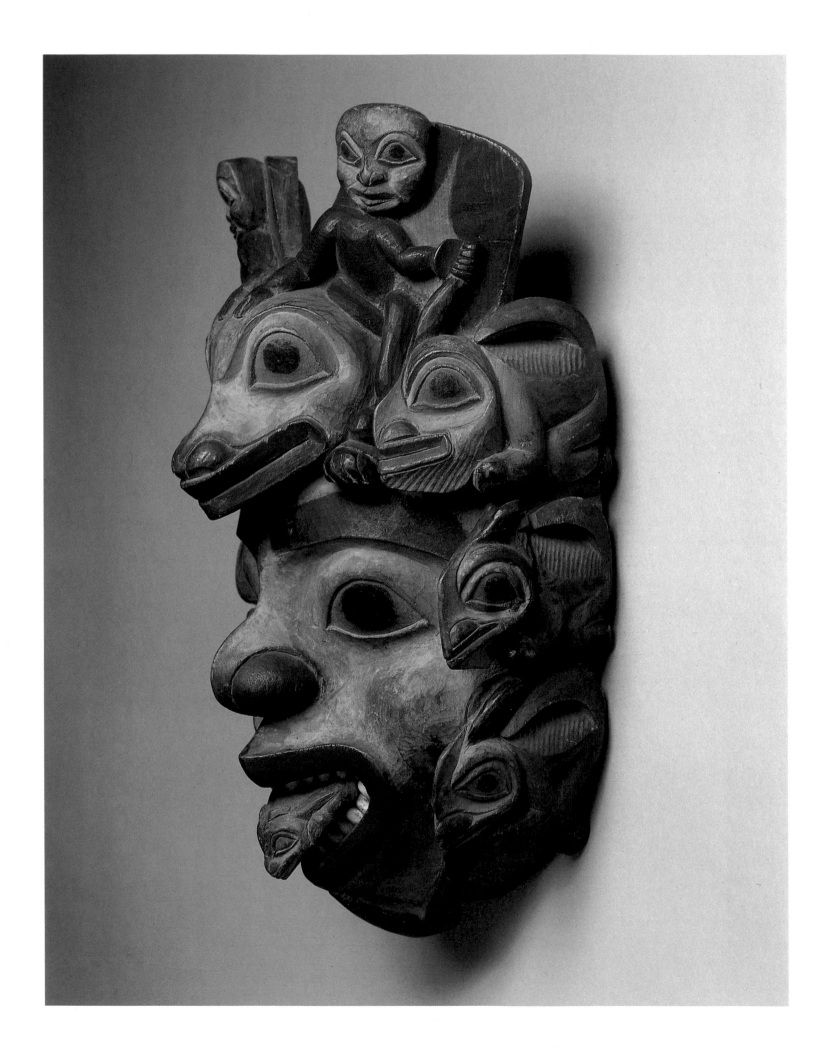

CHAPTER II

THE OLDEST RELIGION

ALTHOUGH DATING to at least as far back as the Mesolithic, if not as early as the Upper Paleolithic, shamanism has persisted in its most ancient form among a fairly large number of non-agricultural, hunting societies of the nineteenth and twentieth centuries, including various north European and Siberian, as well as American Indian peoples.

JOAN M. VASTOKAS

SHAMANISM is frequently described as humanity's oldest religion. Some scholars, however, do not believe that it can be properly classified as a religion, pointing out that shamans are not priests, that they do not supervise the moral order of their communities, and that they do not assume formally designated responsibilities. Furthermore, it is claimed that shamans neither worship specific deities nor follow a carefully prescribed set of liturgies and laws (see Guédon, 1984b, p. 175). It seems, nonetheless, that the more we examine the structures and functions of shamanism, the more it can be understood to be a form of religion, albeit one that is not codified and standardized.

Shamanism possesses several elements that are essential to any definition of a religion. Perhaps the most important is the fact that shamanism concerns itself with the same issues that are addressed by the established, formally organized faiths. Chief among these issues is the metaphysical question of what exists beyond the visible world and how whatever does exist can be brought to benefit the individual and the community. Because shamanism is often associated with nonliterate cultures, no formal written structure or creed governs it. However, in the absence of the religious texts that are created by literate societies, shamanism has developed its own equally complex and widespread systems of symbols that serve exactly the same purposes.

Other interesting similarities between shamanism and religion can also be noted. Although shamanism does not identify a single supreme being or a series of named deities in its pantheon, the spirits of animals provide this focus and represent a parallel concept. In addition there are recognized places of power in various parts of the world, such as cave sanctuaries and other sacred precincts, where shamanic rituals are repeatedly held. These sites often have even greater sacred significance than the churches, temples, and other houses of worship that are constructed to serve the more formally organized religions.

It is true that a shaman is not a priest. He does not represent himself as an interpreter of the laws and strictures issued from on high, nor as one who can pass them on to his people. Shamans nonetheless do communicate with the animal spirits and their powers and bring them to the assistance of the people they serve. As practitioners, they have recognized and often well-defined duties. Like priests, shamans also usually have titles, and when they do not, they are given a special name.

No. 11. Tlingit Mask. As one of the most complex of all Tlingit shamans' masks, this example combines representations of three guardian spirits in animal form and two in human form. Emmons (n.d., Notes, NMAI) identifies the animal at the top center as a land otter, whose tail can be seen on the chin of the mask. He describes the six heads on the sides as those of mountain goats, although Dockstader (1960, no. 87) calls them frogs. A frog emerges from the mouth, and the two human figures at the top are unidentified. The mask is said to have passed through two generations of shamans and to have been owned by Kowee, a hereditary chief of the Auk tribe who was also a shaman; he died around 1850 (Emmons, n.d.). Seven of a set of eight masks (one having been exchanged back to Emmons in 1922) and thirteen other items from Kowee's grave house at Berner's Bay are in the American Museum of Natural History, New York (E 2683–2703; de Laguna in Emmons, 1991, p. 456, table 31). This particular mask was removed from Kowee's grave house several years after his death and sold to Emmons at Point Lena sometime before 1893. Wood, opercula, and red, black, and blue-green pigment; height 13 inches; c. 1830–50. National Museum of the American Indian, Smithsonian Institution, Washington, D.C., 9/8032. Purchased from Emmons, 1919

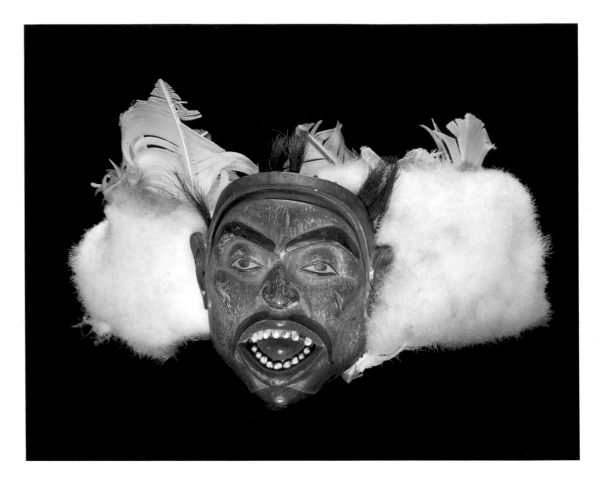

No. 12. Tlingit Headpiece. The protruding tongue and half-closed eyes represent a dying man, the effect of which is enhanced by open wounds in the center of the forehead and on the left cheek. They correspond to those on a full-sized mask from the same grave house (no. 58). Some shamans owned both a maskette and a full-sized mask of the same spirit helper. Collected by Emmons in 1884–93 from the nephew of Nolk, a Hutsnuwu shaman who died about 1865 and was buried with his paraphernalia in a grave house at Chait Bay, Admiralty Island. Wood, human hair, eagle tail feathers, swansdown, opercula, and black, red, and blue-green pigment; height 5¼ inches (maskette only); c. 1840–60. American Museum of Natural History, New York, E 945½. Purchased from Emmons, 1893

Although there is no written universal shamanic creed or doctrine, there are some remarkably consistent behavior patterns and traits associated with the system as it is practiced in various widespread parts of the world and at different times that reveal a shared world view. Undoubtedly, these common denominators have as much to say about what makes us human as they do about the evolution of religion. Mircea Eliade (1964, p. 504) has referred to the "ecstatic experience" of shamanism as a "primary phenomenon because we see no reason whatever for regarding it as the result of a particular historical moment, that is, as produced by a certain form of civilization. Rather, we would consider it fundamental to the human condition, and hence known to the whole of archaic humanity. . . ." Therefore, whether we study the shamanic practices of the Huichol of Mexico, the Eskimos of the Arctic, the Aborigines of Australia, the peoples of northern Siberia, or the Indians of the Northwest Coast (to mention only a few), certain similar basic elements and variations on them will always be found.

Shamanism is generally associated with nonliterate cultures that subsist on hunting, gathering, fishing, or a combination of these activities. These groups have little or no agriculture and often migrate with the seasons to follow their food sources. To bring food, health, and protection from evil, they seek connections with the animal powers through the rituals of the shaman.

To become a shaman, an individual must receive a sense of mystical vocation that marks him as a person possessing the unusual abilities a successful practitioner must have. These exceptional traits might be acquired through heredity and may be recog-

nized at a young age, or they could come at any time during a person's life through exposure to spirit powers. Awareness of the presence of these forces is usually occasioned by the onset of some sort of illness, visions, or particularly vivid dreams. Once the call has been received, it must be accepted. To do so, the individual removes himself to a setting away from the community. This could be in the depths of a forest, in the middle of the desert, on top of a height, in a cave, or anywhere it is thought his exposure to supernatural forces might be attained.

Thus removed and isolated, the novice seeks to establish connections with the spirit world through a series of ecstatic trances that are brought on by such means as using hallucinogens or other drugs, enduring privation from food, water, or sleep, or drinking salt water or other emetics. Usually this wilderness sojourn is carried out under the guidance of another shaman or assistant, and it takes the form of the mystical death and rebirth of the novice. It is during this time that the neophyte begins to learn of the world of the dead and of animal spirits, and to speak in the secret languages of animals. From these experiences, the shaman gains his powers to work and communicate with the supernatural.

The majority of the spirits with which the shaman makes his alliances are animals. This reflects a widespread belief within the cultures that practice shamanism that animals inhabited the earth long before human beings and are therefore essential to people because of the unique knowledge they possess (Campbell, 1983, pp. 48–49). Animals are also regarded as superior to humans in their ability to communicate, and

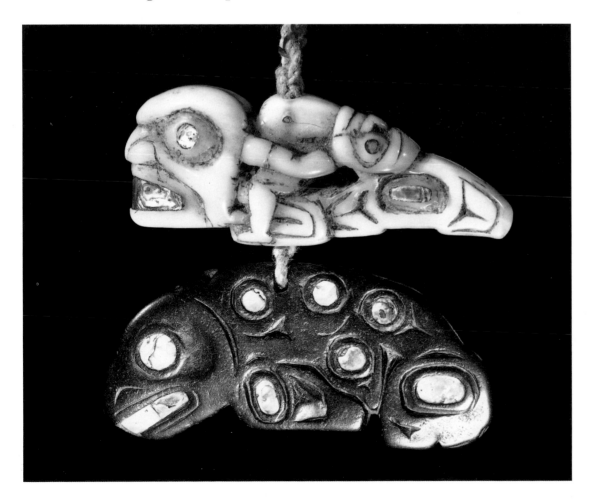

No. 13. *Haida Amulets*. The ivory amulet (top) shows a grimacing head with a kneeling figure and a raven behind. The stone amulet is a double-headed sea mammal. Although collected by Charles F. Newcombe at the Tsimshian village of Lakalzap (Greenville), the amulets are said to be of Haida origin. This is corroborated by the use of argillite, a material found only on the Queen Charlotte Islands, the home of the Haida. Ivory, argillite, abalone, and twine; length of ivory amulet 2¼ inches; c. 1820–40. Royal British Columbia Museum, Victoria, 9546. Purchased from Newcombe, 1907

while they understand us, we know little about them (MacDonald, 1983b, p. 120). A shaman must thus learn to make connections with this other world to be properly prepared to carry out his duties.

When the novice returns to the community, he is regarded as someone reborn and sometimes must even be reeducated into the ways of his society. He achieves recognition as a shaman when he is able to prove that he knows the chants, songs, secret languages, and stories associated with his practice and that he is capable of engaging in trance activities. When he has demonstrated his powers, he is given the great responsibility of overseeing the spiritual equilibrium of the community. His specific duties vary from culture to culture but always include curing illness. The belief that sickness is caused by the loss of one's soul or by witchcraft is widely held. Many shamanic séances specifically seek to restore the soul to its host body to effect a proper cure. If witchcraft is thought to be the cause, the shaman must locate the evildoer and cause that person to remove the spell. The dances, chants, and songs that a shaman performs are accompanied by percussion instruments such as drums, rattles, and staffs that provide the rhythm. They are believed to summon spirits and to put the shaman into the trance state that will enable him to communicate with the animal powers.

When he achieves a state of ecstasy, a shaman is capable of many actions that are far beyond the abilities of ordinary people. For example, he is believed to possess the mystical knowledge of flight, which accounts for the use of feathers and bird imagery in much of shamanic performance and paraphernalia. Flying enables the shaman to visit the three levels of the universe: earth, air, and water. These are respectively the middle, upper, and lower worlds that exist in shamanic lore throughout the world. They are thought to be connected by a central axis, which might take the form of a house post, a tent pole, an opening in the middle of a tent, a pillar, or a tree (Eliade, 1964, pp. 259–64).

In addition to serving as an intermediary between the supernatural and the real world, the shaman is also believed to have the power to transform himself into other beings. A shaman is thought literally to become possessed by the spirit he calls upon for assistance during a performance, and he thus enacts his transformation. When he is not performing, the practitioner might make himself into another creature to carry out his responsibilities.

Reverence for bones is another common shamanic theme. Because bones are the longest lasting parts of the body, it is believed that they are the source of all life, that the soul resides in them, and that animals can be reborn from their bones (ibid.,

No. 14. *Haida Staff.* Although this object has been tentatively identified as an amulet (Haberland, 1979, p. 110), it was probably carried as a staff (see also no. 22). It is not certain that it was used by a shaman, but because such carvings were not commonly displayed by chiefs at potlatches or other ceremonies, it is included here. A raven has a reclining human figure wearing an animal headdress on its back. At the left is a kneeling human figure, its head thrown back. Bone; length 13 inches; c. 1850–70. Museum für Völkerkunde, Basel, IV A 101. Purchased from W. O. Oldman, 1908

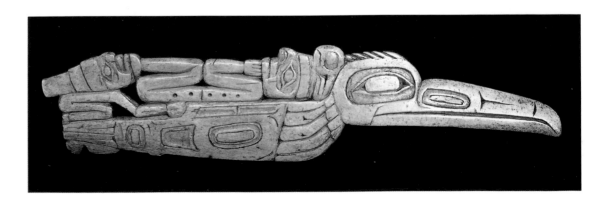

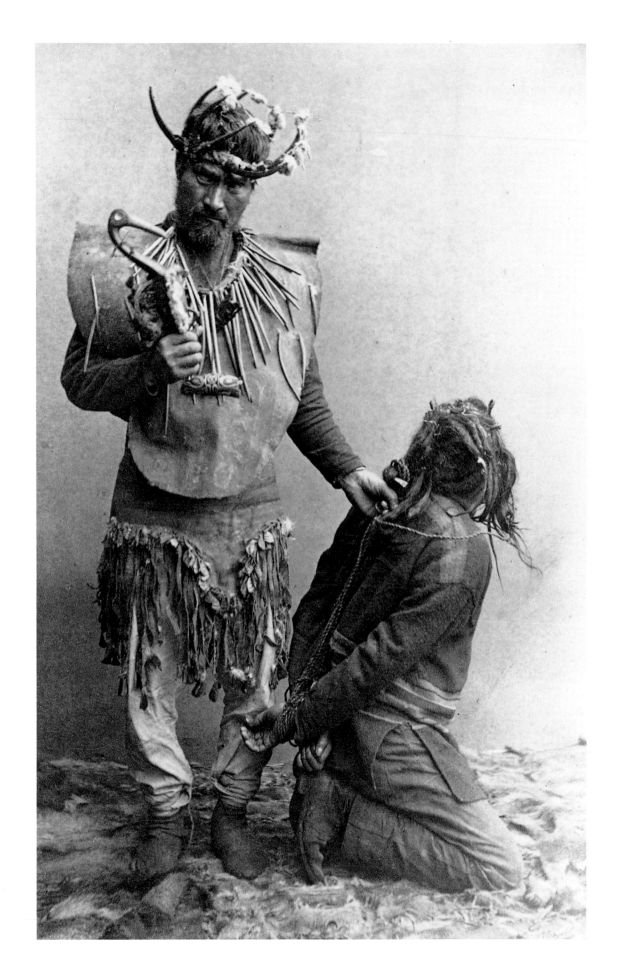

Fig. 4. Shaman Torturing a Witch. This is another of the six photographs that Edward de Groff made at Sitka in 1889 (see fig. 1). Both de Laguna (in Emmons, 1991, p. 401) and this author (Wardwell, 1993, p. 47) have stated that the shaman and the other man switched places for the photographs showing the shaman in a curing pose. Examination of other images in the series, however, shows us to have been mistaken. The shaman, Dr. Pete, is blind in one eye and wears a crown, a necklace with bone and ivory pendants, an ivory amulet (no. 278), a tunic, and an apron with puffin beak and deer dewclaw appendages. In his right hand, he carries an oystercatcher rattle (no. 415). Photograph by Edward de Groff, Sitka, 1889. Alaska State Library, Juneau, PCA 91–28

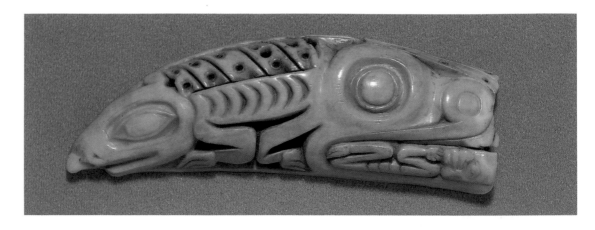

No. 16. Tlingit Amulet. Emmons (n.d., Notes, NMAI) identifies the large figure as a sea bear devouring a human, and states that the carving represents the visions of a shaman who was dreaming or in a trance state. The figure at the left, with its rib bones prominently shown, is probably a land otter. Collected by Emmons from the grave house of a Hoonah shaman near Hoonah. Whale tooth; length 5⅜ inches; c. 1840–60. National Museum of the American Indian, Smithsonian Institution, Washington, D.C., 9/7951. Purchased from Emmons, 1921

No. 15. Tlingit Amulet. Whereas most Tlingit art is symmetrical, the asymmetrical composition of this amulet reflects a tendency in some shamanic objects to ignore certain stylistic canons of this expression. This may suggest that such objects are not part of the everyday world but linked to the realm of the supernatural. The rich composition of interrelated forms shows a bear devouring a human, with a devil-fish below. A seated human figure is at the lower right, and an animal head, identified by Emmons (n.d.) as a whale, appears at the upper right. The heads of two sand hill cranes are at both sides. Collected by Emmons at Dry Bay, 1884–93. Walrus ivory; height 4⅞ inches; c. 1820–40. American Museum of Natural History, New York, E 2708. Purchased from Emmons, 1893

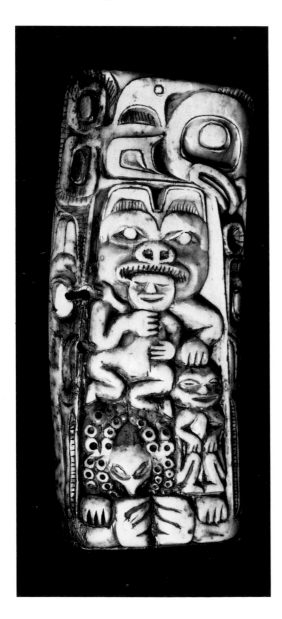

pp. 160–65). For these reasons, bones are never destroyed but rather carefully preserved in shamanic societies. They are found in the kits of shamans in all parts of the world. They may appear as bundles tied together, as larger single, undecorated examples, or as complete skeletons of birds and small animals. In certain places, with the Northwest Coast being a prime example, some bones are elaborately carved and used as amulets in shamanic performances. Objects of ivory, antler, and teeth have similar significance and use.

Closely related to the presence of actual bones is their depiction, usually as skeletons, on some of the objects and costumes used by shamans to proclaim their wearer as one who has died and been resurrected. He is thus seen to have left the profane world behind in order to operate in the supernatural realm (ibid., p. 63). A commonly encountered variation on this theme is the so-called x-ray imagery in which both the inner and outer parts of the body – the organs and the skeleton – are represented (Campbell, 1983, pp. 131–33). Such images not only symbolize the magical anatomy that the shaman can sometimes see while he is in a trance, but also relate to the shamanic iconography of bones. An allied motif often encountered in shamanic art is the devouring figure, which like the others, has obvious reference to death, rebirth, and transformation.

Controversy continues over the meaning of the various congruencies found in shamanic art from around the world. Some structuralist scholars see representations of ancestors or death cult imagery where we "shamanists" find x-ray depiction, or interpret trees, posts, and poles as symbols of agriculture and fertility rather than axes connecting zones of the cosmos. The structuralists claim that such comparisons are superficial and do not take into account variables of the environment, historic events, or social interrelationships, and they debunk the entire concept of a shamanic world view. Their opinions are summarized by Aldona Jonaitis (1986, pp. 144–45). We nonetheless find the evidence of the existence of such shared concepts sufficiently persuasive, even if we admit it is not always possible to know as much as we would like about the conditions under which shamanic material was made.

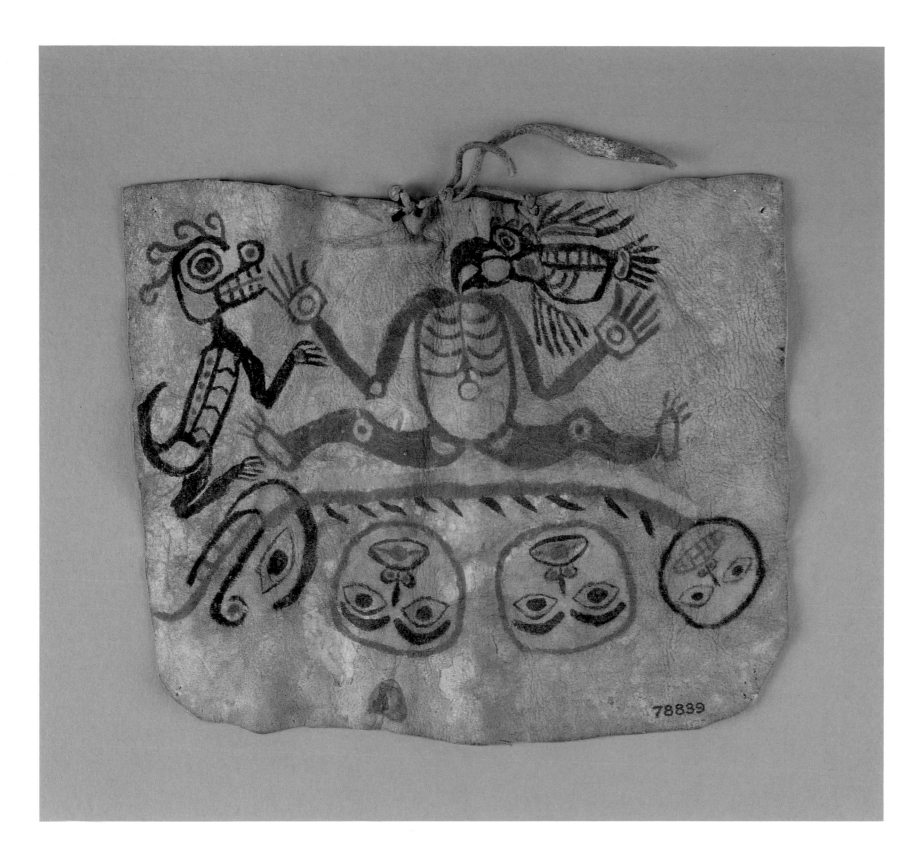

No. 17. Tlingit Miniature Tunic. Originally the costume was made for a doll similar to that shown in no. 61. Despite its small size, its iconography is as complex as that painted on any full-scale tunic. Emmons (n.d., Notes) describes the painted motifs as a headless man with an eagle "eating" the neck, a wolf, and, at the bottom, a canoe-shaped spirit fish carrying two human heads. Collected from a shaman of the Stikine tribe at Wrangell. Deerskin and black, red, and blue pigment; height 5⅝ inches; c. 1840–60. Field Museum of Natural History, Chicago, 78839. The Carl Spuhn Collection. Purchased from Emmons, 1902

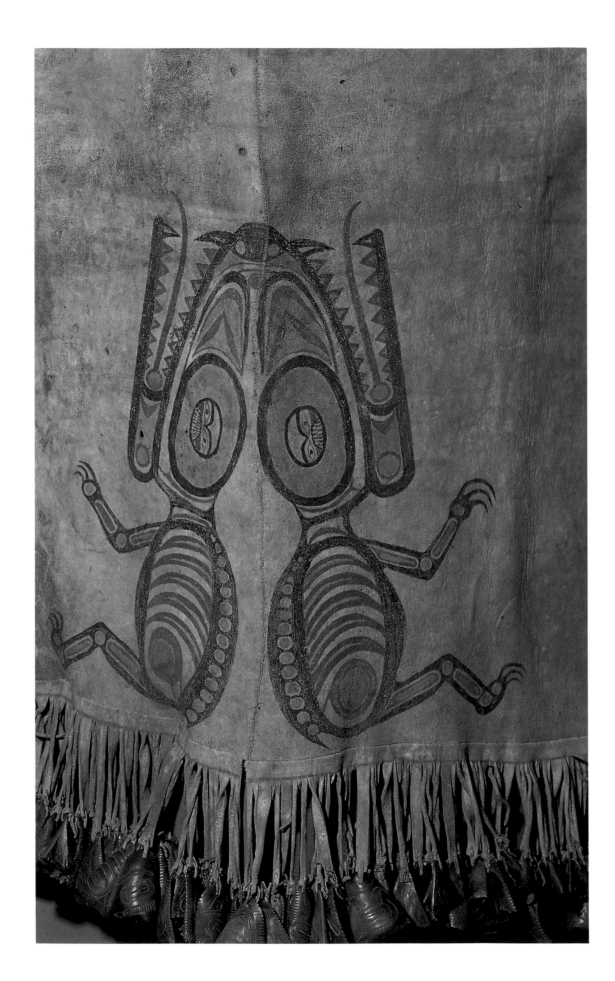

No. 18. Tsimshian Apron (detail). The bold painting on this shaman's apron depicts a splayed bear in the x-ray style, with a row of devilfish tentacles along the spine. The faces of spirit figures appear in the eyes, and each of the caribou hooves tied onto the fringes is carved with an animal or human face. Emmons (n.d., Notes, NMAI) says it was "worn by an old chief shaman of Kispiox," where Emmons collected the piece. Caribou skin and hooves, and black, red, and blue-green pigment; width 42 inches (entire apron); c. 1840–60. National Museum of the American Indian, Smithsonian Institution, Washington, D.C., 6/6315. Purchased from Emmons, 1917

The correspondence of these and other aspects of shamanism in widespread parts of the world would suggest that it is an ancient system. Indeed, certain of the elements mentioned above have been found in the cave paintings of the Magdelenian culture in Europe from about 18,000 to 12,000 B.C. Although in this period the representation of the human form is not as common as that of animals, there is evidence that when it does appear it depicts shamanic activities. Scenes of dancers wearing animal costumes at Les Trois Frères, Le Gabillou, and Lascaux in southern France suggest transformation. The well-known painting at Lascaux of the male figure who falls over backward with his mouth wide open has been interpreted as representing an ecstatic trance. An example of bird imagery also at Lascaux corresponds to the use of this motif in shamanic art of much later periods (Campbell, 1983, p. 156).

Because of its size, strength, and anthropomorphic appearance, the bear appears in shamanic iconography wherever the two exist together. Shamanism could even have been practiced as early as Neanderthal times. The first known evidence of human burial occurred among the Neanderthal of the Mousterian period as far back as 70,000 to 50,000 B.C. Such activity indicates a belief in the existence of the hereafter and the beginnings of a concept of the spirit. The roots of shamanism in the Old World therefore stretch back to at least the Upper Paleolithic period, although they could be considerably older.

It has been suggested that the fundamental elements of shamanism were carried to the New World by the earliest peoples who came across the Bering Strait between Siberia and Alaska at the end of the last ice age, between 10,000 and 12,000 years ago (Furst, 1973–74, p. 52). At that time, due to the rising levels of the sea, the Bering Land Bridge no longer existed, and the migrations occurred either by boat or over the ice in winter (Arutinov and Fitzhugh, 1988, p. 118). The archaeological remains from this

No. 19. Tlingit Amulet. As in no. 18, a skeletonized bear with a row of devilfish tentacles along the spine is depicted. It crouches over two spirit figures represented as being either dead or in trance states. Bone and rawhide; length 2¼ inches; c. 1840–60. Private collection

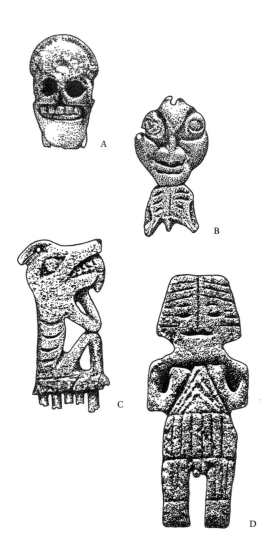

Fig. 5. Prehistoric Carvings. Each of these four objects from British Columbia may suggest the existence of a prehistoric shamanic belief system and iconography on the Northwest Coast. Death imagery, skeletonization, the protruding tongue, and what could be a shaman's costume can be found among the sculptures. These and similar pieces are dated from about 1100 B.C. to the late prehistoric period. A: *Skull carving.* Collected at Locarno Beach, Fraser River Delta. Deer bone; height 1½ inches; c. 500 B.C. Museum of Anthropology, University of British Columbia, Vancouver. B: *Head and torso carving.* Collected at Marpole Site, Fraser River Delta. Antler; height 1⅞ inches; 1100 B.C.–A.D. 350. Museum of Anthropology, University of British Columbia, Vancouver. C: *Comb bridge with a seated wolf or bear.* Collected at Garden Island Site, Prince Rupert Harbor. Sea mammal bone; height 2¼ inches; A.D. 800–900. Canadian Museum of Civilization, Ottawa. D: *Figure pendant.* Collected at Montague Harbor. Antler; height 3½ inches; A.D. 200–1200. Royal British Columbia Museum, Victoria. Drawings by Deborah Reade after Carlson, 1983a, pp. 108, 141, 146; and Clark, 1971, p. 66

early period consist only of chipped stone tools and hunting points and therefore do not provide any artistic evidence of a shamanic system in the New World. However, by the time sculpture begins to appear during the Olmec period in Mexico in about 1200 B.C., figures suggesting man-animal transformation are found. Later pre-Columbian objects show curing rituals, bird imagery, animal spirit helpers, masked dancers, and shamans in combat with evildoing witches (Furst, 1973–74, pp. 44–56).

Although the parallels are not quite as clear, Joseph Campbell (1983, pp. 212–16) also notes hints of shamanic iconography in the form of masked dancers and bird imagery on some stone and shell artifacts from Mound Builder sites in the Eastern Woodlands of North America, dating from about A.D. 700 to 1200. In general, it also appears that the world view of the ancient Woodland Indians, who lived from about the fifth century B.C. to the time of Columbus, like that of all Native Americans, was strikingly similar to that which has already been described. Their universe was composed of the sky world, the earth, and the underworld, inhabited, respectively, by a celestial bird, people and animals, and an underwater monster. These three realms were connected by a central axis, and only shamans in an ecstatic trance or those who had died could travel from one level to another (Penney, 1985, pp. 180–98).

The archaeological record from other parts of the New World suggests that evidence of shamanism would be found among the ancient objects unearthed at various sites along the Northwest Coast. No figurative sculpture of any kind has yet been found dating from earlier than the second millennium B.C., and the first known artifacts that might refer to shamanic practices date from about 500 B.C. to A.D. 200. Found at several places along the Lower Fraser River in British Columbia, these objects include bone and antler carvings of a skull (fig. 5a), what appears to be a horned serpent, a sea monster, a human head, and a torso showing the rib cage (fig. 5b and Borden, 1983, p. 143, figs. 8:12a, 8:16–19). To these can be added a fragment of the soapstone pipe excavated at Yale, British Columbia, and tentatively dated to A.D. 400–1200. (Carlson, 1983b, pp. 200–201, fig. 11:3). It shows a human face with a protruding tongue, an important motif in Northwest Coast shamanic art of the historic period. Another object prominently displaying this detail is a bone comb with a bear or wolf figure seated on its bridge dating from about A.D. 800. They x-ray style is also evident through the depiction of the animal's rib bones (fig. 5c). Although the association of all of these objects with shamanism must remain speculative, their forms and details suggest the connection.

Six small elk antler sculptures in male and female form, dated to between A.D. 200 and 1200, also have possible shamanic significance. Five of them were found at sites around northern Puget Sound, and one example was excavated at Kwatna Bay on the central coast of British Columbia (Carlson, 1983c, p. 124). Stylistically they all represent principles of southern Salish carving, and the Kwatna example may therefore have been a trade object. The three thought to be female wear fringed skirts similar to those worn by shamans, and all are perforated so that they could have been worn as pendants. Although there is no contextual evidence that would associate these figures with shamans (fig. 5d), some believe that they were power objects used by such practitioners, and they have been compared to pendants used by Siberian shamans (Carlson, 1983b, p. 201, fig. 11:4; 1983c, pp. 123–24, fig. 7:2; Holm, 1987b, p. 52).

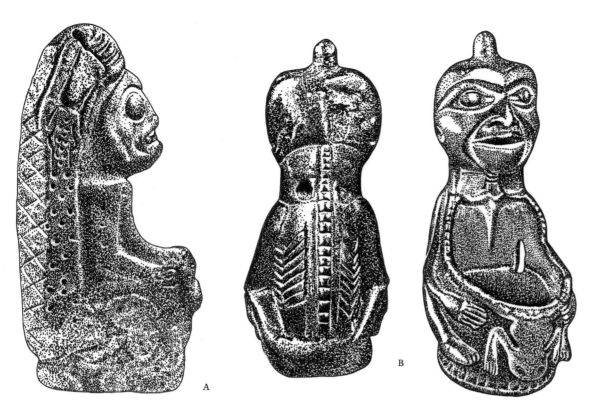

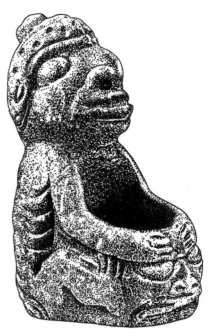

Fig. 6. Prehistoric Seated Figures Holding Bowls. These four seated stone figures are among about sixty that have been found at sites around the Fraser River and on Vancouver Island in British Columbia; most are thought to date from the first millennium A.D. All depict elements that are associated with shamanism, including x-ray imagery and animal and monster forms. In addition, the objects themselves may have been used by shamans in various ways. A: Collected at North Saanitch, Vancouver Island. Height 14 inches. Seattle Art Museum, 83.223. B: Collected at Lytton, Fraser River. Height 5¾ inches. Royal British Columbia Museum, Victoria. C: Collected at Lytton, Fraser River. Height 3½ inches. Simon Fraser University Museum of Archaeology and Ethnology, Burnaby, British Columbia. D: Collected at Marpole Site, Fraser River Delta. Height 4 inches. Museum of Anthropology, University of British Columbia, Vancouver. Drawings by Deborah Reade after Duff, 1975, pp. 63, 66, 74, 76

A number of ancient bone objects from scattered sites in British Columbia have also recently been said by George MacDonald (1983b, p. 109) to "relate directly to shamanism." These include a pointed clawlike form with two perforations on the bottom that suggest it may have been part of a shaman's crown (ibid., fig. 15e); a bone tube pierced for suspension, with eye forms at each end similar to the soul catchers used in historic times (ibid., fig. 6:15a); and perhaps three carved pendants (ibid., figs. 6:15b–d). MacDonald (ibid., p. 105, fig. 6:6; p. 109) also discusses a group of flat slate objects of abstract human form that he suggests may have been used as mirrors by shamans for meditation or to locate the lost souls of those they were trying to cure (ibid., figs. 6:6, 6:15).

Of different form and material are the sixty-odd steatite (soapstone) and stone figures in kneeling or sitting postures, each holding a small bowl between their legs. All come from around the mouth of the Fraser River and are known to be prehistoric. Although their dates are uncertain, they are generally thought to be from the first millennium A.D. Many show evidence of skeletonization with depictions of the ribs and backbones, and some have their heads thrown back as if in a trance. Toads, frogs, serpents, and monster forms appear with a number of these figures and suggest the representation of spirit helpers.

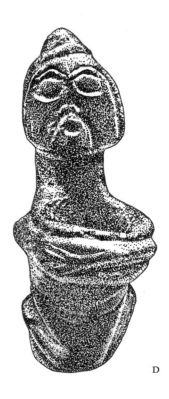

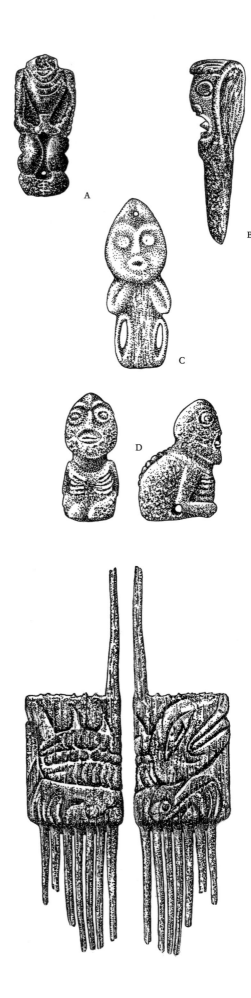

There is considerable speculation concerning the use of these carvings. Wilson Duff (1956, pp. 58–59) has summarized various accounts that suggest functions that are all connected to shamanism. He mentions that, as water containers, they might have enabled shamans "to see distant places," and cites two sources that indicate their use by shamans in puberty rites for young women. Other references suggest that they were employed to bring rain, to mix medicine, and to represent the guardian spirit of the owner. He concludes, "They could be used for clairvoyance, prophecy, curing, or other operations for which the shaman used his guardian spirit powers, and for the even greater range of uses for which the ritualist used his spells – in life-crisis rites, sorcery, love magic, etc."

Roy Carlson (1983b, p. 201), however, "suspects that they are actually tobacco mortars used in conjunction with pipes in the same style, and that both were employed in shamanic curing rituals involving smoking." He continues, "Whatever speculations one wishes to make regarding their specific use, it can be said with high probability that these bowls relate to shamanic practices." Bill Holm (1983, p. 120, no. 204) agrees with Carlson, stating that "there is no doubt that they were powerful shamans' objects."

Duff (1956, pls. 19 A, C, D, G–J; 20 A–G) also publishes a number of smaller steatite objects from the same general area and period that could have served as shamans' amulets, although he suggests that certain examples may have served as *atlatl* (spear thrower) weights. They are in the form of human figures, heads, and birds, some showing x-ray imagery and one with a pronounced protruding tongue. Several are pierced for suspension, as if to be worn as pendants.

A few late prehistoric finds from Ozette also may indicate shamanistic connections. This large Makah village on the Olympic Peninsula of Washington State was continually occupied for at least two thousand years and was an important center for sea mammal hunting. Around A.D. 1500, a huge mudslide, brought on by heavy rains and perhaps a mild earthquake, buried at least four houses with clay from six to twelve feet deep. Underneath this was a layer of water that kept the remains wet. Objects of such ephemeral material as wood and fiber were thus remarkably well preserved, and wood sculptures, utensils, baskets, mats, and rope cordage have been excavated.

Among the over 40,000 specimens thus far recovered from Ozette, several may suggest use by shamans. A small bone carving of a whale, for example, may have been a shaman's amulet, and two combs, although perhaps used for weaving, were possibly made to be worn by shamans. One bears the carving of a bird on its bridge, and the other shows a sea monster (fig. 8). Both are rendered in the x-ray style (Daugherty and Friedman, 1983, p. 193, fig. 10:10; p. 194). The shamanic connection of these objects is admittedly tentative, however. The amulet could simply have been believed to ensure success in whale hunting, with no need for the intervention of a shaman, and it is known that the historic Makah used combs for scratching as well as weaving. Nonetheless, the appearance of imagery relating to shamanic iconography is worth noting.

The imagery that appears on some of the petroglyphs of the Northwest Coast also merits discussion. The cataloguing of the forms depicted is not complete, but certain examples have been noted for their possible representation of shamanic iconography.

DOUGLAS CHANNEL

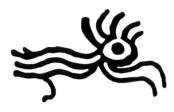

NANAIMO RIVER

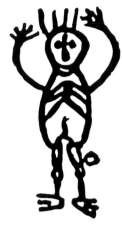

NANAIMO RIVER

Fig. 7. Prehistoric Carvings (opposite, top). These four small works are part of a group of soapstone objects, thought to date to the first millennium A.D., that have been found at various sites around the Fraser River in British Columbia. Three of those illustrated are pierced for suspension, and x-ray imagery and the protruding tongue can be seen on two examples (B and D). From various collections. A: *Human figure pendant*. Collected at Yale. Height 3 inches. B: *Human head carving*. Collected at Lytton. Height 3⅞ inches. C: *Human figure pendant*. Collected at Hope. Height 3½ inches. D: *Seated human figure, possibly a spear-thrower weight or a pendant*. Collected at Yale. Height 2⅝ inches. Drawings by Deborah Reade after Duff, 1956, pp. 146–47

ELCHO HARBOUR

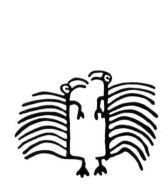

THE DALLES

Fig. 8. Comb (opposite, bottom). Among the well-preserved wooden artifacts that were buried in a landslide at Ozette around A.D. 1500 are two combs that could have been employed for weaving or perhaps worn by shamans, as was the practice in historic times. This one, both sides of which are shown, has relief carvings of a skeletonized sea monster which suggest shamanic association. Height 6½ inches. Makah Tribal Museum, Neah Bay, Washington. Drawings by Deborah Reade after Daugherty and Friedman, 1983, p. 193

WRANGELL

THE DALLES

SKAMANIA

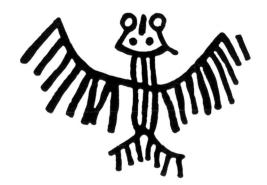

THE DALLES

PETROGLYPH PARK

Fig. 9. Prehistoric Petroglyphs from Various Sites on the Northwest Coast. The renderings that appear on this page and in figs. 10, 13, and 17 were made from undated prehistoric petroglyphs that are found all along the Northwest Coast. They have been selected for their depictions of shamanic imagery, and are not shown in scale to one another. This group shows various bird forms (two of which may be owls), skeletonization, and heads emanating rays of hair. Drawings by Deborah Reade after Hill and Hill, 1974, pp. 267, 270, 271, 278

NOEICK RIVER

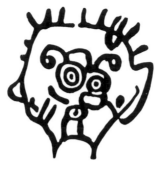

THE DALLES

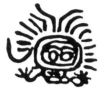

KULLEET BAY

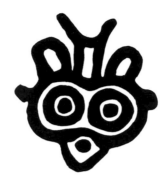

PORT NEVILLE

DENMAN ISLAND

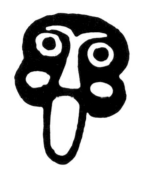

HETTA INLET

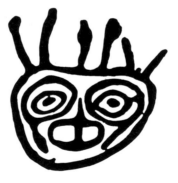

JUMP ACROSS CREEK

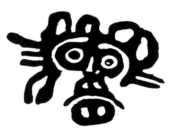

RINGBOLT ISLAND

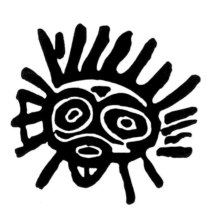

VENN PASSAGE

THORSEN CREEK

MYERS PASSAGE

Fig. 10. Prehistoric Petroglyphs from Various Sites on the Northwest Coast. Shamanic iconography is represented here by the rayed hair, protruding tongues, and x-ray imagery. Drawings by Deborah Reade after Hill and Hill, 1974, pp. 266, 267, 269, 278

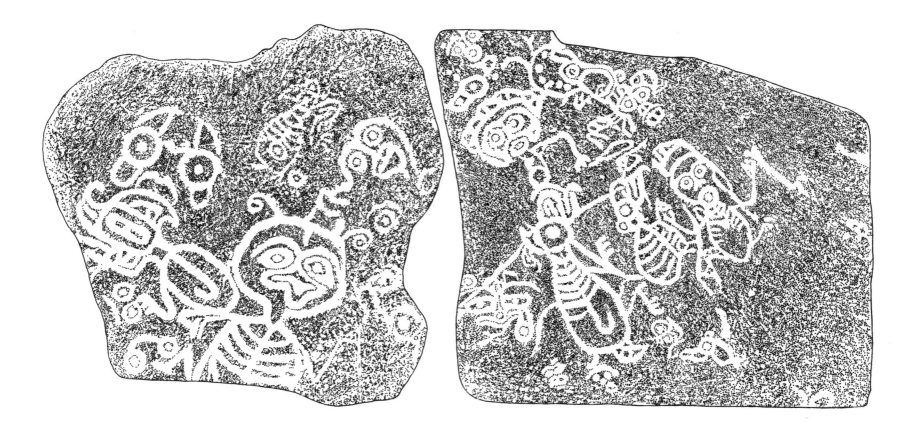

As more work is done, other connections will undoubtedly be found. One basic problem with these rock engravings is that none can be contextually dated as they are never associated with archaeological remains. However, certain stylistic studies have led to the belief that those petroglyphs belonging to what is known as the Basic Rock Art Style of the Northwest Coast are not only ancient, but also represent the ancestral art form of the entire area (Lundy, 1983, p. 92). Stylistic comparisons between the motifs of the rock engravings and the details of some of the stone sculptures of the Fraser River region also suggest that the petroglyphs are at least as old as the Fraser River finds, that is, from the first millennium A.D. There seems to be little question that the majority of these relief carvings are prehistoric.

Even a preliminary survey of the petroglyph motifs found at the more than five hundred known sites reveals certain examples that can be interpreted as relating to shamanism. Figures with protruding tongues, birds, monsters, and skeletonized animals and humans are relatively common. For example, the petroglyph at a site known as Shaman Pool at Kulleet Bay on Vancouver Island shows skeletonized humans, birds, and heads emanating long hair or rays (see Hill and Hill, 1974, pp. 93–95). Writing of the latter motif in connection with Algonkian shamanism, Romas and Joan Vastokas have described it as "supremely shamanistic in character and meaning" (quoted in ibid., p. 265). From their study of these engravings the Hills (ibid., p. 266) conclude that "we are familiar with the haloes, flames and emanations of light associated with trance and hallucinatory experience. There can be little doubt that the heads with rays represent a figure seen in a visionary experience. Further, since the spirit quest of the shaman is an arduous training for just such a trance vision, it is quite likely that the heads with rays are associated with Northwest Coast shamanism."

Fig. 11. Prehistoric Petroglyphs from Ringbolt Island, Skeena River, British Columbia. Because of the use of bird, land mammal, and fish forms, the scenes carved into these two glyph panels have been interpreted as representing the upper, middle, and lower realms of the shamanic world. X-ray and devouring imagery and bears are also motifs associated with shamanism. Drawings by Deborah Reade after MacDonald, 1983b, p. 119

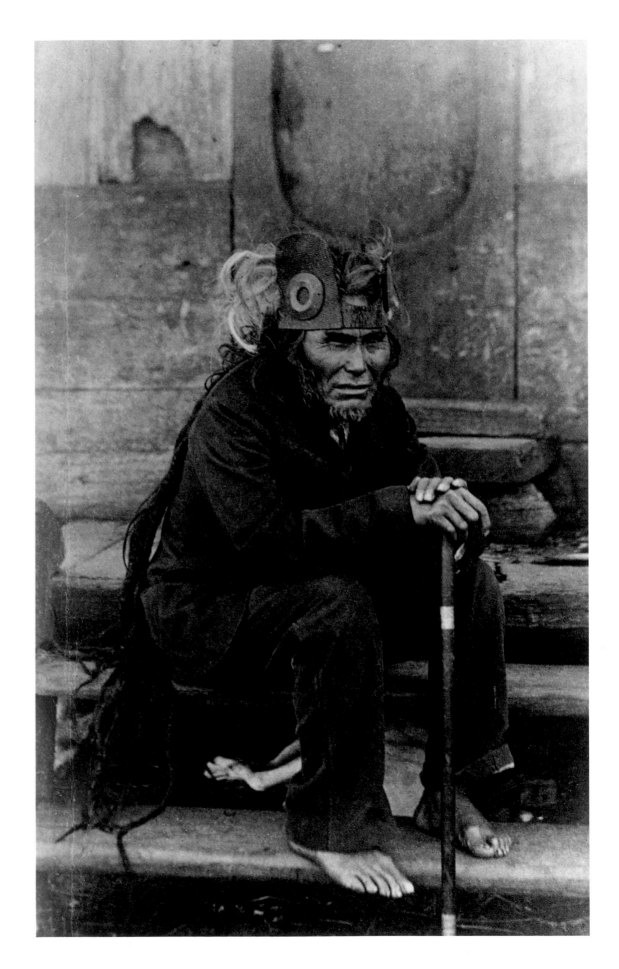

Fig. 12. Tekic, Little Stone's Father, a Tlingit Tequedi Shaman, on the Steps of Bear House, Khantaak Island. De Laguna (1972, pt. 2, pp. 718–19; pt. 3, pl. 65) reports that this photograph was taken about 1888, shortly before Tekic's death. His brother, who was to have cared for his body, had died, and there was no shaman to replace him. He wanted his picture taken before he cut his hair, which would deprive him of his shamanic powers. Soon after the photograph was made, he cut his hair, and then died. His body, along with the headpiece from which he had obtained his powers from the Child of the Sun, was placed in a grave house on Lost River. Several years later, at the urging of the mission at Port Mulgrave (Yakutat), it was removed for burial in a coffin. Photograph, c. 1888. American Museum of Natural History, New York, 41618

The rayed figures could well represent shamans, who during the historic period on the Northwest Coast did not cut their hair. Furthermore, when C. F. Newcombe (quoted in ibid., p. 94; see also p. 29) first inquired about the significance of the Kulleet Bay relief in 1931, he was informed by the local chief that it was probably carved by ancient shamans during their training and that "'the carved figures represented those seen in dreams.'"

Another site at Petroglyph Park near Nanaimo on Vancouver Island contains several images of monsters with protruding tongues. Douglas Leechman (quoted in ibid., p. 103) has been cited as suggesting they were carved by "'boys or medicine men seeking visions induced by fasting and privation in which their guardian spirits might appear. . . .'"

Especially notable is a set of glyph panels from Ringbolt Island on the Skeena River in British Columbia (fig. 11) that have been described by George MacDonald (1983a, p. 120; p. 119, figs. 6:37, 6:38) as representing "shamans communicating with bear spirits." He identifies five common elements between the reliefs and Tsimshian cosmology of the historic period: (1) control of animals by their own "masters," with the bear being the most important; (2) the representation of the upper, middle, and lower worlds by the use of birds, animals, and fish, respectively; (3) the superior ability of animals to communicate, as symbolized by the exaggeration of the tongue, ear, and eye forms; (4) the importance of the skeleton, shown in the now-familiar x-ray style; and (5) the role of the shaman as the intermediary between man and the spirit world, which MacDonald suggests is the thesis of the entire relief series.

As single instances of shamanic relationships, each of these examples might well be seen to be somewhat speculative. Together, however, all of this prehistoric material offers considerable evidence of the antiquity of shamanism along the entire Northwest Coast. It is therefore not difficult to agree with Roy Carlson (1983b, p. 204) when he writes, "A basic belief in spirit power and control through shamanistic practices were [*sic*] probably part of the belief system of the earliest inhabitants of the Northwest Coast." He further suggests that these beliefs date to as early as the beginning of the second millennium B.C., even if there is as yet no archaeological evidence to support this theory.

The tremendous variety, iconographic richness, and artistic quality of the shamanic art of the historic period are additional strong indications of the antiquity of this system of thought on the Northwest Coast. An expression of such complexity and depth most certainly could not have appeared *ex nihilio*. Such an intricate series of beliefs required a considerable period of development and a long and ancient tradition to produce the efflorescence of art and content that is the subject of this volume. Unfortunately, only a few intriguing fragments that show evidence of such a past have survived, but they do reveal something of the deep roots of shamanism along the Northwest Coast.

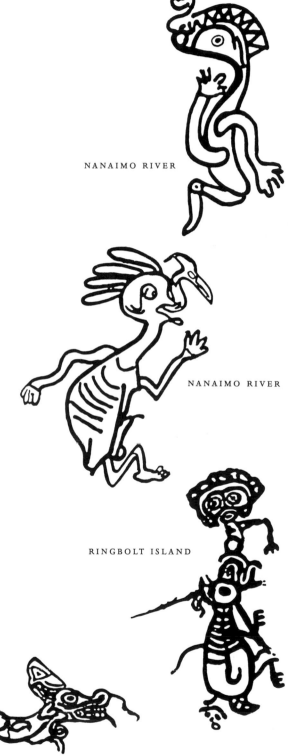

Fig. 13. Prehistoric Petroglyphs from Various Sites on the Northwest Coast. Motifs relating to shamanism illustrated here are sea monsters, skeletonization, devouring imagery, raylike emanations from the hair, and the representation of several creatures in one composition. Drawings by Deborah Reade after Hill and Hill, 1974, pp. 271, 274

NANAIMO RIVER

NANAIMO RIVER

RINGBOLT ISLAND

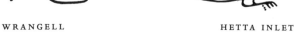

WRANGELL HETTA INLET NANAIMO RIVER

CHAPTER III

VISIONS
AND SPIRIT QUESTS

IN OLDEN TIMES, *there were in this country a great many shamans who were like supernatural beings among the people, and who, through their magic worked wonders among them. Everybody was afraid of their supernatural powers. They could heal the sick, and punish those that did not believe in them. They would help those who paid much, and kill those who were against them.*

FRANZ BOAS

THE PRACTICE OF SHAMANISM on the Northwest Coast predictably closely follows the general patterns of this belief system that are described in Chapter II. Onset of unusual symptoms, followed by a wilderness sojourn during which symbolic death occurs, the subsequent acquisition of alliances with the spirit world, the rebirth and return to the community, the demonstration of newly found powers, and the performance of rituals most often associated with the curing and counteracting of witchcraft are the essential components of shamanism in this region as they are elsewhere in the world. It is only in details that the distinctive qualities of the practice on the Northwest Coast can be discerned.

As one reads the following summary, it must be remembered that the shaman was an individual who deliberately set himself apart from the normal activities and behavior of his community so that he could fulfill his spiritual duties. The experiences of each shaman are unique. For every reference to the episodes in the lives of the shamans made here, there are others that were exclusive to particular individuals. There could be no strict formula for the ways in which a shaman came to or practiced the profession, and we can thus only provide a broad view of the basic aspects of the discipline.

On the Northwest Coast, there were various ways by which an individual could become a shaman. Inheritance of the powers possessed by a close relative was probably the method employed by those who ultimately became the most successful practitioners. Usually the calling was passed from uncle to nephew, but in some cases it might have gone from father to son or from an older to younger brother (Jonaitis, 1986, pp. 52, 155 n. 2). If inherited, the spirit might have been revealed to the novice prior to the death of the practicing shaman, in which case, his susceptibility to the experience could become evident at an early age. Alternatively, relatives of a dead shaman might have sought to expose themselves to his paraphernalia or some of his remains.

Frederica de Laguna (1972, pt. 2, p. 673), for example, reports one episode from the Yakutat Tlingit during which hair from the deceased shaman was passed around to

Fig. 14. Grave House of a Tlingit Shaman on the Chilkat River below Yandestaki. Emmons's notes (n.d.) accompanying the photograph identify this as a shaman's grave, but he also published it as a chief's grave (1908, pp. 70, 72). Chiefs, however, were not buried in such structures unless they were also shamans, and the Chilkat chief's blanket displayed on the front of this shaman's grave house suggests that this was the case here. Photograph by Emmons, c. 1885. American Museum of Natural History, New York, 335778

Fig. 15. Grave House of a Shaman. This photograph was taken at an unknown location on an expedition to Tlingit and Haida sites led by George Dorsey in 1897. Photograph by Edward P. Allen, 1897. Field Museum of Natural History, Chicago, 860

various nephews to ascertain which of them might become infected by the spirit. Exposure to the shaman's grave house after interment could also bring about this result. To prepare for such contact, the younger relative first had to fast and undergo ritual cleansing to prevent serious illness or even death.

Abnormal physical appearance was sometimes considered to mark certain individuals as future shamans. Those with such attributes as crossed eyes, red hair, a hunched back, or a double crown might be trained from a young age for their forthcoming responsibilities (Keithahn, 1963, p. 18). Shamans also came from the ranks of certain chiefs and their close relatives. Because of their doubly prestigious positions in their societies, such highborn shamans were especially respected and much feared (de Laguna, 1972, pt. 1, p. 466).

Women could become shamans as well as men, although at least among the Tlingit there seems to have been such a taboo against menstrual fluids that they could not enter the practice until after menopause, and even then they were not thought to be as powerful as male shamans (ibid., pt. 2, p. 676). Although there were many female Tsimshian shamans, among these people too the most famous and successful were men (Guédon, 1984a, p. 147; Garfield, 1951, p. 38). The use of the male gender in referring to shamans throughout this book has thus been done only for stylistic reasons and does not suggest that women shamans did not exist on the Northwest Coast.

Sometimes even individuals who did not wish to become shamans were forced to assume the position. Among the Tsimshian, for example, anyone might be compelled to become a shaman just because he had inadvertently come into contact with some of a shaman's paraphernalia or grave house (Guédon, 1984b, p. 176). Others might have an encounter with a spirit at any place or time and for no apparent reason. John

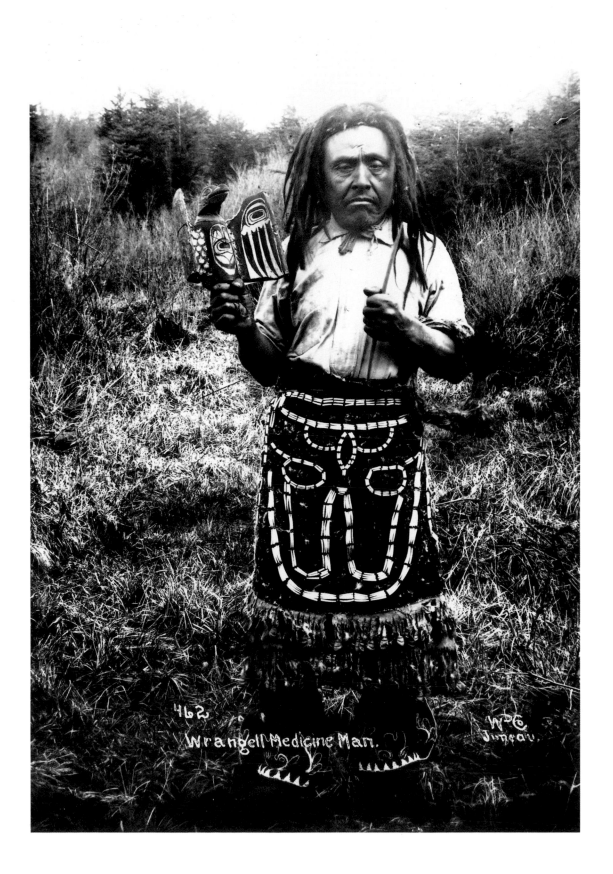

462 Wrangell Medicine Man. W&P Co Juneau.

Fig. 16. Tlingit Shaman of Wrangell. All early photographs of shamans were obviously posed, and Wyatt (1989, p. 66, pl. 23) believes that this man is wearing a wig to represent the uncut hair of a practitioner. However, although the photograph is not completely clear, the shaman's own hair may be shown. Wyatt also identifies the eagle sculpture with movable wings which the shaman carries in his right hand as now being in the Washington State Museum in Seattle. The apron has a fringe decorated with puffin beaks, and the dentalium shells on the front are sewn in the shape of an upside-down bear's head. The apron is part of the Rasmussen Collection, now in the Portland Art Museum, Oregon Art Institute (Gunther, 1966, p. 88, cat. 132). Photograph by Winter and Pond, Juneau, c. 1900. Alaska State Library, Juneau, 87–250

Fig. 17. Prehistoric Petroglyph from The Dalles, Oregon. This petroglyph, representing an owl in flight, is closely related to several others from the same site on the Columbia River (see fig. 9). Drawing by Deborah Reade after Hill and Hill, 1974, p. 78

Swanton (1905, p. 38) writes of Tlingit spirits coming into Haida country to seek out those who were inclined toward shamanism. Marius Barbeau (1958, pp. 39–41) quotes Isaac Tens, a Gitksan Tsimshian, who tells of the unexpected events that caused him to enter the profession:

Thirty years after my birth was the time when I began to be a swanassu (medicine-man). I went up into the hills to get fire-wood. While I was cutting up the wood into lengths, it grew dark towards the evening. Before I had finished my last stack of wood, a loud noise broke out over me, chu———, and a large owl appeared to me. The owl took hold of me, caught my face, and tried to lift me up. I lost consciousness. As soon as I came back to my senses I realized I had fallen into the snow. My head was coated with ice, and some blood was running out of my mouth.

I stood up and went down the trail, walking very fast, with some wood packed on my back. On the way, the trees seemed to shake and to lean over me; tall trees were crawling after me as if they had been snakes. I could see them. Before I arrived at my father's home, I told my folk what had happened to me, as soon as I walked in. I was very cold and warmed myself before going to bed. There I fell into a sort of trance. It seems that two halaaits *(medicine-men) were working over me to bring me back to health. But it is now all vague in my memory. When I woke up and opened my eyes, I thought that flies covered my face completely. I looked down, and instead of being on firm ground, I felt that I was drifting in a huge whirlpool. My heart was thumping fast.*

. . . While I was in a trance, one of [the medicine men working over me] . . . told me that the time had arrived for me to become a halaait . . . *like them. But I did not agree; so I took no notice of the advice. The affair passed away as it had come, without results.*

Another time, I went to my hunting grounds on the other side of the river here. . . . After I reached there, I caught two fishers in my traps, took their pelts and threw the flesh and bones away. Farther along I looked for a bear's den amid the tall trees. As I glanced upwards, I saw an owl, at the top of a high cedar, I shot it, and it fell down in the bushes close to me. When I went to pick it up, it had disappeared. Not a feather was left; this seemed very strange. I walked down to the river, crossed over the ice, and returned to the village of Gitenmaks. Upon arriving at my fishing station on the point, I heard the noise of a crowd of people around the smokehouse, as if I were being chased away, pursued. I dared not look behind to find out what all this was about, but I hastened straight ahead. The voices followed in my tracks and came very close behind me. Then I wheeled round and looked back. There was no one in sight, only trees. A trance came over me once more, and I fell down, unconscious. When I came to, my head was buried in a snow bank. I got up and walked on the ice up the river to the village. There I met my father who had just come out to look for me, for he had missed me. We went back together to my house. Then my heart started to beat fast, and I began to tremble, just as had happened a while before, when the halaaits . . . *were trying to fix me up. My flesh seemed to be boiling, and I could hear Su———. My body was quivering. While I remained in this state, I began to sing. A chant was coming out of me without my being able to do anything*

to stop it. Many things appeared to me presently: huge birds and other animals.
They were calling me. I saw a meskyawawderh *(a kind of bird), and a* mesqag-
weeuk *(bullhead fish). These were visible only to me, not to the others in my house.*
Such visions happen when a man is about to become a halaait; *they occur of their*
own accord. The songs force themselves out without any attempt to compose them.
But I learned and memorized those songs by repeating them.

Because of the great responsibilities and the unusual, often lonely existence of shamans, to be a shaman required intelligence, a strong personality, and great sacrifice. Not all of those who had such experiences as those Tens described wished to become involved. Nonetheless, no matter what the circumstances (and despite Tens taking "no notice of the advice" of the shamans who assisted him after his first encounter), once the call had been received, it could not be permanently rejected, for to do so could bring illness or death (de Laguna, 1972, pt. 2, pp. 646, 719–20).

Evidence of possession by spirits took many forms. It could consist of such physical symptoms as dizziness, fainting spells, frothing at the mouth, buzzing in the ear, convulsions, heightened or diminished pulse, and trances. In other instances, the process might be considerably less dramatic. For example, an individual's behavior over a period of time could indicate he was becoming possessed. He might become meditative or absentminded, seek to be alone, sleep frequently and have vivid dreams, or, when awake, experience visions of supernatural beings.

Most novices experienced their spirit encounters in the wilderness. Before embarking on such a vigil, he purified himself through such actions as abstaining from sex, fasting, limiting the intake of fresh water, drinking such purgatives as salt water or a potion made from the thorny devil's club shrub, and bathing in cold water followed by flagellating (ibid., pp. 676–77; Guédon, 1984a, p. 146). For the Tlingit, the abstinence and fast might last from four to eight days (de Laguna, 1972, pt. 2, p. 674). Such privations, fatigue, and the ingestion of strong liquids could bring about the visions and trances that were necessary for spirit encounters. Unlike shamans in other parts of the world, those of the Northwest Coast did not rely on hallucinogens to cause these events, depending on their inherent mental discipline rather than the unpredictable and sometimes uncontrollable effects of drugs.

Among the groups covered in this volume, there was much variation in the methods by which the novice acquired his powers and supernatural helpers, a process that could take several years. What Marie-Françoise Guédon (1984b, p. 181) has written about Tsimshian shamanism could apply all along the coast: " . . . The modes of acquisition of shamanic powers seem to have been as numerous as the shamans themselves. . . ." The basic results were nonetheless the same, and all such experiences included falling into trances and learning new songs. When the future shaman was finally ready, he went on his first vision quest, often to the forest or some other remote area.

The wilderness vigil was sometimes solitary. More often, however, the novice placed himself in the care of assistants who guided him during his trances and encounters. At least one assistant was necessary, and there might be as many as five. Some may have been associated with the previous shaman and would therefore know

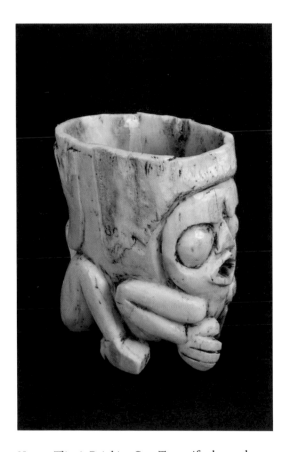

No. 20. Tlingit Drinking Cup. To purify themselves in preparation for a séance, shamans sometimes drank salt water from cups made of basketry, wood, or ivory. Those made of wood and ivory were carved to represent spirit helpers. A raven is on the back of this piece, and Emmons (n.d., Notes) describes the crouching figure on the front as "a shaman singing." He states further that the cup "was never touched by another and [was] endowed with great spirit power." Collected by Emmons from the Tongass tribe near Portland Canal. Walrus ivory; length 2⅝ inches; c. 1820–40. Field Museum of Natural History, Chicago, 78004. Purchased from Emmons, 1902

No. 21. Haida Rattle. Round rattles were used mostly by shamans and were often carved with images that are metaphors of shamanic activities. Here a bird, either an eagle or a hawk, is devouring a frog. This may be a reference to the ability of shamans to transform themselves into different animals. Wood, rawhide, and red, black, and traces of blue pigment; length 10¼ inches; c. 1840–60. Former collection: James Hooper. The Eugene V. and Clare E. Thaw Collection, Fenimore House Museum, Cooperstown, New York

No. 22. Haida Staff (opposite, top). As with another Haida staff (no. 14), there is no information accompanying this example to indicate shamanic use. However, the fact that it is in the form of a land otter, the most important of all shamanic guardian spirits, would suggest such an association. Collected by Fillip and Adrian Jacobsen in British Columbia, 1885–86 (see Cole, 1985, p. 131). Whalebone; length 15⅜ inches; c. 1840–60. Field Museum of Natural History, Chicago, 18387. Purchased from Carl Hagenbeck at the World's Columbian Exposition, Chicago, 1893

No. 23. Tlingit Throwing Stick (opposite, right). Such throwing sticks were used only by the Tlingit, and most, including this example, have early collection dates. Although they relate to the throwing sticks of the Eskimo, which were used for hunting, it has been shown that they could not have been employed for this purpose on the Northwest Coast (see p. 218). It is now believed that they were carried by shamans, perhaps to launch real or imagined projectiles toward evil spirits. At the top an eagle perched over a bear face, and on the bottom is a wolf or land otter with a reclining human and a frog head at its feet. Collected by Captain Thomas Robinson before 1813. Wood; length 15¼ inches; c. 1750–1800. Peabody Museum of Archaeology and Ethnology, Harvard University, Cambridge, 95-20-10/48390

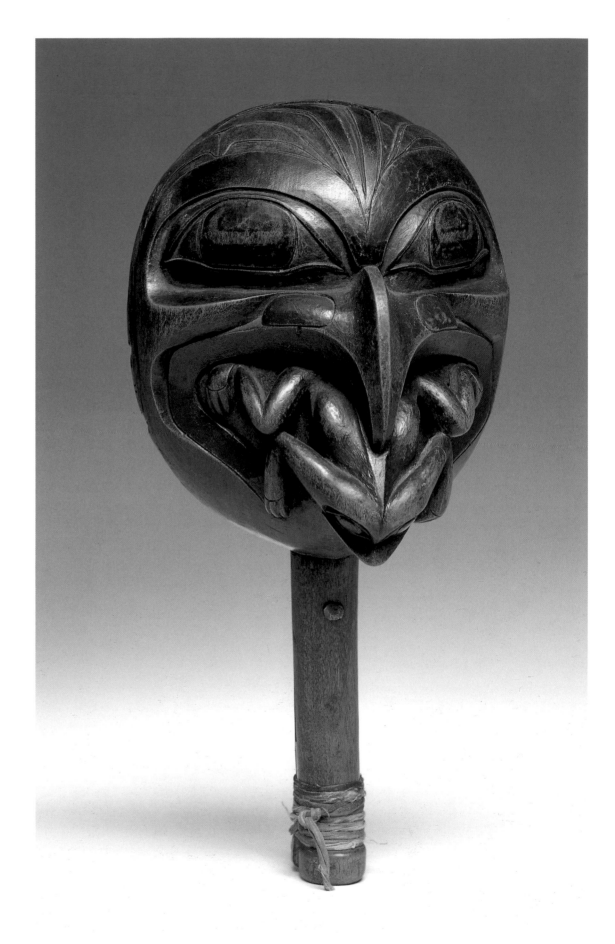

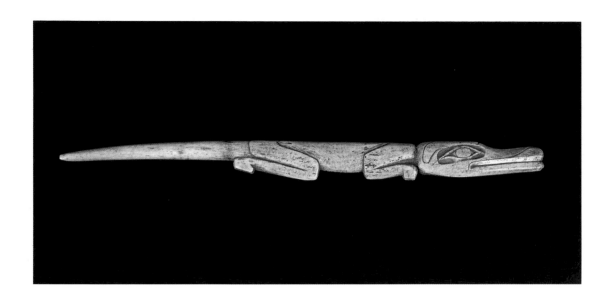

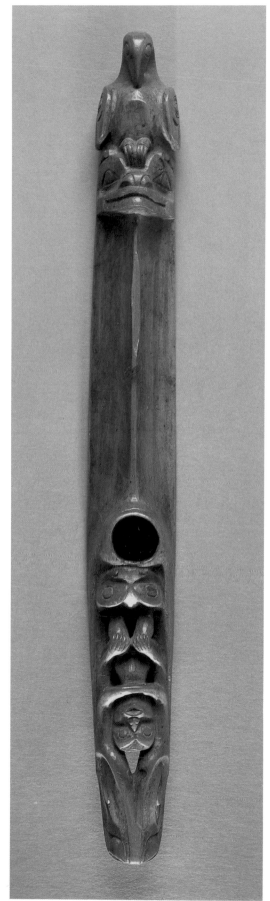

some of the intricacies of the experience. Because of their past exposures to spirit powers, they could also perform certain acts still forbidden to the novice (de Laguna, 1972, pt. 2, pp. 675, 679).

All of the assistants were relatives of the novice, usually uncles. Isaac Tens had four, each one a cousin. During the year he underwent his ordeal, they watched over him and tried to learn the new songs as he acquired them (Barbeau, 1958, pp. 41, 42). Later, when the shaman was able to practice himself, his assistants would help by bringing his paraphernalia to him, guiding him in his dances, beating drums and sticks, shaking rattles, waving charms over ill patients, singing, and generally participating in the séances. They too would sometimes go into trances, and a few ultimately became shamans themselves.

For the Tlingit, the spirit quest could last as long as eight days. At some point during this period, an animal would appear before the novice and die, having been killed by such means as fixing it with a particularly powerful gaze, uttering a certain word, or brandishing a special club (de Laguna, 1972, pt. 2, p. 677). A part of the tongue of the animal was then cut as the shaman asked the animal spirit (called *yek*) to confer certain powers upon him, thus forming their alliance (Olson, 1961, p. 208). The spirit then taught the shaman songs for his future use. Finally, the piece of tongue was tied into a bundle that was either incorporated into the shaman's kit or secreted nearby. If the latter, each year thereafter the shaman had to return to it in order to renew his connection with the animal spirit (de Laguna, 1972, pt. 2, p. 680).

The taking of tongues in this manner was practiced chiefly by the Tlingit. However, John Swanton (1905, p. 40) records some stories that mention the practice, and writes, "As among the Tlingit, shamans of the Northern Haida used to cut off the corners of land otters' tongues and catch the blood on bundles of twigs." According to Marie-Françoise Guédon (1984b, p. 197), "the custom . . . was not general, not even frequent among the Tsimshian." Viola Garfield (1951, p. 46) claims that though the use of the tongue appears in Tsimshian tales associated with shamans, it was "only one of the many agencies through which a shaman received power." References to this practice elsewhere along the coast are not known.

In those instances in which the novice had difficulty receiving the call, he would associate himself with the remains of a dead shaman. He might visit the grave house and hold the skull of the deceased (de Laguna, 1954, p. 176), or even take more drastic measures. Aurel Krause (1956, p. 195) reports that if the shaman-to-be had not been successful on his wilderness quest, he would spend the night in a deceased shaman's grave house and place a tooth or the tip of one of the fingers from the dead man in his mouth to bring success to his quest.

Over time the shaman would go on additional retreats to gain new powers, for his reputation and abilities increased with the number of alliances he could secure. The most important *yek* in the Tlingit shaman's service was that of the land otter, "in whose tongue is contained the whole secret of shamanism" (ibid.). All Tlingit shamans therefore sought an encounter with this animal, and it was often the first with which they became allied.

Among the Tsimshian, some novices actually hired older, experienced shamans to teach them their songs and share other secrets of their profession. The established practitioners also assisted the initiates during their spirit encounters, helped them to work with the spirits, and revived them from their trances (Garfield, 1951, p. 41).

The Bella Coola relied on special spirit beings to initiate shamans into the mysteries of their calling. The most powerful is called Kle-klati-ē'īl ʟaʟaiā'iʟ. Franz Boas (1898, pp. 42–43) quotes Adrian Jacobsen's description of an encounter between this and the future shaman:

> He [Kle-klati-ē'īl ʟaʟaiā'iʟ] lives in the woods, where the youth who intends to be initiated tries to find him. When the spirit meets him, the youth faints. When he recovers, he begins to sing a song, the tune and words of which have been given to him by the spirit. Now he has become a shaman, who uses this song in all his incantations; but he does not retain it throughout life, because he meets his guardian spirit almost every year, and then he receives new songs. The Indians believe that Kle-klati-ē'īl has human shape, but he is clothed in cedar-bark, and wears a great many rings of cedar-bark. Some of these he gives to the shaman.

Shamans had similar relationships with several other Bella Coola deities, including Skaia, perhaps an avatar of ʟaʟaiā'iʟ, who lived in the rivers and took the form of a salmon; a beautiful man representing the sun descended to earth; a female, called ʟ'ētsā'apēʟāna, who flew through the air; and sī'siuʟ, who lived in the water and gave the shaman the power to cure illness (ibid., pp. 43–45).

Among the Tlingit, such spirit helpers were thought to come from the three realms of the universe that I. Veniaminov described in 1840 as the upper spirits of the sky that show themselves as the northern lights, the spirits of the earth that come from the north and inhabit a place on the mainland, and the water spirits of the underworld (cited by de Laguna, 1972, pt. 2, p. 835).

Other animals that shamans relied on as spirit helpers were those that inhabit border areas of the environment such as the shoreline, the water's surface, or the tops of trees. Their behavior was thought to represent their supernatural ability to move through the different zones of the cosmos, such as the shore birds that fly, walk on the land, and eat from the water; the water birds that fly, float on the surface, and dive for

No. 24. Bella Coola Mask. Boas (1898, pl. XI, no. 9, and pp. 42–43) identifies this mask as Kle-klati-ē'īl ʟaʟaia'iʟ, a powerful Bella Coola spirit that induces novices to become shamans. Collected by Boas and George Hunt, 1897. Wood, bear hide, nails, and black pigment; height 9¾ inches (mask only); c. 1860–80. American Museum of Natural History, New York, 16/1529

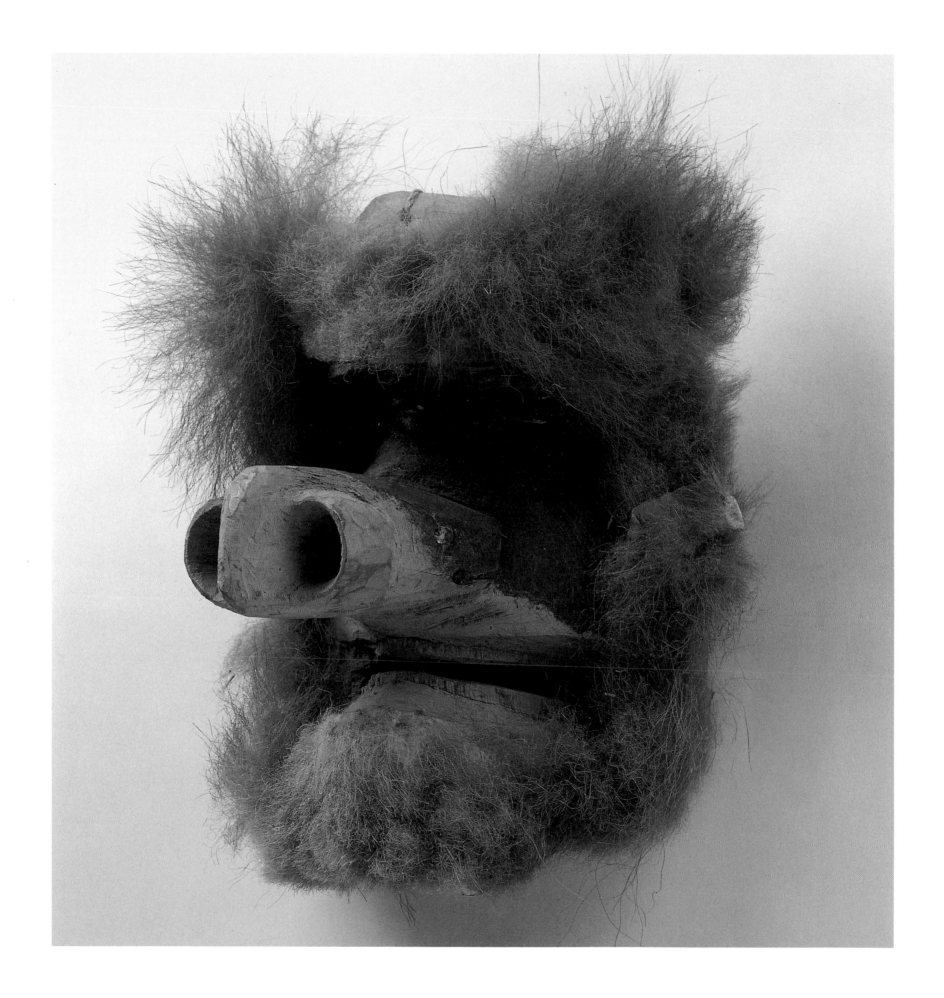

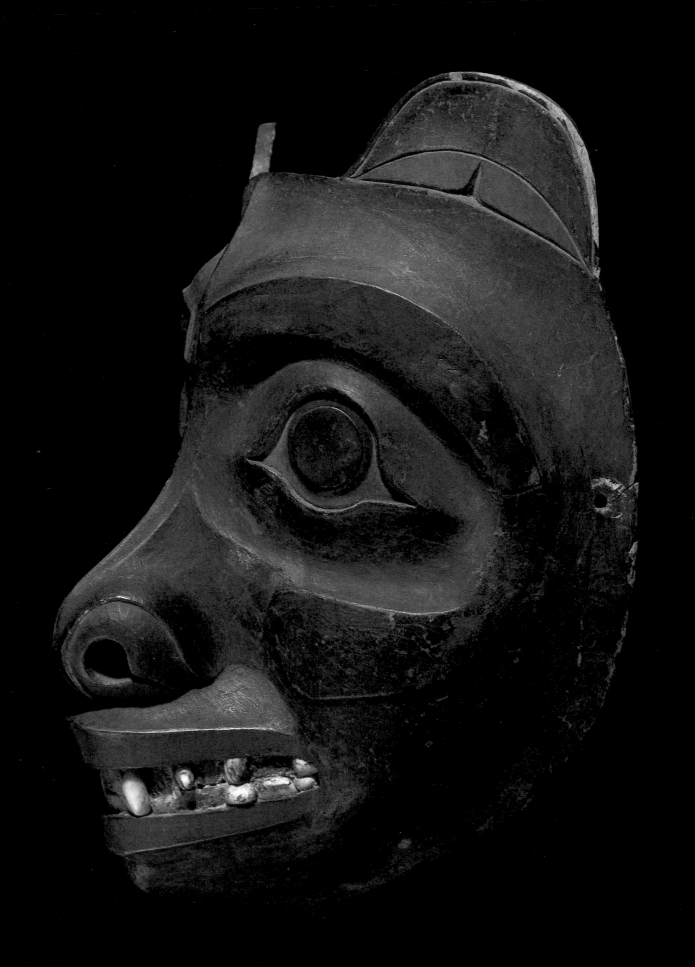

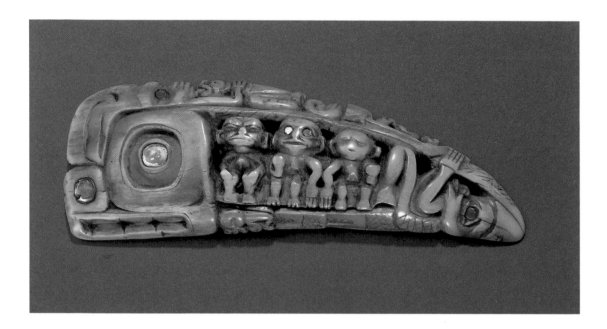

food; sea mammals; land otters; and mountain goats (Jonaitis, 1986, pp. 90–97). Spirits that appear in more secular contexts, such as eagles, bears, wolves, salmon, and ravens, were employed as supernatural assistants as well. It has been suggested that they represent the rational, known world of the social community, the "safe abode into which . . . [the shaman] can return after his travels beyond its limits" (ibid., p. 96). The beings upon which the shaman depended for his powers therefore symbolized a balance between the supernatural and secular worlds.

One concept of spirit helpers that represents an important aspect of Northwest Coast shamanism often went far beyond the identification of specific animal and supernatural beings. The Tsimshian shaman's alliance with spirit helpers has been best described as including a series of images and points of view in the mind of the practitioner that brought certain powers into his service. Such powers were not necessarily represented by tangible objects or creatures but were certain concepts that might occur in thoughts or dreams and then serve as catalysts to the shaman's attitudes and performances. These concepts include such abstractions as the ideas of a canoe, which could be used as a means of travel or as a container; a rope that could connect the shaman to his patient or other places or could be unknotted to effect a cure; and fishnets and bear snares that could capture souls (Guédon, 1984b, pp. 200–204). At times, tangible representations of such ideas are found in the kits of shamans. Small model canoes, knotted cedar bark ropes, and other such objects were used to represent certain of these abstract mental images. More commonly, however, such concepts were not given physical form.

The Haida spirit of the sweat house, mentioned by Marius Barbeau (1958, p. 6), was similarly an image in the mind of the shaman rather than something that was rendered into a tangible object. The concept refers to the process of purification and preparation undergone by some shamans in the sweat house prior to practicing. However, whatever the nature of his spirit assistants, throughout his professional life the successful shaman would continue to add helpers of all kinds to his service as a way of maintaining and increasing his powers.

When the novice finally felt strong enough to assume the position of shaman, he had to prove his capabilities to the members of his community. Again, this event could take many forms. Among the Tlingit he might call together the men of his family to teach them his newly learned songs. His power grew as the songs were sung and he continued his regimen of fasts, sexual abstinence, and the avoidance of taboos (de Laguna, 1972, pt. 2, p. 681).

One account of the validation of a new Tlingit shaman's powers tells of the gathering of all the people of the village of Klukwan in the house of the recently deceased shaman. While they chanted and danced, two boxes containing shamanic paraphernalia were lowered through the smoke hole. The objects were removed one at a time and held by the fire. The novice then appeared and went into a trance after one in attendance had placed one of the dead man's necklaces over his head. When he recovered, the paraphernalia was replaced in its boxes and lifted out through the smoke hole, and swansdown was blown into the air. The villagers then left, while the novice's clan remained to fast for four days. A similar public ceremony was held on the last night of the fast, when the new shaman was accepted in the community (Krause, 1956, pp. 201–2). At this time he took his professional name, which was based on what he had said in his trances and given to him by one of his assistants.

From the Tsimshian, it was reported that the father of a novice invited all the local shamans to his house, compensating them for their presence. For several days they sang songs that had been the property of the shaman who had lived there previously. The novice then sang his own song, walked around the fire four times, and retired. The father next distributed gifts to those present and gave a feast to validate the powers of the new shaman (Miller, 1984, pp. 139–40). Isaac Tens also tells of being strengthened by other shamans of his village who had been summoned by his father. All those who witnessed the event were paid to ensure the acceptance of his newly acquired powers (Barbeau, 1958, p. 42).

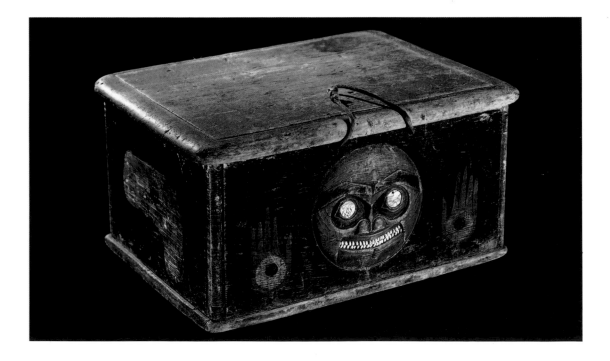

No. 27. Tsimshian Box. Shamans kept their paraphernalia in boxes, some of which were carved and painted similarly to those used by chiefs. Others, such as this example, are decorated with motifs representing shamanic spirits. The museum records identify the face as the moon. Collected by Charles F. Newcombe at Gitlakdamiks in 1913 and thought to be part of the paraphernalia belonging to a shaman named Skedin's. Wood, abalone, opercula, rawhide, and red and black pigment; height 15 inches; c. 1840–60. Royal British Columbia Museum, Victoria, 1564. Purchased from Newcombe, 1913

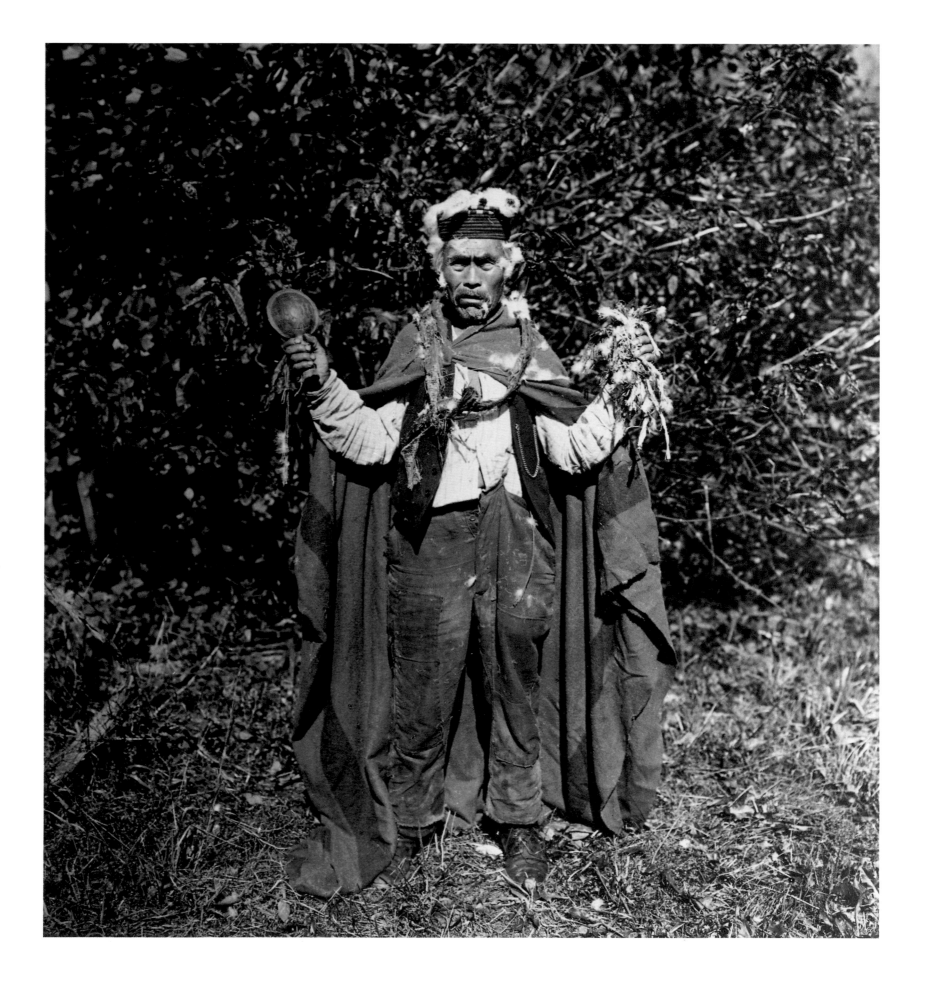

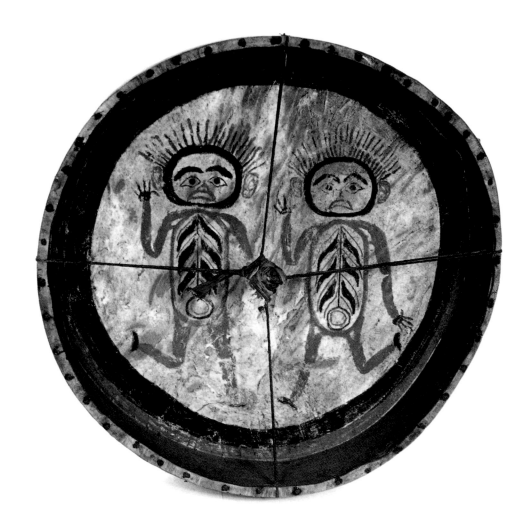

No. 28. Tlingit Tambourine Drum. Tambourine drums were commonly used during shamanic séances. Most are undecorated, but some are painted with crest designs or depictions of spirit helpers. Although there is no provenance for this example to indicate that it was once owned by a shaman, the rayed heads and x-ray painting style strongly suggest that it was. Wood, animal skin, tacks, and red and black pigment; diameter 21 inches; c. 1840–60. Sheldon Jackson Museum, Sitka, I.A.35a, b. Given by Jackson, 1888

After an individual had established himself as possessing the proper powers and spirit alliances, he could begin his career as a practicing shaman. Each demonstration he gave was different and obviously depended on the sources of the powers he wished to display and what he had been hired to do. The successful shaman would perform throughout his career both to show that he still had his strength and to announce the acquisition of new alliances and abilities. During each of these performances among the Tlingit, the shaman walked around the fire in the house where the rite was being held while his assistants sang his songs (de Laguna, 1972, pt. 2, p. 682). Many stories tell of magical events that took place on such occasions: objects were made to move or levitate suddenly, the dead were brought to life, the shaman walked on hot coals or placed a burning object in his mouth without being harmed, wounds were immediately healed, and masks were worn without evidence of any attachment to hold them to the face (ibid., pp. 705–6).

The shaman's most important function was healing. It was very risky for a shaman to refuse to treat an ill person, because he might then be suspected of having caused the disease himself (Barbeau, 1958, p. 48). Numerous accounts report curing séances. After the shaman's requisite fast and ritual preparation, he and his assistants came to the house of a sick person, which had also been cleaned and purified. (The shaman would not perform in the presence of menstruating women, for the discharge was

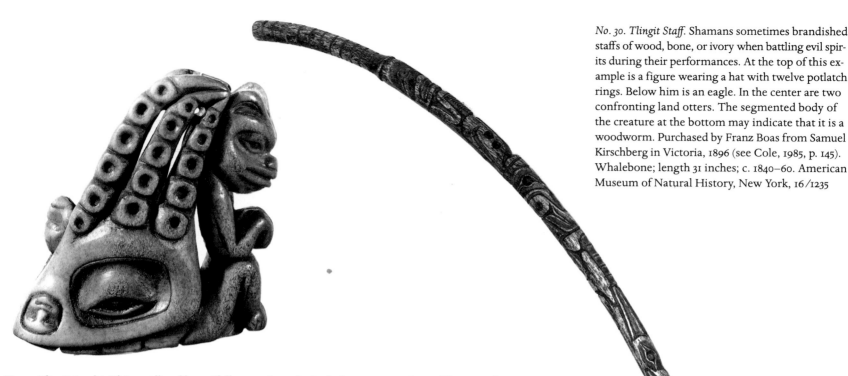

No. 30. Tlingit Staff. Shamans sometimes brandished staffs of wood, bone, or ivory when battling evil spirits during their performances. At the top of this example is a figure wearing a hat with twelve potlatch rings. Below him is an eagle. In the center are two confronting land otters. The segmented body of the creature at the bottom may indicate that it is a woodworm. Purchased by Franz Boas from Samuel Kirschberg in Victoria, 1896 (see Cole, 1985, p. 145). Whalebone; length 31 inches; c. 1840–60. American Museum of Natural History, New York, 16/1235

No. 29. Tlingit Amulet. This small and beautifully carved amulet includes representations of four guardian spirits. The predominant figure is a devilfish with a seated bear behind it. Two small human faces are on the front. Collected by Emmons from the grave house of a Hoonah shaman near Hoonah, 1884–93. Bone; height 2¾ inches; c. 1840–60. American Museum of Natural History, New York, E 2711. Purchased from Emmons, 1893

considered extremely powerful and repellent to spirits [de Laguna, 1972, pt. 2, p. 760].) Those in attendance were mostly members of the patient's family.

The séance began with drumming and other rhythmic accompaniment made by tapping sticks and staffs and shaking rattles. This gradually built into a crescendo. It was believed that spirits were attracted by these sounds and would come to aid the shaman. He and his assistants also sang songs relating to the task at hand. At some point, the shaman might go into a trance, the depth of which depended on the seriousness of the illness he had been asked to cure. Often he would perform a dance that related to a supernatural protector.

Other séance activities might include dialogues between the shaman and his assistants, explanations of what was being attempted to those in attendance and the ailing individual, and the use of amulets, rattles, masks, and other objects in various ways. Such objects as oddly shaped stones, pieces of braided cedar bark, and charms might be placed on the floor around the patient in seemingly random but actually premeditated arrangements. To effect a successful cure, it was important that the patient completely believe in the powers of the shaman. This faith could be strengthened by the quantity of the objects employed and the number of spirit helpers in attendance.

The specific curing process used was determined by what was considered to be the cause of the illness. If it was thought that a disease had introduced itself into the patient, activities were directed to removing it from the body. If it was believed that a witch had caused the disease by the introduction of a foreign body, this too had to be removed from the afflicted, and the evildoer had to be identified, forced to confess,

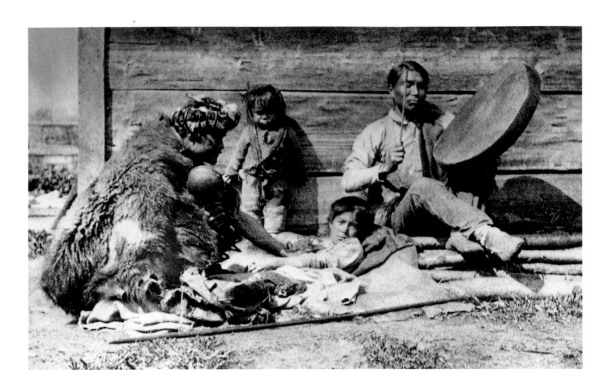

Fig. 19. Tsimshian Shaman Practicing Over a Boy. The shaman, identified by Emmons as being from Kitwancool (Royal British Columbia Museum, n.d., Notes), wears a bear claw crown and a bearskin cloak, and carries a plain round rattle in his right hand. The seated figure at the right is beating an undecorated tambourine drum. As most healing sessions took place inside the patient's house at night, this scene is obviously a staged reenactment. Photograph by George Emmons, c. 1915. Royal British Columbia Museum, Victoria, 4192

and sometimes punished. If, however, it was thought that the disease had resulted because the soul had strayed from the body either by being attracted away by spirits or by having been frightened out, the shaman would have to locate it and return it to the host. In extreme cases, the shaman would go into a deep trance that enabled him to travel to the land of the dead where the patient's soul had gone. This was a great challenge to the shaman for he had to face death and then return to the living. When he recovered from the trance, he would sometimes recount his adventures in the land of the dead (Guédon, 1984b, p. 199).

Among the curing methods the shaman employed were handling and rubbing the patient's body, covering it with red ocher and swansdown, fanning the person with an eagle's tail to restore breath, using bone tubes to suck or blow the disease or evil from the body, and blowing water onto the patient. The afflicted parts of the body might also be touched with such objects as amulets, rattles, the crown of bear claws or horns worn on the shaman's head, and, among the Tlingit, the maskette the shaman carried on his forehead.

It has been stated that Tlingit shamans only performed curing rites related to the expulsion of evil spirits or the removal of disease by magic, and that they did not use medicinal herbs and plants, which are said to have been the responsibility of older women in the community (Emmons, n.d., Notes). However, because shamans also had good knowledge of the properties of such natural curatives, they undoubtedly sometimes also applied products made from them as a part of the healing process. Plant substances were likewise employed to attract a loved one, to bring wealth, or to kill. Shamans had skill in surgery as well, and they could treat boils, infections, and burns and assist in childbirth. Their success as healers therefore relied on both practical knowledge as well as assistance from the supernatural. (For an account of the medicinal skills of shamans, see de Laguna, 1972, pt. 2, pp. 654–66.)

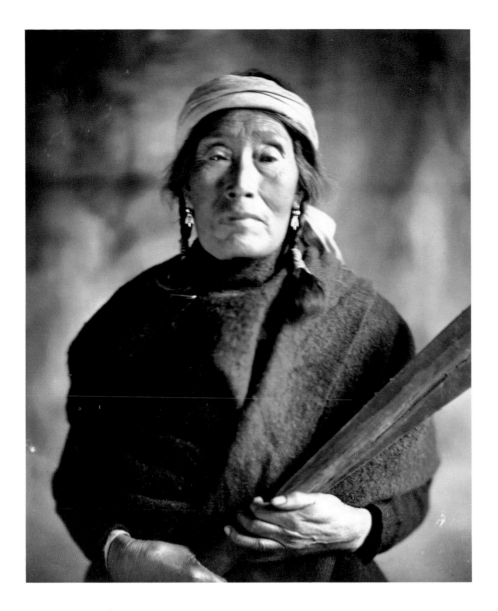

Fig. 20. War-ne-la, a Female Kwakiutl Shaman of the Koskimo. B. W. Leeson, who made this photograph, writes of his experience with War-ne-la: "Known for her knowledge of herbs, occult powers and many cures. Losing our direction, the writer at one time was with a bunch of canoes lost in an early morning fog. War-ne-la, being in one of the canoes, was called upon to disperse the fog. She gravely took all her clothes off above the waist, and standing up in the bow of her canoe commenced a loud harangue. A slight breeze seemed to spring up immediately and the fog to thin out. Looking around at the faces in the canoes it was easily seen it was quite expected and as a matter of course." (Royal British Columbia Museum, n.d., Notes). Photograph by B. W. Leeson, c. 1914. Vancouver Public Library, 14072

Although healing was the prime occupation of shamans, their weighty obligations to assure the spiritual equilibrium of the community, to provide communication with the nonhuman world, and to maintain ancient traditions brought many other responsibilities. In general, they were called on to bring about a successful outcome to events that could not be controlled through conventional and rational means. It would be impossible to list every task given to powerful shamans because they were often asked to solve unique problems or to respond to situations that had never before occurred. However, the following compilation of activities from various sources will give some idea of the great range of acts a shaman might be asked to perform and suggests why they were so highly regarded in Northwest Coast culture.

Shamans were called on to deal with both practical problems and events caused by supernatural forces, which were believed to be involved in almost all functions for which a shaman was hired. Shamans might be asked to help assure an abundant supply of food for the community by naming the location of plentiful berries, fish, and game. For example, they might be able to predict a good salmon run or even to describe its actual occurrence, as reported in a Tsimshian myth recorded by Franz

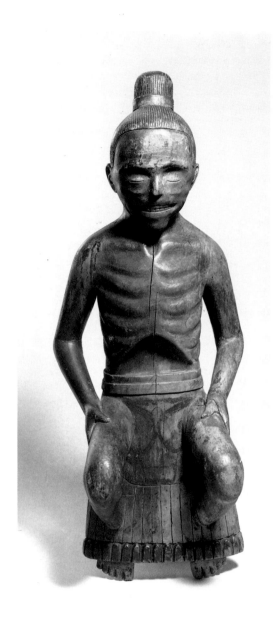

No. 31. Haida Figure. This figure of a dead shaman is one of four thought to have been carved by Charles Gwaytihl or Simeon Stilthda, Haida artists who worked chiefly at the end of the nineteenth century in Masset. It was probably meant to be seen in a prone position, as is the one shown in its burial house (no. 34; see also nos. 63, 64, 494). All such figures were likely made for sale to outsiders. According to the accession records, this example is said to have been brought to Saint Louis from Oregon at the turn of the century. Wood and red, black, and blue-green pigment; height 22 inches; c. 1870–1900. The Saint Louis Art Museum, 132.76. Purchased, 1976

Boas (1916, p. 474). Through his ability to visit the fish in their habitat, "a shaman sees what is going on in the house of the Spring Salmon. He sees them start on their journey up Skeena River, and knows they will arrive eight days after the breaking-up of the ice." In another myth a shaman taught some starving Tsimshian to catch halibut. The skills of the shaman could also guarantee success in hunting by attracting game to the hunter, enhancing his ability to shoot accurately, and bestowing on him the skill to outdo a rival. One Tlingit story tells of how a female shaman helped a chief acquire a magic arrow that never missed its target (de Laguna, 1972, pt. 2, pp. 712–13).

For practical purposes, shamans always accompanied war parties, since only they could kill the souls of enemies and thereby assure the success of the encounter. They could also discover the location of enemies, spy on them, weaken them, and attack the spirits of their shaman. They could warn of an impending enemy attack, predict the outcome of a battle, instill courage, and assure good marksmanship.

During their careers, shamans had to develop skills of communication that gave them the benefit of the doubt if their predictions did not come true or if their statements were thought to have proven false. As Frederica de Laguna (ibid., p. 582) has written, "Since the shaman's pronouncements [about the chances of success] were always couched in Delphic ambiguity, it was possible for eager warriors to disregard apparently discouraging prophecies that recommended caution."

Other shamanic responsibilities included the maintenance or restoration of good luck and the prediction and sometimes manipulation of the weather and the future. On long voyages, shamans often rode in the front of canoes to prevent accidents, drownings, and bad weather. They could attract a loved one to an individual, find lost objects and people, discover thefts, and recover stolen goods. Shamans could tell whether a taboo had been broken and could communicate with individuals who were far away from their homes and even with infants too young to talk. Only they could rescue those who had been kidnapped by land otters, and identify and capture witches and other evildoers. As intermediaries between the human and spirit worlds, they could speak and interrelate with animals and the dead. Able both to swim underwater and to fly, they could travel and explore such faraway places as the moon, mountaintops, and the depths of the sea.

The physical appearance of shamans set them apart from the secular world as much as did their actions and abilities. Because of the rigors of their fasts and privations, many were emaciated and had drawn, gaunt facial expressions. Their most distinguishing feature was their long, uncombed dirty hair. Sometimes it was twisted into eight braids to which extra strands were added so that they fell to the knees. It was believed that much of a shaman's power was in his hair and that if it were cut, death could result (de Laguna, 1954, p. 176). During some séances, the locks were reported to move of their own accord (de Laguna, 1972, pt. 2, p. 764). When the shaman was not performing, his hair was often worn in a ball on top of his head, kept in place with carved bone pins. Haida shamans are said always to have worn a bone piercing their septum (Swanton, 1905, p. 40). Fingernails were not cut, and the clothing worn by shamans when they were not practicing was usually dirty and unkempt.

Many shamans lived on the outskirts of their villages. Because of the nature of their lives, they did not participate in the everyday activities of their community and only

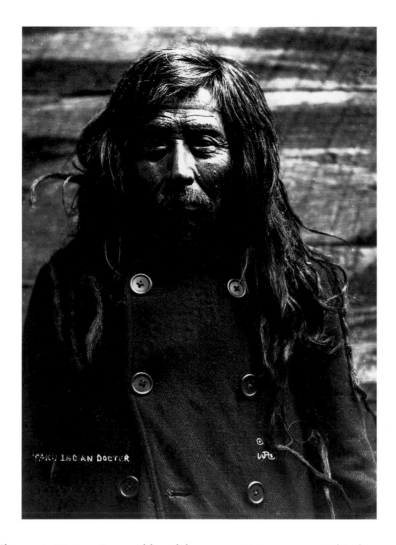

Fig. 21. Tlingit Shaman in Western Dress. Although he wears a Western overcoat, this shaman still has the unkempt hair that distinguished practitioners. The photograph identifies him as being from Taku. Photograph by Case and Draper, Juneau, c. 1905. Alaska State Library, Juneau, 78-215

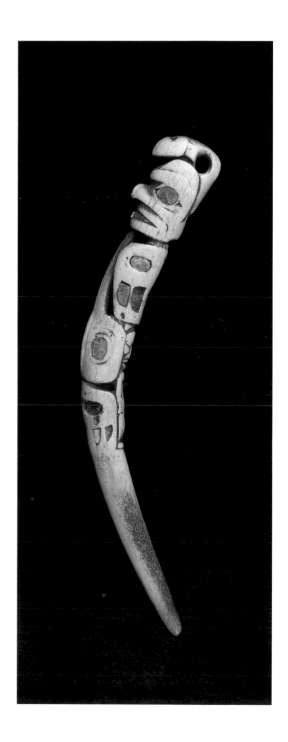

No. 32. Tlingit Hairpin. The museum records describe this as a hairpin, although the carving is pierced for suspension and could have been hung from the neck as an amulet. When they were not performing, shamans kept their hair in place with combs and pins. The predominant figure is a hawk, behind which is a small man. Collected by Edward Ayer in 1892, probably from Carl Spuhn (see Cole, 1985, p. 125). Bone and abalone; length 7⅜ inches; c. 1820–40. Field Museum of Natural History, Chicago, 14332. Given by Ayer, 1894

appeared as they were needed. However, those who came from a good lineage, such as shamans who were also chiefs, did occupy dwellings in the center of the village next to those of other important families. A famous Haida shaman of Masset, K!oda'-i, Beak of the Eagles Living Up Masset Inlet, known to the whites as Ku-té, or Doctor Kude, lived in a large house among those of the chiefs and other leading families. (fig. 22). Although it was behind a chief's house, it did have its own large, fine frontal pole, a symbol of great prestige (MacDonald, 1983a, p. 149). In Skidegate, the shaman called Great Splashing of Waves was also the chief of Those Born at Rose Spit. He owned two houses, each with impressive frontal poles (ibid., pp. 46–47).

As the skills of a shaman increased, his status rose as well, and shamans who were particularly successful could also construct their houses among those of chiefs' families. Gutcda, for example, a noted shaman of the Tlingit, lived in Far Out House at Dry Bay, which despite its name was centrally located and was one of the most important of the village (de Laguna, 1972, pt. 2, pp. 318, 463). In these hierarchical and extremely competitive societies, shamanic performances had their obvious counterpart in the potlatch. The major purpose of this long and elaborate ceremony was to

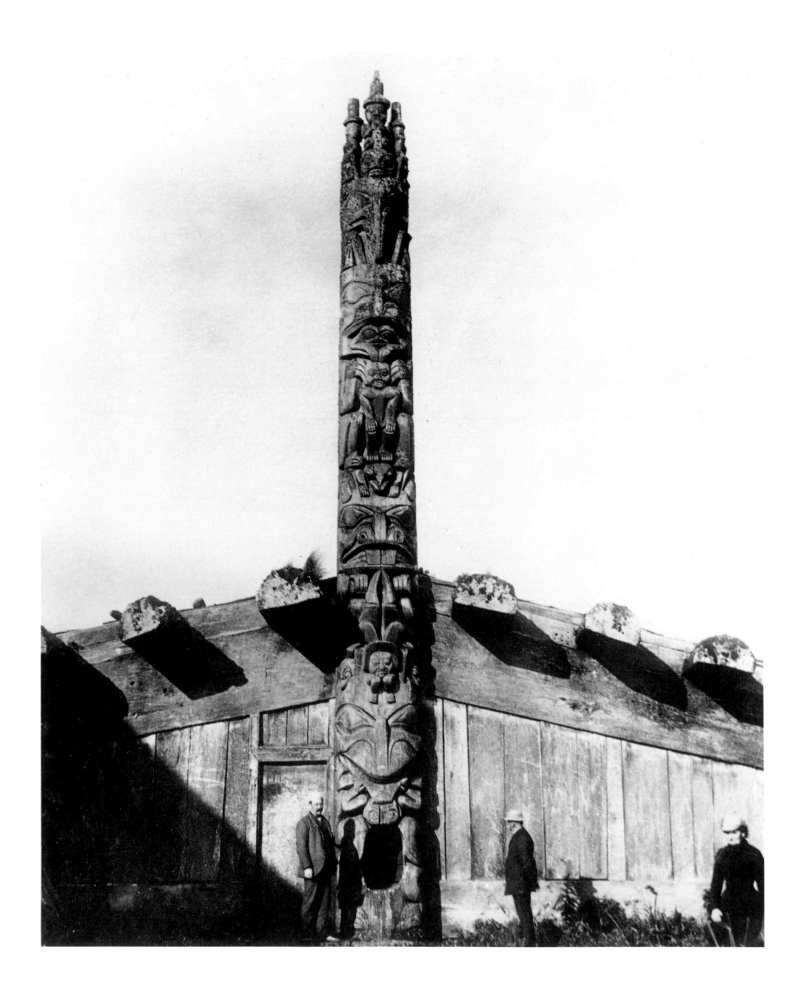

maintain and enhance the social position of chiefs and leading families. The dramatic séances of the shaman might include enactments of his battles and victories over rivals, the identification of evildoers, and the proper resolution of the events he was asked to control. The social status of a shaman who was successful in such activities was enhanced in the same way as that of the families who could give a series of great potlatches.

As professionals, shamans were paid for their services, and some became wealthy in the process. Their fees varied widely. Most accounts tell of those who were paid for their curing powers. It is reported that some Kwakiutl shamans were not allowed to set their fee and had to accept whatever was given (Boas, 1966, p. 137). Among the Tlingit, the amount might be set through consultation with the shaman's spirit helpers (Jonaitis, 1988, p. 95), or through bargaining with their clients (Jonaitis, 1986, p. 61). Whatever was decided had to be paid in advance to assure the presence of spirit assistants. As one Tlingit informant told Frederica de Laguna (1972, pt. 2, p. 703): "'That's the law. Those Yeks never help without paying, you know.'"

Among the Tsimshian, the fee might also depend on the wealth of the family and their anxiety over the condition of the patient (Barbeau, 1958, p. 48). As opposed to the Kwakiutl practice of accepting whatever had been offered, one Tsimshian shaman, when asked to cure the daughter of a chief, is reported to have been unsatisfied with his fee. He did not touch it and left the house, refusing to return until it had been increased to include the hand of the daughter in marriage if he could cure her. The chief finally agreed, the cure was successful, and the marriage took place (ibid., pp. 70–71).

There are many reports of the kinds of payment that were made. Franz Boas (1935, pp. 97–98) writes that Kwakiutl fees might have consisted of canoes, blankets, sea otter pelts, slaves, houses, and the daughters of chiefs. Reporting a Tsimshian episode during which a shaman restored life to the daughter of a chief, he describes the pay as comprising "slaves, costly coppers, canoes and all kinds of goods" (1916, p. 328). William Libbey (quoted in de Laguna, 1972, pt. 2, p. 721), describing attempts to cure a Tlingit dying of arsenic poisoning in 1886, cites the fee, which had to be paid before the shaman agreed to help, as "'a musket and 20 yards of cotton cloth representing a money value of $20.'" By the end of the nineteenth century, blankets were quite commonly used. Anywhere from one to forty or more might be paid, depending on the situation. If the patient died, the fees were expected to be returned.

One notorious case, however, involved a Chilkat shaman named Skundoo, several pieces of whose paraphernalia are included among the illustrations (see nos. 178, 438). Skundoo had been asked to cure another shaman and was paid forty blankets for his work. He identified the witch who had caused the disease, and the unfortunate man died from the torture Skundoo inflicted to force him to confess. A few days later, however, the patient died as well, and Skundoo resolutely refused to refund the forty blankets. The law of the white man then intervened. Skundoo's hair was cut, and he was sentenced to three years in San Quentin prison. He finally returned to his people, his hair grown long again, and, according to Edward Keithahn (1963, p. 18), because he had survived the experience, his stature became greater than ever. After this incident, however, he gave up the practice of shamanism, although he continued to

Fig. 22. Home of the Haida Shaman Doctor Kude at Masset. The most famous shaman of Masset, Doctor Kude had the great wealth and prestige required to live in a house such as this. It is classified as House 26 in MacDonald's (1983a, p. 149) study of early Masset. He describes the crests on the fine pole (from the top) as three watchmen standing on a supernatural snag, an eagle, a bear holding a human and with a frog emerging from its mouth, a beaver grasping a stick and with a human face on its tail, and a standing bear devouring a human and with cubs at its ears. Photograph by Richard Maynard, 1888. American Museum of Natural History, New York, 39991

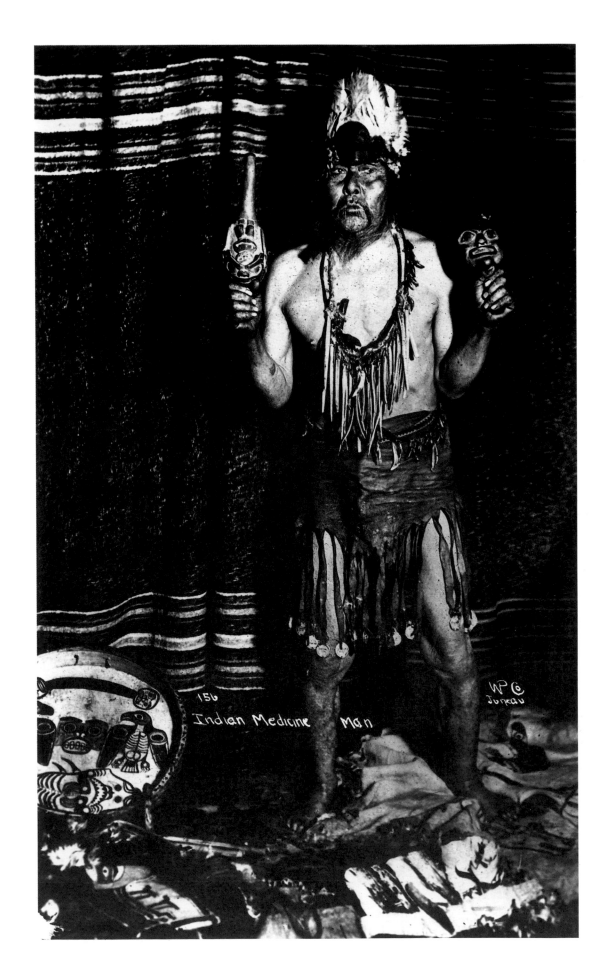

Fig. 23. Skundoo, a Chilkat Shaman, with Ceremonial Paraphernalia. This photograph, which was taken after Skundoo had been to prison at San Quentin, is one of several he posed for, probably for a fee. He wears a feather headdress with a maskette, a necklace with bone pendants, and an apron with various objects attached to the fringes. He carries an oystercatcher rattle in his right hand and a round rattle in his left. The tambourine drum on the floor is painted with a shark and an eagle in the x-ray style. Other items of shamanic use are strewn about. Photograph by Winter and Pond, Juneau, 1894. Alaska State Library, Juneau, 87–258

pose for several photographs and provide George Emmons (1991, pp. 370–71) with information about his past activities.

Petr Tikhmenev, writing in 1863 (quoted in de Laguna, 1972, pt. 1, p. 379), describes a sea otter hunt of the Yakutat Tlingit, the success of which was the responsibility of a shaman. He was paid a fee, but even if the hunt was not successful, he was usually allowed to keep at least a part of it:

> *The Sorcerer nearly always escapes the danger of being deprived of his remuneration, and if his words do not come entirely true, he is generally left in possession of his gifts or at least half of it [sic], since ill success in hunting or any other disaster happening to the party is always ascribed by the Shaman to a failure on the part of the hunters to live up strictly to their observances. . . . Sometimes these misfortunes are ascribed to incontinence on the part of a hunter's wife, etc. If a man is wounded while hunting sea-otter an investigation is made to discover the cause of it among his wives or their relatives.*

Because a shaman led a life of such challenge and responsibility, replacing one who had died was a serious matter for the community. It was understandably regarded as a grave misfortune to be without the services of a successful practitioner. It has been estimated that in the nineteenth century, there were as many as five to ten shamans per thousand Tlingit (Olson, 1967, p. 111). Great care was therefore taken to observe the proper rituals over the body of a deceased shaman to assure prompt succession.

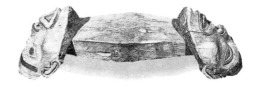

No. 33. Tlingit Headrest. Emmons (n.d.) writes that this was used by a shaman during the "first initiation in Spirit communion, and later while fasting and practicing. The two faces . . . are representatives of . . . spirits, and instruct the shaman how he is to hold his lips. The open mouth is talking or singing and also signifies anger." Collected by Emmons, 1882–87. Wood and black pigment; length 20¼ inches; c. 1830–50. American Museum of Natural History, New York, 19/259. Purchased from Emmons, 1888

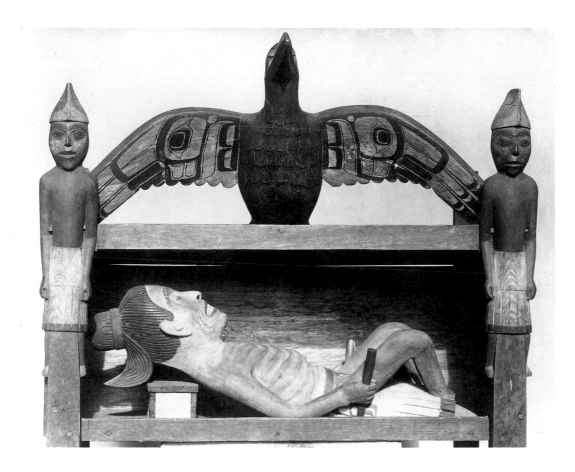

No. 34. Haida Model of a Shaman's Grave. Made by Charles Gwaytihl or Simeon Stilthda, both Haida carvers, this model demonstrates how a dead shaman was placed in his grave house. His paraphernalia might have been kept in the box under his head. The figures on the posts are guardians wearing shamans' hats. According to MacDonald (1983a, p. 28, pl. 21), the raven on the roof represents the crest of the dead shaman. Collected by Israel W. Powell, 1881. Wood and red, black, and blue-green pigment; height 26¼ inches; c. 1870–80. American Museum of Natural History, New York, 16/739. Heber R. Bishop Collection

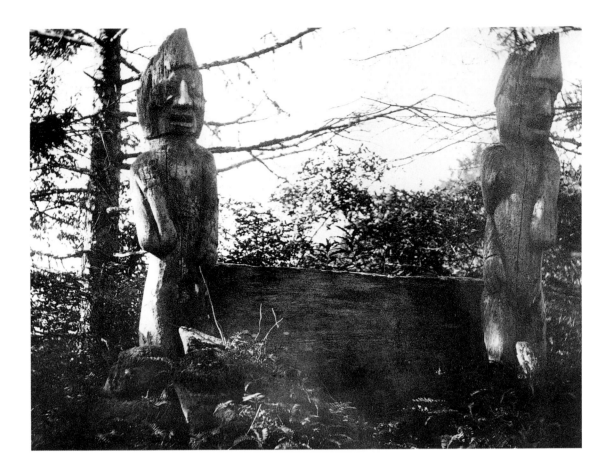

Fig. 24. Grave House of the Haida Shaman Sinigukla at Skotsgais Point Near Skidegate. Information in the archives at the Royal British Columbia Museum (n.d., Notes) identifies this as the grave house of the shaman Sinigukla, who died in 1859. Both of the guardian figures wear shamans' hats. Photograph by Charles F. Newcombe, 1900. Field Museum of Natural History, Chicago, 16312

Accounts of the funeral ceremony vary, but in general they can be looked upon as enactments of a shaman's journey through the various spheres of the universe to which he had traveled during his professional life. A description of a Haida rite illustrates this particularly well (MacDonald, 1983a, p. 28):

> At death, his [the shaman's] body was hoisted through the smoke hole of the house, symbolizing his journey to the upper world. Then his body was placed in a canoe drawn up sideways to the beach to impede his return, and he was borne across the water to symbolize his final journey to the underworld. En route the canoe was turned around three hundred and sixty degrees in the water to symbolize crossing the celestial axis.

John Swanton (1908c, p. 430) tells of a similar Haida ritual.

Frederica de Laguna (1972, pt. 2, p. 673) describes the Tlingit as carrying the shaman's body around his house in a sunwise direction eight times and then removing it head first through a hole in the right wall "so that his spirit would soon return." Another description of a Tlingit shaman's funeral, written in 1840, states that the body was placed in a different corner of the shaman's lineage house on each of the four days after death. On the fifth day, the corpse was dressed in the shaman's full costume, tied to a board, and carried to the forest (I. Veniaminoff, cited in Jonaitis, 1986, pp. 61–62).

Unlike that of a layperson, the shaman's body was not cremated but taken from the village and placed in a cave or grave house, where it was laid out above ground and surrounded by his paraphernalia. Cave sites were little more than overhanging rock

Fig. 25. Islet Near Henslung Cove with the Grave House of the Kiusta Shaman Gorgie. MacDonald (1983a, p. 192) reports that in 1897 George Dorsey, Curator of Ethnography at the Field Museum in Chicago, had visited this site of Gorgie's burial house, which had been built on the top of a nearly inaccessible rock. By then the house was in ruin, and only two hats belonging to the shaman were found (see also Cole, 1985, pp. 170–71). The location of a shaman's grave house on such an unusually shaped and remote site reflected the otherworldly nature of the shamanic profession and the often isolated lives of its practitioners. Photograph by Charles F. Newcombe, 1913. Royal British Columbia Museum, Victoria, E 627B

shelters into which the shaman's body and his paraphernalia had been placed. Emmons (1991, p. 394) suggests that such interments may have antedated those in grave houses, which were built after the metal tools that facilitated their construction became available in the nineteenth century. The grave houses were sometimes elevated on four posts, gabled, and guarded by carvings as tall as six to eight feet which represented spirits who protected the area from the uninitiated and evil influences. The location of these structures on bluffs overlooking the sea, deep in the forest, near beaches, and on unpopulated remote islets was another reference to the isolated life of the shaman. It also reflected his involvement with spirits and the different levels of the cosmos and those animal spirits that inhabited such border regions.

As time went on, the corpse became mummified. The grave house was maintained by specially selected assistants until it decayed to such an extent that it became necessary to remove the remains to a new structure. In one instance, the bones of six long-dead Tlingit shamans were taken from their respective burial houses on the Akwe River and placed in a single grave house built on a point of land across from Dry Bay. Those who handled the remains were extremely well prepared and purified to avoid harmful exposure to the spirits of the dead shamans. Construction of the new house took four days, and those who did the actual work had "to have four days to get over" the experience (de Laguna, 1972, pt. 2, p. 646). Indeed, two of those involved in this episode did become infected by the spirits, but both refused the call and both were reported to have died as a result (ibid. and pp. 719, 720).

Following interment, great effort was made to identify a new shaman to take the

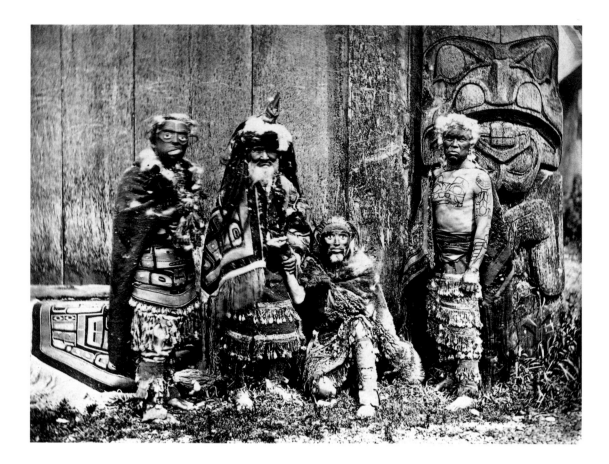

Fig. 26. Four Haidas in Ceremonial Dress. The shaman Doctor Kude stands second from the left. The photograph is accompanied by the following undated note by James G. Swan: "The left hand figure with the mask represents the wife of the one kneeling who is also masked and is supposed to have been dead, and the medicine man [Kude], who holds his hand, has brought him to life. The right hand man is showing his tatoo [*sic*] marks with pride." The figure to the right is Xa'na of Grizzly Bear House, whose tattoos of a bear head and a seated bear are visible. The two masked figures are mistakenly identified as shamans by Jonaitis (1988, fig. 27) and Blackman (1990, pp. 250–51, fig. 12). The masks and leggings are in the American Museum of Natural History. Franz Boas (n.d.) catalogued them, describing the mask on the left (16/379 [Malin, 1978, pl. 47]) as the "face of a man who has just seen a spirit," and the mask on the right (16/396) as representing "Tarhtchakt, an old Indian of good nature." He does not ascribe shamanic use to either the masks or the leggings (16/335). It has also been established here that Haida shamans did not wear masks (see p. 10). Photograph by Edward Dossetter, 1881. American Museum of Natural History, New York, 337179

place of the deceased. In addition to the techniques mentioned at the beginning of this chapter, Ronald Olson (1961, p. 211) reports another means of selection. At a gathering of the clan held each day for four days after the funeral, the chief shouted the name of a spirit who had been in the service of the shaman four times in the hope that it would return and inhabit someone who was in attendance. This was followed by the singing of the deceased shaman's songs. In the incident reported a spirit did not come because the shaman's instructions for his burial had been violated, and the people were therefore without a shaman and his essential services. Most of the time, however, there were other less powerful or apprentice shamans who were willing to assume the position, and the cycle was continued.

With the coming of the outside world to the Northwest Coast, the role of the shaman began to diminish, not only because of the assiduous and uncompromising work of Christian missionaries but also because some of the white man's medicines were found to be more effective than the cures of the shaman against such exotic diseases as smallpox, tuberculosis, and alcoholism. The introduction of scientific knowledge and technology also played a part in the waning of shamanism, as predictions of animal behavior and natural phenomena such as salmon runs and the weather could be made by science rather than the shaman.

Some missionaries and naval officers responded to the injustices that shamans carried out against those accused of witchcraft by subjecting the practitioners to public ridicule. De Laguna (in Emmons, 1991, pp. 409–11) recounts several such episodes. One, which occurred at Sitka in 1882, was reported by Commander Henry Glass, USN, as follows:

Fig. 27. Group Portrait at Masset. In contrast to the 1881 photograph of Doctor Kude (fig. 26), here the shaman, who stands third from the right, wears Western dress. By this time, he had been converted to Christianity by the Anglican missionary William H. Collison, shown second from the left. It appears, however, that at his death, Kude was laid to rest in the manner of a shaman and placed in a grave house above the ground (MacDonald, 1983a, p. 149). Photograph by Robert Reford, c. 1890. Pacific Archives of Canada, National Photography Collection, Ottawa, c 60824

An investigation left no doubt of the guilt of the leading Shaman of the village, and he was arrested and confined in the guard-house just as he had about completed all his preparations for leaving Sitka in a very hurried manner. All the Indians were assembled in front of the guard-house, the witch-doctor was brought out, and the case and the absurdity of his pretensions explained through an interpreter. It was announced that the Shaman's hair would be cut off close to his head, that he would be scrubbed thoroughly, to deprive him of the supernatural powers he claimed, and then be kept at work for a month, and afterwards banished from the Sitka settlement. He was first invited, however, to test his powers, in the presence of the Indians, in bringing any plagues he chose on the commander and his officers and men. The sentence was carried out, to the delight of all the Indians present, but banishment was not found necessary, for the Shaman was not proof against the ridicule to which he was subjected, and left the village of his own accord at the expiration of his confinement.

Acceptance of the Christian doctrine probably had the greatest impact on the decline of shamanism, as the statements and actions of former shamans emphasize. In 1863, the bishop of Caledonia quoted a newly converted Tsimshian shaman as saying: "'I have given up the lucrative position of sorcerer. Been offered bribes to practice my art secretly. I have left all my mistaken ways. My eyes have been bored (enlightened). I cry every night when I remember my sins. The Great Father Almighty sees everything'" (quoted in Halpin, 1984, p. 302). William Collinson, the missionary at Masset, describes the conversion of the Haida shaman K!oda'-i as follows: "Ku-té several years before he died had his hair cut, and embraced Christianity. [He] . . . gave me his most important spirit catching charm and it was sent to the Oxford University Museum where it can be seen today" (quoted in MacDonald, 1983a, p. 149). Isaac Tens himself underwent a similar experience: "'Now I use a different method in treating my patients. I employ nothing but prayers which I have learned at

the church. I pray like the minister – the Lord's Prayer. It has been translated into Gitksan by the Rev. Mr. Price of Kitwanga. I have entirely given up the practice of the *halaait* [medicine men]'" (quoted in Barbeau, 1958, p. 54).

The ancient tradition of shamanism survived well into this century, however, and as late as 1945, Edward Keithahn (p. 86) could still write that "a few Shamans still practice their occult art and a belief in witchcraft is still quite general in the native villages." Yet there could be no question that shamanism was dying out even as Keithahn wrote. Ronald Olson (1961, p. 207) observed that Tlingit shamans were "almost a thing of the past; in 1933 there were only two practitioners, a half-breed at Hoona and a woman living in Angoon." The most poignant comment about the perceived end of this millennia-old tradition on the Northwest Coast was made by one of Frederica de Laguna's informants sometime in the early 1950s (quoted in 1972, pt. 2, p. 671): "'All the doctors die off when the White People came, because nobody believe it any more.'"

It is, however, too soon to conclude that the basic human needs that the shaman addressed no longer exist and can be forgotten even in the face of the impressive achievements of science and technology. The more we embrace and believe in the information they bring us, the more unanswered questions there seem to be. We have found that we cannot always predict the weather or the run of salmon upstream. Illness cannot always be overcome only with new drugs, lasers, and the latest microchip technology. A successful cure requires the full belief and participation of the patient along with a close bond with the doctor; the shaman interacted with his charge in exactly the same way.

Recently, many new theories concerning holistic medicine and symbolic healing have been developed. They have given rise to a form of neoshamanism that seeks to restore to our lives those elements of this ancient practice that were lost but have been found to be important to human thought and survival. Marie-Françoise Guédon (1984b, pp. 204–5) cites Carl and Jean Simonton's treatment of cancer patients as being closely akin to the shamanic approach, for they have stated that "'it is our central premise that an illness is not purely a physical problem but rather a problem of the whole person, that it includes not only body but mind and emotions. We believe that emotional and mental states play a significant role both in *susceptibility* to disease, including cancer, and in *recovery* from all disease.'"

The Simontons encourage their patients to create a mental image of their illness and the treatment that includes visions of both the body's ability to heal itself and its natural defenses and culminates in a view of the person being free of the ailment. These images are personal and can only be seen and understood by the individual employing them. This approach, which has become known as *imaging*, is widely practiced today, and many professionals believe it to be an essential part of treatment.

Today, therefore, some believe that shamanism is not dying out but merely undergoing its own transformation. In its new form, it reflects both the shortcomings as well as the benefits of science and the continuing need of humans to have a sense of understanding that only it can provide. Indeed, Marjorie Halpin (1988, p. 535) has recently suggested that the discipline still exists: "Although shamanism on the Northwest Coast is rarely reported today, this may only mean that it has gone under-

Fig. 28. Female Nootka Shaman from Clayoquot Sound, Vancouver Island. The shaman wears a cedar bark tunic, and her hair is strewn with eagle down. Her feather headdress includes a number of large plumes with serrated edges. Photograph by Edward S. Curtis, c. 1914. Royal British Columbia Museum, Victoria, PN 5410

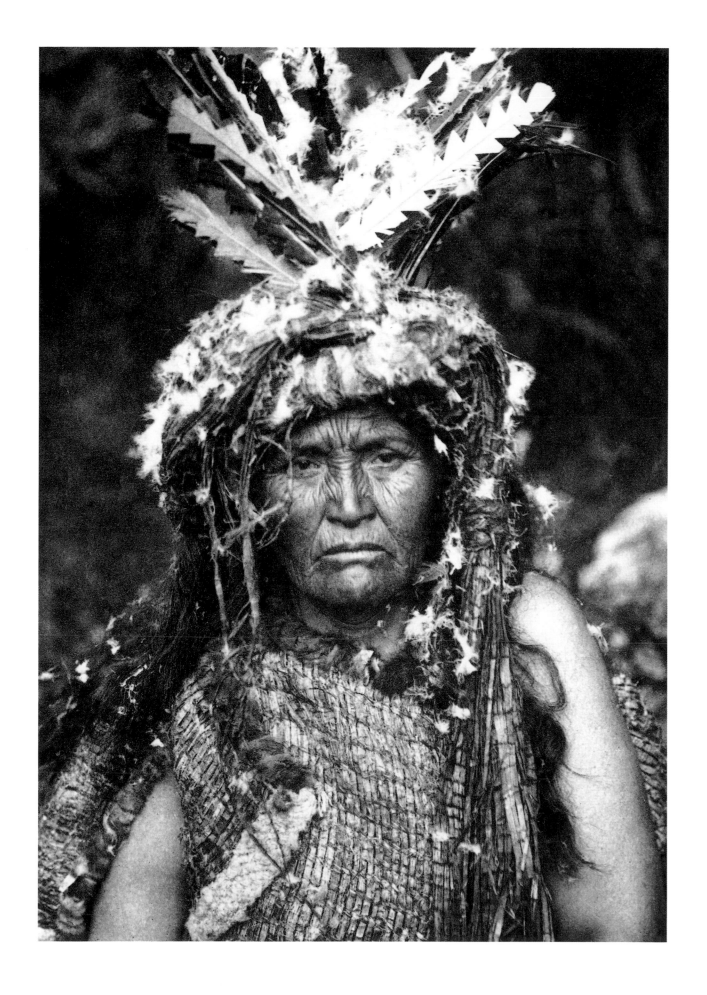

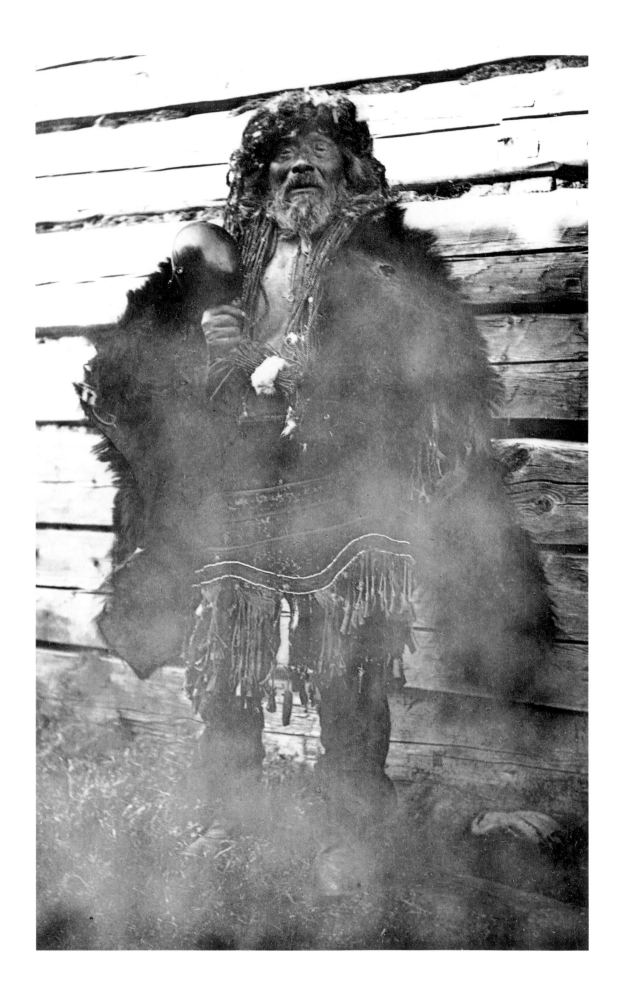

Fig. 29. Tsimshian Shaman. Museum records iden-
tify the shaman as Amaget of Kispiox. He wears an
animal skin robe, a beaded necklace, and a feathered
headdress. Photograph by George Emmons, c. 1909.
Royal British Columbia Museum, Victoria, PN 4407

ground like so many other sacred practices that are not reported to skeptical and transient visitors."

We do not wish to suggest that all aspects of shamanism are benign. Some components of its practice depend on intimidation, and, as has been seen, the torture and even death of perceived but perhaps innocent evildoers. Indeed, Frederica de Laguna (in Emmons, 1991, pp. 404–12) provides ample evidence of the cruelty visited upon accused witches as it was recorded by missionaries and sailors well into the twentieth century. In addition, some shamans were undoubtedly charlatans who could cause undue suffering, disappointment, starvation, defeat, and death when their cures and predictions failed. The explicit and macabre content of certain of the stories recounted here and the sometimes threatening nature of the objects also reveal the dark and violent aspect of Northwest Coast shamanism. However, if shamanism continues to survive, and we would like to believe that those elements of its beneficial nature are still being sought after and utilized, something of what is described here may still be occurring. Perhaps works of art are still being made and used in this context as they have been for the past two thousand years or longer. Such objects may not necessarily resemble those that appear in this volume, but they would have the same purposes and significance. It is also possible that such objects are no longer regarded as necessary and that the performances alone satisfy the present requirements of shamanism. Whatever its contemporary manifestation, this ancient system will most likely continue to survive in one way or another because it deals with elemental human problems and questions that cannot be solved through any other means.

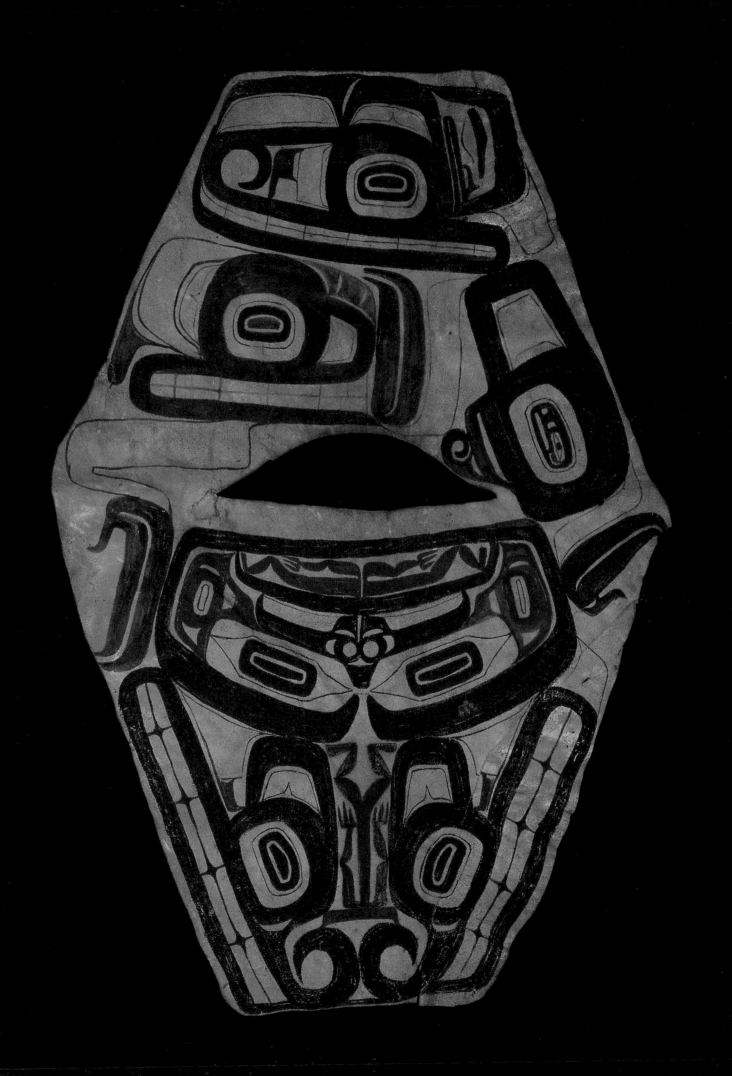

CHAPTER IV

OBJECTS OF POWER

UNFORTUNATELY, *we can no longer meet the Tlingit, Tsimshian, and Haida shamans and observe them practicing; we can only visit museums that display their rich and varied assortments of sacred paraphernalia. During these visits, we can appreciate the exquisite delicacy of certain shamanic artworks, the vivid expressionism of others, and the uncompromising roughness of yet others. We can, by studying the style of their art, arrive at a deeper understanding of what they experienced and how they accomplished the awesome responsibilities of safeguarding the welfare of their people.*

ALDONA JONAITIS

IN GENERAL TERMS, much of the art that was made for shamans follows the basic design principles of all Northwest Coast painting and sculpture. The elements of the organization of the art in two dimensions were carefully set forth by Bill Holm in *Northwest Coast Indian Art: An Analysis of Form*, which has become the quintessential reference on the subject since its publication in 1965. The following brief summary does not do justice to Holm's work, but has been offered to provide an approach to looking at two-dimensional shamanic art.

Northwest Coast decoration is achieved by painting or shallow relief carving or a combination of the two on such materials as wood, copper, ivory, bone, antler, and stone. The designs are skillfully adapted to the surfaces they cover. Painted designs were also applied to animal skin, and weavings in the form of aprons made of dyed mountain goat wool employ similar design conventions.

Prior to the coming of the outside world, the shamanic artist's palette was limited to black, red, blue, green, and blue-green, all of which were derived from earth colors, metal salts, or vegetable dyes from the environment. In the nineteenth century, synthetic pigments soon took the place of the natural ones, but the preference for the same colors remained, with only yellow and white newly incorporated.

The most distinctive element of Northwest Coast art is what Holm (ibid., pp. 29, 37) calls the "formline," which he describes as

the characteristic swelling and diminishing linelike figure delineating design units. These formlines merge and divide to make a continuous flowing grid over the whole decorated area, establishing the principal forms of the design. . . . [They] rarely retain . . . the same width for any distance. Generally they swell in the center of a given design unit and diminish at the ends. The width of a formline usually changes with a major change of direction. . . . [They] are essentially curvilinear. The curves are gentle and sweeping, breaking suddenly into sharper semiangular curves and, immediately upon completing the necessary direction change . . . , straightening into a gentle curve again.

No. 35. *Tlingit Tunic.* The bold, painted formlines on this tunic include images associated with shamanic art. At the bottom is a headless figure, while the large animal head in the center devours a human. At the upper right is the profile of a human head with a closed eye that indicates a trance state. Emmons (n.d.) identifies the head below as that of a salmon, and interprets the motif at the bottom center as a sculpin with spirits on each side, although it may well be a bear. For unknown reasons, some of the formlines at the top have not been filled in with black. Collected by Emmons in 1884–93 from the nephew of Nolk, a Hutsnuwu shaman who died about 1865 and was buried with his paraphernalia in a grave house at Chait Bay, Admiralty Island. Animal skin and black and red pigment; width 22½ inches; c. 1840–60. Former collections: American Museum of Natural History, New York, E 980; Staatliches Museum für Völkerkunde, Dresden. Private collection

No. 36. Tlingit Covered Chest. The broad, relief-carved formlines on this chest are characteristic of Tlingit work of the early nineteenth century. Chests were used by shamans to hold their paraphernalia. This one and nos. 37 and 46 are similar in style to those made to store the property of chiefs, and, if it were not for their provenance, nothing in their appearance would have suggested shamanic associations. Emmons (n.d.) identifies the motif on this chest as representing a mythical sea spirit. Collected by him from the grave house of the shaman of the Takdentan clan near Hoonah, 1884–93. Wood, twine, and spruce root; height 10¼ inches; c. 1800–1820. American Museum of Natural History, New York, E 1211. Purchased from Emmons, 1893

It is the formline that gives such a fluid quality to all Northwest Coast art, whether it is painting, relief carving, or three-dimensional sculpture.

Holm divides formlines into primary and secondary categories and describes the motifs and the colors used by each. Separate design units include ovoid eyes and joints, lenticular-shaped eyelids, u-forms of considerable variety, and curved eyebrows. Other anatomical features such as hands, feet, claws, feathers, tails, flukes, fins, mouths, tongues, and teeth also appear. The two-dimensional elements described by Holm can be found in such shamanic objects as the painted aprons, robes, and tunics, the woven aprons, and the relief carvings on certain boxes, rattles, and amulets.

For three-dimensional sculpture, the formline concept plays a part in the organization and placement of features, but there was not as standardized a system for the creation of sculpture as there was for the shallow relief carvings and woven and painted designs. The basic characteristics of Northwest Coast representational sculpture have been studied and described from as early as 1918 by Herman Haeberlin and 1927 by Franz Boas (pp. 183–298). Their findings were summarized in 1936 by Leonhard Adam, who lists the eight fundamental aspects of this expression:

1. *Stylization rather than realism.*
2. *Schematic characterization through the exaggeration of certain anatomical features.*
3. *Splitting of forms to cover the entire surface of an object.*
4. *The dislocation of split details to other parts of the decorated surface.*
5. *The representation of one creature in frontal view through the use of two confronting profiles.*
6. *Symmetry, with some exceptions.*
7. *The reduction of elements of monumental art to objects of small scale.*
8. *The illogical transformation of details into new representations.*

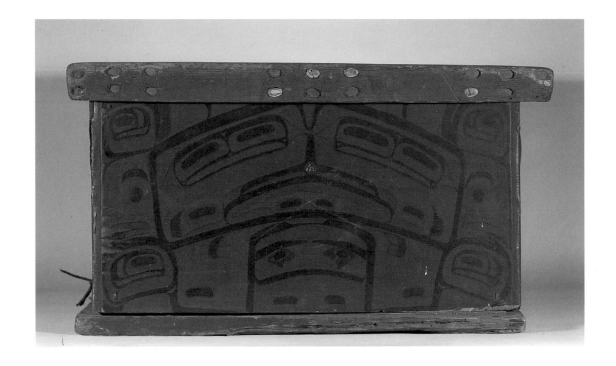

No. 37. *Tlingit Covered Chest.* Emmons (n.d.) identifies the painting on this chest as representing a mythical sea spirit. Collected by him from the grave house of a shaman of the Kiksadi clan of the Sitka tribe at Peril Strait, thirty miles north of Sitka, 1884–93. Wood, rawhide, and black and red pigment; height 13¼ inches; c. 1840–60. American Museum of Natural History, New York, E 652. Purchased from Emmons, 1893

The sculptural elements noted by Adam are especially applicable to crest art. Certain shamanic objects such as masks, guardian figures, sculptured rattles, combs, and some amulets do follow these conventions, but there are more exceptions to the rule of symmetry in shamanic art than in crest art, particularly among amulets, masks, and the paintings on skin tambourine and wood box drums. The asymmetrical carvings and paintings suggest artists' deliberate attempts to violate this principle. Perhaps such irregular designs were chosen to suggest the world outside of the norm with which the shaman was involved.

Shamanic art is also mostly of small scale. With the exception of some of the over-life-size grave guardian figures, few monumental objects were made for shamans' use. Most of it was designed to be carried or worn. Some of the sculptures are marvels of miniature carving showing an even greater variety of form and content than do the small-scale works made for crest display.

Both crest art and shamanic art can be remarkably realistic. This is especially evident in some early Tlingit masks that can almost be regarded as idealized portraits. On the whole, however, both expressions tend to be stylized with the exaggeration of outstanding physical characteristics of each creature depicted. The high degree of abstraction found in such examples of crest art as Chilkat blankets, painted and relief-carved boxes, and canoe paintings is absent from shamanic art except for a few woven aprons and some of the paraphernalia boxes.

Not all shamanic art is finely carved and made. Some pieces are distinctly crude, and it has been pointed out (Pasztory, 1981, pp. 12, 28) that the visual beauty of the objects employed by shamans was not a requisite to the success of the shamanic performance. The pure quantity, not the quality, of the magical artifacts that a shaman possessed and used validated his status and enhanced his powers. In much the same way, the great numbers of crest objects that were owned and displayed at feasts and potlatches reinforced the prerogatives of chiefs and other important families. Thus,

No. 38. *Tlingit or Tsimshian Amulet.* The three figures cleverly incorporated into the design of this small amulet are a raven at the top, a seal below its beak, and the head of a shaman wearing a crown at the right. The fluid quality of Northwest Coast art is well represented here. Collected by Emmons at Port Simpson. Stone, abalone, and red pigment; length 2¾ inches; c. 1840–60. National Museum of the American Indian, Smithsonian Institution, Washington, D.C., 16/476. Purchased from Emmons, 1928

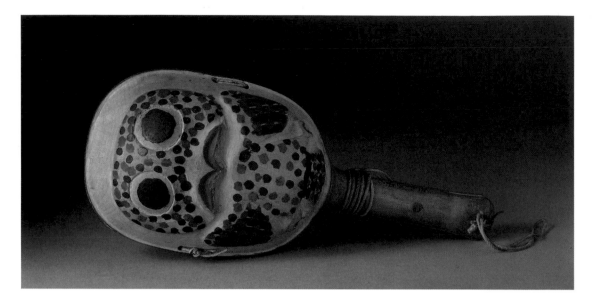

No. 39. Tsimshian Amulet. Made by Charlie Smith, a shaman of Kispiox, where Marius Barbeau collected this piece in 1927. The museum records provide the following information: "Used for extracting the pain from the body of the patient. If the patient had a sore left, this would be attached to the sore while the doctor sings and performs. The medicine man had a dream of his patient and what to use for him. The dream had it that a rock carved in this shape, if it were placed on the patient, would cure him." Stone and ocher; length 3½ inches; c. 1900–1925. Canadian Museum of Civilization, Ottawa, VII–C–1414. Given by Barbeau, 1927

No. 40. Tsimshian Rattle. This rattle was made by the shaman Isaac Tens, and according to Marius Barbeau (n.d.), its form and decoration were inspired by a dream of Tens's patient Alexander Mott. An owl is painted on the side shown and a human head on the other. Collected by Barbeau at Hazelton, 1920–21. Wood, twine, and red and black pigment; length 11 inches; c. 1900–1920. Canadian Museum of Civilization, Ottawa, VII–C–945

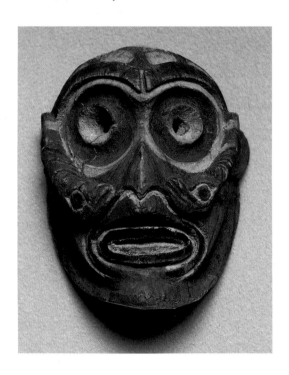

No. 41. Tlingit Headdress Maskette. The iconography of this maskette is similar to that of nos. 114 and 115. Although its carving details and the application of pigment are not as carefully rendered as those on the other examples, this in no way would have lessened the object's shamanic importance. The blue pigment is not indigenous. Wood and red, white, black, and blue pigment; height 3¾ inches; c. 1860–80. National Museum of the American Indian, Smithsonian Institution, Washington, D.C., 21/3680. Purchased, 1949

not all shamanic objects were necessarily the best examples of the expression, for what they depicted was sometimes more important than their aesthetic appearance. This explains, in part, why so much of both crest and shamanic art was made and still exists today (ibid., p. 12).

Certain shamanic objects may even have been deliberately made to appear crude to symbolize the shaman's opposition to the standards of the secular world (Jonaitis, 1983, p. 131). In some cases, the carver of such works was the shaman himself. Some must have had excellent artistic capabilities, but they were not primarily artists (Holm, 1983, p. 118, no. 201).

Two Tsimshian objects in the Canadian Museum of Civilization in Ottawa bear documentation that they were made by their shaman owners. One is a stone curing amulet carved by shaman Charlie Smith with designs that were inspired by his dream of his patient (no. 39). The other is a rattle in the form of an owl made by Isaac Tens, which was based on an image from the dream of one of his patients (no. 40). Neither of these pieces is of high aesthetic quality, but obviously what they represented was of more significance than how they appeared. In order to show this aspect of shamanic art, a few objects of less than good quality have been included in this volume. Works in this category did, in fact, form a significant part of each shaman's kit, and some could well have had more power and meaning to their owners and those who saw them in use than those pieces of great aesthetic merit.

If the shaman was not a skilled artist yet wished to own and use fine objects, he had to commission a master carver, weaver, or painter to create them (Jonaitis, 1988, p. 95). As a rule, the artist was related to the shaman. Among the Tlingit, if the piece was to be a sculpture of wood, bone, or probably ivory, it was likely made by a brother or male cousin; if it was to be an object of animal skin, weaving, or basketry, it was probably made by his sister or a female cousin (de Laguna, 1972, pt. 2, pp. 687–88). If,

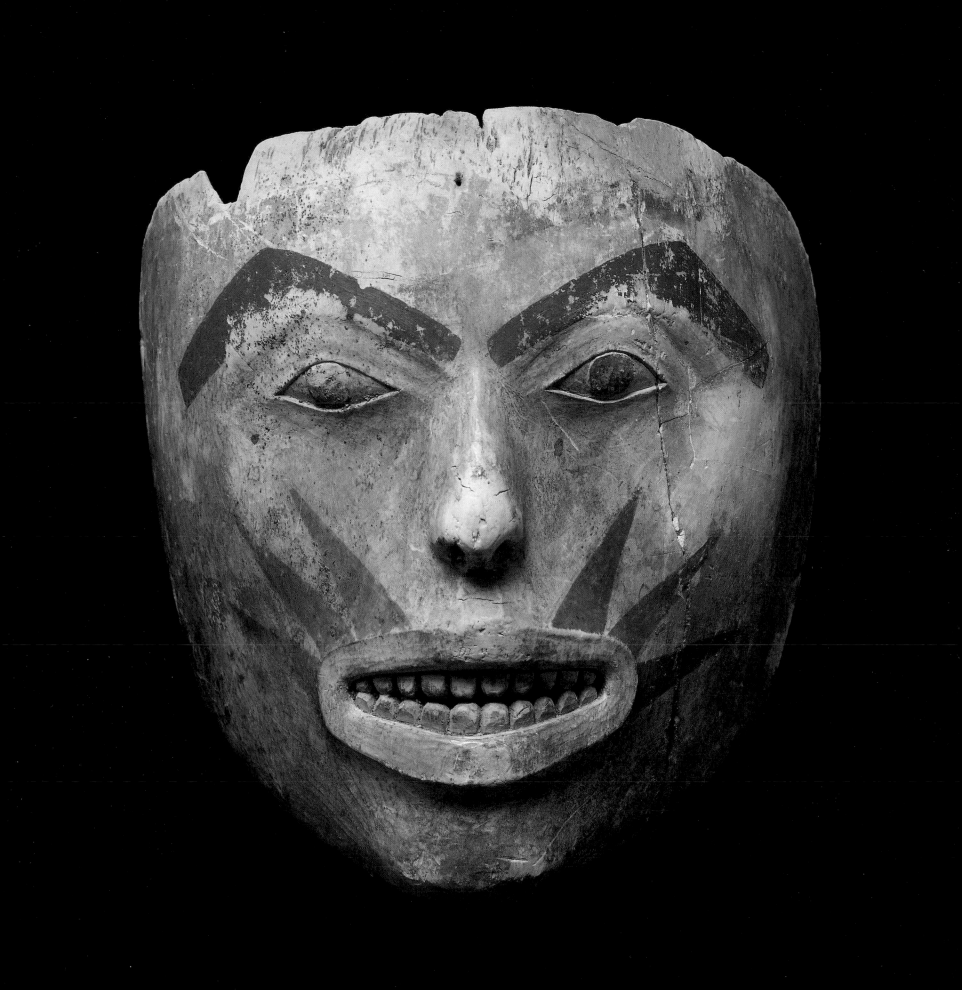

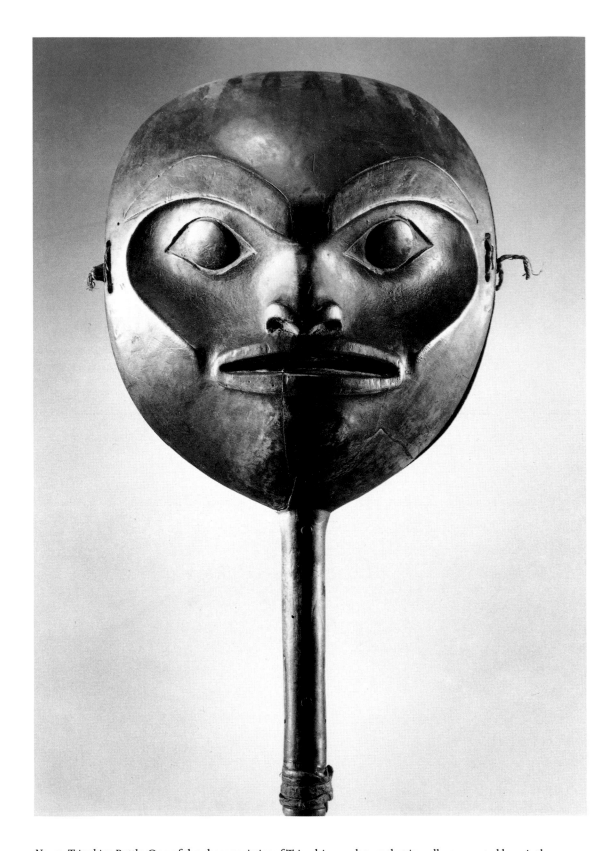

No. 42. Tlingit Mask (previous page). Emmons (n.d., Notes, NMAI) identifies this beautiful early mask as representing the sun. Although its exact provenance is missing, it relates closely to a group collected by Emmons in the 1880s from one or more shamans' grave houses around Port Mulgrave (Yakutat) and Dry Bay (see esp. nos. 2 , 98, and 103). Wood and red, black, and blue-green pigment; height 7⅝ inches; c. 1790–1820. Former collection: Museum of the American Indian, New York; removed from the collection at an unknown date. Rietberg Museum, Zurich, RNA/204. Given by Eduard van der Heydt

No. 43. Tsimshian Rattle. One of the characteristics of Tsimshian sculpture that is well represented here is the manner in which the underlying bone structure of the face is indicated by the sharp delineations of form around the cheeks and eyes. The well-worn handle shows long use, and this rattle may have been the property of more than one generation of shamans. Wood, spruce root, rawhide, and black pigment; length 12⅝ inches; c. 1830–50. The Metropolitan Museum of Art, New York, 1978. 412.97. The Michael C. Rockefeller Collection, bequest of Nelson A. Rockefeller, 1979

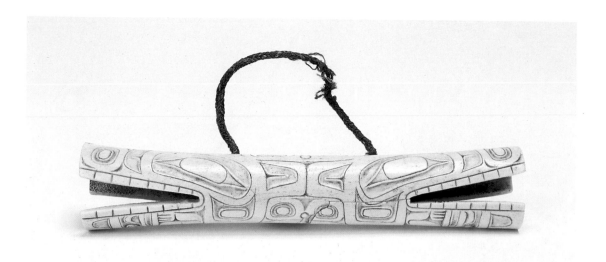

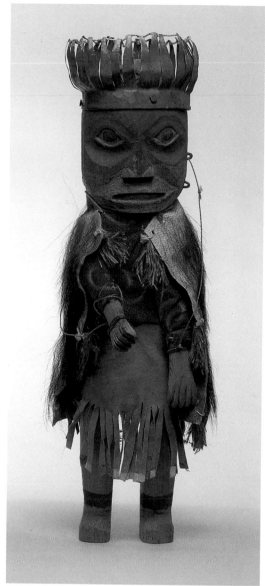

No. 44: Tsimshian Soul Catcher. Although bone soul catchers were commonly used by Tlingit and Haida shamans, they are now all thought to have been made by the Tsimshian and exchanged with neighboring peoples. This one typically shows an open-mouthed animal head at each end. Below the lower jaws are carved forepaws, probably of bears. Collected by Lieutenant F. M. Ring at Port Simpson, 1872. Bone and wool cord; length 9 inches; c. 1840–60. National Museum of Natural History, Smithsonian Institution, Washington, D.C., 10983. Given by Ring, 1872

however, no relative of the shaman was a talented artist, anyone else could be hired, even a member of another group, for those who saw any shamanic object still considered it to have been made by a kin of the practitioner (Jonaitis, 1978, p. 66 n. 7). Those artists commissioned to execute the more complex works must have been carefully advised by their patron as to exactly what images he wished the finished piece to contain.

Among the Tsimshian, only members of an elite group of artists called the *gitsontk* were allowed to make the objects that were used in secret society ceremonies and at initiations. It has been suggested that the round rattles used by Tsimshian shamans might have been made by the *gitsontk* as well (Shane, 1984, p. 165). There is at least one recorded instance of a member of this group making a shamanic object. In 1918, a Tsimshian shaman from Kispiox named Nooks asked his nephew, Charles Mark, who was a *gitsontk,* to carve him an image to represent a medicine woman that was subsequently used in a ritual to cure a patient of influenza (Guédon, 1984b, pp. 202–4). This object, called the "Woman of Sickness," is now in the Canadian Museum of Civilization (no. 45).

Much of the material carried and used by the shaman could not be categorized as art at all. Instead it consisted of natural objects and undecorated items that were thought to have magical qualities in and of themselves. They did not so much act as receptacles of those powers as provide a catalyst through which they could be called upon (Miller, 1984, p. 144). Several fairly complete shamans' kits have survived in museums. The contents, as listed on the accession cards, of one that was collected from the Tlingit by George Emmons and is now in the National Museum of the American Indian (16/1719) in Washington, give some idea of the variety of paraphernalia, man-made and natural, that was used and kept by a practicing shaman:

No. 45. Tsimshian Figure: "Woman of Sickness." Guédon (1984b, pp. 202–4) gives a full account of the creation and use of this figure. It was made in 1918 by the shaman Charles Mark at Gitzekula to counteract an influenza epidemic. Mark, a member of an elite group of carvers called *gitsontk*, had been asked to make the image by his uncle, the shaman Nooks. After the figure was shown to all the shamans of the neighboring villages, it was placed near the patient, who lay at the rear of the house, and then was hidden from view. The shamans sang the song of the figure to the words: "It is the Woman of Sickness who is causing me to be sick." The patient is said to have magically vanished and the figure to have appeared in his place, thus effecting a cure. Collected by Marius Barbeau at Kitwanga, 1924. Wood, tin, animal skin, cotton, cedar bark, tacks, twine, and white, red, and blue pigment; height 19 inches; 1918. Canadian Museum of Civilization, Ottawa, VII–C–1156. Given by Barbeau, 1924

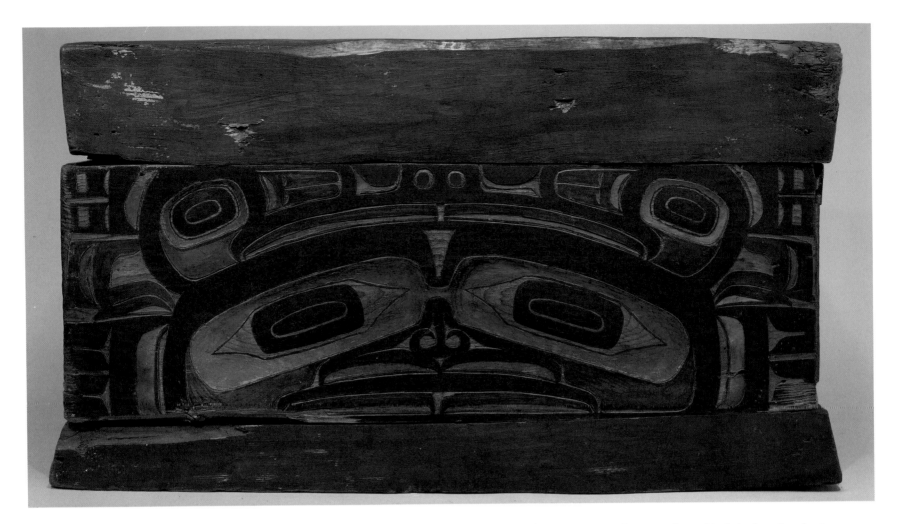

No. 46. Tlingit Chest (above) *with Contents* (opposite). This chest (letter H below) was wrapped in a cedar bark mat and placed in the hollow of a cedar tree on the west coast of Prince of Wales Island, most probably by an unknown shaman in the early nineteenth century. In 1941, the tree was blown down, and the chest was rediscovered by a Tlingit. The relief carving, with broad formlines that depict the face of a bear, and the use of indigenous pigments suggest an early date for the chest. In it were a human skull and some charred bones, a beaver skin headdress, and two smaller boxes containing the following objects: *Mask of a human in a trance* (no. 47).
A: *Three dolls.* Wood and traces of black, red, and blue pigment; height of each c. 7½ inches. B: *Maskette of a human.* Wood; height 3 inches. C: *Maskette of a raven.* Wood, copper, and black and blue pigment; height 4¾ inches. D: *Spear point.* Wood and black pigment; length 10 inches. E: *Human head with a hat.* Wood and traces of black and blue pigment; height 7⅞ inches. F: *Fragment of a bird rattle with a bird carved on the back.* Wood, cedar bark, and black pigment; length 7¾ inches. G: *Small box.* Wood and cedar bark; height 1½ inches. H: *Chest.* Wood, shell, and black, red, and blue-green pigment; height 12½ inches; c. 1790–1820. Private collection

Two cedar bark hats, one with two ermine skins, and a cylindrical potlatch ring, the other with a maskette attached. Two cedar bark headrings, one with a wolf head maskette, the other with a human maskette attached. A bear skin headdress with abalone shell ears. Two pairs of cloth leggings decorated with puffin beaks. A caribou skin apron decorated with puffin beaks. A pair of rattles in the form of land otters (no. 400). An oyster catcher rattle with two flying shamans on the back (no. 69). A pair of rattles in the form of human faces. Two masks in the form of human faces. Two maskettes in the form of human faces (nos. 129, 166). A headdress of brown bear ears. A necklace of uncarved ivory pendants. A small wood figure in the form of a kneeling man. A crown with eight wood points, each with a human head at the bottom (no. 309). A box cover made of wood sticks sewn together. Four wood spreaders. Oval wood piece from the bottom of a box. Eleven bear tooth pendants, carved and uncarved. Twenty-one bone pendants in various flat and cylindrical shapes, some carved, one in the shape of a killer whale. Two haliotis shell pendants. A pair of haliotis shell earrings. Two triangular carved ivory pendants. Four ivory amulets representing a land otter and a beaver (no. 253), a killer whale, a land otter, and a brown bear with a wolf. A fragment of a pendant made from a sea mammal tooth.

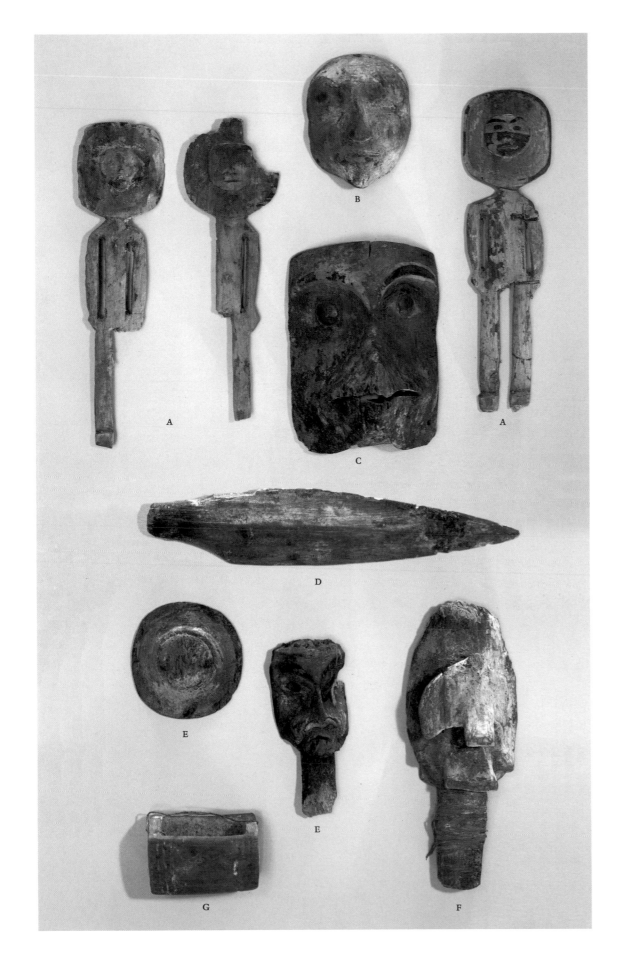

A

B

C

A

D

E

E

G

F

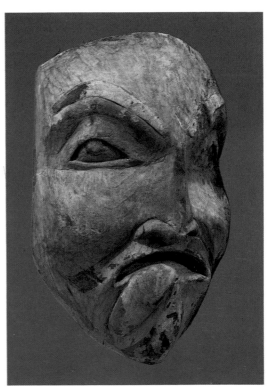

No. 47. Tlingit Mask. Human in a trance with a protruding tongue. This was among the contents of the old chest shown on the opposite page (no. 46). This mask has been attributed to the Henya tribe by Alan Sawyer (1993) on the basis of the arched eyebrows and upper eyelids, straight lower lids, pointed chin, and open eye sockets extending downward to merge with cheeks that fill out at the level of the nostrils. Wood and traces of black pigment; height 8¼ inches; c. 1790–1820. Private collection

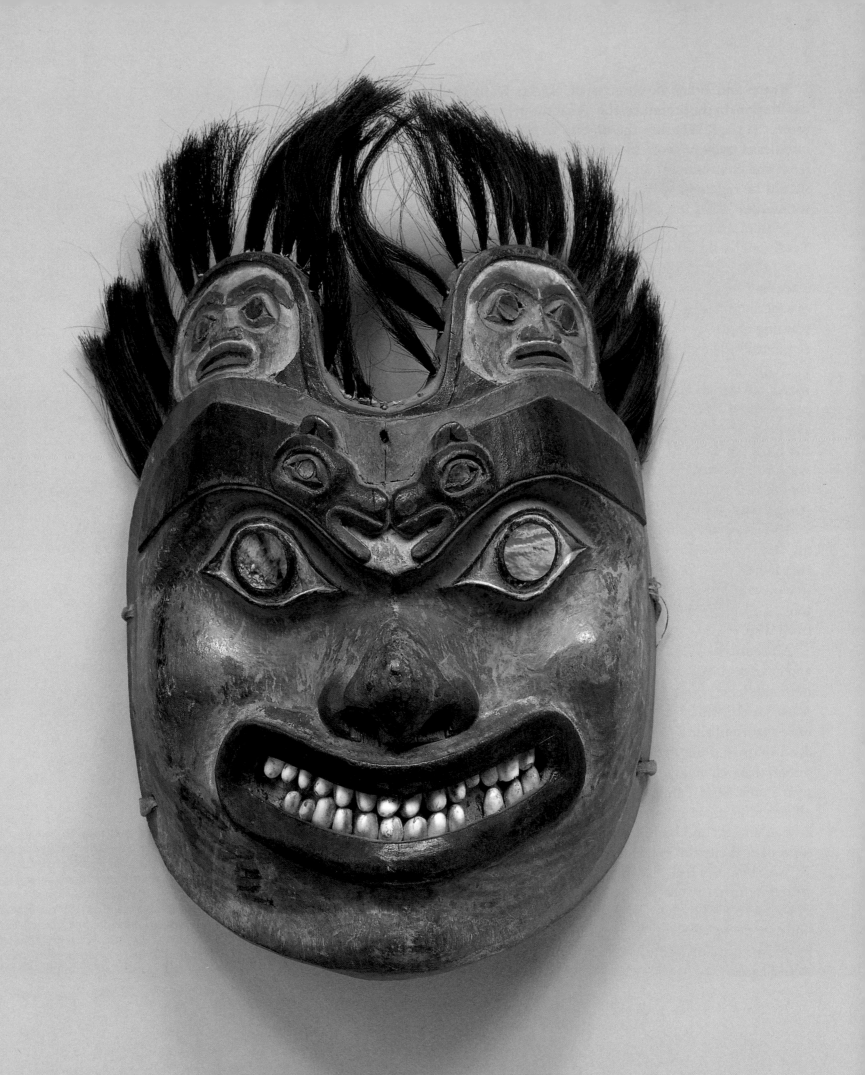

CHAPTER V

SPIRIT HELPERS

THEY HAVE A TRUELY SAVAGE *and incongruous appearance: but this is heightened when they assume what may be called their monstrous decorations. These consist of an endless variety of carved wooden masks and visors applied on the face or to the upper part of the head or forehead. Some of these resemble human faces, furnished with hair, beards and eyebrows, others the heads of birds, particularly of eagles, and many the heads of land and sea animals such as wolves, deer and porpoises, and others. But in general, these representations much exceed the natural size; and they are painted and often strewed with pieces of foliaceous mica, which makes them glitter, and serves to augment their enormous deformity. . . . It may be concluded, that, if travellers or voyagers, in an ignorant and credulous age, when many unnatural and marvellous things were supposed to exist, had seen a number of people decorated in this manner without being able to approach too near as to be undeceived, they would readily have believed and their relations would have attempted to make others believe that there existed a race of beings partaking of the nature of man and beast, more especially when besides the heads of animals on their shoulders, they might have seen the whole bodies of their men-monsters covered with quadruped skins.*

CAPTAIN JAMES COOK, *Nootka Sound, April 1778*

BECAUSE OF its sometimes personal nature, the meaning of certain examples of Northwest Coast shamanic art will remain obscure. The selection of the various animal, human, and spirit forms and their placement in compositions on objects referred to the individual spirit quests, alliances, visions, dreams, and experiences of their shaman owner, and their true significance would have been known only to him.

There are, however, a number of motifs and figures that frequently appear, and the collection data that accompany the objects that depict them are often consistent. At the turn of the century, George Emmons, an American Navy lieutenant, collected much Northwest Coast material for sale to museums. His detailed notes on the objects he sold provide a wealth of information that has been incorporated into this study. Even if all of it may not be entirely accurate, a good part probably is. Combined with the field data and mythologies compiled by such investigators as John Swanton, Franz Boas, Marius Barbeau, and Frederica de Laguna, it provides a good overall view of the iconographic content of this art.

HUMAN MOTIFS

The representation of human faces and fully rendered figures in many poses appears

No. 50. Tlingit Mask. The round face, thick lips, clenched teeth, and broad, flat nose identify the animal represented as a bear. Human faces are carved into the ears on top of the head. Emmons (n.d., Notes, NMAI) describes the figures on the eyebrows as land otters. By the same artist as nos. 139 and 141, the latter which was the property of the Chilkat shaman Skundoo. As this was collected by Emmons at Chilkat, it too may have belonged to Skundoo. Wood, human hair, and black, red, and blue-green pigment; height 13 inches; c. 1840–60. National Museum of the American Indian, Smithsonian Institution, Washington, D.C., 9/8030. Purchased from Emmons, 1920

throughout all examples of both crest and shamanic art of the Northwest Coast. Those included here represent various spirit helpers and guardian figures as well as images from the shamanic world.

Many examples of the human form appear among the masks used by Tlingit shamans. Often they are combinations of both animal and human elements, obviously made to represent the shaman's relationship to an animal spirit and his ability to transform himself into it. Some complex masks of humans show smaller animal forms such as land otters, mice, wolves, bears, and frogs carved in relief on the cheeks, chin, forehead, and under the eyes and engaged in various activities. Masks of this nature do not appear in crest art.

A number of very realistic depictions of the human face are found among these masks. Some may well be portraits (Holm, 1987b, p. 232), particularly the early, naturalistic, and archaic examples collected by Emmons. These are often accompanied with his notes stating that some of the material recovered had passed through as many as five generations of shamans. These objects would date from the first quarter of the nineteenth century, if not earlier. Other masks in this series are idealized depictions of young men and women. Numerous masks of highborn women wearing labrets exist from this period, and most are painted with asymmetrical designs that show the sort of face paintings that were applied on ceremonial occasions.

Emmons's notes describe an almost limitless variety of spirits represented by Tlingit masks. They show beings associated with places and things such as glaciers, mountains, the water, the sky, the moon, the sun, stars, the north wind, clouds, and the air. Depictions of old age are quite common, perhaps to symbolize wisdom or a phase of life that is close to death, and therefore to represent a form of transformation. There are also both good-natured and angry spirits, as well as those of Athabaskan Indians, chiefs, peacemakers, spirits from the land of dead shamans, and at least one "of a man who sits in the bow of a canoe, spear in hand, when traveling with a war party" (de Laguna, 1972, pt. 3, pl. 201; see also pls. 174, 175, 179–81, 184–95, 197, 199–202, 206, 207).

As mentioned, another series of masks represents the onset of a trance state, with obvious reference to the activities of the shaman. In this group are also those showing incipient death by the use of such stylistic conventions as a thick, protruding tongue, closing eyes, and a limp jaw. Those that bear bleeding wounds on the forehead and cheeks depict dying warriors, and may have been used to tell of the success of shamans who had accompanied war parties.

Other masks show men in the process of drowning, a death that was dreaded above all others, because if the body was lost and thus not cremated, the soul was fated to wander the earth forever (Gunther, 1972, p. 141). Those who drowned were also believed to have been kidnapped by land otters and forced to live with them, ultimately to be transformed into the animals themselves and destined to prey on other humans in their new lives (Jonaitis, 1978, p. 63). Many of these masks have the same features as those representing trances, although one group actually depicts the various stages of the change from a human to a land otter. Gradually elongating mouths and the growth of prodigious amounts of facial hair are their identifying characteristics. Masks in the form of skulls show death as having already occurred,

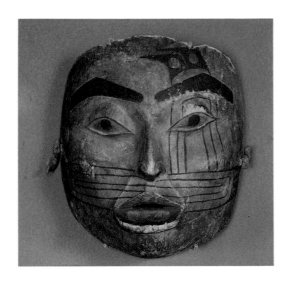

No. 51. Tlingit Mask. A number of Tlingit shamans' masks with labrets represent highborn women. This one has the asymmetrical face paintings representing clan insignia that were worn during potlatches and other ceremonial occasions. It is one of six masks collected by Emmons or Carl Spuhn from the grave house of an unidentified shaman of the Kiksadi clan on the banks of a salmon stream flowing into Dry Bay, north of the Alsek River. The shaman had lived on the west coast of Prince of Wales Island. Wood and red, black, and blue pigment; height 9¾ inches; c. 1820–40. Field Museum of Natural History, Chicago, 79250. Purchased from Emmons, 1902

No. 52. Tlingit Mask (opposite). Emmons (n.d.) describes this mask as representing a young man who "lives above" (presumably in the sky). Collected by Emmons from the grave house of a shaman of the Kiksadi clan of the Sitka tribe at Peril Strait, thirty miles north of Sitka, 1884–93. Wood, abalone, animal hide, and red, black, and blue-green pigment; height 8 inches; c. 1840–60. Former collection: American Museum of Natural History, New York, E 655; exchanged to Emmons, 1914. National Museum of the American Indian, Smithsonian Institution, Washington, D.C., 9/8034. Purchased from Emmons, 1920

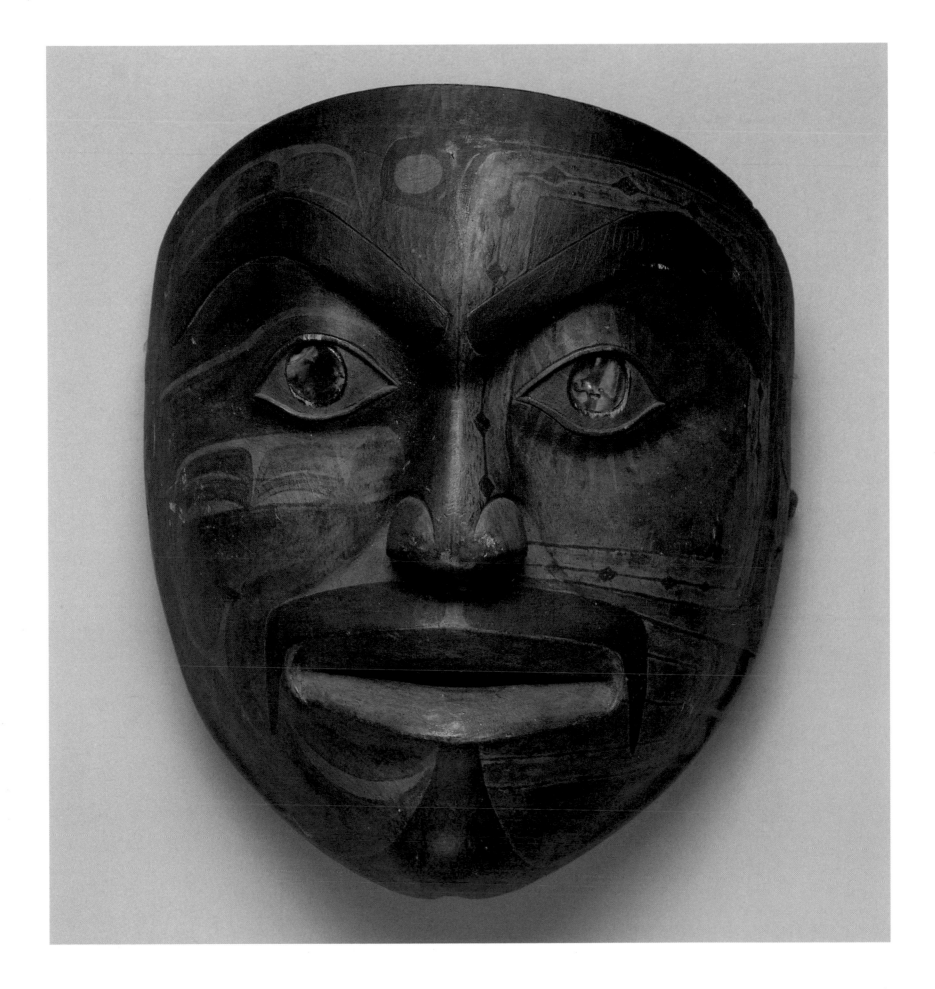

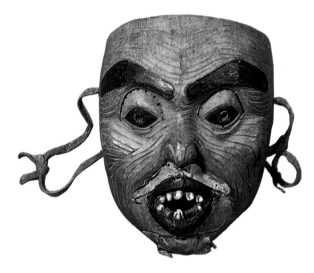

No. 53. Tlingit Mask (above). Masks depicting wrinkled and aged individuals who may be close to death are probably metaphors for the shaman's ability to move between the worlds of the living and the dead. This one represents an old man and is painted blue, a color sometimes associated with ghost spirits. Wood, copper, animal hide, opercula, and black and blue-green pigment; height 8¼ inches; c. 1820–40. Former collection: Museum of Fine Arts, Boston. Peabody Essex Institute, Salem, Massachusetts, E/16700. Acquired 1908

No. 54. Tlingit Mask (right). The relief figures on the cheeks and forehead represent mice. Because of their furtive movements and their tendency to gather small objects together, mice were regarded by the Tlingit as skilled robbers that could also aid shamans by detecting thieves (de Laguna in Emmons, 1991, pp. 371–72). Collected by Emmons from a Henya shaman's grave house near Tuxecan. Wood and red and black pigment; height 10 inches; c. 1860–80. National Museum of the American Indian, Smithsonian Institution, Washington, D.C., 9/8036. Purchased from Emmons, 1919

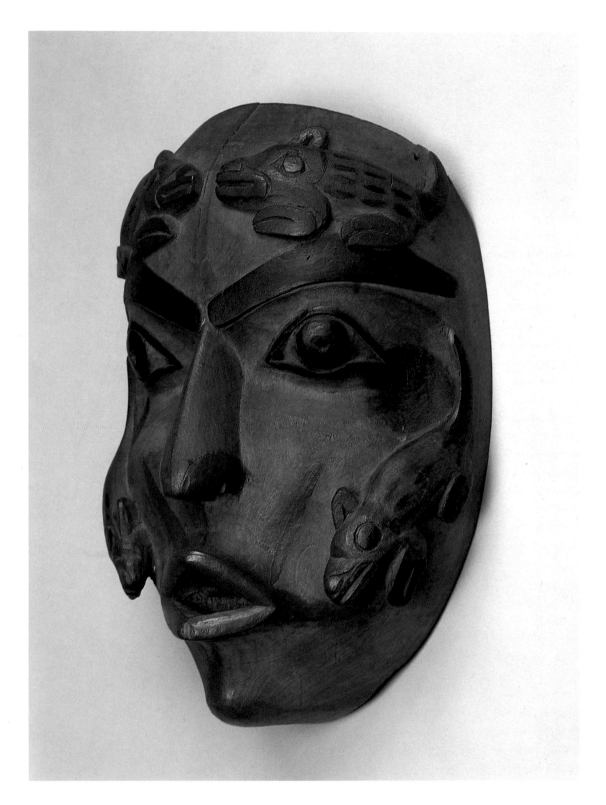

and these sometimes feature carvings of mice or land otters under the eyes and on the cheeks.

Shamans themselves are represented by those masks depicting trances and by some examples in which the lips are pursed or the mouths are opened in different positions. The pursed lips could suggest the sucking and blowing that the shaman would perform while curing. For the shaman, the use of the mouth was more impor-

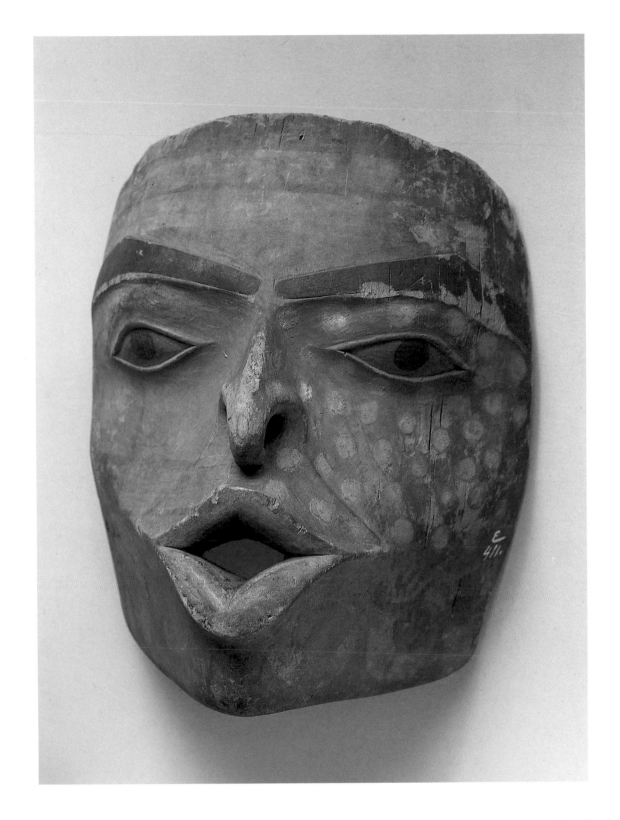

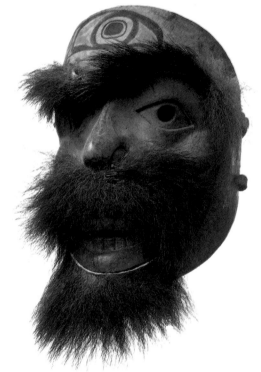

No. 56. Tlingit Mask (above). Emmons (n.d.) describes this mask as depicting a chief and the painting on the forehead as a raven. Collected by Emmons from the grave house of Gutcda, a Tlukwaxdi shaman, on Dry Bay near the mouth of the Alsek River, c. 1888. The shaman photographed by Edward de Groff at Sitka in 1889 wears this mask (see fig. 1). Some of the bearskin has been restored. Wood, rawhide, bearskin, and black, red, and blue pigment; height 9½ inches; c. 1840–60. American Museum of Natural History, New York, E 402. Purchased from Emmons, 1893

No. 55. Tlingit Mask (left). An early mask with pursed lips said by Emmons (n.d.) to represent a shaman singing. Collected by him in 1884–93 from the grave house of Setan, a Tlukwaxdi shaman on the Akwe River, a few miles west of Dry Bay near an old, deserted village. Wood and black, orange, and blue pigment; height 8 inches; c. 1790–1820. American Museum of Natural History, New York, E 411. Purchased from Emmons, 1893

tant in curing than the laying on of hands (Guédon, 1984b, p. 206). Some masks of shamans with pursed lips are said to have been used to blow the swansdown used in shamanic performances (Emmons, n.d., E 396). Such an expression could also represent whistling, which was another method of communication between a shaman and a soul and was sometimes used to summon spirits. Other mouth positions show shamans in the act of talking and singing as they performed.

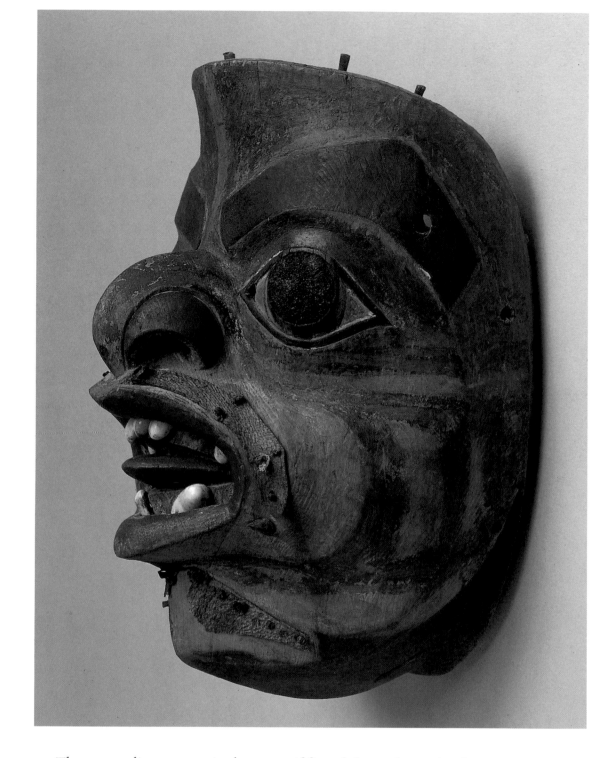

No. 57. Tlingit Mask. The protruding tongue and grotesque expression of this bold mask probably depict imminent death by drowning. Collected by Lieutenant T. Dix Bolles at Lower Chilkat Village. Wood, opercula, animal skin, and black, red, and blue-green pigment; height 10 inches; c. 1820–40. National Museum of Natural History, Smithsonian Institution, Washington, D.C., 73780. Given by Bolles, 1884

No. 58. Tlingit Mask (opposite). Dying man. The wounds on the face are in the same places as those on the maskette (no. 12) from the same grave house. Emmons (n.d.) describes it as "the face of a dying man who has been killed in a fight with a knife," and says that it was worn by a shaman impersonating the spirit of the warrior. Collected by him in 1884–93 from the nephew of Nolk, a Hutsnuwu shaman who died about 1865 and was buried with his paraphernalia in a grave house at Chait Bay, Admiralty Island. Although it is not listed with the other objects from this group in the Emmons catalogue (ibid., E 943–987), it is undoubtedly part of this set because of its iconography and provenance. Wood, animal skin, human hair, opercula, and black, red, and light orange pigment; height 9⅝ inches (mask only); c. 1800–30. American Museum of Natural History, New York, E 2501. Purchased from Emmons, 1893

The protruding tongue is also a motif found throughout Northwest Coast art. In general, the tongue has been described as "the organ through which life force is transferred at death" (Jonaitis, 1986, p. 54). For shamans in particular, it could sometimes symbolize their ability to communicate with animals (MacDonald, 1983b, p. 120). It was also an organ that could cure, and there are Tlingit maskettes with slim, elongated tongues that were touched to the ailing parts of a patient (no. 179). The very importance to Tlingit shamans of the capture of the tongues of animals to add to their paraphernalia indicates something of its potency as a source of spiritual power.

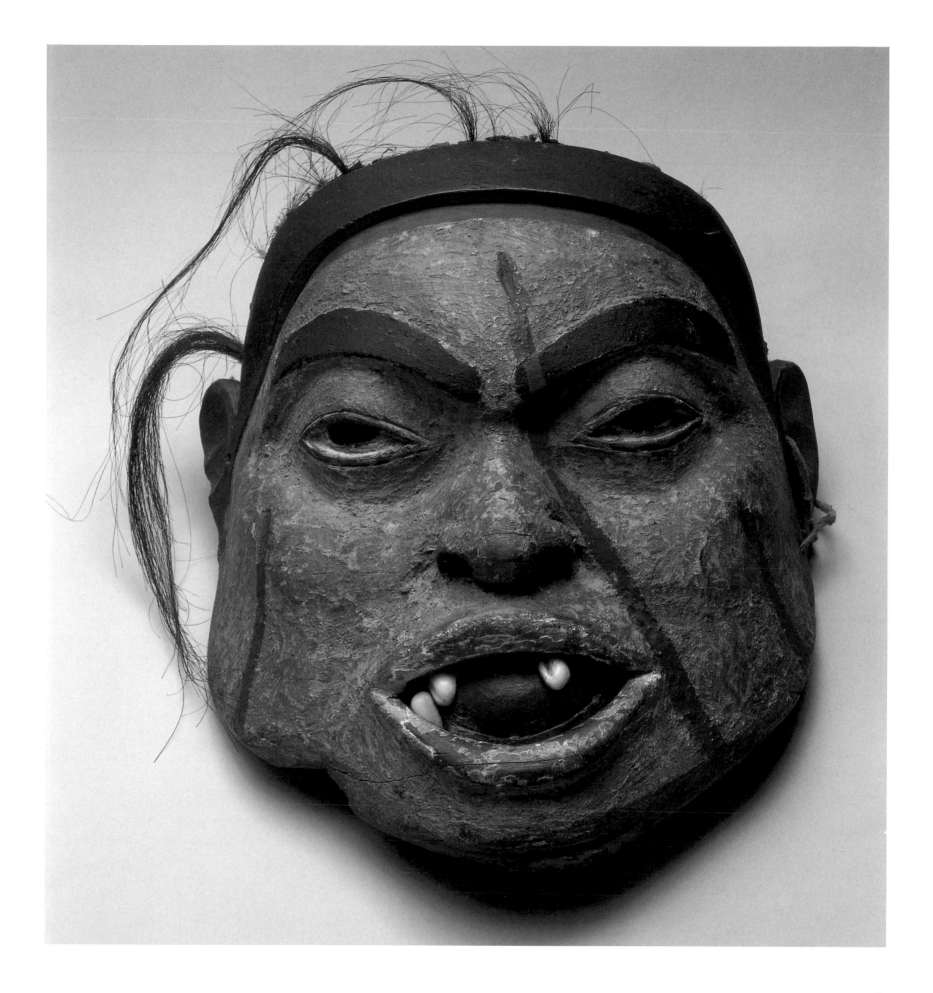

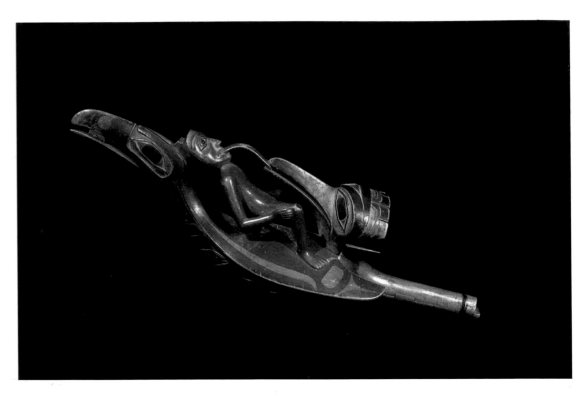

No. 59. *Tlingit Rattle.* Most raven rattles are conceived in this manner, and show the tongue-to-mouth imagery that is a well-known feature of Northwest Coast art. A reclining figure on the back of a raven extends his tongue to the mouth of a kingfisher. The bird head at the bottom, which Emmons (n.d.) identifies as an owl, has a frog at the beak. Although some raven rattles have been found in shamans' burials (see no. 395), most, including this example, were used by chiefs at secular ceremonies. Collected by Emmons at Sitka, 1882–87. Wood and black, red, and blue-green pigment; length 12⅜ inches; c. 1840–60. American Museum of Natural History, New York, 19/803. Purchased from Emmons, 1888

No. 60. *Tsimshian Amulet.* The open-mouthed expression probably represents a shaman singing. Collected by William A. Newcombe at Gitlakdamiks, 1905. Ivory, abalone, cedar bark, and brown pigment; height 4½ inches; c. 1830–50. Canadian Museum of Civilization, Ottawa, VII–C–266

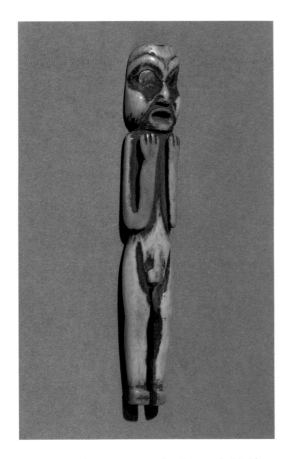

Fig. 31. Guardian Figures at the Grave of a Haida Shaman at Masset (opposite). Both of these figures no longer exist, but they appear to have been at least life-sized. Each wears a fringed apron, and the heads are adorned with shamans' crowns. Photograph by Charles F. Newcombe, 1900. Royal British Columbia Museum, Victoria, 36

In its most spectacular manifestation, the tongue appears on some objects as extended from the mouth of a reclining shaman figure to an animal. This detail has been explained in various ways. Bill Holm (Vaughan and Holm, 1982, p. 78, no. 42) sees it as a possible power transfer from animal to human. Aldona Jonaitis (1986, p. 135) suggests that it is the agency through which the life force is passed from one being to another, and she further quotes Emmons's notes that state that it represents the transfer of the knowledge of speech between the two (ibid., p. 54). There may be sexual imagery represented as well (Duff, 1981, p. 218). Because of its prevalence, there can be no question that the protruding tongue is a highly important shamanic motif even if it also often appears in crest art. Its significance probably varied from one object type to the next, and at various times any one of the above meanings could have been assigned to it.

There is a puzzling aspect to the appearance of the reclining shaman figure with its tongue extended to a frog or bird on the backs of raven rattles, objects used mostly by chiefs at feasts and potlatches in secular and not shamanic contexts. Yet several raven rattles are known to have been found in shamans' graves, and some of these and others having shamanic associations are included here. It is therefore possible (although this cannot be proved) that the raven rattle was originally carved for shamanic use and only later became incorporated in crest ceremonies. However, it has also been suggested that a shaman's use of such a well-known object associated with secular events might have been a way to demonstrate his social prestige and his facility in participating in both levels of society (Jonaitis, 1986, p. 120).

The human figure is also found in freestanding sculptures. The majority of these are guardian figures that range in size from carvings of only a few inches decorating headbands or garments to protect the shaman during the performances to those as tall as seven feet designed to keep evil spirits and trespassers from a shaman's grave

No. 61. Tlingit Doll. This doll is accompanied by four miniature masks that are most probably replicas of full-sized masks that were in the kit of their shaman owner. The figure may have been left with a patient with the appropriate mask affixed to it after the shaman had completed his performance. Also accompanying the figure, but not shown here, are a headpiece with a bird carving and a small hat. Collected by John J. McLean from a shaman's box. Wood, animal skin, human hair, beads, brass tacks, and red, white, black, and blue-green pigment; height 5¼ inches (figure only); c. 1840–60. National Museum of Natural History, Smithsonian Institution, Washington, D.C., 68011–17. Given by McLean, 1882

No. 62. Tsimshian Puppet. Articulated figures were used by Tsimshian shamans for displays of magic during their performances. This carving appears to be quite old, and the more recent costume of mattress ticking was probably added shortly before it was collected. Wood, cotton, human hair, animal skin, cedar bark, and red and black pigment; height 28 inches; c. 1840–60. Private collection

house. The latter, which were often erected outside of the structure, assume aggressive poses reflecting their function. Some originally held knives, clubs, or wands to strike any who threatened to venture near. The figures on the headbands or clothing are in various standing and kneeling poses, and some headless examples are shown upside down (de Laguna, 1972, pt. 3, pl. 193 [top]). Their facial expressions often depict the act of singing or speaking or take on a trancelike appearance similar to those of some masks.

Certain Tlingit doll-like carvings represent shamans. These can be identified by their long hair and often by their shamanic clothing and ornament, such as painted aprons and tunics and miniature necklaces of cedar bark and bone. One series of quite small dolls are equipped with their own miniature mask sets. The significance of these figures is unclear. Bill Holm (1983, p. 117, no. 200) mentions that Emmons's notes state that they were playthings used to teach boys about the activities of shamans, although he believes that their high quality suggests that they had greater meaning than simply as toys. They may have been used in séances to imitate the actions of shamans or as amulets that were left with a patient to represent the shaman when he was not in attendance. The Tsimshian made puppets depicting shamans that may also have been used during displays of magic (Barbeau, 1958, pp. 55–57, pls. 66–69).

Some canoe models show a shaman seated at the bow or among the other passengers to bring them good fortune. Because these miniature canoes were made for sale to foreigners, it has been plausibly suggested that some of the shaman dolls might have been made for similar commercial purposes (Aldona Jonaitis, 1989, personal communication). Those doll-size figures included in this volume, however, are believed to have been made for shamanic functions.

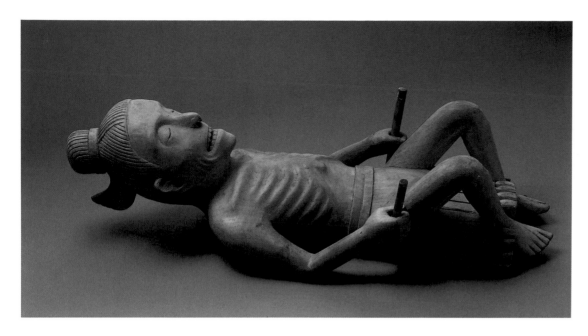

No. 63. *Haida Figure*. This figure of a dead shaman, like nos. 31, 64, and 494, was carved by either Charles Gwaytihl or Simeon Stilthda. As does the figure in the grave house (no. 34), this one holds two staffs. Collected by Sheldon Jackson, 1870–79. Wood; height 17 inches; c. 1870–79. The Art Museum, Princeton University. On permanent loan from the Department of Geological and Geophysical Sciences, 5160. Given by Jackson, 1882

There are, however, three figure sculptures of larger size, shown representing dead shamans, that were most likely made for sale (nos. 31, 63, 64). Each is in a reclining position with the knees flexed to show the manner in which the shaman was laid out in his grave house. They have gaunt expressions, sunken cheekbones, desiccated skin, and prominent rib bones. A complete model of a shaman's mortuary also exists, showing one of these figures in place, his head resting on a box that would have contained his paraphernalia (no. 34).

These four sculptures are usually attributed to a Haida artist named Charles Gwaytihl, who lived in Masset and died sometime around 1912. Most of his work dates from the 1880s. He carved some rattles, crest frontlets, and a few masks for use, but his sculptures of figures and most of the masks were made for sale (Macnair et al., 1980, p. 182; Holm, 1981, pp. 176–77, 179–81). This artist also made a carving of a sphinx that was based on a picture in a Bible that was shown to him by Reverend Collinson sometime between 1874 and 1878. The sculpture is now in the British Museum and is accompanied with the information that it was made by Simeon Stilthda, who also lived in Masset (Holm, 1981, p. 176 n. 1). This has caused Holm to reconsider the Gwaytihl attribution, and he now suggests that the works formerly assigned to him may in fact have been made by Stilthda (personal communication, 1992). Aside from the question of their authorship, because none of the four dead shaman figures shows much evidence of use and surface wear, and because there are no known counterparts of this type of figure sculpture from the Northwest Coast outside of these examples, they were probably made for foreigners. Even if they did not serve a ceremonial function, they are included here as a discrete body of works by one artist that demonstrate the manner in which a shaman was buried, and therefore have some iconographic relevance.

No. 64. *Haida Figure*. This figure, carved by either Charles Gwaytihl or Simeon Stilthda (see also nos. 31, 63, and 494), bears an old label stating "Hydah medicine man. This man was lost in the woods. He fell and broke both legs and was found as represented here, starved to death." Such information may have been added to enhance the monetary value of the figure, as it is now known that these carvings simply represent shamans as they were laid out in their burial houses. Wood, and red and black pigment; height 22¼ inches; c. 1870–1900. British Museum, London, 1944-AM-2-131. Given by Mrs. Harry Beasley, 1944

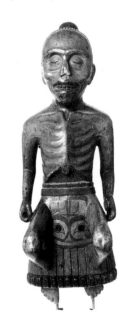

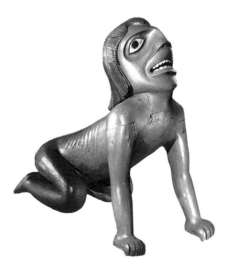

No. 65. *Haida Canoe Prow*. Such figures, which represent men being transformed into land otters, decorated chiefs' canoe prows. Wood and red, black, and white pigment; length 22 inches; c. 1880–1900. Former collection: Jelliman, Masset. Royal British Columbia Museum, Victoria, 10660. Purchased from William A. Newcombe, 1961

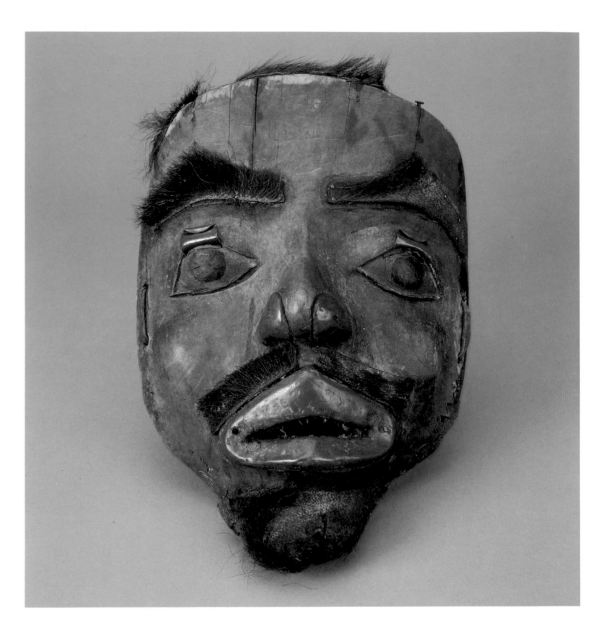

No. 66. Tlingit Mask. One of the three known masks by the same artist that depict a drowning man who is assuming the characteristics of a land otter (see also nos. 148 and 150). The copper flaps over the eyes were attached to strings so that they could be pulled closed. Emmons (n.d., Notes) describes it as representing "the spirit of all who are drowned." Collected by him from a shaman of the Auk tribe at Stevens Passage. Wood, copper, bearskin, nails, and black and blue pigment; height 11½ inches; c. 1840–60. Field Museum of Natural History, Chicago, 78669. Purchased from Emmons, 1902

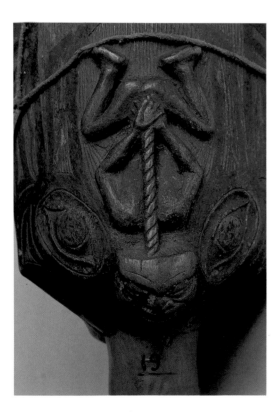

No. 67. Tlingit Rattle (detail). This detail of an oyster-catcher rattle (no. 403) shows the technique shamans used to bind witches to force confessions from them. The hands are tied behind the accused, and his long hair is tied to his wrists.

A small group of Tlingit quasihuman carvings depicting the land otter man forms another category of figure sculpture. Although they were made for crest purposes, mostly to ornament the canoe prows of chiefs (Collins et al., 1973, p. 231, no. 287), they are included in this volume because the transformation of humans into the land otter was such an important shamanic concept. These carvings, three to four feet long, show squatting men with faces bearing intense, grimacing expressions. They have long hair, and clawlike fingers and toes to indicate their metamorphosis. Masks of this subject have thick applications of animal hair, and their features indicate incipient drowning.

Land otter men were thought to embody both the ghosts of those who had drowned and been captured by the animals as well as the spirit of the animal itself. Although they were much feared and dreaded, they could at times come to the assistance of members of their family. They were occasionally known to help kin who had been kidnapped by the land otters to escape or to visit their relatives and bring them good fortune (de Laguna, 1972, pt. 2, p. 748).

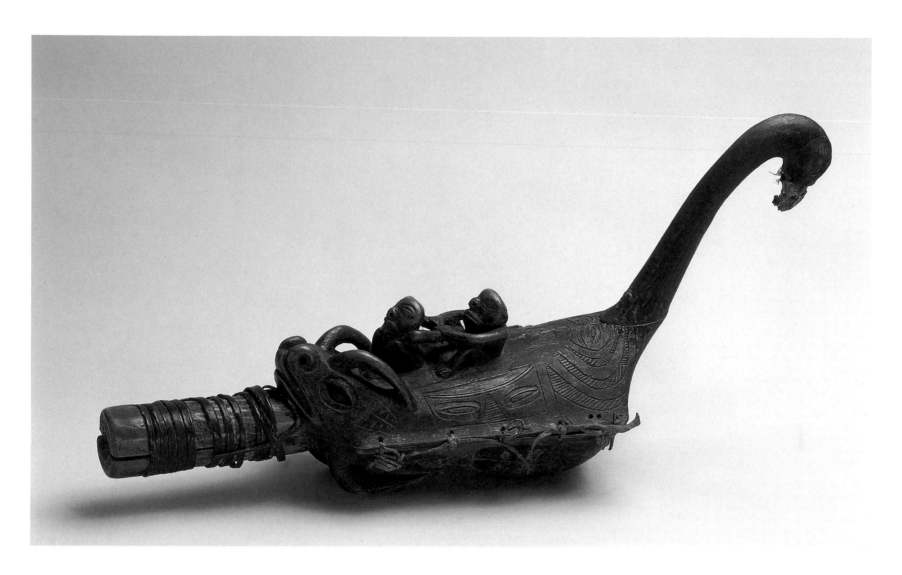

A human form that is unique to shamanic art, appearing predominantly in scenes carved on the backs of Tlingit oystercatcher rattles, is the bound witch. He is shown kneeling, with his long hair pulled behind him and his hands tied at his back by one or two others who represent shamans. Sometimes his hair is tied to his hands as well, forcing his head up and back. This represents the capture of the sorcerer after he has been identified by the shaman.

When someone was suffering from a witch's spell among the Tlingit, a confession had to be forced from the sorcerer by the shaman through methods such as the deprivation of food and water, beatings, forced drinking of sea water, placement of the naked suspect on hot ashes, and threats of death through starvation and drowning (ibid., p. 737). If a confession was obtained, a cure resulted. This practice was apparently followed by the Haida as well. Reverend Collinson reported the binding, incarceration, and torture of a slave who was thought to have caused the illness of Chief Stilta of Masset. It was believed that the evil spirit had to be forced from the slave for the chief to recover (quoted by MacDonald, 1983a, p. 28).

Tsimshian witches were sometimes killed after their discovery but not tortured while alive (Boas, 1916, p. 564), while at other times, the shaman only had to gather the materials that had been used to cast a spell and wash "them clean of harmful intent"

No. 68. Tlingit Rattle. Oystercatcher. Emmons (n.d.) identifies the figure on the body as "a fish that inhabits the waters of inland lakes." The figure of a bound witch faces the handle. Emmons believed it to have been carved with stone tools and to have been over one hundred years old at the time he collected it in 1882–87 from the Chilkat. However, although it is of an early style, metal tools were used in its manufacture. Wood, rawhide, abalone, and traces of red, black, and blue pigment; length 13⅝ inches; c. 1820–40. American Museum of Natural History, New York, 19/812. Purchased from Emmons, 1888

No. 69. *Tlingit Rattle*. Oystercatcher. Two shamans, perhaps flying, are shown, one on top of the other. A hawk head is on the bottom, and the head of an otter faces the handle. Part of the complete set of a shaman's paraphernalia of unknown provenance collected by Emmons. Wood, rawhide, cotton, and red and black pigment; length 13⅝ inches; c. 1840–60. National Museum of the American Indian, Smithsonian Institution, Washington, D.C., 16/1719J. Purchased from Emmons, 1928

(Miller, 1984, p. 141). This may explain why the image of the bound witch does not appear in Tsimshian art.

Witches, known as "masters of sickness," were the exact antitheses of shamans. They brought the disease, evil, and discord that shamans were asked to combat. They could be male or female and were the epitome of evil. As antisocial beings, they practiced their craft in secrecy, whereas the shamans performed in public. Among the Tlingit, they gained their power from their possession by evil spirits and dwelled in graveyards, where they communicated with the dead.

These sorcerers had many of the same capabilities as shamans, including flying, changing shape, transforming themselves into other animals, especially birds, and entering into trance states, but the purpose was always directed toward evil (de Laguna, 1972, pt. 2, pp. 731–32; Jonaitis, 1986, p. 60). Witches were responsible for recruiting others into their craft, and even worse, "his victims were traditionally his own close relatives, true siblings or the immediate members of his own lineage and sometimes their spouses and children" (de Laguna, 1972, pt. 2, p. 728).

To practice their evil, witches would cast a spell over belongings or leavings of their victims such as nail cuttings, hair, pieces of clothing containing sweat, saliva, or excreta, morsels of uneaten food, or any other "fragment of the victim's own person"

(Swanton, 1905, p. 41; see also de Laguna, 1972, pt. 2, p. 730). Kwakiutl sorcerers used similar items, even collecting cedar bark into which the unfortunate person had breathed (Boas, 1966, pp. 148–49). These materials were made into bundles that were sometimes manipulated to cause pain and illness to certain parts of a victim's body. They might also be left with a body or ashes to cause sickness or death in the person from whom they had been taken (ibid.).

Franz Boas (1916, pp. 563–64) gives a particularly detailed and gruesome account of witchcraft among the Nass River Tsimshian. To obtain their powers, the sorcerers visited a graveyard and stole a portion of a corpse, which they put into a watertight box. Strings were then tied to a stick and attached to the end of various objects associated with the intended victim. This device was held over the corpse fragment, and if any part touched it, the victim would die. If it remained suspended above, he would become very ill for a long time. The use of his hair brought headaches, a piece of his moccasin caused his foot to rot, and employment of his saliva made him contract consumption.

Many aspects of witchcraft on the Northwest Coast are mirrored in similar practices and beliefs in other parts of the world. Acquiring parts of the victim's body and making of images from them, casting evil spells, and claiming the ability to fly and transform themselves are common activities of sorcerers in many societies. The association of shamanism with the countering of witchcraft is undoubtedly of great antiquity, and could be rooted in the origins of the system.

On the Northwest Coast, combating witchcraft was an important part of the shaman's responsibility, and it may seem surprising that the sorcerer does not appear more frequently as a motif in their art. Although the bound witch is found in a few freestanding sculptures of a relatively late date as well as on oystercatcher rattles, amulets (no. 268), and staffs (no. 340), it does not appear on textiles and the painted and relief designs on boxes, nor as a motif on masks or other paraphernalia.

The witch is a secondary theme in shamanic art because the representation of such a malevolent member of the community only illustrated a specific activity and responsibility of the shaman. It was much more important to depict his spirit alliances, the real sources of his power on the materials he used.

ANIMAL MOTIFS

Animals form an equally large proportion of beings shown in Northwest Coast shamanic art. Some are hybrid creatures of identifiable animals, while others are fantastic monsters that have no counterpart in nature. For the latter, we must rely on collection notes, field data, and the word of early informants to tell us what they can of such otherworldly representations. When such data exist, they have been incorporated in the object descriptions accompanying the reproductions that follow.

Many of the animals in shamanic art, however, represent animal species that can be readily identified, and the reasons for their use are well known. Among them, the land otter is paramount. It appears with a sinuous, elongated body, often in a streamlined swimming pose with its legs tucked underneath. It has a long, thick tail; alert eyes; and a powerful, bearlike mouth; it appears singly or in combinations with other animals and humans. The ribs are usually shown in the x-ray style.

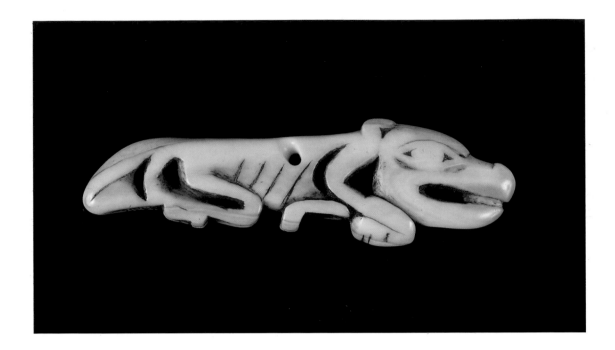

Depictions of the otter are almost entirely related to shamanic paraphernalia. As noted, it was the most powerful spirit in the service of the Tlingit shaman, for only he had the power to control it and bring it to his aid. All along the coast, no other creature was more greatly feared or thought to have more supernatural power.

The Tlingit, Tsimshian, Haida, and Kwakiutl all tell stories of people, often children, who had been kidnapped by land otters when they were lost or in the deep forest, or who had drowned and been captured by these animals. These unfortunates were kept in "land otter villages" or their dens until they were transformed into the animals themselves. Shamans could sometimes save them, but as Franz Boas (1916, p. 862; see also p. 860) has mentioned, many of the stories "hinge on the point that, if a traveler accepts the food of the otters or follows their call, he is lost and can never return."

Besides kidnapping people, land otters were thought to cause insanity (Halpin, 1984, p. 286), natural disasters such as storms and avalanches, illness, skin disease, and accidents other than drowning (Jonaitis, 1986, pp. 91–92). Particularly frightening was the awareness that all land otters had originally been humans and therefore shared the intelligence and knowledge of both species (Jonaitis, 1978, p. 63). This enabled them to lure individuals to them by imitating human voices or even appearing to be a parent or other relative.

Some natural activities of the land otters were readily equated to those of humans: they ate fish and shellfish, had a capacity for play, and communicated with each other by a series of "whistles, grunts and chuckles" (Jonaitis, 1986, p. 90). On the other hand, their completely animal-like behavior also allowed them to swim skillfully underwater and remain there for minutes at a time, dive for fish, and live in dens on the land. By occupying one of the border regions of the environment, they exemplified the qualities of so many of the shaman's spirit helpers which suggest transformation. It is not surprising that such creatures were so greatly respected and became such potent spirits to the shaman.

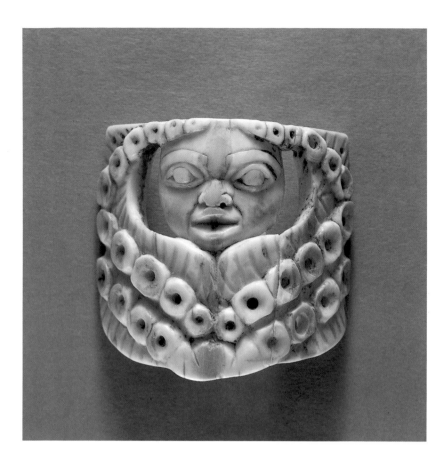

No. 71. Tlingit Amulet. A well-carved human face, perhaps speaking or singing, is surrounded by two pairs of devilfish tentacles. Collected by Edward G. Fast at Sitka, 1867–68. Walrus ivory; height 2¾ inches; c. 1830–50. Peabody Museum of Archaeology and Ethnology, Harvard University, Cambridge, 69–30–10/1907. Purchased from Fast, 1869

The devilfish, or octopus, also appears prominently in shamanic art. Although it is also a crest symbol, the devilfish has been described as "the most frequently illustrated spirit helper from the sea" (Jonaitis, 1980, p. 43). It is rarely shown as a single image but is usually found in complex compositions with other animal and human forms, especially the otter. This may be a way of representing its amorphous, invertebrate anatomy, its natural tendency to incorporate its body into its surroundings, and its means of capturing and devouring its prey. At times, it is only represented by the tentacles that appear on the rims or eyebrows of masks, on the sides of vessels and rattles, and in the place of vertebrae along the backs of human and animal forms. Reference to transformation is obviously made through such use of the devilfish motif and its details.

The natural behavior of this creature suggests both human and supernatural connections. It constructs its dwelling by moving rocks and pebbles; it examines its environment, collects its food, and defends itself by using its arms; and it seems to use its large eyes for intelligent observation, all traits that speak of human activities. The otherworldly aspects of the devilfish are indicated by its ability to change its color, shape, and even texture; to live both in and out of the water; and to defend itself by ejecting ink (ibid., pp. 44, 45). This animal also has a powerful and menacing reputation that is enhanced by Tlingit and Haida myths that tell of a giant devilfish destroy-

No. 72. *Tlingit Rattle*. On the back of an oystercatcher a seated shaman is capturing a witch. A mountain goat head faces the handle. Collected by Emmons from a grave house on Chichagof Island, 1914. Wood, ivory, abalone, beads, and red, black, and blue-green pigment; length 12⅛ inches; c. 1820–40. National Museum of the American Indian, Smithsonian Institution, Washington, D.C., 3/6667. Purchased from Emmons, 1914

ing villages. Clearly, this could be understood to be a spirit that might greatly add to the powers of the shaman who could form an alliance with it.

In addition, the eight arms of the devilfish gave it a special status among the Tlingit, who regarded this number as auspicious. We have noted, for example, the practice of carrying the body of the deceased shaman around his house eight times. The number has other spiritual connections as well: Young girls often spent two years (eight seasons) in seclusion during puberty, the vision quest frequently lasted eight days, and the most powerful shamans formed alliances with eight spirits. Magical acts were repeated eight times, the shaman often wore his hair in eight braids, and the body was believed to be constructed of eight major bones (ibid., p. 45; de Laguna, 1954, pp. 175–76).

A number of spirit birds also appear regularly in shamanic art because of their ability to live on or near the water and fly. These include sand hill cranes and geese (both also associated with witches; see Jonaitis, 1986, p. 78), and gulls. Because their diving abilities symbolize a shaman's capacity to travel underwater, puffins, kingfishers, grebes, cormorants, and mergansers also appear (ibid., p. 88).

The most important was the oystercatcher, which was the principal animal form on the rattles used by Tlingit shamans. The deep black color of this bird, with its bright red beak and yellow-rimmed eye, gave it mysterious qualities, and its sharp, piercing cry and nervous, furtive behavior on the rocks and along the shore were well suited to shamanic actions (Vaughan and Holm, 1982, p. 120). Like other spirit helpers, this bird inhabits border regions of the environment, living along the shoreline and

No. 73. Tlingit Rattle. The most common type of rattle used by Tlingit shamans was in the form of an oyster-catcher with representations of spirit helpers or scenes of shamanic activity carved on the back. This one has the head of a mountain goat facing the handle and a hawk head on the bottom. Concerning the use of this rattle, Emmons (n.d., Notes) writes that "sometimes it may be touched to the part affected or left with the patient in the absence of the shaman as a spirit guard." Collected from a shaman of the Tequedi clan at Klukwan and said to have passed through several generations of shamans. Wood, eagle down, rawhide, and red, black, and blue pigment; length 12½ inches; c. 1840–60. Field Museum of Natural History, Chicago, 79135. The Carl Spuhn Collection. Purchased from Emmons, 1902

eating the mollusks it plucks from the intertidal zone. The oystercatcher is also among the first to sound the alarm and fly off at the approach of danger, which suggests a guardian function similar to the one that the shaman performed for his people (Furst and Furst, 1982, p. 122).

An animal often carved next to the handle of an oystercatcher rattle is the mountain goat, which is also employed as a crest symbol. It can be identified by its two horns and rather pointed mouth. Its ability to climb, jump, and move about in extremely difficult terrain was thought to imitate the shaman's faculty to travel through the realms of the cosmos. The goat was also said to serve a guardian role, going before the shaman to protect him from danger (Jonaitis, 1986, pp. 94–95). Mountain goat horn was sometimes used to make the tines on shamans' crowns; horns in general are a symbol of shamanic spiritual power in many parts of the world (Furst and Furst, 1982, p. 125). Some of the horned animals that appear on the ends of oystercatcher rattles that have been identified as mountain goats actually more likely represent supernatural monsters, for they have broader snouts and large, upturned, round eyes (Vaughan and Holm, 1982, p. 120). Some even have the body of a fish (no. 414).

No. 74. Tlingit Rattle Fragment. From an oystercatcher rattle. A kneeling bound witch is between the horns of a mountain goat. Collected by Emmons from an old grave house near Chilkat, before 1912. Wood and red, black, and blue-green pigment; length 3⅞ inches; c. 1840–60. Former collection: Museum of the American Indian, New York, 3/2257; exchanged 1961. Private collection

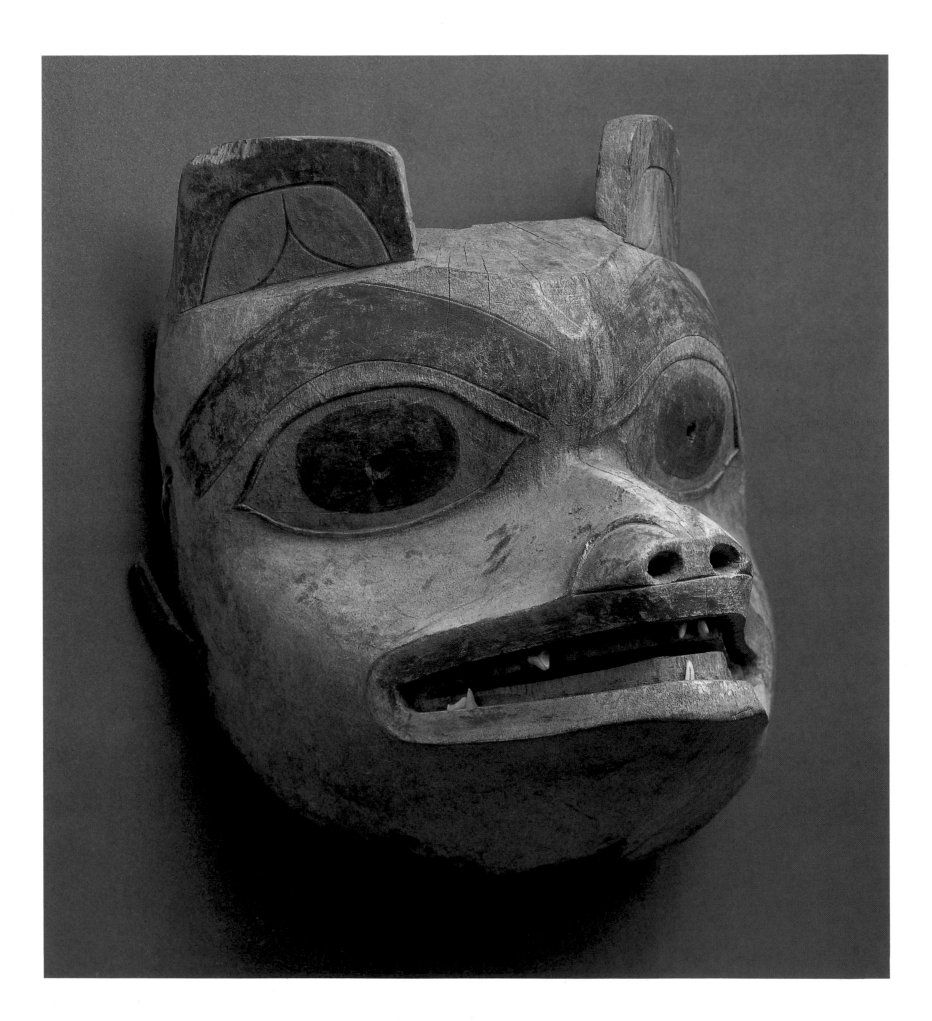

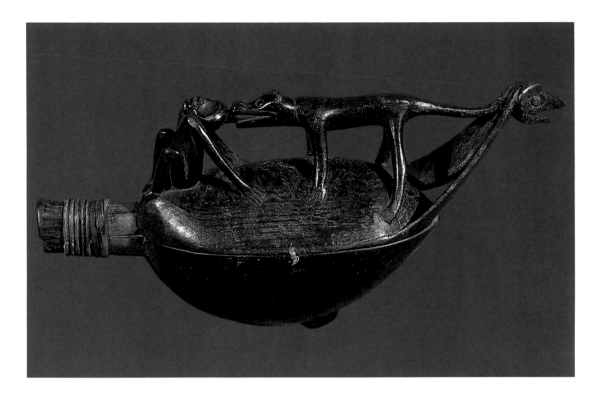

The dog, which occupies an interesting niche in Northwest Coast society, also occasionally appears in shamanic art. Although it is found on only a few rattles and masks (unless some of the carvings said to represent wolves are in fact dogs), it was important in shamanic iconography. By being related to such animals as coyotes, wolves, and foxes yet living with and accompanying humans, and eating their foods, the dog was thought to inhabit its own marginal region.

Because of its alliance with both humans and animals, the dog served both potentially harmful and protective roles (Amoss, 1984). Witches could turn others into sorcerers "by touching them with a dogskin, dog's paw, or another part of a dead dog" (de Laguna, 1972, pt. 2, p. 734), and yet live dogs could warn of witches' presence by barking in the direction of a graveyard (ibid., p. 732). The Tlingit shamans Gutcda and Tekic were known to have relied on their own dog spirits to help them identify witches (ibid., p. 736). Dogs were also the principal enemies of land otters, which were naturally frightened of them. They could identify land otter men for what they really were by barking at them and forcing them to reveal their true identity (ibid., p. 746). Because of their highly developed sense of smell and their quick arousal at the approach of danger or the unexpected, dogs play a guardian role in communities the world over. The use of spirit dogs to detect witches and other evildoers is widespread wherever shamanism is practiced.

Mice were also able to assist both witches and shamans. It was reported that Haida witches were created by being inhabited by as many as ten mice, which had to be expelled to bring about a cure (Keithahn, 1963, p. 84). Among the Tlingit they were known to steal materials that witches used against their victims and to kill people by eating out their insides (Swanton, 1908c, p. 471). The death of Chief Stilta of Masset was attributed to a sickness introduced by the spirit of a mouse (MacDonald, 1983a, p. 28), and a mouse was said to have taught "the black arts" of sorcery to two young Haida

No. 76. *Rattle* (origin uncertain). Gunther (1966, pp. 162–63, cat. no. 269) emphasizes the shamanic iconography of this rattle, which shows the capture of a witch, most probably by a dog. The face of a hawk is on the bottom. Although collected at Alert Bay and traditionally attributed to the Kwakiutl, it may be from further south, perhaps from the Nootka or Westcoast. Collected from Dan Cranmer of Alert Bay by a Captain Acton. Axel Rasmussen obtained it from Acton in 1933. Wood and spruce root fibers; length 11½ inches; c. 1850–70. Portland Art Museum, Oregon Art Institute, 48.3.367. Rasmussen Collection. Purchased, 1948

No. 75. *Tlingit Mask* (opposite). Emmons (n.d.) describes this as representing the spirit of a dog, and says it was used to cure "troubles of the head," which de Laguna (1972, pt. 3, p. 1110, pl. 190) interprets as witchcraft. Collected by Emmons in 1884–93 from the grave house of Gutcda, a Tlukwaxdi shaman, on Dry Bay near the mouth of the Alsek River. De Laguna (ibid., pt. 2, p. 736) further states that Gutcda was known to summon his dog spirit to identify witches. She quotes an informant who saw him do this: "When the Indian Doctor sends his spirit around to find out the witch, he [Gutcda] goes around in a circle barking like a dog. He stops in front of that witch and barks like anything." The shaman could well have worn this mask at such times. Wood, animal teeth, and black and traces of red and blue-green pigment; height 8½ inches; c. 1830–50. American Museum of Natural History, New York, E 399. Purchased from Emmons, 1893

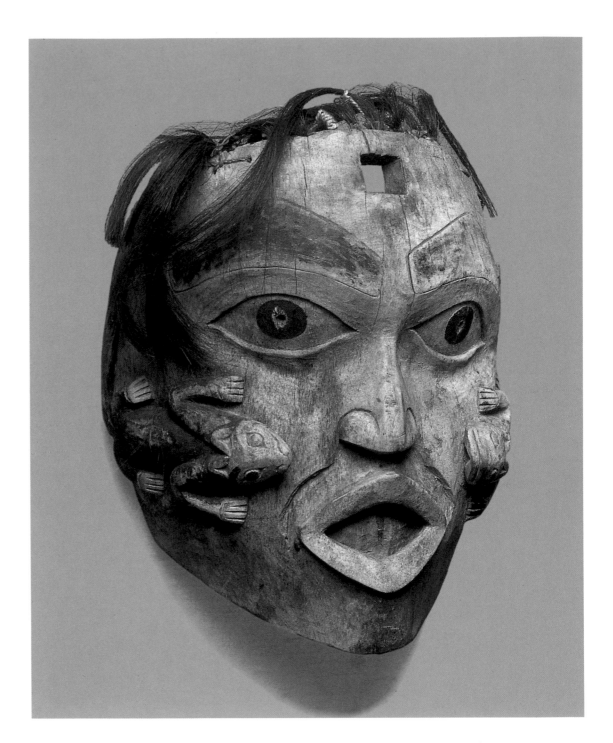

No. 77. Tlingit Mask. Emmons (n.d.) describes the animals on the cheeks as mice, which are eating "out the secrets of witchcraft and the spirit of the dead." De Laguna (in Emmons, 1991, p. 399) notes that the mouse was the strongest of all animal spirits in the service of witches. Collected by Emmons from the grave house of an unidentified shaman of the Gu-nah-ho people at Dry Bay, 1884–93. Wood, human hair, animal hide, and traces of black pigment; height 7¼ inches (mask only); c. 1790–1820. American Museum of Natural History, New York, E 2511. Purchased from Emmons, 1893

men, thus accounting for the origins of witchcraft among this group (de Laguna, 1972, pt. 2, p. 733).

The beneficial side of mice is represented by several Tlingit shaman masks collected by George Emmons that show figures of mice on the cheeks. He reports that they are eating out the secrets and spirits of witches so that they can be passed on to the shaman (Jonaitis, 1988, pp. 97, 98, pl. 36; de Laguna, 1972, pt. 3, pl. 186 [top]). Mice were also used by shamans to discover witches, as John Swanton (1905, p. 42) describes among the Haida. The names of all the inhabitants of a village were recited to a mouse. When it moved its head at the mention of a specific name, the sorcerer was identified. In another Haida myth recounted by Frederica de Laguna (1972, pt. 2,

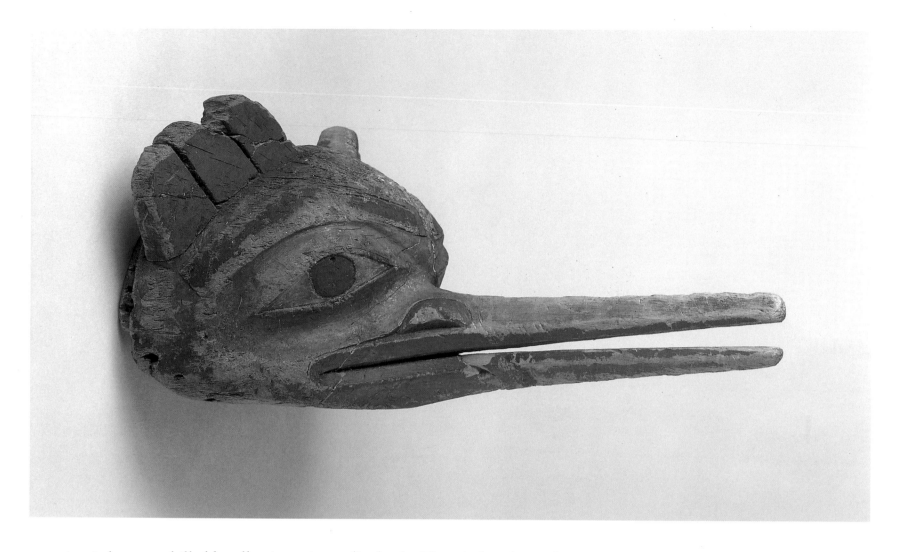

p. 739), witches were killed by allowing mice to die slowly. The witches themselves gradually took on similar symptoms and finally died.

Despite their various roles in Northwest Coast mythology, however, mice appear only rarely in shamanic art. Besides the Tlingit masks showing them on the cheeks (and several of the same masks have land otters in similar positions), they are occasionally found among the other creatures carved on the backs of oystercatcher rattles.

Other spirit animals that are infrequently represented are mosquitoes, owls, and woodworms. Their ability to suck blood can explain mosquitoes' role as a shamanic symbol, for they served as metaphors for the manner by which the shaman sucked the disease or evil from his patient. Emmons (n.d., 19/922), referring to a shaman's headdress representing a mosquito in the collection of the American Museum of Natural History, New York, writes, "The mosquito is supposed to draw bad blood from the patient." These insects were believed to have been born from the ashes of a powerful cannibalistic monster that had been killed and cremated (Boas, 1916, pp. 740–41; Collins et al., 1973, p. 244, no. 307). Mosquitoes appear as masks with long, sharp proboscises.

Owls were powerful spirits along the coast. Among the Tsimshian, they were thought to be the cause of death when they flew directly over an individual's head (Boas, 1916, p. 452). Tlingit witches could also appear as owls (de Laguna, 1972, pt. 2,

No. 78. Tlingit Mask. This fine old mask with its sharp proboscis and malevolent expression depicts a mosquito, which, in shamanic art, is a metaphor for the shamans' ability to suck illness from their patients. Collected by Lieutenant T. Dix Bolles at Wrangell. Wood and black, red, and blue-green pigment; length 15½ inches; c. 1800–1820. National Museum of Natural History, Smithsonian Institution, Washington, D.C., 73800. Given by Bolles, 1884

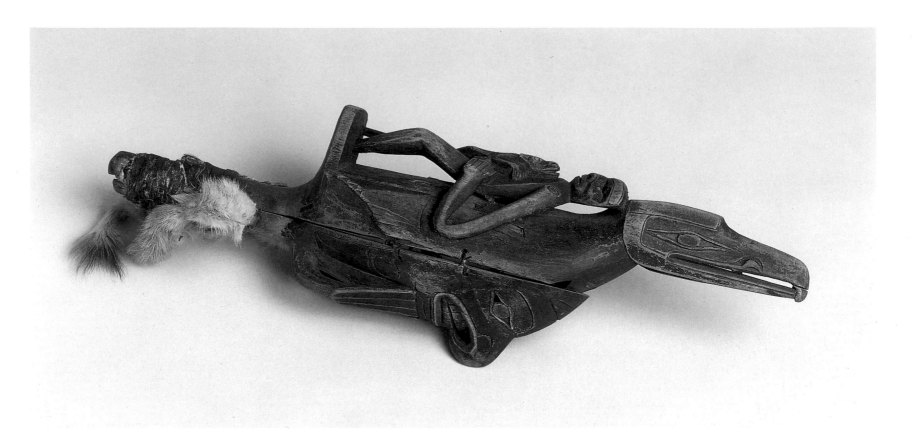

p. 732). This bird must also have served a beneficent purpose as a spirit helper because shamans' masks representing owls are known from the Tlingit, and the owl occasionally appears among other animals on amulets.

The woodworm serves as the eyebrows on a few Tlingit maskettes. While essentially a crest emblem, it was known for its supernatural ability to grow to giant size and to change itself into other creatures (Borden, 1983, p. 134). By being able to bore through wood, it was also thought to have strong powers of perception (Swanton, 1908c, p. 464).

To show the shaman's skill at functioning in both the social and sacred worlds, a number of animals appear as both crest and shamanic symbols. Aldona Jonaitis (1986, p. 89, Table 3) has inventoried the types and frequencies of the animal images – crest and shamanic – found among the contents of twenty-three Tlingit shamans' grave houses. Bears are the crest animals most commonly represented among the objects Jonaitis examined. These mammals were thought to share many traits with humans, including appearance, the ability to stand erect on hind legs, and the ways of storing food for winter and gathering it for their young; they were even believed to understand human speech and thought (ibid., p. 81). Bear imagery is carved on Northwest Coast shamanic masks, amulets, rattles, and staffs, and is painted on costumes. The bear, of course, is an important shamanic spirit throughout the world, and we have already noted the antiquity of its association with this discipline (see Campbell, 1983, pp. 54–56, 147–55).

The golden eagle also appears prominently among the surveyed objects, as does the killer whale, which in shamanic art is often shown in the x-ray style. The Tlingit believed whales were given life by a man who had carved their images in yellow

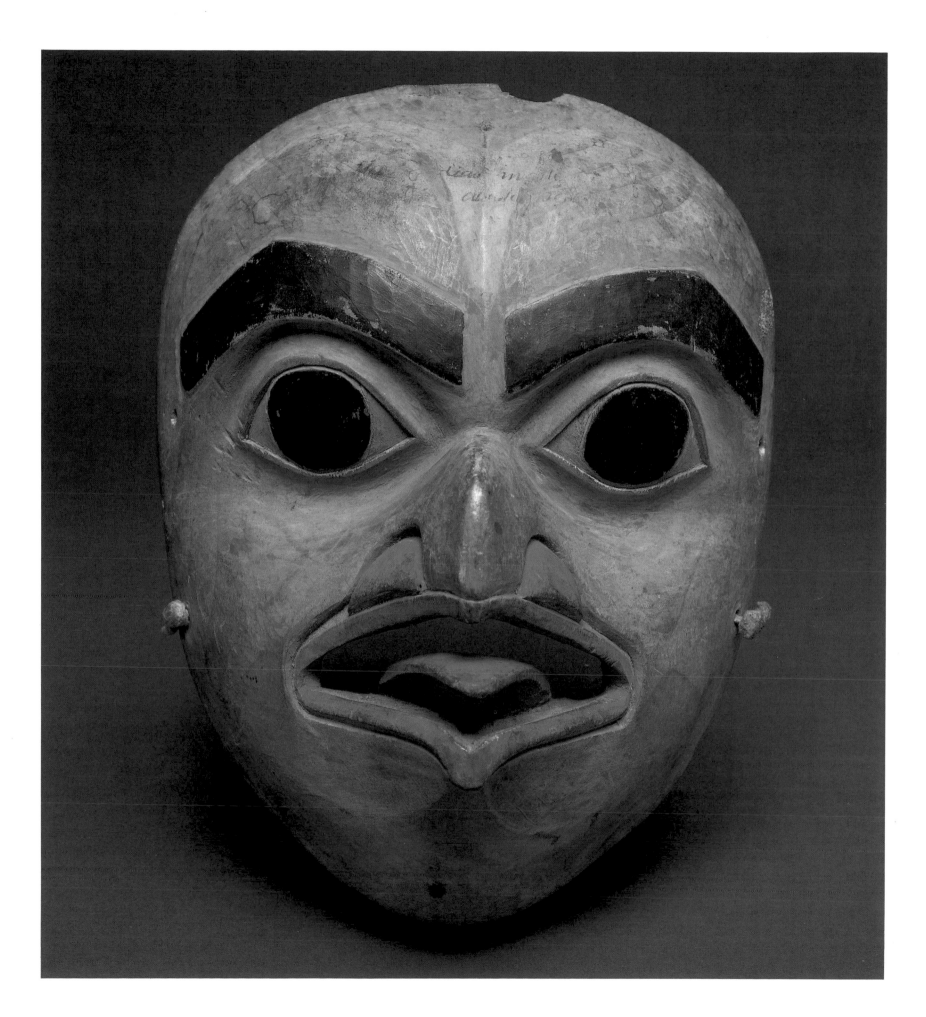

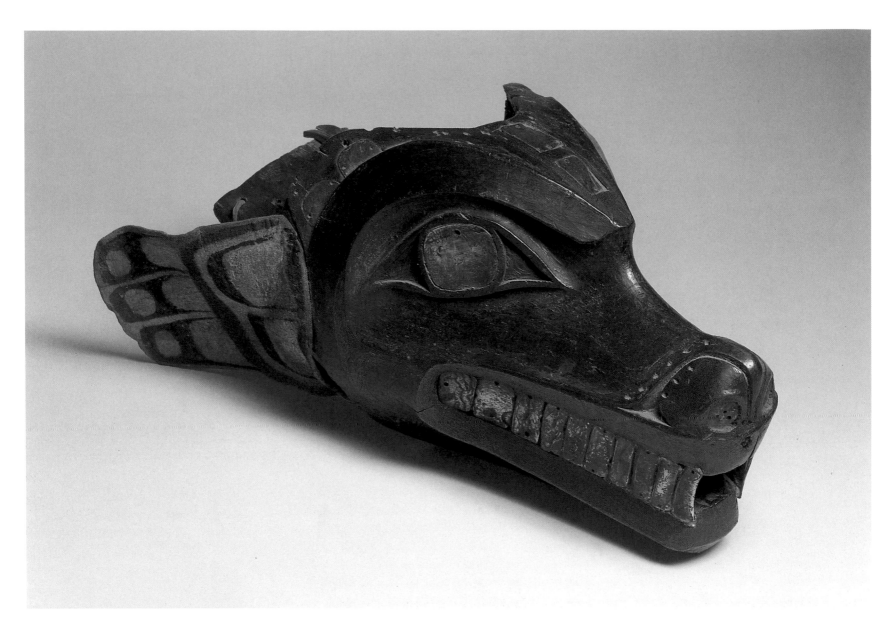

No. 81. Tlingit Visor Mask. Sea lion. Although there is no collection information that associates this mask with a shaman, it is very similar to no. 120, which was the property of a practitioner. Harner and Elsasser (1965, p. 34) believe that a killer whale fin may have originally been attached to the top of the mask, and therefore suggest that it represents a sea bear or sea wolf. Holm (1995) however, believes that both this and no. 120 represent sea lions, because the holes above the nose at one time were inlaid with the bristles of this mammal. Most of the teeth have been restored. Wood, abalone, animal hide, and black and red pigment; length 13½ inches; c. 1840–60. Private collection

cedar. This close relationship to humans places killer whales in a category similar to that of land otters (Jonaitis, 1978, p. 64).

The raven is understandably often found in both crest and shamanic expressions, for Raven was unquestionably the most important animal that appears in Northwest Coast mythology and art. Among much else, he formed the earth's land masses, brought sunlight to the world, gave all its inhabitants, both human and animal, their present form, and taught fishing and the craft of building to humans. He had the ability to talk, predict the future, and warn of impending danger. Raven also was thought to have taught both shamans and witches their arts (Jonaitis, 1986, pp. 72–74).

Frogs (in reality, toads) appear in both contexts as well. Their ability to transform themselves from animals of the water (tadpoles) to land-living amphibians suggests their affinities with the shaman's practices. They were also associated with witches and as such were much feared by the Tlingit. The slime from their skin was thought to be poisonous and was used by sorcerers to make a victim's eyes pop out and mouth bulge like a frog's (Swanton, 1908c, pp. 457, 470; quoted in ibid., p. 76).

Depictions of bald eagles, wolves, cranes, salmon (perhaps because of the myth of a boy who was kidnapped by salmon and later returned home to become a shaman [ibid., p. 75]), sculpins (described by George Emmons as noiselessly carrying "'the Doctor through space invisibly'" [quoted in ibid., pp. 121–22]), and halibut complete the list of those forms found in both crest and shamanic expressions. These are by no means, however, all of the animals depicted on shamanic objects. Some became associated with individual shamans by virtue of their own experiences or what had been passed on to them by their predecessors. For example, sharks, albatrosses, and chitons are also represented in Tlingit shamanic art.

A number of scholars have summarized the types of spirits and forces that aided shamans. In their compilations, there is a mixture of animal beings and elements of nature that can be rendered into tangible objects as well as those that represent mental images that cannot be given sculptural or two-dimensional form. Marius Barbeau (1958, p. 6) cites the following spirits of the Haida shaman: the otter, hawk, salmon, and bear, which they share with the Tlingit, and "the Mink, . . . the Bullhead, the Canoe, the Sweat-house, the Moon, . . . and other potent beings of the nether world." John Swanton (1905, p. 38) describes the primary Haida spirits as "the Canoe People, the Ocean People, the Forest People and the Above People" in yet another reference to the different realms of the shamanic world. Among the spirits of the Gitksan Tsimshian shaman, Barbeau (1958, pp. 44, 75) mentions bees, spiders, squirrels, cranes, the sun, the moon, stars, the wind, rainbows, the bear snare, and the "Woman of Sickness." Marie-Françoise Guédon (1984b, pp. 193–95) provides a similar sample, which includes squirrels, bears, various birds, bees, "Bagus" the woodsman, ghosts, astronomical bodies, the mountain goat, and the lynx.

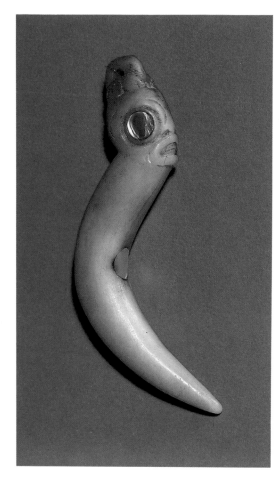

No. 82. Tlingit Amulet. The flat, broad nose, thick lips, and prominent ears suggest the representation of a bear. Antler and abalone; length 3⅝ inches; c. 1840–60. Private collection

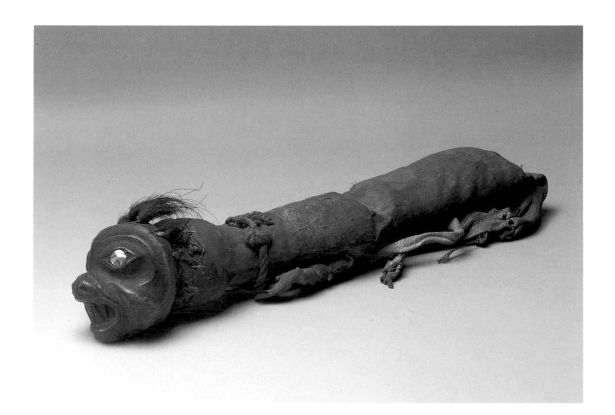

No. 83. Tsimshian Staff. Emmons (n.d., Notes, NMAI) identifies the head as that of a mink, and says that this object was carried by a shaman as a staff or a wand. Among the Tlingit, mink were associated with witchcraft and also were allied with land otter men (de Laguna in Emmons, 1991, pp. 399, 404). Four similar cylindrical Tsimshian shamans' staffs of animal skin were collected by Charles F. Newcombe along the Nass River in 1914, and are now in the Royal British Columbia Museum, Victoria (1567–9; 1579). They represent a marmot, a bear, a weasel, and an otter, and each contains bones and magical substances. None, however, is ornamented with an animal head, as seen here. Collected by Emmons at Gitksan. Wood, human hair, animal skin, twine, abalone, and red pigment; length 9½ inches; c. 1840–60. National Museum of the American Indian, Smithsonian Institution, Washington, D.C., 3/5018. Purchased from Emmons, 1914

It is also apparent, particularly among the more complex examples of carving and painting, that not all the beings represented in the art used by shamans are spirit helpers. Many objects illustrate esoteric ideas such as the contents of dreams or the personal experiences of their shaman owners. Whatever the reasons for their inclusion in the art, this general listing gives some indication of the richness of imagination, ideas, and meaning contained within the expression.

As is evident from the illustrations that accompany the following catalogue section of the book, shamans employed a wide variety of objects during their performances. For convenience, these objects are divided into groups representing the major forms in which the shamanic art of the Northwest Coast appears. Although in this context they are separated from one another, it should be remembered that in practice many objects were usually displayed together to express the power, reputation, and supernatural affiliations of their shaman owner. A shaman rarely would have relied on a single piece to express these concepts, but rather would have depended on the combined effect of the many carved and painted works that were revealed in various juxtapositions during a single performance. As is suggested by some of the posed photographs, a practitioner might carry a rattle in one hand and a staff in the other, wear a necklace with bone and ivory pendants, have a soul catcher suspended from his neck, be clothed in a painted tunic or apron, and chant to the rhythm of a drum bearing the image of a spirit helper. Dolls might also have been manipulated, and, if he were Tlingit, the shaman would wear a mask or maskette.

Though it is possible to admire these objects simply as the extraordinary creations they most certainly are, each must also be regarded as part of a more complex totality that combines an ancient belief system with conspicuous display, theater, and now-lost stories of individual encounters with the world of the supernatural. Now that these fine works are no longer in ritual use or the property of their once powerful masters, we must rely on the art itself to convey something of this totality to us.

Fig. 32. Tlingit Shaman. This individual was photographed wearing different costumes several times by Winter and Pond (see also fig. 33), Juneau, c. 1900. Alaska State Library, Juneau, 87–247

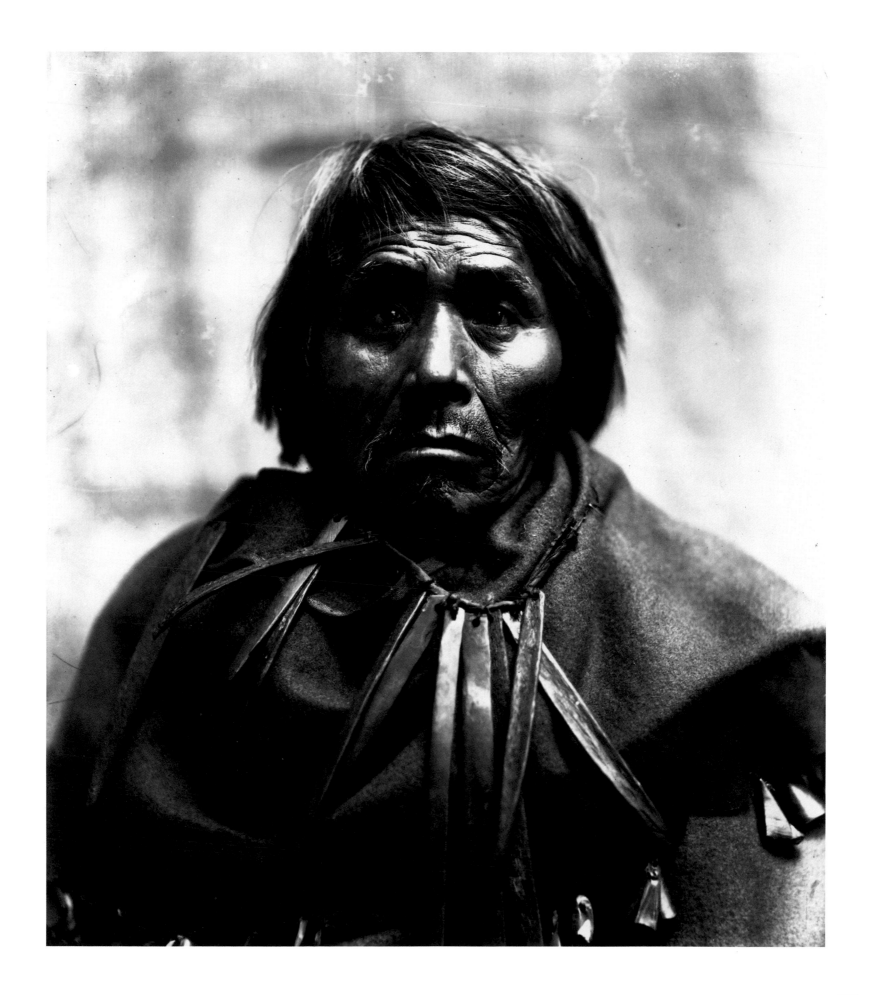

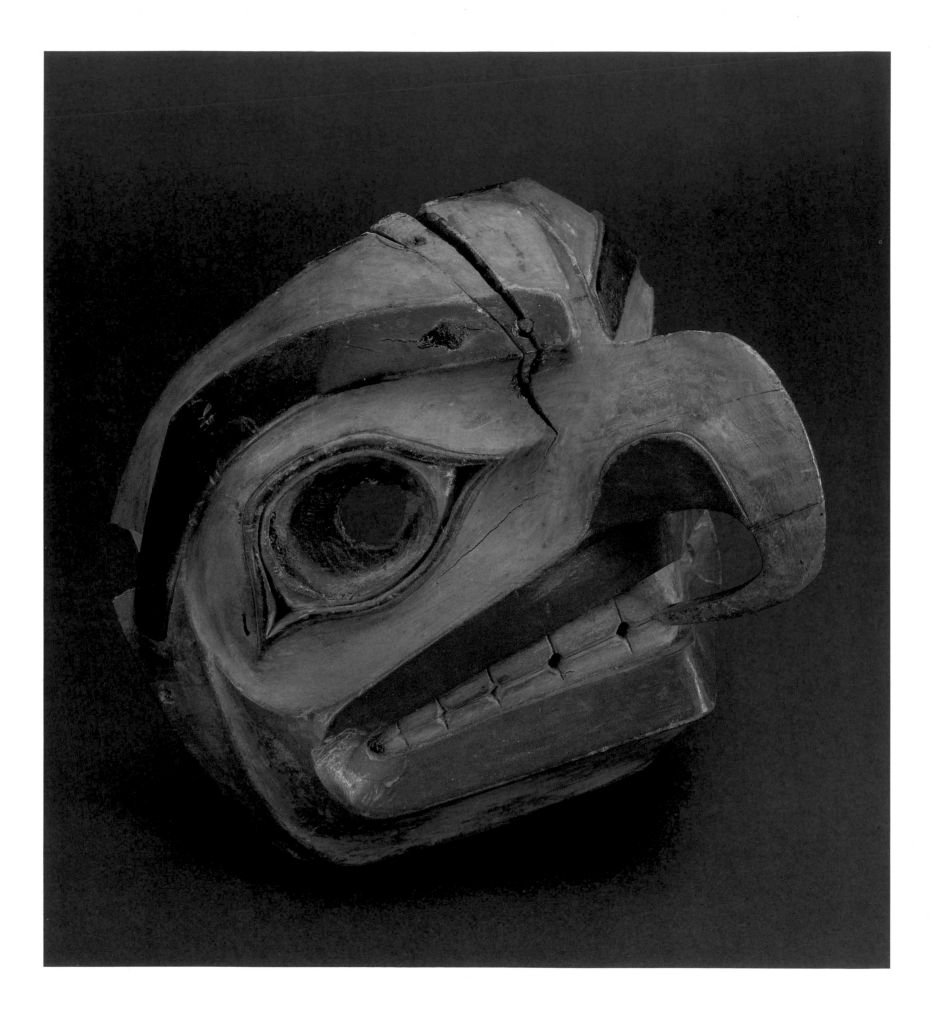

CHAPTER VI

A COLLECTION OF SHAMANIC OBJECTS

MASKS

DE LAGUNA (1972, pt. 2, p. 690), referring to the Tlingit, writes, "the most important part of a shaman's outfit, except for the tongues he had cut, consisted of his masks." They were worn to represent and to enable the shaman to take on the powers of the spirit helper who was being called upon to assist him in his duties. As the spirit possessed the wearer, his movements and the sounds he made imitated its characteristics. Among the peoples of the Northwest Coast, only the Tlingit made masks for shamanic use. Each Tlingit shaman owned his individualized set of masks, and those with the most power had eight in their kits. During a single performance, all of a shaman's masks might be worn sequentially to display the full range of his abilities to move among the living and dead, in the world of animals, and to the realm of the supernatural (Jonaitis, 1981a, pp. 127–28). The individual masks were accompanied with their own ritual chants and movements, which identified them with the helping spirits they represented.

Emmons (1991, pp. 376–77) expresses his appreciation of Tlingit shamans' masks as works of art as follows: "The mask exemplified the perfection of Tlingit art in carving. The realism of the features in their expression of feeling, the elaboration of ornamentation, and the technical excellence of workmanship and finish gave it a superiority over all other masks of the Northwest Coast. In the shaman's mask, the Tlingit excels in originality, truthfulness, and elegance of carving."

Almost all masks were made of wood and painted. Emmons (ibid., p. 377) believes those without eyeholes drilled through to be the oldest type. Inlays of abalone and operculum were frequently added, and hair and strips of copper and animal fur were often applied as well. Some copper masks having shamanic iconography are also known. Included in this group are a mosquito mask in the National Museum of the American Indian (Dockstader, 1960, no. 121), another in same collection (2146) with devilfish tentacles on the cheeks, and one in the Peabody Museum of Archaeology and Ethnology with a shaman's crown (Vaughan and Holm, 1982, p. 101, no. 62). However, despite their use of motifs that depict shamans' paraphernalia and their spirit helpers, none of the known copper masks was found in shamans' burials. Furthermore, Emmons (1991, pp. 379–80) implies that they were made for commercial purposes. No examples are therefore shown in this volume.

Certain similar mask types appear quite frequently in shamans' kits, including those showing trance expressions or incipient death by drowning; representations of shamans themselves; and depictions of highborn women wearing labrets, the land

No. 84. Tlingit Mask (opposite). Hawk. Collected by Emmons from the grave house of a Yakutat shaman who lived on the inland waters between Bering and Dry Bay. Wood and black, red, and blue pigment; height 5⅞ inches; c. 1820–40. Field Museum of Natural History, Chicago, 78325. Purchased from Emmons, 1902

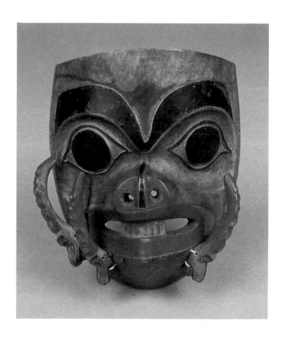

No. 85. Tlingit Mask. A bear face with three attached carvings of land otters whose bodies are formed of devilfish tentacles. Collected by Emmons from the grave house of a Gu-nah-ho shaman at Dry Bay. Wood and red, black, and blue-green pigment; height 7½ inches; c. 1840–60. Thomas Burke Memorial, Washington State Museum, Seattle, 2032. Purchased from Emmons, 1909

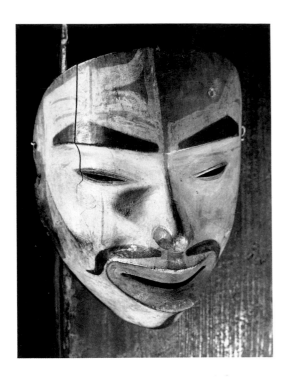

No. 86. Tlingit Mask. Man with mustache. Collected by Captain Urey Lisiansky at Sitka, 1806. Wood and black, red, and blue-green pigment; height 9⅜ inches; c. 1770–1800. Museum of Anthropology and Ethnography, St. Petersburg, Russia, 238/2

otter man, bears, wolves, and eagles. In addition, there is an almost infinite variety of other animal, human, insect, celestial, and natural forms to be found among Tlingit masks (see p. 80). Several elaborate examples even incorporate three or four spirits into a single mask. Others are unique, and were inspired by the individual spiritual experiences of their owners. Although the majority of Tlingit masks are conventional face coverings, shamans also employed visors and headdresses with carved figures worn in front and on top of the head.

A shaman's paraphernalia might also include wood frontlet maskettes, four to five inches high, attached to headbands covered with eagle, duck, or swan skin from which the feathers had been removed to leave only the down (Vaughan and Holm, 1982, p. 94). The headbands were also sometimes embellished with additional carvings of human figures, seal or sea lion whiskers, cedar bark, braided human hair, animal tails, and eagle or magpie tail feathers.

The maskettes are sometimes miniatures of full-size masks in a shaman's kit, but a number represent completely different beings. De Laguna (1972, pt. 2, p. 693) cites Emmons as stating that they were worn for "'general dances,' for dancing in the evening after a day of fasting to bring good fortune to the shaman's family, and also for dancing around the sick and bewitched." Jonaitis (1986, p. 28) also records Emmons's comment that maskettes came into use during later times and that they had less significance than face masks. Emmons claims that they were worn both a curing ceremonies and at other, less important public events. Because most examples show extremely detailed workmanship, and because they often incorporate so many materials that they might be regarded as conglomerations of magical substances, the maskettes must have been endowed with considerable power regardless of when they actually came into general use.

No. 87. Tlingit Mask (opposite). Shaman singing. Collected by Captain Edward G. Fast at Sitka, 1867–68. Wood and red, black, and blue-green pigment; height 8¾ inches; c. 1820–40. Peabody Museum of Archaeology and Ethnology, Harvard University, Cambridge, 69–30–10/1600. Purchased from Fast, 1869

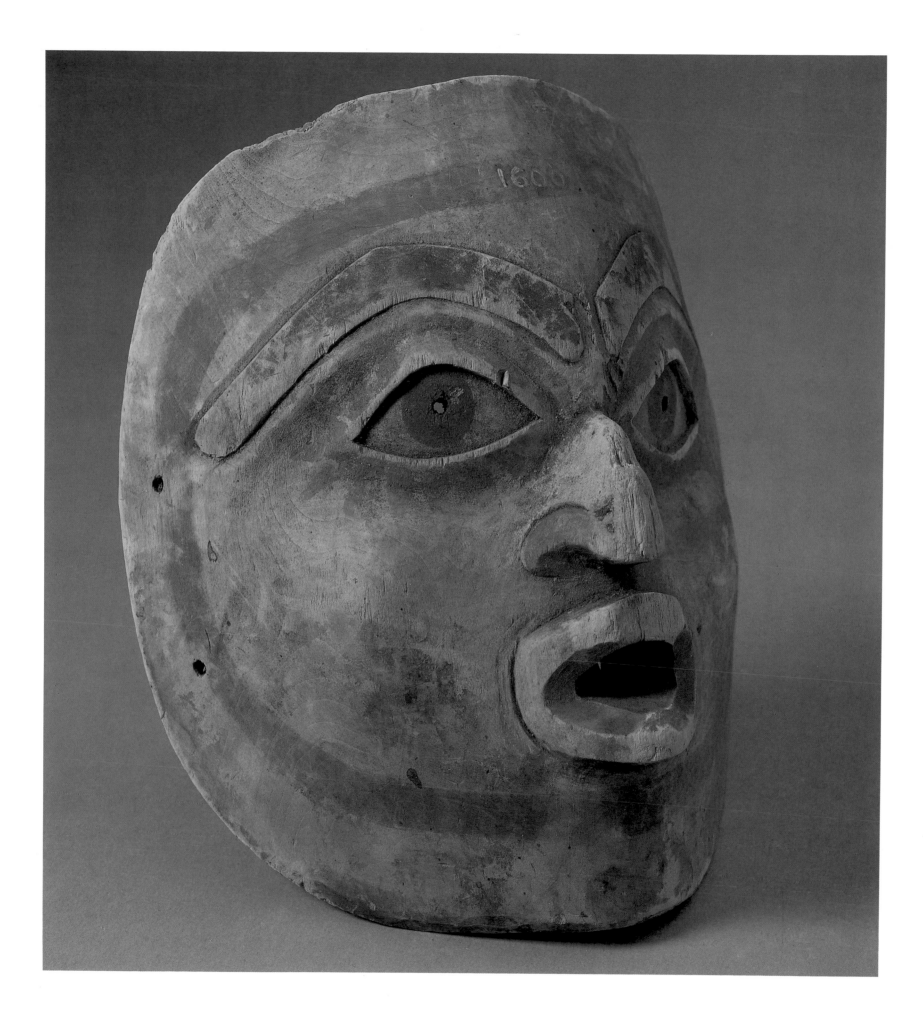

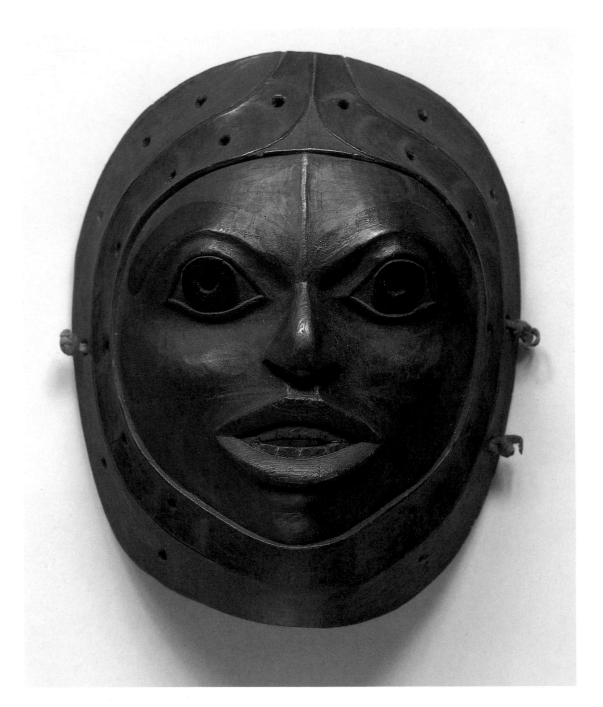

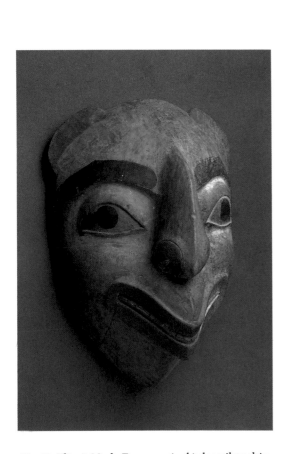

No. 88. *Tlingit Mask*. Emmons (n.d.) describes this mask as a sun dog spirit. It is by the same artist as no. 91. Collected by Emmons in 1884–93 at Berner's Bay from the grave house of a shaman and chief of the Auk tribe named Kowee, who died around 1850. Wood and black, red, blue, and traces of white pigment; height 9¼ inches; c. 1830–50. American Museum of Natural History, New York, E 2684. Purchased from Emmons, 1893

No. 89. *Tlingit Mask*. Emmons (n.d.) describes this mask as representing the spirit of the sun. Collected by him from the grave house of a Sitka shaman of the Kiksadi clan at Peril Strait, 1884–93. Wood, animal hide, and black, red, and blue-green pigment; height 8⅝ inches; c. 1840–60. Former collection: American Museum of Natural History, New York, E 654; exchanged to Emmons, 1922. National Museum of the American Indian, Smithsonian Institution, Washington, D.C., 11/1752. Purchased from Emmons, 1922

THE SHAMAN OF CAT ISLAND
(Tlingit)

At the time the Tanta kwan tribe lived in the village of Dasahuk on Cat Island there was a shaman among them by the name of Kushkan. He was of the Tekwedih clan and of Thunderbird House. His spirit told him to cut the tongue from a red snapper. Kushkan's first spirit was

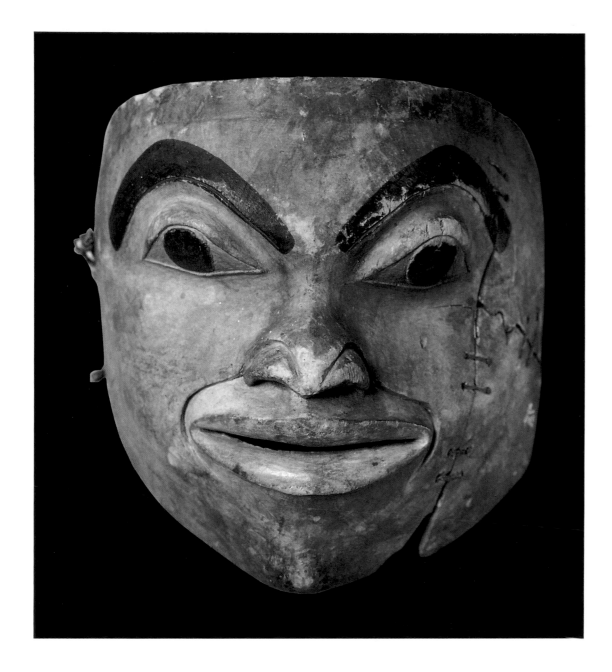

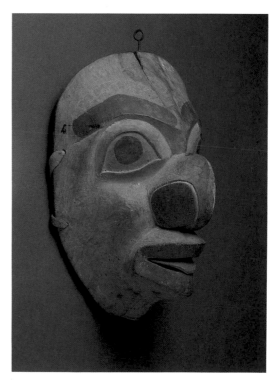

No. 90. *Tlingit Mask*. Emmons (n.d.) writes that the mask represents "a good natured spirit that lives in the air." Collected by him in 1884–93 from the grave house of Setan, a Tlukwaxdi shaman, on the Akwe River, a few miles west of Dry Bay near an old, deserted village. Some of the objects used by Setan were said to have passed through as many as five generations of shamans. This example and other masks from his grave, such as nos. 2, 55, 110, 122, and 143, certainly date from the first part of the nineteenth century, if not earlier. Wood, fiber, and traces of red, black, and blue-green pigment; height 7¼ inches; c. 1790–1820. American Museum of Natural History, New York, E 409. Purchased from Emmons, 1893

No. 91. *Tlingit Mask*. Emmons (n.d.) describes this mask as a "spirit living in the stars." It is by the same artist as no. 88. Collected by Emmons in 1884–93 at Berner's Bay from the grave house of a shaman and chief of the Auk tribe named Kowee, who died around 1850. Wood, animal hide, and black, red, blue, and traces of white pigment; height 8⅞ inches; c. 1830–50. American Museum of Natural History, New York, E 2689. Purchased from Emmons, 1893

named . . . "power." The spirit told Kushkan to go (i.e., his soul to go) to the Tsimshian and "kill" a certain famous shaman there. He did this and the "dead" shaman's spirit came into him and gave him four songs. His helpers joined him in singing them. At the end of the eight days' vigil they returned to Dasahuk. People were anxious to see what Kushkan would do. They came together in Mountain House. . . . Kushkan sat at the head of the house, his helpers at his side. Most of his paraphernalia he had taken from the graves of shamans. First he showed what spirits he had acquired. The first spirit to enter him was the Tsimshian power. Kushkan told his helpers to give him a . . . dance headdress . . . but he spoke this in Tsimshian and the helpers did not understand. Then Kushkan became conscious and told his helpers what he wanted. Then the spirit entered him again. He put on the headdress but did not tie it. As his helpers sang, Kushkan danced. The headdress moved from his head down his back, then onto his right shoulder, then to his left shoulder. Then it moved again to his head and he came out of his trance.

Next the red snapper spirit entered him and he acted like a red snapper. His helpers took a short pole and line with a steel hook for "bait." (During the novitiate they had done this but had used a piece of stick for a "hook.") This gear was then given to any doubters in the audience. Kushkan would then swallow the hook and the holder of the rod would jerk the line. But the hook would come out without hurting Kushkan. Then his spirit named "Strong" came to him. A line of men held a pole, but Kushkan would need only nudge the pole to bowl them over. Then another of his spirit powers entered him. His helpers put a red-hot iron down his throat without harm. His fourth spirit entered him. He took his wolf knife, cut a man's face from scalp to chin, then threw his knife away and pressed the sides of the cut together. He sang his four spirit songs and all four spirits entered him. Then he called for feathers, put them on the cut. Next ne painted the man's face. Only a slight scar from the cut remained. This ended his performance. Still another magical trick was that when he put on a robe of dressed moose hide, no one could pull it off, even though it was not tied.

On one occasion a jealous woman had her adolescent daughter (who was in isolation) look through a crack in the wall as Kushkan swallowed the fishhook. As it was jerked out it caught in his mouth. But his spirit told him that the girl had looked on him.

On one occasion Kushkan was away from the village. A lad named Yashut fell ill and in a few days became abnormally thin. This was because he and another lad had gone to a nearby island and shot a sea gull. The bird's tongue stuck out and the boys cut it off and threw it away in play. A few days later Yashut fell ill. When Kushkan returned he was offered a large sum to attempt a cure. His spirit came into him. When he came out of the trance he asked, "Were you playing with a sea gull and did you cut off its tongue?" When the boy replied that he had, Kushkan said, "Your ancestor's spirit helpers wish to come to you." He agreed to train the boy in shamanizing. He and the lad fasted for four days and in a few days the illness was gone.

Then the whole Ganahadi clan went on a strict diet and were continent while the boy went through his novitiate. Yashut and the helpers went from place to place. The chief helper (ikthankau) would cut off the tongues of various animals. On the point at Port Chester were many shamans' graves and the party stayed in a cave there. One grave was that of Kahwan who was Yashut's great-grandfather. Kahwan's spirits came and asked for leaf tobacco for their master (Kahwan). Yashut told his helpers to bring eight pieces of the tobacco wrapped in cedar bark. They placed this at the grave. The spirits thanked the giver and told him to stay there four days so that all Kahwan's spirits would come to him. Four times they gave tobacco and each time it was gone in the morning.

The fourth night Yashut's spirit entered him and his helpers heard him babbling. He told his men to be sure not to drink fresh water; and that they were to get some things from the grave of Kahwan. In the grave house were two carvings of the head and shoulders of men-spirits called iktdakye' gi ("spirits which sit at the door"). When the helpers tried to take these the grave house shook, for the dead man's spirit did not wish to part with these. That night Yashut's spirit told him to get the tongues of a dog; a mink, and a deer. But they did wrong and kept the whole deer to eat. Then they started home.

At the village Kushkan was sitting in front of his house. When the canoe came near he called on a spirit called aniggagayeggi (a spirit which lived under the water out from the village). Kushkan "poured water into the mouth of this spirit" which caused an invisible whirlpool. He wished to see if Yashut would "see" this whirlpool. Yashut was lying in the bottom of the canoe, covered with a blanket. But as they came to the "whirlpool" he told his men to back water and to

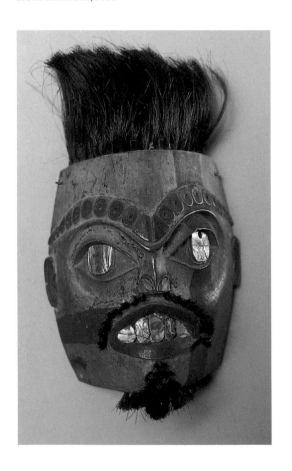

No. 92. Tlingit Maskette. Devilfish tentacles form the eyebrows. Emmons (n.d.) writes that this was "used by shamans in dances when at enmity with shamans in other communities." Collected by him from the Chilkat, 1882–87. Wood, abalone, human hair, and red and traces of blue-green pigment; height 6⅞ inches; c. 1840–60. American Museum of Natural History, New York, 19/920. Purchased from Emmons, 1888

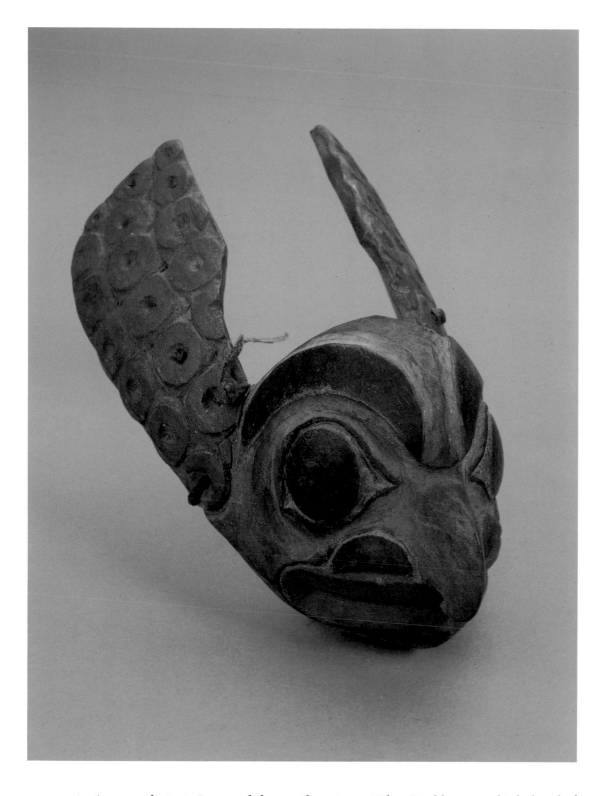

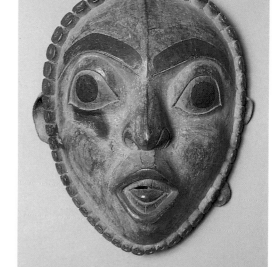

No. 93. Tlingit Maskette. Hawk and devilfish. Collected from the grave house of a Xatkaayi shaman on a salmon stream flowing into Dry Bay north of the Alsek River. The shaman had lived on the west coast of Prince of Wales Island. Wood, animal skin, and black and red pigment; length 5½ inches; c. 1840–60. Field Museum of Natural History, Chicago, 77852. The Carl Spuhn Collection. Purchased from Emmons, 1902

No. 94. Tlingit Mask. Devilfish tentacles surround the face. Collected by Emmons in 1884–93 at Berner's Bay from the grave house of a shaman and chief of the Auk tribe named Kowee, who died around 1850. Wood, animal skin, and black, red, and blue pigment; height 9⅛ inches; c. 1830–50. American Museum of Natural History, New York, E 2683. Purchased from Emmons, 1893

go sunwise (counterclockwise) around the spot four times. When Kushkan saw this he laughed and said, "My grandson is a real shaman." As the canoe was beached Yashut's father killed two slaves in honor of his son's becoming a shaman.

Yashut performed his tricks to show his power. Afterward there was a feast. The deer they had killed was eaten. That night Yashut's spirit told him he had done wrong and said, "Now one by one your clansmen will die, until none are left." (*And so it came to pass, for now only a few Ganahadi remain.*) (Olsen, 1961, p. 209–10)

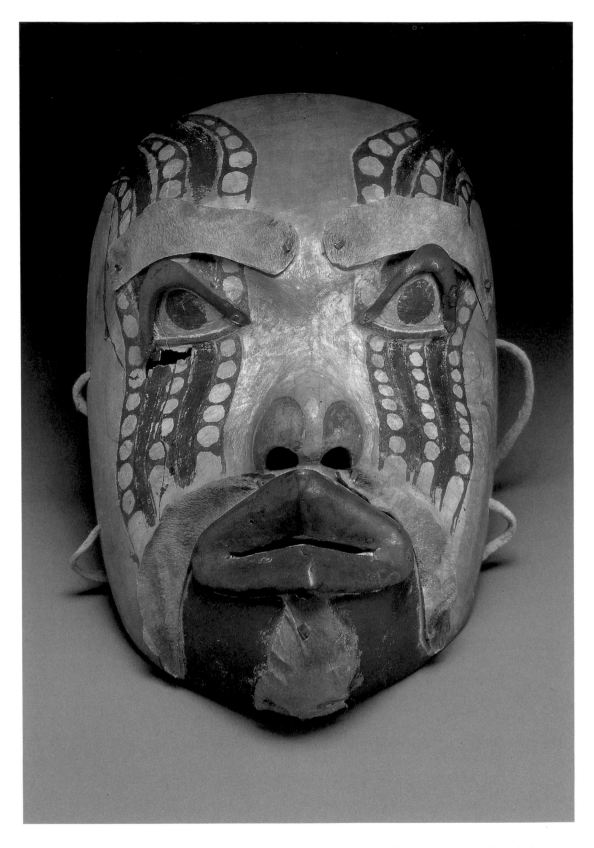

No. 95. Tlingit Mask. The facial tattoos represent devilfish tentacles. The dark blue coloring is ink and of more recent origin than the other pigments. By the same artist as no. 96. Collected by William Libbey from the grave house of an unknown shaman near Port Mulgrave (Yakutat), 1886. Wood, animal skin, nails, copper, and brown, white, and blue pigment; height 9¾ inches; c. 1840–60. The Art Museum, Princeton University. On permanent loan from the Department of Geological and Geophysical Sciences, 3923. Given by Libbey, 1886

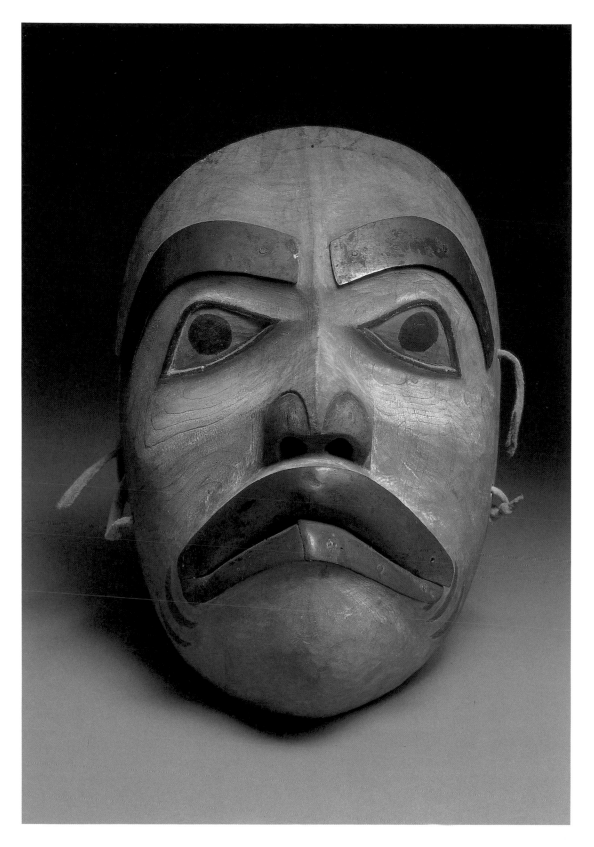

No. 96. Tlingit Mask. The downturned mouth and gill slits on the cheeks identify this mask as representing a shark. By the same artist as no. 95. Collected by William Libbey from the same shaman's grave house near Port Mulgrave (Yakutat), 1886. Wood, copper, rawhide, and black, red, and traces of blue-green pigment; height 9⅜ inches; c. 1840–60. The Art Museum, Princeton University. On permanent loan from the Department of Geological and Geophysical Sciences, 3922. Given by Libbey, 1886

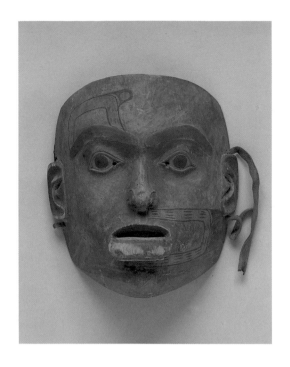

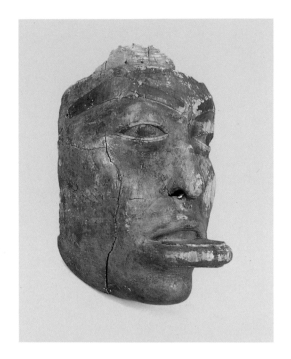

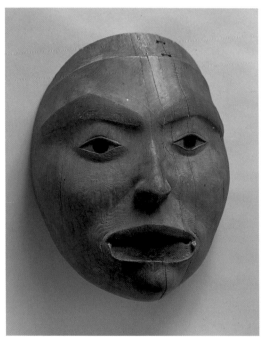

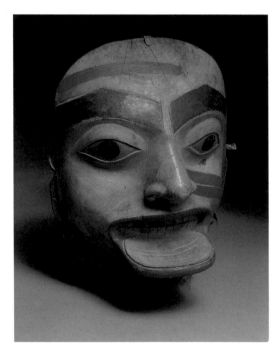

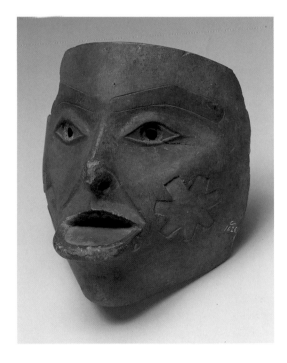

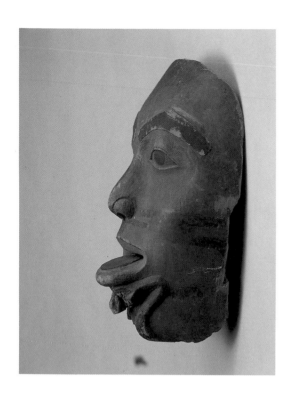

No. 102. Tlingit Mask. This mask representing the spirit of an older woman with a labret belongs to the same grave group as no. 101. A frog spirit emerges from under the labret. Collected by Emmons from the grave house of a Gu-nah-ho shaman at Dry Bay, 1884–93. Emmons (n.d.) states that some objects from this grave had been passed to the shaman through several generations of predecessors; the early, naturalistic carving style of this mask suggests that it is one of these items. It is most probably by the same artist as nos. 2 and 98. Wood, and red, black, and blue-green pigment; height 8¼ inches; c. 1790–1820. Former collection: American Museum of Natural History, New York, E 1627; exchanged to Emmons, 1922. National Museum of the American Indian, Smithsonian Institution, Washington, D.C., 11/1754. Purchased from Emmons, 1922

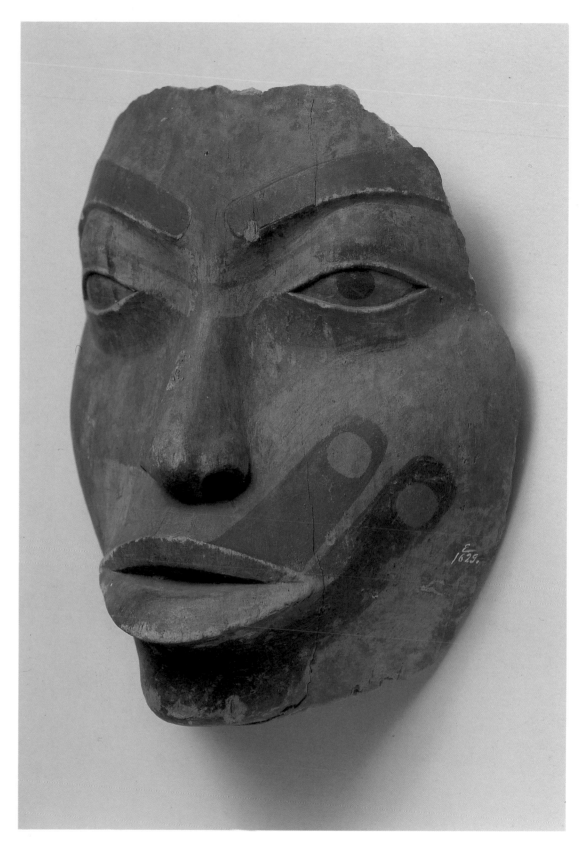

No. 103. Tlingit Mask. Emmons (n.d.) describes this early mask as depicting a young woman wearing the facial painting of the fin of a blackfish. However, as de Laguna (1972, pt. 3, p. 1130) suggests, it is more likely a killer whale fin. Collected by Emmons from the grave house of a Xatkaayi shaman at Dry Bay, 1884–93. Wood and black and blue-green pigment; height 7¼ inches; c. 1790–1820. American Museum of Natural History, New York, E 1629. Purchased from Emmons, 1893

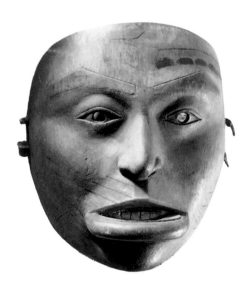

No. 104. Tlingit Mask. Woman with labret. Collected by G. Chudnovsky on Admiralty Island about 1890. Wood, animal hide, and red, black, and traces of blue-green pigment; height 8⅜ inches; c. 1820-40. Museum of Anthropology and Ethnography, St. Petersburg, Russia, 211–6

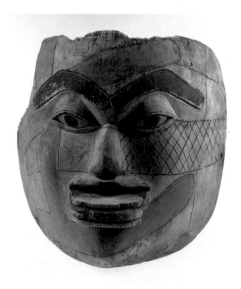

No. 105. Tlingit Mask. Woman with labret. Collected by Captain Edward G. Fast at Sitka, 1867–68. Wood and red, black, and traces of blue-green pigment; height 7¾ inches; c. 1830–50. Peabody Museum of Archaeology and Ethnology, Harvard University, Cambridge, 69–30–10/1606A. Purchased from Fast, 1869

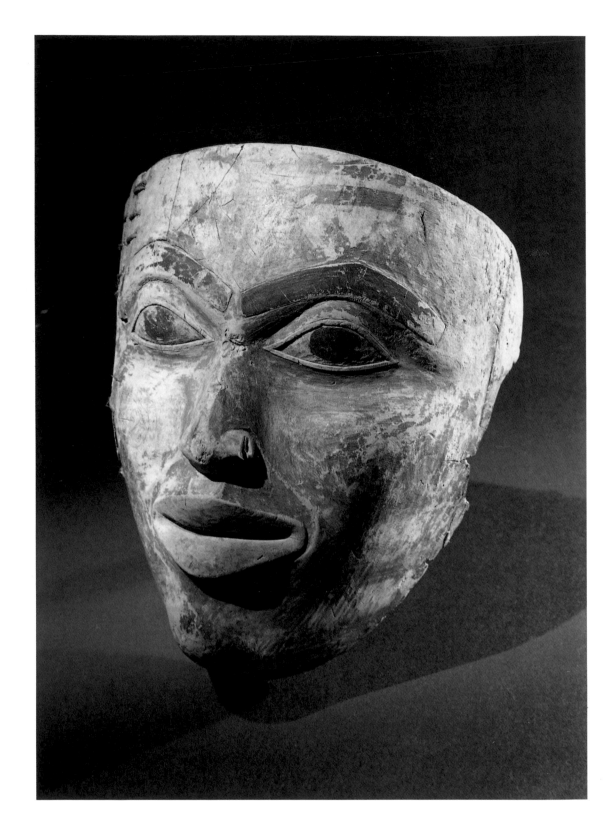

No. 106. Tlingit Mask. Emmons (n.d., Notes) writes that this mask represents a young woman who lived on an island in Dry Bay and became possessed by a shaman. Collected by him from the grave house of a Gu-nah-ho shaman at Dry Bay. Wood and red, black, and blue-green pigment; height 7¼ inches; c. 1820–40. Field Museum of Natural History, Chicago, 78285. Purchased from Emmons, 1902

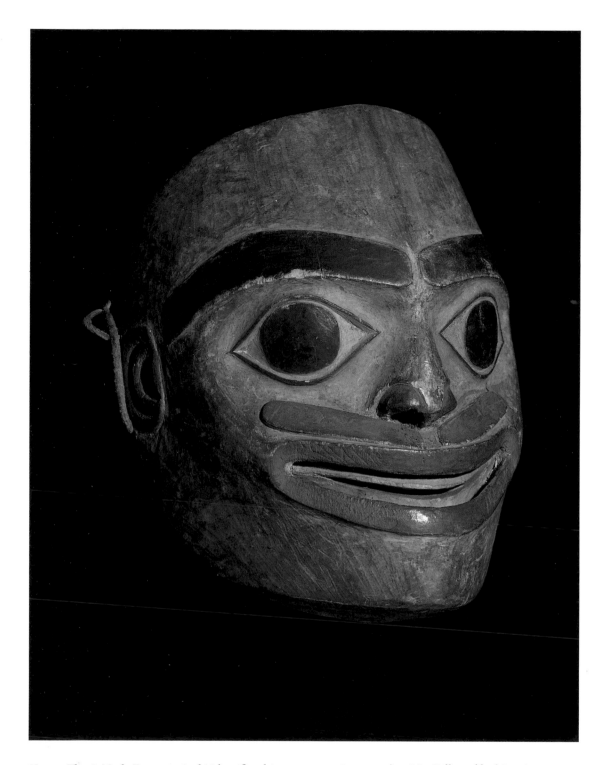

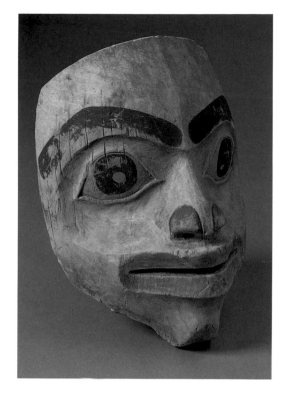

No. 109. Tlingit Mask (above). Bear. Collected by Captain Edward G. Fast at Sitka, 1867–68. Wood and red, black, and blue-green pigment; height 8½ inches; c. 1820–40. Peabody Museum of Archaeology and Ethnology, Harvard University, Cambridge, 69–30–10/1603. Purchased from Fast, 1869

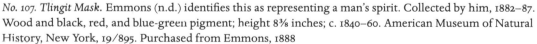

No. 107. Tlingit Mask. Emmons (n.d.) identifies this as representing a man's spirit. Collected by him, 1882–87. Wood and black, red, and blue-green pigment; height 8⅜ inches; c. 1840–60. American Museum of Natural History, New York, 19/895. Purchased from Emmons, 1888

No. 108. Tlingit Mask (right). Emmons (n.d.) describes this mask as representing Karton, an Indian who lived "some time since near Port Simpson, British Columbia. One of eight brothers. . . .The position of the mouth represents him talking very loud and angry while the double ear indicates that he can hear a great distance." Collected by Emmons from a shaman's grave house below Yandestaki, 1882–87. The four masks in this group, all now in the American Museum of Natural History (see also nos. 25 and 125), were said to have been made at Port Simpson (ibid., 19/850–53). Wood and black, red, and blue-green pigment; height 9¼ inches; c. 1840–60. American Museum of Natural History, New York, 19/850. Purchased from Emmons, 1888

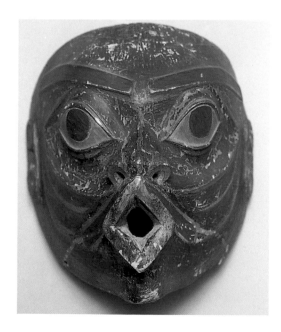

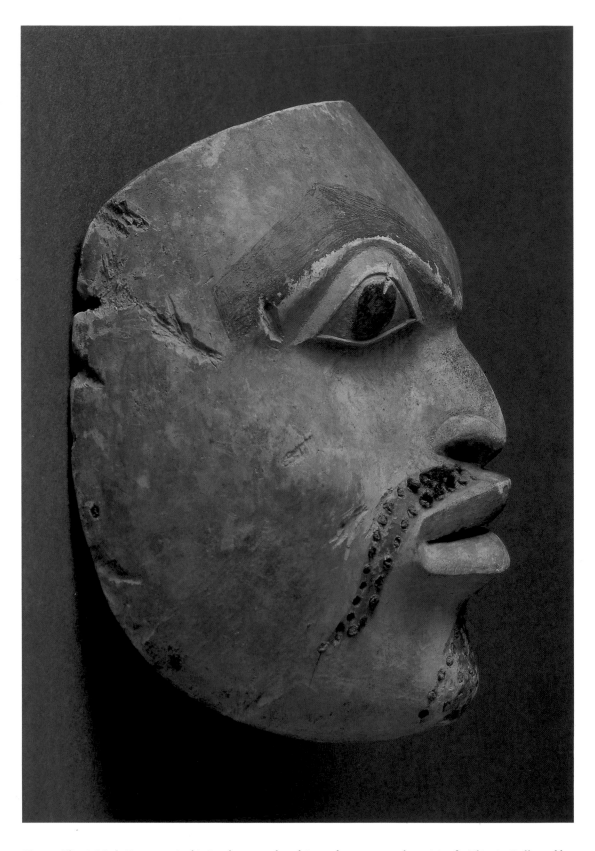

No. 110. Tlingit Mask. Emmons (n.d.) simply states that this mask represents the spirit of a Tlingit. Collected by him in 1884–93 from the grave house of Setan, a Tlukwaxdi shaman, on the Akwe River, a few miles west of Dry Bay near an old, deserted village (see no. 90). Wood, human hair, and black and traces of red and blue-green pigment; height 8 inches; c. 1790–1820. American Museum of Natural History, New York, E 412. Purchased from Emmons, 1893

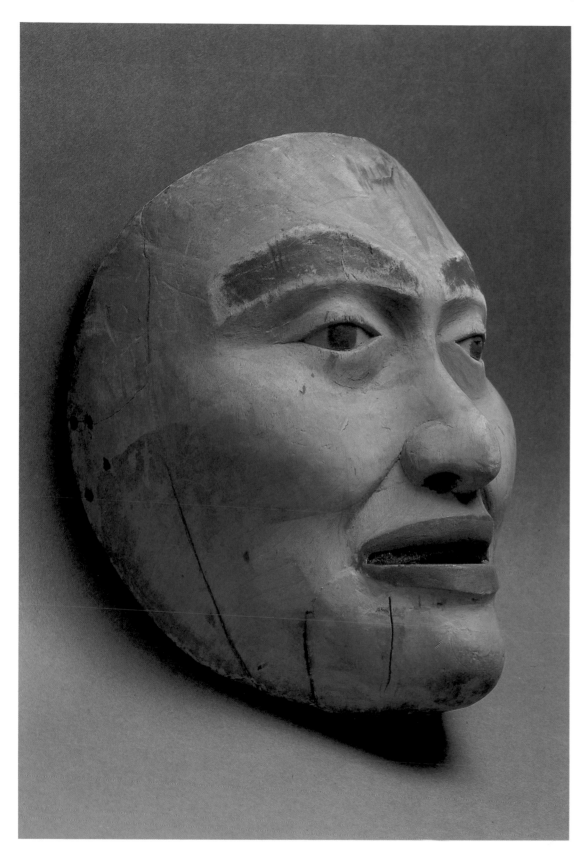

No. 111. Tlingit Mask. Emmons (n.d.) describes this mask as representing the spirit of an old man. Collected by him from the grave house of a Hutsnuwu shaman near Angoon, 1884–93. Wood, animal hide, and red, black, and blue pigment; height 8½ inches; c. 1810–30. American Museum of Natural History, New York, E 2360. Purchased from Emmons, 1893

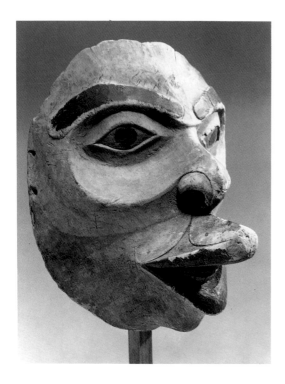

No. 112. *Tlingit Mask.* Emmons (n.d.) states that this mask represents the "spirit of a Doctor," while de Laguna (1972, pt. 3, p. 1099, pl. 181) suggests that it is an Athabaskan. An earlier photograph (ibid.; King, 1979, pl. 92) shows an ivory pin in the nose, which would favor Emmons's interpretation (see p. 50 in this volume and no. 166). Collected by Emmons in 1884–93 from the grave house of Setan, a Tlukwaxdi shaman, on the Akwe River, a few miles west of Dry Bay near an old, deserted village. Wood and red, blue, and black pigment; height 8½ inches; c. 1790–1820. Former collections: American Museum of Natural History, New York, E 413, exchanged to Emmons, 1915; Museum of the American Indian, New York, 9/7984, exchanged 1966. The Metropolitan Museum of Art, New York, 1978.412.148. Given by Gertrud Mellon

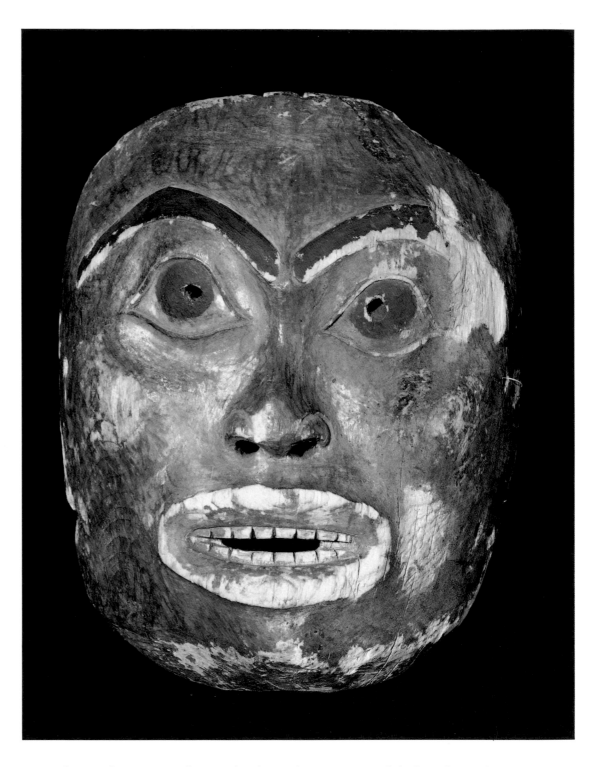

No. 113. *Tlingit Mask.* Emmons (n.d.) states that this mask represents an Athabaskan who is either "very angry or talking very loud, and bird's down is blown out through lips during the dance" (see also de Laguna, 1972, pt. 3, p. 1103, pl. 185). Collected by Emmons from the grave house of an unidentified Yakutat shaman, 1882–87. Wood and black, red, and blue-green pigment; height 9 inches; c. 1820–40. Former collections: American Museum of Natural History, New York, 19/869, exchanged to Emmons, 1921; Museum of the American Indian, New York, 11/1755, exchanged 1969. Glenbow Museum, Calgary, AA 1015

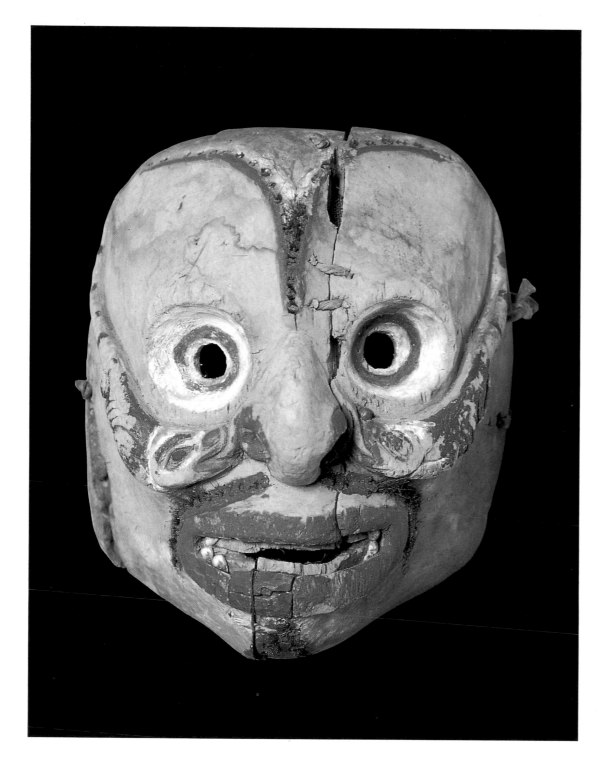

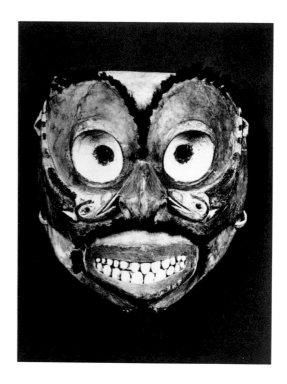

No. 115. Tlingit Mask. This mask has the same iconography as no. 114 but is of a later date. Collected by Emmons at Upper Chilkat Village. Wood, opercula, animal hide, human hair, and red, black, and green pigment; height 7⅞ inches; c. 1840–60. Field Museum of Natural History, Chicago, 78147. Purchased from Emmons, 1902

No. 114. Tlingit Mask. Emmons (n.d.) describes the mask as depicting a dead owl. The figures below the eyes are said to be land otters extracting the secrets from the shaman through his nose. Collected by Emmons in 1882–87 at Sitka from an unidentified shaman. Wood, opercula, spruce root, hair, twine, and red and white pigment; height 8⅛ inches; c. 1800–1820. American Museum of Natural History, New York, 19/864. Purchased from Emmons, 1888

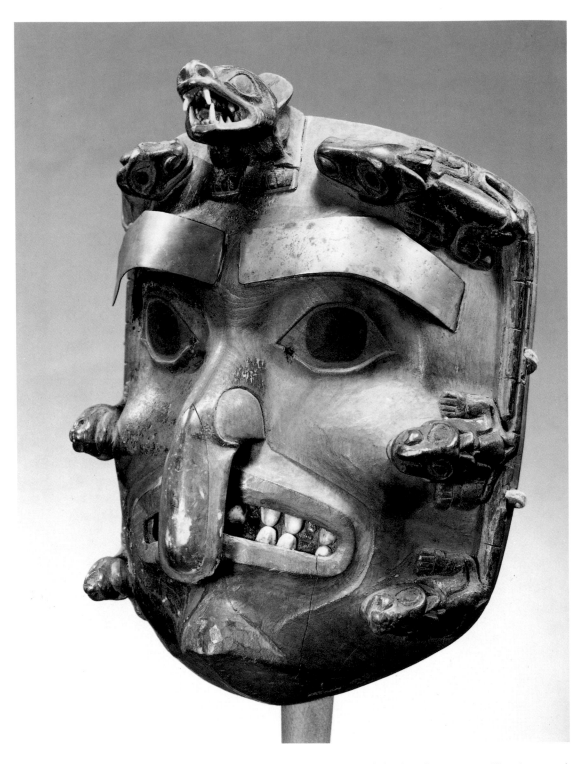

No. 116. Tlingit Mask. Emmons (n.d.) states that this mask represents an Athabaskan shaman. A wolf head is carved at the top, and the six other figures are land otters. Collected by Emmons from a shaman's grave house at Hoonah, 1882–87. Wood, copper, opercula, animal teeth, and red and blue-green pigment; height 7¾ inches; c. 1840–60. American Museum of Natural History, New York, 19/860. Purchased from Emmons, 1888

No. 117. Tlingit Mask (opposite). A bear face with two land otters emerging from the cheeks and another at the top of the head. Collected by Captain Edward G. Fast at Sitka, 1867–68. Wood, opercula, animal hide, and red, black, and blue-green pigment; height 10½ inches; c. 1830–50. Peabody Museum of Archaeology and Ethnology, Harvard University, Cambridge, 69–30–10/1609. Purchased from Fast, 1869

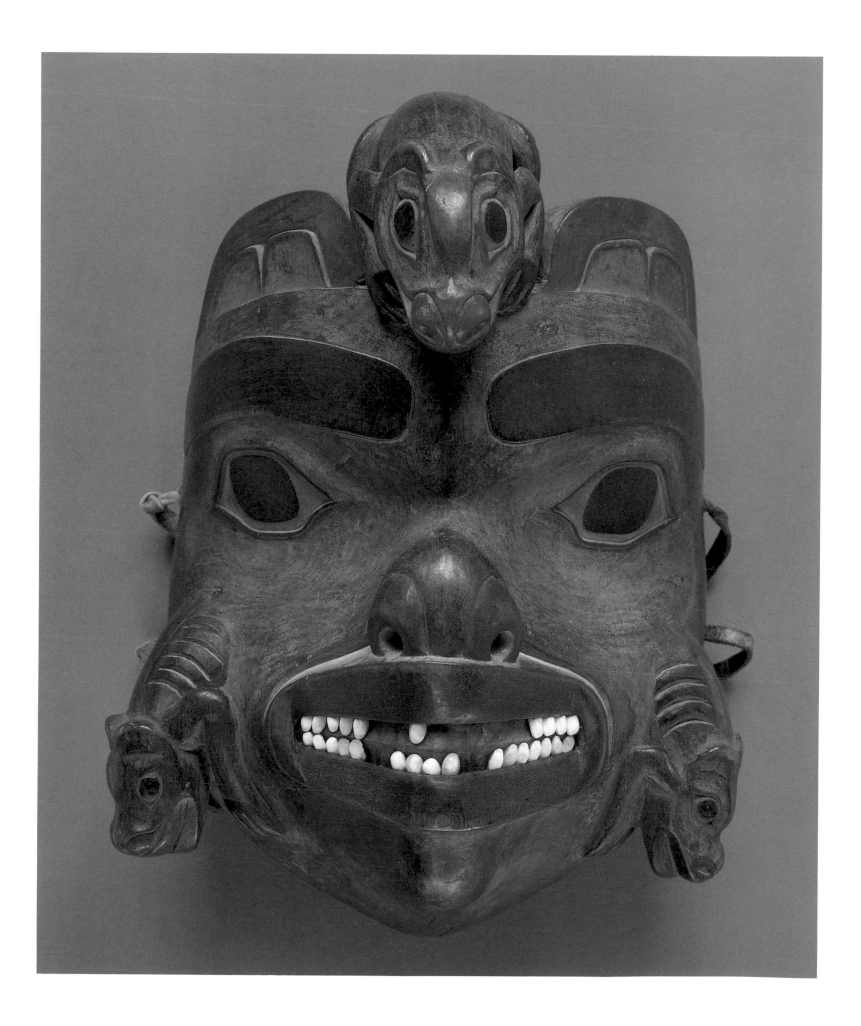

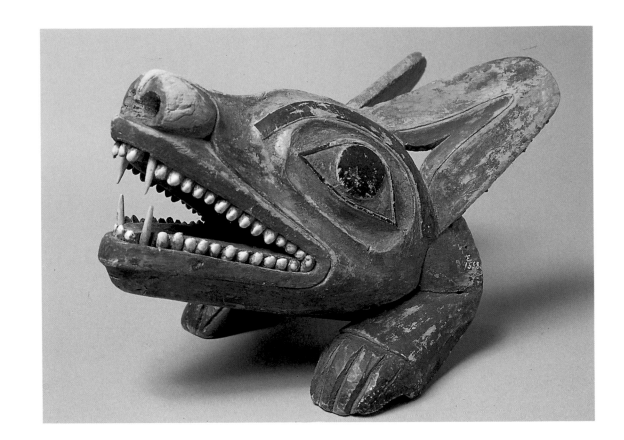

No. 118. *Tlingit Visor Mask*. Wolf. Part of a set of objects that had been in the grave house of Quadjusé, a Xatkaayi shaman, on the Alsek River. The material was obtained from his heirs by Emmons, 1884–93. Most of the teeth have been restored (see de Laguna, 1972, pt. 3, p. 1123, pl. 200). Wood, opercula, animal teeth, and black, red, and traces of blue-green pigment; length 9¼ inches; c. 1820–40. American Museum of Natural History, New York, E 1598. Purchased from Emmons, 1893

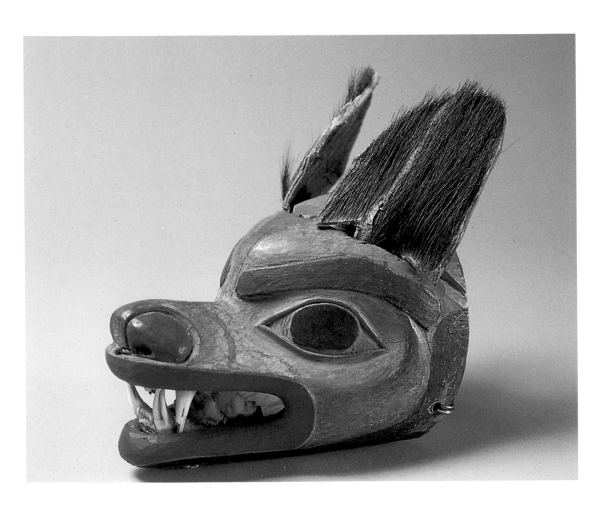

No. 119. *Tlingit Maskette*. Wolf. Collected by Emmons from a shaman's grave house at Yandestaki, 1882–87. Wood, animal jaw, animal hide, and black, red, and blue pigment; length 5½ inches; c. 1840–60. American Museum of Natural History, New York, 19/995. Purchased from Emmons, 1888

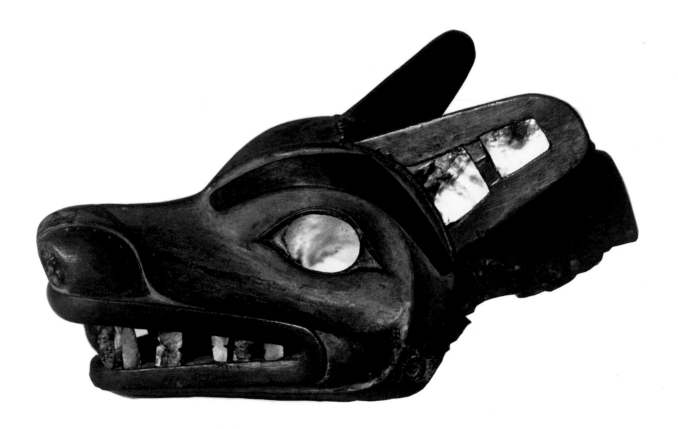

THE GREAT SHAMAN CALLED FOOL
(Kwakiutl)

I am a hunter of all kinds of animals, I always go paddling about, for this is what I desire, seals, for I try out the oil from the blubber, to be bought by my tribe for gravy. I always get many hair seals; and so I am never poor. I was the principal one who does not believe in the shamans, when they speak about taking out sickness from sick people, and when they say that they see the souls of men; and formerly I did not believe in shamans, for I used to tell them aloud that they were lying when they were curing the sick; for I would sit down among them when they were beating time for the shamans when curing those who were very sick, and therefore I was really hated by the shamans of the Nā′k!wax·daᵉxᵘ. I just wish to talk about this first.

One fine day I paddled on the sea shooting seals with the one who was always my steersman, whose name was Lē′lamēdᴇnōl, for he was courageous. Nothing frightened him, neither gales nor all the bad animals, or the bad fishes, or the sea monsters which are often seen by hunters when they hunt game at night. Therefore hunters ask courageous men to be their steersmen.

Now I was paddling along at A′xolis. Then I saw a wolf sitting on a rock, rolling about on the rock, scratching with his fore paws both sides of his mouth. When I came near he saw us. He whined. He was never afraid of us and I stepped out of my small canoe and went to where he was sitting on the rock. When I came up to him, the wolf was whining and I saw that his mouth was bleeding. I looked into his mouth and saw a deer bone crossways in his mouth, stuck between the teeth on both sides of his mouth, and it was really firmly imbedded. The wolf was sitting on a rock watching me and evidently expected me to do something; to kill him or help him

No. 120. *Tlingit Visor Mask.* Sea lion. Collected from the grave house of a Tlukwaxdi shaman on a salmon stream flowing into Dry Bay north of the Alsek River. The shaman had lived on the west coast of Prince of Wales Island. Although this mask has understandably been identified as depicting a wolf (Jonaitis, 1986, pl. 41), Holm (1995) believes it represents a sea lion. See note for no. 81. Wood, abalone, and red and black pigment; length 11⅜ inches; c. 1840–60. Field Museum of Natural History, Chicago, 79254. The Carl Spuhn Collection. Purchased from Emmons, 1902

out of his trouble. I sat down on the rock close to him and I spoke to him, as he was sitting still, looking at me. I said to him, "You are in trouble, friend. Now I shall be like a great shaman and cure you, friend. I will take out your great trouble and set you right, friend. Now reward me, friend, that I may be able, like you, to get everything easily, all that is taken by you, on account of your fame as a harpooneer and of your supernatural power. Now reward my kindness to you, friend. Go on! Sit still on the rock and let me get my means of taking out that bone," said I to him, as I went and took cedar twigs from a cedar tree inland from me. I twisted the cedar twigs and now they were a good rope. After I had done so, I went to where the wolf was sitting on the rock, just always keeping his mouth open. I took hold of the back of his head and put the thin end of the cedar rope into his mouth and I tied it to the middle part of the bone in his mouth and I pulled at it. Then the bone came out after that. [The wolf] only stared at me and I spoke to him and said, "O, friend your trouble has gone. Now take care of your mind and reward me for what I have done to you," said I to him. After I had said so to him the wolf turned around to the right and trotted away, not fast. He did not go far before he stopped and turned his face. Then he howled. Once he spoke and howled and went into the woods. I stepped into my small traveling canoe and paddled with my steersman Lē′lamēdᴇnōl. Now we never talked about the wolf as we paddled along.

Now night came and I wished to anchor inside of Foam-Receptacle, for no wind ever blows there. Now we lay down in our small travelling canoe, floating on the water; but really my eyes went to sleep. Lē′lamēdᴇnōl also did the same. His eyes also really went to sleep, for we had risen early when we started before nearly daylight came in the morning; and so we were very sleepy.

Now I dreamed of a man who came to me in a dream speaking to me in a dream. In my dream he said to me, "Why do you stay here? There are many seals lying on this island, friend. Take care, friend, I am Harpooneer-Body on whom you took pity today, and now I reward you for kindness to me, friend. There is nothing hereafter that you will not obtain, whatever you wish to get. This also, do not lie down with your wife for four years, to pass through all that you will have to do," thus he said in my dream, Harpooneer-Body to Fool. Then in my dream he disappeared.

I woke up and called Lē′lamēdᴇnōl. When he awoke he hauled up the anchor. We went ashore and I washed in the sea. After I had done so I went aboard our small traveling canoe. I wished to see whether my dream would come true regarding the words that Harpooneer-Body had said in my dream, that there were many seals lying on the rocks on the island, for I did not believe in dreams and shamans and all the sayings of the people, for I only believed in my own mind. Then we paddled away before daylight came and we arrived at the island without trees. Now I saw that it was really covered with seals that were tight asleep. I took my yew wood seal club, stepped out of my small canoe and clubbed four large seals. Then a great number of seals tumbled into the water. Then I put the four large seals aboard my small canoe and we went home.

Now there was one thing I believed, namely the words of Harpooneer-Body, that he had said in my dream. Now it was really easy for me to get seals when I went out hunting and also all kinds of animals. Two years later, beginning at the time when I took out the bone from the wolf, I went to Victoria with my late nephews, Hā′mēlᴇlasᴇmēᵋ and his late younger brothers Kwā′nas and Owner-of-Throwing-away-Property, Ts!ᴇxᵋē′d, and also their late wives and their late children. I was with my wife. It was in the summer of 1871. We came home now trav-

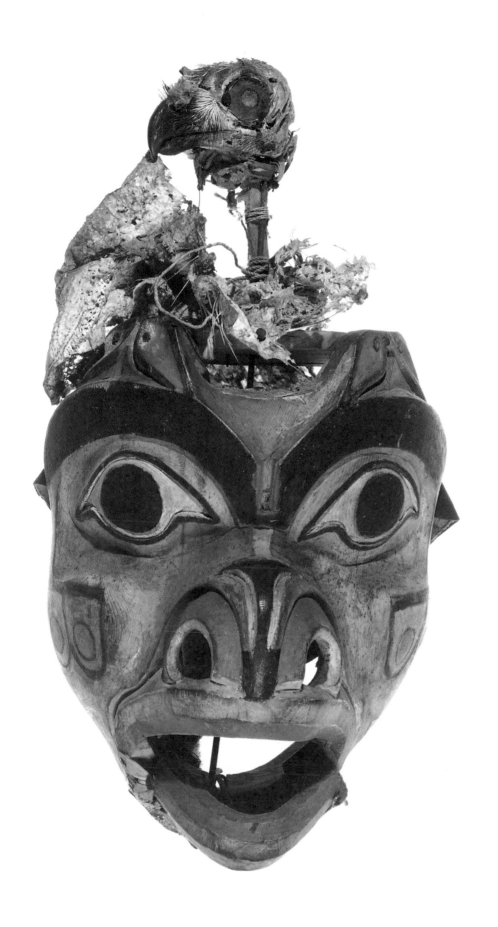

No. 121. Tlingit Mask: "Owl-of-the-Heavens." A specific spirit helper of the shaman Seyaku, who owned this mask. Kaplan and Barsness (1986, p. 197, pl. 228) quote from Louis Shotridge's field notes regarding the use of this mask, which was made at Hoonah and "represented an owl sitting on a stump, the carved part being a stump and on this was fixed a stuffed owl. Operated by the performer, the stuffed owl moved as if restless and looked about for its prey, while the jaw of the mask rattled, producing a sound like that of an impatient owl." The bird skull seems to be that of an eagle. Collected by Shotridge from the Snail House at Hoonah, 1924. Wood, bird skin, bird skull, spruce root, and black, red, and blue-green pigment; height 9½ inches (mask only); c. 1840–60. The University Museum, University of Pennsylvania, Philadelphia, NA 6831

eling in a large canoe. We came to Rock Bay, at the north side of Seymour Narrows. We went ashore there. After we had stepped out of our canoe the late Hā'mēlɛlasɛmēᵉ saw much clothing and four nice boxes full of very good clothing on the beach; and also two flour bags and all kinds of food. We did not see any man who owned them. Then we took them aboard and went away. When we came to Beaver Cove a northeast wind sprang up. We stayed there for six days. It was ten days after we had left from where we had found the boxes. Now my whole crew became sick and we started in the morning and it was calm. We arrived at A'xolis. We unloaded our cargo there. Now we all were sick with the great smallpox. We got it where the boxes were found by us. We all lay in bed in our tent. I was lying among them. Now I saw that all our bodies swelled and were dark red. Our skins burst open and I did not know that they were all dead and I was lying among them. Then I thought that I also was dead. I was as in a sleep and I awoke on account of many wolves who came whining and others howling. Two of them were licking my body and I saw two wolves vomit up foam and putting it on my body. The two wolves tried hard to put the foam all over my body. They did not treat me well when they turned over my body. Now my body was quickly getting stronger and also my mind. The two wolves kept on licking my body. After they had licked off all they had vomited, they vomited foam again and put it on my body. Again they licked it off and then I saw that they had taken the scabs from the sores on my body. Now I saw that I was lying among my dead past nephews.

Now it was evening and the two wolves took a rest. I must have been afraid, being the only one who was still alive, therefore I crawled away and went to the shelter of a thick spruce tree. And so I lay down that night. Now I had no bedding; only a shirt which I had on. Then it was as though the two wolves came and one lay down on each side of me. When daylight came in the morning the two wolves got up aⁿd again licked my body. They licked it for a long time and vomited white foam and put it on my body, my face and my head. Then they licked the foam off again. Now I was getting strong, I was strong enough to stand up and now I recognized that the one wolf was the one who had been in trouble with the bone which I had taken out of the mouth of the wolf. Then the many wolves did not leave me. Indeed, I walked among them. Indeed I became well and I lay down when the other wolf came, the one of whom I had dreamed at Foam-Receptacle and who told me his name was Harpooneer-Body. He sat down seaward from me and nudged me with his nose that I should lie on my back, and he vomited and pushed his nose against the lower end of my sternum. He vomited the magic power into me. After he had done so he sat down. I was getting sleepy and I went to sleep. Then I dreamed of the wolf who was still sitting there. In my dream he became a man. In my dream he laughed and spoke and said, "Now take care, friend, now this shaman-maker has gone into you. Now you will cure the sick and you will catch the souls of the sick and you will throw sickness into anyone whom you wish to die among your tribe. Now they will be afraid of you," said he to me in my dream. Then I woke up and my body was trembling and my mind was different after this, for all the wolves had left me. Now I was a shaman. Now I walked and went to Fern-Point. Then I met Qwē'salalis there. I told him that my whole crew was dead, killed by the smallpox. Then Qwē'salalis was afraid of me, and he left me and went home to Tē'guxstēᵉ. I stayed for a long time in a house at Fern-Point. I did not mind it, for I stayed in one of the houses and there was much food in the seven houses which are at Fern-Point. There were also two canoes there. I was never depressed and I kept on singing my sacred songs every evening, the four sacred songs of the wolf, for I was just like drunk all the time and I was always happy. More than one moon I stayed at Fern-Point, then Spearing-Dance paddled along in the evening going toward Tē'guxstēᵉ. He heard me

singing my sacred song and he reported to the Nā′k!wax·daᵉxᵘ at Tē′guxstēᵉ. Immediately the Nā′k!wax·daᵉxᵘ wished to come for the new shaman that was heard singing his sacred songs at Fern-Point, to cure the chief, Causing-to-be-well.

Now the wolf came in my dream and warned me to be ready for the chief, Causing-to-be-well who was very sick. "Now you will suck out his sickness and throw upward his sickness. Do not apply your mouth more than four times when you treat him," said in my dream the wolf to me. Then I woke up after that. At once began to tremble my body and my stomach. I sang my sacred song and, when it had been day for a long time, I stopped singing. Then I heard many men talking outside of my house and Endeavoring-to-Invite spoke and said, "We come to ask you, great treasured one, to take pity, to bring back to life our friend, chief Causing-to-be-well, with your water of life, friend," said he. Then all the men went aboard their traveling canoe, a large canoe. Endeavoring-to-Invite came into my house and begged me to go aboard with them. I followed him and we went aboard the traveling canoe. We arrived at Tē′guxstēᵉ. When we arrived at the beach of the house of Causing-to-be-well all the men stepped out of our traveling-canoe and they all went into the house of Causing-to-be-well. They made a fire in the middle of the house. As soon as the fire blazed up four shamans went to call all the men and all the women and all the children that all should come and watch the new shaman. When they had all come in the four shamans called me, for I was still sitting in the canoe. I walked among the four shamans and we entered the house where they were beating time for me. When I went in I saw Causing-to-be-well sitting on a new mat in the rear of the house. As soon as all the men had seen me I went in with the four shamans and they all beat fast time with batons on the boards. Then my body and my belly began to tremble and I sang my sacred song while I was still standing in the doorway of the house with the four shamans. Then I went to the place where Causing-to-be-well was sitting and the four shamans followed me. Then I treated him, and I followed the instructions given by the wolf what I should do, and now I have the name Fool as a shaman's name. It is ended after this. (Boas, 1930, pp. 41–45)

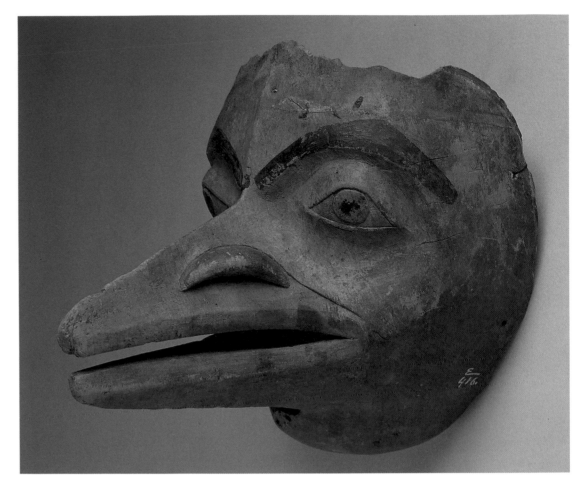

No. 122. Tlingit Mask. Raven. Collected by Emmons in 1884–93 from the grave house of Setan, a Tlukwaxdi shaman, on the Akwe River, a few miles west of Dry Bay near an old, deserted village. Wood, and black and traces of blue-green pigment; height 7½ inches; c. 1790–1820. American Museum of Natural History, New York, E 416. Purchased from Emmons, 1893

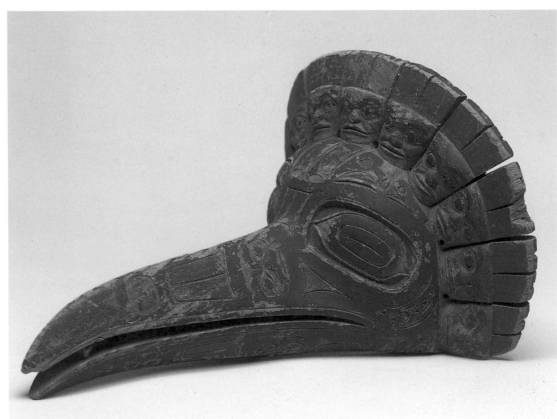

No. 123. Tlingit Mask. Raven. Emmons (n.d.) describes the faces on the bill as Tlingit spirits and those over the head as helping spirits. Collected by him from the grave house of a Sanya shaman on Cat Island, 1884–93. Wood and black, red, and blue-green pigment; length 8⅝ inches; c. 1830–50. American Museum of Natural History, New York, E 2512. Purchased from Emmons, 1893

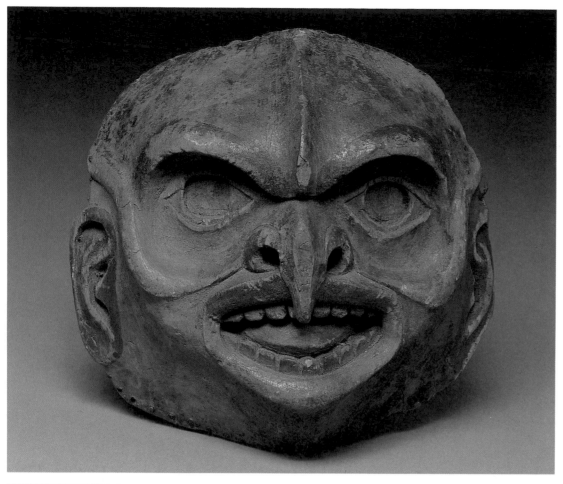

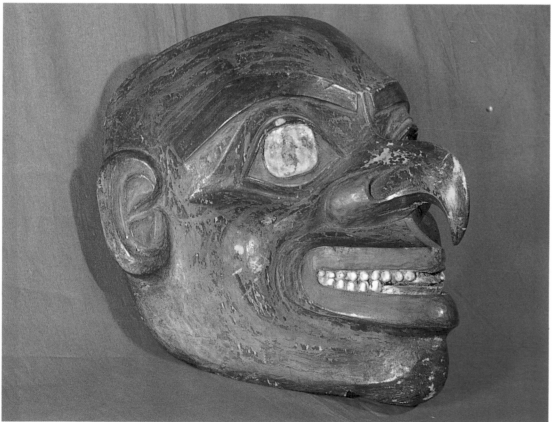

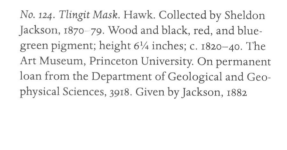

No. 124. Tlingit Mask. Hawk. Collected by Sheldon Jackson, 1870–79. Wood and black, red, and blue-green pigment; height 6¼ inches; c. 1820–40. The Art Museum, Princeton University. On permanent loan from the Department of Geological and Geophysical Sciences, 3918. Given by Jackson, 1882

No. 125. Tlingit Mask. Eagle. Collected by Emmons with nos. 25 and 108 from a shaman's grave house below Yandestaki in 1882–87, and said to have been made at Port Simpson. Wood, abalone, and black and blue pigment; height 8⅞ inches; c. 1830–50. American Museum of Natural History, New York, 19/852. Purchased from Emmons, 1888

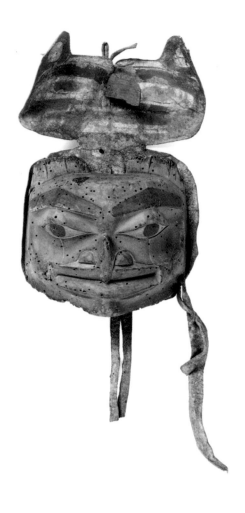

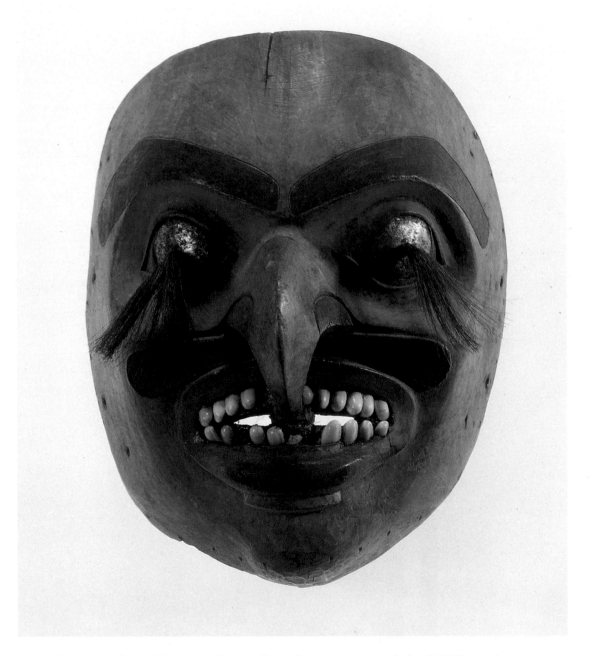

No. 126. *Tlingit Mask* (left). Hawk. Another bird is shown on the hide addition at the top. Said to have been owned by a Mexican lawyer associated with the Spanish Captain Alejandro Malaspina, who visited Port Mulgrave (Yakutat) in 1791. The mask was brought to England with a collection of Aztec objects. Wood, animal hide, and black, red, and blue-green pigment; height 10¾ inches; c. 1790–1820. Museum of Mankind, London, 49.6–29–59

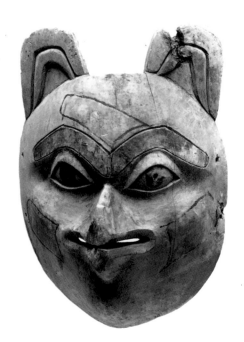

No. 127. *Tlingit Mask* (above). The recurved beak indicates the representation of a hawk (Collins et al., 1973, p. 242, pl. 303). This is the only known mask with hair coming from the eyes, the significance of which is not clear (de Laguna, 1988a, p. 272, pl. 372). Museum records state that it is from an early collection. Wood, iron, human hair, opercula, and black, red, and blue-green pigment; height 8¾ inches; c. 1820–40. Museum of Anthropology and Ethnography, St. Petersburg, Russia, 5795–26. Accessioned 1938

No. 128. *Tlingit Mask*. Although part of the beak is missing, the round face and large ears indicate the representation of an owl. Collected by Captain Edward G. Fast at Sitka, 1867–68. Wood, and black, red, and blue-green pigment; height 9¾ inches; c. 1820–40. Peabody Museum of Archaeology and Ethnology, Harvard University, Cambridge, 69–30–10/1602. Purchased from Fast, 1869

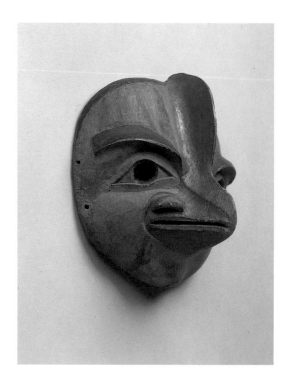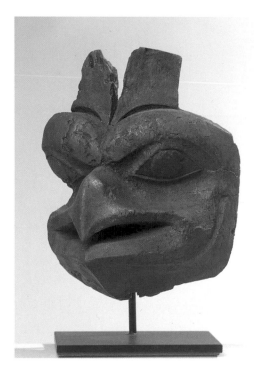

No. 129. Tlingit Maskette (left). Owl. Part of an entire set of shaman's paraphernalia of unknown provenance collected by Emmons. Wood, glass, and black and blue-green pigment; height 4⅜ inches; c. 1840–60. National Museum of the American Indian, Smithsonian Institution, Washington, D.C., 16/17190. Purchased from Emmons, 1928

No. 130. Tlingit Maskette (right). Eagle. Wood and black, red, and traces of blue-green pigment; height 3⅞ inches; c. 1820–40. Private collection

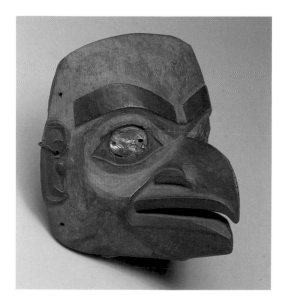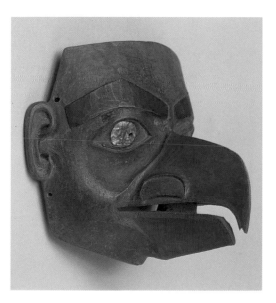

No. 131. Tlingit Maskette (left). Eagle. By the same artist as no. 132. Collected by Emmons in 1882–87 from the grave house of an unidentified shaman at the mouth of the Chilkat River near Yandestaki. Wood, abalone, and black, red, and blue-green pigment; height 5⅜ inches; c. 1840–60. American Museum of Natural History, New York, 19/918. Purchased from Emmons, 1888

No. 132. Tlingit Maskette (right). Eagle. By the same artist as no. 131, and probably from the same grave house. Collected by Emmons at Chilkat, 1882–87. Wood, abalone, and black, red, and blue-green pigment; height 4¼ inches; c. 1840–60. American Museum of Natural History, New York, 19/925. Purchased from Emmons, 1888

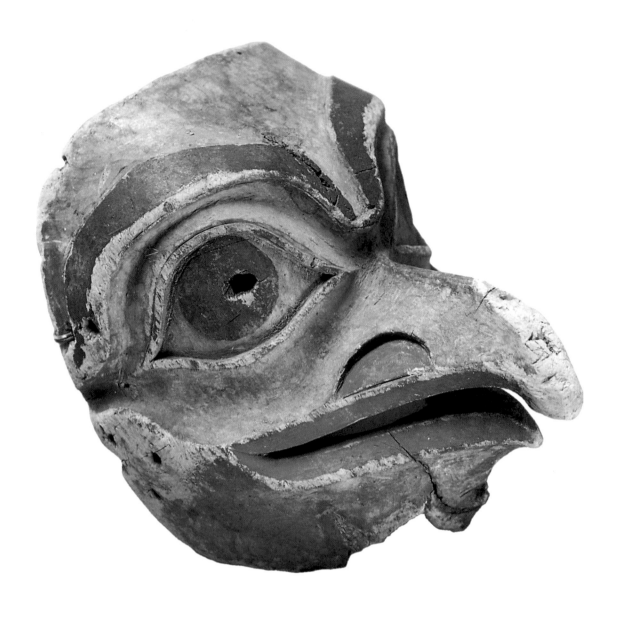

No. 133. Tlingit Mask. Eagle. Collected by Emmons from the grave house of an unidentified shaman in the area of the Ankau and the Lost rivers, twenty miles south of Port Mulgrave (Yakutat), 1884–93. Wood and black, red, blue, and traces of white pigment; height 8¾ inches; c. 1810–30. American Museum of Natural History, New York, E 2486. Purchased from Emmons, 1893

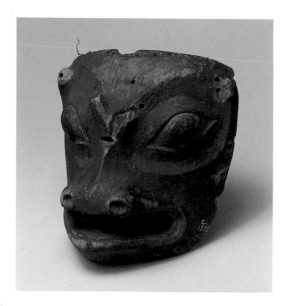 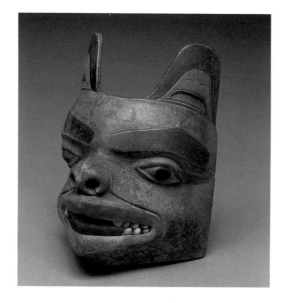

No. 134. Tlingit Maskette (left). Bear. The maskette was originally ornamented with human hair. Collected by Emmons, 1884–93. Wood and black pigment; height 5⅜ inches; c. 1800–30. American Museum of Natural History, New York, E 1378. Purchased from Emmons, 1893

No. 135. Tlingit Maskette (right). Bear. Collected by William Libbey from the grave house of an unidentified shaman at Port Mulgrave (Yakutat), 1886. Wood, opercula, and black and blue-green pigment; height 5½ inches; c. 1825–50. The Art Museum, Princeton University. On permanent loan from the Department of Geological and Geophysical Sciences, 3919. Given by Libbey, 1886

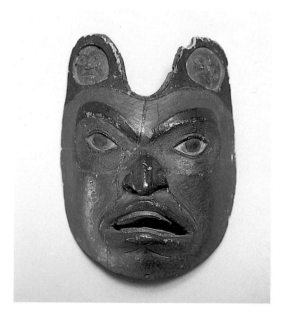 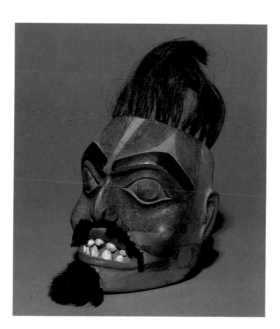

No. 136. Tlingit Maskette (left). Bear. Although Emmons (n.d.) identifies this maskette as representing a wolf, the broad face and mouth and large rounded ears indicate that it is a bear. Collected by Emmons from the Hutsnuwu clan, 1882–87. Wood and black, red, and traces of white pigment; height 5¾ inches; c. 1840–60. American Museum of Natural History, New York, 19/917. Purchased from Emmons, 1888

No. 137. Tlingit Maskette (right). Although this maskette appears to have the face of a human, Emmons (n.d.) describes it as representing the spirit of a groundhog or a marmot, and writes that it was used to treat "swellings and inflammation." Collected by him from the Chilkat, 1882–87. Wood, human hair, abalone, dentalium, and black, red, and blue-green pigment; height 4⅜ inches (maskette only); c. 1840–60. American Museum of Natural History, New York, 19/921. Purchased from Emmons, 1888

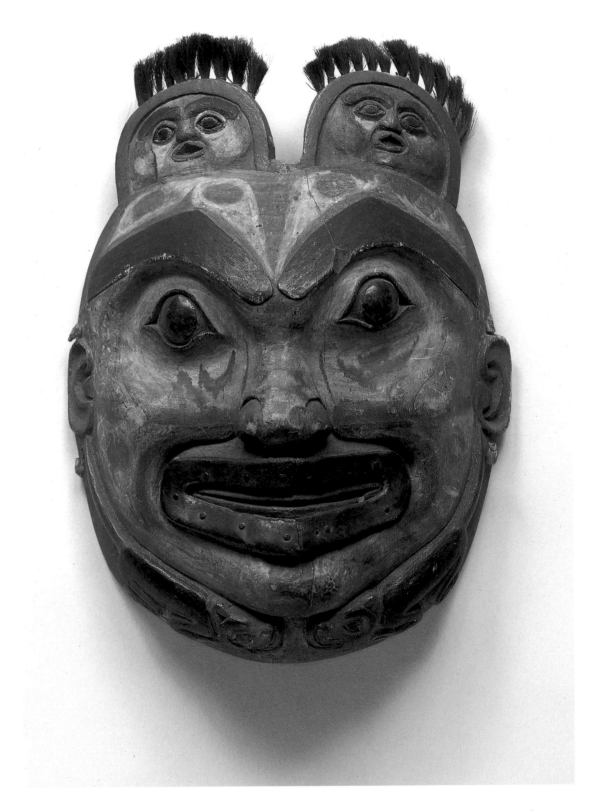

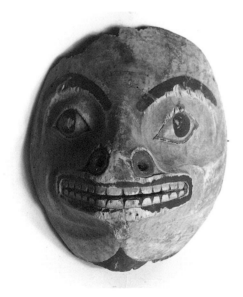

No. 138. Tlingit Mask. Bear. From a grave house at a deserted village on Cleveland Passage, Admiralty Island. Wood and black and blue pigment; height 7½ inches; c. 1820–40. Sheldon Jackson Museum, Juneau, I.A.140ab. Given by F. E. Frobese, 1888

No. 139. Tlingit Mask. Bear. The figures on the chin of this mask, which is by the same artist as nos. 50 and 141, are land otters. Collected from a Hoonah shaman at Glacier Bay. Wood, copper, human hair, animal hide, and black, red, and blue-green pigment; height 10¼ inches; c. 1840–60. National Museum of the American Indian, Smithsonian Institution, Washington, D.C., 2/2061. Purchased, 1909

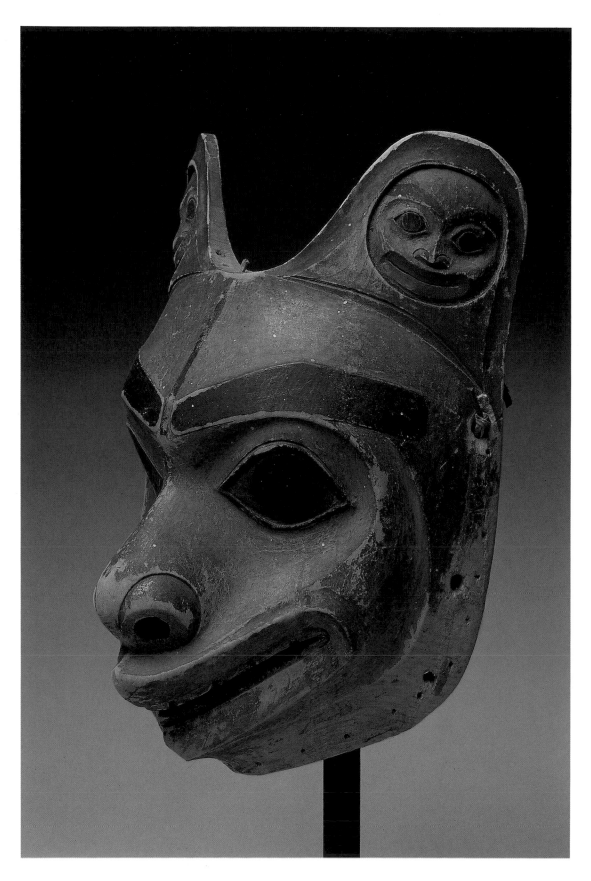

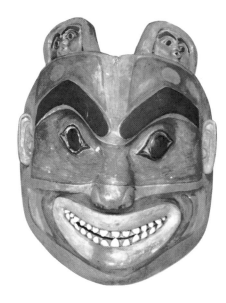

No. 141. Tlingit Mask. Bear. By the same artist as nos. 50 and 139. It was collected at Haines or Klukwan from Schwatka, the brother of the Chilkat shaman Skundoo, and was among Skundoo's articles of practice. Wood, copper, opercula, and black, red, and brown pigment; height 9½ inches; c. 1840–60. St. Joseph Museum, Missouri, 143/5608

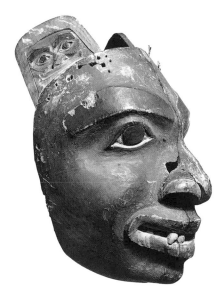

No. 142. Tlingit Mask. Bear. Haberland (1962, p. 62) interprets this mask as representing a sea bear because of the protruding fangs and the shape of the nose. Collected by Emmons from a grave house near Sitka. Wood, animal teeth, and black, red, blue-green, and traces of white pigment; height 11 inches; c. 1840–60. Former collections: Museum of the American Indian, New York, 9/7983; Charles Ratton; Eduard von der Heydt. Rietberg Museum, Zurich, RNA 206. Given by von der Heydt

No. 140. Tlingit Mask. Bear. Found with nos. 157 and 266 in an old box containing a shaman's paraphernalia (Paalen, 1943, p. 19, top, second from right). Wood, rawhide, and black, red, and blue-green pigment; height 10⅛ inches; c. 1820–40. Former collection: Wolfgang Paalen. Private collection

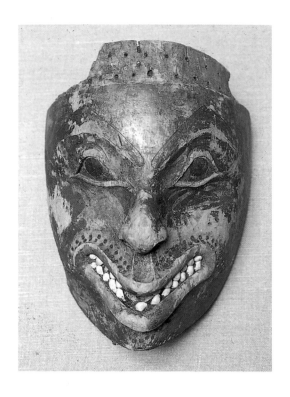

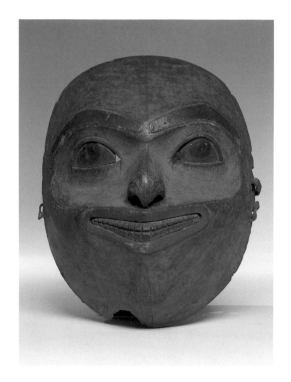

No. 143. Tlingit Mask (far left). Land otter man. Collected by Emmons in 1884–93 from the grave house of Setan, a Tlukwaxdi shaman, on the Akwe River, a few miles west of Dry Bay near an old, deserted village. Wood, human hair, opercula, and traces of red, black, and blue-green pigment; height 8¾ inches; c. 1790–1820. American Museum of Natural History, New York, E 410. Purchased from Emmons, 1893

No. 144. Tlingit Mask (left). The sharply pointed, grimacing mouth indicates a depiction of the land otter man (see no. 143). Traditionally attributed to the Haida. Wood, rawhide, and black, red, and blue-green pigment; height 9 inches; c. 1840–60. National Museum of the American Indian, Smithsonian Institution, Washington, D.C., 2/9389. Purchased from C. Fulda, 1910–12

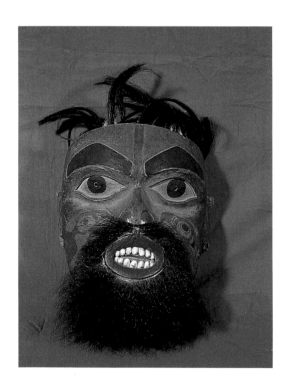

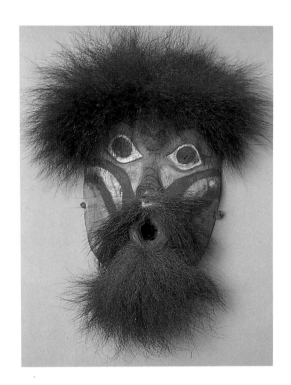

No. 147. Tlingit Mask (opposite). Devilfish. Although the painting on the cheeks represents devilfish tentacles, this mask has often been referred to as representing a land otter man and has features similar to those of no. 146. Collected by Alton L. Dickerman at Sitka, c. 1883. Wood, copper, bear hide, opercula, rawhide, nails, and black, red, and blue pigment; height 9¾ inches (mask only); c. 1830–50. Former collection: Colorado Springs Fine Arts Center, 5006. The Eugene V. and Clare E. Thaw Collection, Fenimore House Museum, Cooperstown, New York

No. 145. Tlingit Mask. Land otter man. The heads of eagles are painted on the cheeks. Collected by Emmons from the grave house of Gutcda, a Tlukwaxdi shaman, at Dry Bay near the mouth of the Alsek River, 1884–93. Wood, bear fur, human hair, opercula, rawhide, and black, red, and blue-green pigment; height 8⅝ inches (mask only); c. 1840–60. American Museum of Natural History, New York, E 400. Purchased from Emmons, 1893

No. 146. Tlingit Mask. Land otter man. Collected by Emmons from the grave house of an unidentified shaman at Dry Bay, 1884–93. Wood, bear fur, rawhide, and black, red, white, and blue pigment; height 8⅛ inches (mask only); c. 1840–60. American Museum of Natural History, New York, E 342. Purchased from Emmons, 1893

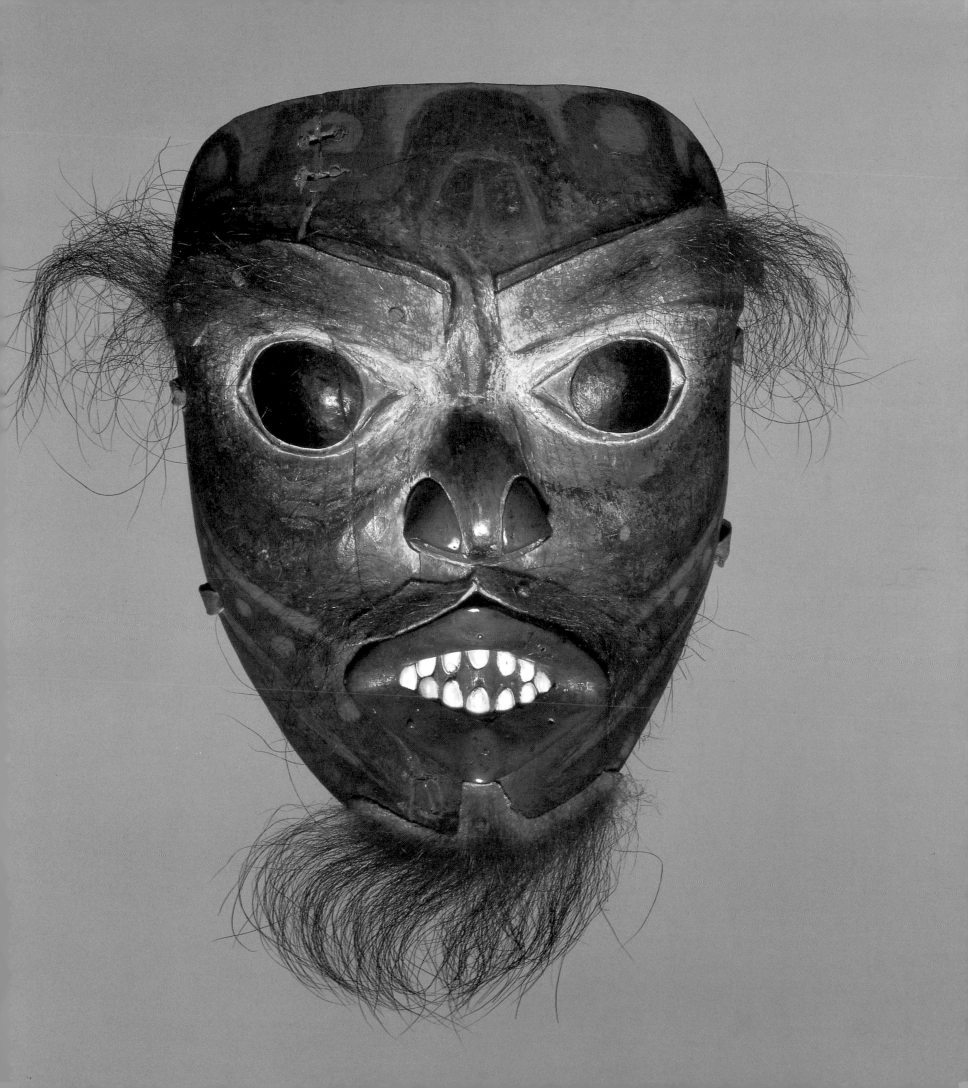

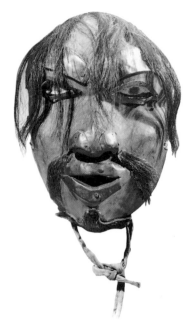

No. 148. *Tlingit Mask.* Land otter man. See no. 150. Collected by G. Chudnovsky at Angoon, 1890. Wood, copper, bearskin, human hair, rawhide, nails, and black, red, and white pigment; height 11 inches; c. 1840–60. Museum of Anthropology and Ethnography, St. Petersburg, Russia, 211–7

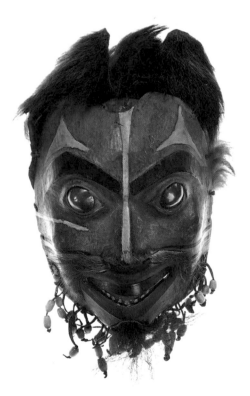

No. 149. *Tlingit Mask.* A man being transformed into a land otter. Collected by Louis Shotridge at Klukwan, 1917. Wood, animal skin, beads, copper, opercula, and black, red, and white pigment; height 9⅝ inches (mask only); c. 1840–60. The University Museum, University of Pennsylvania, Philadelphia, NA 5777

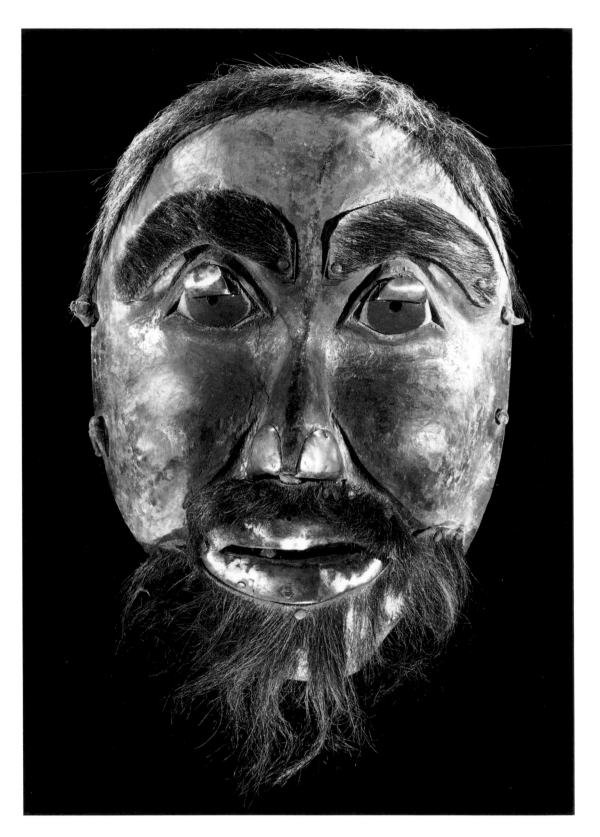

No. 150. *Tlingit Mask.* Land otter man. This mask is by the same artist as nos. 66 and 148. Collected by James G. Swan at Sitka. Wood, copper, bearskin, rawhide, nails, and black and blue-green pigment; height 12⅝ inches; c. 1840–60. National Museum of Natural History, Smithsonian Institution, Washington, D.C., 18929. Acquired from Swan, 1875

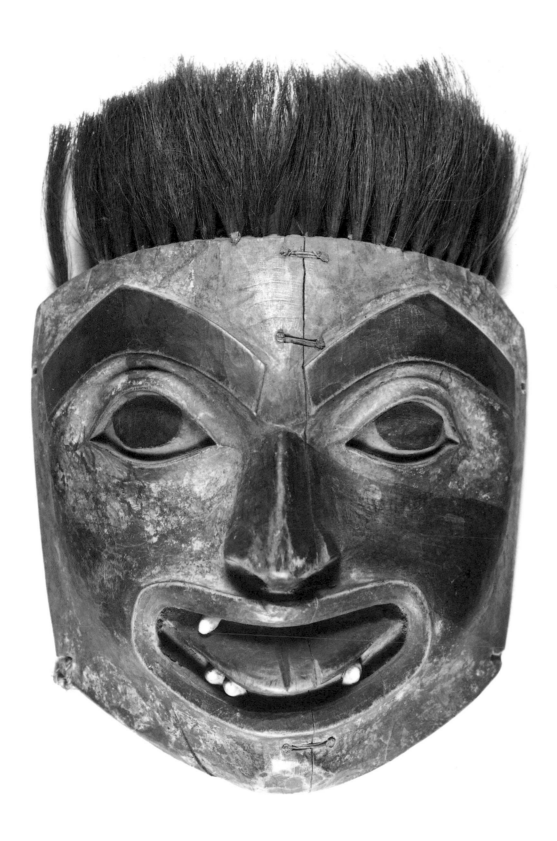

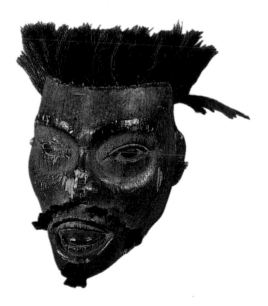

No. 151. *Tlingit Mask*. Dying man. This maskette belonged to the Chilkat shaman Skundoo. Wood, human hair, opercula, and black, red, and blue-green pigment; height 7⅞ inches; c. 1840–60. Cincinnati Art Museum, 1889.294. Given by Mr. and Mrs. W. W. Seely, 1889

No. 152. *Tlingit Maskette*. Dying man. Collected by Emmons, with nos. 165 and 473, at Sitka before 1920. Wood, human hair, and black, red, and blue-green pigment; height 4 inches (maskette only); c. 1840–60. Former collection: Museum of the American Indian, New York, 9/7889; exchanged 1944. Cranbrook Institute of Art, Bloomfield Hills, Michigan, 3226

No. 153. Tlingit Maskette (left). Dying man. Collected by Captain Edward G. Fast at Sitka, 1867–68. Wood and black, red, and traces of blue-green pigment; height 5¼ inches; c. 1830–50. Peabody Museum of Archaeology and Ethnology, Harvard University, Cambridge, 69–30–10/1667. Purchased from Fast, 1869

No. 154. Tlingit Maskette (right). Dying man. Such maskettes represent the onset of death or a trance. Because of the "sharp ridge of bone above stretched cheeks and lips," Holm (1987b, p. 234, no. 99) believes that death is shown here. Collected by Emmons at Klukwan before 1905. Wood, human hair, and red and blue-green pigment; height 3⅞ inches (maskette only); c. 1840–60. Thomas Burke Memorial, Washington State Museum, Seattle, 2264. Acquired, 1909

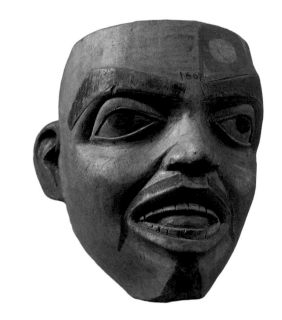

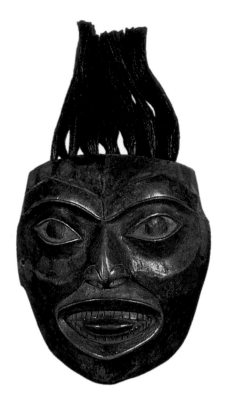

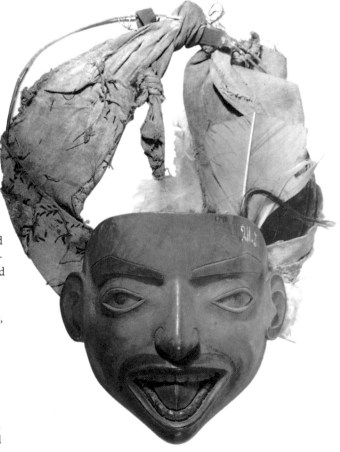

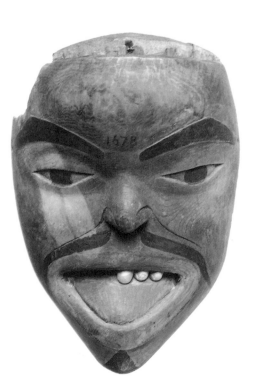

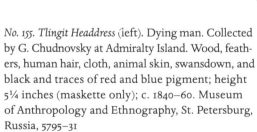

No. 155. Tlingit Headdress (left). Dying man. Collected by G. Chudnovsky at Admiralty Island. Wood, feathers, human hair, cloth, animal skin, swansdown, and black and traces of red and blue pigment; height 5¼ inches (maskette only); c. 1840–60. Museum of Anthropology and Ethnography, St. Petersburg, Russia, 5795–31

No. 156. Tlingit Maskette (right). Dying man. Collected by Captain Edward G. Fast at Sitka, 1867–68. Wood, opercula, and black, red, and blue-green pigment; height 4⅞ inches; c. 1820–40. Peabody Museum of Archaeology and Ethnology, Harvard University, Cambridge, 69–30–10/1678. Purchased from Fast, 1869

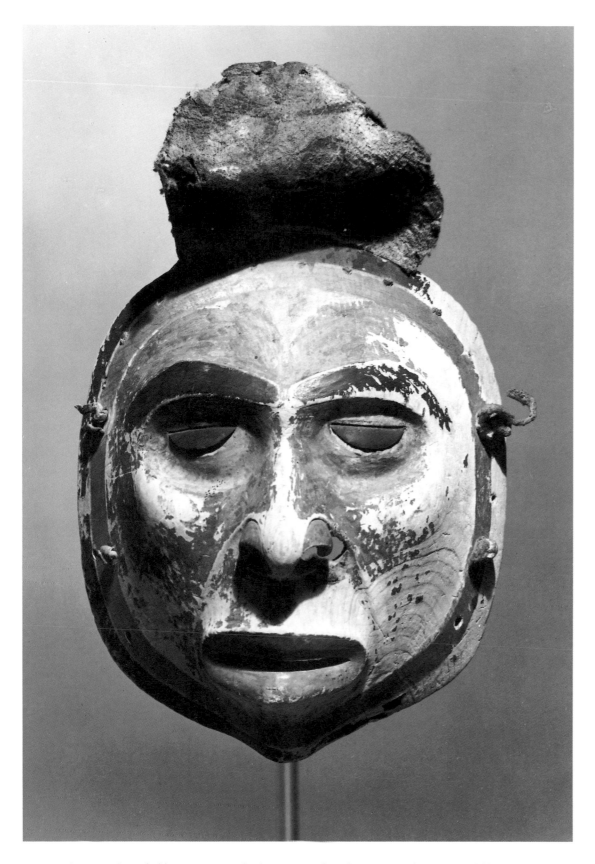

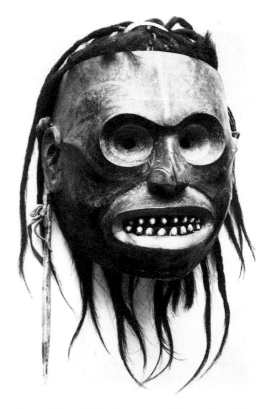

No. 158. *Tlingit Mask.* Emmons (n.d.) describes this as a death head. Collected by him at Chilkat, 1882–87. Wood, opercula, walrus ivory, human hair, ermine skin, rawhide, and red, white, and blue-green pigment; height 7⅞ inches (mask only); c. 1820–40. American Museum of Natural History, New York, 19/854. Purchased from Emmons, 1888

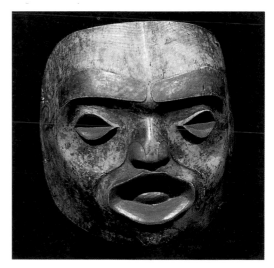

No. 159. *Tlingit Mask.* Dying man. An old label on the back in Emmons's handwriting reads, "Doctor dancing mask representing a Nass River [Tsimshian] Indian." Wood, rawhide, and black, red, and blue pigment; height 8⅛ inches; c. 1840–60. Former collection: John C. Brady, Governor of Alaska. American Museum of Natural History, New York, 16.1/966. Given by Mrs. Edward H. Harriman, 1912

No. 157. *Tlingit Mask.* Probably represents a dead man. Found, with nos. 140 and 266, in an old box containing a shaman's paraphernalia (Paalen, 1943, p. 19, lower right). Wood, animal hide, and black, red, and white pigment; height 13⅝ inches; c. 1820–40. Former collection: Wolfgang Paalen. The Metropolitan Museum of Art, New York, 1979.206.440. The Michael C. Rockefeller Collection, bequest of Nelson A. Rockefeller, 1979

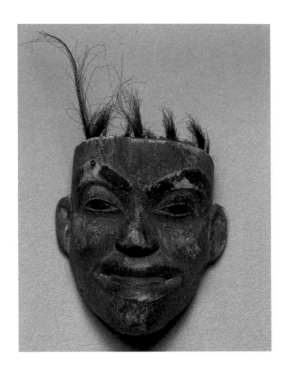

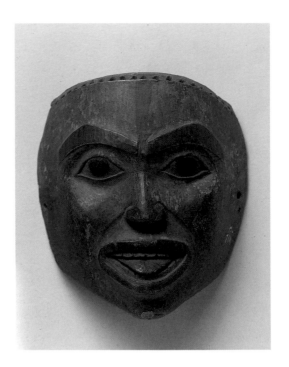

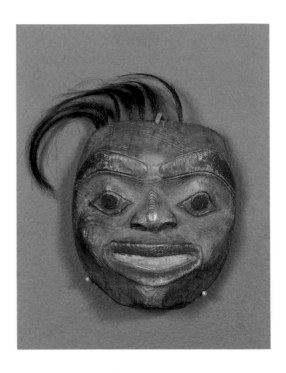

No. 160. Tlingit Maskette. Shaman in a trance. Collected by Emmons. Wood, human hair, and black, red, and blue-green pigment; height 4¼ inches (maskette only); c. 1830–50. National Museum of the American Indian, Smithsonian Institution, Washington, D.C., 2/9068. Purchased from Emmons, 1910–13

No. 161. Tlingit Maskette. Dying man. Emmons (n.d.) describes the maskette as representing a Tlingit who was killed in a fight. When he collected it in 1884–93 from the grave house of a Hoonah shaman near Hoonah, it was still attached to a band with eagle down and eagle tail feathers. Wood and black, red, and blue pigment; height 4⅝ inches; c. 1840–60. American Museum of Natural History, New York, E 710. Purchased from Emmons, 1893

No. 162. Tlingit Maskette. Grimacing human. Wood, human hair, and red, black, and blue pigment; height 4¼ inches (maskette only); c. 1840–60. Former collection: Alfred P. Swineford, Governor of Alaska (see Cole, 1985, p. 132). Field Museum of Natural History, Chicago, 17889. Purchased from E. O. Stafford, 1897

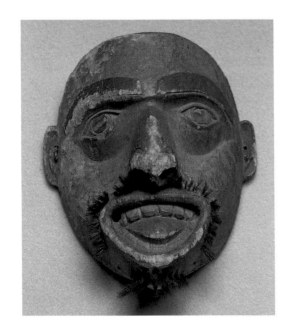

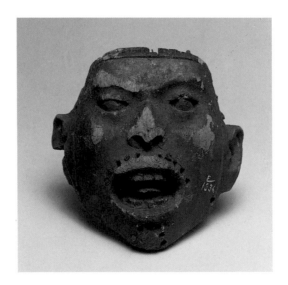

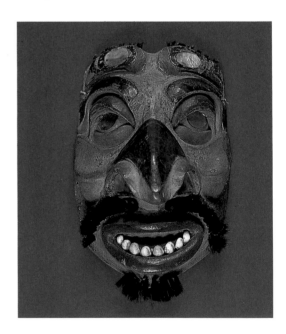

No. 163. Tlingit Maskette. Dying man. Collected by Emmons from a shaman's grave house on the shore of Sitka Bay near Sitka. Wood, human hair, abalone, and black, red, and blue pigment; height 5¼ inches; c. 1830–50. National Museum of the American Indian, Smithsonian Institution, Washington, D.C., 1/2511. Purchased from Emmons, 1907

No. 164. Tlingit Maskette. Dying man. Collected by Emmons from the grave house of a Sitka shaman on the bluff of an islet about twelve miles south of Sitka, 1884–93. Wood and black and red pigment; height 4⅜ inches; c. 1800–30. American Museum of Natural History, New York, E 1936. Purchased from Emmons, 1893

No. 165. Tlingit Maskette. Shaman in a trance. Collected by Emmons, with nos. 152 and 473, from the grave house of a Sitka shaman. Wood, human hair, abalone, opercula, and black, red, and blue-green pigment; height 5½ inches; c. 1840–60. National Museum of the American Indian, Smithsonian Institution, Washington, D.C., 9/7891. Purchased from Emmons, 1920

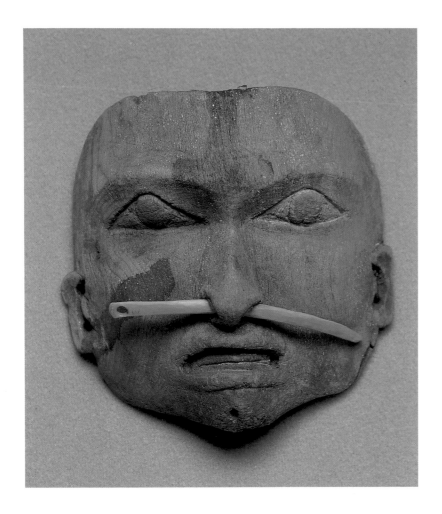

FORMING A SPIRIT ALLIANCE
(Tlingit)

Not far northward from Klukwan lived a shaman who had very little power so that the people did not honor him. One time he left his own town, and went to another farther north where there was a sick person. Numbers of shamans had been employed unsuccessfully; and when he came, they had him perform. But the other shamans made fun of him, causing him to stumble as he went around the fire. When he saw what they were doing, he stopped and left the place. As he paddled along, he drank salt water. Coming at a certain place, he stopped, got a land otter, and cut the right part of the tip of the tongue off. He did this to get more power. Then he went back to his old home at the mouth of the Karta River, and followed up the stream on foot. When he had got a long way up, he heard someone shouting between him and the river. He went towards the sound for a long time; and when it was low, he went slowly. Coming close to the river, he heard someone calling, "Put me together!" Then he went down from the woods to a deep place in the river where he heard more shouting, and saw a dog salmon bone lying there. He saw that this had caused the noise. Taking it up, he saw that the skin had been peeled off the bones, and the flesh removed, so that only these two parts remained. Then he began to blow upon these, and to slip the skin over the bones. When he had blown for some time, the salmon began to struggle in his hand, and at last came to life. He blew more, and then let the salmon go into the river. There it began to jump about, and went down to the sea. Now he got power from this salmon and became more powerful. (Swanton, 1909, pp. 246–47)

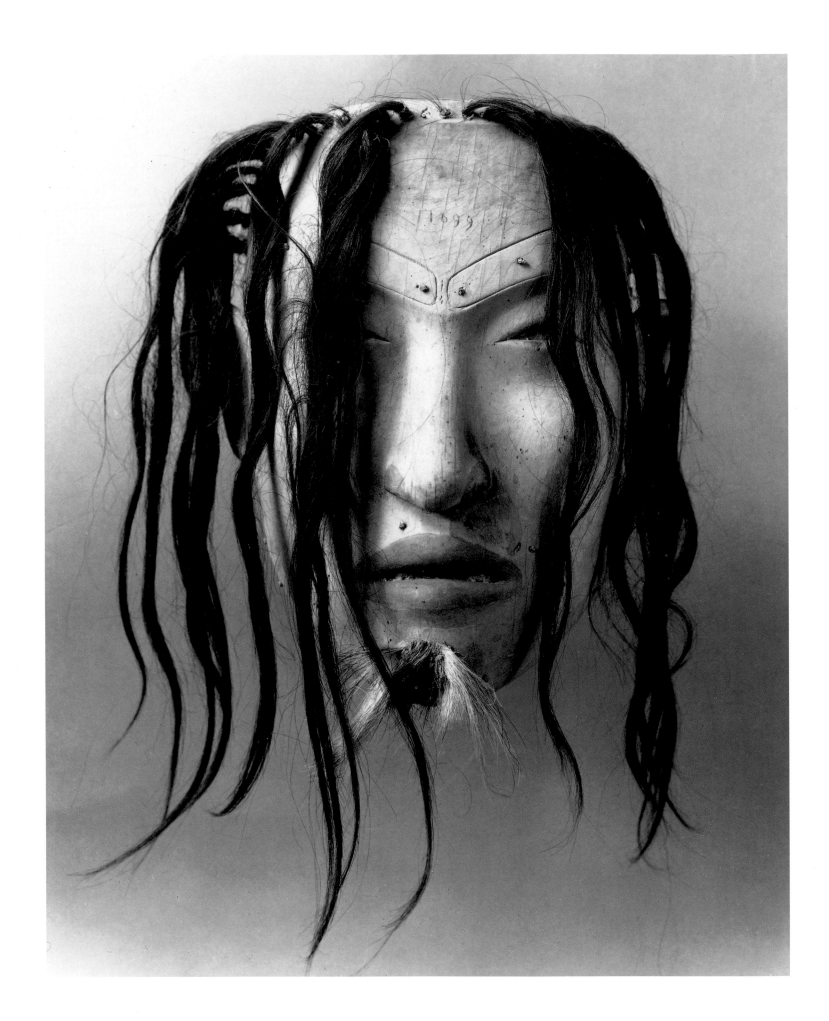

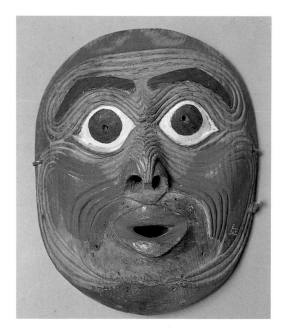

No. 169. Tlingit Mask. De Laguna (1972, pt. 3, p. 1098, pl. 180) describes this mask as representing a chiton. It seems, however, to be by the same artist and of the same subject as no. 170, which Emmons describes as an old man. Collected by Emmons from the grave house of a shaman at Dry Bay, 1884–93. Wood, animal hide, and black, red, and traces of blue pigment; height 8¼ inches; c. 1830–50. American Museum of Natural History, New York, E 343. Purchased from Emmons, 1893

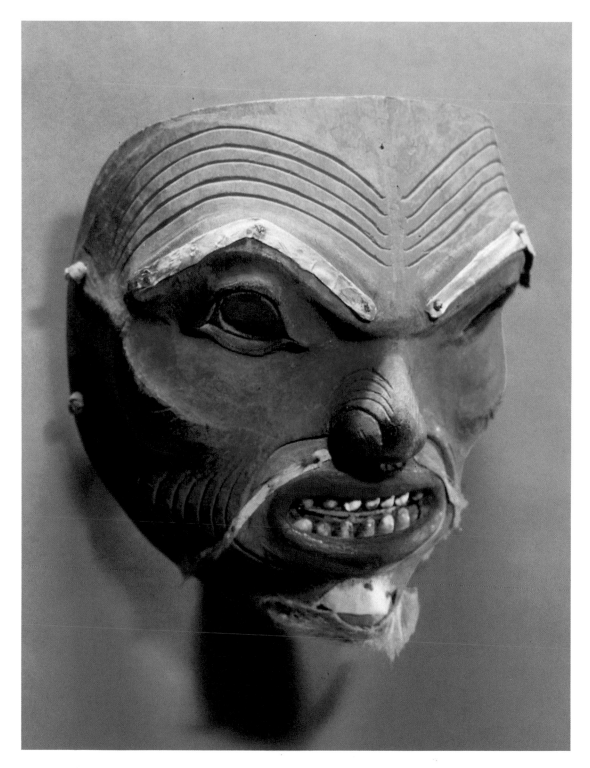

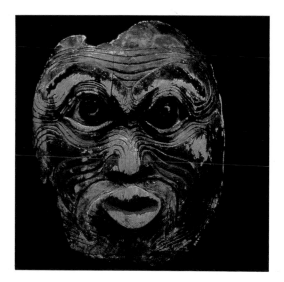

No. 168. Tlingit Mask. Old man. Collected by Emmons from the grave house of a Chilkat shaman at Yandestaki, 1882–87. Wood, animal hide, opercula, and red and blue pigment; height 8¼ inches; c. 1820–40. American Museum of Natural History, New York, 19/892. Purchased from Emmons, 1888

No. 167. Tlingit Mask (opposite). Holm (Vaughan and Holm, 1982, p. 95) notes that the expression is one of trance or death, and suggests that the mask may be a portrait of a shaman. The object has been attributed to the Haida by Emmons (ibid.), but is given to the Tlingit here in the absence of evidence that Haida shamans used masks. Collected by Captain Edward G. Fast at Sitka, 1867–68. Wood, human hair, animal skin, and black and red pigment; height 7 inches (mask only); c. 1820–40. Peabody Museum of Archaeology and Ethnology, Harvard University, Cambridge, 69–30–10/1699. Purchased from Fast, 1869

No. 170. Tlingit Mask. Old man. Probably by the same artist as no. 169. The area above the mouth originally had a copper inlay. Collected by Emmons in 1884–93 from the grave house of a Sitka shaman of the Kiksadi clan on a small island in Sitka Bay near the hot springs. Wood and black and red pigment; height 7⅞ inches; c. 1830–50. American Museum of Natural History, New York, E 2251. Purchased from Emmons, 1893

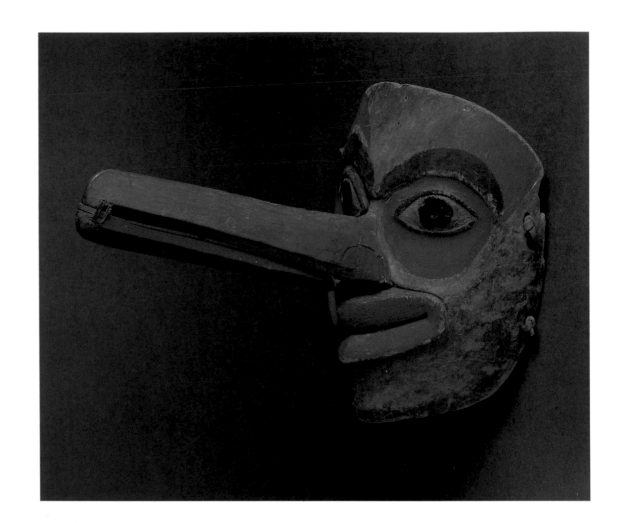

No. 171. Tlingit Mask. Mosquito. Collected by Emmons in 1882–87 from the grave house of an unidentified shaman at Port Mulgrave (Yakutat). Wood, animal hide, and traces of black, red, and blue pigment; height 9¼ inches; c. 1830–50. American Museum of Natural History, New York, 19/880. Purchased from Emmons, 1888

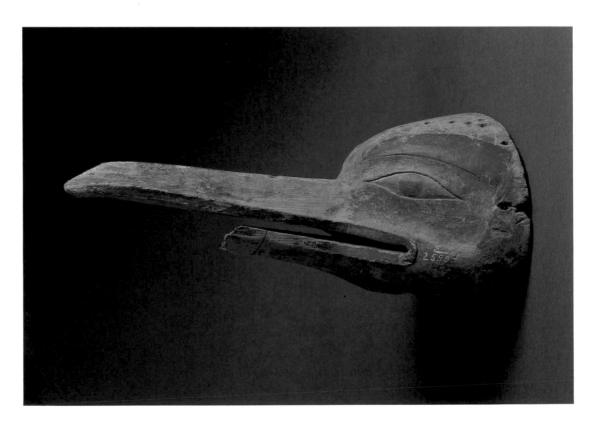

No. 172. Tlingit Mask. Mosquito. Collected by Emmons from the grave house of a Hoonah shaman at Icy Strait near Hoonah, 1884–93. Human hair had originally been pegged into the holes on top of the head (Emmons, n.d.). Wood, and black and blue-green pigment; length 14¾ inches; c. 1810–30. American Museum of Natural History, New York, E 2599. Purchased from Emmons, 1893

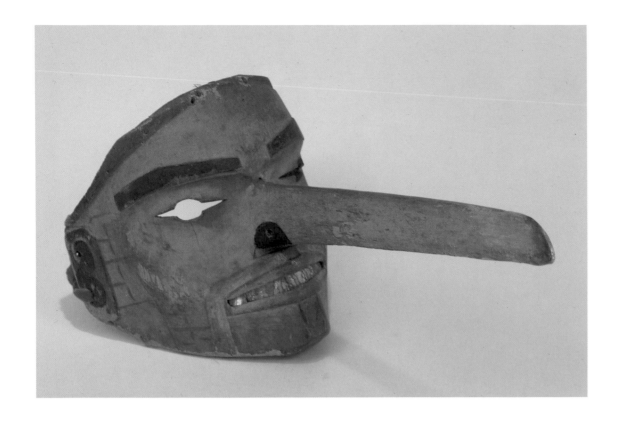

No. 173. Tlingit Mask. Mosquito. This early mask was found in a chest (no. 460) with other examples of a shaman's paraphernalia. The proboscis has been restored. Wood, abalone, and black and traces of blue-green pigment; height 8½ inches; c. 1790–1820. Private collection

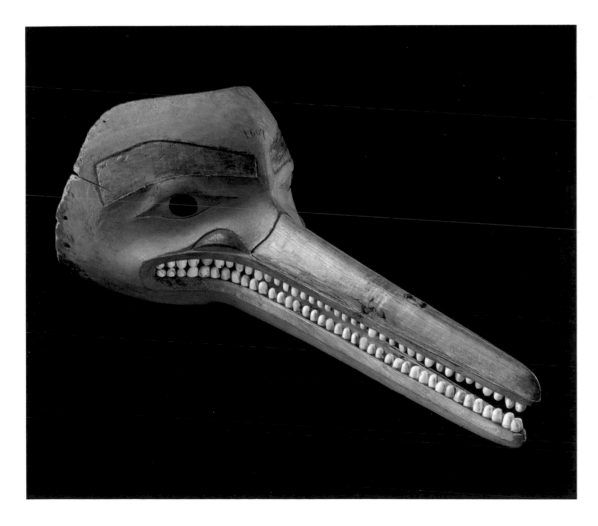

No. 174. Tlingit Mask. Mosquito. Collected by Captain Edward G. Fast at Sitka, 1867–68. Wood, opercula, and traces of black, red, and blue-green pigment; length 14½ inches; c. 1830–50. Peabody Museum of Archaeology and Ethnology, Harvard University, Cambridge, 69–30–10/1607. Purchased from Fast, 1869

No. 175. *Tlingit Mask*. Mosquito. Museum records indicate that this is from an early collection. Wood, rawhide, and black, red, and blue pigment; height 8¼ inches; c. 1810–30. Museum of Anthropology and Ethnography, St. Petersburg, Russia, 2448–13

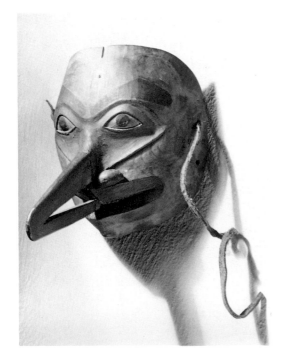

No. 176. *Tlingit Mask*. Mosquito. Collected by Ilia G. Vosnesenski at Sitka, 1843. Wood, animal hide, abalone, feathers, eagle down, walrus whiskers, and black, red, and blue pigment; length 19⅝ inches; c. 1810–30. Museum of Anthropology and Ethnography, St. Petersburg, Russia, 571–20

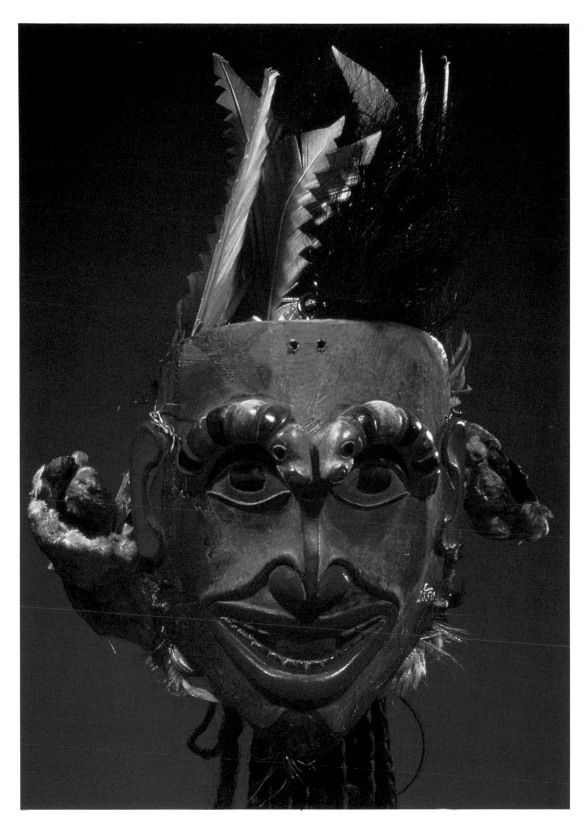

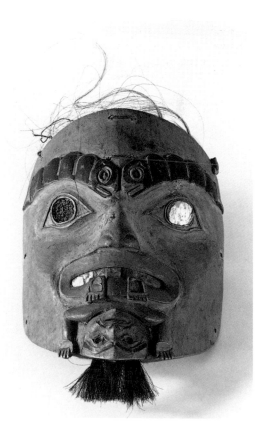

No. 178. Tlingit Mask. The figures on the eyebrows are woodworms. The mask was part of the paraphernalia of the Chilkat shaman Skundoo. Wood, abalone, human hair, and red and black pigment; height 6 inches; c. 1840–60. Cincinnati Art Museum, 1889.295. Given by Dr. and Mrs. W. W. Seely, 1889

No. 177. Tlingit Headdress. The expression indicates either incipient death or a trance, and the figures on the eyebrows are woodworms. Collected by Emmons at Klukwan in 1884–93, and said by him to have been the property of a Chilkat shaman. Because its provenance and iconography are similar to those of no. 178, this headdress may also have belonged to the shaman Skundoo. Wood, bear fur, swansdown, eagle feathers, blue jay wings, and black, red, and blue pigment; height 7 inches (mask only); c. 1840–60. American Museum of Natural History, New York, E 2350. Purchased from Emmons, 1893

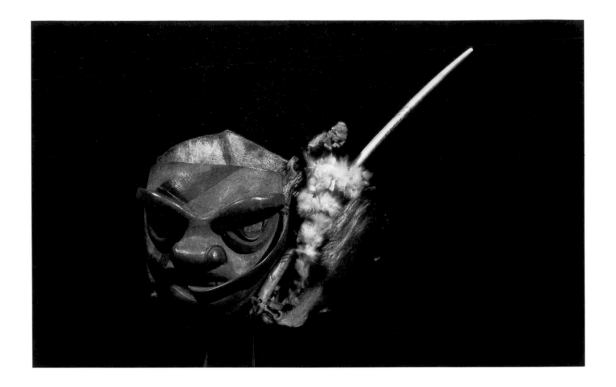

No. 179. Tlingit Headdress. Emmons (n.d.) writes that this headdress was worn to heal wounds and that the tongue of the maskette was touched to the afflicted area to bring about a cure. The walrus ivory amulet attached to the band is carved in the form of a land otter. Collected by Emmons at Chilkat from a Chilkat shaman, 1882–87. Wood, bearskin, ermine skin, abalone, walrus ivory, and black, red, and blue-green pigment; height 4¾ inches (maskette only); c. 1840–60. American Museum of Natural History, New York, 19/916. Purchased from Emmons, 1888

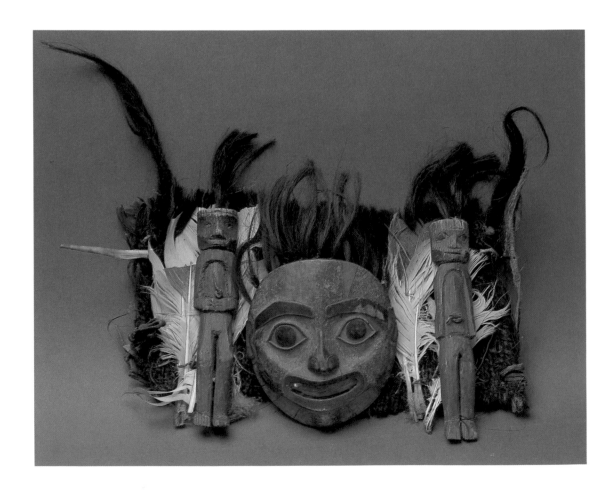

No. 180. Tlingit Headdress. Two guardian figures are attached to the headdress on both sides of the maskette. Wood, feathers, swansdown, animal skin, human hair, rawhide, quills, opercula, and red, black, and blue-green pigment; height 4¾ inches (maskette only); c. 1840–60. American Museum of Natural History, New York, 16.1/1000. Given by Mrs. Edward H. Harriman, 1912

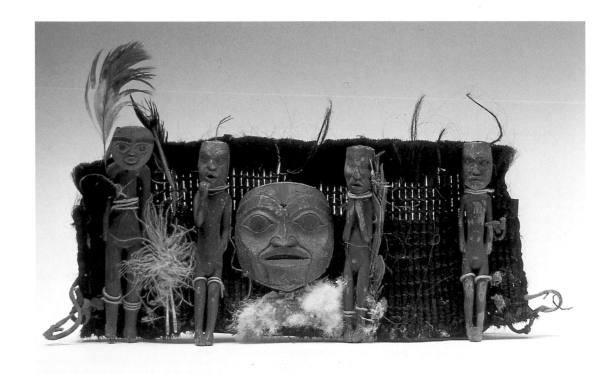

No. 181. Tlingit Headdress. Emmons (n.d.) describes the maskette as representing a powerful chief, and says the four wood guardian spirits added great power to the headdress itself. The framework is made of plaited human hair. Collected by Emmons at Chilkat, 1882–87. Wood, human hair, swansdown, bird skin, feathers, animal skin, and black, red, and blue-green pigment; height 5¾ inches; c. 1840–60. American Museum of Natural History, New York, 19/913. Purchased from Emmons, 1888

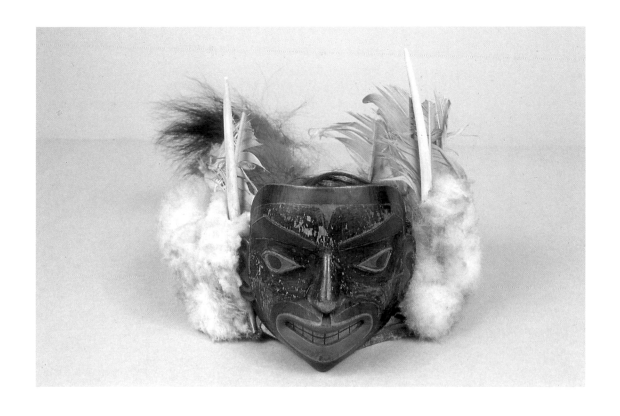

No. 182. Tlingit Headdress. Dying man. Collected by Emmons in 1884–93 from the nephew of Nolk, a Hutsnuwu shaman who died about 1865 and was buried with his paraphernalia in a grave house at Chait Bay, Admiralty Island. This object appears in one of the photographs of a shaman taken by Edward de Groff at Sitka in 1889 (see Holm, 1987b, p. 238). Wood, antler, swansdown, foxtail, eagle feathers, and black, red, and blue-green pigment; height 11¾ inches; c. 1840–60. Former collection: American Museum of Natural History, New York, E 948. Thomas Burke Memorial, Washington State Museum, Seattle, 1–11392. Acquired by exchange from the American Museum of Natural History, 1936

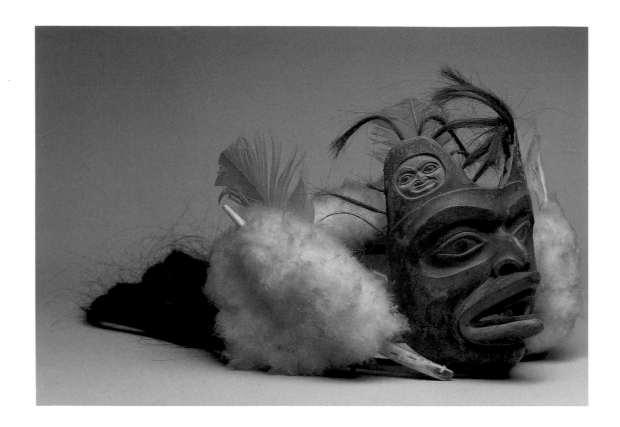

No. 183. Tlingit Headdress. Emmons (n.d.) identifies the maskette as a wolf. Collected by him in 1884–93 from the nephew of Nolk, a Hutsnuwu shaman who died about 1865 and was buried with his paraphernalia in a grave house at Chait Bay, Admiralty Island. Wood, eagle feathers, eagle down, human hair, bone, cedar bark, spruce twigs, and black and blue pigment; height 6¼ inches (maskette only); c. 1840–60. Former collection: American Museum of Natural History, New York, E 946; exchanged to Emmons, 1921. National Museum of the American Indian, Smithsonian Institution, Washington, D.C., 11/1747. Purchased from Emmons, 1922

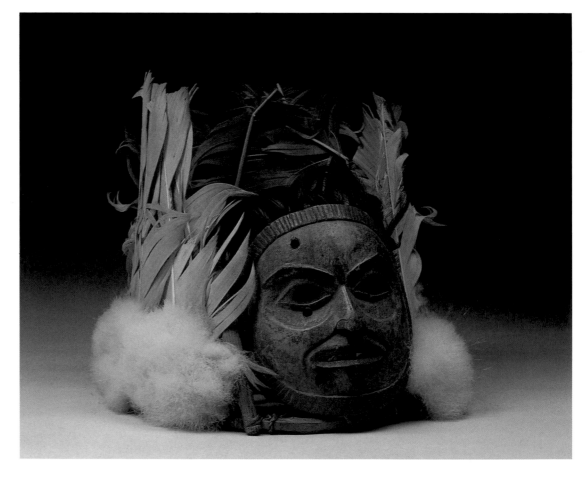

No. 184. Tlingit Headdress. Emmons (n.d., Notes, NMAI) writes that the maskette represents the sun and that the grooves cut around the face are rays. Collected by him at Chilkat. Wood, animal skin, bald eagle tail, and black, red, and blue-green pigment; height 4¾ inches (maskette only); c. 1840–60. National Museum of the American Indian, Smithsonian Institution, Washington, D.C., 11/1746. Purchased from Emmons, 1922

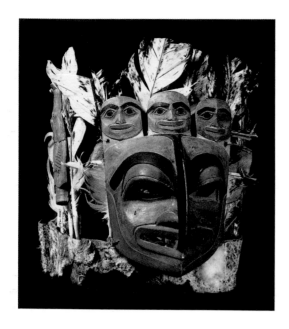

No. 185. Tlingit Headdress (two views). Man in a trance with upside-down skeletonized headless figures on both sides of the headdress. By the same hand as no. 186. Collected in 1888. Wood, animal hide, feathers, abalone, and black, red, and blue-green pigment; height 13 inches; c. 1840–60. Museum für Völkerkunde, Basel, IV a 101. Given by Alfo Iselin

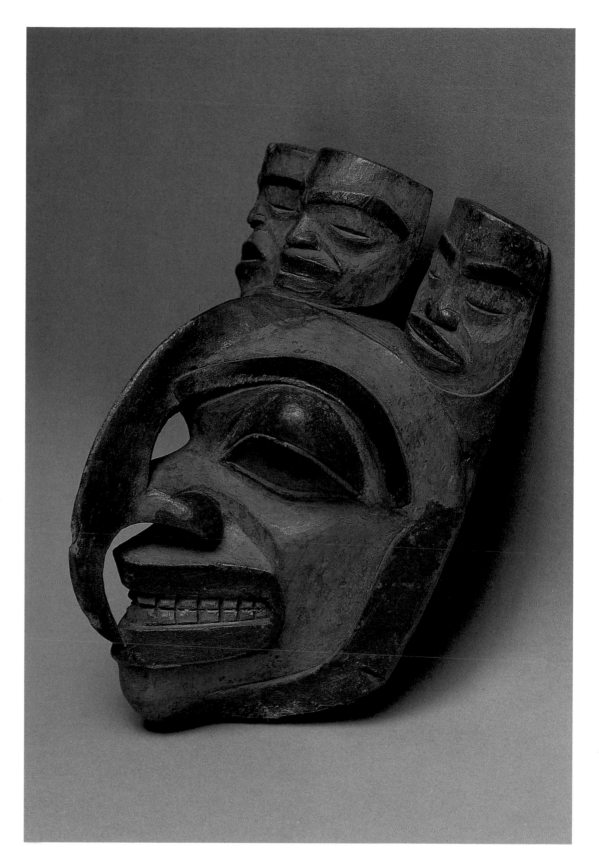

No. 186. Tlingit Mask. Man in a trance. This mask is by the same hand as no. 185, although here the eyes of the three faces on the top are closed, not open. Collected by Emmons at Sitka. Wood and black, red, white, and traces of blue-green pigment; height 7 inches; c. 1840–60. National Museum of the American Indian, Smithsonian Institution, Washington, D.C., 9/7888. Purchased from Emmons, 1920

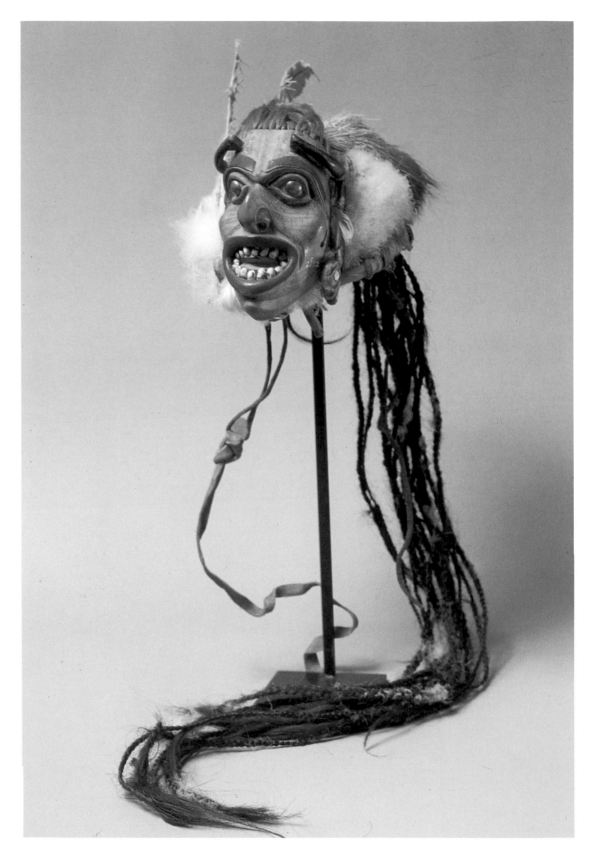

No. 187. Tlingit Headdress. Dying man. Collected by Emmons in 1884–93 from the nephew of Nolk, a Hutsnuwu shaman who died about 1865 and was buried with his paraphernalia in a grave house at Chait Bay, Admiralty Island. Wood, bear fur, swansdown, eagle feathers, bone, and black and blue-green pigment; height 4¾ inches (mask only); c. 1840–60. American Museum of Natural History, New York, E 944. Purchased from Emmons, 1893

No. 188. Tlingit Headdress. The two figures on the cheeks are mice. Collected by Emmons at Klukwan, 1884–93. Wood, brass, opercula, spruce twigs, swansdown, ermine skin, caribou tail, human hair, feathers, and black, red, and blue pigment; height 5½ inches (mask only); c. 1840–60. American Museum of Natural History, New York, E 2372. Purchased from Emmons, 1893

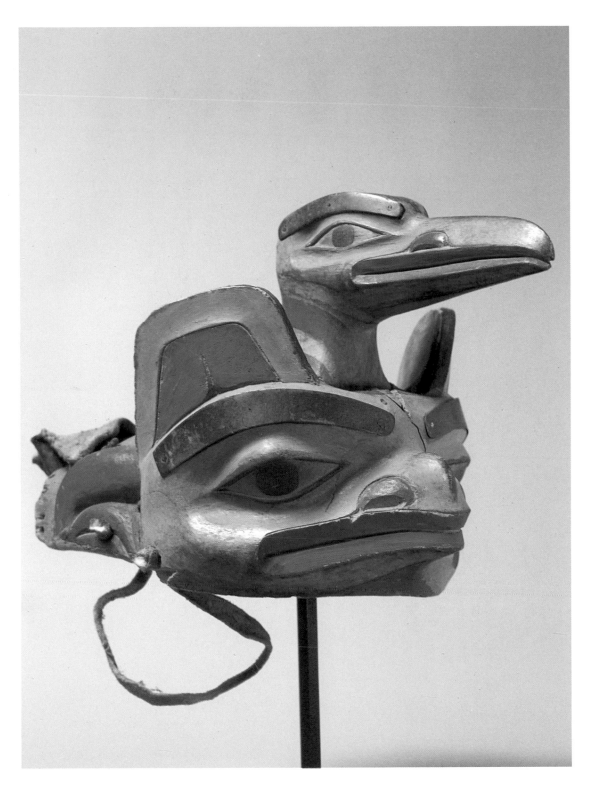

No. 189. Tlingit Headdress. Frog and kingfisher. This headdress, worn on top of the head, is by the same artist as a shaman's mask from the same grave house, now in the American Museum of Natural History (E 2362), and a crest headdress of unknown provenance in the Museum of Anthropology and Ethnography in St. Petersburg, Russia, collected in the 1840s (571–19 [see de Laguna, 1988a, pp. 278–79, pl. 382]). It would appear to have been made for crest display, but Emmons (n.d.) reports that he collected it from the grave house of a Hutsnuwu shaman at Angoon, 1884–93. Because the similar St. Petersburg example was made for clan use, this may originally have been a clan headdress that was later incorporated into shamanic use or that was owned by a shaman who was also a chief. Wood, copper, animal hide, twine, and black, red, and blue-green pigment; height 10 inches; c. 1830–50. American Museum of Natural History, New York, E 2364. Purchased from Emmons, 1893

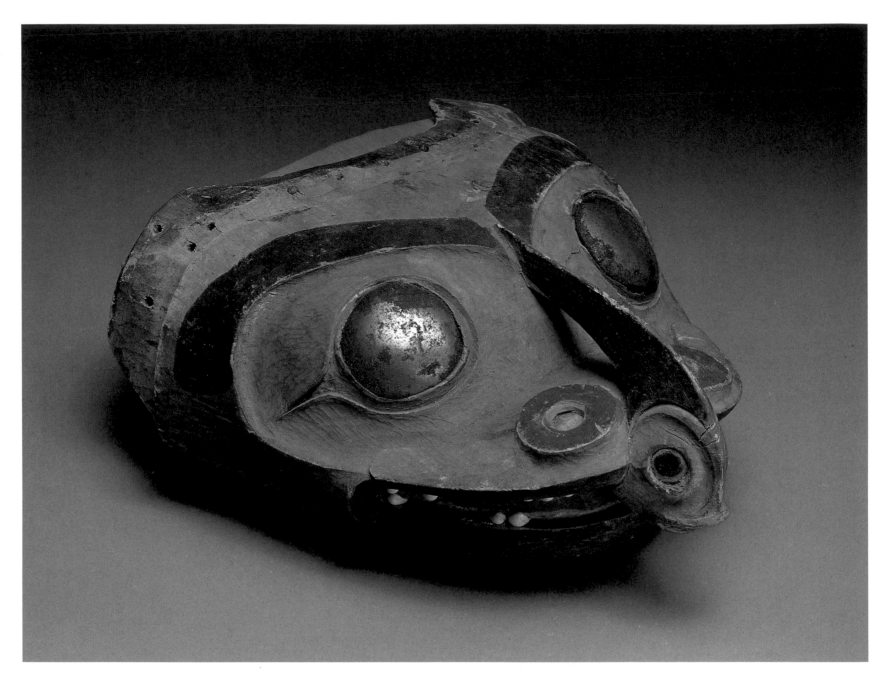

No. 190. Tlingit Headdress. Sculpin. Another smaller fish head, perhaps also a sculpin, forms the nose. Collected by Sheldon Jackson, 1870–79. Wood, opercula, iron, and red, black, and blue-green pigment; length 9⅞ inches; c. 1830–50. The Art Museum, Princeton University. On permanent loan from the Department of Geological and Geophysical Sciences, 3925. Given by Jackson, 1882

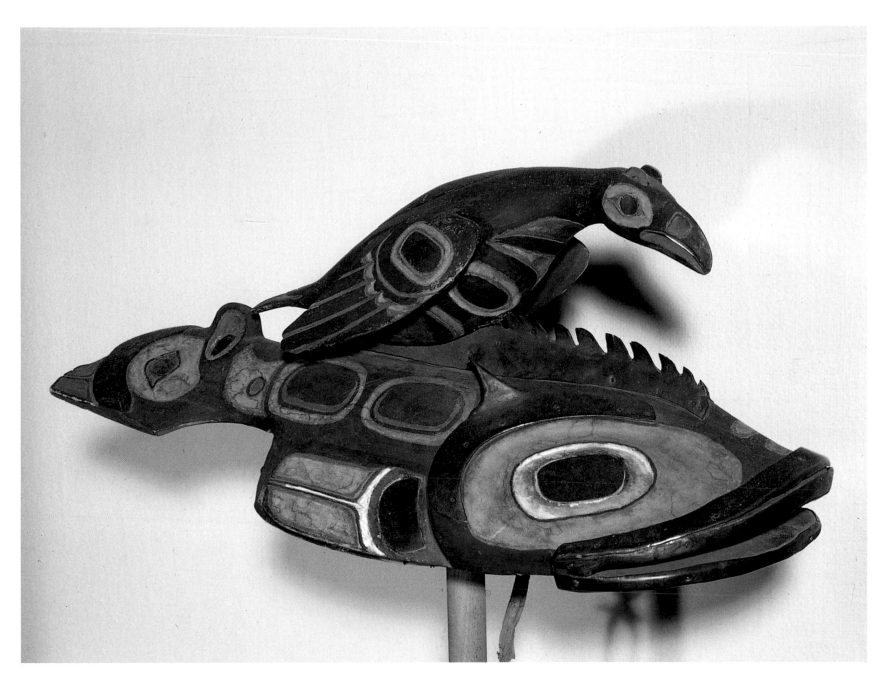

No. 191. Tlingit Headdress. Emmons (n.d.) describes the bird on the sculpin's back as a "grebe or diver," although Barbeau (1953, p. 167, pl. 131), who also attributes it to the Haida, correctly identifies it as a raven. At the rear is the head of a hawk. Collected by Emmons from the grave house of a Hutsnuwu shaman at Angoon, 1884–93. Wood, copper, animal hide, and black, red, and blue pigment; length 21 inches; c. 1840–60. Former collection: American Museum of Natural History, New York, E 2366; exchanged to Emmons, 1921. Montreal Museum of Fine Arts, 46.Ab.3. Given by F. Cleveland Morgan, 1946

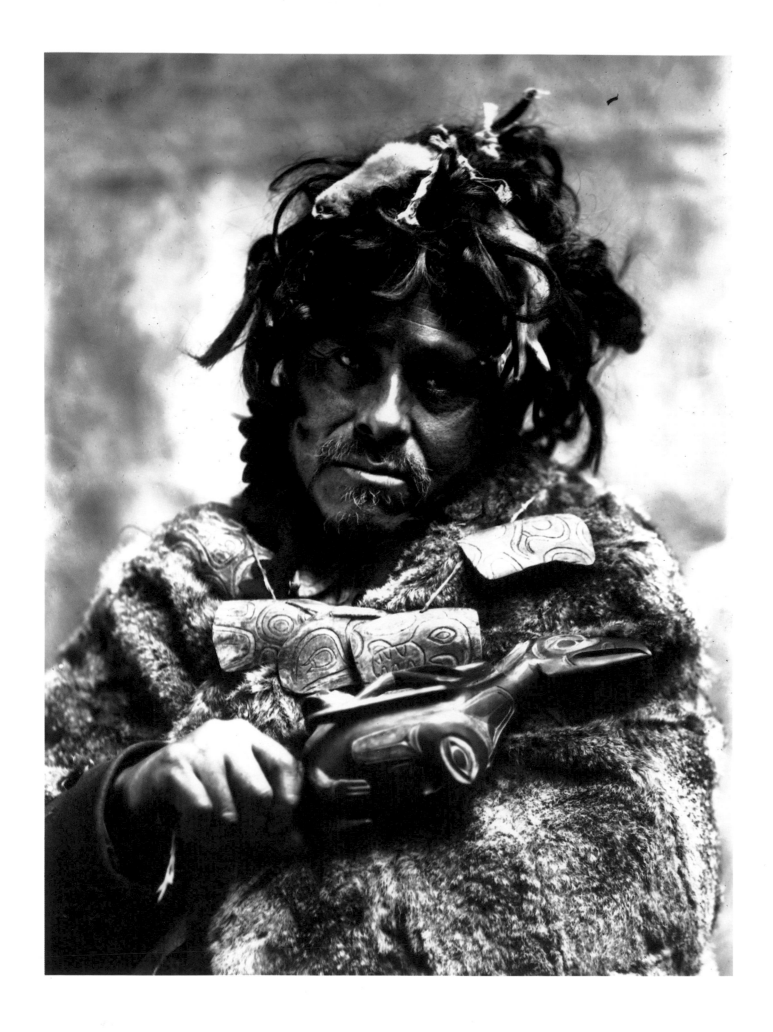

AMULETS

SHAMANS WORE amulets either as single pendants or in groups as part of necklaces; others were sewn to animal hide tunics or aprons. Most are therefore pierced for suspension. Many are uncarved, and were used to enhance the overall appearance of the shaman and to add a rhythmic noise to his performance as they clashed together during his dances. Some were also left with a patient after a shaman's performance to sustain some of his powers. De Laguna (in Emmons, 1991, p. 385) refers to one that is documented as having been transferred from the shaman's neck to that of the patient to ward off illness. Another was said to have first been warmed by the fire, then rubbed against the afflicted region, and finally left with the sick person.

Those amulets that are carved depict animal and human spirit helpers as well as narrative scenes inspired by dreams and trance visions. The finest examples in terms of delicacy of carving, the integration of forms, and conformity to the shape of the original material are the most exquisite of the shamanic arts, certainly of the Northwest Coast if not the world.

ACQUIRING A SPIRIT HELPER
(Tlingit)

A famous shaman of Sitka allowed himself to be thrown into the sea. With relatives and friends, he went out in a bay at the foot of Mount Edgecumbe, let himself be wrapped in a mat, and tied with a strap of otter, his shamanistic power, and after four loud exclamations was lowered into the sea. The people with him at first had great fear for his life and had first refused to do it. Faster than a stone and faster than a whale which had been shot, he went to the bottom so that the line to which he was fastened could scarcely follow. At the end of this line, his boatmates had tied the bladder of a land otter. After they waited in vain for some time for a sign from him, they went ashore in order to mourn for their friend. The following day they went back to the place without seeing anything unusual. But when they returned the fourth day they heard a sound like a shaman's drum and as they followed it, they saw the shaman hanging on a steep cliff without being tied down, his face streaming with blood, his head downwards, and small birds swarming around. With difficulty the friends got him into their boat in which he at once regained consciousness and returned home with them. All these wonders were due to the fact that the shaman had acquired a powerful new spirit. (Krause, 1956, p. 196)

Fig. 33. Tlingit Shaman (opposite). He wears a necklace of four bone amulets, has ermine skins in his hair, and carries a raven rattle. Another photograph of this shaman, now in the archives of the Royal British Columbia Museum, Victoria (13864), tentatively identifies him as Koot-Keek, an Auk shaman of Juneau. See also fig. 32. Photograph by Winter and Pond, Juneau, c. 1900. Alaska State Library, Juneau 87–244

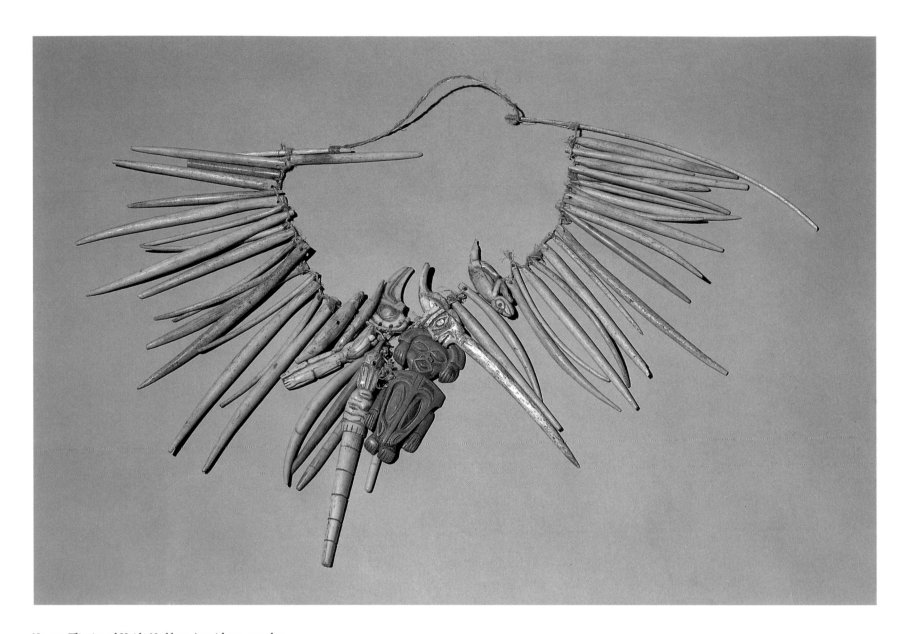

No. 192. Tlingit and Haida Necklace. As with no. 193, the elements composing this necklace could have come from different groups and were probably made at different times. The images on the ten carved amulets are a human figure wearing a shoulder robe, a man wearing a hat with potlatch rings, and various animals and birds. Collected by Israel W. Powell on the Queen Charlotte Islands in 1879, and traditionally attributed to the Haida. Sinew, bone, and whale and walrus ivory; length of largest amulet 10¼ inches; c. 1820–60. Canadian Museum of Civilization, Ottawa, VII–B–56

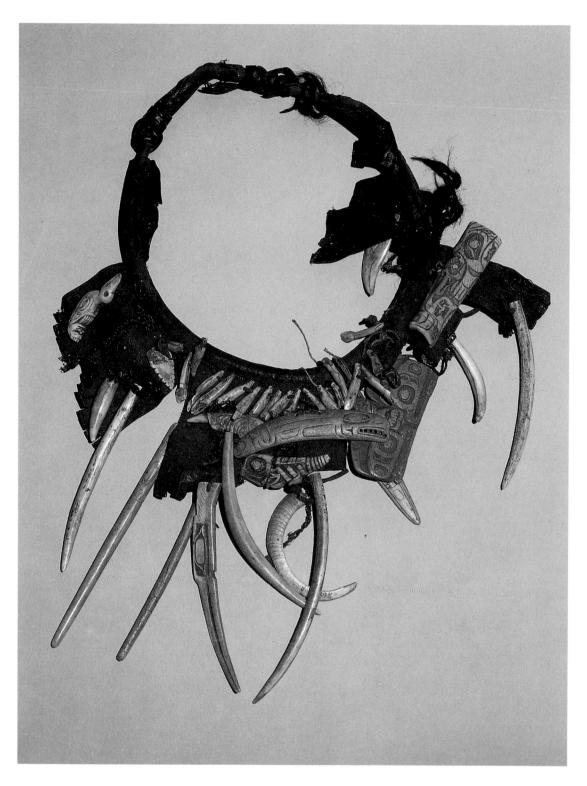

No. 193. Tlingit and Haida Necklace. This complete necklace consists of numerous carved and undecorated pendants. A number of the amulets now shown separately could have come from such a necklace. Dating and attribution to a specific group are difficult, as the elements could have been made at different times and places and assembled at others. The carved amulets appear to be Haida and Tlingit, and the images carved on the larger examples include a bird and a human, two crane heads, two land otters, a sea mammal with human and animal figures, an owl between the heads of two sea mammals, and a swimming bird. Collected by A. A. Aronson at Fort Rupert and traditionally attributed to the Kwakiutl. Wood, root cord, rawhide, sinew, horsehair, bone, animal teeth, and whale and walrus ivory; length of largest amulet 8½ inches; c. 1820–60. Canadian Museum of Civilization, Ottawa, VII–E–294. Acquired 1908

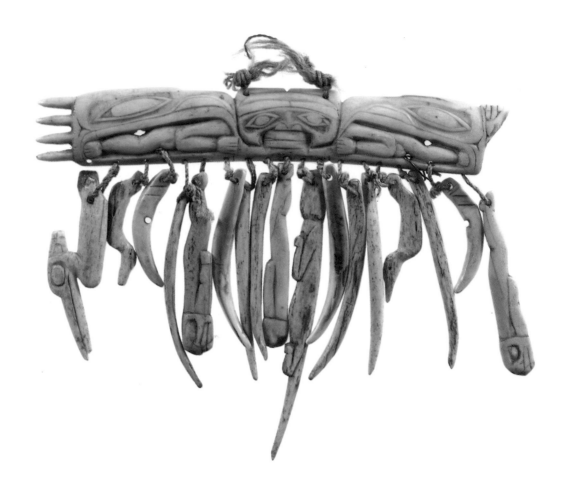

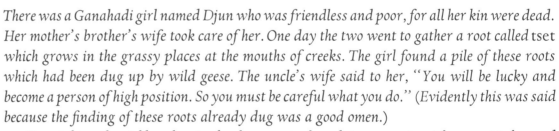

No. 194. *Tsimshian Amulet with Pendants.* Two confronting eagles with a human face and a splayed reclining body. The pendants include three bird figures, a land otter, and three swimming anthropomorphic sea mammals. Collected by James G. Swan at Port Simpson. Spruce root, bone, and walrus ivory; length 5½ inches; c. 1840–60. National Museum of Natural History, Smithsonian Institution, Washington, D.C., 89021. Acquired from Swan, 1884

A TANTA KWAN WOMAN SHAMAN
(Tlingit)

There was a Ganahadi girl named Djun who was friendless and poor, for all her kin were dead. Her mother's brother's wife took care of her. One day the two went to gather a root called tset *which grows in the grassy places at the mouths of creeks. The girl found a pile of these roots which had been dug up by wild geese. The uncle's wife said to her, "You will be lucky and become a person of high position. So you must be careful what you do." (Evidently this was said because the finding of these roots already dug was a good omen.)*

One night as the girl lay sleeping her housemates heard strange noises. They went to her and saw that she was acting like a shaman. In time she came to be famed for curing, foretelling the future, finding lost articles, ferreting out cases of witchcraft, and telling when a taboo had been broken.

On one occasion a chief's wife had such a terrible pain in her head that she screamed in agony. Djun was called in and given many gifts. In a few days the woman was well. Later the chief's daughter had a similar illness. Each night Djun went into a trance and sang songs as she worked over the girl. The fourth night she came out of her trance at the end of her second song. She said she must have more payment before she could diagnose what was causing the illness. Then the father of the girl paid her much more. Again she went into a trance. She circled the watchers four times, going "sunwise," i.e., counterclockwise. She grabbed at the cause of sick-

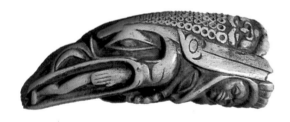

No. 195. *Tlingit Amulet.* A raven with a devilfish on its back devours a human. On the bottom is a human head surmounting another head with a large thorax, perhaps a dragonfly. On the back is a devilfish with a human face. Collected by Emmons at Chilkat, 1884–93. Whale tooth; length 6 inches; c. 1820–50. American Museum of Natural History, New York, E 2715. Purchased from Emmons, 1893

ness with her hands. *Finally she began as if pulling in a line, the "line of witchcraft." People watched to see which one of those present would be pointed out as guilty. In front of each one present the shaman "pulled on the line" while looking intently into the person's face. But this time it was not a person who was guilty but a wren. They were in Raven House, which is always built with double doors. The shaman came to the doors. She continued to sing and signalled that the doors be opened. When this was done she continued pulling in the "line." Soon a wren came hopping in. Then the spirit came out of her and she told the people to catch the bird. They caught it and, following the shaman's instructions, tied up its wings and legs. She told them to put it at the rear post of the house and to treat it the same as a human witch or wizard for four or eight days. Accordingly the bird was given no food and only salt water to drink. To the water was added the slimy, mossy water from the bilge of canoes.*

After four days the shaman told them to let the bird out, tied to a long string leash. The bird led them back of the village. Everyone in the village followed. They came to a moss-covered, sloping windfall. The bird indicated the log. Under it they found a human skull and in this the bird had built a nest. The bird had intended no harm but had used some of the girl's hair in nest building and thus had almost killed her.

They carefully carried the skull to the beach, followed by the bird. Djun told them to take out the nest a bit at a time and drop it into deep water. They did this, and also dropped the skull in deep water. They let the bird free. The following morning the girl was well.

On another occasion Djun was called in to treat a sick person. When she came out of her trance she said that the sick woman had been bewitched by Tawasi'si, a high chief. His clan (Wolf) was numerous and powerful, while Djun's clan (the Ganahadi) was relatively weak. The chief said, "I did not bewitch the woman. Are you going to believe that poor useless girl Djun? Let the proof be shown in public!" Djun agreed to this.

A small stream ran through the village. The Wolf houses were on one side of the stream, the Raven (Ganahadi) houses on the other. That night Djun's spirit gave her a new song which ran, "I wish that the great chief, he who has the name Tawasi'si, would respect this poor child." The next morning the two clans lined up on either side of the stream, armed. The Ganahadi sang this new song. Djun's helpers had dressed her hair in a special way and had put two pointed bones in it. Now, when a shaman takes such a "pointing bone," points it at a person and says, "Huh," the person pointed at will, if he is a wizard, move in whatever direction the bone moves. An innocent person, on the other hand, will be able to remain still.

The accused chief was dressed in his finery and had on a ceremonial ringed hat. As her clansmen sang, Djun pointed the bone at the chief, then moved it to his right. He almost fell over, being jerked by the power. Then she pointed the bone to his left, and again he was jerked so violently that the hat rings swayed. Then she pointed the bone upward and the chief bent sharply backward. She pointed the bone down and he bent forward. His clansmen, seeing this, felt almost disgraced. For an innocent person would not do this compulsive bending. The chief's clansmen went home in shame.

Later Djun married and through her shamanizing became the richest woman among the Ganahadi. She bore two daughters, named Tlanat and Guglan. These two became the mothers of all of the Ganahadi among the southern Tlingit.

It is remarkable that Djun had become a shaman and got her spirit power, though she had never cut the tongue of a living creature. (Olsen, 1961, pp. 214–16)

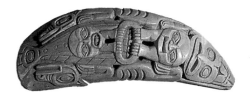

No. 196. *Tlingit Amulet.* Emmons purchased this charm from an old shaman in 1882–87, and Emmons (n.d.) quotes the shaman's interpretation of the design "as representing land otters on either side.... The fish, a halibut, is supposed to be coming up sea to the shore, and the two small 'yakes' or spirit men are holding open its mouth which represents sea water. Above all, the owl represents a high mountain, and there he sits and tells the Indians the future, for the Indian knows well the owl's language." The amulet was originally attached to a "dancing robe." Whale tooth; length 5⅞ inches; c. 1820–50. American Museum of Natural History, New York, 19/457. Purchased from Emmons, 1888

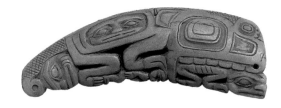

No. 197. *Tlingit Amulet.* A monster, perhaps a sea bear, with a human head carved in the center of its back, devours a bear. A human head is at the left, and a reclining human is on the bottom. Emmons (n.d.) identifies the heads as spirits of dead witches. Emmons found the amulet carefully wrapped in a skin bag in 1882–87 in a grave house at Port Mulgrave (Yakutat). Whale tooth; length 4½ inches; c. 1820–50. American Museum of Natural History, New York, 19/477. Purchased from Emmons, 1888

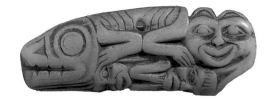

No. 198. *Tlingit Amulet.* The figure on the left is a bear. On the right is the face of an unidentified creature, perhaps a land otter man. On the bottom is a double-headed human figure, and the head at the right may represent a shaman wearing a crown. Whale tooth; length 3¾ inches; c. 1820–50. Private collection

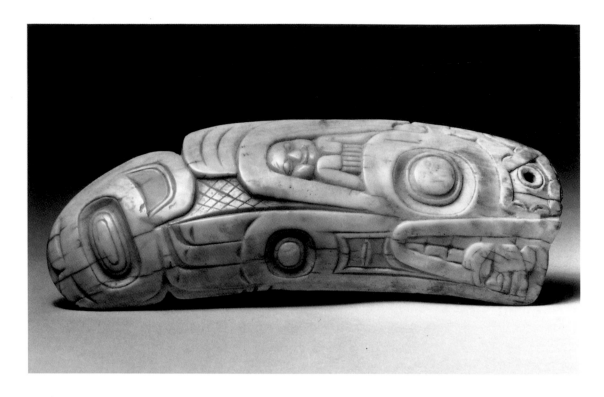

No. 199. Tlingit Amulet. A sea mammal devours a human head. Collected by Captain Edward G. Fast at Sitka, 1867–68. Whale tooth; length 5¼ inches; c. 1820–50. Former collection: Peabody Museum of Archaeology and Ethnology, Harvard University, Cambridge. Denver Art Museum, 1953.570

No. 200. Tlingit Amulet. A whale with two human figures in the center of its body. Another human face is below the feet of the figures, and above is an animal face with two small human faces on its ears. Collected by Captain Edward G. Fast at Sitka, 1867–68. Whale tooth; length 5⅞ inches; c. 1820–50. Former collection: Peabody Museum of Archaeology and Ethnology, Harvard University, Cambridge. Denver Art Museum, 1953.511

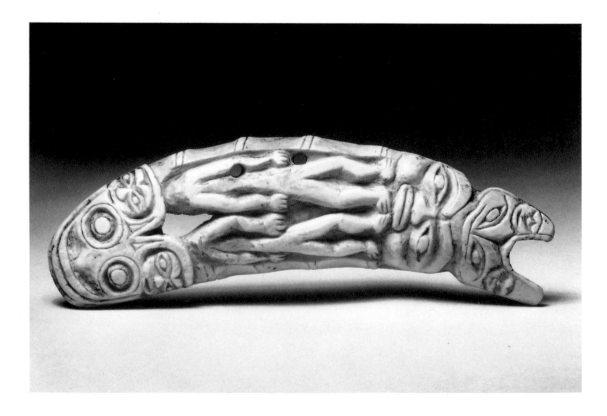

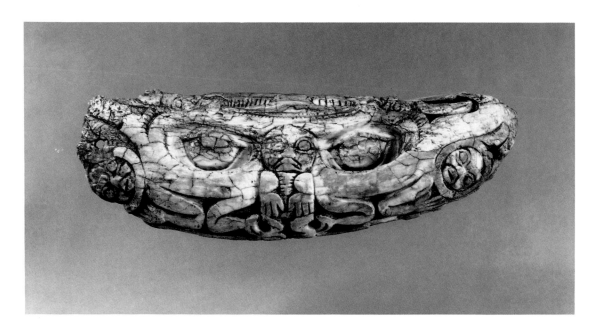

No. 201. Tlingit Amulet. Although eroded, the figures of two land otters, a large face, a human figure, and two human heads can be discerned. It is similar in composition to no. 205. Whale tooth; length 6⅛ inches; c. 1800–1850. Private collection

No. 202. Tlingit Amulet. A sea mammal with a human figure in its blowhole devours a man. On the top are two birds, one surmounting the other; a squatting bear; a squatting human; and perhaps a frog. The bottom figure has a human head but cannot otherwise be identified. Collected by Emmons. Whale tooth; length 6⅝ inches; c. 1820–50. Former collection: Harry Beasley (Emmons and Miles, 1939, pl. xix, fig. 1). Mr. and Mrs. Raymond Wielgus Collection, Tucson

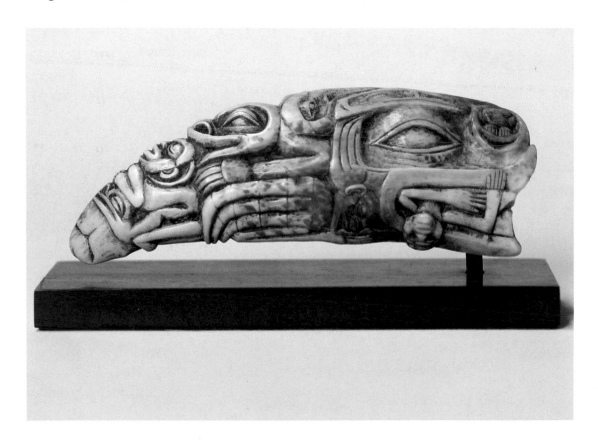

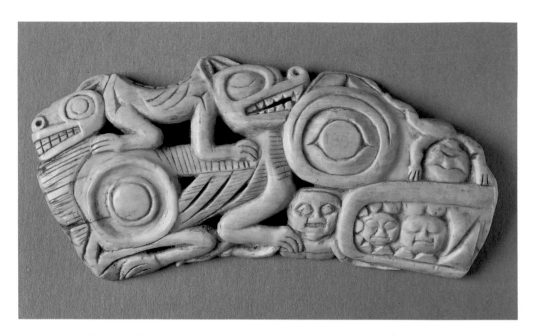

No. 203. Tlingit Amulet. A crouching bear with an inverted dead man over its nose has two human heads in its mouth. On the back of the crouching bear is another bear figure, its eyes closed as if in a trance, with another animal head behind it. A human is in front of the bear's forepaw. Collected by Captain Edward G. Fast at Sitka, 1867–68. Whale tooth; length 4¾ inches; c. 1800–1850. Peabody Museum of Archaeology and Ethnology, Harvard University, Cambridge, 69–30–10/1894. Purchased from Fast, 1869

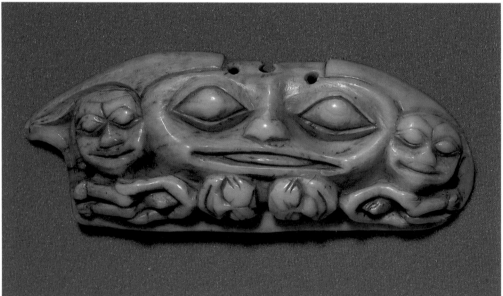

No. 204. Tlingit Amulet. Emmons (n.d., Notes, NMAI) identifies the large face in the center as "the spirit above." Collected by him from the grave house of a Hoonah shaman near Hoonah. Whale tooth; length 4⅝ inches; c. 1820–50. National Museum of the American Indian, Smithsonian Institution, Washington, D.C., 9/7953. Purchased from Emmons, 1920

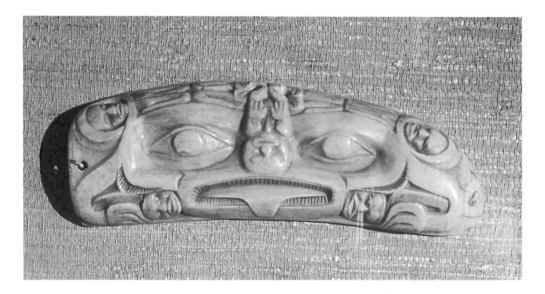

No. 205. Tlingit Amulet. One of six amulets originally attached to an animal skin apron. A large animal face with a protruding tongue and legs with claws at the sides has three reclining human figures at the top and two human heads at the bottom. Emmons (n.d.), who collected this from a grave house containing the bodies of two shamans near Hoonah in 1882–87, describes it as representing a most powerful and dreaded spirit that lived in a "far distant country in the clouds." Whale tooth; length 6⅛ inches; c. 1820–50. American Museum of Natural History, New York, 19/450. Purchased from Emmons, 1888

172

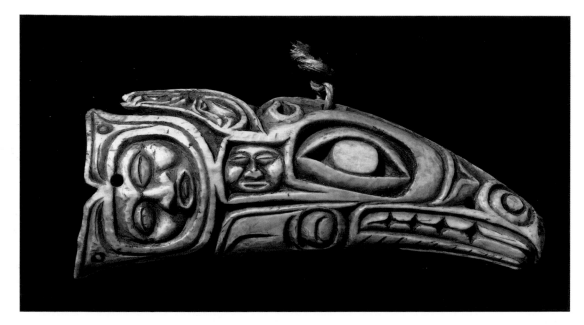

No. 206. *Tlingit Amulet.* Emmons (n.d.) describes this as an eagle spirit. The two human faces are shown in trance states. By the same artist as no. 207; both were originally attached to a moose skin robe. Collected by Emmons from a grave house containing the bodies of two shamans on a rocky promontory near Hoonah, 1882–87. Whale tooth; length 5⅛ inches; c. 1840–60. American Museum of Natural History, New York, 19/453. Purchased from Emmons, 1888

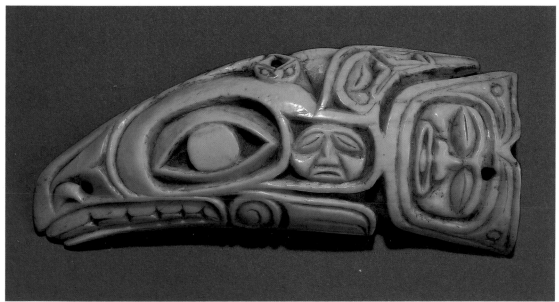

No. 207. *Tlingit Amulet.* This charm forms a pair with no. 206, which Emmons (n.d., Notes, NMAI) indicates he collected at the same time and from the same grave house near Hoonah. Whale tooth; length 5⅛ inches; c. 1840–60. National Museum of the American Indian, Smithsonian Institution, Washington, D.C., 4/1669. Purchased from Emmons, 1915

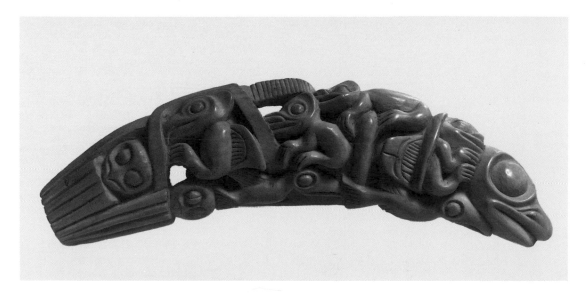

No. 208. *Tlingit Amulet.* Three squatting figures, probably bears, and a seated bird with a devilfish below. An animal head is at the right, and the face of an owl is at the left. Two flying birds are on the bottom. Collected by John J. McLean. Whale tooth; length 4⅞ inches; c. 1820–50. National Museum of Natural History, Smithsonian Institution, Washington, D.C., 74990. Acquired 1884

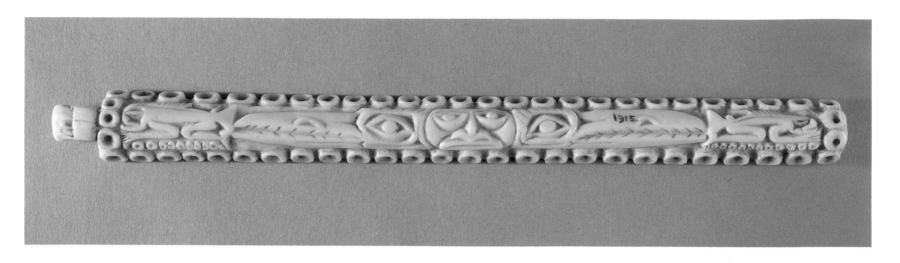

No. 209. Tlingit Amulet. A human face is flanked by two bird heads (perhaps ravens), and two anthropomorphic fish forms are carved at the ends. Devilfish tentacles frame the composition. Collected by Captain Edward G. Fast at Sitka, 1867–68. Walrus ivory; length 10¼ inches; c. 1820–50. Peabody Museum of Archaeology and Ethnology, Harvard University, Cambridge, 69–30–10/1915. Purchased from Fast, 1869

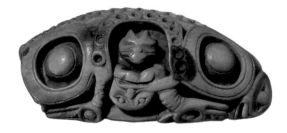

No. 210. Tlingit Amulet. The three identifiable figures shown upside down on the bottom are a bird head, a devilfish, and a wolf head. Whale tooth; length 3¼ inches; c. 1820–50. National Museum of the American Indian, Smithsonian Institution, Washington, D.C., 18/5911. Purchased, 1933

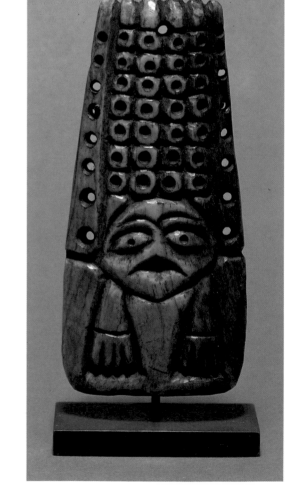

No. 211. Tlingit Amulet. Devilfish with human face and arms. Collected by Emmons. Bone; length 4⅛ inches; c. 1840–60. Former collection: Harry Beasley (Emmons and Miles, 1939, pl. xix, fig. 2). Private collection

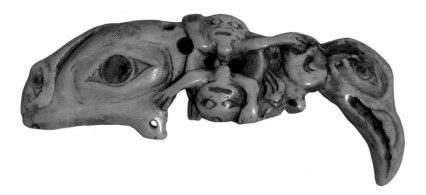

No. 212. *Tlingit Amulet.* Three figures are in the center, with an animal head and a bird head at the left and a raven head at the right. The worn surface and simple detailing indicate an early date. Collected by Emmons at Sitka. Antler and abalone; length 4 inches; c. 1790–1820. National Museum of the American Indian, Smithsonian Institution, Washington, D.C., 4/1659. Purchased from Emmons, 1915

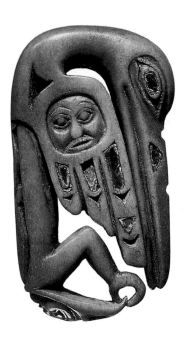

No. 214. *Tsimshian Amulet.* The anthropomorphic figure of a crane has a human face on the shoulder and a reclining human figure, with its head resting in the center of the tail, along the back. Collected by Charles F. Newcombe from J. Priestley at Aiyansh, 1909. Antler and abalone; height 2⅞ inches; c. 1820–50. Royal British Columbia Museum, Victoria, 9681

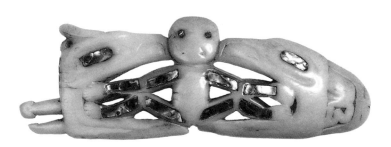

No. 213. *Tlingit Amulet* (two views). Emmons (n.d., Notes, NMAI) identifies the birds as a raven and an eagle, and the figure in the center as a "great sky spirit." A small crouching figure is at the right. Considerable wear and the use of simple formlines suggest the early dating. Collected by Emmons at Sitka. Walrus ivory and abalone; length 3¾ inches; c. 1790–1820. National Museum of the American Indian, Smithsonian Institution, Washington, D.C., 9/7955. Purchased from Emmons, 1920

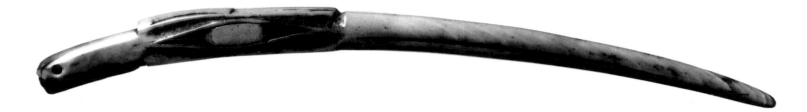

No. 215. Tlingit Amulet (above). Head of a crane. Whale tooth; length 7⅝ inches; c. 1790–1820. Private collection

No. 216. Haida Amulet (left). Gunther (1962, p. 68, no. 66) identifies the figure as a whale, but it may be a seal. The head of another animal appears at the tail. Stone; length 4 inches; c. 1840–60. Former collection: Wolfgang Paalen. The Metropolitan Museum of Art, New York, 1979.206.896. The Michael C. Rockefeller Collection, bequest of Nelson A. Rockefeller, 1979

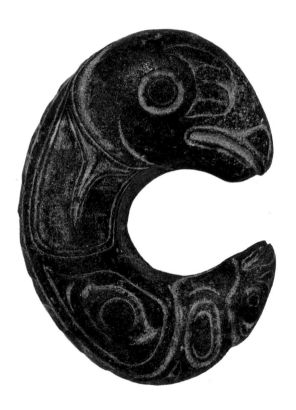

No. 217. Tlingit Amulet (above). Although no information associates this pendant with a shaman, the owl head iconography suggests the possibility. Similar stone carvings were also used for scratching, as it was believed to be bad luck to scratch oneself with the fingernails. Collected by Emmons on Admiralty Island. Stone; height 2⅜ inches; c. 1840–60. Field Museum of Natural History, Chicago, 78028. Purchased from Emmons, 1902

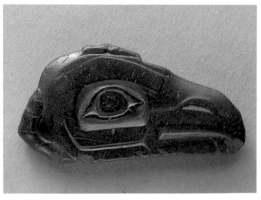

No. 218. Tlingit Amulet (left). This piece shows extensive wear and the use of simple broad formlines to represent a raven head. Collected by Captain Edward G. Fast at Sitka, 1867–68. Stone; length 2⅜ inches; c. 1790–1820. Peabody Museum of Archaeology and Ethnology, Harvard University, Cambridge, 69–30–10/1811. Purchased from Fast, 1869

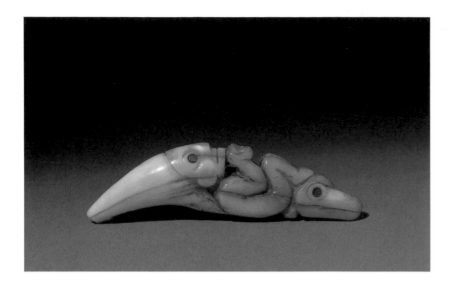

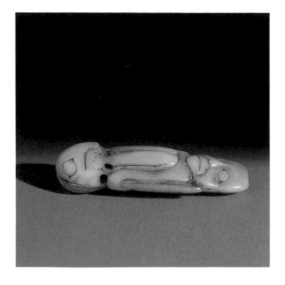

No. 219. *Tsimshian Amulet.* A human figure is seated over the head of a bird. Collected by H. C. Wrinch on the Skeena River. Bear tooth and metal; height 2¾ inches; c. 1820–50. Canadian Museum of Civilization, Ottawa, VII–C–1641. Acquired, 1937

No. 220. *Haida Amulet.* A bear or human head surmounts a perched eagle. Ivory and abalone; height 3¾ inches; c. 1840–60. The Brooklyn Museum, New York, 86.224.175. Bequest of Ernest Erikson, 1986

No. 221. *Tsimshian Amulet.* An eagle sits over a squatting human figure. Collected by William A. Newcombe at Gitlakdamiks, 1905. Ivory; height 2 inches; c. 1820–50. Canadian Museum of Civilization, Ottawa, VII–C–213a. Purchased from Newcombe, 1905

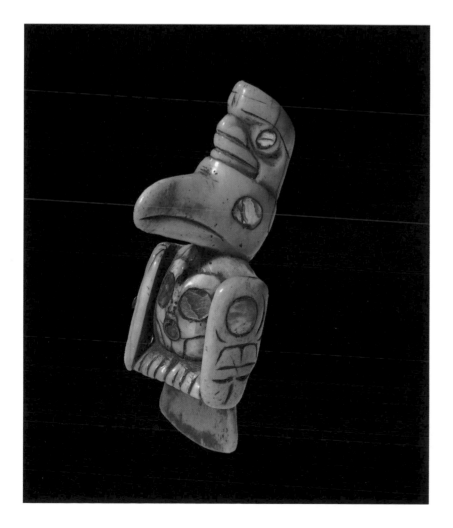

No. 222. *Tlingit Amulet* (two views). A human figure squats on the back of a raven, and another unidentified animal is on the bottom. Animal tooth; length 1⅞ inches; c. 1820–50. Milwaukee Public Museum, 57139. Acquired by exchange from L. Winterhalter, 1961

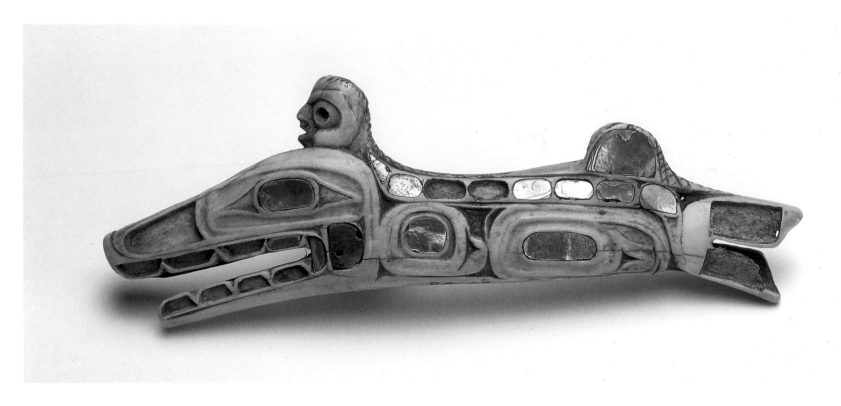

No. 223. Tsimshian Amulet. A killer whale with a human figure on the back. Although this is not a soul catcher, the overall appearance and carving details of the eyes and oval forms suggest that it may come from the same workshop that created nos. 6, 283, 286, and 289. Collected by Lieutenant F. M. Ring near Port Simpson, 1870. Antler and abalone; length 7½ inches; c. 1840–60. National Museum of Natural History, Smithsonian Institution, Washington, D.C., 9813

No. 224. Tsimshian Amulet. A killer whale with human figures on two dorsal fins. Collected by Emmons on the Nass River. Antler and abalone; length 7¾ inches; c. 1820–50. National Museum of the American Indian, Smithsonian Institution, Washington, D.C., 10/4585. Purchased from Emmons, 1921

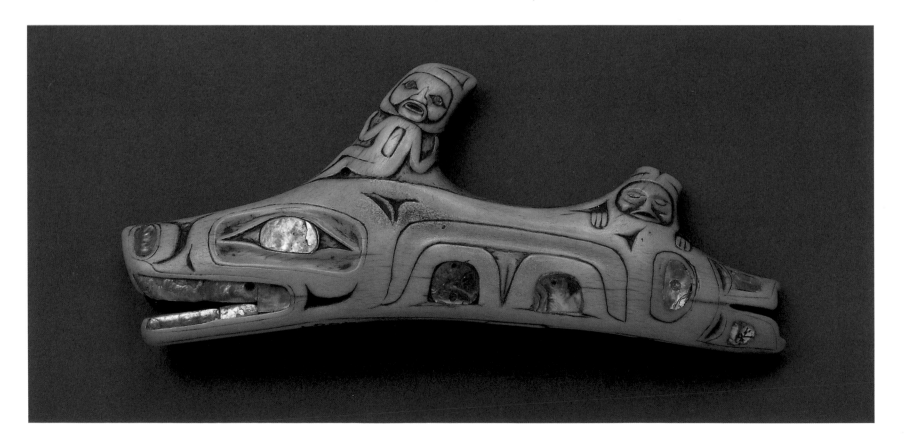

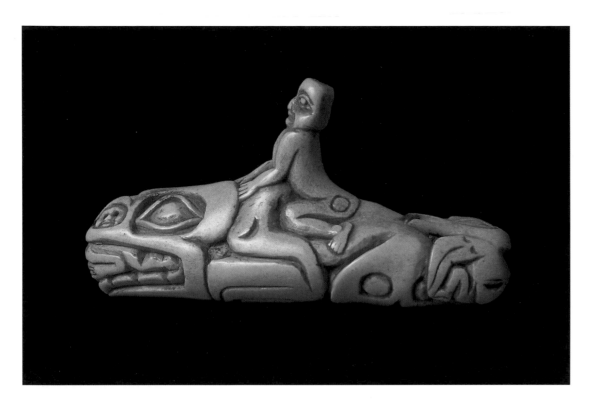

No. 225. Tlingit Amulet. A killer whale with a seated man on its dorsal fin devours a human. Collected by Emmons from a grave house near Angoon, 1884–93. Antler and abalone; length 4¼ inches; c. 1840–60. American Museum of Natural History, New York, E 2710. Purchased from Emmons, 1893

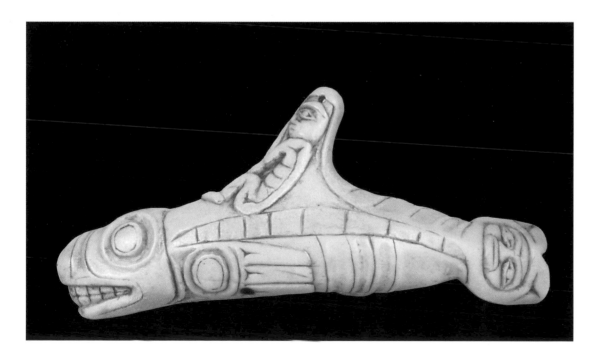

No. 226. Tlingit Amulet. A killer whale with a seated human figure on the dorsal fin and a human head on the tail. Collected by Emmons from the grave house of a shaman of the Stikine tribe at Wrangell before 1905. Antler; length 5⅛ inches; c. 1820–50. Thomas Burke Memorial, Washington State Museum, Seattle, 920. Purchased from Emmons, 1909

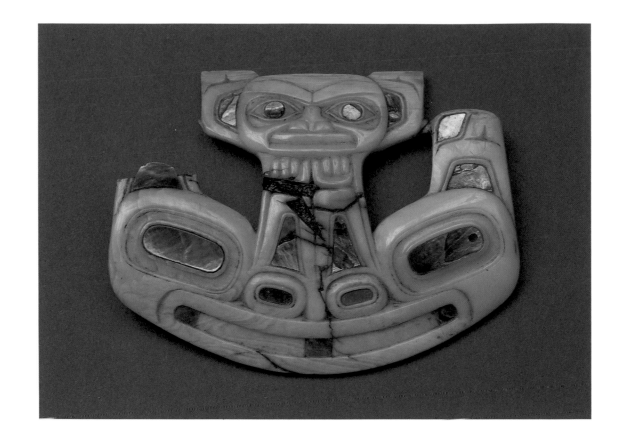

No. 227. *Tsimshian Amulet*. Feder (1971, p. 45, no. 31) identifies the figure as a sculpin, but it seems more likely to be a diving whale. A human face and hands are on the tail. Collected by Emmons at Kitwanga. He writes (n.d., Notes, NMAI) that this amulet "belonged to the chief shaman of Kitikshan [*sic*] at Kitwanga. Thought to have been made by the Niska [*sic*; the Tsimshian of the Lower Nass River] and procured from them by the Kitikshan [*sic*] as the work of the latter people was of too crude a nature to have produced such a beautiful article." Although Emmons says the material is mammoth ivory, it is whale tooth. Whale tooth and abalone; height 3 inches; c. 1820–50. National Museum of the American Indian, Smithsonian Institution, Washington, D.C., 9/7942. Purchased from Emmons, 1920

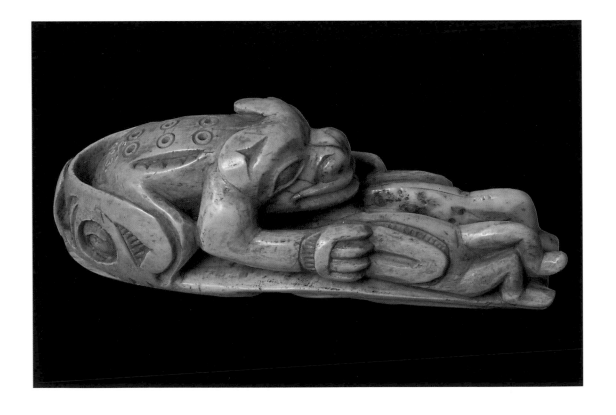

No. 228. *Tlingit Amulet*. Emmons (n.d.) describes the bottom figure as "a water spirit . . . which can carry the Doctor noiselessly through space." On the back is a bear with two reclining humans; a devil-fish is on the bottom. Collected by Emmons in 1884–93 from a female Hoonah shaman who lived at Hoonah. The amulet was said to have been passed down to her through several generations. Whale tooth; length 5¼ inches; c. 1820–50. American Museum of Natural History, New York, E 2423. Purchased from Emmons, 1893

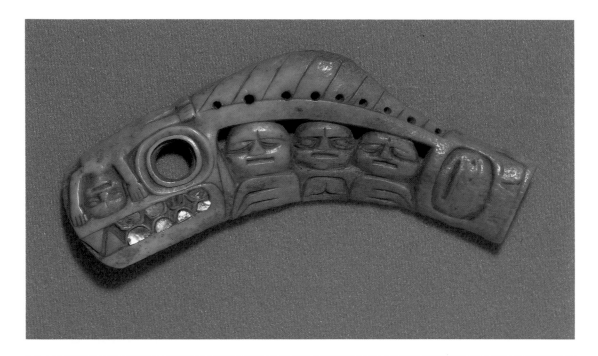

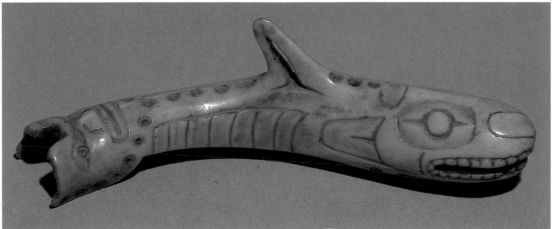

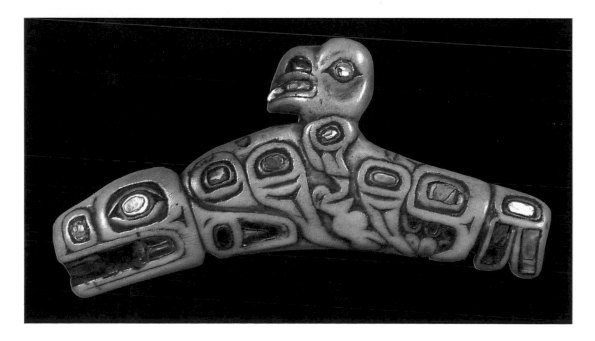

No. 229. Tlingit Amulet. A whale with three heads on the body and another on the tail. A human figure, upside down, is on the nose. Collected by Emmons (n.d., Notes, NMAI) from a grave house near Angoon. This piece matches the description of an amulet collected by Emmons in 1884–93, reportedly from a grave house on the Chilkat River (American Museum of Natural History, New York, E 2162; exchanged to Emmons, 1922). He (n.d.) writes of it as "carved to represent a whale spirit with . . . spirits underneath and one over the nose." The discrepancy in provenance is puzzling. Antler and abalone; length 4⅝ inches; c. 1820–50. National Museum of the American Indian, Smithsonian Institution, Washington, D.C., 11/1820. Purchased from Emmons, 1922

No. 230. Tlingit Amulet. A killer whale with a human face on the tail. Collected by Lord Bossom, c. 1900. Antler; length 5¼ inches; c. 1840–60. Canadian Museum of Civilization, Ottawa, VII–A–252. Acquired 1955

No. 231. Tlingit Amulet. The front of a whale is on the left, with the head of an eagle on the dorsal fin and its body to the right. The small figure below the eagle's shoulder feathers is a small bird held by a talon. By the same artist as an example published by Barbeau (1953, pl. 229, top), the present location of which is unknown. Collected by Emmons. Antler and abalone; length 5⅛ inches; c. 1820–40. Former collection: Harry Beasley (Emmons and Miles, 1939, pl. XIX, fig. 3). Private collection

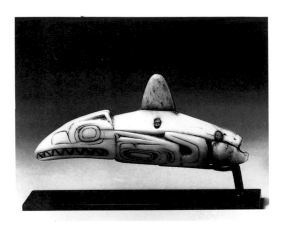

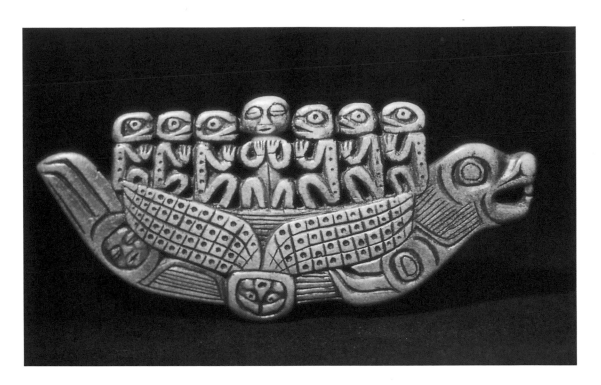

No. 232. *Tlingit Amulet*. Killer whale. Collected by Emmons. Walrus ivory and bone; length 3¼ inches; c. 1840–60. Former collection: Harry Beasley (Emmons and Miles, 1939, pl. XXI, fig. 2). Private collection

No. 233. *Tlingit Amulet*. A spirit canoe in the form of a sea lion with a devilfish on its body is carrying seven spirits. The face at the joint below the rear flipper represents a human in a trance. Said to have passed through several generations of Sitka shamans. Collected by Emmons at Sitka. Antler; length 5 inches; c. 1820–50. National Museum of the American Indian, Smithsonian Institution, Washington, D.C., 9/7948. Purchased from Emmons, 1920

No. 234. *Tsimshian Amulet*. Killer whale. Collected by Emmons at Gitksan. Antler and abalone; length 6½ inches; c. 1840–60. National Museum of the American Indian, Smithsonian Institution, Washington, D.C., 9/7954. Purchased from Emmons, 1920

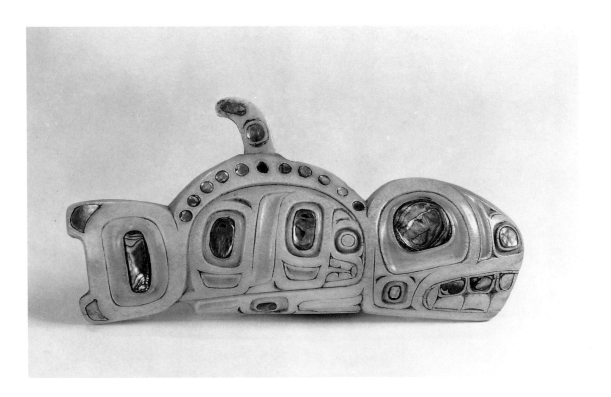

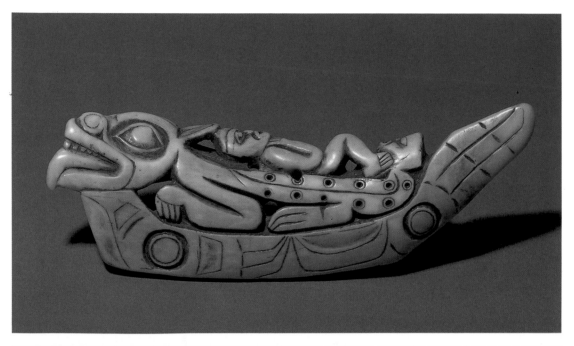

No. 235. *Tlingit Amulet*. A head canoe with sea lion flippers at the stern carries a land otter, the back of which is a devilfish with a human head. A reclining human, perhaps a shaman singing, is on the back of the otter. Holm (1987a, pp. 152–55) dates the head canoe to the early historic period. Although representations of the canoe could have been used on later objects, its depiction here suggests that the amulet was carved during the first part of the nineteenth century. Whale tooth; length 6⅛ inches; c. 1800–1830. Private collection

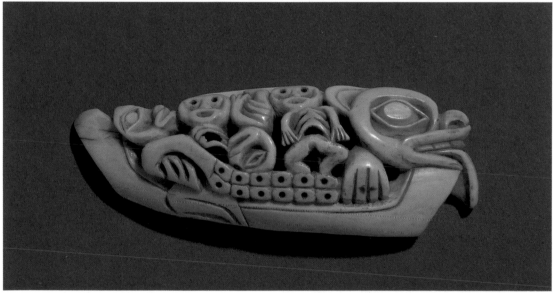

No. 236. *Tlingit Amulet*. A head canoe carries a land otter, three skeletonized spirit figures, and a devilfish with a human head. The combination of spirit figures, a land otter, and a devilfish on a head canoe is related to that of no. 235. Collected by George Heye, c. 1907. Whale tooth; length 4¼ inches; c. 1800–1830. National Museum of the American Indian, Smithsonian Institution, Washington, D.C., 1301. Given by Heye, 1907

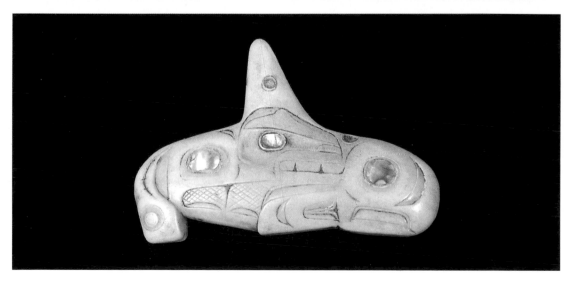

No. 237. *Haida Amulet*. A killer whale with an animal head below the dorsal fin and a bird head at the tail. Collected by Lieutenant F. M. Ring, c. 1870. Antler and abalone; length 3⅝ inches; c. 1820–50. National Museum of Natural History, Smithsonian Institution, Washington, D.C., 9813

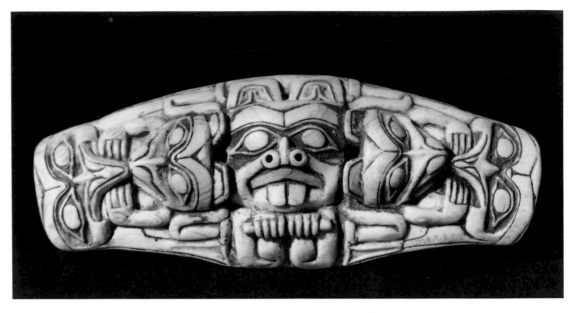

No. 238. Haida Amulet (two views). A beaver flanked by crouching bears confronting the heads of birds on the front, and a killer whale with an arrow-shaped tongue on the back. Whale tooth amulets are rarely carved on both sides as here. Given to the artist Paul Kane by George William Allan, 1846–48. Whale tooth; length 4½ inches; c. 1820–40. Royal Ontario Museum, Toronto, 946–81–8. Given by Mary Raymond Willis, a descendant of Paul Kane, 1946

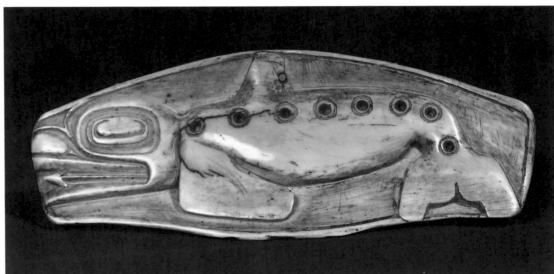

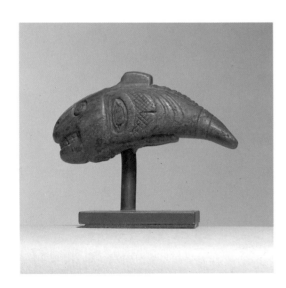

No. 239. Haida Amulet. A whale with a reclining human figure at the bottom and a human face in its blowhole. Stone and red pigment; length 1⅞ inches; c. 1840–60. Private collection

No. 240. Tlingit Amulet. Sculpin. Collected by Edward Ayer, probably from Carl Spuhn, 1892 (see Cole, 1985, p. 125). Sea lion tooth; length 3½ inches; c. 1840–60. Field Museum of Natural History, Chicago, 14321. Given by Ayer, 1894

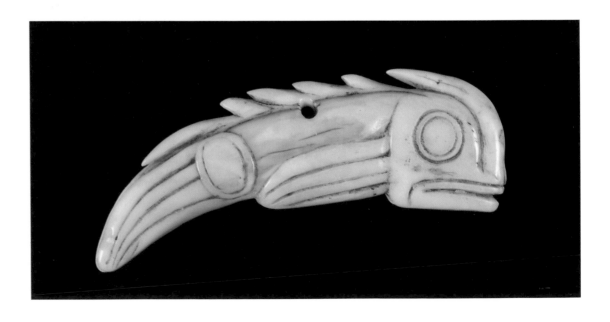

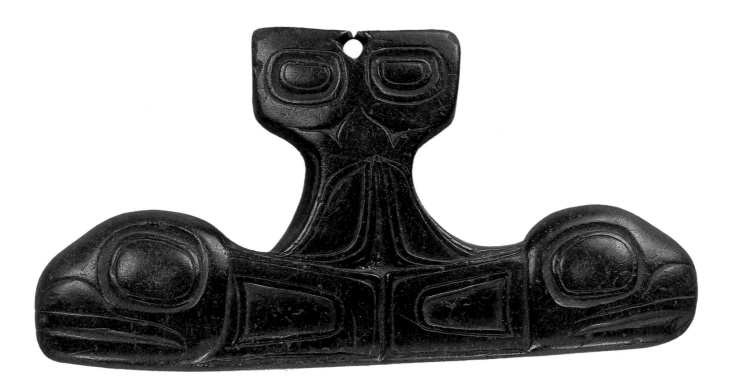

No. 241. Haida Amulet. Two whale figures, back to back. Collected by Emmons. Argillite; length 6¾ inches; c. 1840–60. National Museum of the American Indian, Smithsonian Institution, Washington, D.C., 9/7967. Purchased from Emmons, 1920

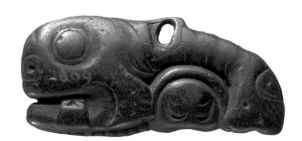

No. 242. Tlingit Amulet. A whale with a devilfish on the bottom. Extensive wear indicates considerable age. Collected by Captain Edward G. Fast at Sitka, 1867–68. Stone; length 2¾ inches; c. 1790–1820. Peabody Museum of Archaeology and Ethnology, Harvard University, Cambridge, 69–30–10/1809. Purchased from Fast, 1869

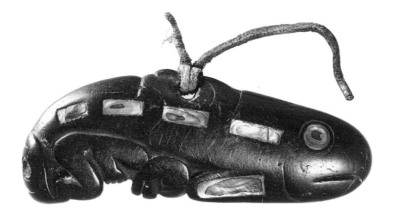

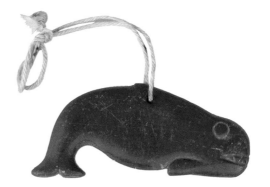

No. 244. Tsimshian Amulet. Whale. Collected along the Skeena River. Stone and twine; length 2¼ inches; c. 1840–60. Field Museum of Natural History, Chicago, 18054. Given by Mrs. O. Morrison, 1893

No. 243. Haida Amulet. A whale with a crouching human figure at the bottom. Argillite and abalone; length 3⅝ inches; c. 1820–50. Museum of Mankind, London, 6823. Purchased from Dr. P. Comrie, R.N., 1870

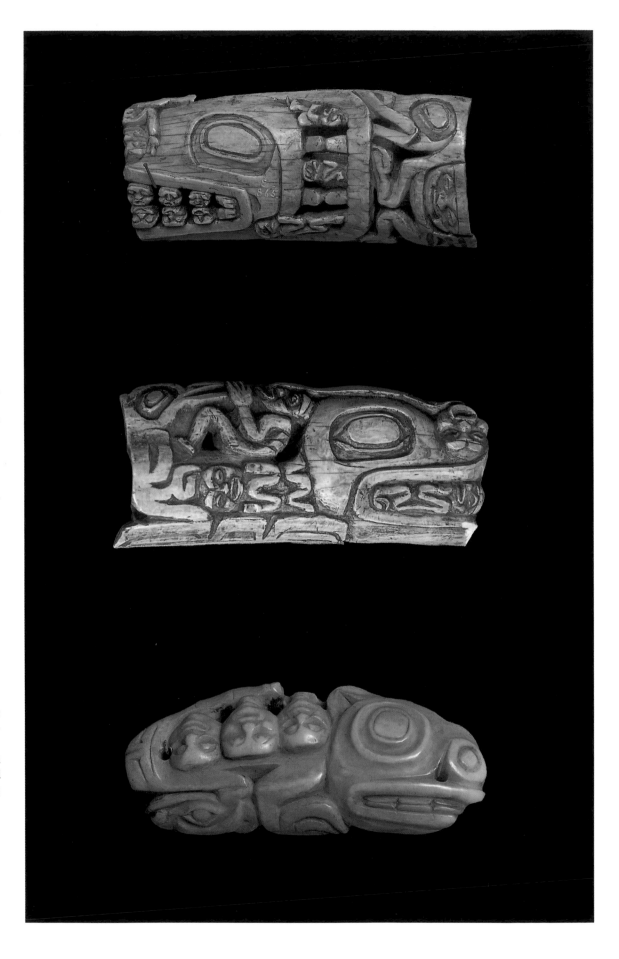

No. 245. Tlingit Amulet. Emmons (n.d.) describes the figure as a whale with a wolf at the back. A figure of a human is on the snout, and three double-headed faces are in the mouth. Three small seated and squatting figures are behind the whale's head. Originally attached to a dancing robe with no. 246, which is by the same artist. Collected by Emmons from the grave house of a Hutsnuwu shaman near Angoon, 1884–93. Bone; length 5½ inches; c. 1840–60. American Museum of Natural History, New York, E 865. Purchased from Emmons, 1893

No. 246. Tlingit Amulet. A bear with a human face on its snout devours a human. Behind its head is a reclining human holding the head of a raven. Another splayed human figure is above the bear's claw. Originally attached to a dancing robe with no. 245, which is by the same artist. Collected by Emmons from the grave house of a Hutsnuwu shaman near Angoon, 1884–93. Bone; length 5½ inches; c. 1840–60. American Museum of Natural History, New York, E 864. Purchased from Emmons, 1893

No. 247. Tlingit Amulet. Emmons (n.d.) identifies the large figure as a bear; a land otter is on the bottom of the other end. The three heads are those of witches. Originally attached to a moose skin robe. Collected by Emmons in 1882–87 from a grave house on a rocky promontory near Hoonah which contained the bodies of two shamans. Ivory; length 3¾ inches; c. 1820–50. American Museum of Natural History, New York, 19/452. Purchased from Emmons, 1888

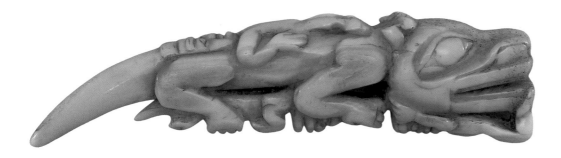

No. 248. Tlingit Amulet. A land otter with a reclining human figure on its back and two human figures underneath. Collected by Emmons. Animal tooth; length 5¼ inches; c. 1820–50. Former collection: Harry Beasley (Emmons and Miles, 1939, pl. xix, fig. 4). Private collection

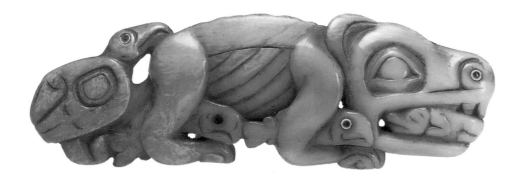

No. 249. Tlingit Amulet. A bear with two salmon between its claws devours a land otter. At the left is a bird form. Collected by Emmons. Animal tooth and bird bone; length 4⅞ inches; c. 1820–50. Former collection: Harry Beasley (Emmons and Miles, 1939, pl. xx, fig. 2). Private collection

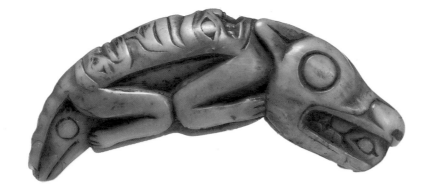

No. 250. Tlingit Amulet. A land otter with two heads on its back devours an animal. Under its tail is a bird head. Collected by Emmons. Animal tooth; length 4 inches; c. 1820–50. Former collection: Harry Beasley (Emmons and Miles, 1939, pl. xx, fig. 1). Private collection

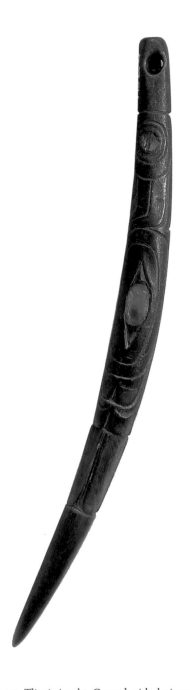

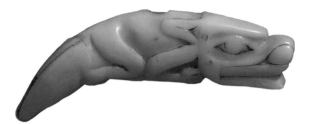

No. 252. *Tsimshian Amulet.* The thick tail denotes representation of a land otter. Bear tooth; length 2¾ inches; c. 1820–50. Private collection

No. 253. *Tlingit Amulet.* A bear with a land otter on its back. Part of an entire shaman's kit of unknown provenance collected by Emmons. Ivory; length 4 inches; c. 1840–60. National Museum of the American Indian, Smithsonian Institution, Washington, D.C., 16/1719uu. Purchased from Emmons, 1928

No. 251. *Tlingit Amulet.* Carved with designs of an unidentified animal. Amulets of mountain goat horn are unusual, and this was probably one of other such elements of a necklace. Collected by Emmons. Mountain goat horn and abalone; length 6⅜ inches; c. 1840–60. National Museum of the American Indian, Smithsonian Institution, Washington, D.C., 5/4225. Given by Harmon Hendricks, 1916

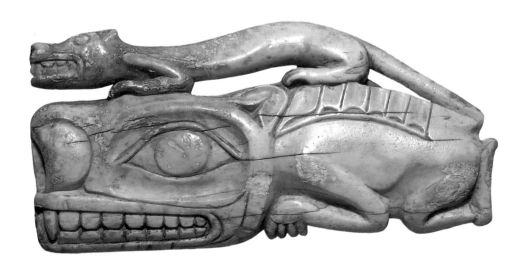

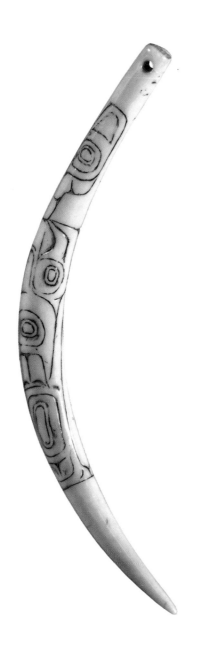

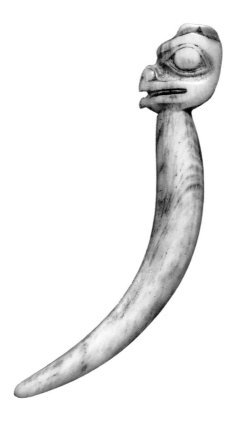

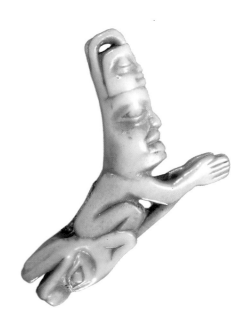

No. 254. *Tlingit Amulet.* A bear head at the top. Collected by George Davidson. Whale tooth; height 4⅜ inches; c. 1840–60. Lowie Museum of Anthropology, University of California at Berkeley, 2–19102. Given by the estate of Ellinor Davidson

No. 255. *Tlingit Amulet* (left). Carved with designs representing a bear. Ivory; length 6 inches; c. 1840–60. The Metropolitan Museum of Art, New York, 1979.206.1023. The Michael C. Rockefeller Collection, bequest of Nelson A. Rockefeller, 1979

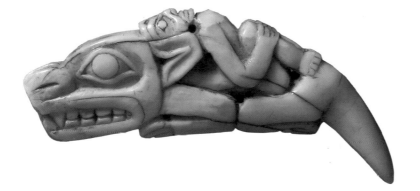

No. 256. *Tlingit Amulet.* A crouching figure with upraised hands has the head of a man in a trance on its head. At the bottom is a bear head. Antler; length 3 inches; c. 1820–50. Mr. and Mrs. Raymond Wielgus Collection, Tucson

No. 257. *Tlingit Amulet* (left). A human figure lies on the back of a land otter. Sea lion tooth; length 3⅞ inches; c. 1840–60. Private collection

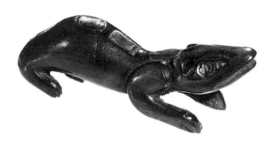

No. 258. *Tlingit or Haida Amulet*. Land otter. Most amulets were made to be worn, but this unique freestanding sculpture is not pierced for suspension. It was probably manipulated during séances. Mountain goat horn and abalone; length 2½ inches; c. 1840–60. Museum of Mankind, London, 1959–AM–1. Given by James Dunster, 1959

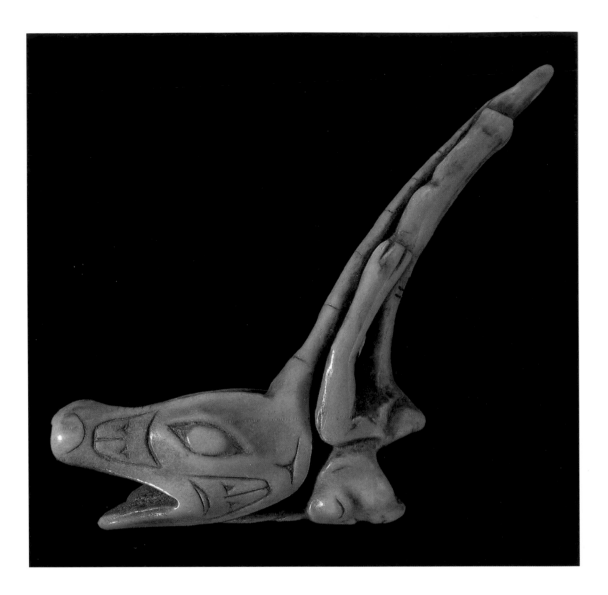

No. 259. *Tlingit Amulet* (right). Emmons (n.d., Notes, NMAI) identifies the figure behind the wolf head as a witch. Collected by him at Hoonah. Antler; length 5¼ inches; c. 1820–50. National Museum of the American Indian, Smithsonian Institution, Washington, D.C., 11/349. Purchased from Emmons, 1922

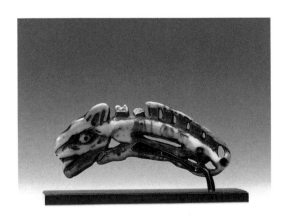

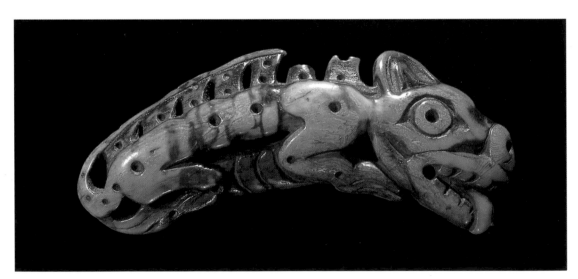

No. 260. *Tlingit Amulet* (two views). Land otter. The evidence of considerable wear, dark color, and simplified sculptural details suggest an early date. Whale tooth; length 4½ inches; c. 1750–1800. Mr. and Mrs. Raymond Wielgus Collection, Tucson

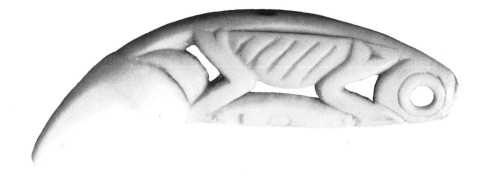

No. 261. Tlingit Amulet. Gunther (1962, p. 99, no. 332) identifies the animal as a killer whale, but it is more likely a land otter. Collected by Midshipman W. Bower Scott in 1792 on George Vancouver's voyage around the world. Bear tooth; length 4⅜ inches; c. 1700–50. Royal Albert Memorial Museum, Exeter, England, 792

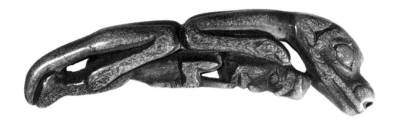

No. 262. Tlingit Amulet. Land otter holding a human figure. Collected by a naval officer in Alaska, c. 1895. Bone; length 3⅝ inches; c. 1840–60. Museum of Mankind, London, 1951 AM.9.1. Purchased from Mrs. K. Cowden, 1951

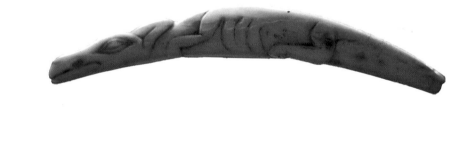

No. 263. Tlingit Amulet. Land otter. Collected by Emmons. Walrus ivory; length 4 inches; c. 1840–60. Former collection: Harry Beasley (Emmons and Miles, 1939, pl. XXI, fig. 4). Private collection

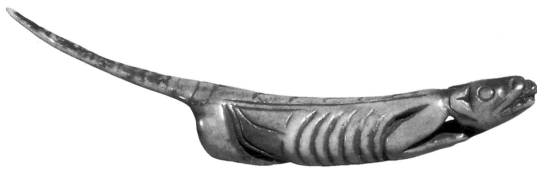

No. 264. Tlingit Amulet. Land otter. Collected by James G. Swan. Walrus ivory; length 5¼ inches; c. 1800–1850. Museum für Völkerkunde, Vienna, 19.763. Acquired from Franz Steindachner, 1876 (see Cole, 1985, p. 19)

No. 265. Tsimshian Amulets (right). Two standing human figures. Collected by Emmons. Mountain goat horn, cedar bark, and red pigment; height of longer amulet 2¼ inches; c. 1850–70. National Museum of the American Indian, Smithsonian Institution, Washington, D.C., 5/4231. Given by Harmon Hendricks, 1916

No. 266. Tlingit Amulet (far right). A bear with three human heads in its mouth is in the center; below are two human and two animal heads. An animal head, perhaps a land otter, is at the bottom. Figures and heads of at least fifteen human and animal spirits appear in this complex carving. Found with nos. 140 and 157 in a box containing a shaman's paraphernalia (Paalen, 1943, pp. 19, 36). Walrus ivory; height 3¾ inches; c. 1820–50. Former collection: Wolfgang Paalen. The Metropolitan Museum of Art, New York, 1979.206.518. The Michael C. Rockefeller Collection, bequest of Nelson A. Rockefeller, 1979

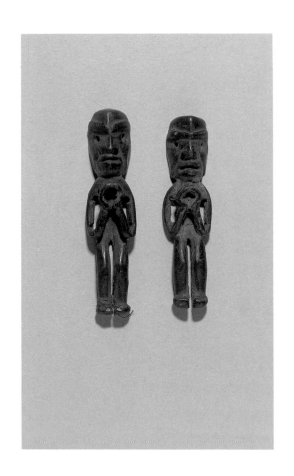

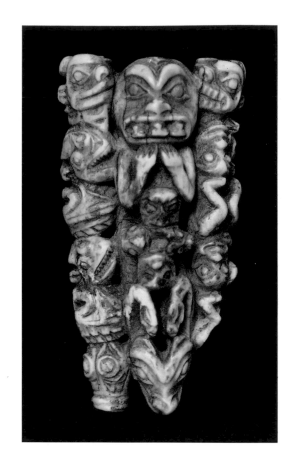

No. 267. Tlingit Amulet (right). Bound witch. Collected by Emmons from a grave house containing the bodies of two shamans near Hoonah, 1882–87. The amulet had been attached to a moose skin robe. Ivory; height 2¾ inches; c. 1820–50. American Museum of Natural History, New York, 19/455. Purchased from Emmons, 1888

No. 268. Tlingit Amulet (far right). Three human figures with seated bears in profile at the sides are carved on both the front and the back. Undecorated ivories of this shape were attached to the end of hide sheaths for fighting knives. This example was reworked to serve as an amulet. Collected by Emmons from the grave house of a Hutsnuwu shaman, 1884–93. Ivory; height 3¼ inches; c. 1820–50. American Museum of Natural History, New York, E 2713. Purchased from Emmons, 1893

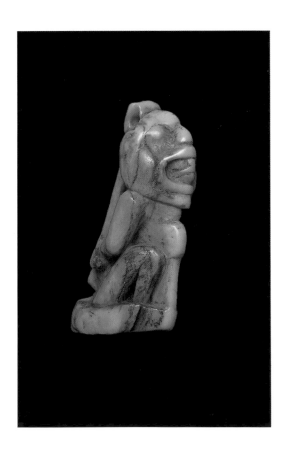

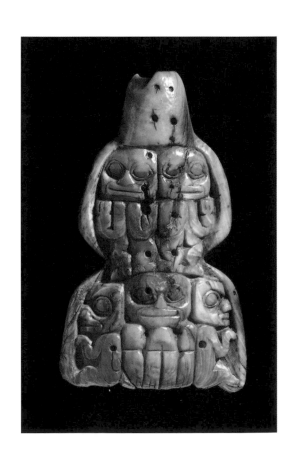

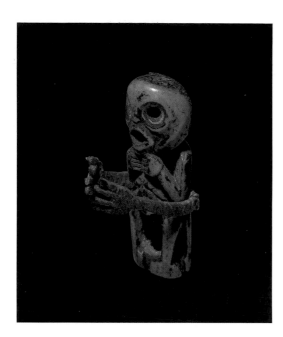

No. 269. *Bella Bella Amulet.* Emmons (n.d., Notes, NMAI) describes this as a death or witchcraft medicine figure. It was shown by a shaman only to those he wished to kill, presumably witches. Emmons collected the amulet from the missionary James M. Tate, who had received it from its shaman owner on the condition that it never be seen by the Bella Bella. Amulets from the Bella Bella are rare. Ivory, animal skin, and black pigment; height 2 inches; c. 1820–50. National Museum of the American Indian, Smithsonian Institution, Washington, D.C., 11/3860. Purchased from Emmons, 1922

No. 270. *Tlingit Amulet.* A shaman wearing a crown. Collected by Emmons at Angoon. Walrus ivory; height 1⅝ inches; c. 1840–60. Thomas Burke Memorial, Washington State Museum, Seattle, 1821. Purchased from Emmons, 1909

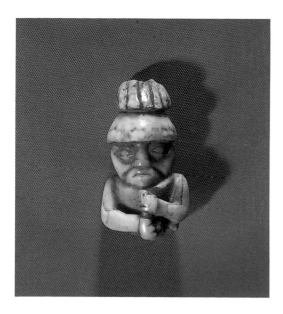

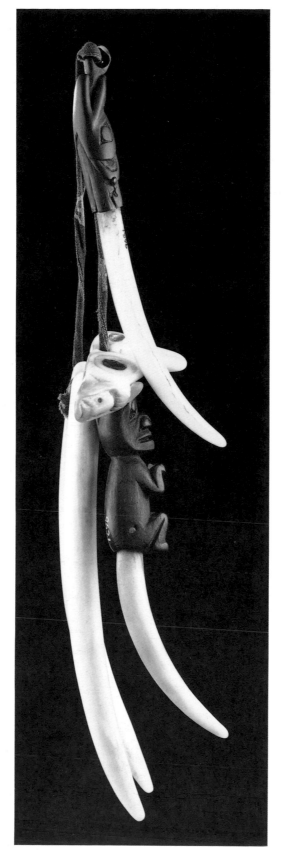

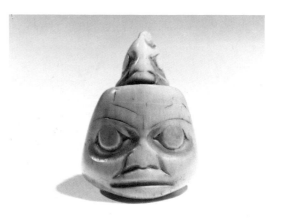

No. 272. *Haida Amulet.* A human face with an animal head on top. Ivory; height 1¾ inches; c. 1820–50. The Brooklyn Museum, New York, 86.224.176. Bequest of Ernest Erikson, 1986

No. 271. *Tsimshian Pendant (center).* A crouching human and a bird figure with an animal head, both of horn, are at the top, and an ivory fish is in the center. Four undecorated ivory tines have been added to this unique pendant. Collected by Charles F. Newcombe from J. Priestley at Aiyansh. Whale ivory, mountain goat horn, abalone, and rawhide; length approximately 8 inches; c. 1820–50. Royal British Columbia Museum, Victoria, 9621. Purchased from Newcombe, 1917

No. 273. *Tsimshian Amulet.* A seated woman wearing a labret. Collected by Charles F. Newcombe at Lakalzap (Greenville), 1913. Bone; height 3⅜ inches; c. 1830–60. Royal British Columbia Museum, Victoria, 10034

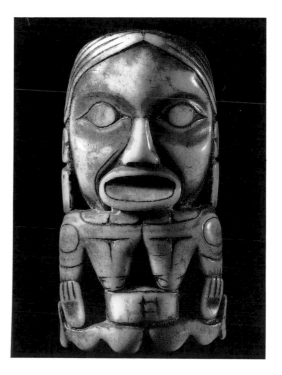

No. 274. Tlingit Amulet. A double-headed animal, perhaps a bear, with a seated human figure in a trance in the center. Purchased at Wrangell. Ivory; length 2⅞ inches; c. 1820–50. National Museum of the American Indian, Smithsonian Institution, Washington, D.C., 2/2089. Acquired 1909

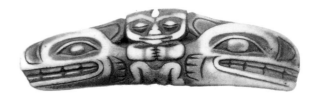

No. 275. Tsimshian Amulet. A double-headed bear with a human face in a trance in the center. Collected by Charles F. Newcombe at Lakalzap (Greenville), 1917. Ivory; length 2¾ inches; c. 1830–50. Royal British Columbia Museum, Victoria, 9547a. Acquired from Newcombe, 1917

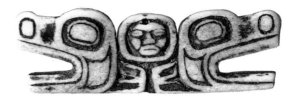

No. 276. Tsimshian Amulet. A double-headed animal, perhaps a whale, with a splayed human figure in the center. Bone and abalone; length 3 inches; c. 1830–50. Museum of Mankind, London, 1949 AM.22.107. Purchased from the William O. Oldman Collection, 1949

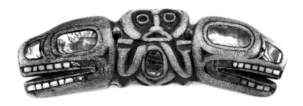

No. 277. Tsimshian Amulet. A double-headed bear with a human face in the center. The downturned, fleshy facial features of the human show it is by the same artist as nos. 293 and 294. Collected by Emmons at Gitlakdamiks. Ivory; length 2¾ inches; c. 1840–60. National Museum of the American Indian, Smithsonian Institution, Washington, D.C., 1/4659. Purchased from Emmons, 1907

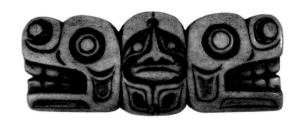

No. 278. Tlingit Amulet. A squatting human figure between two animal heads, with a devilfish below and two smaller human heads at the top. The shaman photographed by Edward de Groff at Sitka in 1889 wears this amulet in two of the photographs of the series (see fig. 4). Collected by Emmons from an old Chilkoot shaman, c. 1888. Ivory; length 3½ inches; c. 1820–50. American Museum of Natural History, New York, E 2705. Purchased from Emmons, 1893

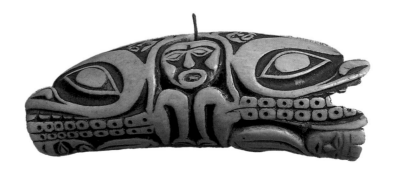

THE INITIATION OF A SHAMAN
(Tlingit)

A few weeks before we visited in the Chilkat village of Klukwan in January, 1882, an old sha-man of the Raven clan had died and was buried with . . . ceremonies. . . . During our visit a new shaman was initiated. All the adults of the Raven clan fasted for four days, the children, only two days, while the new shaman fasted eight days with only a break on the morning of the fifth day when he received a morsel of food. The whole tribe was assembled in the house of the dead shaman and in the evenings ceremonial dances were executed in the light of the blazing fire, accompanied loudly on the drum. The participants, men and boys, stood around the fire, the boys nearer the blaze, all dressed in festive, clean clothing, decorated with fresh conifer twigs which were garlanded around the neck. In the background, and along the left wall from the entrance squatted the women with the small children, while the rest of the space was crowded with spectators. At the right of the entrance on a raised platform stood the leader of the cer-emonial, who, with the help of several old Indians, gave the beat for all the songs. On a rack close to him hung all the regalia of the shamans, heavy with teeth, beaks and other kinds of rattles, which they wore around the neck, their headgear with its ermine which cascaded down the back, the dance aprons woven of mountain goat wool, various masks and many other things. Two old shamans, recognized by their long, unkempt hair and fantastic headgear, were also present. The songs were sung in chorus, accompanied by the drum and the beating together of wooden sticks. The drum was a brightly painted wooden box with one side covered with skin. It was pounded with the feet. Occasionally the songs were interrupted by the shouting of ques-tions and answers; then all the participants resumed with greater enthusiasm, shaking their clenched fists and stamping on the floor, as they moved toward the fire and back again. All these movements were carried out with extraordinary rhythm and great precision. These were only short pauses between the individual songs, of which four were sung with great ear-nestness and concentration by the assembly. During the third song two wooden chests were lowered through the smoke hole, and the masks, rattles and drums which they contained were unpacked. Each mask was held near the fire while the song was continued without interruption.

The fourth song was sung in a lively tempo. During the wildest part, a young Indian, who had remained hidden among the back rows of the dancers, plunged forward suddenly almost through the fire toward the wooden drum and fell to the ground unconscious after some con-vulsive contortions and when someone near him had thrown one of the shaman's necklaces over his head. This was the new shaman. For a time he remained apparently unconscious while the song continued as though nothing had happened. When he gained consciousness he with-drew into the rows of spectators and soon thereafter the ceremony ended.

The shaman's regalia which was contained in the two chests was removed in the same way in which it was introduced, namely through the smoke hole, and as a conclusion to the ceremony down, which had been lowered through the smoke hole, was blown into the air. (Krause, 1956, pp. 201–2)

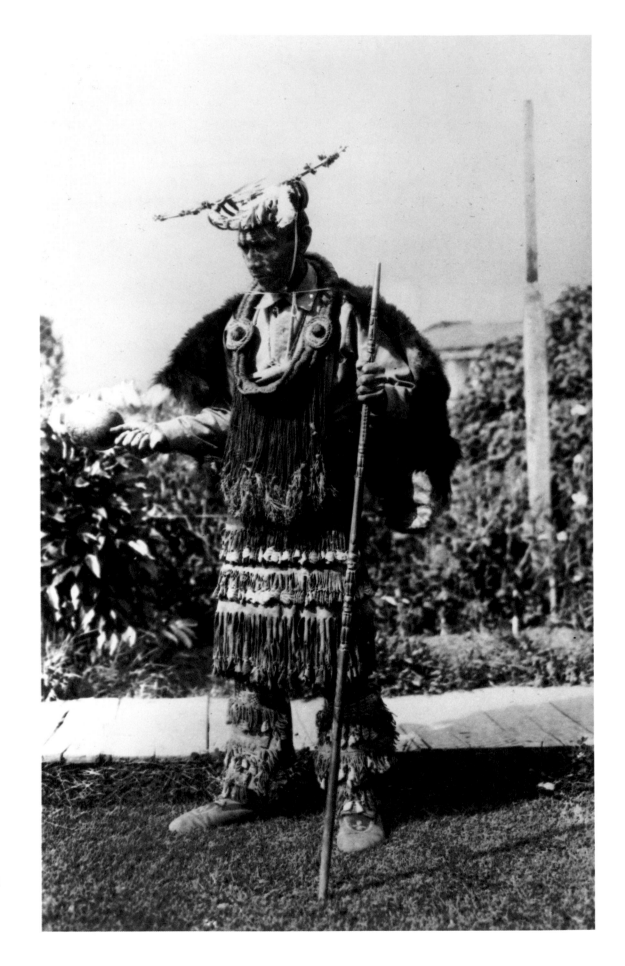

Fig. 34. Claude Mark, a Tsimshian Shaman of the Gitksan. He wears a crown and a soul catcher, and carries a relief-decorated rattle and a carved staff. Photograph possibly by Marius Barbeau, 1924. National Museums of Canada, Ottawa, 59800

SOUL CATCHERS

SOUL CATCHERS are an important subcategory of amulets. Hollow cylinders that are carved in relief and pierced for suspension, almost all are made of bone, which is often said to be the femur of a bear. Those made of bone are now thought to have been made only by the Tsimshian (Holm, 1983, p. 119, no. 203), but were used by the Tlingit, Haida, and Bella Bella as well. The few wood examples are not necessarily of Tsimshian origin; one is sheathed in copper (no. 297). There is one undecorated Tsimshian stone specimen in the Canadian Museum of Civilization (VII-C-572). Some are inlaid with abalone on the front, but rarely on the back. Originally they had plugs of cedar bark stuffed into each end.

Barbeau (1958, p. 57) describes soul catchers as "one of the most potent charms in a medicine bag." Shamans, who wore them suspended from their necks, used them to recover souls that had left a patient's body and were thus causing illness. With the aid of chanting and trances, a shaman could locate a soul, induce it to enter the container, hold it there by inserting the cedar bark plugs, and finally return it to the host to effect a cure. Soul catchers could also be used for blowing out or sucking away disease and evil. They served other purposes as well. Miller (1984, p. 141), for example, states that a shaman's spirit helpers occupied the soul catcher's center.

Each end of a soul catcher is carved in relief with an open-mouthed animal that Holm (1983, p. 119, no. 202) suggests could represent a wolf, whale, or bear. In the center is often a human figure, sometimes with hands, arms, or the entire body shown in a splayed pose. A number of amulets that are in the form of a double-headed animal with a face in the center (see nos. 274–78) may have had a significance similar to that of soul catchers. The double-headed monster is important to Northwest Coast mythology as a being that could change shape and move through the realms of air, water, and earth (see Guédon, 1984b, p. 208). Guédon (ibid., p. 202) believes the inspiration for this motif may have been the otter canoe, "often described as having a mouth at each end.... This is one of the indications that the so-called soul-catcher could indeed be a representation of the otter-canoe." She (ibid.) also mentions the use of such a canoe by other shamans as they were "travelling to look for the lost soul of a patient or even catching and swallowing the soul."

THE SHAMAN MOUTH AT EACH END
(Tsimshian)

At the end of our ancestors' time the people lived on Skeena River.... One day some hunters left their home and went toward the east. They came to a great lake named Lake Of The Beginning. This was the lake of Skeena River. When the hunters reached there, the waters of the great lake began to rise, and the lake overflowed. The waters ran down the Skeena River, and almost all the villages on the river were swept by the currents. The hunters looked on, and, behold! a great whale rose to the surface of the lake. The water of the Lake Of The Beginning rose because the great whale came up. It had gills like a fish, and four fins in a row along the back, like the fin of a

killer whale which is near its spouting-hole. When the great whale went down, the waters subsided.

The next year two brothers of the same village started and went to the Lake Of The Beginning to get supernatural power. The elder one went out into the water; and when the water reached above his knees, he went down to the bottom of the great lake. Then the water rose again as before, and the great whale came out. The younger brother remained on the shore. He saw the waters rising higher and higher, and the Skeena River was flooded again, for the water of the great lake rose higher than ever.

As soon as the man had gone down, he saw a large house at the bottom of the lake. He entered; and no one was in there, but a large fire was burning in the middle of the house, and he himself sat down on a mat which was spread by the side of the fire. After he had been sitting there for a while, the door opened suddenly, and, behold! a flash of lightning came in. This happened four times. Thunder was rolling four times. It was a terrible thunderclap. After it had thundered four times, it began to hail, and it was terrible hail. Soon after this a large Grizzly Bear came out from the carved screen in the middle of the rear of the house. The Grizzly Bear came toward the man who was seated on the mat by the large fire.

The Grizzly Bear stood in front of him, and said, "Open my back!" Thus spoke the Grizzly Bear to the man. The man did so, and the Bear had become a carved box. Then the Thunderbird came from behind the carved screen. The Thunderbird came up to the man, and said to him, "Take me and put me into the box!" The man took it and put it into the grizzly-bear box, and the Thunderbird became a drum, and the lightning was his red ocher. Then Living Eyes came forth from behind the carved screen; and after a while, behold! a very large animal came in at the door, which they call at this time Mouth At Each End. It came toward the man, stood in front of him, and said, "Take me and put me into the box!" A Cuttlefish also came, went toward the man, and said, "Take me and put me into the box!" The man took both of them and put them into the grizzly-bear box. At last the Living Eyes came in. It was the hail. It was a baton. It also went toward the man, and said, "Take me and put me into the box!" The man took it and put it into the carved box. Still no living person was to be seen in the house.

Then he started for home; and the live Grizzly Bear said to him, "Your name shall be Mouth At Each End."

The man came ashore with the Grizzly Bear walking by his side. The man had been in the depths of the Lake Of The Beginning quite a long while....

Then all the supernatural beings in the mountains heard that Mouth At Each End had a really great supernatural helper, and tried to kill him. Mouth At Each End, however, knew about it, and was ready to fight with them. As soon as one of the supernatural powers of a shaman came secretly to kill him, the shaman Mouth At Each End sent his supernatural helpers Mouth At Each End and Cuttlefish, who killed those who tried to murder their master; or, if a shaman came through the water, Mouth At Each End and Cuttlefish would go into the water and destroy him; or, if a shaman with his supernatural helpers came overland, the Grizzly Bear would fight him and destroy him; or, if a supernatural power came up flying through the air, Thunderbird and Lightning with Hail would destroy him. Therefore the supernatural beings from all parts of the world could not kill this shaman, Mouth At Each End.

(Boas, 1916, pp. 346–48)

No. 279. Tsimshian Soul Catcher (opposite, two views). This extremely elaborate example shows crouching bears at the ends and a splayed human figure on one side, with a more conventional, two-headed animal on the other. Emmons (n.d., Notes, NMAI) states that it belonged to the head chief of the Eagle clan of Kitwancool, who was also a shaman. According to Emmons, the soul of an ailing patient was blown back into his body through this object. Collected by Emmons at Kitwancool. Bone and abalone; length 8¼ inches; c. 1840–60. National Museum of the American Indian, Smithsonian Institution, Washington, D.C., 9/7935. Purchased from Emmons, 1920

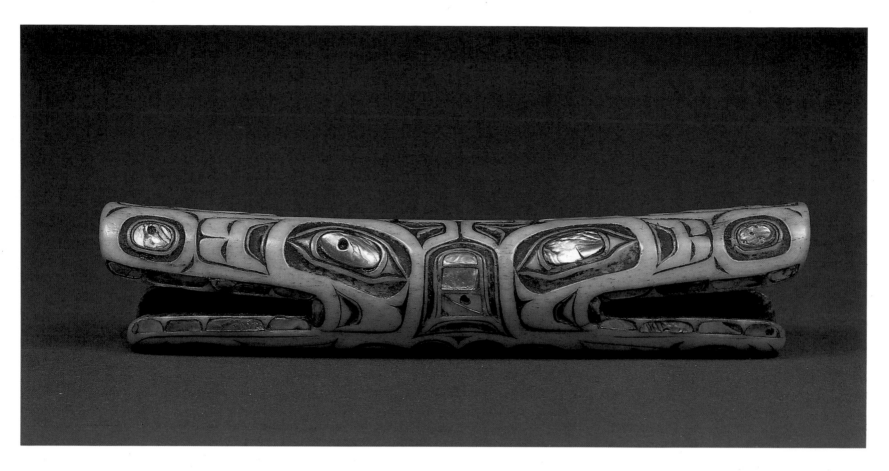

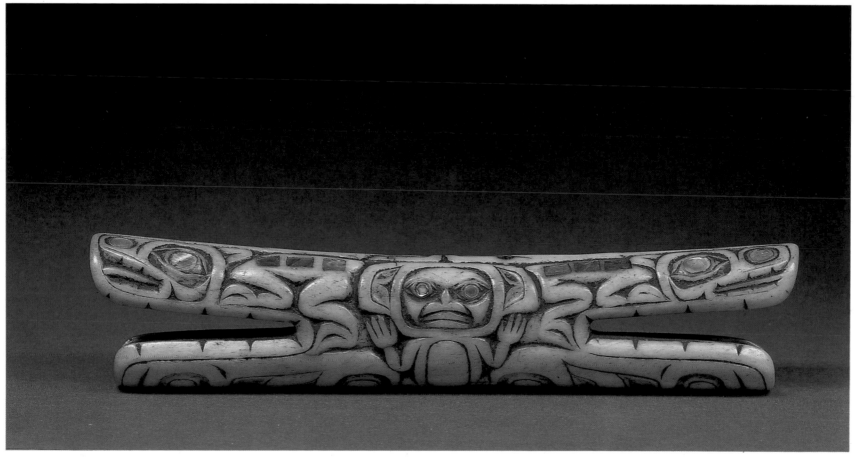

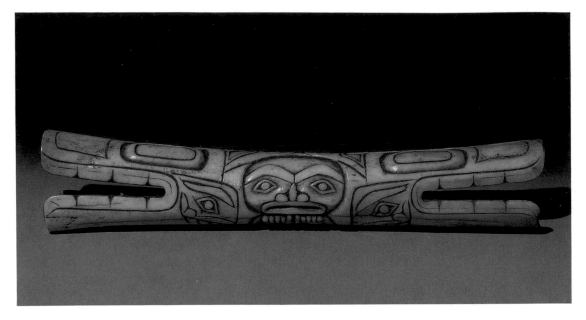

No. 280. Tsimshian Soul Catcher. A seated human figure flanked by two faces in profile and two animal heads. Collected by William A. Newcombe in 1905 on the Nass River at a village called "Guin-eh-ne" in the museum records. Bone; length 7⅜ inches; c. 1840–60. Canadian Museum of Civilization, Ottawa, VII–C–169. Acquired from Newcombe, 1909

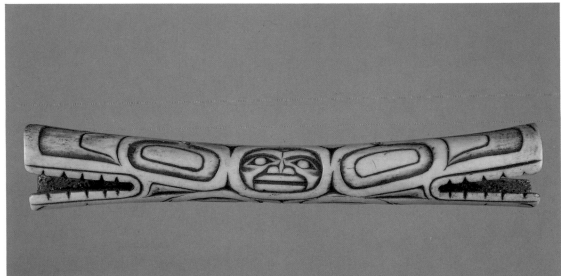

No. 281. Tsimshian Soul Catcher. A human face between two animal heads. Bone; length 6⅜ inches; c. 1840–60. The Eugene V. and Clare E. Thaw Collection, Fenimore House Museum, Cooperstown, New York

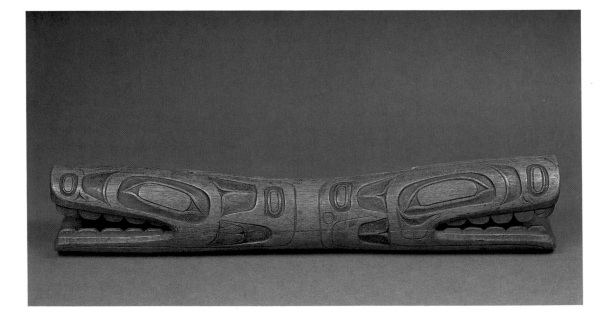

No. 282. Haida Soul Catcher. Bear heads at the ends. This unusual wood example was collected at Tanu by Thomas Crosby. Because it is not made of bone, it may well be of Haida and not Tsimshian manufacture. Wood and traces of red pigment; length 12⅞ inches; c. 1850–70. National Museum of the American Indian, Smithsonian Institution, Washington, D.C., 1/8055. Acquired 1908

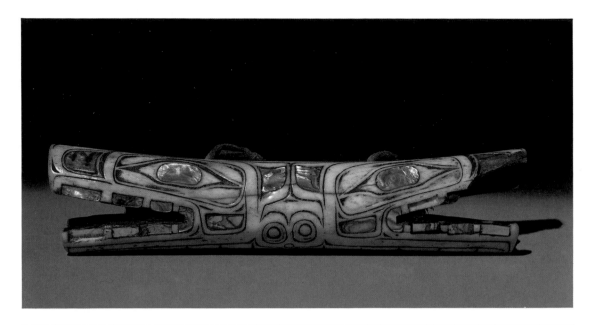

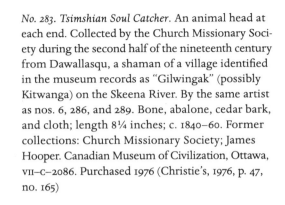

No. 283. *Tsimshian Soul Catcher*. An animal head at each end. Collected by the Church Missionary Society during the second half of the nineteenth century from Dawallasqu, a shaman of a village identified in the museum records as "Gilwingak" (possibly Kitwanga) on the Skeena River. By the same artist as nos. 6, 286, and 289. Bone, abalone, cedar bark, and cloth; length 8¼ inches; c. 1840–60. Former collections: Church Missionary Society; James Hooper. Canadian Museum of Civilization, Ottawa, VII–C–2086. Purchased 1976 (Christie's, 1976, p. 47, no. 165)

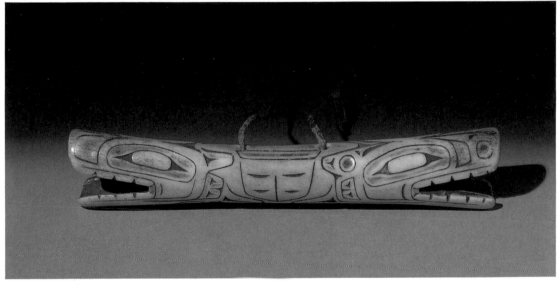

No. 284. *Tsimshian Soul Catcher*. Although the ornamentation on most soul catchers is symmetrical, close examination of this example reveals subtle differences between the designs at the ends of the noses and those at the ears of the two animal heads. Collected by William A. Newcombe at Gitlakdamiks, 1905. Bone and rawhide; length 6¾ inches; c. 1840–60. Canadian Museum of Civilization, Ottawa, VII–C–249. Acquired from Newcombe, 1909

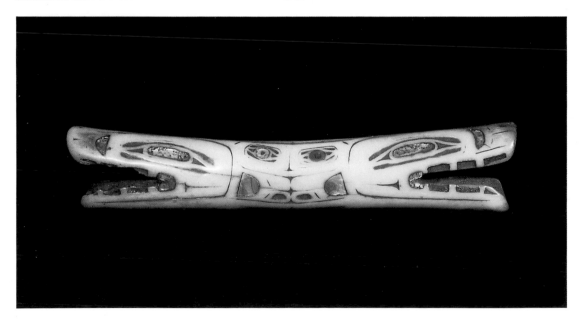

No. 285. *Tsimshian Soul Catcher*. Extensive wear and the broad, early formline designs suggest that this object was used by several generations of shamans and is of considerable age. As with no. 291, the cedar bark stoppers are still in place. Although collected from the Haida on the Queen Charlotte Islands by A. A. Aronson, it is here attributed to the Tsimshian on the basis of Holm's (1983, p. 119, no. 203) statement "that most very well documented examples [of soul catchers] were collected from that tribe, and information on them comes from the Tsimshian." Purchased from Aronson by James A. Terry, c. 1882 (see Cole, 1985, p. 125). Bone, abalone, and cedar bark; length 6½ inches; c. 1750–1800. American Museum of Natural History, New York, T 22644. Purchased from Terry, 1891

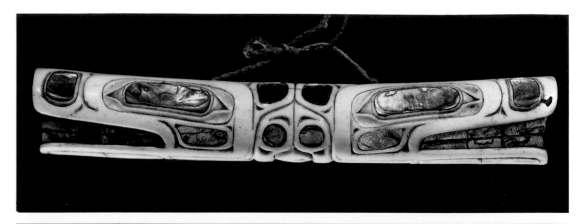

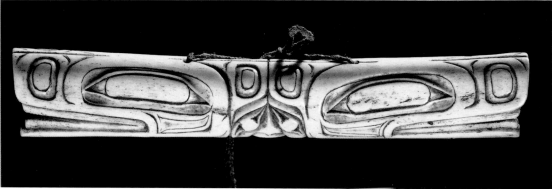

No. 286. *Tsimshian Soul Catcher* (two views). An animal head, probably a bear, at each end. By the same artist as nos. 6, 283, and 289. Collected by Charles F. Newcombe from J. Priestley at Aiyansh. Bone, abalone, and rawhide; length 7½ inches; c. 1840–60. Royal British Columbia Museum, Victoria, 9620. Acquired from Newcombe, 1912

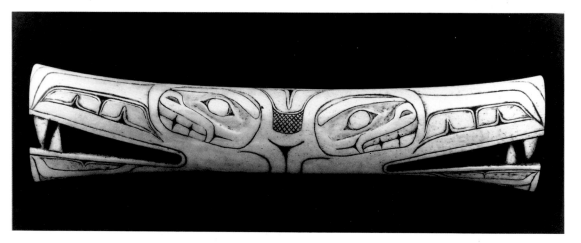

No. 287. *Tsimshian Soul Catcher*. Two bear heads placed back to back, with animal mouths at the ends. The separately carved canine teeth are an unusual detail on a soul catcher. This view is of the back. The other side is carved with two animal heads similar to those on other examples. Collected by George Davidson. Bone; length 8 inches; c. 1840–60. Lowie Museum of Anthropology, University of California at Berkeley, 2–19099. Given by the estate of Ellinor Davidson

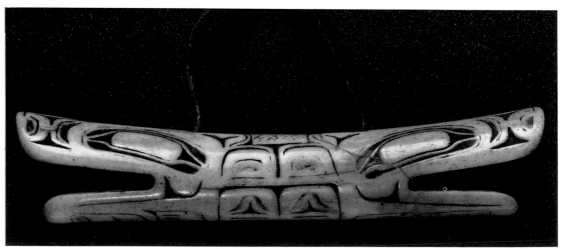

No. 288. *Tsimshian Soul Catcher*. An animal head, probably a bear, at each end. Gunther (1966, p. 243) quotes Sam Jackson, a previous owner, as saying that such objects could be used by anyone, not just shamans. After fasting and deprivation from water, visions were induced and magic could be practiced by the owner. Acquired by Jackson from a Captain Acton on the Skeena River, 1932; collected from him by Axel Rasmussen. Described as grizzly bear bone by Gunther (ibid.). Bone, rawhide, and red pigment; length 7 inches; c. 1830–50. The Portland Art Museum, Oregon Art Institute, 48.3.81. Axel Rasmussen Collection. Purchased 1948

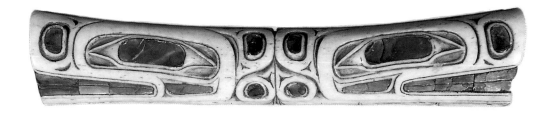

No. 289. *Tsimshian Soul Catcher.* An animal head at each end. Although most soul catchers are reputed to be made of bears' femur bones, this one was said to have been made of human bone (Emmons, n.d., Notes, NMAI). The mosaic inlays of the teeth, elongated eye forms, ovoid shapes at the snout and below the eyes, and ovoid and circular patterns in the center suggest that this is by the same artist as nos. 6, 283, and 286. Collected by Emmons from the Gitksan. Bone and abalone; length 6⅞ inches; c. 1840–60. National Museum of the American Indian, Smithsonian Institution, Washington, D.C., 9/7933. Purchased from Emmons, 1920

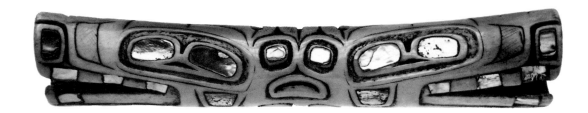

No. 290. *Tsimshian Soul Catcher.* A schematic human face between two animal heads, the eyes of which represent faces themselves. Collected by Emmons from the Gitksan. Bone and abalone; length 7½ inches; c. 1840–60. National Museum of the American Indian, Smithsonian Institution, Washington, D.C., 9/7934. Purchased from Emmons, 1920

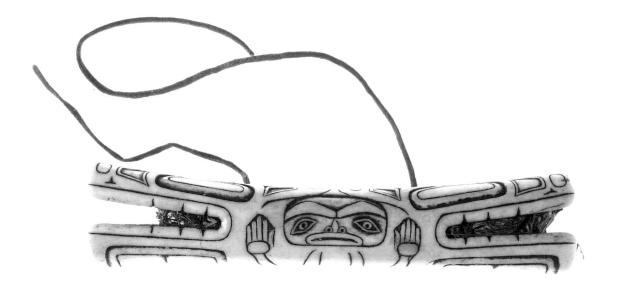

No. 291. *Tsimshian Soul Catcher.* A human figure with upraised arms between two animal heads. The cedar bark stoppers that were placed at both ends to hold the soul after it had been captured are still in place. Bone, cedar bark, and rawhide; length 8¼ inches; c. 1850–70. The University Museum, University of Pennsylvania, Philadelphia, NA 4263. Acquired from the W. S. Sutton Collection, before 1923

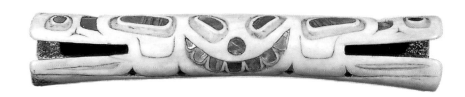

No. 292. *Tsimshian Soul Catcher.* The head of an unidentified creature between two animal heads, probably bears. Although collected from the Haida on the Queen Charlotte Islands by G. Mercer Dawson in 1878, this is probably of Tsimshian origin (see no. 285). Bone and abalone; length 6¾ inches; c. 1840–60. McCord Museum, Montreal, 1244. Dawson bequest

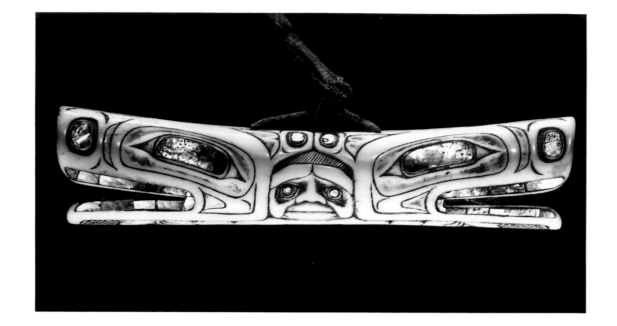

No. 293. Tsimshian Soul Catcher. A splayed human figure with its arms spread along the base between two animal heads. By the same artist as no. 294. Collected by Charles F. Newcombe from J. Priestley at Aiyansh. Bone, abalone, and rawhide; length 7⅛ inches; c. 1840–60. Royal British Columbia Museum, Victoria, 9619. Acquired from Newcombe, 1912

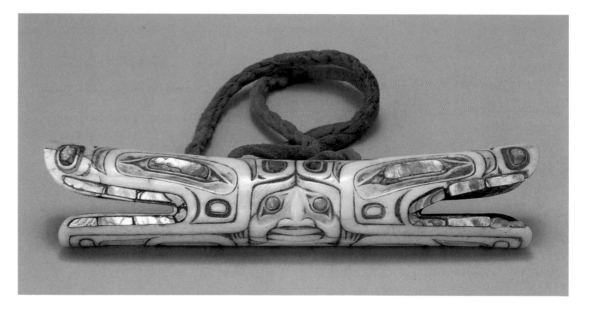

No. 294. Tsimshian Soul Catcher. A human is shown between two animal heads. The hands appear under the heads of the animals, and the legs and feet are on the other side. Holm (1983, p. 119, no. 203) describes the animal heads as "wolflike" and dates this to the 1860s. It may be slightly earlier. By the same artist as no. 293. Bone, abalone, and rawhide; length 7⅝ inches; c. 1840–60. Seattle Art Museum, 91.1.83. Given by John Hauberg

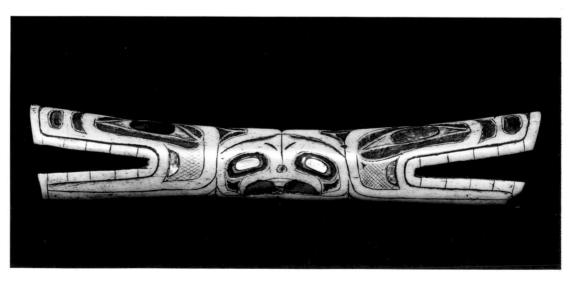

No. 295. Tsimshian Soul Catcher. A face, perhaps a hawk, between two animal heads. Bone and abalone; length 7¾ inches; c. 1840–60. Museum of Mankind, London, 1939 AM.11.1. Given by P. I. Boorman, 1939

No. 296. *Tsimshian Soul Catcher*. A human head between two animal heads. Collected by the Halifax Literary and Philosophical Society before 1902. Bone, abalone, and rawhide; length 7½ inches; c. 1840–60. Former collections: Halifax Literary and Philosophical Society, England; James Hooper. Mr. and Mrs. John Putnam Collection, Seattle. Purchased 1976 (Christie's, 1976, p. 47, no. 166)

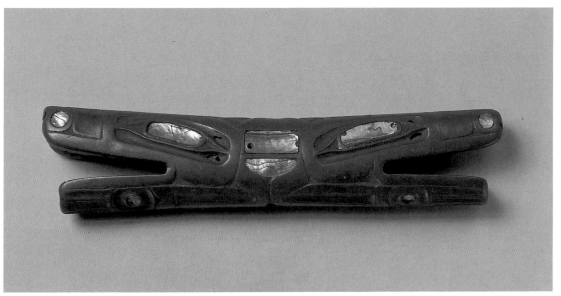

No. 297. *Haida Soul Catcher*. An animal head at each end. The only known soul catcher made of an engraved copper sheet attached to a wood core. Collected from Nakanzoot, a Masset shaman, 1870. Wood, copper, and abalone; length 6¼ inches; c. 1840–60. National Museum of the American Indian, Smithsonian Institution, Washington, D.C., 10/1099. Given by Harmon Hendricks, 1920

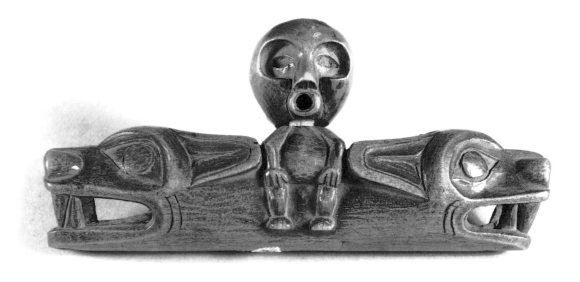

No. 298. *Bella Bella Soul Catcher*. A unique example showing a human seated between two wolf heads. The Janus head of the figure is detachable. On the side shown the mouth is in a singing position; on the other side it is speaking (Inverarity, 1950, no. 163). Collected by the Reverend George H. Raley from the Kitlope of Gardner Channel. Wood; length 6½ inches; c. 1850–70. University of British Columbia Museum, Vancouver, A 1774. Purchased, MacMillan Fund, 1948

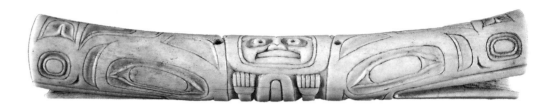

No. 299. Tsimshian Soul Catcher. The head and torso of a human with hands raised to its chin between two animal heads, probably bears. At the back are two bear claw designs. Collected by Emmons. Bone; length 8½ inches; c. 1850–70. Former collection: Harry Beasley (Emmons and Miles, 1939, pl. XVII, fig. 1). Private collection

THE SHAMAN GAANISTEN-GAKKAHWAN
(Tlingit)

About 1850 one of the shamans among the Tanta kwan was Gaanisten of the Hashittan clan. He wished to acquire all the spirits which the famed shaman Nuwat had had. When all these had come to him a male land otter appeared to him in a dream and told him to cut off its tongue. The spirit told him in this dream that Land Otter would meet him. One day they (his helper and he) saw three land otters following their canoe, diving like porpoises. One of these came to rest and floated up, dead. They took this one to a cave and cut off its tongue. That night its spirit came to Gaanisten, gave him a song, and told him the otter's name, Gakkahwan ("face of frost"). He was usually called by this name afterward. Even today the Hashittan have this for a personal name. The two men returned to their camp and fasted four days, drinking salt water during this time. (This was to make the shaman pure, so that the spirit would remain with him.) (Olsen, 1961, p. 212)

CUPS

CUPS WERE USED by shamans of the Tlingit and perhaps other groups to drink either salt water or an emetic made from devil's club root during the purification rituals prior to their performances. The cups may be made of ivory, wood, or basketry, and their designs represent the shaman's spirit helpers.

PREDICTION OF SMELT RUN
(Tlingit)

The run of smelt, the oil fish, was very late and because of this the Indian population was in great need. So a shaman, after he had fasted for four days, went out to sea in a canoe with all his paraphernalia and let himself be lowered to the bottom on a twenty fathom line. When, after some time he allowed himself to be raised again, and he appeared with his rattles and bells which he had taken down with him, he announced that the smelt would come the following day. The next morning many seals and killer whales were seen which are certain indications of the arrival of the fish run and when they went to the river they saw the fish in great numbers. (Krause, 1956, pp. 196–97)

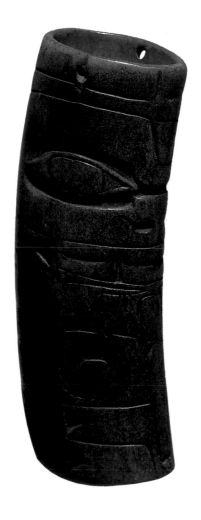
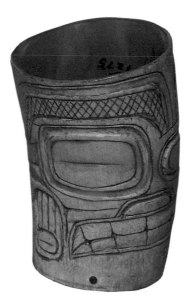

No. 300. Tlingit Drinking Cup (far left). Emmons (n.d.) identifies the carving as a brown bear, and writes that "in preparing for exhibition dances before his family, the Doctor fasts and cleanses his stomach by something [an emetic], and to this end drinks salt water from a cup or basket kept for this purpose." Collected by him at Sitka, 1884–93. Bone and wood; height 4¼ inches; c. 1830–50. American Museum of Natural History, New York, E 2497. Purchased from Emmons, 1893

No. 301. Tlingit Drinking Cup (left). Emmons (n.d.) describes the design as a sea lion. He says the cup was "used by the Doctor to drink salt water from on the day that he fasts, when he dances at night for the good health of his clan." Collected by Emmons from the Sanya tribe, 1884–93. Walrus ivory; height 2¾ inches; c. 1840–60. American Museum of Natural History, New York, E 1275. Purchased from Emmons, 1893

COMBS

SHAMANS WORE both combs and hairpins during curing ceremonies as well as when they were not practicing (Gunther, 1966, p. 148). They are decorated with both spirit helpers and what appear to be crest emblems. Because combs were also used by chiefs and highborn women, it is difficult to know their intended use without adequate collection data. Those included here were either found in shamans' graves or display pronounced shamanic iconography. The majority are made of wood and are sometimes decorated with abalone inlay; there are also examples of mountain goat horn and baleen. Although all of those illustrated are Tlingit, they were also used by female Tsimshian shamans (Guédon, 1984b, p. 196).

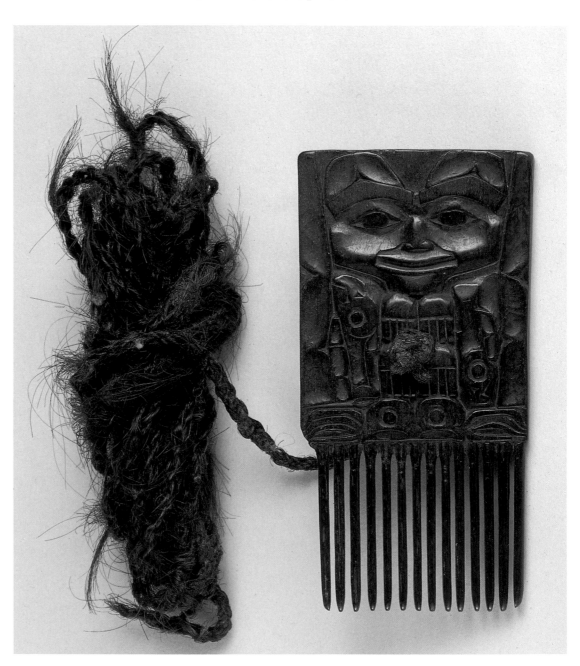

No. 302. Tlingit Comb (two views). Emmons (n.d.), who describes this as a shaman's comb, identifies the figures on one side as a bear with two salmon and an owl below, and those on the other as a bear with a raven. Collected by him at Chilkat, 1882–87. Baleen and human hair; height 5 inches; c. 1840–60. American Museum of Natural History, New York, 19/448. Purchased from Emmons, 1888

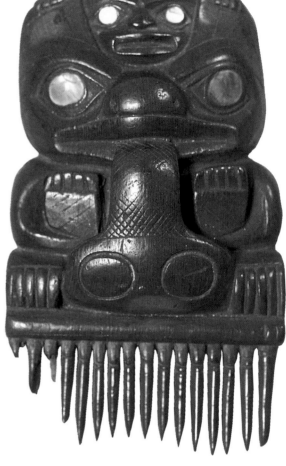

No. 304. Tlingit Comb. The large figure is a bear. A spirit figure above has its hands on the bear's ears and its feet below the bear's head. Although there are no collection data that indicate that this was used by a shaman, the combination of the spirit figure with the bear suggests that it may have been. Collected by Emmons. Wood and abalone; height 5⅛ inches; c. 1830–50. American Museum of Natural History, New York, 16.1/795. Purchased from Emmons, 1926

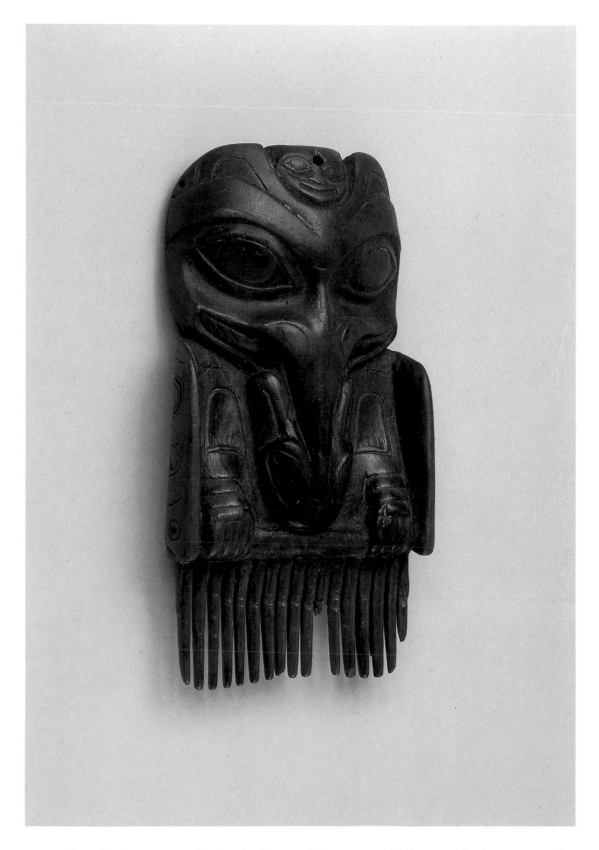

No. 303. Tlingit Comb. Emmons (n.d.) identifies the central figure as a sand hill crane with a frog in its mouth. A Tlingit spirit appears between the ears of the crane. Collected by Emmons from the grave house of a shaman of the Sanya tribe near Tongass, 1884–93. Wood; height 5⅝ inches; c. 1830–50. American Museum of Natural History, New York, E 2557. Purchased from Emmons, 1893

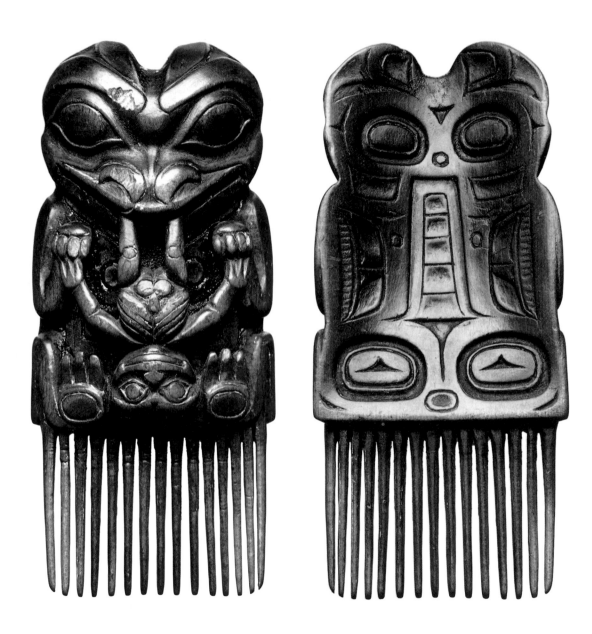

No. 305. Tlingit Comb (two views). Holm and Reid (1975, p. 161) suggest that the animal devouring a man is a bear or a wolf. Although there are no collection data that confirm this to have been associated with a shaman, the skeletonization of the figure and the devouring imagery suggest that it may have been. Wood; height 5¾ inches; c. 1830–50. Private collection

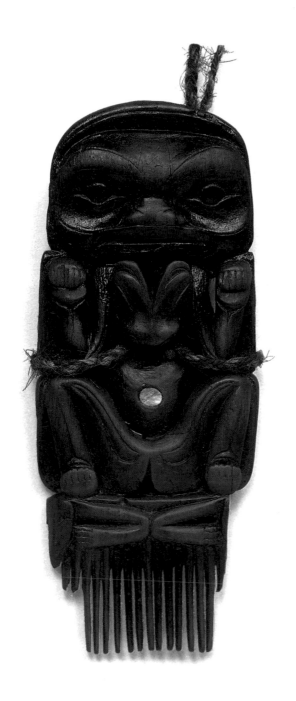

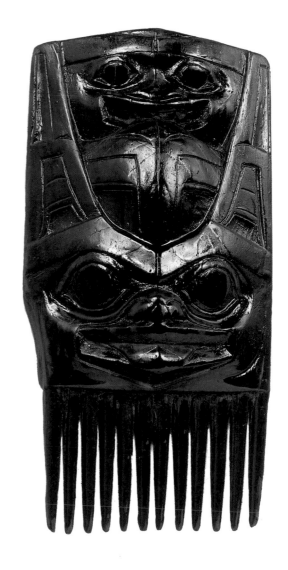

No. 306. Tlingit Comb. A bear with a wolf head on its chest is shown over a crouching animal on one side. On the other side is a land otter, which suggests shamanic use. Collected by Emmons at Angoon. Wood, abalone, human hair, and cedar bark; height 5¾ inches; c. 1830–50. National Museum of the American Indian, Smithsonian Institution, Washington, D.C., 9/7966. Purchased from Emmons, 1920

No. 307. Tlingit Comb. A human head between the ears of a brown bear. Emmons (n.d., Notes, NMAI), who collected this piece, describes it as a shaman's comb. Wood; height 5¼ inches; c. 1840–60. National Museum of the American Indian, Smithsonian Institution, Washington, D.C., 18/5784. Purchased from Emmons, 1933

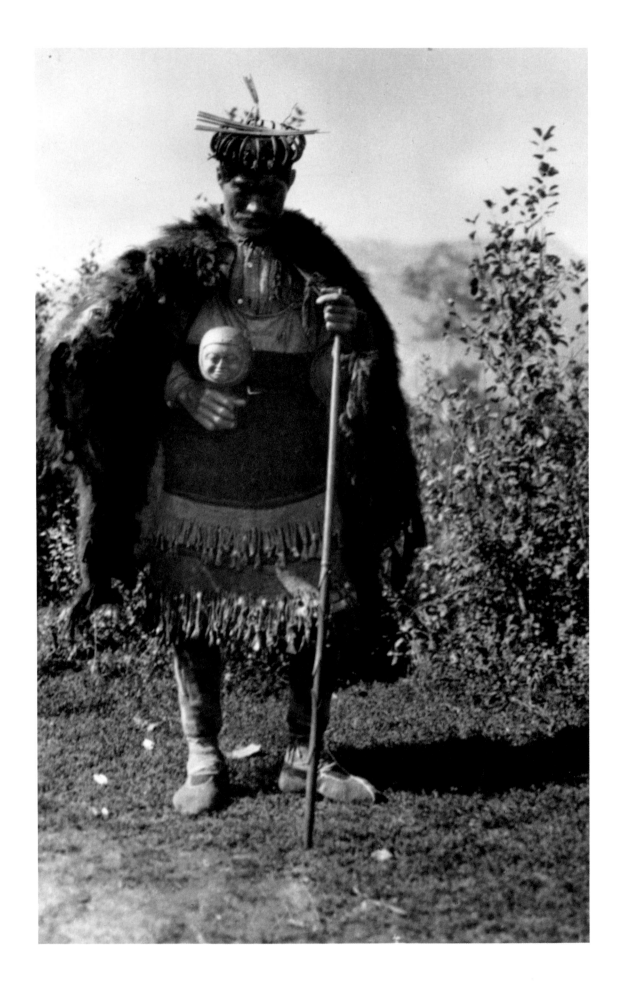

Fig. 35. Tsimshian Shaman at Hazleton. He wears a crown, and carries a round rattle in the form of a human face and a staff with two soul catchers carved on the lower half. The crown and the staff are now in the Royal British Columbia Museum, Victoria (12616, 12619). They were acquired in 1965 as part of a shaman's outfit that also includes an undecorated soul catcher, a model canoe, three wood objects, and a bamboo whistle. Photograph, c. 1920. Canadian Museum of Civilization, Ottawa, 62474

CROWNS

SHAMANIC CROWNS are in the form of curved tines representing bear claws that are attached to an animal hide or cloth headband. They may be made of bear and lynx claws, mountain sheep and mountain goat horn, beaver teeth, wood, rolled copper, antler, and, in at least one instance, the rims of abalone shell (Vaughan and Holm, 1982, p. 100). Many are undecorated, but some have faces of spirit helpers and even whole figures carved into their bases. Some have inlays of abalone, dentalium, or metal; dentalium shells, bird quills, puffin beaks, and ermine skin might also be added to the headband.

When worn, the rattling of the points together, like the shaking of rattles and drumming, helped summon the spirits that the shaman used for healing (Kaplan and Barsness, 1986, pp. 197, 227). Jonaitis (1986, p. 28) quotes Emmons's description of the crowns' "wonderful curative power [which] drew out sickness when they were removed from the shaman's head and touched to the afflicted part of a sick person."

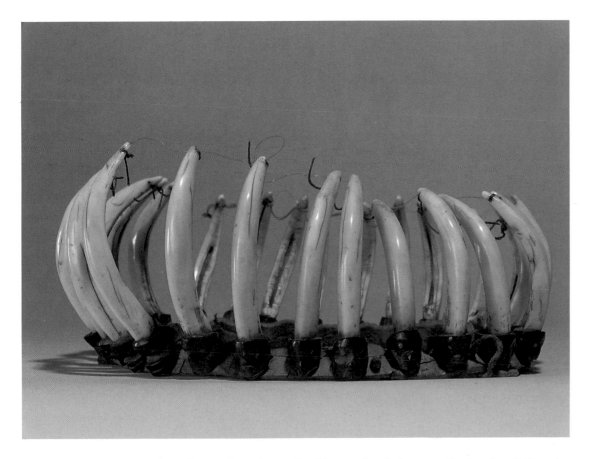

No. 308. Tsimshian Crown. A bear, frog, eagle, or human head is carved at the bottom of each point. Collected by Emmons. Mountain goat horn, ivory, rawhide, and brass; height 4¾ inches; c. 1840–60. National Museum of the American Indian, Smithsonian Institution, Washington, D.C., 2/4335. Purchased from Emmons, 1909

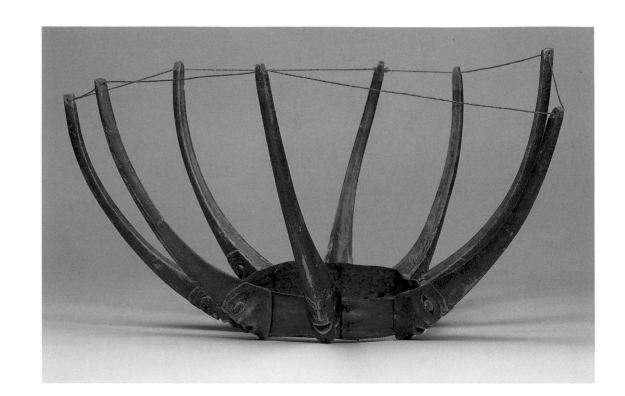

No. 309. Tlingit Crown. A human head in a singing or speaking pose is carved at the bottom of each point. Part of an entire set of a shaman's paraphernalia of unknown provenance collected by Emmons. Wood, animal hide, twine, and black and red pigment; height 9¾ inches; c. 1840–60. National Museum of the American Indian, Smithsonian Institution, Washington, D.C., 16/1719t. Purchased from Emmons, 1928

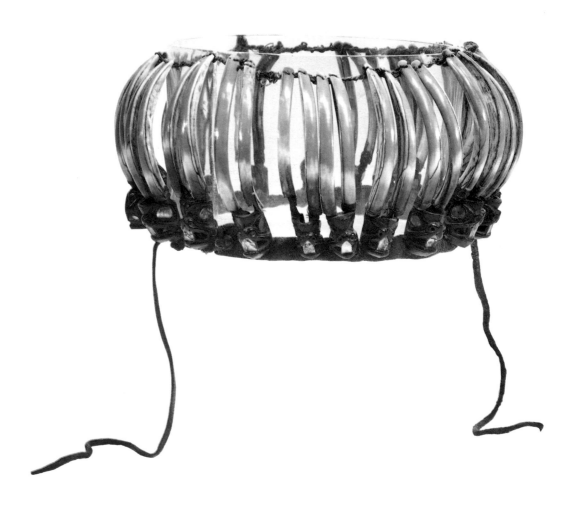

No. 310. Tsimshian Crown. A beaver head is carved at the bottom of each two points with the exception of one in the center that represents a frog. Collected by Emmons from an old shaman at Lakalzap (Greenville), and said to have been handed down through several generations of shamans. According to Emmons (n.d., Notes, NMAI), it was the most elaborate of its kind and "parted with with great reluctance." Mountain goat horn, beaver incisors, abalone, twine, rawhide, animal skin, and red pigment; height 4½ inches; c. 1840–60. Former collection: Museum of the American Indian, Heye Foundation, New York, 9/8047; purchased from Emmons, 1920. Private collection

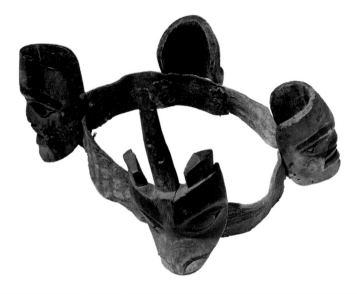

No. 311. *Tlingit Crown*. Three human heads and a bear head. Holm (Vaughan and Holm, 1982, p. 100) mentions that this was worn by the chief Sitka Jack at a potlatch in 1877, and dates it to the mid-nineteenth century. Because such crowns are common among shamanic paraphernalia, Holm speculates that Sitka Jack was also a shaman. Wood, animal skin, and black, red, and green pigment; height of largest maskette 5½ inches; c. 1840–60. Peabody Museum of Archaeology and Ethnology, Harvard University, Cambridge, 04–10–10/62981. Given by Lewis Farlow, 1904

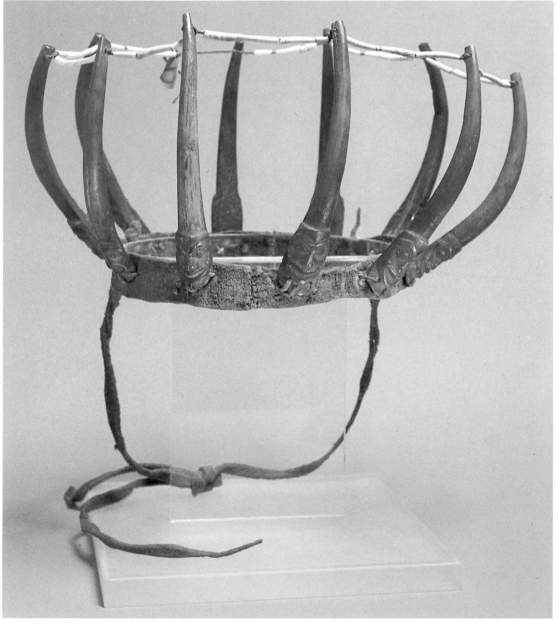

No. 312. *Tlingit Crown*. A human head is carved at the bottom of each point. Collected by Emmons at Chilkat, 1882–87. Mountain sheep horn, animal skin, dentalium, puffin beak, and twine; height 6⅞ inches; c. 1840–60. American Museum of Natural History, New York, 19/1010. Purchased from Emmons, 1888

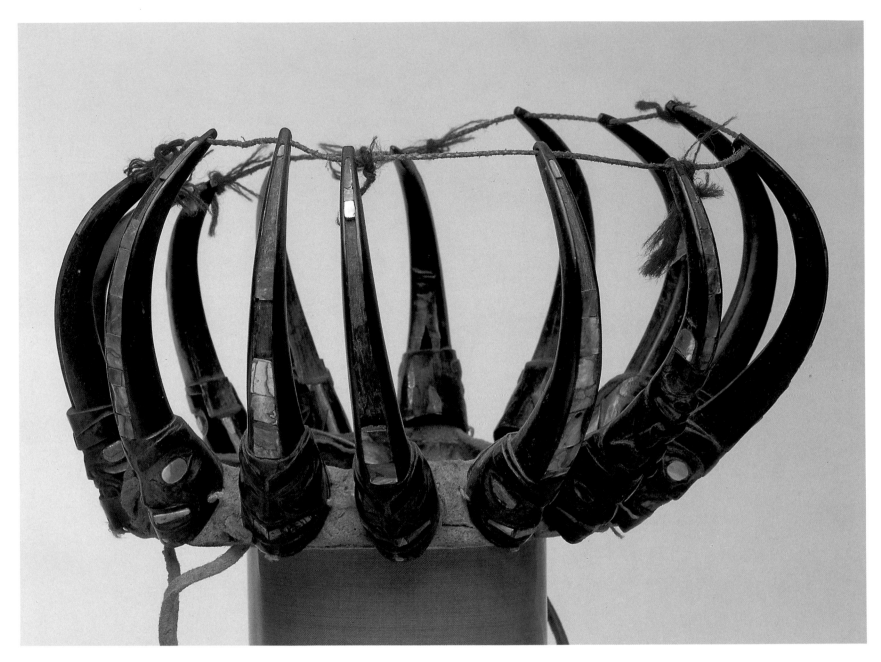

LALAIA'IL AND THE COUNTRY OF THE DEAD
(Bella Coola)

No. 313. *Tsimshian Crown.* A seated bear in the center, with bear heads at the bottom of every other point. Collected by Israel W. Powell at Metlakatla, 1879. Mountain goat horn, wood, red wool, rawhide, fur, cedar bark, and abalone; height 6 inches; c. 1840–60. Canadian Museum of Civilization, Ottawa, VII–C–4

There is a special deity who initiates the shamans. His name is LALaiā'iL. *He lives in the woods. He carries a wooden wand wound with red cedar-bark, which he swings in his hands, producing a singing noise. Around his neck he wears a large ring made of strips of bear-skin and red cedar-bark. He sometimes plays in ponds which are believed to be in certain mountains. When he jumps into the water, it boils. When a woman meets him, she begins to menstruate; when a man meets him, his nose begins to bleed. When initiating a person, he touches the chest of the latter with his wand and paints his face with the design of the rainbow. Then he swings his wand, the noise of which causes the person who hears it to faint. He creates sexual desire in man and animals. A shaman who was initiated by this being told me that he very often sees* LA-LAIā'iL, *who tells him who will die and who will fall sick. Sometimes he sees that the body of a*

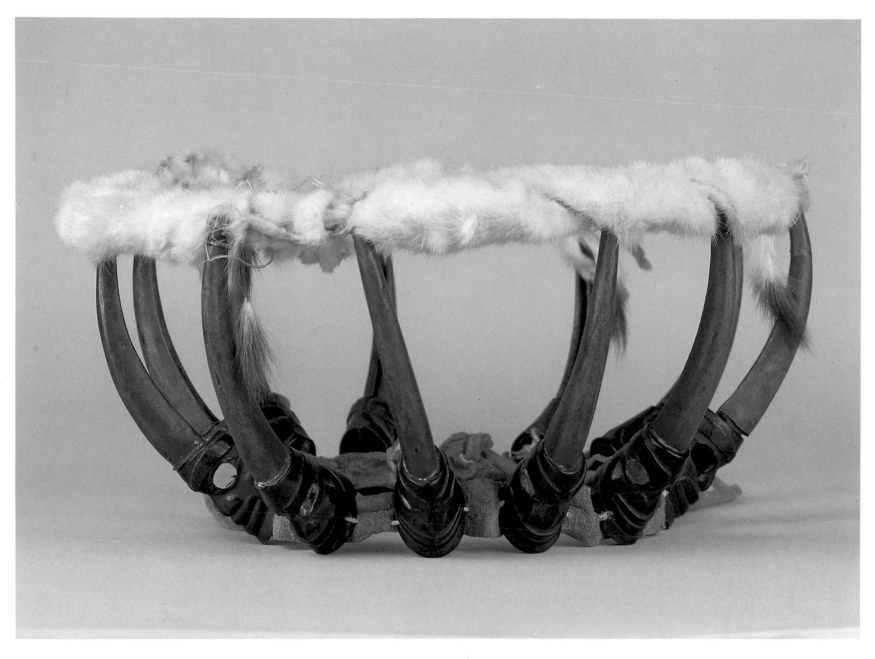

person is black. Others he sees dancing on their heads. These are signs that they will die at an early date. I obtained from this man the description of the visit to the country of the ghosts. He told me that when reaching the country of the dead, he saw the ghosts of his deceased relatives sitting in the house. When they saw him, they began to weep, and said, "Don't come here. We don't want to see you so soon." While they were speaking to him, the chief's speaker entered the house, and called all the people to come to the dancing-house of the ghosts. One of the ghosts painted his face black and white, and tied long strips of white and red cedar-bark in his hair. The people were called four times. Then they started to go to the dancing-house. The entrance to the door was over a narrow plank. When he had just stepped on the plank, he suddenly saw LALAIĀ'IL, *with his large neck-ring made of red cedar-bark and strips of black bear-skin, who took hold of him, turned him round, and told him to return to his own country, because, if he should once enter the dancing-house, he would not be able to return. Then he revived; and from that time on,* LALAIĀ'IL *was his supernatural helper.* (BOAS, 1898, p. 42)

No. 314. *Tlingit Crown.* A human head is carved at the bottom of each point. Mountain goat horn, abalone, copper, ermine skin, and animal skin; height 6⅞ inches; c. 1850–70. National Museum of the American Indian, Smithsonian Institution, Washington, D.C., 17/6681. Acquired 1930

STAFFS

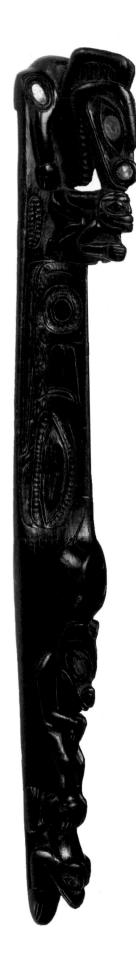

SHAMANS USED carved and painted staffs for a variety of purposes. A type of cane was employed to detect witches (de Laguna, 1972, pt. 2, p. 696), while batons and tapping sticks were used to beat time during dances and to attract spirits. Dance wands carved and painted with representations of helping spirits were carried by shamans during performances to combat evil spirits and to maintain balance (Gunther, 1966, p. 155).

Certain examples take the form of war picks (nos. 334, 344) to symbolize the actual fighting of hostile spirits by the shaman. They were used to subdue land otters during the spirit quest as well as during curing ceremonies (de Laguna, 1972, pt. 2, p. 589). Reference to other weapons is found in the scimitar and rapier shapes of some whalebone staffs (no. 30 [see Gunther, 1966, p. 157]), and in bows with matching arrows used for healing (no. 336). Knives and hunter's clubs are also found in shamans' paraphernalia.

The Tlingit throwing stick is another type of staff that, as Holm (1988, p. 282) persuasively argues, was probably used by shamans. He supports his statement by noting that the relief carvings on the sticks employ shamanic iconography; that no examples are shaped to fit the hand properly; and that the Tlingit would have had no need of such a one-handed hunting implement, as a bow was more effective in the two-man boats that were used. He (ibid.) thus concludes that shamans may have used the sticks "as weapons in the struggles against malevolent supernatural beings." A number of these sticks were collected at the beginning of the nineteenth century, and all examples display early stylistic traits. This accounts for their late-eighteenth-century dating in this publication.

THE GHOST WHO FOUGHT WITH THE GREAT SHAMAN
(Tsimshian)

In olden times many different things happened among the people. Some were good and others bad, and some were funny. And so it is with this story of the ghost and the great shaman.

In a village on Nass River there was a chief who had an only son. When the boy had grown up to be a youth, he had four friends who were of the same age as he. It was the custom of princes to choose some good and wise young men to be his friends; and so it was with this prince. Every day they went into the woods and built a small hut, to which they used to go every day. The prince pretended to be a shaman, and his four friends were his singers. They made a skin drum, and had a board on which to beat time; and so they went to their hut day by day. Their parents did not know what they were doing. Soon after they had had their breakfast in the morning, they went to their little hut, and played there all day until evening. At dusk they came home. They did this day by day and month by month and year by year.

No. 315. Tlingit Throwing Stick. Below the finger hole is a bear over a frog. At the opposite end is a bear head and a squatting human. The shallow relief carving in the center may also represent a bear. Wood and abalone; length 14¾ inches; c. 1770–1800. Private collection

Finally, when the prince was full grown, one day they went in another direction to hunt squirrels. Before evening they came home; and before they reached there, they passed by the graveyard a little behind the village, on the bank of a brook behind the town; and as they were passing by, they saw one of the coffins open.

The young prince said, "Shall I go into that open coffin there?" His friends asked him to desist; but he did not pay any attention to what they said, and jumped into the open coffin. He lay down in it; and as soon as he lay down there, he was dead. Then his four friends were very sorry. They stood around the coffin, weeping.

Before dark one of the young men went home, and three staid there. After a while another of the young men went home, and two staid there. After a while still another one went home, and one, who loved the prince most, still remained.

When it was very dark, this young man feared that the ghosts would come and take him. Therefore he ran down to his house; and all the young men, as soon as they reached their home, forgot what had happened to them and to their prince in the graveyard.

Late at night the chief, the father of the prince, and his wife, inquired for their only son. Then the prince's friends remembered what had happened as they were passing the graveyard, and how the prince had insisted on lying down in the open coffin.

Therefore the chief ordered his great tribe to light their torches and to go to the graveyard on the same night. Therefore all the people lighted their torches of pitch wood and maple bark and torches made of olachen. They set out for the graveyard, and found the body of the prince lying in the open coffin. They took it away and carried it down to the chief's house. There were many people. They placed him on a wide board in front of the large fire in his father's house.

The prince's heart was still beating. Therefore his father asked all the shamans from the other tribes to come. He told them what had happened to his son; and he said that he wanted to have his only son come back to life, and that therefore he had called them all. Thus said the chief, and promised them a rich reward if they could restore his son to life.

So they began to dance. Each of the shamans put his charms on the dead prince; and finally, when the various charms had been put on him, he came back to life. The shamans had been working over him for four days and four nights. Then each received his reward, as the chief had promised before.

Now the prince had become a great shaman, because he was filled with the charms of the different shamans, and because he had pretended to be a shaman ever since his boyhood; and his four friends were his attendants, and always went before him.

After a short time one of his father's people died—the head man of his father's tribe. Then the prince said to his father, "I will go and restore him to life." The father said, "My son, can you do that?"

The prince put all the carved bones around his neck. He put on his crown of grizzly-bear claws and put on his dancing-apron, took his rattle in his right hand and the white eagle tail in his left. He blackened his face with charcoal, and strewed eagle down on his head. Then he went with his four attendants, and went to the house where the dead one was. All the people of the village came to the house.

No. 316. *Tlingit Throwing Stick*. At the top is the head of a bear surmounting an unidentified animal and a frog. At the other end is a crouching bear. Wood; length 14½ inches; c. 1770–1800. Denver Art Museum, 1954.378. Given by Frederick Douglas, 1954

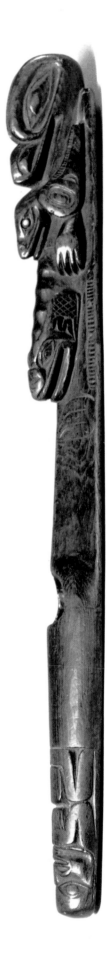

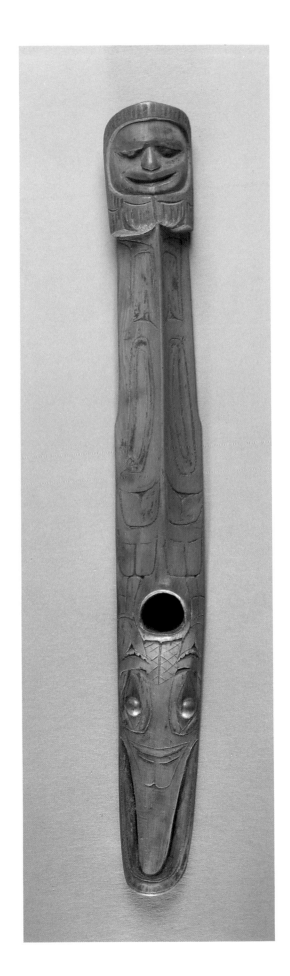

In the evening the prince began his shaman's songs, and his attendants' songs followed. After the first song, he stood at the end of the large fire, and said, "This man's soul is now in the village of the Ghosts, and my supernatural helper says that I shall take his soul back again to his body from the village of the Ghosts. Bring me a new cedar-bark mat, and let all the people in this house beat time on a plank, and thus help my attendants, and let them sing as loud as they can until I come back!" Then all the people did as he had wanted them to.

Then he put on the new cedar-bark mat and started in the dark of the night. Everybody in the house was singing. They beat the skin drum and beat the boards with sticks. Now, the shaman prince went to the graveyard; and when he had arrived there, he saw a quiet river, and the village of the Ghosts on the other side. There was a narrow bridge across the river. He went across, and ran as fast as he could, his supernatural power leading him toward the chief of the Ghosts.

The shaman entered the chief Ghost's house, and there he saw the soul of the dead man sitting in the rear of the house. The chief of the Ghosts was sitting by his side, and all the Ghosts were assembled in the house to see the newcomer. The shaman went right in, and saw the soul of the one who had just died sitting there. Then the shaman prince took him by the shoulders, and said, "I will take you back to your body;" and he went out of the house of the chief of the Ghosts.

The prince came back to the house in which the dead body was while all the people were singing. He entered, and said that he had taken the soul of the dead man and brought it back again. He kept his left hand closed, and rattled with the rattle which he held in his right hand. He went around the fire four times, following the course of the sun. Then he went toward the body of the dead man, and put the soul of the dead body into it. As soon as the soul went into the body, the one who had been dead sat up. He had come back to life.

Then all the people were astonished to see what the shaman prince had done. The news of the prince's success soon spread over the whole country. After some time another relative of his father died while the shaman prince was absent. When the prince came home, he saw that his father grieved. He asked him, "What makes you so sorrowful, father?" and they informed him that one of his father's nieces had died three days before.

So the prince ordered his people to assemble; and when all the people were in, the shaman prince went, as he had done before, and brought back the soul of his cousin from the town of the Ghosts. Then all the villagers round about spread the fame of the shaman prince, and of his ability to bring back the souls of dead people from the town of the Ghosts. When any one died in some other village, they sent for him, and offered him great reward if he should bring back the souls of the dead.

He did this for a long time, and no one was dying in all the villages, because the great shaman was among the people. Therefore all the Ghost-town people hated the shaman prince, because no souls of the dead came to the Ghost town. Therefore their hatred of the prince increased greatly.

Therefore they assembled and held a council, and determined to try to kill the prince. They all agreed to cut off the ends of the bridge when the shaman prince should come again to get the

No. 317. Tlingit Throwing Stick. At the top is the head of a spirit figure; the rest of the stick is carved in the form of an unidentified animal, perhaps a bird (see Vaughan and Holm, 1982, p. 76, no. 40). Collected by Roderick McKenzie. Wood and brass tacks; length 15¼ inches; c. 1770–1800. Former collection: American Antiquarian Society, Worcester, Massachusetts; acquired 1811. Peabody Museum of Archaeology and Ethnology, Harvard University, Cambridge, 95-20-10/48392. Donated by the American Antiquarian Society, 1895

soul of a dead one. As soon as the council of the Ghosts ended, they went and took the soul of a man. Two days later the man died. The shaman prince, however, knew that the Ghosts had held a council against him. His chief supernatural power had told him so; and his supernatural power had said to him, "Go and bring back the souls of your people. If you are afraid of the Ghosts' council, you shall surely die; but if you do as I order you, I will protect and guard you; but remember, if you disobey my orders, a dreadful punishment awaits you."

Then the shaman prince assembled all his people, and ordered them to wait until he should come back, and to sing all his songs while he was away. Then all his people kept on singing.

Now the shaman prince went on his way until he arrived by the bank of the river that runs in front of the ghosts' town. He went to the bridge, and his supernatural power carried him across. He went to the house of the chief of the Ghosts, who takes the souls of the dead first. All the souls of the dead go first to the house of this great chief. Therefore the shaman prince went right to it. He went in and snatched the soul of the dead one from the cold hands of the cruel Ghosts. Then he ran out quickly, and the Ghosts pursued him over the bridge.

He had almost arrived at this end of the bridge that had been cut by the Ghosts, when both his feet went down into the water of the river, but his body fell on the dry land. He arose again, and ran down as fast as he could; but before he reached his father's house, he fell down and began to groan.

Now, the people in the house heard him groaning. They took their torches, and, behold! the shaman prince was lying there. They took him in and placed him on a wide plank in front of the fire.

Then his supernatural power came to him. The people in the house saw that part of his foot was badly scorched, and the hearts of all the people who were in the house failed them. As far as the water had reached on both of his feet when he fell at the end of the bridge of the Ghosts, his flesh was burned and scorched. The river was the Boiling-Oil River. No one gets out of it who drops into it. The shaman had fallen into it.

His supernatural power said to him, "Arise, and run around the fire, following the course of the sun, four times. Then you will soon get better." His feet were very sore, but he tried to do what his supernatural power had told him. He ran around the fire once, and twice, and three times, and four times, and his feet were healed. Now, when his feet were healed from their burns, he had more power than before.

He went often into the Ghost town and brought back the souls of the dead; and although men or women had been dead two, three, or four days, still the shaman prince went to the Ghost town and brought their souls back. (Boas, 1916, pp. 322–26)

No. 318. Tlingit Throwing Stick. At the top is an eagle confronting an unidentified animal. On the bottom is a bird with an otter in its beak; above it is the head of a human in a trance with its tongue extended to the otter. Collected by Roderick McKenzie. Wood and abalone; length 13¼ inches; c. 1770–1800. Former collection: American Antiquarian Society, Worcester, Massachusetts; acquired 1811. Peabody Museum of Archaeology and Ethnology, Harvard University, Cambridge, 95-20-10/48391. Donated by the American Antiquarian Society, 1895

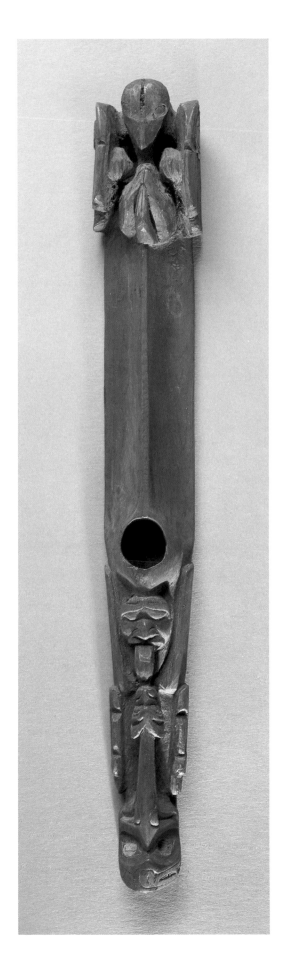

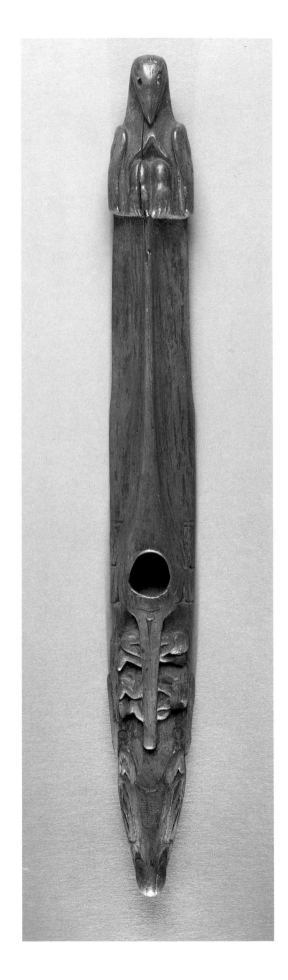
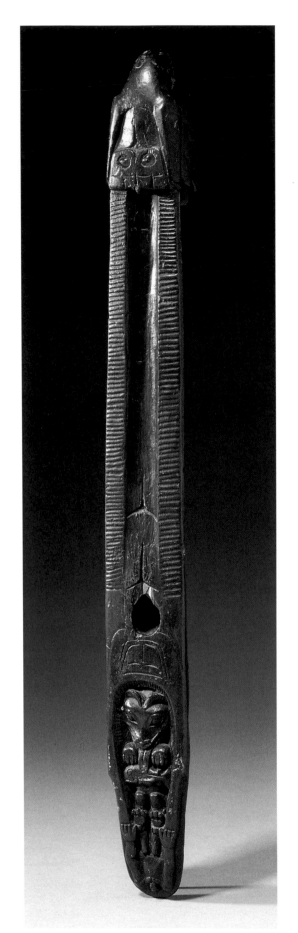
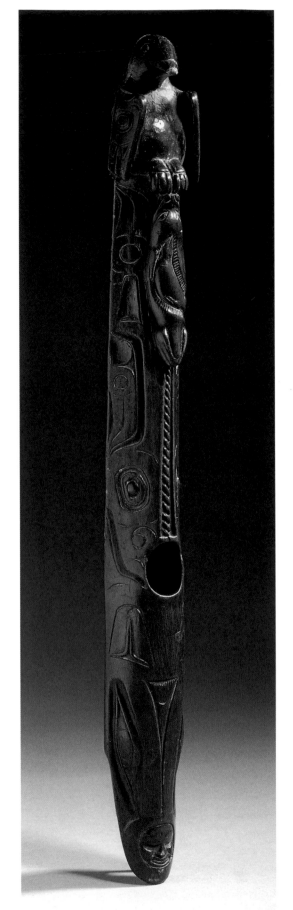

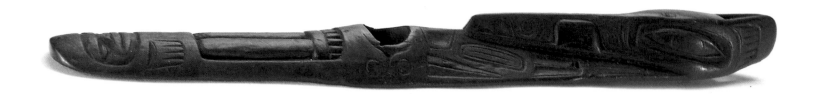

No. 321. *Tlingit Throwing Stick.* Holm (1988, p. 282, no. 388) identifies the bird as a merganser or a kingfisher. At the other end is a man in a trance. Collected by James G. Swan at Sitka. Wood and iron; length 15¼ inches; c. 1770–1800. National Museum of Natural History, Smithsonian Institution, Washington, D.C., 20771. Acquired from Swan, 1876

No. 322. *Tlingit Throwing Stick.* An animal, perhaps a bear with its tongue stretching upward, is on the left. A long-beaked bird is at the other end. Wood; length 13⅜ inches; c. 1770–1800. Private collection

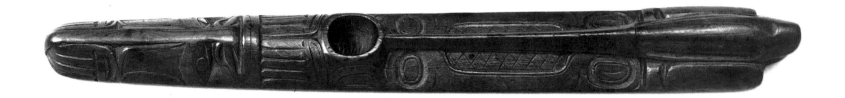

No. 323. *Tlingit Throwing Stick.* On the right is the upside-down head of a bear. A small frog was carved separately and attached with small wood pegs over the finger hole. The addition of this element rendered the piece even less adaptable for hunting and adds support to Holm's (1988, p. 282) theory that throwing sticks were used for shamanic purposes. Wood, pebbles, and abalone; length 13⅝ inches; c. 1770–1800. Private collection

No. 319. *Tlingit Throwing Stick* (opposite, left). An eagle is perched at the top. At the bottom, two human figures, one shown in profile and one shown frontally, are on the back of an animal, perhaps a wolf or a land otter. Wood, glass bead, and abalone; length 13¼ inches; c. 1770–1800. Former collection: Museum of Fine Arts, Boston. Peabody Museum of Archaeology and Ethnology, Harvard University, Cambridge, 99-12-10/53092. Gift of the heirs of David and Augusta Kimbell, 1899

No. 320. *Tlingit Throwing Stick* (opposite, right, two views). An eagle is perched at the top. Below its talons is a seal with a rope extending from its rear flippers to the finger hole. At the bottom is the head of a bear with a human face in a trance on the snout, and the body and paws of a bear are carved in relief on the shaft. On the back at the bottom a crouching bear holding a salmon is carved in high relief. Wood and blue and green beads; length 14¾ inches; c. 1770–1800. The Eugene V. and Clare E. Thaw Collection, Fenimore House Museum, Cooperstown, New York

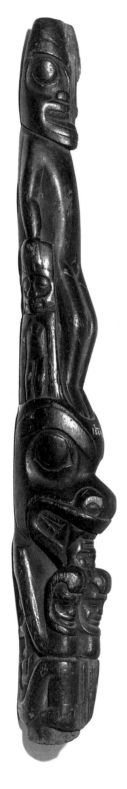

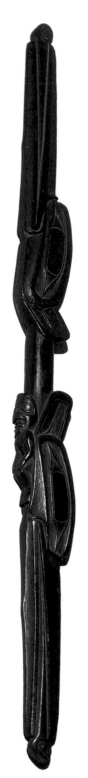

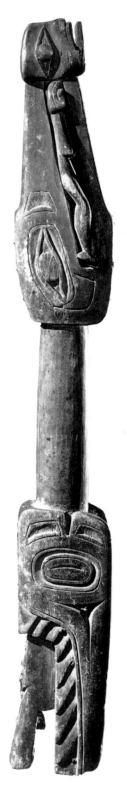

No. 324. *Tlingit Staff Top.* Emmons (n.d.) identifies the figure at the top as a shaman with his hands on two spirit figures, and the one at the bottom as "a bear eating a Tlingit." He suggests the object may be of Haida origin. Collected by Emmons from the Auk tribe, 1884–93. Wood, length 15⅞ inches; c. 1840–60. American Museum of Natural History, New York, E 1564. Purchased from Emmons, 1893

No. 325. *Haida Staff.* Two raven heads are devouring wormlike figures. A reclining spirit is at the bottom of one of the raven heads. Although traditionally referred to as a chief's baton (Musée de l'Homme, 1969, no. 115), this could well have been used by a shaman. It is similar in style to no. 329. Collected by Israel W. Powell on the Queen Charlotte Islands, 1879. Wood; length 35 inches; c. 1840–60. Canadian Museum of Civilization, Ottawa, VII–B–117. Given by Powell, 1879

No. 326. *Haida Staff.* A raven is devouring a human at one end, and its wings and tail are shown at the other end. The devouring imagery suggests shamanic use. Wood; length 15 inches; c. 1840–60. Former collection: Jelliman, Masset. Royal British Columbia Museum, Victoria, 10654. Purchased from William A. Newcombe, 1961

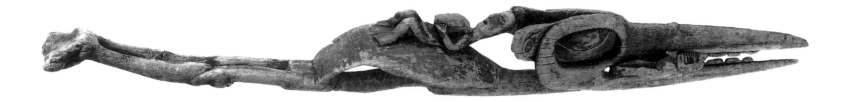

No. 327. *Tlingit Staff.* A crane spirit with a human body. The reclining figure in the center is in a trance. Jonaitis (1986, pl. 63) describes the figure in the crane's mouth as a witch. Collected from a Daklawedi shaman at Chilkat and said to have passed through five generations of shamans. Wood; length 36 inches; c. 1790–1820. Field Museum of Natural History, Chicago, 79134. The Carl Spuhn Collection. Purchased from Emmons, 1902

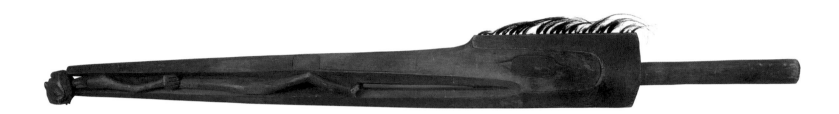

No. 328. *Tlingit Staff.* A crane devours a human. Emmons (n.d., Notes) describes the staff's use as follows: "The shaman carries this wand when dancing around the sick. At this time, the shaman is exorcizing the evil spirit which has entered the sick and is also contending with the hostile spirits of the surrounding air." Collected on Chichagof Island, and said to have belonged to a Hoonah shaman. Wood, human hair, and red and black pigment; length 41¼ inches; c. 1840–60. Field Museum of Natural History, Chicago, 78027. The Carl Spuhn Collection. Purchased from Emmons, 1902

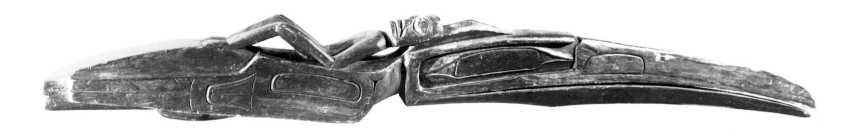

No. 329. *Haida Staff.* A raven with a human on its back. Museum records indicate this object had a shamanic function. Collected by James Deans on the Queen Charlotte Islands. Wood and traces of red pigment; length 37⅛ inches; c. 1840–60. Field Museum of Natural History, Chicago, 17887. Given by Deans, 1890

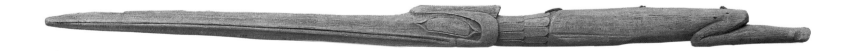

No. 330. *Tlingit Staff.* In the form of a crane, and identified by Emmons (n.d.) as shamanic. Collected by him from the Chilkat, 1882–87. Wood; length 31⅜ inches; c. 1840–60. American Museum of Natural History, New York, 19/1214. Purchased from Emmons, 1888

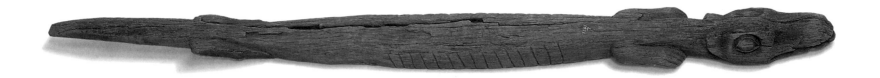

No. 331. Tlingit Staff. A crouching land otter whose ribs are showing. Collected by Emmons in 1884–93 from a shaman's grave in a rock cave at Nakwasina Bay, north of Sitka. Wood; length 37¼ inches; c. 1830–50. American Museum of Natural History, New York, E 1097. Purchased from Emmons, 1893

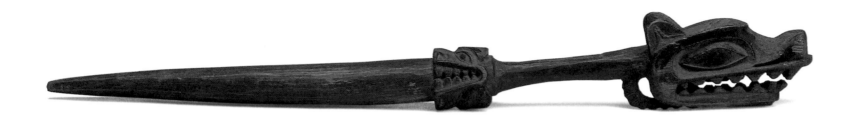

No. 332. Tlingit Staff. Two wolf heads are shown on the handle, which is carved in the form of a fighting knife. Collected by Emmons from a shaman's grave house at Chilkat, 1882–87. Wood and traces of red and black pigment; length 19⅞ inches; c. 1840–60. Former collection: American Museum of Natural History, New York, 19/1205; exchanged to Emmons, 1914. National Museum of the American Indian, Smithsonian Institution, Washington, D.C., 4/1070. Purchased from Emmons, 1915

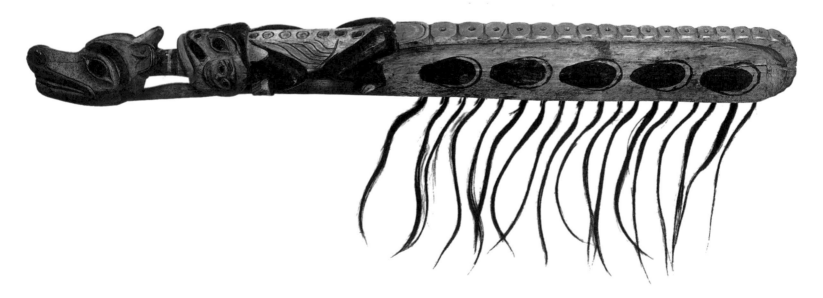

No. 333. Tlingit Staff. A wolf head appears on the handle. Behind the wolf head is a crouching land otter whose backbone is carved with devilfish tentacles, which are also found along the remaining length of the staff. The five painted oval forms at the top may represent animal tracks. Shamanic use is indicated by the land otter and devilfish tentacle motifs. Collected by Emmons at Port Mulgrave (Yakutat). Wood, human hair, and red and black pigment; length 32 inches; c. 1840–60. National Museum of the American Indian, Smithsonian Institution, Washington, D.C., 16/6792. Purchased from Emmons, 1929

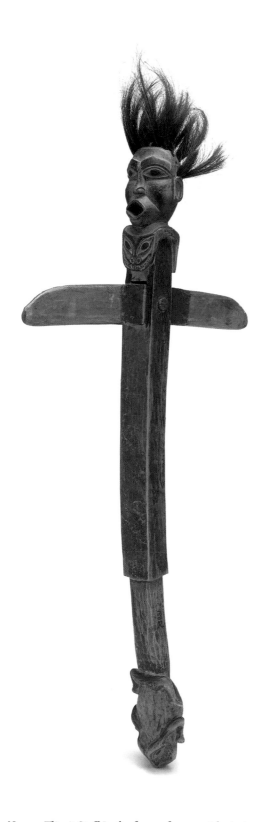

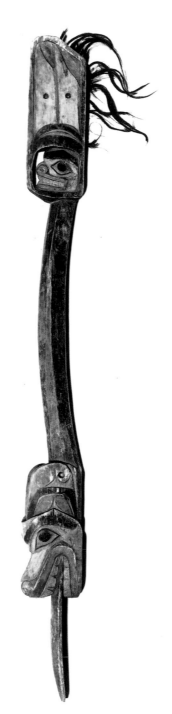

No. 334. *Tlingit Staff.* In the form of a war pick. A singing shaman wears a tunic with an animal design, perhaps a bear. At the bottom is a frog. Collected by Lieutenant T. Dix Bolles at Hoonah, 1884. Wood, human hair, and red and black pigment; length 26⅜ inches; c. 1840–60. National Museum of Natural History, Smithsonian Institution, Washington, D.C., 73831. Given by Bolles, 1884

No. 335. *Tlingit Staff.* The figure at the bottom with the protruding tongue is a wolf, and that at the top is a bear. Collected by Emmons in 1882–87 from a shaman's grave house at Port Mulgrave (Yakutat), and said by him (n.d.) to have been used as a "spirit wand in dancing." De Laguna (1972, pt. 3, p. 1097, pl. 179) suggests that this staff may have come from the same grave house as the material collected by William Libbey which is now at the Princeton University Art Museum (see nos. 95, 96, and 338). Wood, human hair, and red, black, and blue-green pigment; length 51 inches; c. 1840–60. American Museum of Natural History, New York, 19/1250. Purchased from Emmons, 1888

No. 336. *Tlingit Bow.* On the use of bows by shamans, de Laguna (1988a, p. 275, no. 376) writes that "ceremonial bows were often made with matching arrows and were sometimes used in curing ceremonies." At each end of this example is a head, representing a singing and a speaking shaman. Collected by William B. Stevens at Sitka. Wood, human hair, animal gut, and red and black pigment; length 106½ inches; c. 1840–60. National Museum of Natural History, Smithsonian Institution, Washington, D.C., 324930. Given by Stevens, 1923

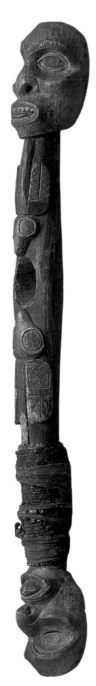

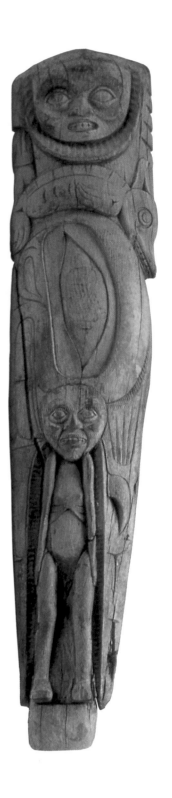

No. 337. Haida or Tlingit Staff. Boas (n.d.) catalogues this staff as Kwakiutl, but it is probably Haida or Tlingit. He also refers to it as a speaker's staff, but the land otter on the head of the figure on the bottom and the fact that the figure at the top is wearing a shaman's hat suggests shamanic use. Collected by Israel W. Powell, 1881. Wood; length 45¼ inches; c. 1850–70. American Museum of Natural History, New York, 16/942. Heber R. Bishop Collection

No. 338. Tlingit Staff. The hole originally contained another piece of wood placed horizontally, so that its form would have been that of a war pick (see no. 344). One of the heads is of a dead person, while the other is in a speaking or singing position; de Laguna (1972, pt. 3, p. 1089, pl. 171) suggests that they represent witches being strangled. Two bird forms are carved between the heads. Collected by William Libbey from the grave of an unknown shaman at Port Mulgrave (Yakutat), 1886. Wood, rawhide, and red, black, and blue-green pigment; length 16½ inches; c. 1840–60. The Art Museum, Princeton University. On permanent loan from the Department of Geological and Geophysical Sciences, 5063. Given by Libbey, 1886

No. 339. Tlingit Staff. At the top is a human face with a trance expression. Below the face is a sea lion on top of a raven that devours a human. Collected by Emmons from the Chilkat, 1884–93. Wood; length 27 inches; c. 1820–40. American Museum of Natural History, New York, 19/1161. Purchased from Emmons, 1893

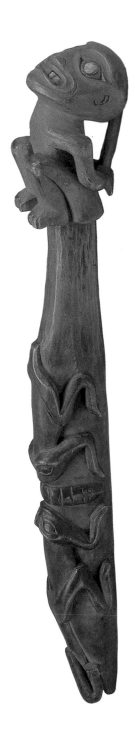

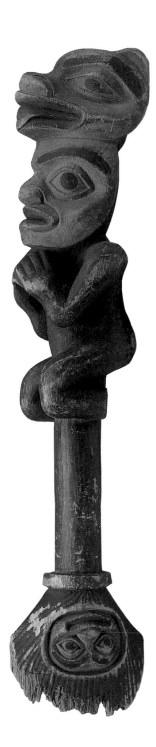

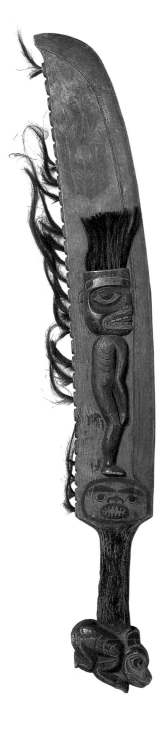

No. 340. *Tlingit Staff.* At one end are two confronting froglike animals with a woodworm between them; at the other end is a bound witch, an image that indicates shamanic use. Collected by B. A. Whalen. Wood, abalone, and orange pigment; length 15⅞ inches; c. 1850–70. National Museum of the American Indian, Smithsonian Institution, Washington, D.C., 4635. Purchased from Whalen, 1905

No. 341. *Tlingit Staff.* A bear head is carved over a kneeling human figure. According to Emmons (n.d., Notes, NMAI), this staff was used to destroy hostile spirits. Collected by him with nos. 407, 433, and 448 from the grave house of a shaman of the Stikine tribe near Wrangell. Wood and black, red, and blue-green pigment; length 16¾ inches; c. 1840–60. National Museum of the American Indian, Smithsonian Institution, Washington, D.C., 1/2513. Purchased from Emmons, 1907

No. 342. *Tlingit Staff.* Emmons (n.d., Notes, NMAI) describes this as a shaman's wand, and calls the central figure a "dream spirit." A land otter is at the bottom, and a headless skeletonized human figure is painted upside down at the top. A row of devilfish tentacles is on the back. Collected by Emmons. Wood, human hair, and red, black, and blue-green pigment; length 26 inches; c. 1840–60. National Museum of the American Indian, Smithsonian Institution, Washington, D.C., 18/5785. Purchased from Emmons, 1933

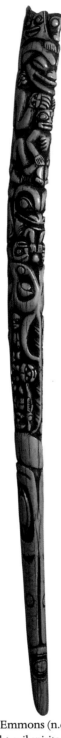

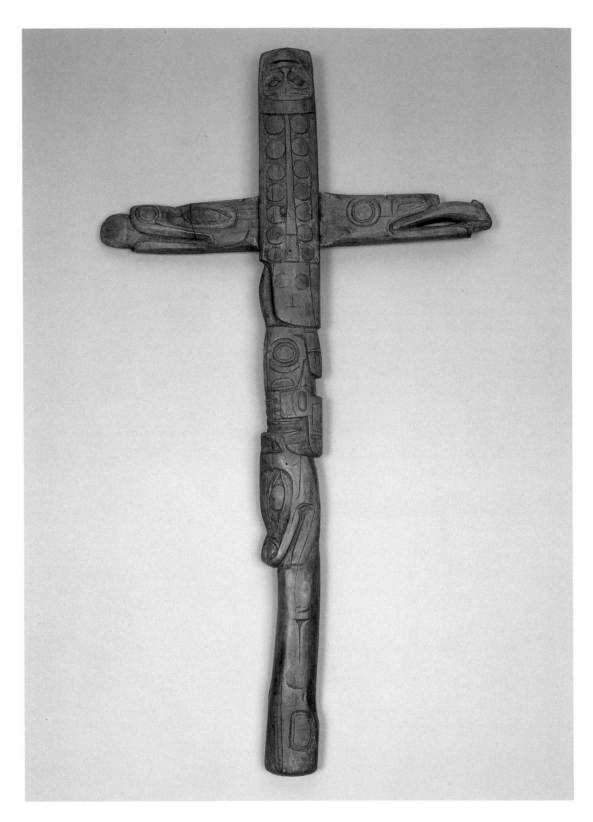

No. 343. Tlingit Staff. Emmons (n.d.) states that this was used both to fight evil spirits and to detect witches. He describes the figures from top to bottom as a land otter with small spirits surmounting another land otter, a devilfish, a mountain goat, and a crane. Purchased by him in 1882–87 at Klukwan from a Chilkat shaman "who set great value by it." Emmons (1991, p. 381) also refers to this type of staff in general: "The most beautiful wands were made of walrus tusks shaped as daggers and carved." Walrus ivory; length 24½ inches; c. 1820–40. American Museum of Natural History, New York, 19/359. Purchased from Emmons, 1888

No. 344. Tlingit Staff (two views). In the form of a war pick. The heads of a wolf and a land otter are on the crosspiece. Below the crosspiece on both sides is a land otter, above which is a devilfish on one side and a form identified by Emmons (n.d., Notes) as a dragonfly on the other. According to him (ibid.), besides being employed during healing rites, this staff was "used during spirit quest to kill the otter and other animals whose spirits he [the shaman] wished to obtain. This was done by merely making a motion towards the animal and not by actual contact." Collected by Emmons from the grave house of a shaman at Dry Bay. Wood; length 22⅜ inches; c. 1840–60. Field Museum of Natural History, Chicago, 78152. Purchased from Emmons, 1902

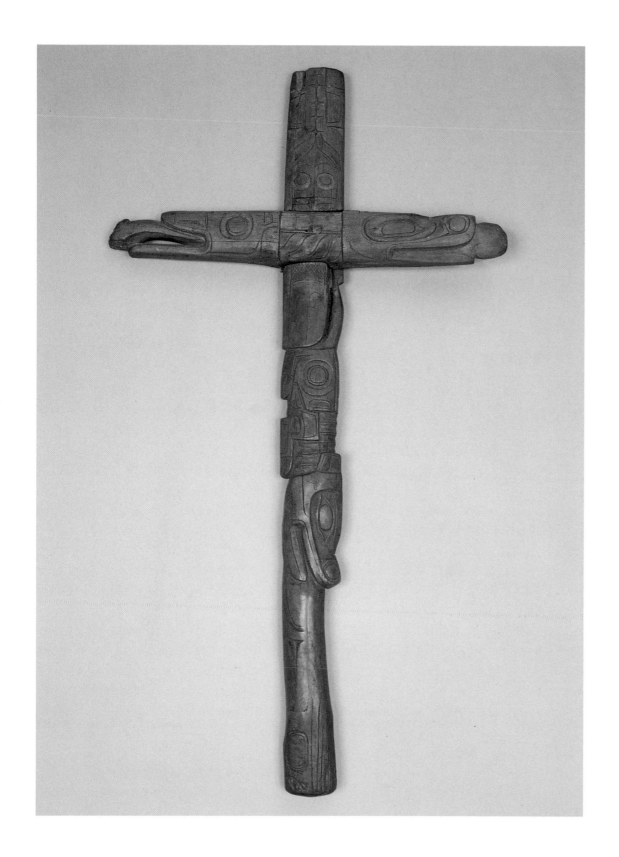

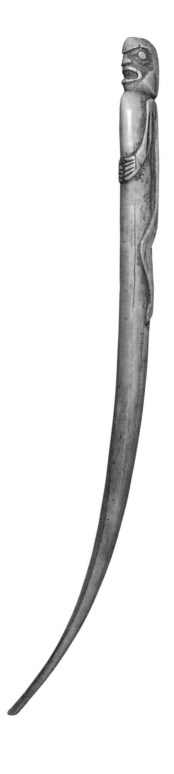

No. 345. Tlingit Staff. Emmons (n.d.) refers to this staff as a spirit knife that a shaman used to fight evil forces. Said to have passed through several generations of shamans before he collected it from a Chilkat shaman, 1884–93. Walrus ivory; height 23¼ inches; c. 1820–40. American Museum of Natural History, New York, E 628. Purchased from Emmons, 1893

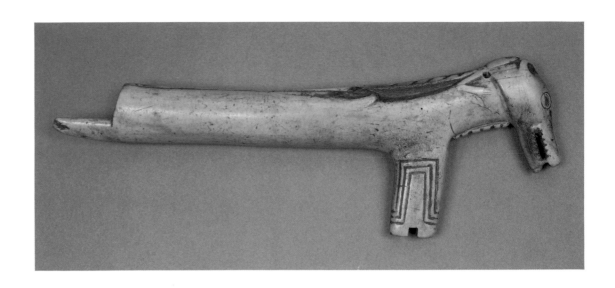

No. 346. *Haida Staff.* The head is a bear. Behind the head is a land otter carved in relief. This object was used similarly to the staffs in the form of war picks (see nos. 338, 344). It shows considerable wear and probably dates to the eighteenth century. Collected by George Dorsey in 1897 from a shaman's grave house at Kung (see Cole, 1985, p. 170). Antler and abalone; length 14 inches; c. 1780–1800. Field Museum of Natural History, Chicago, 53026

THE SHAMAN WHO WENT INTO THE FIRE
(Tlingit)

A little boy's friends were all gone. His uncle was a great hunter, and the little boy was always going around far up in the woods with bow and arrows. He was growing bigger. He also went out with his uncle. His uncle went about everywhere to kill things. He always brought plenty of game down from the mountains.

One time he again went hunting. At that time the inside of the house was full of the sides of mountain sheep, on racks. His uncle's wife hated her husband's little nephew very much. When she went outside for a moment, he broke off a little piece of fat from the sides of mountain sheep hanging on the rack, to put inside of his cheek. Although there was so much he broke off only so much. Then his uncle's wife looked all around. The end piece was not there. "Is it you that has done this?" she said to her husband's little nephew. He cried and said, "No." Then she put her hand inside of his cheek. "Why don't you go up on the mountain?" [she said.] She scratched the inside of his cheek. Blood ran out of his mouth. While crying he pulled his uncle's box toward him. He took his uncle's whetstone out of it. Meanwhile his uncle was far away.

Then he started off into the woods, carrying the whetstone, and came out to a creek. He came out on a sandy bank, pounded [or scooped] it out like a salmon, and made a nest beside the water. He stayed upon it overnight. His dream was like this. He was told, "Let it swim down into the water." It was his spirit that told him to do this.

When his uncle came down he missed him. He asked his wife, "Where is my nephew?" She answered. "He went up that way with his bow and arrows."

When [the boy] got up farther he made another nest. This man was named "For-little-slave." He made eight nests. Now his spirit helper began to come to him on the last. At that time he took his whetstone down into the creek, and it swam up in it. Then he lost his senses and went right up against the cliff. He stayed up there against the cliff. Everything came to hear him there – sea gulls, eagles, etc. When his spirits left him they would always be destroyed – the eagles, sea gulls, all of them.

Now, his uncle hunted for him. After he had been out for eight days he discovered the nest his nephew had made by the creek. He saw all the nests his nephew had camped in. His uncle looked into the creek. The salmon was swimming there, and he camped under the nest. After-

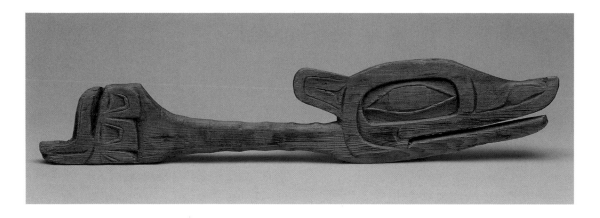

No. 347. Tlingit Staff Top. The head is that of a land otter, indicating its shamanic use. Wood; length 19½ inches; c. 1840–60. Former collection: John Brady, Governor of Alaska. National Museum of Natural History, Smithsonian Institution, Washington, D.C., 274312. Given by Edward H. Harriman, 1912

ward he listened. In the morning he heard the beating made by shamans' sticks. He heard it just in the middle of the cliff. Then he came up underneath it. Before he thought that [his nephew] had seen him, his nephew spoke to him: "You came under me the wrong way, uncle." The uncle pitied his nephew very much. "Come up by this corner," said his nephew. Ever afterward he was named, "For-little-slave." Then his uncle asked him, "What caused you to do this?" He did not say that his uncle's wife had scratched the inside of his cheek. Instead he said to his uncle: "Cave spirits told me to come here." This was a big cave, bigger than a house.

Then his spirits came to him while his uncle was with him. They went inside, and his uncle beat time for him. Then he told his uncle to remember this: "When the spirit Nixâ' runs into the fire with me, do not let me burn up. While I am getting small throw me into a basket." That was the way he did with him. It ran into the fire with him, and he threw him into the basket. Then he always came to life inside of the basket. He became a big man again.

That same evening he sent out his uncle to call, "This way those that can sing." Then the cliff could hardly be seen for the mountain sheep that came down to look into the cave. When they were seated there, he whirled about his bow and arrows and all the mountain sheep were destroyed. The inside of the cave was full of them. Now, he said to his uncle: "Take off the hides." He was singing for great Nixâ'. When the spirit came out of him he reminded his uncle, "When it runs into the fire with me, don't forget to take me out and put me into the basket."

After all of the sheeps' sides were covered up he sent him for his wife. He came up with his wife into the cave. Then he said to his uncle: Take the half-basket in which we cook. "Mash up the inside fat for your wife." His spirits took out the woman's bottom part from her. For this reason the woman never got full eating the mountain-sheep fat. She could not taste the fat. He put her in this condition because she had scratched the inside of his cheek.

By and by he said to his uncle: "Make your mind courageous when Nixâ' comes in." In the evening he told his uncle to go out and call. The cliffs could hardly be seen. Grizzly bears came in front of the house to the door of the cave. They extended far up in lines. Then his uncle started the song for the spirit. They kept coming inside. Suddenly a grizzly bear came in. It was as if eagle down were tied around its ears. At that [the uncle's] wife became scared and broke in two. He did this to her because she had scratched on the inside of his cheek on account of the fat. His spirit also ran into the fire with him. While his uncle stood in fear of the grizzly bear, For-little-slave burned up in the fire.

At that the cave creaked, and every animal ran into its skin. The things they were drying did so. They did so because the shaman had burned up. So the shaman and his uncle also were finally burned up. (Swanton, 1909, pp. 267–72)

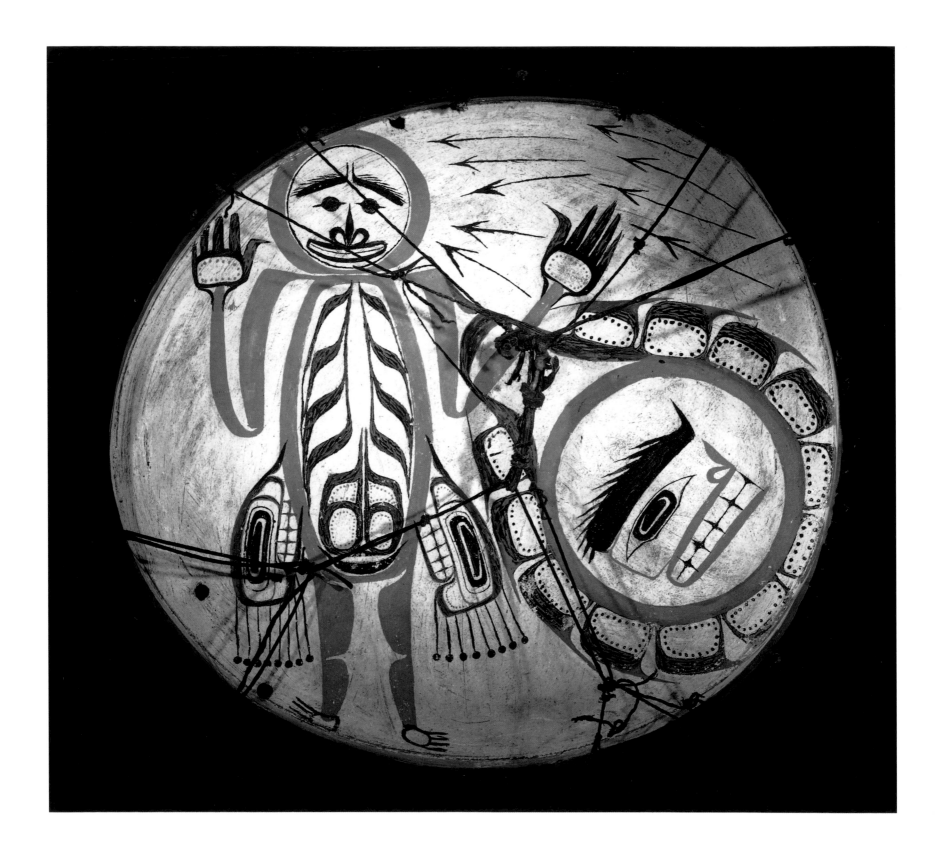

234

DRUMS

ANIMAL SKIN tambourine drums are important shamanic instruments in Siberia, among the Eskimo, and on the Northwest Coast. Most are undecorated, but a few Tlingit and Haida examples are painted on the inside with animal and human designs.

Tsimshian shamans used only these types of tambourine drums (Guédon, 1984b, p. 196), but the Tlingit also occasionally used large bentwood box drums during their performances. These instruments, which were more often used by chiefs and their families in secular dances, were hung from a beam by a rope attached through holes in the top, or tilted on one corner and held so that the sound would not be muffled (Holm, 1987b, p. 176). They were beaten by the fist or a drumstick on the inside to give a deep, full tone. Those used for shamanic ceremonies are painted with representations of guardian spirits and stories associated with their owners.

No. 348. Haida Tambourine Drum. (opposite) Although there are no data concerning the use of this drum, Macnair et al. (1980, p. 30) designate it as shamanic. While admitting their subjectivity, they write that "the main figure in this painting appears to be a shaman, whose ribs and pelvis are shown in x-ray form and who wears an apron. Beside him is an expansively rendered creature, probably a spirit helper. Two flights of arrows threaten the shaman." Collected by Donald Mackay before 1905. Deerskin, wood, and red and black pigment; diameter 24½ inches; c. 1860–80. Former collection: Jelliman, Masset. Royal British Columbia Museum, Victoria, 10630. Purchased from William A. Newcombe, 1931

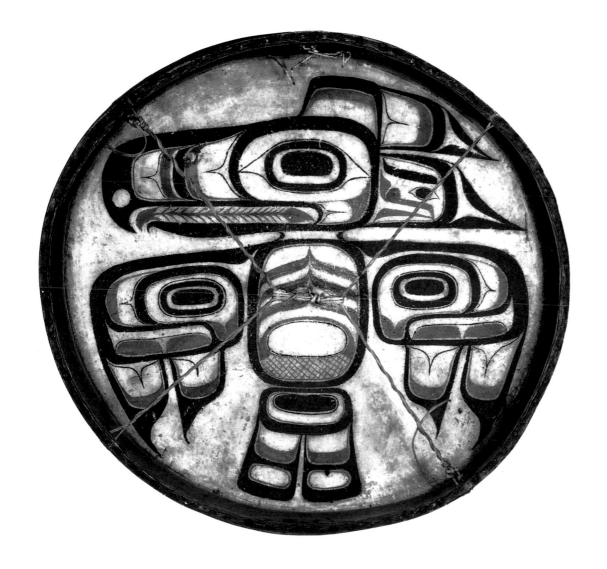

No. 349. Tlingit Tambourine Drum. Owned by a shaman known as Tongass George (Feder and Malin, 1962, no. 38); the painting of an eagle was probably his crest emblem. Wood, animal skin, and red and black pigment; diameter 27 inches; c. 1860–80. Former collection: Walter Waters, Wrangell. Denver Art Museum, 1953.388

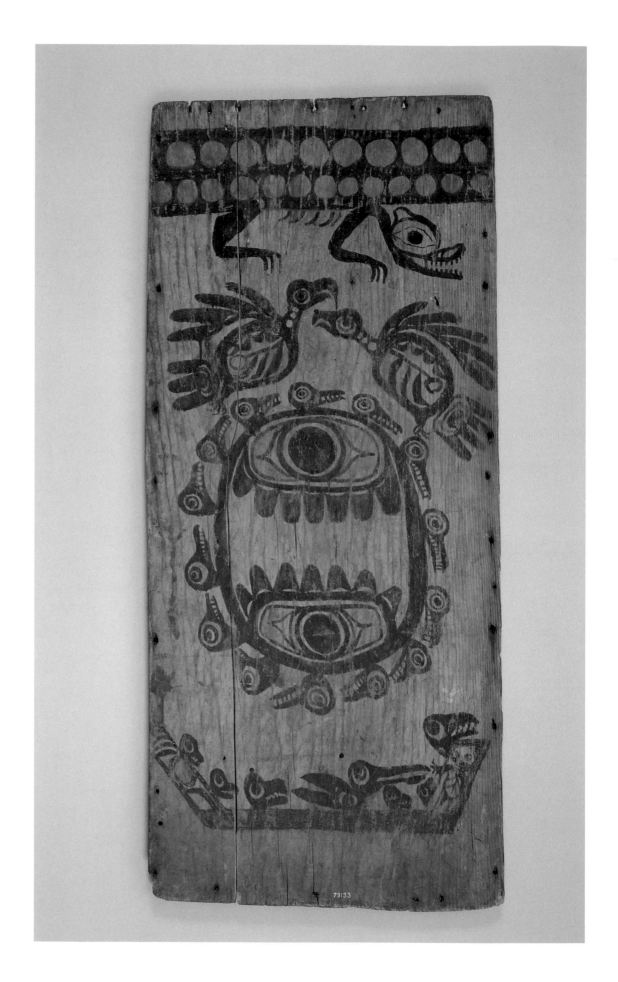

No. 350. Tlingit Box Drum Top. Although Emmons (n.d., Notes) describes this panel as a box cover, it is probably the top of a box drum. He interprets the design as representing the spirit of a lake surrounded by mergansers. At the bottom is a spirit head canoe containing birds, and at the top is a land otter with two rows of devilfish tentacles on its back. The two bird forms below the otter are an eagle and a raven. The depiction of a head canoe would date the object to the first part of the nineteenth century, when such canoes were used (Holm, 1987a, pp. 152–55). Collected from a grave house on the Chilkat River near Yandestaki. Wood and red and black pigment; height 38 inches; c. 1810–40. Field Museum of Natural History, Chicago, 79133. The Carl Spuhn Collection. Purchased from Emmons, 1902

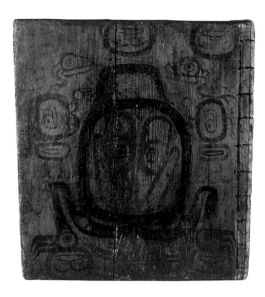

No. 351. *Tlingit Box Drum* (two views). Emmons collected this drum with ten other objects from a cave in a cliff rising above Whitewater Bay on Admiralty Island. The objects had belonged to a shaman of the Desitan clan of the Hutsnuwu tribe who lived at Neltushkin. One side of this box drum (left) shows a bear at the top with a frog emerging from its mouth. Below are four horizontal headless spirit figures, and at the bottom is another large animal head. Emmons interprets the painting on the side shown at the right as representing a raven's nest surrounded by ravens. There is also a painting of a killer whale on the inside of the long plank at the bottom of the drum, which suggests that the piece may have been salvaged from another box. Wood, spruce root, and red and black pigment; height 33½ inches; c. 1830–60. Thomas Burke Memorial, Washington State Museum, 1221. Purchased from Emmons, 1909

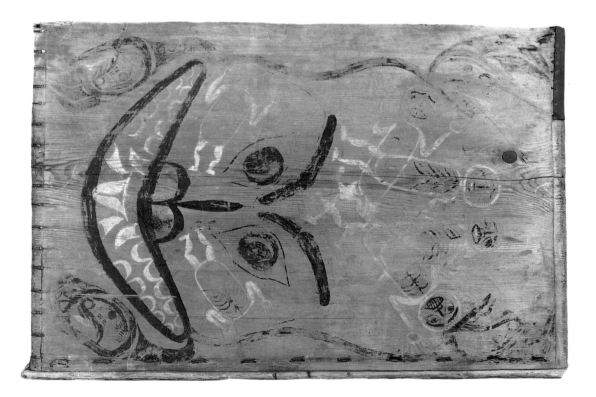

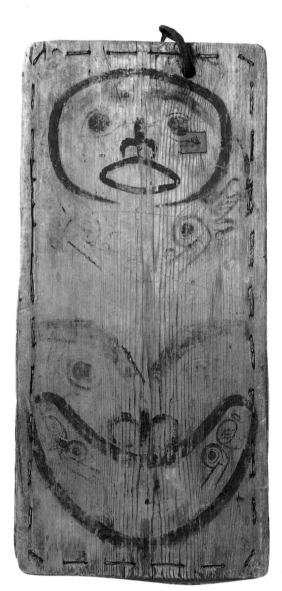

No. 352. *Tlingit Box Drum* (two views). According to Emmons (n.d., Notes), the large animal on both the top and one side of the drum (shown here) is a frog. He describes the figures depicted in the x-ray style as "spirits tumbling down from the skies." On the top (right), the animals in the mouth of the frog and below the face may represent land otters. Collected at Klukwan, and said to have descended through several generations of shamans in the Ganaxadi clan. Cedar, rawhide, and red and black pigment; height 33¾ inches; c. 1830–50. Field Museum of Natural History, Chicago, 78724. The Carl Spuhn Collection. Purchased from Emmons, 1902

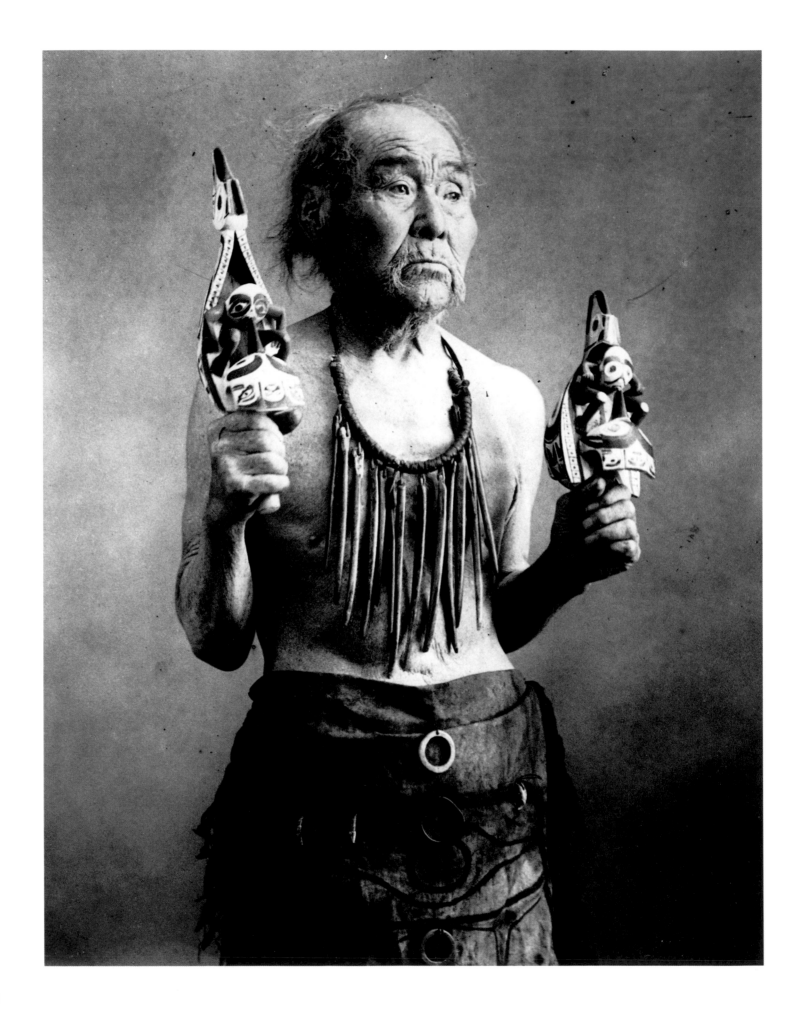

RATTLES

THE RATTLE was a very important piece of shamanic equipment along the entire Northwest Coast. Its sound provided rhythm for songs, dances, and chants, and attracted spirits to the séances. Wherever it was used, a supernatural presence was thought to be in attendance. The most common form was the round rattle, a globular instrument made of two hollowed pieces of hardwood, usually maple, lashed together, and containing pebbles. Many examples are completely plain. Others are painted and carved with shallow relief designs. A third type, fully three-dimensional, takes the form of animal or human heads. Holm (1983, p. 31) suggests that the origin of the design of the round rattle was the human skull.

Although some round rattles were made for potlatch and secret society ceremonies, the majority were used by shamans. Guédon (1984b, p. 211) describes Tsimshian shamans' "round wooden rattles with or without figures carved on them"; Swanton (1908c p. 464) refers to the "oval rattles such as Haida shamans always employed"; Holm (1987b, p. 128) writes that among the Kwakiutl, "globular rattles were reserved for shamans' work"; and, speaking of the Tlingit, Jonaitis (1986, p. 30) states that "another rattle, owned only by shamans, was the globular type." A variation of the round rattle is found in several doughnut-shaped examples (nos. 378, 379).

Raven rattles were made in large numbers, especially by the Tlingit. Most of them were used by wealthy families in secular ceremonies, but a few (see no. 395 and p. 86) were found in shamans' graves. Swanton (1909c, p. 464) claims that the use of such "chief's rattles" proclaimed the shaman's high social rank to his public. It should also be remembered that Raven taught both shamans and witches the secrets of their crafts (p. 104), and it would therefore seem logical that shamans would employ a rattle depicting him during their performances.

Another distinctive form of the Tlingit shamans' rattle is shaped as an oystercatcher with groups of human and animal figures on its back. The feet of the bird often curve to the bottom of the rattle, which is carved in relief with the head of another bird, usually a hawk. Many are decorated with ermine skin. The beak of wood, ivory, bone, or even the actual bill of the oystercatcher itself (no. 48) is affixed separately. The animals most frequently shown on these rattles are such helping spirits as land otters, devilfish, mountain goats, frogs, and sculpins. On the use of the oystercatcher in this context, Holm (Holm and Reid, 1975, p. 212) has said that "the oystercatcher is a crazy bird in nature, a peculiar one to watch on the rocks. Mysterious. The sort of bird I think would have something to do with doctors."

The human figures on the backs of these rattles represent shamans engaged in their activities. Some are shown in the act of capturing, torturing, and tying up witches, whereas others depict reclining shamans in trance states forming alliances with animal helping spirits. One (no. 69) even seems to portray two shamans in flight.

Other shamans' rattles are in human shape (nos. 385, 429); some are conceived horizontally as batons (nos. 427, 428), and one (no. 426) takes on the shape of a miniature totem pole. As opposed to the raven rattles, which are essentially similar and follow fairly rigid sculptural formulas, each shaman's rattle is a unique creation.

Fig. 36. Tlingit Shaman (opposite). He wears a painted apron and ivory necklace, and carries two raven rattles. Photograph by Case and Draper, Juneau, c. 1905. Alaska State Library, Juneau, PCA 3965

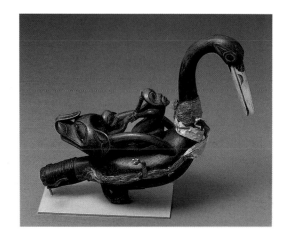

No. 353. Tlingit Rattle. Oystercatcher. A mountain goat head faces the handle. Between the mountain goat horns a shaman is tying up a witch. Collected by William Libbey from the grave house of a shaman near Port Mulgrave (Yakutat), 1886. Wood, ermine skin, bird skin, bone, rawhide, and black, red, and blue pigment; length 12 inches; c. 1830–50. The Art Museum, Princeton University. On permanent loan from the Department of Geological and Geophysical Sciences, 5153. Given by Libbey, 1886

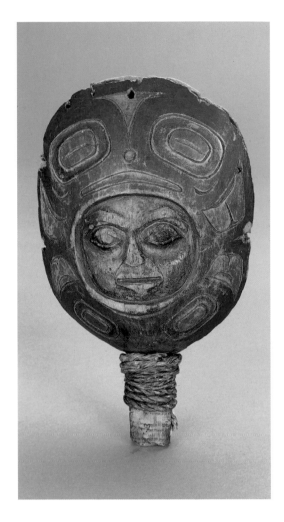

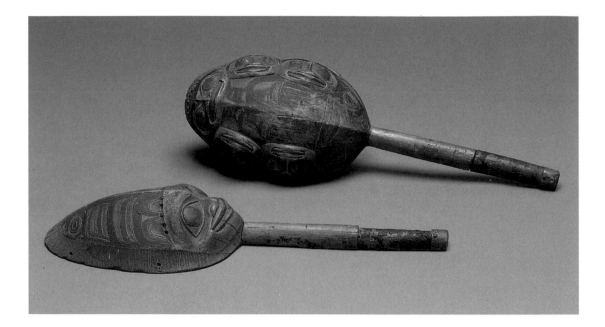

No. 354. *Tlingit Rattle*. A woman wearing a labret is on both sides. According to Emmons (n.d., Notes), the relief carvings on the borders represent fish. Part of the complete kit of a shaman of the Xatkaayi clan who lived on the west coast of Prince of Wales Island. Collected by Emmons from the shaman's grave house on the shores of a salmon stream flowing into Dry Bay, north of the Alsek River. Wood, cedar bark, and red and black pigment; height 6¼ inches; c. 1830–50. Field Museum of Natural History, Chicago, 77849. Purchased from Emmons, 1902

No. 355. *Tlingit Rattle* (two views). De Laguna (1972, pt. 3, p. 1095, pl. 177) describes the side shown below as representing the spirit of a chiton and the side shown at the top as depicting the heads of five frogs. Collected by William Libbey from the grave house of an unknown shaman near Port Mulgrave (Yakutat), 1886. Wood and red, black, and blue-green pigment; length 10 inches; c. 1830–50. The Art Museum, Princeton University. On permanent loan from the Department of Geological and Geophysical Sciences, 5152. Given by Libbey, 1886

This again reflects the personal nature of shamanic art and the fact that it represents the world of the supernatural, which was far removed from the controlled and standardized life of the community (see Jonaitis, 1986, pp. 120–22).

CONTROLLING THE WEATHER
(Haida)

A man and his wife, a woman of the Slaves above referred to, went into the woods to gather hemlock-sap. When they reached home (they were in camp at the time), the woman said something that displeased her husband, and he struck her. Then he saw lightning flash in the house, "like moonlight." He struck her again, and the flash was so great that the house almost began to burn. The woman then fell down, and lay there all night. When her husband went to see her in the morning, she lay as though she were dead, but her heart was still beating. Her husband then put her into the canoe and took her back to Ninstints, where he placed her in a mat and carried her to the upper end of the house. After she had lain there awhile, she began to call out like a shaman. She said her power was from the Moon. At the same time she transmitted it to a man of her own family, named Amalhā'lait, and lay near by while he performed. They tied the man's hair up on the back of his head with a piece of red "flannel;" and when he ran around the fire, he told the other men to take hold of this cord and try to pull him down. But, although he was a small man, he generally pulled them right after him. When the people went to the West Coast for black cod, these two accompanied them; and every time they went out fishing, they took a clean mat out doors and made this woman sit upon it. Then as long as they staid out, and she commanded the weather to remain calm, it did so. If a breeze started, she told it to stop, and it obeyed. When they came ashore, and she went in, the wind at once sprang up. Each of the fishermen usually brought two or three black cod in to her, so that she obtained a heap after each fishing. She prophesied that they would find back of Ninstints a long stick with a split in it. This she told them to put in front of the houses, and said that when it rolled down, the town would be gone. By and by some one "went with her," whereupon the spirit left her and never returned. Her name was Chief's-Child. (Swanton, 1905, p. 39)

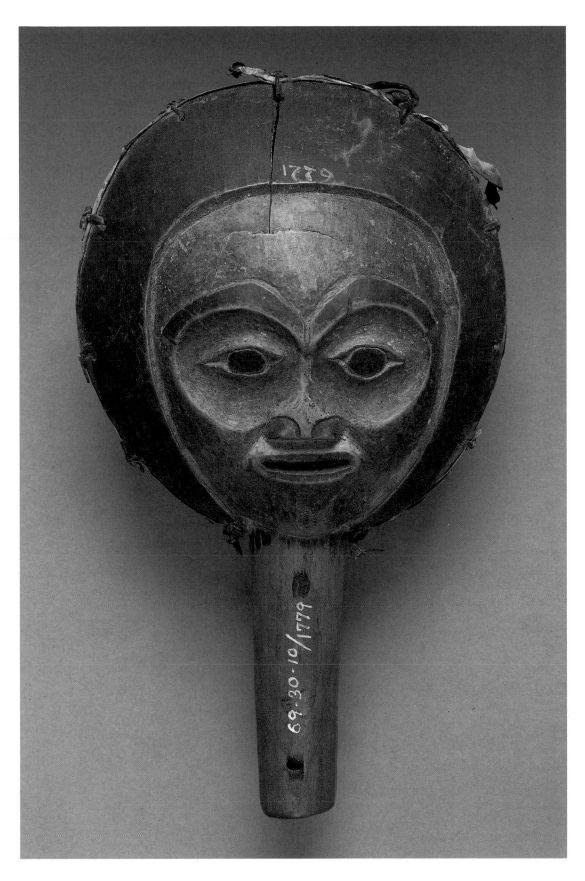

No. 356. Tlingit Rattle. Human face. Collected by Captain Edward G. Fast in Sitka, 1867–68. Wood, rawhide, and red, black, and blue-green pigment; height 10 inches; c. 1830–50. Peabody Museum of Archaeology and Ethnology, Harvard University, Cambridge, 69–30–10/1779. Purchased from Fast, 1869

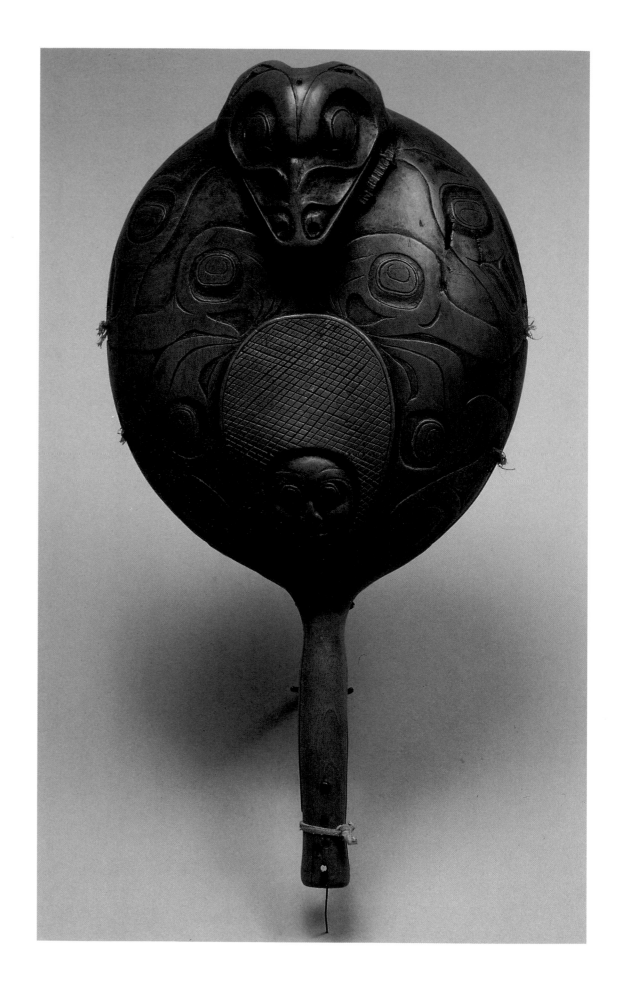

No. 357. *Tsimshian Rattle* (two views). The principal animal on the front is a beaver (right), and a frog appears in relief on the back (far right). Collected by Emmons from Chief Goga Sienmidcaks at Kitwanga, 1909. Emmons (n.d., Notes, NMAI) states that the chief was also a shaman and that the beaver was his family crest. Wood; height 11¾ inches; c. 1830–50. National Museum of the American Indian, Smithsonian Institution, Washington, D.C., 9/7998. Purchased from Emmons, 1920

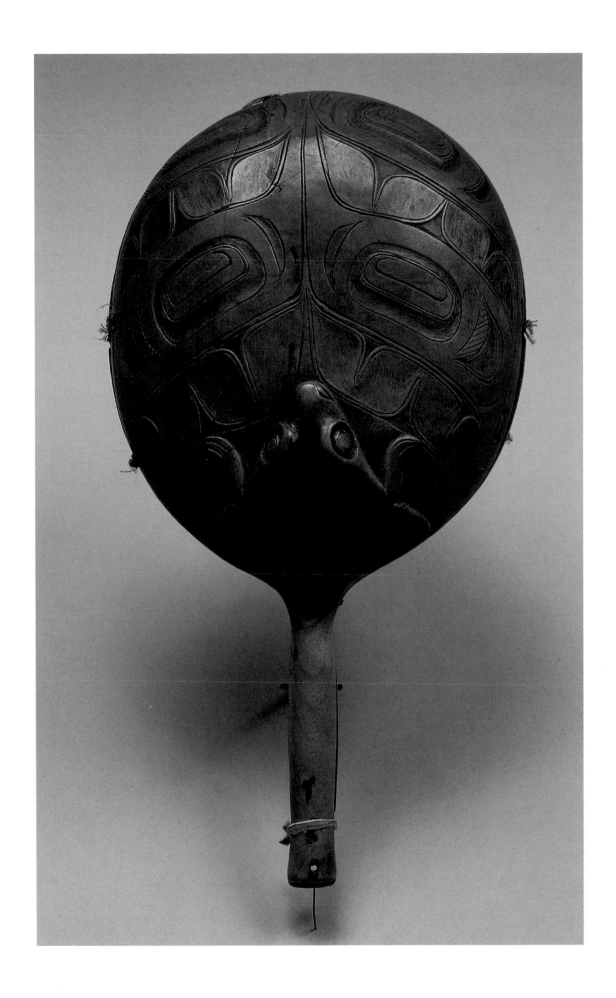

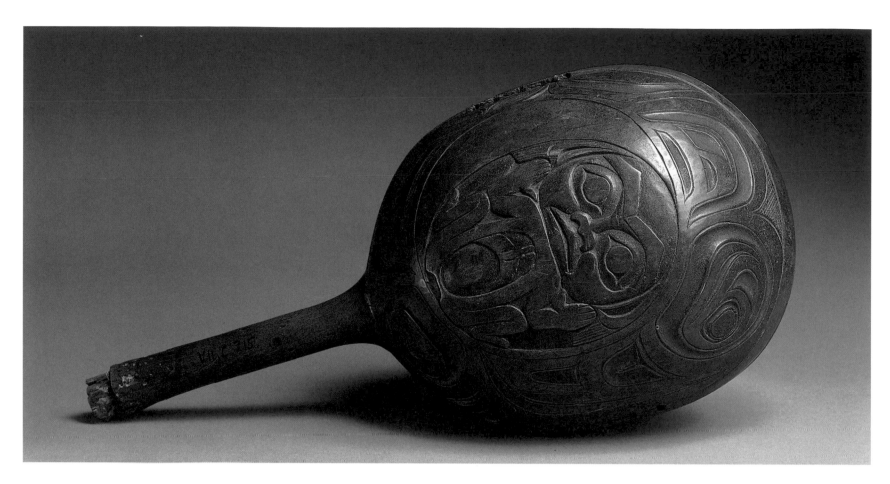

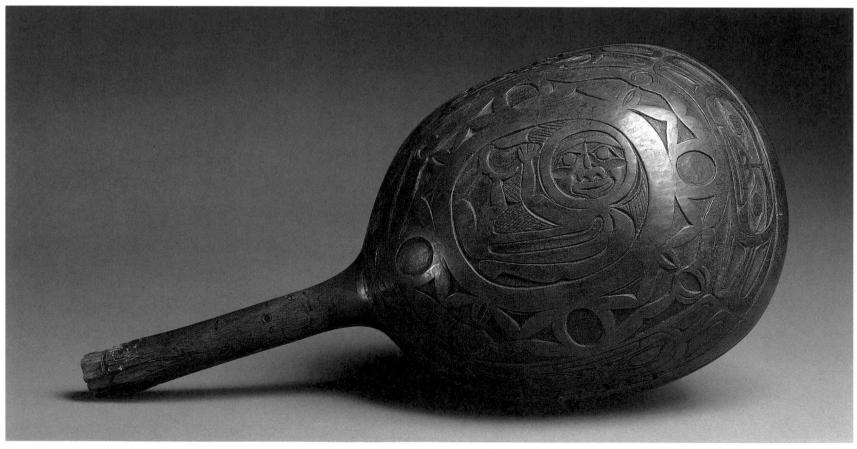

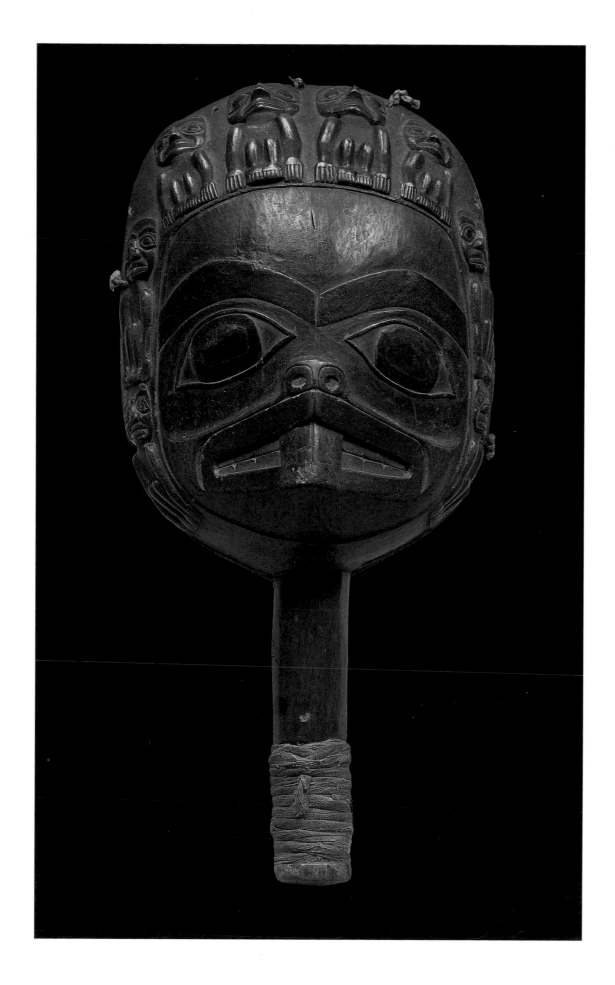

No. 358. *Tsimshian Rattle* (opposite, left; two views). On the side shown at the top are four spirit figures, similar to those on no. 379, surrounding a contorted figure. The frontal figure on the side shown on the bottom may represent the crescent moon, as suggested by the form to its left. Collected by William A. Newcombe at Gitlakdamiks, 1905. Wood and twine; height 12⅜ inches; c. 1830–50. Canadian Museum of Civilization, Ottawa, VII–C–215

No. 359. *Haida Rattle.* Eight spirit figures surround the head of a beaver. Collected by Thomas Crosby at Tanu. Wood, spruce root, and red, black, and traces of blue-green pigment; height 12½ inches; c. 1840–60. National Museum of the American Indian, Smithsonian Institution, Washington, D.C., 1/8027. Acquired 1908

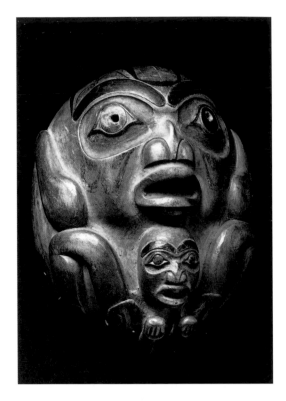

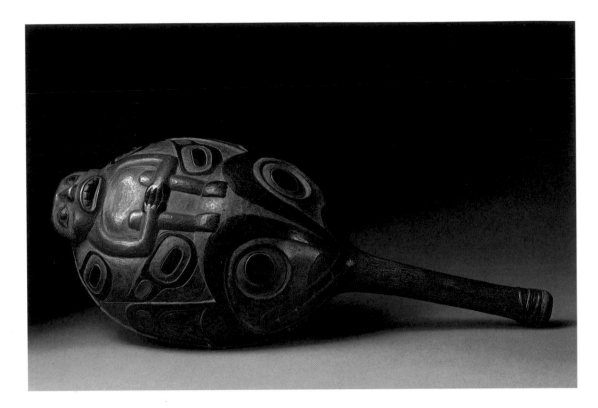

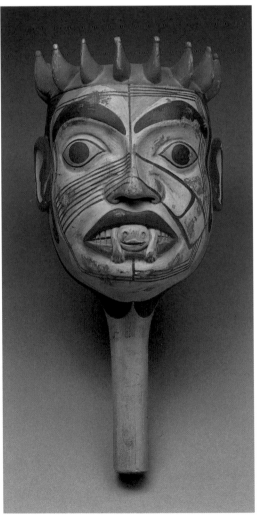

No. 360. *Haida Rattle Fragment* (upper left). Emmons (n.d.) writes that this carving shows "one spirit within another, both singing." Collected by him in 1884–93 at Sitka, although it is of Haida origin. Emmons describes the piece as a headdress ornament, but it is most likely the front of a round rattle (see Wardwell, 1978, p. 84, no. 53). Wood and red, black, and green pigment; height 6½ inches; c. 1840–60. American Museum of Natural History, New York, E 1373. Purchased from Emmons, 1893

No. 361. *Tsimshian Rattle* (above). Both museum records and Gunther (1962, p. 84, no. 143) ascribe shamanic use to this rattle, which is decorated with relief designs of a whale and a human who wears a killer whale headdress. Collected by Israel W. Powell, 1879. Wood, brass tacks, spruce root, and red, black, and green pigment; length 9¾ inches; c. 1840–60. Canadian Museum of Civilization, Ottawa, VII–C–5

No. 362. *Haida Rattle* (lower left). The exotic pigments and lack of signs of extensive use suggest that this rattle is of a late date and may have been made for sale. In addition, no rattles from earlier times show a shaman's crown, as seen here. This example relates to a group of masks with shamans wearing crowns which are also thought to be from a late period (King, 1979, p. 81, fig. 8). Wood and red, black, and blue pigment; height 13¼ inches; c. 1890–1920. National Museum of the American Indian, Smithsonian Institution, Washington, D.C., 21/527. Purchased, 1947

No. 363. *Tlingit Rattle* (opposite, upper left). The face of a hawk. Wood and black and traces of red pigment; height 8¾ inches; c. 1840–60. American Museum of Natural History, New York, 16.1/2543

No. 364. *Haida Rattle* (opposite, far right). A bear head with a protruding tongue. The design on the other side is a hawk. Wood, rawhide, and black and red pigment; height 14¾ inches; c. 1840–60. National Museum of the American Indian, Smithsonian Institution, Washington, D.C., 8/1650. Purchased from Fred Harvey, 1918

No. 365. *Haida Rattle* (opposite, lower left). The side shown represents the face of a woman wearing a labret, the other, the face of a man (see Wardwell, 1964, p. 65, no. 161). Wood and cedar bark; height 9⅞ inches; c. 1820–40. Former collections: Museum of the American Indian, New York, 2/6363, purchased 1910–12; Claude Lévi-Strauss. Rijksmuseum voor Volkenkunde, Leiden, 2935–2

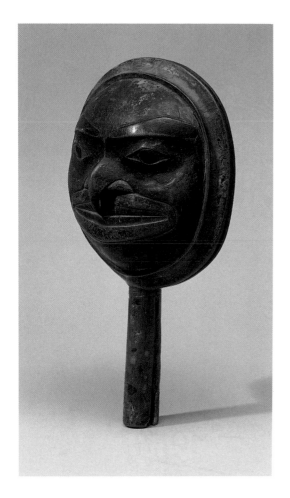

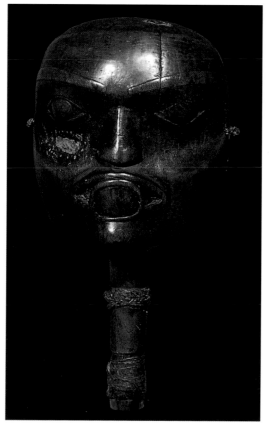

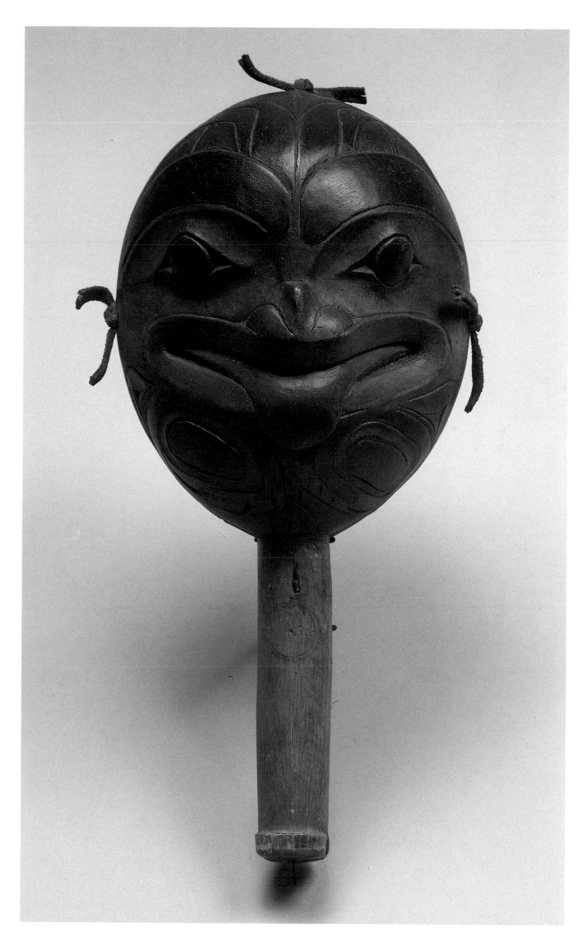

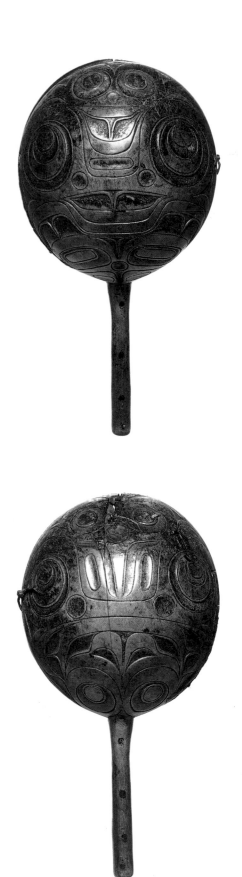

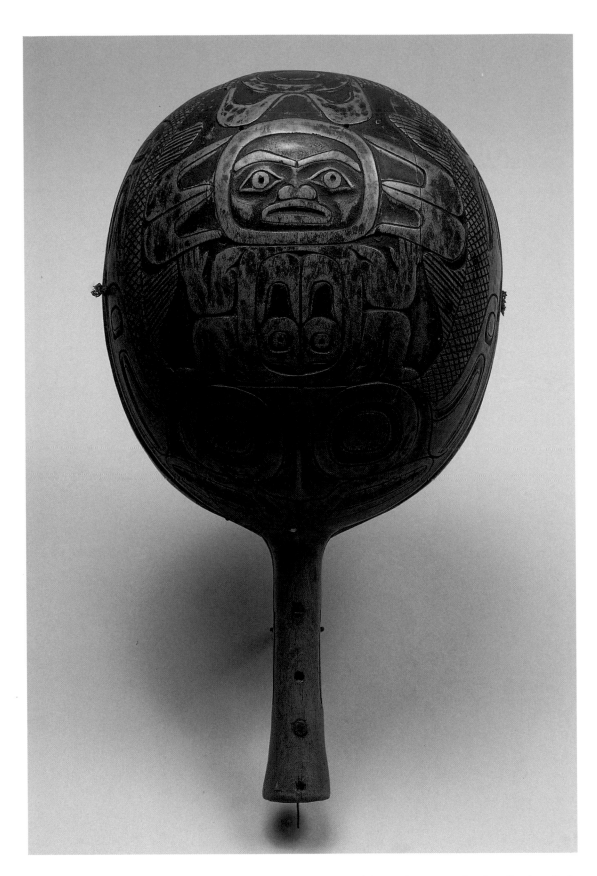

No. 366. Haida Rattle (two views). The relief designs are too abstract to be interpreted. Wood and rawhide; height 11⅛ inches; c. 1830–50. Private collection

No. 367. Tsimshian Rattle. Emmons (n.d., Notes, NMAI), who collected this rattle at Aiyansh, identifies the relief designs on the side shown as a whale with a human figure in the center, and those on the other side as a mythical water spirit and a human with the head of an owl. Wood; height 12¼ inches; c. 1840–60. National Museum of the American Indian, Smithsonian Institution, Washington, D.C., 9/7995. Purchased from Emmons, 1920

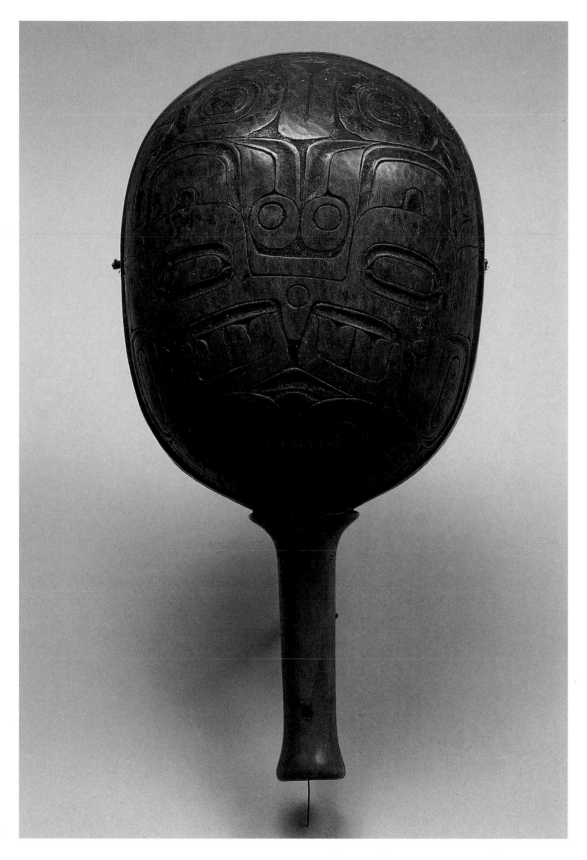

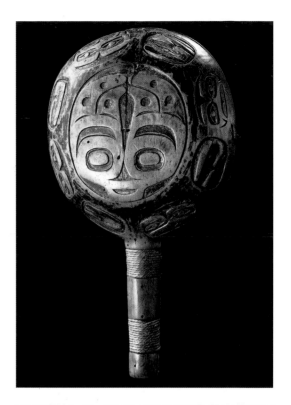

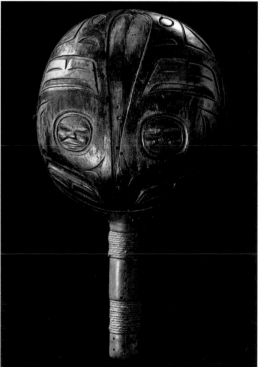

No. 368. Tsimshian Rattle. Emmons (n.d., Notes, NMAI), who collected this rattle, identifies the relief designs as a hawk on one side and an owl on the other. Wood; height 12¼ inches; c. 1840–60. National Museum of the American Indian, Smithsonian Institution, Washington, D.C., 11/3846. Purchased from Emmons, 1922

No. 369. Haida Rattle (two views). Museum records identify the face on the side shown at the bottom as that of a horned owl; the bird's tail feathers with eight spirit heads around the border are on the side shown at the top. Collected by W. B. Anderson on the Queen Charlotte Islands, 1889. Wood, twine, and black and traces of red pigment; height 10½ inches; c. 1830–50. Royal British Columbia Museum, Victoria, 114

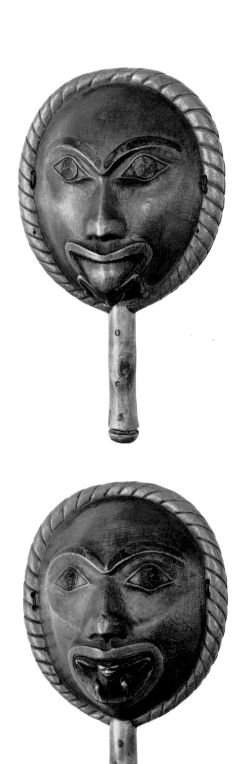

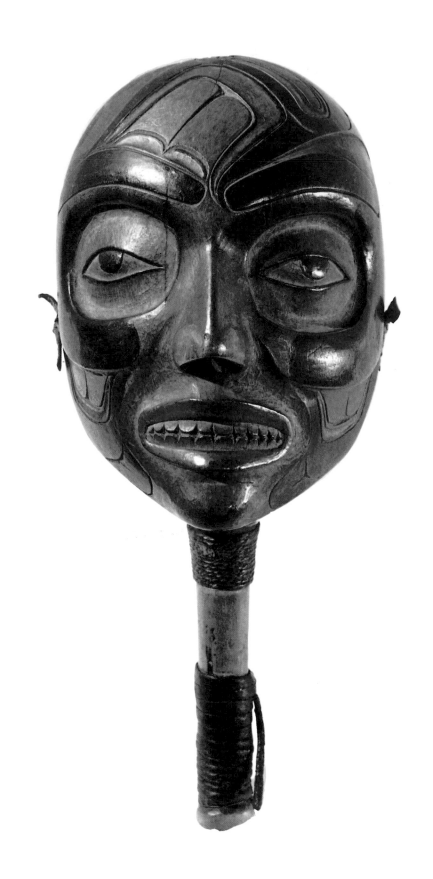

No. 370. Tlingit Rattle (two views). Similar composition to that of no. 374. The design framing the face probably represents braided cedar bark (see Holm and Reid, 1975, p. 207, no. 83). Wood, rawhide, and red and black pigment; height 11¼ inches; c. 1840–60. Private collection

No. 371. Tlingit Rattle. The face expresses a trance condition. Collected by Emmons. Wood, cedar bark, rawhide, and red and black pigment; height 10¼ inches; c. 1840–60. Milwaukee Public Museum, 7325. Purchased 1911

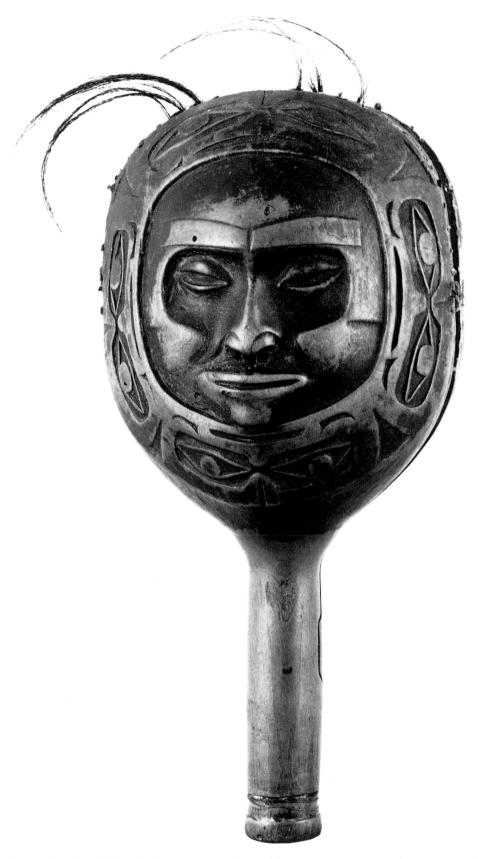

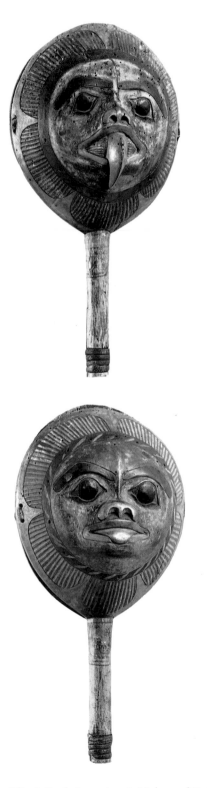

No. 372. *Tsimshian Rattle*. The faces on both sides could represent trance or death expressions. Holm (Holm and Reid, 1975, p. 208) describes them as "corpses or faces from the land of the dead." Collected by Donald Mackay before 1905. Wood and human hair; height 10½ inches; c. 1820–40. Former collections: Jelliman, Masset; William A. Newcombe; Royal British Columbia Museum, Victoria, 10651. Private collection

No. 373. *Tlingit Rattle* (two views). Holm and Reid (1975, pp. 202–5, no. 82) state that the striated border indicates the depiction of a cockleshell. The face shown at the top may represent the spirit of the cockleshell, and that on the bottom may be a bear or a human. Wood, rawhide, and red, black, and traces of blue-green pigment; height 12⅝ inches; c. 1820–40. Former collections: Helena Rubinstein; Jay Leff. Private collection

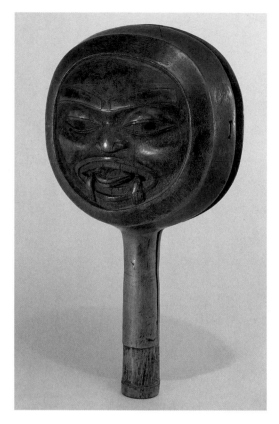

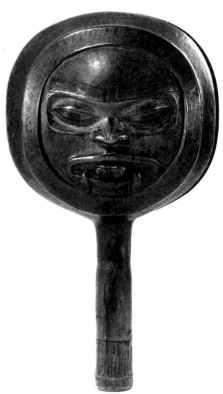

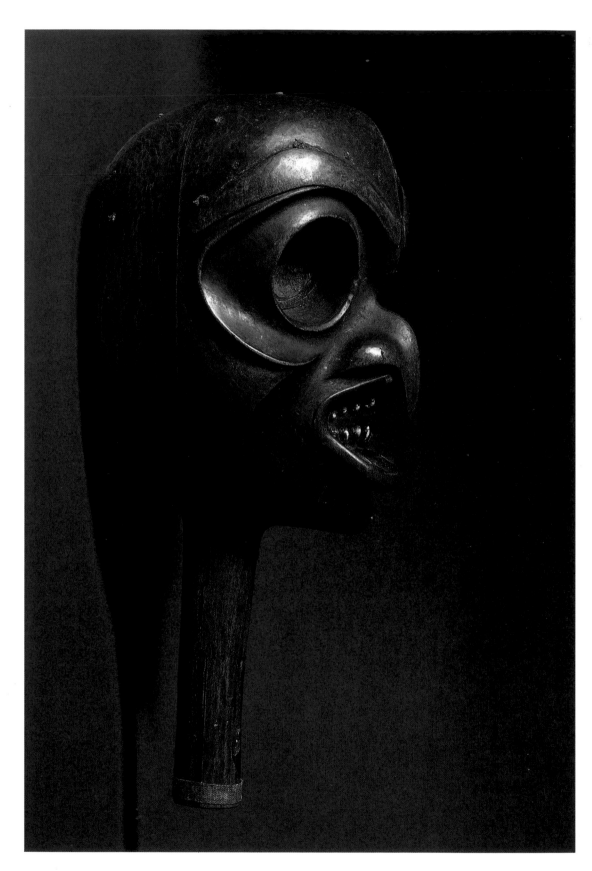

No. 374. Tlingit Rattle (two views). A frog being devoured by a human from the front and rear is shown on the two sides of the rattle. Maurer (1977, no. 430) dates this to c. 1800. It may be slightly later. Wood and red, black, and traces of blue-green pigment; height 9¼ inches; c. 1820–40. Private collection

No. 375. Tsimshian Rattle. The labret indicates that a female spirit is shown. According to Gunther (1962, p. 84, no. 141), this type of carving is of an early Tsimshian style. Collected by William A. Newcombe at a village identified in the museum records as "Guin-eh-ha," 1905. Wood, opercula, and traces of red pigment; height 10 inches; c. 1830–50. Canadian Museum of Civilization, Ottawa, VII–C–149. Purchased from Newcombe, 1908

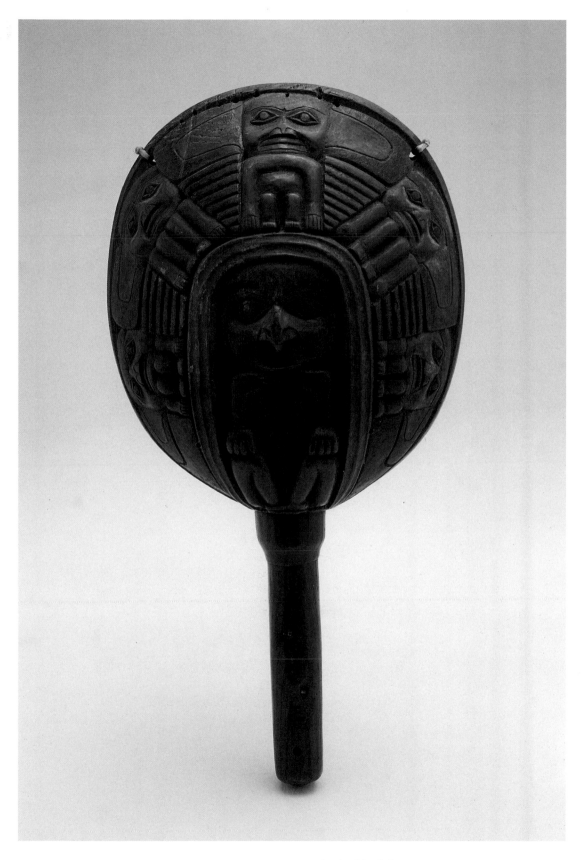

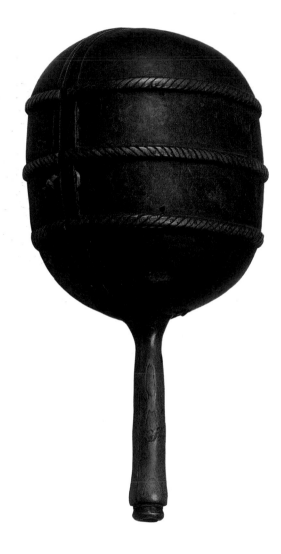

No. 376. Haida Rattle. Six figures are shown, the center one with a bird beak for a nose. The figures on the border have large earlike forms stretching from their heads. This rattle belonged to Tsilwax, a shaman of Haina, where James G. Swan collected the object. Wood and traces of black pigment; height 11¾ inches; c. 1840–60. National Museum of Natural History, Smithsonian Institution, Washington, D.C., 89052. Acquired from Swan, 1883

No. 377. Tsimshian Rattle. As all Tsimshian shamans' rattles are round, such use may be suggested for this unusual example. Emmons (n.d., Notes, NMAI) describes it as being "ornamented with three carved ridges imitating laid up [cedar bark] rope of native make." Collected by him at Gitlakdamiks. Wood; height 10¼ inches; c. 1840–60. National Museum of the American Indian, Smithsonian Institution, Washington, D.C., 1/4185. Purchased from Emmons, 1907

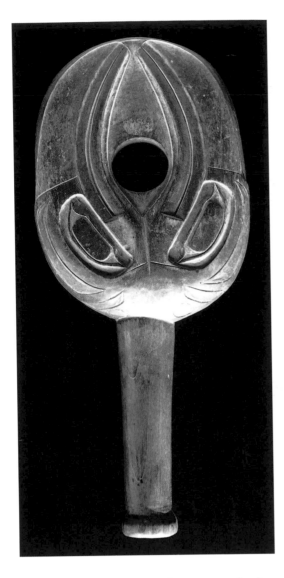

No. 378. *Tlingit Rattle.* Two confronting raven heads are shown on this doughnut-shaped rattle. Its round shape indicates shamanic use, as corroborated by Holm (Vaughan and Holm, 1982, p. 122, no. 84). Collected by Captain Edward G. Fast at Sitka, 1867–68. Wood and red, black, and traces of blue-green pigment; height 9⅜ inches; c. 1830–50. Peabody Museum of Archaeology and Ethnology, Harvard University, Cambridge, 69–30–10/1678. Purchased from Fast, 1869

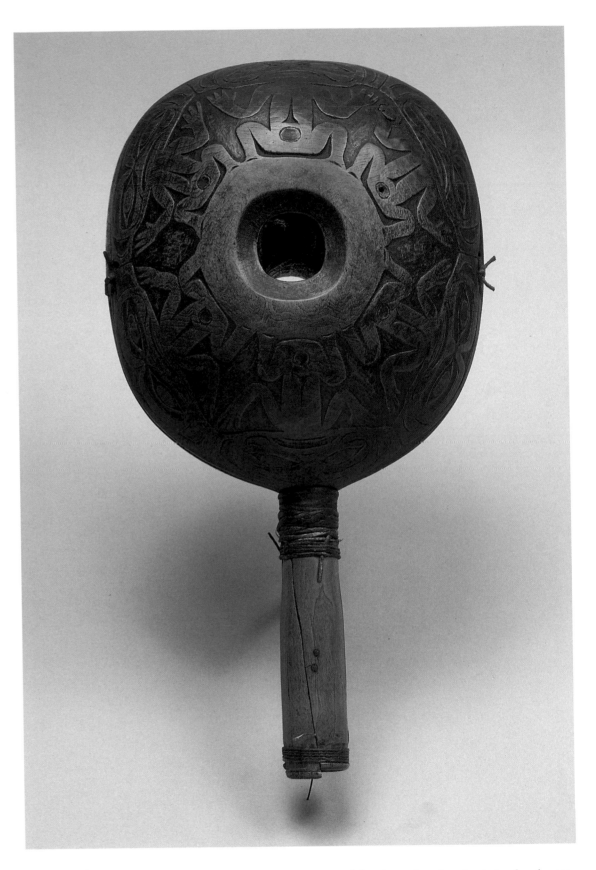

No. 379. *Tsimshian Rattle.* Six spirit figures are shown on this unusual doughnut-shaped rattle; their splayed poses are similar to those on no. 358. Collected by Emmons at Aiyansh. Wood and rawhide; height 11¾ inches; c. 1840–60. National Museum of the American Indian, Smithsonian Institution, Washington, D.C., 1/4184. Purchased from Emmons, 1907

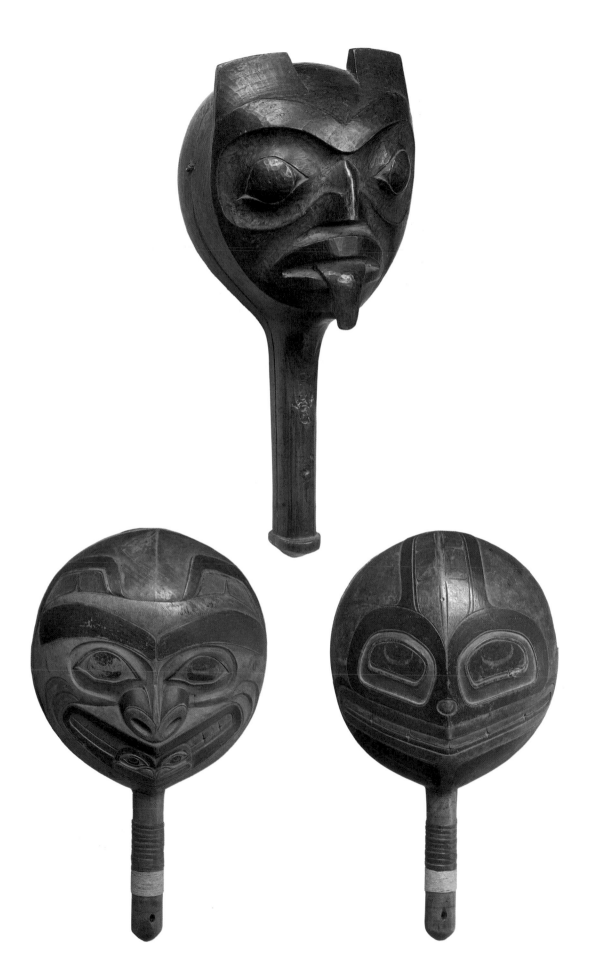

No. 380. *Haida Rattle*. A bear or human head with a protruding tongue. Wood and spruce root; height 12 inches; c. 1840–60. National Museum of the American Indian, Smithsonian Institution, Washington, D.C., 19/1704. Purchased 1936

No. 381. *Haida Rattle* (two views). Museum records identify the face on the side shown at the left as a killer whale with the head of a small killer whale in its mouth, although a bear could be represented. The face shown at the right is described in the records as a sea monster. Collected by William F. Tolmie, 1884. Wood, bark, and red and black pigment; height 13 inches; c. 1840–60. Canadian Museum of Civilization, Ottawa, VII–B–669

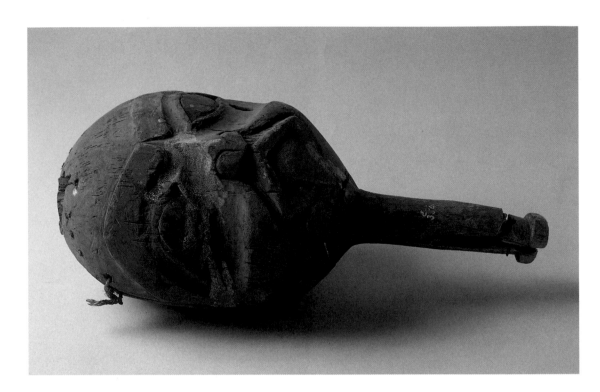

No. 383. *Tlingit Rattle.* A human face with a protruding tongue. Collected by Emmons from the ruins of a grave house of a shaman of the Kiksadi clan near Sitka, 1884–93. He (n.d.) states that the rattle is of a very old type used when contending with hostile spirits. Wood, string, screws, metal, and red, black, and blue pigment; length 12 inches; c. 1820–40. American Museum of Natural History, New York, E 354. Purchased from Emmons, 1893

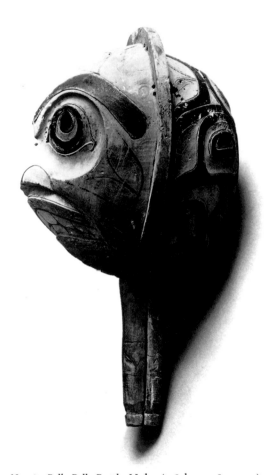

No. 382. *Bella Bella Rattle.* Holm (1987b, p. 128, no. 50) believes that this rattle belonged to a shaman because of its round form, because it was found in a forest cache, and because it is of Bella Bella workmanship but was used by a Kwakiutl, which provides it with exotic origins (see p. 8). He also believes the rattle to be by the same artist who made a well-known chief's settee in the 1880s (now in the Museum für Völkerkunde, Berlin). Collected by Art Church near Nakwakto Rapids, Seymour Inlet. Wood and red and black pigment; height 9½ inches; c. 1870–85. Thomas Burke Memorial, Washington State Museum, Seattle, 1–10. Acquired 1938

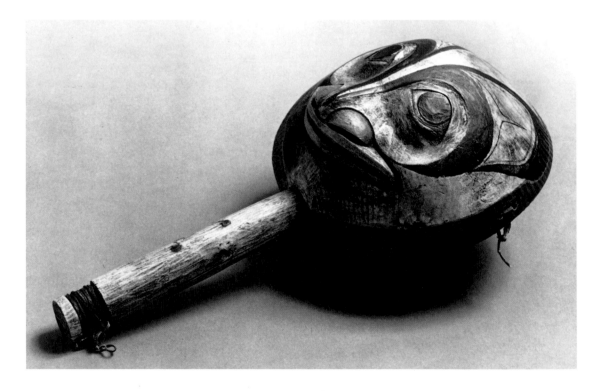

No. 384. *Haida Rattle.* The spherical shape and the depiction of a land otter face lead Holm (1987b, p. 162, no. 65) to believe that this rattle belonged to a shaman. Collected by Emmons on the Queen Charlotte Islands before 1905. Wood, rawhide, and red and black pigment; height 11¾ inches; c. 1850–70. Thomas Burke Memorial, Washington State Museum, Seattle, 1454. Purchased from Emmons, 1909

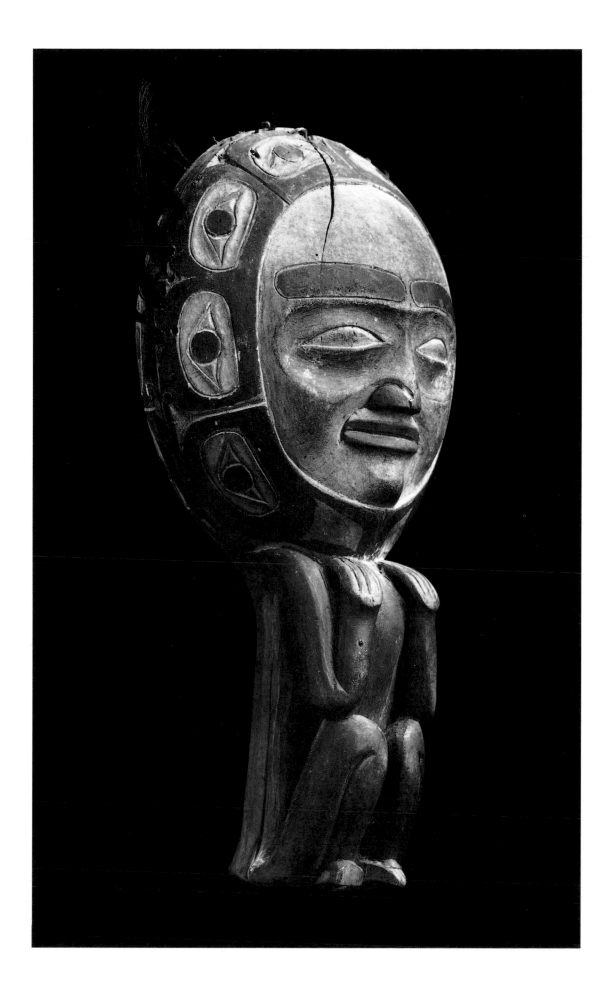

No. 385. *Haida Rattle*. Most Haida shamans' rattles arc round. The form of this one, which depicts a squatting human figure, is unique. Collected by Donald Mackay before 1905. Wood, human hair, and red, black, and blue-green pigment; height 10 inches; c. 1840–60. Former collection: Jelliman, Masset. Royal British Columbia Museum, Victoria, 10650. Purchased from William A. Newcombe, 1961

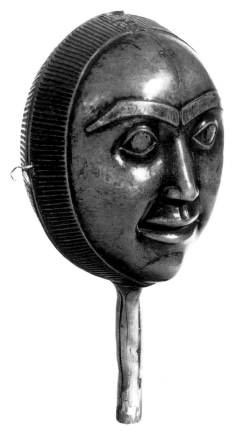
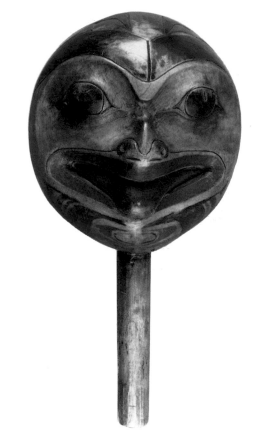
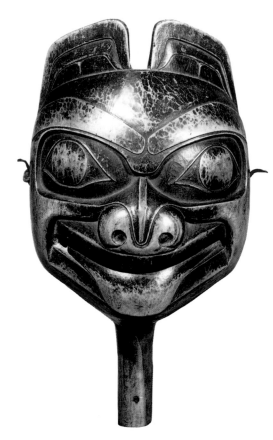
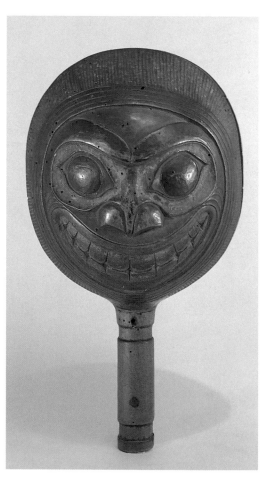
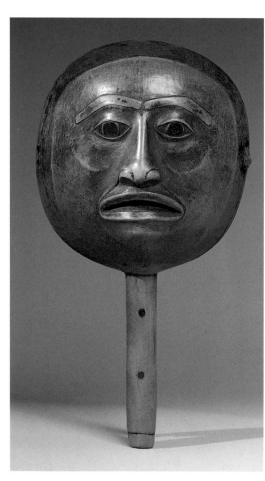
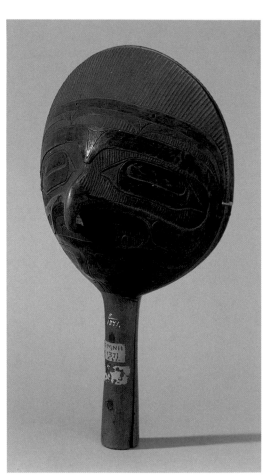

No. 386. Haida Rattle (opposite, upper left). Gunther (1966, p. 232, cat. no. 277) suggests that the face represents the sun or the moon. Wood and rawhide; height 11¾ inches; c. 1830–50. The Portland Art Museum, Oregon Art Institute, 55.256. Acquired by exchange from Robert Campbell, 1955

No. 387. Haida Rattle (opposite, upper center). The side shown represents a bear and on the other side is a hawk. Collected by C. F. Newcombe at Skidegate, 1903–4. Wood, black pigment; height 9¾ inches ; c. 1840–60. Field Museum of Natural History, Chicago, 85208. Purchased from Newcombe, 1904

No. 388. Haida Rattle (opposite, upper right). A bear head with a protruding tongue. Wood, rawhide, iron nail, and black pigment; height 9 inches; c. 1830–50. Museum of Mankind, London, 5930. Purchased, Christie Fund, 1892

No. 389. Tlingit Rattle (opposite, lower left). Each side is carved with a grimacing face, with the one shown somewhat more exaggerated than the other. Wood and red, black, and blue-green pigment; height 9¾ inches; c. 1840–60. Former collection: Lackmuseum, Cologne. Private collection

No. 390. Tsimshian Rattle (opposite, lower center). Human face. Wood rawhide, and black pigment; height 10½ inches; c. 1840–60. The Eugene V. and Clare E. Thaw Collection, Fenimore House Museum, Cooperstown, New York

No. 391. Tlingit Rattle (opposite, lower right). The face of a hawk. Collected by Emmons at Tongass, 1884–93. Wood and red and black pigment; height 11 inches; c. 1850–70. American Museum of Natural History, New York, E 1371. Purchased from Emmons, 1893

No. 392. Tsimshian Rattle (above). Human face. Wood and traces of black pigment; length 10¼ inches; c. 1840–60. Private collection

No. 393. Tlingit Rattle (two views). Emmons's catalogue notes in the Washington State Museum describe the side shown on the left as representing the full moon and that shown on the right as depicting a rayed sun with the face of a hawk in its center. Collected by him from the grave house of a shaman of the Stikine tribe near Wrangell. Wood, rawhide, and red, black, and blue-green pigment; height 11¼ inches; c. 1840–60. Thomas Burke Memorial, Washington State Museum, Seattle, 903. Purchased from Emmons, 1909

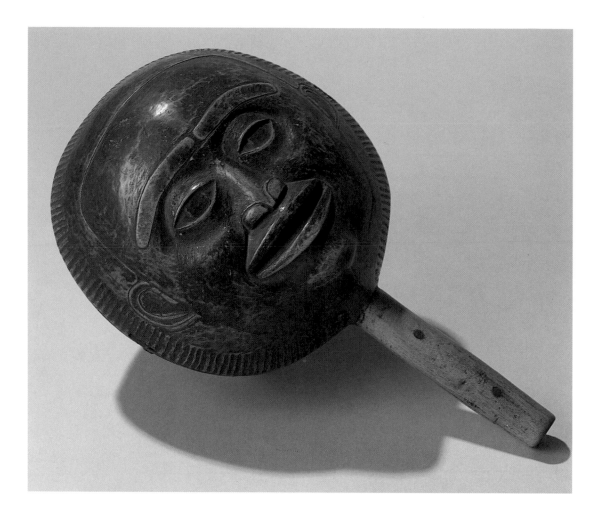

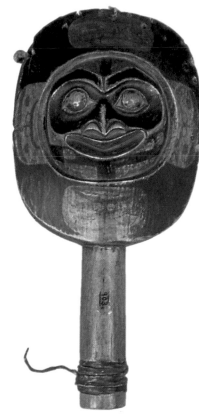
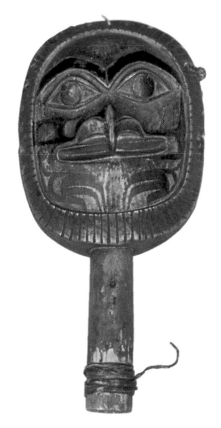

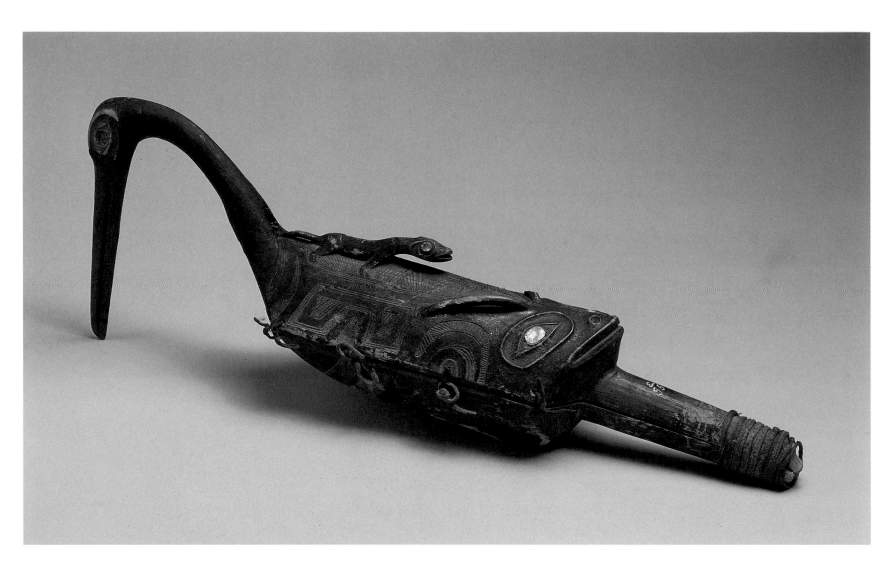

No. 394. Tlingit Rattle. Oystercatcher. Emmons (n.d.) identifies the animal head facing the handle as that of a sculpin. A land otter appears below the neck of the oystercatcher. Collected by Emmons in 1884–93 from the nephew of Nolk, a Hutsnuwu shaman who died about 1865 and was buried with his paraphernalia in a grave house at Chait Bay, Admiralty Island. Wood, abalone, rawhide, and red, black, and blue-green pigment; length 14¾ inches; c. 1790–1820. American Museum of Natural History, New York, E 958. Purchased from Emmons, 1893

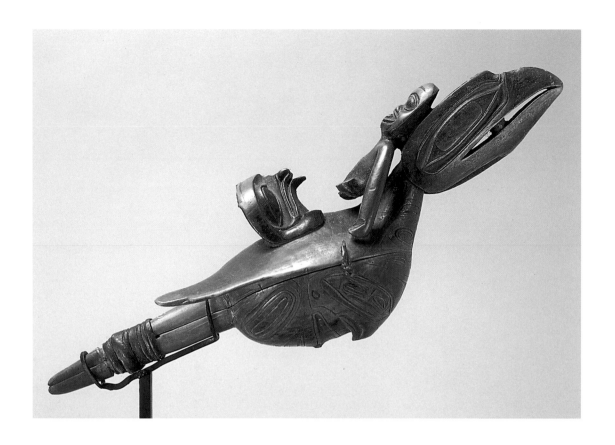

No. 395. Tlingit Rattle. Raven rattles were usually used by chiefs and are associated with crest display ceremonies. However, this old example was found with a shaman's paraphernalia, indicating that the raven form was used by shamans as well. Collected by Emmons in 1884–93 from the grave house of Setan, a Tlukwaxdi shaman, on the Akwe River, near an old deserted village a few miles west of Dry Bay. Wood, rawhide, and traces of red and blue-green pigment; length 12¾ inches; c. 1810–30. American Museum of Natural History, New York, E 421. Purchased from Emmons, 1893

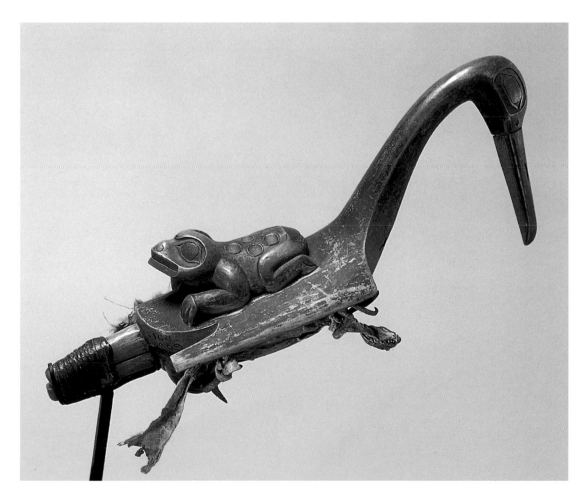

No. 396. Tlingit Rattle. Oystercatcher. A frog is carved on the back. Two old labels on the rattle indicate that it was once the property of a Captain Henriqués, who gave it to a Doctor Sinclair. He in turn presented it to Louis Sayre in 1875. Wood, ermine skin, rawhide, and red and blue pigment; length 11⅞ inches; c. 1820–40. American Museum of Natural History, New York, 16.1/1909. Given by Mary Sayre in memory of Reginald Sayre, 1930

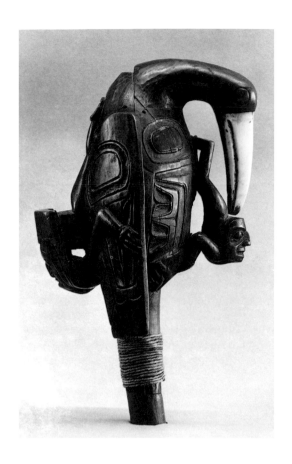

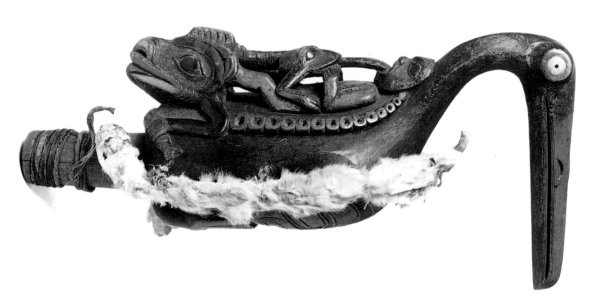

No. 398. *Tlingit Rattle*. Oystercatcher. On the back is a reclining figure, its tongue extended to the mouth of a frog. At the rear of the frog is the head of an otter that holds two salmon in its front paws. Devilfish tentacles are on both sides. Emmons (n.d.) identifies the carving on the bottom as an owl. Collected by him from a shaman's grave at Hoonah, 1882–87. Wood, abalone, rawhide, ermine skin, and red and black pigment; length 11¾ inches; c. 1840–60. Former collections: American Museum of Natural History, New York, 19/809; exchanged to Emmons, 1929; Harry Beasley, 1934. Museum of Mankind, London, 1944.am.2.125. Given by Mrs. Beasley, 1944

No. 397. *Haida Rattle*. This unusual example shows a raven with its head bent back toward the handle and its beak resting on the head of a squatting human. On the bottom is another human figure with its head thrown back. Because its form departs markedly from that of chiefs' raven rattles, a shamanic connection is suggested. The attribution to the Haida is from Bill Holm (1995). Wood, ivory, and twine; height 8¾ inches; c. 1840–60. The Metropolitan Museum of Art, New York, 1979.206.444. The Michael C. Rockefeller Collection, bequest of Nelson A. Rockefeller, 1979

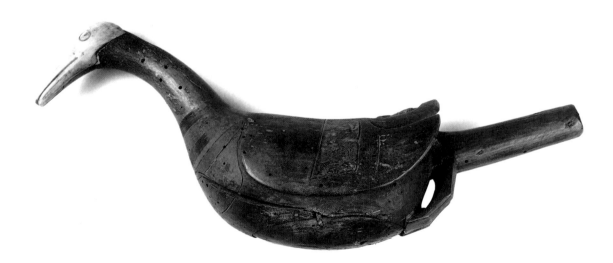

No. 399. *Tlingit Rattle*. This unusual rattle in the form of a loon has a human face with a trance expression carved in the tail feathers. Although the museum records list it as a chief's rattle, this latter detail and the depiction of a diving bird suggest shamanic association. Wood and red, black, and blue-green pigment; length 10½ inches; c. 1840–60. Museum of Mankind, London, 1919.12–16.2. Purchased from Captain Shipster, 1919

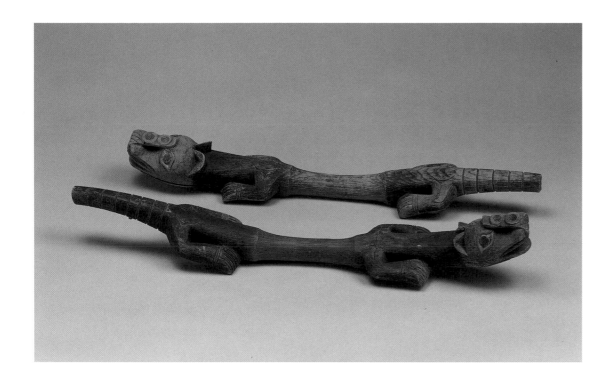

No. 400. Pair of Tlingit Rattles. Land otters with devilfish suckers on their protruding tongues. Although the ends of both tails have broken away, the surviving tip of one shows that each originally had eight serrated sections. Part of a complete set of a shaman's paraphernalia of unknown provenance collected by Emmons. Wood and traces of red, black, white, and blue pigment; length 17½ and 16¼ inches; c. 1840–60. National Museum of the American Indian, Smithsonian Institution, Washington, D.C., 16/1719i. Purchased from Emmons, 1928

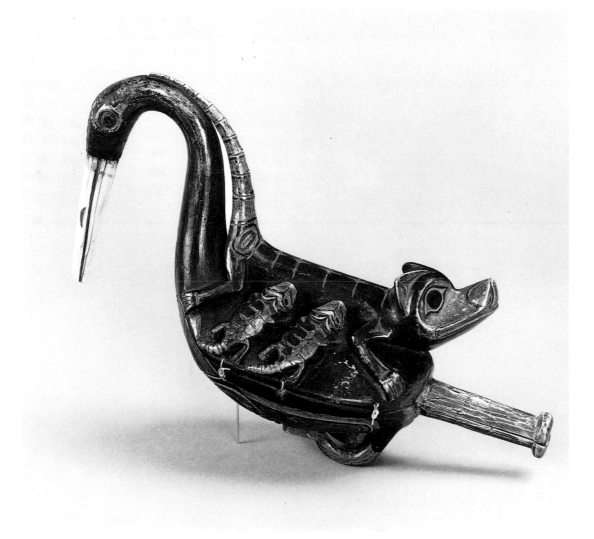

No. 401. Tlingit Rattle. Oystercatcher. An otter on the back of the oystercatcher is shown nursing its four young. The rattle was given to the Reverend Aaron Lindsley in 1879 by a Tlingit woman whom he had converted to Christianity. Wood, ivory, and red and blue pigment; length 11 inches; c. 1830–50. Denver Art Museum, 1938.231. Purchased 1938

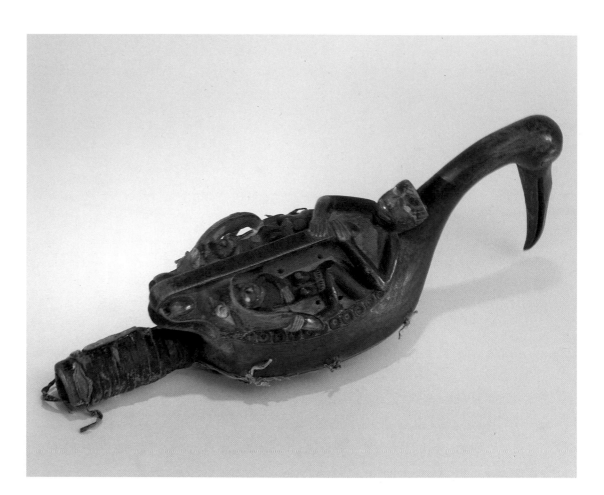

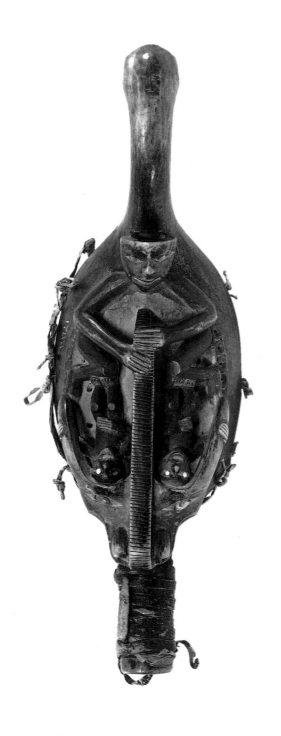

No. 402. Tlingit Rattle (two views). Oystercatcher. A reclining figure is holding the tongue of a mountain goat. Two smaller reclining figures are between the horns of the goat, and devilfish tentacles are carved below them at the sides. The beak of the oystercatcher has been replaced. Collected by Captain Edward G. Fast at Sitka, 1867–68. Wood, abalone, ermine skin, rawhide, and red, black, and blue-green pigment; length 12½ inches; c. 1820–40. Former collection: Peabody Museum of Archaeology and Ethnology, Harvard University, Cambridge, 69-30-10/1788. Private collection

HOW S!AWA'N BECAME A SHAMAN
(Tlingit)

In the town where this occurred a man named S!āwᴀ'n became a shaman. He told the people to leave and go somewhere else because spirits were saying in him, "If you stay in this village, you will all die." There was so much respect for shamans in those days that people obeyed everything that they told them to do. By and by his spirit said to the shaman, "You will be asked to go somewhere, my master. My masters, the people of the village, do you go away with me?" And the village people kept saying to him, "Yes, we are going along with you." Then the spirit said, "The persons that are going to invite me from here are not human beings. They are already getting ready to come."

By and by the canoe came after him. He seemed to know that there was something about to happen, and said, "Somehow or other you people look strange." He put all of his things into small boxes ready to depart. Then he got in and they covered him with a mat until they reached their village, when he got up and saw some fine houses. The fronts were beautifully painted. Among these houses was one with a crowd of people in front which they tried to make him believe was that where the sick person lay. His rattle and belt, however, ran up on the shore ahead of him and entered the proper house, which was in another part of the town. These people were land otters, and they called him by name, "S!āwᴀ'n, S!āwᴀ'n." They said to him, "All the shamans among us have been doctoring him, and they can not do a thing. They can not see what is killing him. That is why we have asked you to come."

No. 403. Tlingit Rattle. Oystercatcher. Emmons (n.d.) identifies the figure on the body as "a fish that inhabits the waters of inland lakes." A bound witch faces the handle. Emmons believes the rattle was carved with stone tools and was over one hundred years old at the time he collected it in 1882–87 from the Chilkat. However, although it is of an early style, close examination of carving details suggests the use of metal tools in its manufacture. Wood, rawhide, abalone, and traces of red, black, and blue pigment; length 13⅝ inches; c. 1810–30. American Museum of Natural History, New York, 19/811. Purchased from Emmons, 1888

Then the shaman thought within himself, "Who will sing my songs for me?" but the land otters spoke out, saying, "We can sing your songs. Don't be worried." Inside of this house there hung a breastplate made out of carved bones, such as a shaman used in his spiritual combats. The land otters saw that he wanted it and said, "We will pay you that for curing him." Then the shaman began to perform. He could see that the land otter was made sick by an arrow point sticking in its side, but this was invisible to the land otters. After he had pulled it out, the sick otter, who belonged to the high-caste people, sat up immediately and asked for something to eat. The shaman kept the arrow point, however, because it was made of copper, and copper was very expensive in those days.

Then one of the land-otter shamans said to him, "I will show you something about my spirits." And so he did. He saw some very strange things. When he was shown one kind of spirit, the land otter said, "You see that. That is Sickness. . . . What he called Sickness was the spirit of a clam. These clams look to the spirits like human beings. That is why the spirits are so strong." He also showed him the Spirit of the Sea . . . , the Spirit of the Land . . . , the Spirit from Above . . . , and the Spirit from Below. . . . All these became the man's spirits afterward.

No. 404. Tlingit Rattle. Oystercatcher. A mountain goat head with a reclining figure behind it is on the back. Collected by Emmons from a shaman's grave house on the Chilkat River near Klukwan. Wood, beads, and traces of red and black pigment; length 12¼ inches; c. 1830–50. National Museum of the American Indian, Smithsonian Institution, Washington, D.C., 1/2523. Purchased from Emmons, 1907

Nowadays, when a man wants to become a shaman, he has to cut the tongue of a land otter and fast for eight days. You can tell a shaman who has been fasting a great deal because his eyes become very sharp.

After he had shown all of the spirits, they said, "We will take you to your town any time you want to go." Then they took him to his own town. They had to cover him up again.

The people of S!āwA'n's village were always looking for him, and one day four men in a canoe saw something far out on the shore which looked very strange. A number of sea gulls were flying around it. Going closer, they saw the shaman lying there on a long sandy beach, the gulls around him. They did not know of any sandy bay at that point, and said that it was the shaman that brought it up there. They then took him into the canoe and brought him over. He was so thin that he appeared to have fasted a long time. After they got him home the spirits began mentioning their names, saying, "I am Spirit of the Sea; I am Spirit of the Land," etc. Every time a spirit mentioned his name, the people would start its songs. (Swanton, 1909, pp. 152–54)

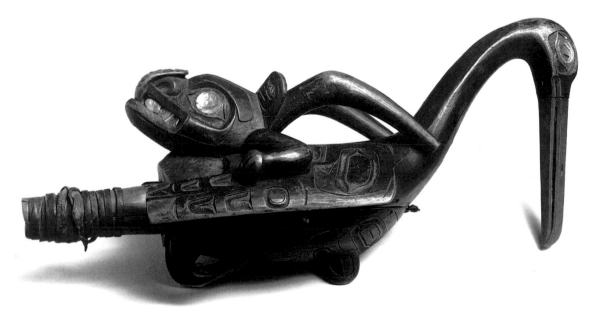

No. 405. Tlingit Rattle. Oystercatcher. Two figures, lying on their stomachs, grasp the horns of a mountain goat. Collected by Lieutenant T. Dix Bolles at Hoonah. Wood, abalone, rawhide, and red and black pigment; length 12¼ inches; c. 1830–50. National Museum of Natural History, Smithsonian Institution, Washington, D.C., 73792. Given by Bolles, 1884

No. 406. Tlingit Rattle. Oystercatcher. A mountain goat head with bear heads carved on its ears is on the back. Emmons (n.d.) identifies the bird head on the bottom as an owl. Collected by him at Yandestaki, 1882–88. Wood, abalone, rawhide, and red and black pigment; length 14½ inches; c. 1840–60. American Museum of Natural History, New York, 19/808. Purchased from Emmons, 1888

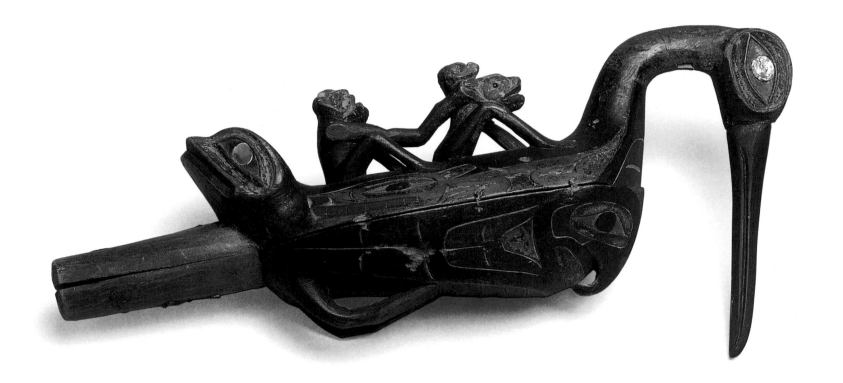

No. 407. *Tlingit Rattle*. Oystercatcher. A frog head faces the handle, and land otters are carved in relief at the sides. On the back are two seated figures, one holding another; this depicts a shaman capturing a witch. The forward figure of the witch with its head thrown back has the head of a bear emerging from its chest (see no. 411). Collected by Emmons, with nos. 341, 433, and 448, from the gravehouse of a shaman of the Stikine tribe near Wrangell. Wood, abalone, beads, and red, black, and green pigment; length 13½ inches; c. 1830–50. National Museum of the American Indian, Smithsonian Institution, Washington, D.C., 1/2522. Purchased from Emmons, 1907

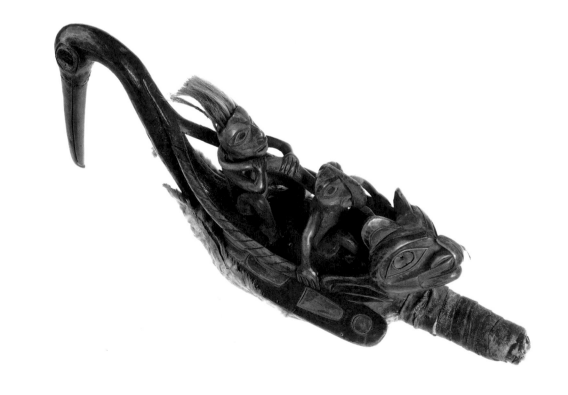

No. 408. *Tlingit Rattle*. Oystercatcher. The head of an animal, perhaps a bear, faces the handle. Behind the animal, a seated shaman is tying up a witch. Wood, ermine skin, human hair, abalone, rawhide, and red, blue, and brown pigment; length 14½ inches; c. 1830–50. The University Museum, University of Pennsylvania, Philadelphia, NA 4972(71). Purchased from Emmons, 1915

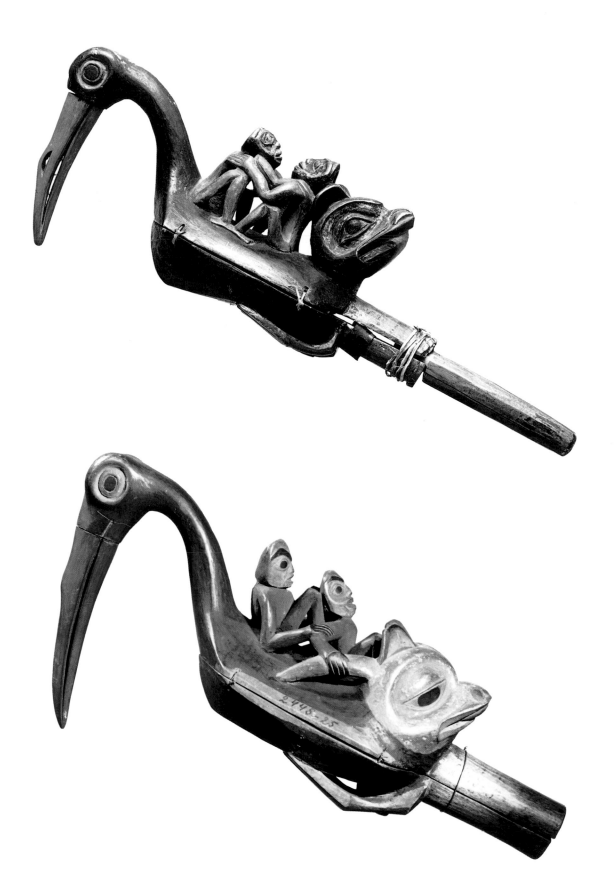

No. 409. Tlingit Rattle. Oystercatcher. The head of an animal, perhaps a bear, faces the handle. The two figures holding each other represent a shaman struggling with a witch (see no. 410). Collected by Captain Edward G. Fast at Sitka, 1867–68. Wood, sinew, and red, black, and traces of blue pigment; length 15 inches; c. 1820–40. Former collection: Peabody Museum of Archaeology and Ethnology, Harvard University, Cambridge, 69–30–10/1706. Private collection

No. 410. Tlingit Rattle. Oystercatcher. Two seated figures are behind the head of a mountain goat. Numerous details, including the shape of the beaks, eyes, and necks of the oystercatchers; the carvings of the two human figures; and the broad, heavy features of the animal heads at the ends, suggest that this rattle is the work of the same artist as no. 409. Collected by Ilıa G. Voznesenski in Alaska, 1839–45. Wood and red, black, and blue pigment; length 13 inches; c. 1820–40. Museum of Anthropology and Ethnography, St. Petersburg, Russia, 2448–25

269

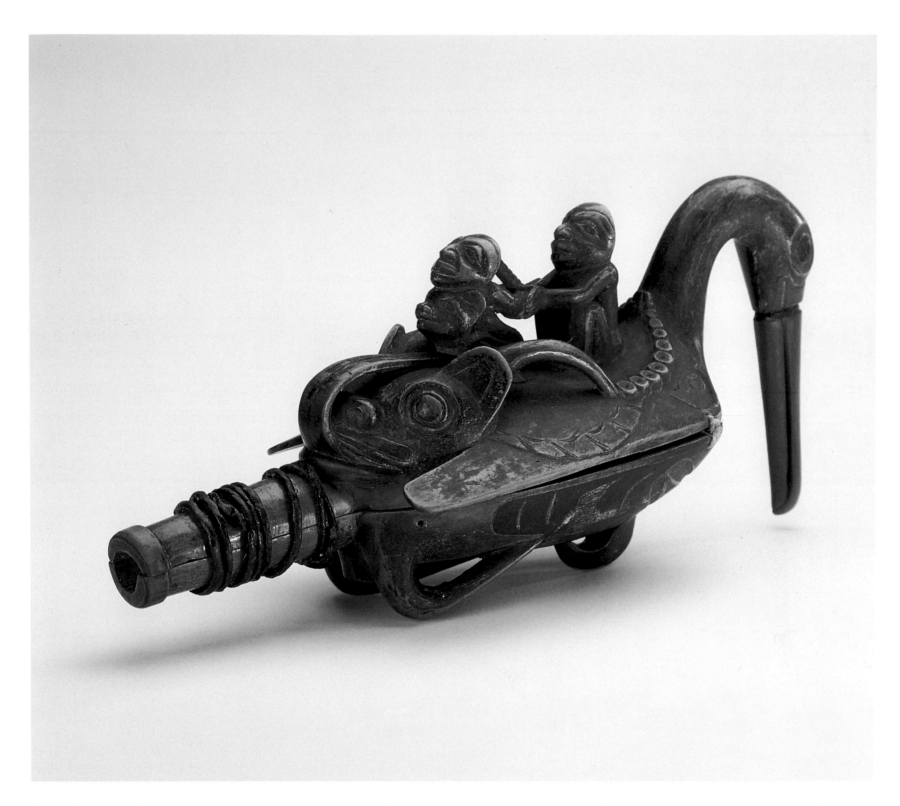

No. 411. Tlingit Rattle. Oystercatcher. A mountain goat head faces the handle. Behind it, a seated shaman between devilfish tentacles is tying up a witch whose head is thrown back and who has the head of a bear emerging from its chest (see no. 407). A hawk head is on the bottom. Collected by G. Chudnovsky on Admiralty Island, 1890. Wood, sinew, and black and red pigment; length 11⅜ inches; c. 1840–60. Museum of Anthropology and Ethnography, St. Petersburg, Russia, 211–2

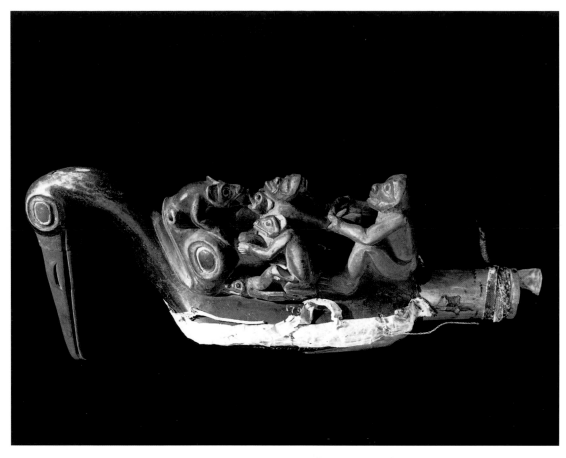

No. 412. Tlingit Rattle. Oystercatcher. A seated shaman ties up a witch who has the head of an animal on its chest. Below is the face of a monster from whose snout a bearlike animal emerges. Other animals, perhaps otters, are on both sides of the witch. Collected by Captain Edward G. Fast at Sitka, 1867–68. Wood, rawhide, ermine skin, and black, red, and blue-green pigment; length 12½ inches; c. 1830–50. Peabody Museum of Archaeology and Ethnology, Harvard University, Cambridge, 69–30–10/1790. Purchased from Fast, 1869

No. 413. Tlingit Rattle. Oystercatcher. A shaman, sitting between the horns of a mountain goat, is tying up a witch from whose mouth a frog emerges. Behind the shaman is a frog with its tongue extended to the mouth of the goat. Wood, cedar bark, ermine skin, and traces of red and black pigment; length 12⅛ inches; c. 1840–60. Museum of Mankind, London, 1949.AM.22.111. Acquired from the William O. Oldman Collection, 1949

No. 414. Tlingit Rattle. Oystercatcher. Emmons (n.d.) describes the two figures on the back of a horned sea monster as "an otter tying a witch spirit with a rope of twisted bark." Two small animal figures are carved below the monster on each side. Collected by Emmons at Angoon. Wood, rawhide, twine, and black, red, and green pigment; length 12½ inches; c. 1840–60. American Museum of Natural History, New York, 16/9379. Purchased from Emmons, 1904

No. 415. Tlingit Rattle. Oystercatcher. Emmons (n.d.) describes the three figures as "witches planning evil." They sit between the horns of a monster that are decorated with the suckers of a devilfish, a creature that can transport them "noiselessly through space." The shaman in one of the series of photographs made by De Groff in Sitka in 1889 carries this rattle (see fig. 4). Collected by Emmons from the grave house of a Chilkat shaman at Klukwan, c. 1888. Wood, rawhide, abalone, human hair, and black, red, and blue-green pigment; length 14½ inches; c. 1840–60. American Museum of Natural History, New York, E 348. Purchased from Emmons, 1893

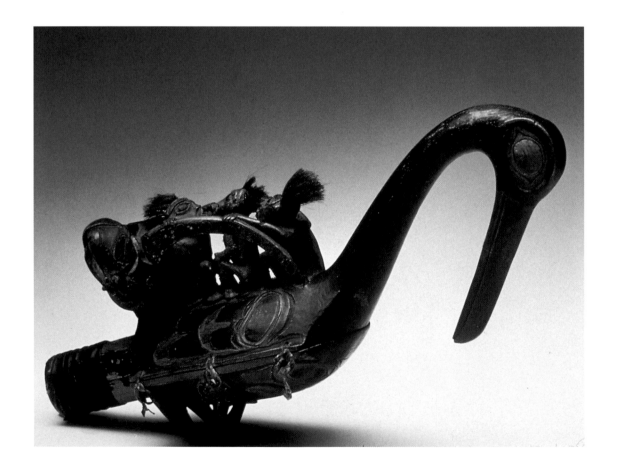

No. 416. *Tlingit Rattle*. Oystercatcher. A skeletonized reclining shaman is split in half, its legs transformed into the horns of a mountain goat, the head of which faces the handle. At each side is a creature with the body of a devilfish tentacle. Collected by Emmons at Port Mulgrave (Yakutat), and said by him to have been the property of a shaman of Dry Bay. Wood, spruce root, ermine skin, and black and red pigment; length 9¾ inches; c. 1850–70. Thomas Burke Memorial, Washington State Museum, Seattle, 2067. Purchased from Emmons, 1909

No. 417. *Tlingit Rattle*. Oystercatcher. A shaman holding a rattle in each hand reclines between two fish. Collected by Emmons at Stephens Passage from a shaman of the Auk tribe. Wood, down, ermine skin, and black and red pigment; length 11⅜ inches; c. 1840–60. Field Museum of Natural History, Chicago, 78670. Purchased from Emmons, 1902

No. 418. Tlingit Rattle. Oystercatcher. A shaman reclines on the back of a horned monster, identified in the museum records as "Ka-Ka Tete the whistling demon." Land otters are at the sides and above the head of the shaman. Collected by Stewart Culin, 1905. Wood, glass, shell, and black and red pigment; length 13 inches; c. 1830–50. The Brooklyn Museum, New York, 05.588.7294

No. 419. Tlingit Rattle (below). Oystercatcher. A reclining shaman grasps the horns of a creature that holds a salmon in its claws. Collected by Captain Edward G. Fast at Sitka, 1867–68. Wood, rawhide, twine, ermine skin, and black, red, and blue pigment; length 13 inches; c. 1820–40. Peabody Museum of Archaeology and Ethnology, Harvard University, Cambridge, 69–30–10/1787. Purchased from Fast, 1869

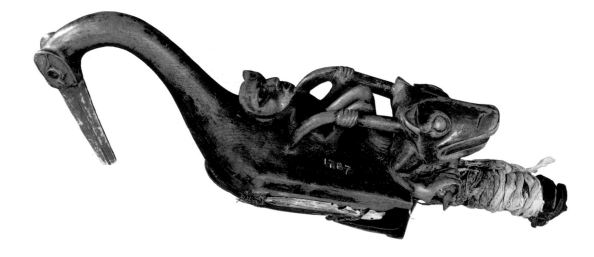

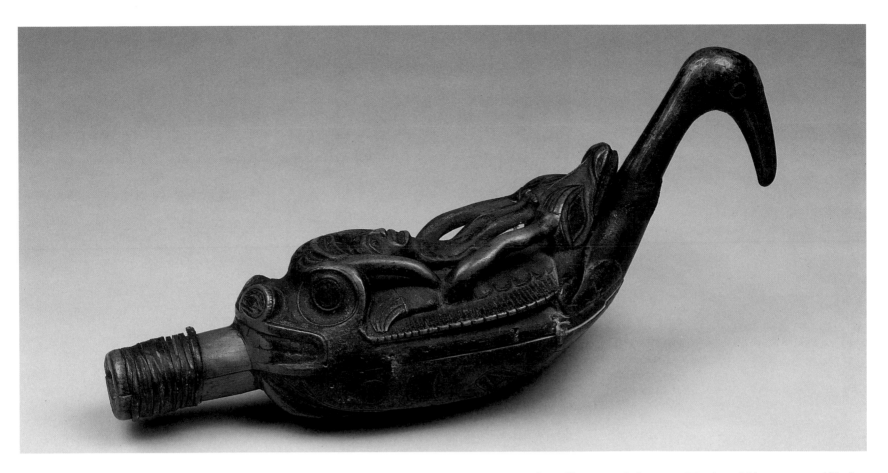

No. 420. Tlingit Rattle. Oystercatcher. A shaman reclines between the heads of two horned monsters. Collected by B. A. Whalen, 1879. Wood, rawhide, copper, and black and red pigment; length 12¼ inches; c. 1820–40. National Museum of the American Indian, Smithsonian Institution, Washington, D.C., 2875. Purchased from Whalen, 1905

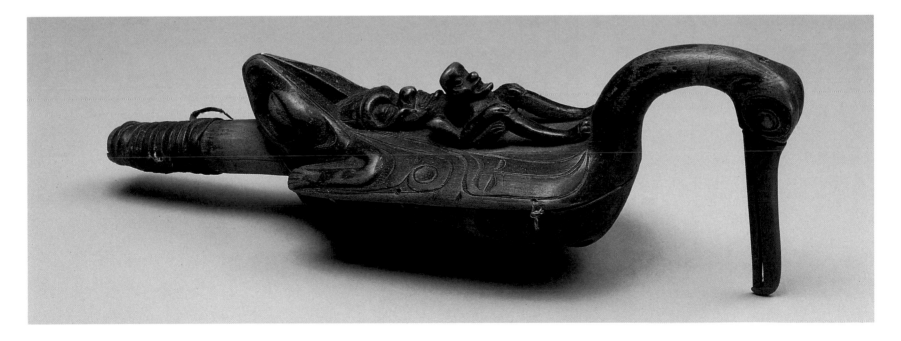

No. 421. Tlingit Rattle. Oystercatcher. A reclining shaman wearing a crown has the head of a female witch spirit and a labret emerging from his stomach. Emmons (n.d.) identifies the animal head next to the handle as a "water frog." Collected by him from the grave house of a shaman of the Sanya tribe on Cat Island, 1888–93. Wood, rawhide, and traces of black, red, and blue-green pigment; length 11 inches; c. 1820–40. Former collection: American Museum of Natural History, New York, ᴇ 2504; exchanged to Emmons, 1914. National Museum of the American Indian, Smithsonian Institution, Washington, D.C., 9/8002. Purchased from Emmons, 1920

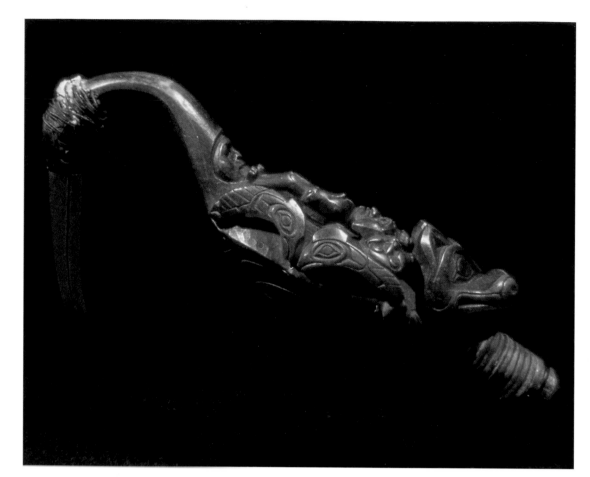

No. 422. Tlingit Rattle. Oystercatcher. A shaman reclines on a headrest, similar to no. 33, decorated with the heads of singing and speaking spirits at the ends. Two fish are at each side, and Emmons (n.d.) identifies the head next to the handle as that of a land otter. Collected by him at Taku, 1882–87. Wood, spruce root, wire, down, and black and red pigment; length 12 inches; c. 1830–50. American Museum of Natural History, New York, 19/806. Purchased from Emmons, 1888

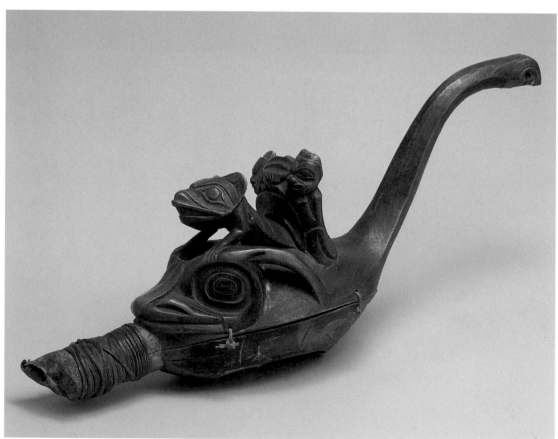

No. 423. Tlingit Rattle. Oystercatcher. Emmons (n.d.) describes the animal head next to the handle as a mountain goat, over which is the "head of a land otter coming out of its hole which is guarded by two witches." A bird head, which Emmons identifies as an owl, is on the bottom. Collected by him from the Chilkat, 1882–87. Wood, rawhide, twine, and traces of blue-green pigment; length 13¾ inches; c. 1820–40. American Museum of Natural History, New York, 19/1276. Purchased from Emmons, 1888

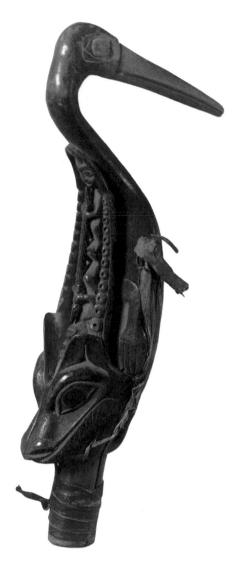

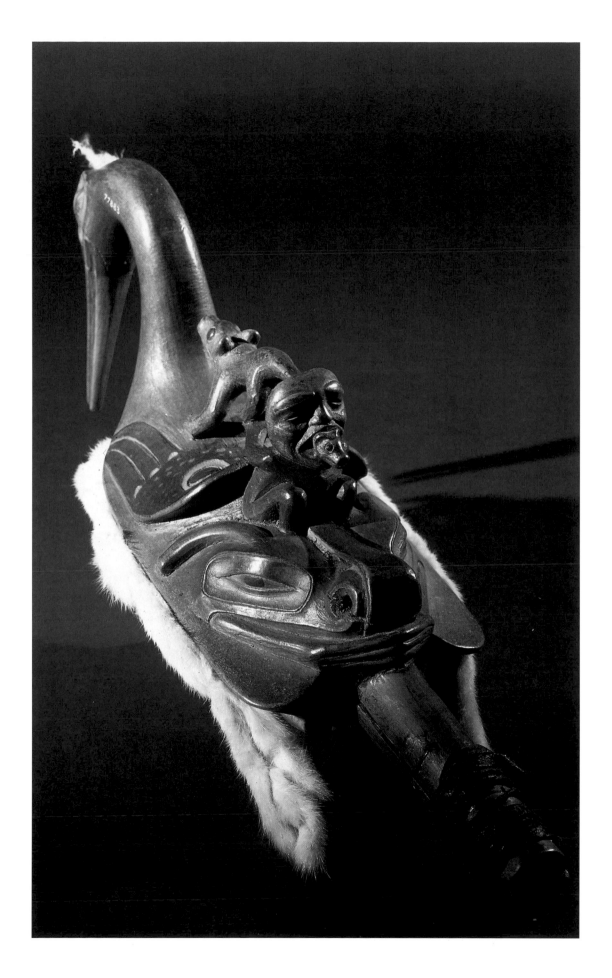

No. 425. Tlingit Rattle (above). Oystercatcher. A shaman reclining between devilfish tentacles holds a staff with animal heads at the ends. The animal facing the handle is a land otter. Wood, rawhide, ermine skin, and black, red, and blue pigment; height 13¾ inches; c. 1840–60. San Diego Museum of Man, 25458. Given by Mrs. Griffing Bancroft, 1940

No. 424. Tlingit Rattle. Oystercatcher. A bound witch sits on the back of a horned monster as the head of an animal emerges from its mouth; a land otter crouches behind the witch. According to Emmons (n.d., Notes), who collected this rattle from the grave house of a shaman of the Hutsnuwu clan near Angoon, it had been kept in the hollow of an old cottonwood tree behind the village when not in use. Wood, rawhide, ermine skin, and black, red, and blue pigment; length 13¼ inches; c. 1840–60. Field Museum of Natural History, Chicago, 77883. Purchased from Emmons, 1902

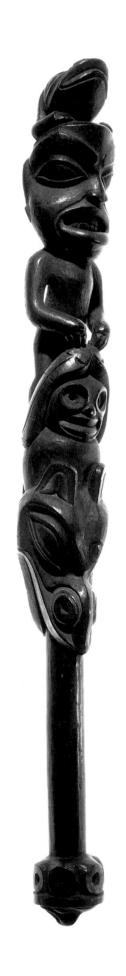

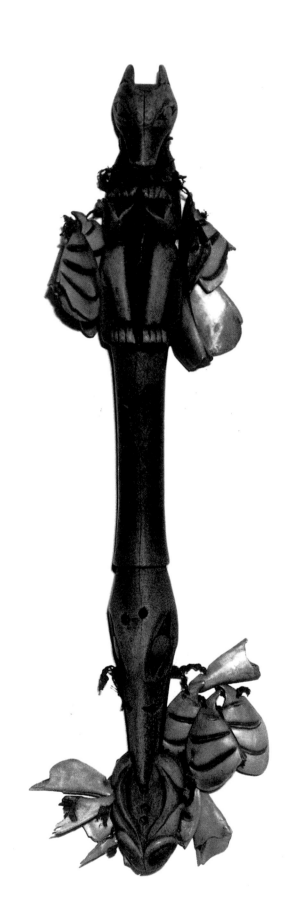

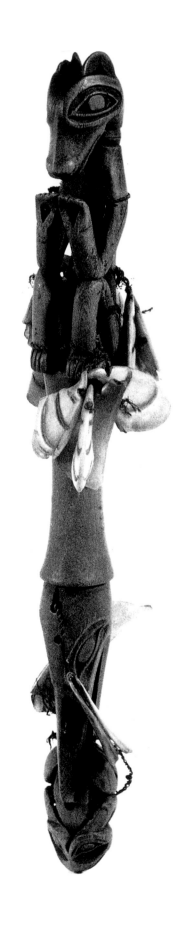

278

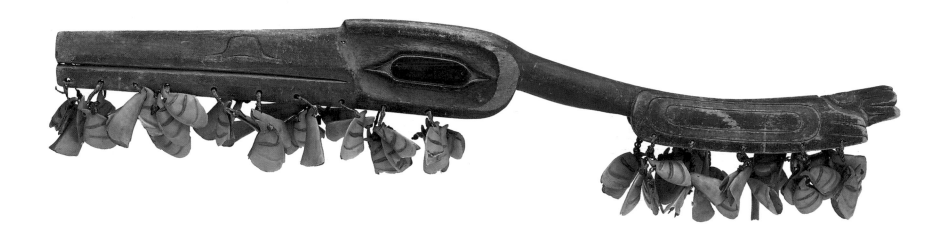

No. 428. Tlingit Rattle. A duck in flight. De Laguna (1988a, p. 274, no. 375) mentions that such rattles were used in sets by shamans. Collected by James G. Swan at Klawock. Wood, animal hide, puffin beaks, sinew, and red pigment; length 21¼ inches; c. 1840–60. National Museum of Natural History, Smithsonian Institution, Washington, D.C., 20828. Acquired from Swan, 1876

No. 426. Tlingit Rattle (opposite, left). Emmons (n.d.) describes the rattle as "of peculiar construction, the only one of the kind I have met with among the Tlingits." Below the handle is a devilfish head; above the handle is a land otter, above which is the head of a "dead Tlingit" with the spirits of two women on its headdress. The figure at the top of the rattle represents a shaman wearing a frog crest headdress. Collected by Emmons from the grave of a Hutsnuwu shaman in a cave on the shore of Chatham Strait, Chichagof Island, 1888–93. Wood and red and black pigment; height 14 inches; c. 1840–60. Former collection: American Museum of Natural History, New York, E 2485; exchanged to Emmons, 1914. The University Museum, University of Pennsylvania, Philadelphia, NA 4976. Purchased from Emmons, 1918

No. 427. Tlingit Rattle (opposite, right; two views). At the top is a seated bear, and at the bottom a raven carries a frog in its beak. Collected about 1872. Wood, cedar bark, and puffin beaks; height 11½ inches; c. 1840–60. Übersee-Museum, Bremen, C 197

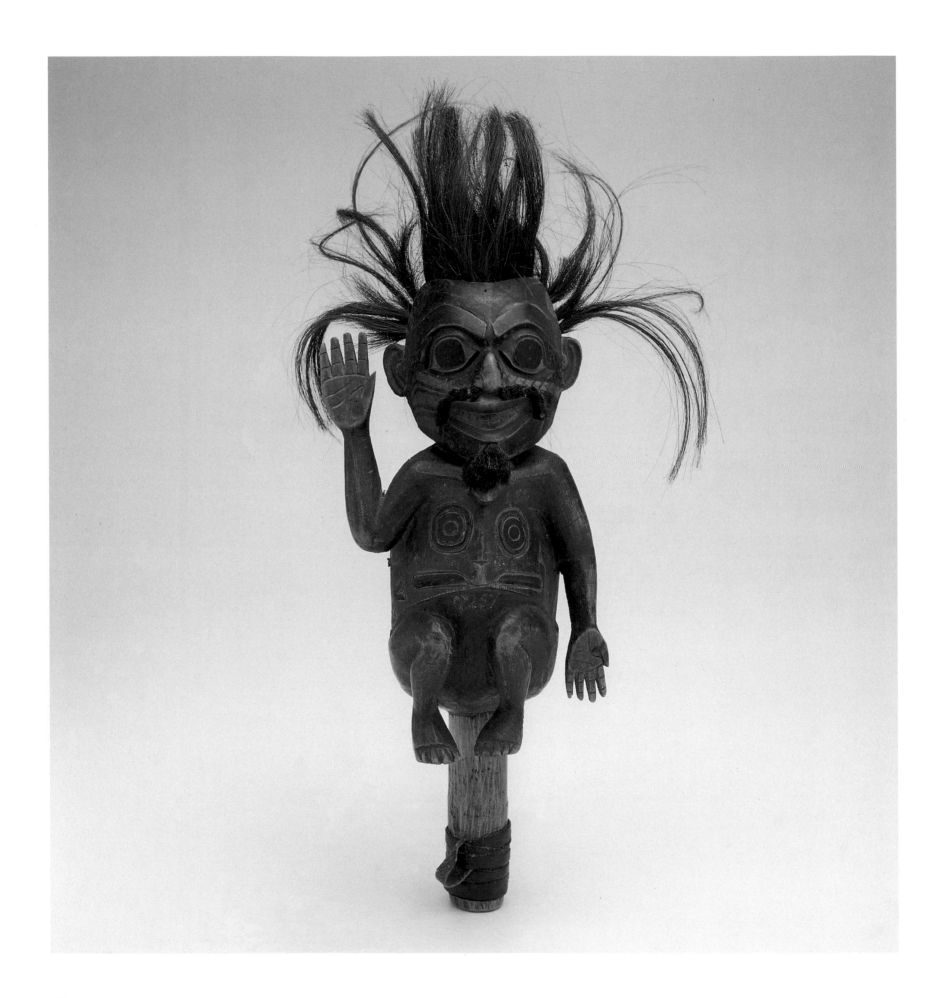

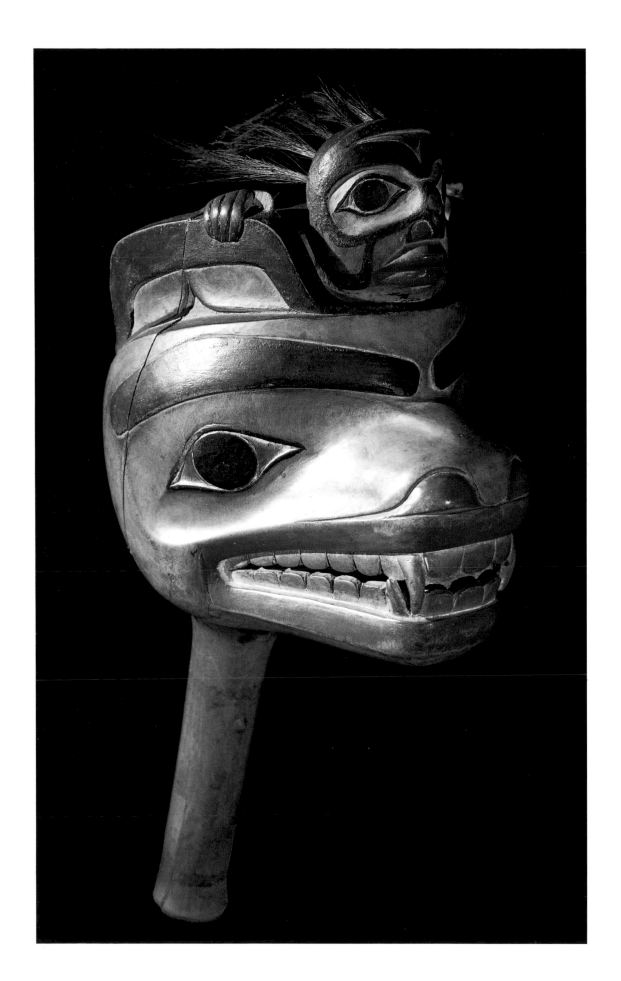

No. 429. *Tlingit Rattle* (opposite, left). A seated shaman. De Laguna (1988a, p. 271, no. 170) notes that the asymmetrically painted face designs are typical of those used by shamans. Collected by Dr. Alexander H. Hoff at Sitka, 1870. Wood, rawhide, human hair, and black and red pigment; height 10 inches; c. 1840–60. National Museum of Natural History, Smithsonian Institution, Washington, D.C., 9257. Given by Hoff, 1870

No. 430. *Haida Rattle.* A bear with a human figure between its ears. Macnair et al. (1980, p. 154) assign shamanic use to this rattle. Collected by Charles F. Newcombe. Wood, human hair, and red and black pigment; height 10⅜ inches; c. 1860–80. Royal British Columbia Museum, Victoria, 9729. Purchased from Newcombe, 1917

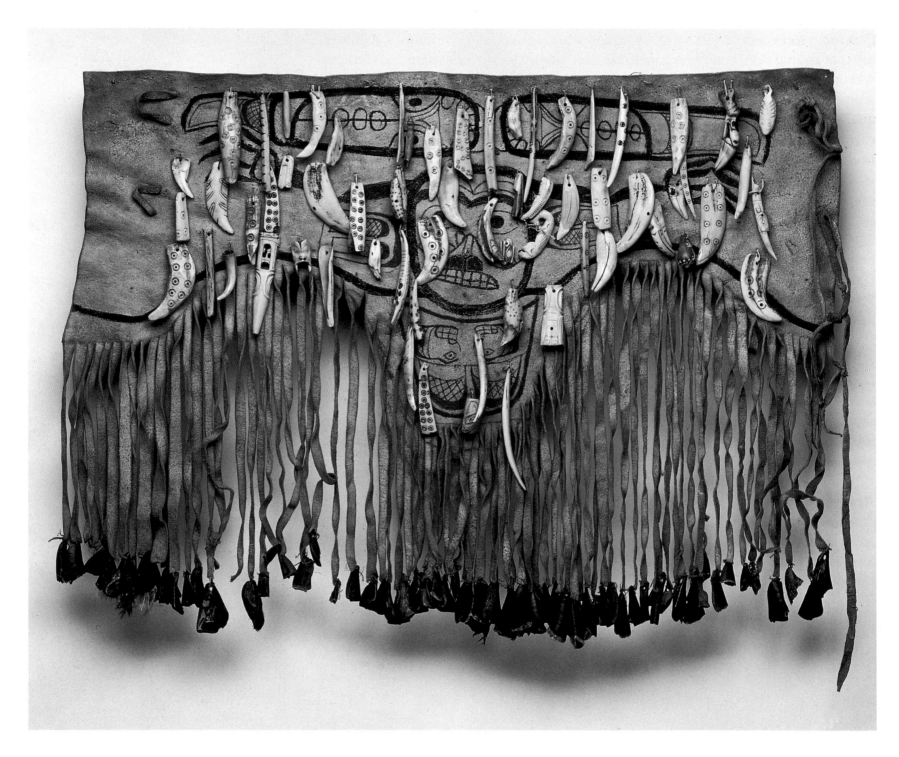

No. 431. Tlingit Apron. The comparatively crude painting shows two opposed fish or sea mammals at the top, a human face with outstretched arms at the center, and two upside-down confronting animal heads at the bottom. Deer dewclaws are attached to the fringes, and sixty amulets are sewn to the central area of the apron. Some of the amulets are undecorated, a number are ornamented with circles and dots, and others are carved to represent spirit figures. Collected by Emmons in 1882–87 from a small shaman's grave on an island near Upper Auk Village. Moose hide, deer dewclaws, bone, walrus ivory, animal and sea mammal teeth, and red and black pigment; length 36 inches; c. 1830–60. American Museum of Natural History, New York, 19/1040. Purchased from Emmons, 1888

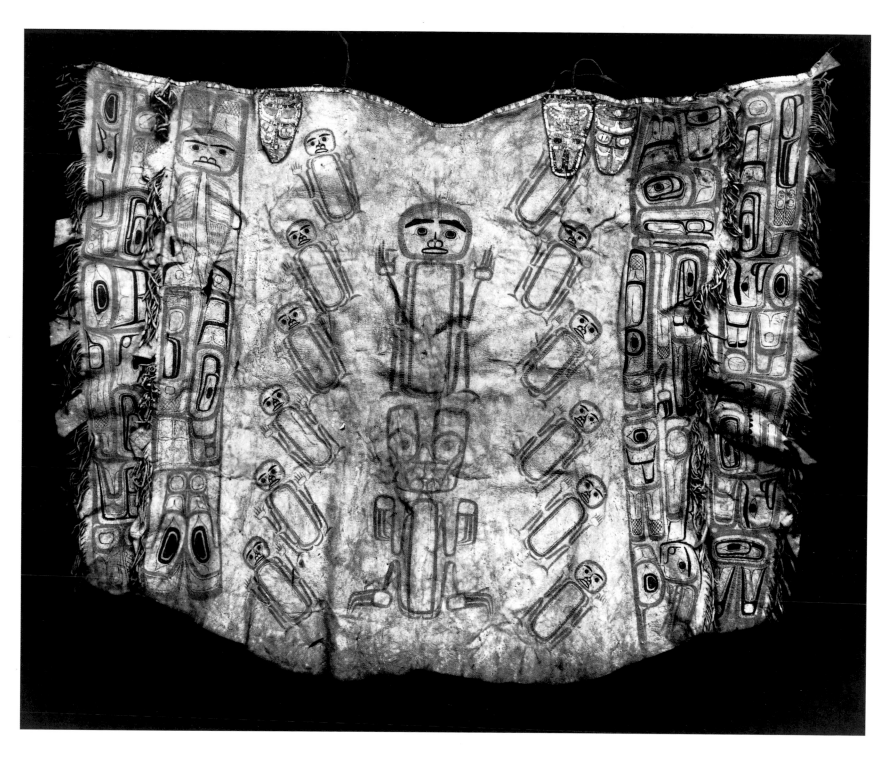

No. 432. Haida Tunic. Emmons (n.d.) describes this tunic as a "doctor's dance blanket," and identifies the twelve smaller figures in the center as spirits of the sky. At the bottom center is a bear, above which is a human figure. A large eagle faces outward on the first panel to the right. The three quillwork elements at the top probably represent dogfish. Collected by Emmons at Howkan, 1884–93. Animal skin, porcupine quills, and black and red pigment; length 47¼ inches; c. 1830–50. American Museum of Natural History, New York, E 1580. Purchased from Emmons, 1893

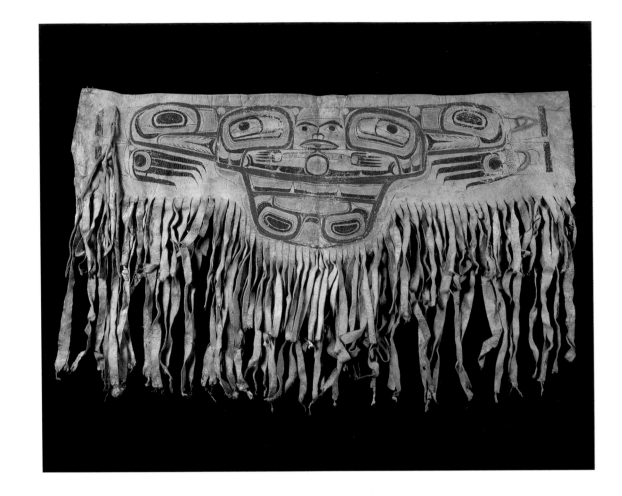

No. 433. Tlingit Apron. Emmons (n.d., Notes, NMAI) indicates that the design on this apron represents a shaman's dream, and the principal figure, a mosquito. Collected by him with nos. 341, 407, and 448 from the grave house of a shaman of the Stikine tribe near Wrangell before 1907. Caribou hide, puffin beaks, and red, black, and blue-green pigment; length 38½ inches; c. 1830–50. Former collection: Museum of the American Indian, New York, 1/2493. Peabody Museum of Archaeology and Ethnology, Harvard University, Cambridge, 08-7-10/72884. Acquired by exchange, 1908

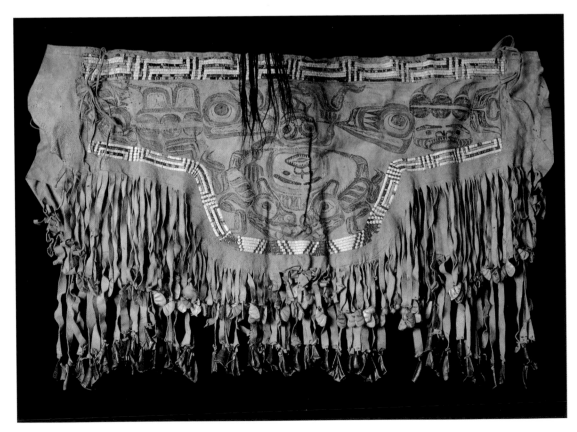

No. 434. Tlingit Apron. Although there is no documentation associating this apron with a shaman, the two animal figures at the lower center are land otters, which suggests the connection, as does the asymmetrical depiction of the profiles of two different animals at each side. Collected by Charles F. Newcombe at Klukwan, c. 1902. Caribou hide, porcupine quills, deer dewclaws, puffin beaks, and black and red pigment; length 36 inches; c. 1830–50. Field Museum of Natural History, Chicago, 79729. Purchased from Newcombe, 1902

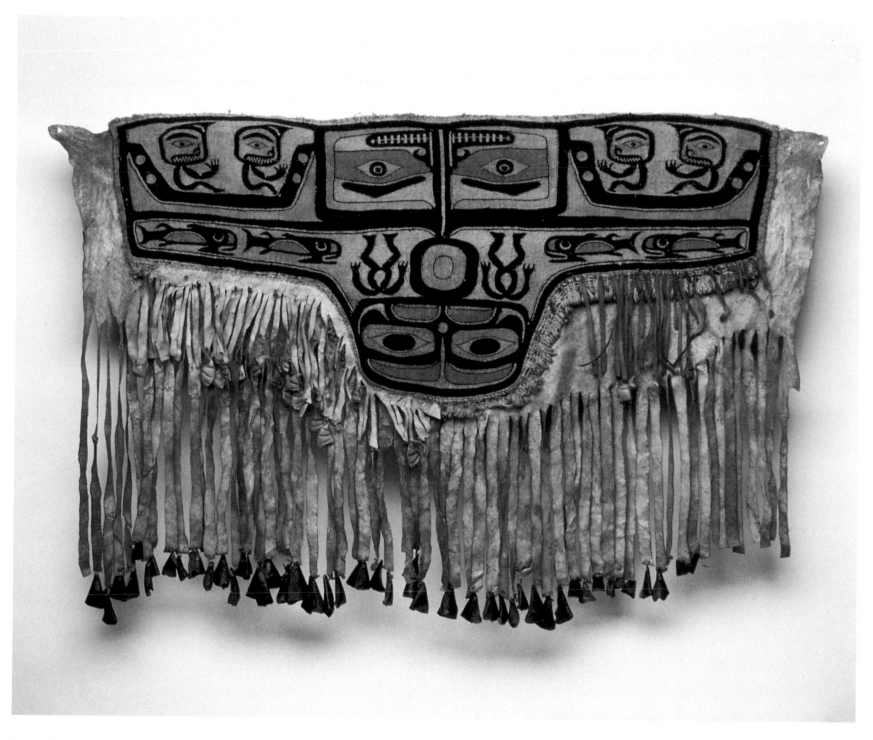

No. 435. Tlingit Apron. Emmons (n.d.) identifies the four fish as sand sharks (dogfish) and the faces in the upper center as confronting bears; two spirit figures in head canoes are at the sides. The inspiration for the design, he writes (ibid.), was "a dream or fancy of the Doctor which he would indicate to the weaver to work out in the robe." According to Kate Pasco (1994), this is an early Chilkat weaving. Bill Holm (1995) dates it to the early nineteenth century. Collected by Emmons at Klukwan, 1884–93. Mountain goat wool, cedar bark, animal skin, puffin beaks, deer dewclaws, and yellow, black, and blue-green pigment; length 41¼ inches; c. 1800–1820. American Museum of Natural History, New York, E 2602. Purchased from Emmons, 1893

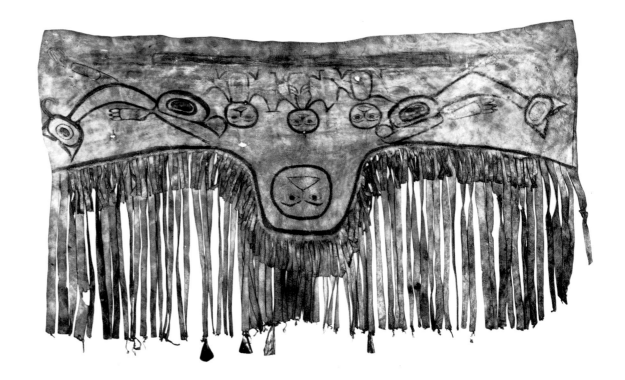

No. 436. Tlingit Apron. Conn (1979, p. 331, no. 464) suggests that this apron was worn by a shaman to prevent malevolent spirits from hiding in his clothing. Animal skin, deer dewclaws, and red and black pigment; length 36¼ inches; c. 1840–60. Former collection: F. R. Mitchell. Denver Art Museum, 1935.191. Purchased, Evans Fund, 1935

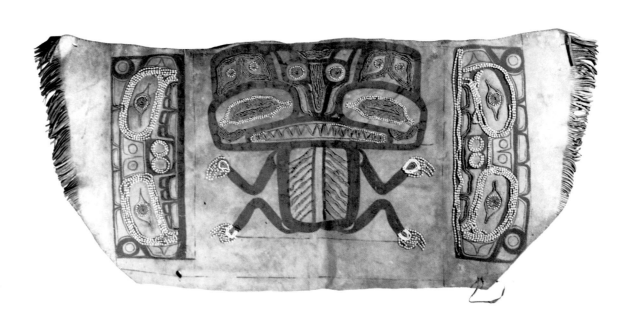

No. 437. Tlingit Apron. Siebert and Forman (1967, nos. 97, 98) call this a shaman's apron. Two bear heads are on each side of a skeletonized bear figure. Museum records indicate that this is from an early collection. Deerskin, blue and white beads, and red pigment; length 41¼ inches; c. 1820–40. Museum of Anthropology and Ethnography, St. Petersburg, Russia, 5795–14

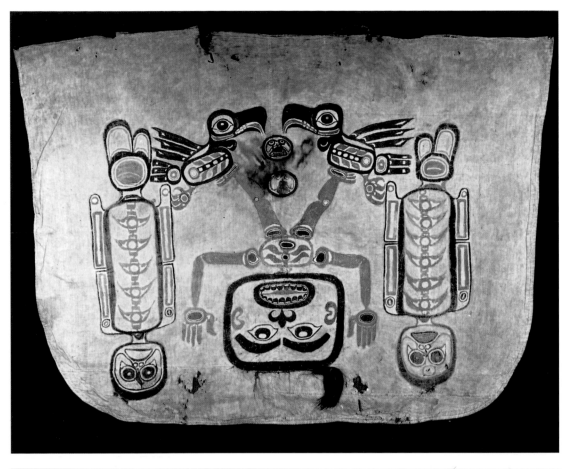

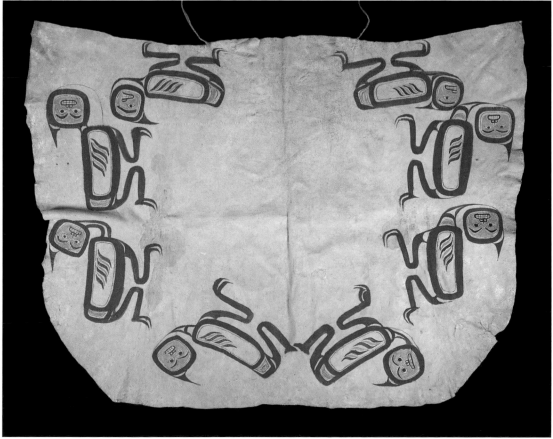

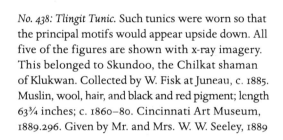

No. 438: Tlingit Tunic. Such tunics were worn so that the principal motifs would appear upside down. All five of the figures are shown with x-ray imagery. This belonged to Skundoo, the Chilkat shaman of Klukwan. Collected by W. Fisk at Juneau, c. 1885. Muslin, wool, hair, and black and red pigment; length 63¾ inches; c. 1860–80. Cincinnati Art Museum, 1889.296. Given by Mr. and Mrs. W. W. Seeley, 1889

No. 439. Tlingit Tunic. Although there is no documentation that indicates this tunic had a shamanic function, the depiction of eight figures suggests such a use. Although they lack dorsal fins, these figures also bear a certain relationship to the sculptures of water spirits that were sewn on some shamans' costumes (see nos. 488–90). Collected by Captain Edward G. Fast at Sitka, 1867–68. Animal skin and black, red, and blue-green pigment; length 61 inches; c. 1830–50. Peabody Museum of Archaeology and Ethnology, Harvard University, Cambridge, 69–30–10/2081. Purchased from Fast, 1869

No. 440. Tlingit Bag (below). A skeletonized bear is embroidered in quillwork. Museum records refer to this as a shaman's bag and indicate that it is from an early collection. It was used to hold amulets and other small items of power. Deerskin, porcupine quills, and yellow and brown pigment; height 8¼ inches; c. 1820–40. Museum of Anthropology and Ethnography, St. Petersburg, Russia, 2520–1

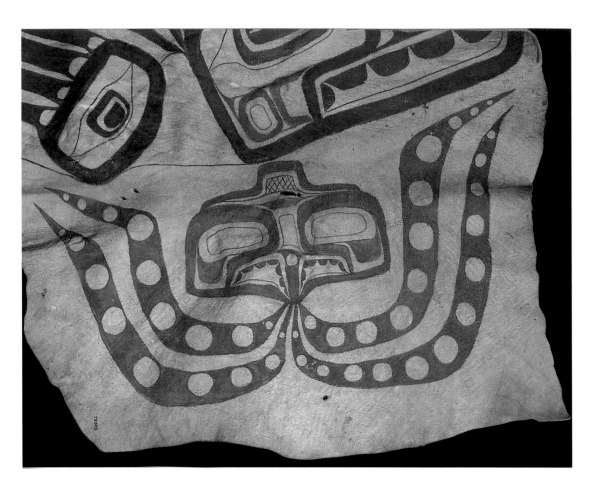

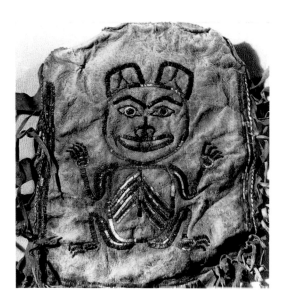

No. 441. Tlingit Costume with Eight Masks (right). The masks, now in the American Museum of Natural History, New York (16.1/995 B220–227), are no longer attached to the cedar bark frame shown in this photograph. They were given to the museum by Mrs. Edward H. Harriman in 1912, and had been in the collection of John Brady, Governor of Alaska. Emmons (n.d.), who collected the costume, writes the following description: "Shaman's dress, worn as a blanket over the shoulders and back, of red cedar bark rope, to which are attached eight flattened wooden masks, and tassels of cedar bark. From an old Tlingit Shaman's grave house of South Eastern Alaska, probably of the Sitka tribe. It was worn when practicing about the sick and bewitched. Each mask face represented that of a particular spirit of the Shaman which he had the power of calling to his assistance in opposing and struggling with hostile witch spirits that caused sickness. These eight masks are ornamentally painted in native mineral colors of black, red ocher, and the blue stone, just as the spirit's face appears to the shaman, but is invisible to all others. This is the only robe of this character I have ever seen or heard of among the Tlingit and is a remarkable piece of great interest." Cedar bark, wood, and red, black, and blue-green pigment; height of each mask approximately 6 inches; c. 1840–60. Photograph by George Emmons, c. 1887. Author's collection, New York

No. 442. Tlingit Robe (above, detail). The devilfish motif is shown. Collected from the grave house of a shaman of the Hutsnuwu clan on the shore of Chatham Strait, Admiralty Island. Animal hide and black and red pigment; length of section shown approximately 12 inches; c. 1830–50. Field Museum of Natural History, Chicago, 78303. The Carl Spuhn Collection. Purchased from Emmons, 1902

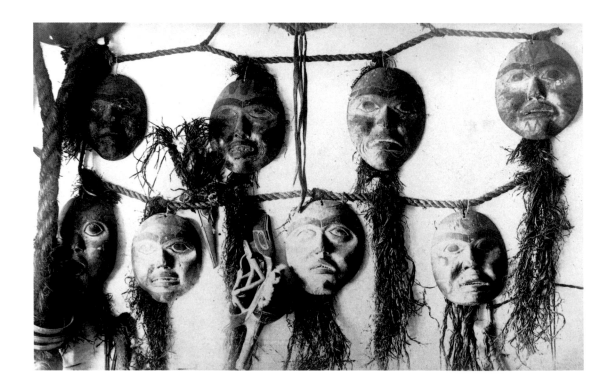

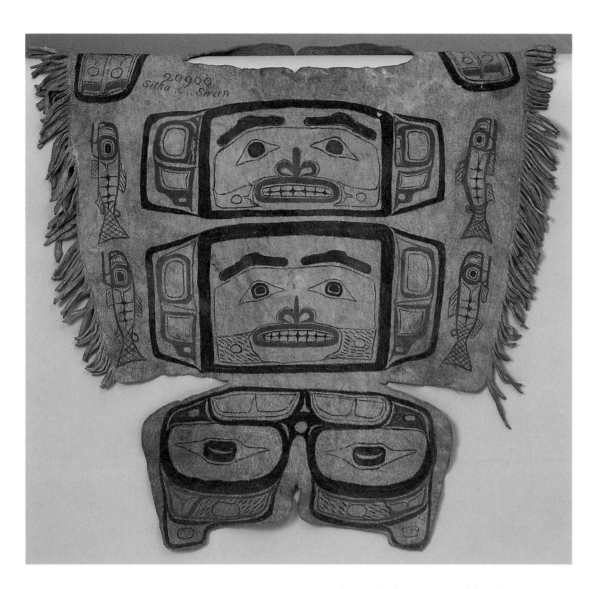

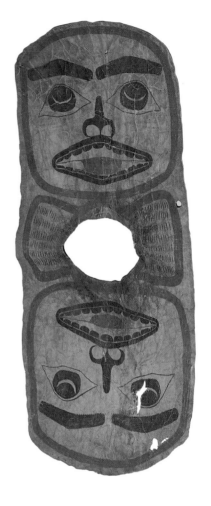

No. 443. Tlingit Tunic. Although there is no documentation that indicates the shamanic use of this object, it relates to other shamans' tunics in general form, and the skeletonized fish at the borders suggest shamanic iconography. Collected by James G. Swan. Animal skin and red and white pigment; length 24¼ inches (exclusive of fringe); c. 1830–50. National Museum of Natural History, Smithsonian Institution, Washington, D.C., 20900. Acquired from Swan, 1876

No. 444. Tlingit Tunic. When worn, the two heads of the spirit figures would have appeared upside down. Emmons (n.d., Notes, NMAI) states that this type of tunic is rare and confined to the Northern Tlingit. Collected by him from a shaman who lived on the Chilkat River. Seal skin and black, red, and traces of blue-green pigment; length 17¼ inches; c. 1840–60. National Museum of the American Indian, Smithsonian Institution, Washington, D.C., 10/1779. Purchased from Emmons, 1920

No. 445. Tlingit Tunic. The figure is a bear. The icon-
ography and style are somewhat similar to those
of no. 35, which belonged to a shaman. Collected
at Chatham Strait, Admiralty Island. Animal skin
and black, red, and blue-green pigment; length 41¼
inches; c. 1840–60. National Museum of the American
Indian, Smithsonian Institution, Washington, D.C.,
11/274. Purchased 1922

THE SHAMAN ONLY ONE
(*Tsimshian*)

[*Three Tsimshian men went down to a place called the Cave of Fear which was known to give supernatural powers to those who sought them. Two of the men were lowered into it, but each was forced to return because he had been stung by a swarm of insects.*]

Then the third man, the steersman of the canoe, tied the end of the cedar-bark line around his body. They let him down gently, and he went right down to the bottom of the dark pit. He did not feel the sting of the insects. There was thick darkness down below, and he groped along the bottom. The line was still tied to his body. While he was groping about there, he heard a noise like the rolling of thunder in the bottom of the great pit. It resounded again and again. Then a great door opened on the east side of the bottom of the pit, and, behold! a hairy young man stood there, who inquired of him why he had come to the pit. The man replied that he had come because they were in need of a great shaman. So the hairy man invited him in. The door which had opened looked like the sun shining through a window. The steersman went in there. Inside, there were not many people, only a great chief sitting in front of a large fire. He wore his crown of grizzly-bear claws filled with eagle down. Two live rattles were on the ground on each side, and he wore his dancing-apron.

When the man came into the house, the chief did not look at him. After a while another door opened on the east side of the house, and a young shaman came in with his crown of grizzly-bear claws on his head, his apron tied around his waist, and a rattle in his right hand, an eagle tail in his left. Then the boards for beating time ran in through the door like serpents, and each laid itself on one side of the large fire. Then weasel batons ran along behind the boards.

The young shaman began to sing his own song; and as he shook his rattle, the weasel batons began to beat of themselves, and a skin drum ran ahead and beat of itself. Then a great many shamans came out, and each took his own supernatural power out of his mouth, and put it into the mouth of the visitor. When they had all done so, the great chief who had been sitting by the fire stood up and stepped up to the man, put his hands on him, and rubbed his eyes four times. Then he went back to his place and sat down, and all the shamans were gone. The man did not see where they had gone to, but they all vanished from his sight.

Suddenly he was again in complete darkness, and he felt that the line was still tied around his body. He shook it and shouted, and they pulled him up. Then the men went back to their own town; and when they had gone halfway, the man in the bow of the canoe fell back in a faint, but the two others poled up the river. Before they arrived at home, the man in the middle of the canoe fell back in a faint, and the man in the stern poled the canoe up to their home.

The two men who had fainted vomited blood as a sign that they had obtained supernatural power, and they became shamans. Only one of them had not obtained supernatural power, and no dream had come to him. He was still waiting. After a long while these two men went about and healed the sick.

Now, at the end of summer, the supernatural powers took the man away from home. Nobody knew where he had gone. At the end of four days, he was found lying on the floor of his house, and around him a terrible whistling was heard. No one went near him. He was alone in his house, and singing and ready to work.

Therefore, he called all the people into his house, and he told them how he had entered the house of the supernatural power in the pit; and he said, "They have given me great powers to do

No. 446. *Tlingit Costume Ornaments.* According to Emmons (n.d.), these thirty-two disks painted with human faces were originally laterally attached to each other by a hide cord. He describes them as part of a shaman's "protective armor," which was "worn on the legs below the knee." As there are too many disks to have been used only for this purpose, they may also have been worn over a tunic or apron. Collected by Emmons from the grave house of a shaman at Dry Bay, 1884–93. Wood, human hair, and red and black pigment; diameter of largest disk 7⅛ inches (exclusive of hair); c. 1850–70. American Museum of Natural History, New York, E 2311. Purchased from Emmons, 1893

what nobody else can do. I will bring back life to the dead." The supernatural power had given him the name Only One.

He did wonderful work among the people, healing them, reviving the dead; and his fame spread through all the villages round about, and many sick people were anxious to see him.

Other shamans tried to kill him with their powers, but he destroyed them all; and not many people died in his time, because the diseases were afraid of him. Every day he was called into another village by rich and poor, and he came to be very wealthy. . . . He did all his duty among the sick people, and those who were sick loved him. (Boas, 1916, pp. 331–33)

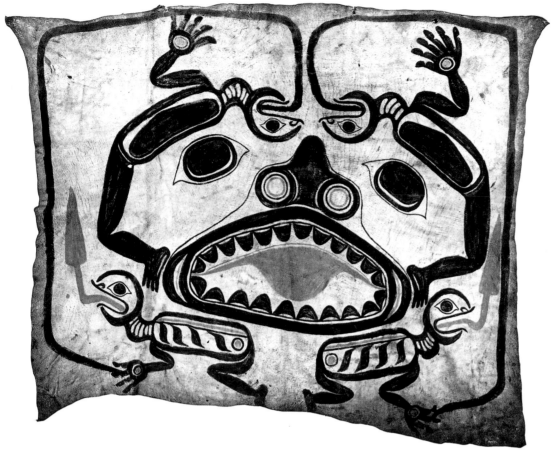

No. 447. Tlingit Apron. Four squatting animals surround a large face, perhaps that of a bear. The tongues of the two figures at the top are extended to run around the edges. The iconography of this painting is undoubtedly shamanic. Walrus hide and red and black pigment; length 57 inches; c. 1840–60. National Museum of the American Indian, Smithsonian Institution, Washington, D.C., 8/1799. Purchased from Fred Harvey, 1918

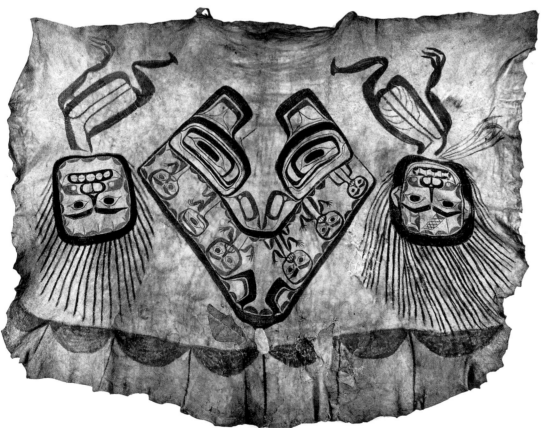

No. 448. Tlingit Tunic. Emmons (n.d., Notes, NMAI) describes the central figure as a bear with spirit figures for teeth. The two upside-down skeletonized figures at the sides show the shamanic iconography of rayed heads (see p. 28). Collected by Emmons with nos. 341, 407, and 433 from the grave house of a shaman of the Stikine tribe near Wrangell. Caribou hide and red and black pigment; length 60 inches; c. 1840–60. National Museum of the American Indian, Smithsonian Institution, Washington, D.C., 1/2492. Purchased from Emmons, 1907

No. 449. Tlingit Hat. Emmons (n.d., Notes, NMAI) describes this as a war hat that a shaman used in combat with evil spirits. It is made from a fragment of a Chilkat blanket. Collected by Emmons at Ketchikan and said to have belonged to a shaman of the Tongass tribe. Mountain goat wool, spruce root, wolf tail, and red, black, and blue-green pigment; length 11½ inches; c. 1860–80. National Museum of the American Indian, Smithsonian Institution, Washington, D.C., 15/1340. Purchased from Emmons, 1926

No. 450. Tlingit Hat. The right-angle geometric design, called "shaman's hat," and the diagonal stripe at the front are typical motifs for these hats (Holm, 1995). Collected by Emmons, who writes (n.d., Notes, NMAI) that it was "with an old outfit found at Klukwan." Spruce root and fur; length 10 inches; c. 1840–60. National Museum of the American Indian, Smithsonian Institution, Washington, D.C., 3/6658. Purchased from Emmons, 1914

No. 451. *Tlingit Hat: "Raven Head Cover."* The wood sculpture represents a raven, and the textile is from a Chilkat blanket that may have been torn up at a potlatch (Kaplan and Barsness, 1986, p. 199, no. 232). On the history of this hat, Kaplan and Barsness (ibid.) quote Louis Shotridge, who collected it in 1924 from the Snail House at Hoonah: "The headdress was made for the first shaman who acquired popularity in the division [clan]. It was called 'Sonya-ka-ta-ka Shada,' meaning 'The Soul of the Southeastern Man Headcover,' but in later years, the original figure was replaced with the present one, and the name changed into that of Raven, obviously with hopes of establishing the name of the clan's practitioner among shamans of rank." Wood, sheep and mountain goat wool, red trade cloth, cedar bark, and red, black, yellow, and blue-green pigment; length 16¾ inches; c. 1850–70. The University Museum, University of Pennsylvania, Philadelphia, NA 6836

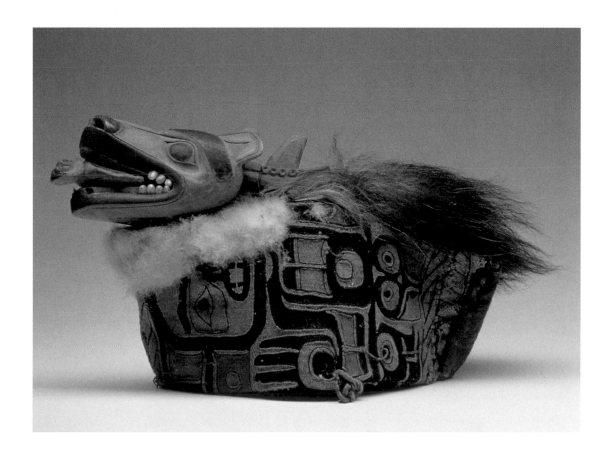

No. 452. *Tlingit Hat.* Emmons (n.d.) describes the Chilkat textile motif as depicting the land otter spirit. The sculpture shows a wolf devouring a human; the wolf's body has a dorsal fin with a line of devilfish suckers below. Collected by Emmons at Chilkat, 1882–87. Wood, mountain goat wool, cedar bark, down, wolf fur, rawhide, opercula, and black, red, yellow, and blue-green pigment; length 8⅝ inches; c. 1830–50. American Museum of Natural History, New York, 19/977. Purchased from Emmons, 1888

No. 453. Haida Hat. The wood sculpture represents a land otter. Collected at Howkan, and said by Emmons (n.d., Notes) to have been the property of "the K'lidsan shaman." Wood, animal skin, wolverine tail, and marten, weasel, and marmot fur; length 19⅞ inches; c. 1850–70. Field Museum of Natural History, Chicago, 79564. The Carl Spuhn Collection. Purchased from Emmons, 1902

ACQUIRING POWERS
(Bella Coola)

Once upon a time there was a man and a woman who had four sons. The three elder ones died. Then the father and mother and the youngest brother were very unhappy, and the old people cried for grief until they died. The young man was now left all alone. He left his village, intending to go away and never to return. He pulled his blanket over his head and walked on. Sometimes he would stop to pray. He lived on the meat of mountain-goats which he shot. He built a small hut high up on the mountains, and dried the meat. He was crying and praying all the time. He prayed to the Sun to give him a gift which would restore his happiness. One day early in the morning he ascended the mountain. He addressed the rising Sun, saying, "Look at me, how unhappy I am." After he had gone a short distance he came to a ravine. The bed of the ravine was filled with pretty pebbles. There he met a beautiful man, who was no other than the Sun, who had descended from the sky. He had caused the water of the creek that runs through the ravine to disappear. When the young man saw the stranger from a distance, he thought, "He seems to be looking for me." He went nearer; and when they met, the Sun said, "I am the one to whom you are praying all the time, and I came to help you. Now be happy. When you open your mouth and speak to me, I know your thoughts at once. I help those who address themselves to me.

No. 454. *Tlingit Headpiece.* A killer whale, worn on top of the head, with its tail extending down the shaman's back. Collected by Louis Shotridge, 1918. Wood, human hair, animal skin, abalone, and red and black pigment; length 25¼ inches; c. 1840–60. The University Museum, University of Pennsylvania, Philadelphia, NA 8493 (OT4)

Take this." With these words he handed the young man a switch carved in the shape of a man. The Sun was carrying it under his arm, the point of the switch directed downward. "Fold your arms and hold this switch to your chest, and then return to the village. When you approach any one, hide the switch under your arm. You will find a person who wears a nose-ornament of beautiful green color. Then you must try to hit the ornament with this switch, and throw it to your right side."

He walked on, and after a while he noticed a man sitting at a distance. Then he hid the switch under his arm. When he came near, he saw that the man wore a large green nose-ring. He hit it with his switch, and threw it to the right-hand side. Then the man said, "You have attained me as your supernatural helper. Your name shall be S'a'tɛma [from 'a'tema,' 'dead']. Many people have seen me, but nobody has done what you did. If you had not struck my nose-ornament, you would have died on seeing me. You shall have the power to heal the sick by the touch of your hands. Whenever a person dies and is put into a box, after the box has been placed in the burial-ground, go there. You will find me sitting on the coffin. If then you knock the nose-ring from out of my nose, I shall leave, and the dead will revive. He will break the box, and will arise."

Then the young man felt very glad. He returned to the village, and by following the instructions of the spirit he resuscitated the dead. He was given many blankets, and the men whom he had resuscitated gave him their daughters in marriage. (Boas, 1898, pp. 43–44)

BOXES AND CHESTS

BENTWOOD SQUARE BOXES and rectangular chests were used by shamans for storing their paraphernalia. They were kept in the shaman's house or in the woods and served to prevent the uninitiated from coming into contact with this powerful material. Some shamans were interred with their property placed in such boxes.

As a rule, shamans' boxes are somewhat smaller than those used by chiefs and wealthy families to store food and clothing, and their size depended on the paraphernalia they were made to hold. Most are decorated with paintings or relief-carved designs representing spirit helpers and other supernatural beings; Emmons said that a number of the Tlingit examples that he collected depict mythical sea spirits (nos. 37, 457, 462). Others show relief carvings of human faces with trance expressions. Emmons also collected one early small box carved with bears and frogs (no. 458) that he said was used to hold the shaman's urine with which the shaman washed himself.

No. 455. Tlingit Chest Panels (opposite). Holm (1983, p. 71, no. 110) dates such carvings to the late eighteenth century through their "massive formlines, minimal background, simple details and ovoid reliefs in eyes and joints." Although there is no documentation to associate this chest with shamanic use, the central face with the protruding tongue suggests the depiction of a shaman in a trance. The same motif appears on a chest panel collected from a shaman's grave (no. 456). Wood and red and black pigment; height 12⅝ inches (each); c. 1790–1810. Private collection

No. 456. Tlingit Chest Panel (below). The face in the center is similar to that of certain masks representing the onset of a trance or incipient death. Below is an upside-down devilfish. Collected by Emmons from a shaman's grave in a cave on the Chilkat River. Wood, opercula, and black, red, and blue pigment; length 27½ inches; c. 1850–70. National Museum of the American Indian, Smithsonian Institution, Washington, D.C., 20/3895. Purchased from Emmons, 1941

No. 457. *Tlingit Box Panels.* Emmons (n.d.) states these are the sides of a box that was "used to hold a Doctor's implements of practice." He describes the design as representing a mythical sea spirit. Collected by him in 1884–93 at Chait Bay, Admiralty Island, from the grave house of a shaman of the Hutsnuwu clan. Wood, rawhide, and traces of blue pigment; height 9¼ inches; c. 1830–50. American Museum of Natural History, New York, E 1579. Purchased from Emmons, 1893

SHAMANS' SPIRIT HELPERS
(Bella Coola)

The same man who gave me the record of his supposed visit to the country of the ghosts told me that at another time he saw L'ētsā'aplēLāna *flying in the air outside of his house. She wore a ring of red cedar-bark around her neck. She was turning round all the time. Songs were coming from all parts of her body. Although she did not open her mouth, it sounded as though a great many people were singing. She gave him a song, or, as the narrator expressed it, "she threw a song into his body." At that time he was sick, suffering from a wound in his leg inflicted by an axe. He said four days after meeting the spirit he was able to walk, and since that time she has assisted him in curing diseases.*

The si'siuL is another helper of the shaman, and the means of curing disease. It appears that it obtains its supernatural power from the fact that it lives in the water in which the supreme deity washes her face. When a person sees a si'siuL, he should throw sand on it, by which means

he will be able to catch it. Its skin is so hard that it cannot be pierced with a spear or knife. The person who catches it should not try to cut it with his knife, but should stretch his hand backward, and thus he will find the leaf of a holly, which is the only thing that can cut its skin. He should not touch the si'siuʟ with his hands, but hold it with hemlock twigs. He should wrap it in white cedar-bark and tie it up in his blanket. If it is not thus tied up, it will disappear. It must not be taken into the house, but should be placed in a small box and hidden under stones, or buried in a hole under the root of a tree. It is a most potent means of curing disease. Sick people will buy small pieces of the si'siuʟ, for which they pay high prices. The piece is thrown into water, in which it is kept for four days. Then the water is used for washing the body. If a healthy person uses this water, he will live to an old age. Sick persons chew the white cedar-bark in which it is wrapped up, in order to regain health. They must not swallow the cedar-bark, but only the saliva that gathers in their mouths. A person who has chewed the cedar-bark becomes invulnerable. The eye of the si'siuʟ is described as about a foot in diameter, and as transparent as rock crystal. (Boas, 1898, pp. 44–45)

No. 458. Tlingit Box Panels. These panels are from a box that Emmons (n.d.) states was used to preserve its shaman owner's urine, with which he would sometimes wash himself. The style of the relief-carved bears and frogs dates to the eighteenth or early nineteenth century (see no. 463). Collected by Emmons in 1884–93 from a shaman's grave house at Grouse Fort, Icy Strait, a village that was said to have been the home of the Kagwantan clan and was abandoned in the early nineteenth century. Wood, animal teeth, cedar bark, and traces of red and black pigment; height 8¾ inches; c. 1780–1810. American Museum of Natural History, New York, E 534. Purchased from Emmons, 1893

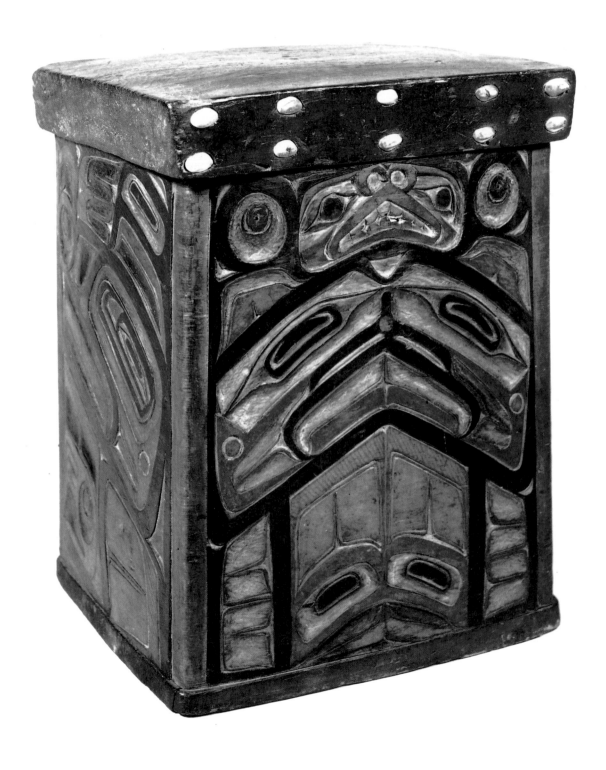

No. 459. Bella Bella Covered Box. Hawthorn (1979, pl. XXVII) describes this box as having been used by a shaman. It was collected at Kitimat by the Reverend George H. Raley in the early twentieth century. Wood, opercula, and black, red, and blue-green pigment; height 13 inches; c. 1860–80. University of British Columbia Museum, Vancouver, A 1764. Purchased, MacMillan Fund, 1948

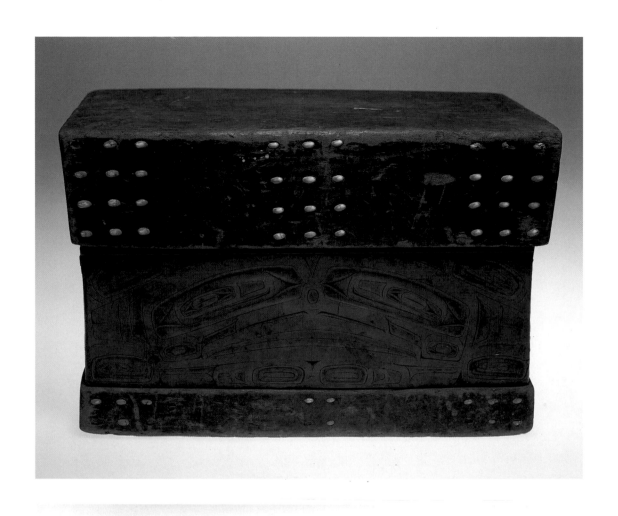

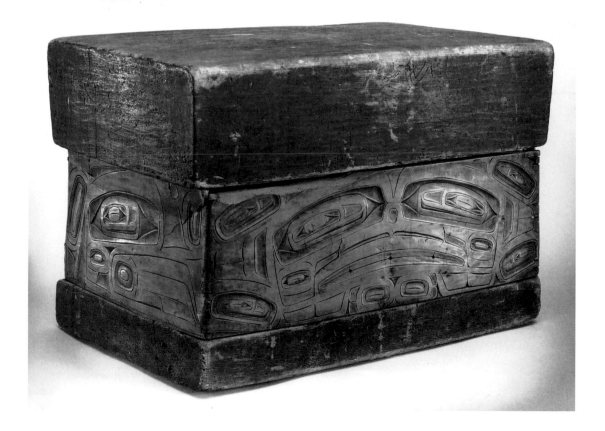

No. 460. Tlingit Covered Chest (two views). A shaman's mosquito mask (no. 173) was found in this chest, which indicates its use to store shamanic paraphernalia. The thick cover and broadly conceived formlines date it to the late eighteenth or early nineteenth century. Wood and opercula; height 13½ inches; c. 1790–1820. Private collection

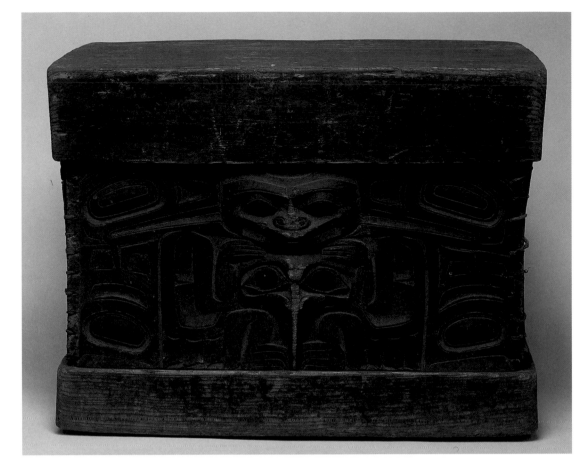

No. 461. Tlingit Covered Chest. The carvings on each side are slightly different. The central motif on each is a bear with a raven below. On the side shown, it is flanked with bear forms in profile; on the other, the flanking animals are ravens in profile. Collected by Emmons in 1884–93 from the nephew of Nolk, a Hutsnuwu shaman who died about 1865 and was buried with his paraphernalia in a grave house at Chait Bay, Admiralty Island. Wood, spruce root, and black pigment; height 14¾ inches; c. 1820–40. American Museum of Natural History, New York, E 987. Purchased from Emmons, 1893

No. 462. Tlingit Covered Chest. This chest dates from the same period as no. 460. Emmons (n.d.) identifies the design as representing a mythical water spirit. Collected by him on the western shore of Chatham Strait from a cave containing the property of a Hutsnuwu shaman, 1884–93. Wood; height 13½ inches; c. 1790–1820. American Museum of Natural History, New York, E 1303. Purchased from Emmons, 1893

No. 463. Tlingit Box (above). The frontal figure, shown in the x-ray style, holds two severed heads in its hands. Holm (1983, p. 66, no. 98) speculates that this box was the property of a shaman. He also suggests that the carving style dates it to the eighteenth century (see also no. 458). Wood, human hair, spruce root, and traces of red pigment; height 12 inches; c. 1780–1800. Private collection

No. 464. Tlingit Covered Box (left). Museum records state that this box is from a grave, leading to the conclusion that it was part of the paraphernalia placed with a shaman in his grave house. Since none of the tops of boxes used to store crest material are carved at all, shamanic association with this example is further supported by the human face in a trance expression on the lid of this example. A similar face with shell inlay is carved on the inside bottom of the box. The figure in relief on the sides is an eagle. Wood, abalone, opercula, human hair, and red and black pigment; height 9⅞ inches; c. 1830–50. National Museum of the American Indian, Smithsonian Institution, Washington, D.C., 19/3497. Acquired from the William M. Fitzhugh Collection, 1936

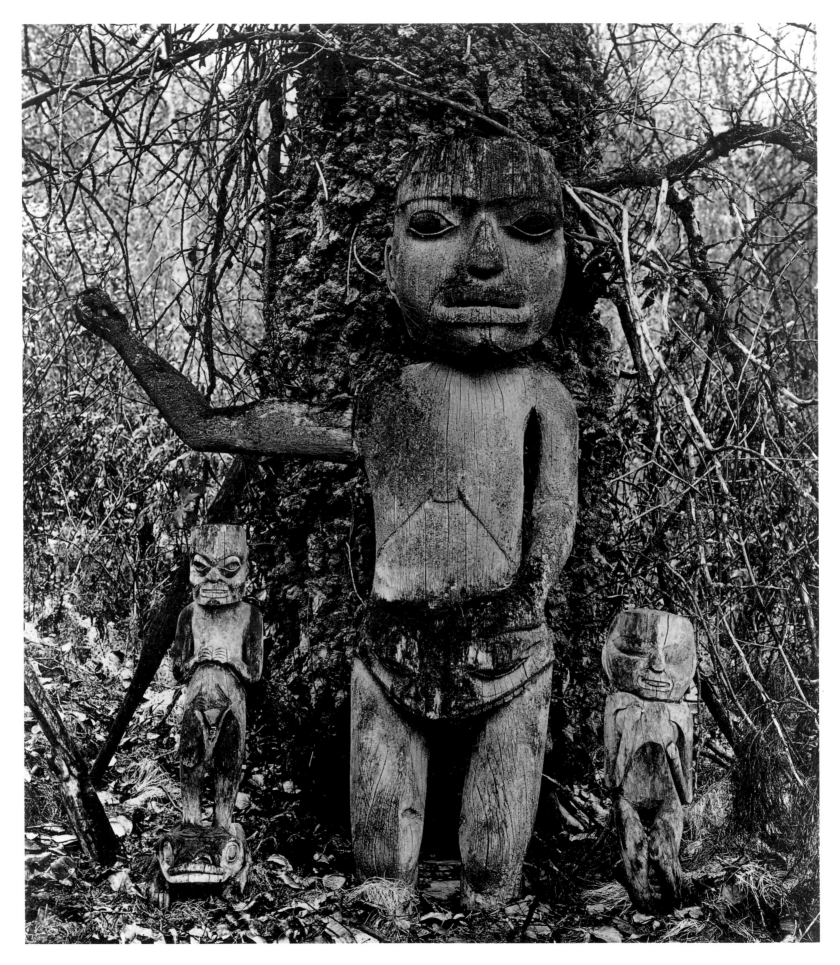

FIGURES

WOOD SCULPTURES of the human form were created for a variety of shamanic purposes. Ranging in height from a few inches to over-life-size, they were made to guard the graves of shamans, to help keep evil spirits and influences away, and to prevent shamans from eating food or drinking water that was spiritually dangerous (no. 468). Some are carved in aggressive poses and carried spears and other weapons with which to battle supernatural forces. One Tlingit figure type (Olson, 1961, p. 210) was called *iktdàkye' gi*, or "spirits which sit at the door."

Carvings in the human form were also worn as pendants that were attached to animal hide tunics, aprons, and headbands. A series of headless figures affixed upside down to headbands are identified by Emmons (n.d. [American Museum of Natural History, New York, E 404]) as guardian figures. Such figures are also painted on some Tlingit aprons. Another group of Tlingit water spirit carvings in the form of crouching humans with dorsal fin attachments were worn on Tlingit shamans' robes (nos. 488–90).

Among the Tsimshian, human puppets were used for curing. Sometimes they actually represented a disease (no. 45) so that the relationship between the shaman and the illness could be enacted in the performance.

Large figures on canoe prows that represent the land otter man were used by chiefs and not shamans, but are included here because of their shamanic iconography (nos. 65, 486, 487). Also represented are examples of sculptures of shamans that were carved for commercial purposes by Charles Gwaytihl or Simeon Stilthda, both Haida artists, (nos. 31, 63, 64).

The Tlingit made a number of male and female figures similar to dolls about which there is conflicting information. Because they are often shown with long hair and dressed in shamanic costumes, they most probably represent shamans themselves. Many are also accompanied by miniature masks, headbands, and tunics that were kept in small boxes similar to those full-size examples used by shamans for storing their paraphernalia. As noted, it has been suggested that these figures were toys (Holm, 1983, p. 117, no. 200). Gunther (1966, p. 52) has also written that they may have been made "for children to acquaint them with the appearance of a shaman so that he could have been avoided." In fact, however, they may have been used to maintain the power of the shaman and, when left with a patient, to represent him after he had completed his performance, as Holm (1983, p. 117) suggests was done with amulets. A crudely carved Tsimshian figure in the Canadian Museum of Civilization in Ottawa (VII-C-1149), for example, made about 1900 by the shaman David May, was said to have had powers similar to his own and to have been left with patients to effect cures.

No. 465. Tlingit Guardian Figure. This figure appears in a photograph made by Winter and Pond in 1895 (Wyatt, 1989, p. 108, no. 63) and in one taken by A. C. Pillsbury in 1900 (fig. 38) of the same site represented in fig. 39. It was collected by Charles F. Newcombe at Klukwan, c. 1900, and is said to be from the grave house of a shaman named Taxetin. Newcombe (n.d.) speculates that it could date from the end of the eighteenth century. Wood; height 25½ inches; c. 1790–1820. Field Museum of Natural History, Chicago, 79756. Purchased from Newcombe, 1902

Fig. 38. Tlingit Carvings Around an Old Tree in the Woods Near Klukwan (opposite). The photograph is accompanied with the following information: "Sept. 20, 1900. Mr. Dalton saw these totems in George Shattridge's [*sic*] long house at Klukwaii [*sic*] till the house was torn down 2 or 3 years ago." The guardian figure no. 465 is at the right. See also fig. 39. Each photographer of this site added his own commentary, none of which agrees in any way with the others. Information concerning the figures themselves should therefore be treated with caution. Photograph by A. C. Pillsbury, 1900. Seattle Public Library

Fig. 39. Wood Carvings Around an Old Tree in the Woods Near Klukwan (above). This photograph, which was taken about 1890, shows the place at which the large guardian figure (no. 467) was found. While visiting this site in 1882, Aurel Krause (1956, p. 204) wrote: "In the woods near Klukwan, away from a path, three male figures carved of wood stood near a tree trunk; the largest had its right arm raised as in the act of throwing a spear and the middle and smaller figures were near it. It seems that these figures were set out of the way here and were feared. Anyone who approached them stood in danger of death and actually, in a crowd of children who accompanied us, only a half-grown girl dared go near them. All around them were bushes thick with huckleberries while they had been picked almost everywhere else. It is said that in times of stress the Chilkat light a fire on the opposite side of the river from the figures and hope in this way to assuage their anger." Several other photographs of this site were made after Emmons had removed the guardian figure. A Winter and Pond image of 1895 identifies the grave with the name "Gow-ge-a-deh-Iktrik" (Wyatt, 1989, p. 108, no. 63). However, de Laguna (in Emmons, 1991, p. 396) identifies the grave as belonging to "Date-hun, a Chilkat shaman of Killerwhale House, Wolf 1. . . . The large figure on the right is 'Gou-ghe yah-tee, drum holder,' for the drum of the shaman was hung on the outstretched arms. Such figures were known as 'ut nut teen, he sees something,' and were made for very special occasions." See also fig. 38. American Museum of Natural History, New York, neg. 336624

No. 466. *Tlingit Guardian Figure* (left). Gunther (1962, p. 52, no. 4) writes that the figure represents a shaman singing, and that the staff and two faces on the kneecaps are devilfish. Collected by Sheldon Jackson, 1870–79. Wood; height 23 inches; c. 1820–40. The Art Museum, Princeton University. On permanent loan from the Department of Geological and Geophysical Sciences, 5159. Given by Jackson, 1882

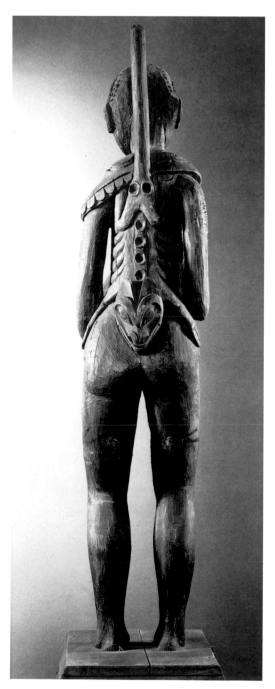

No. 467. *Tlingit Guardian Figure* (two views). According to Emmons (n.d.), the figure is Geastin, a spirit who lives in the sky and kills Tlingit people when encountering them. The figure is represented as a shaman singing, and the figures on the costume at the shoulder and over the groin are spirit fish. On the back is a large land otter. Rattles were originally held in the hands. Collected by Emmons in 1884–93 from a group of carvings near the grave house of a Kagwantan shaman near Klukwan (see fig. 39). Wood, human hair, and traces of red, black, and blue pigment; height 61 inches; c. 1830–50. American Museum of Natural History, New York, E 1915. Purchased from Emmons, 1893

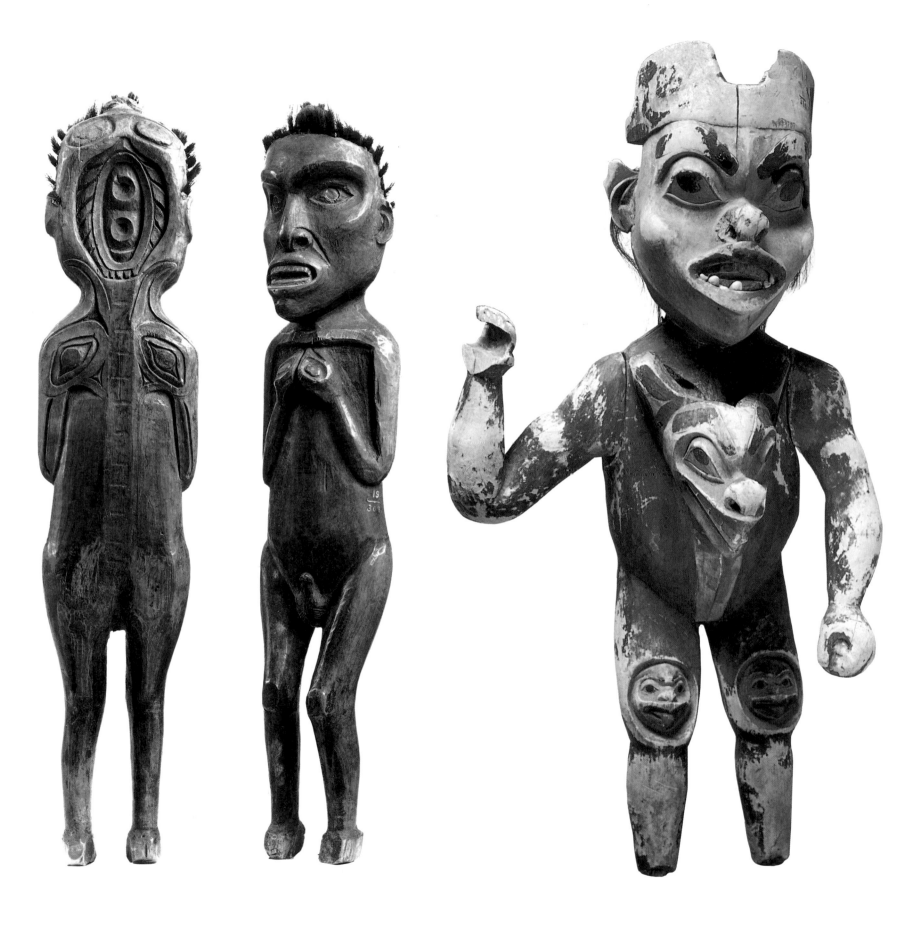

No. 468. Tlingit Guardian Figure (opposite, left; two views). Emmons (n.d.) writes that this figure was used to taste a shaman's water to warn him of any danger that it might have contained from witches or evil spirits. A sand shark is carved on the back. Collected by Emmons at Chilkat, 1882–87. Wood, human hair, abalone, and black pigment; height 17⅜ inches; c. 1840–60. American Museum of Natural History, New York, 19/308. Purchased from Emmons, 1888

No. 469. Tlingit Guardian Figure (opposite, right). Emmons (n.d.) states that this figure was placed at the head of a dead shaman's body to guard it from hostile spirits. The figure originally carried knives or wands as weapons, and stood on the back of a seal, ".which indicates that he does not walk, but glides through space noiselessly" (ibid.). The wolf head on the chest represents a spirit helper, and two spirit heads are carved on the knees. Collected by Emmons from a shaman's grave at Port Mulgrave (Yakutat), 1882–87. Wood, human hair, opercula, eagle down, and red, black, brown, and blue-green pigment; height 23½ inches; c. 1820–40. American Museum of Natural History, New York, 19/378. Purchased from Emmons, 1888

No. 470. Tlingit Guardian Figure (right). The figure wears a frog headdress. Two land otters are draped over the shoulders, and two others encircle the thighs. Spirit heads are carved at the knees. Brown (1987, pp. 158, 171; fig. 20) attributes this carving to a Tlingit sculptor who made totem poles, house posts, frontlets, and feast dishes at the end of the eighteenth and beginning of the nineteenth centuries. Collected by Emmons in 1884–93 from the grave house of a long-dead Xatkaayi shaman at the mouth of a small stream about four miles above Lituya Bay. Wood, glass inlays, and traces of red and black pigment; height 47½ inches; c. 1790–1820. American Museum of Natural History, New York, E 2208. Purchased from Emmons, 1893

No. 471. Tsimshian Puppet (far right). The head of the figure is articulated, and moves from side to side when the attached string is pulled. When Emmons collected this at Kitwanga in 1925, he (n.d., Notes, NMAI) wrote that several of the elders remembered its use by a shaman when they were boys. Wood, human hair, string, and red and black pigment, height 30 inches; c. 1860–80. National Museum of the American Indian, Smithsonian Institution, Washington, D.C., 14/4345. Purchased from Emmons, 1925

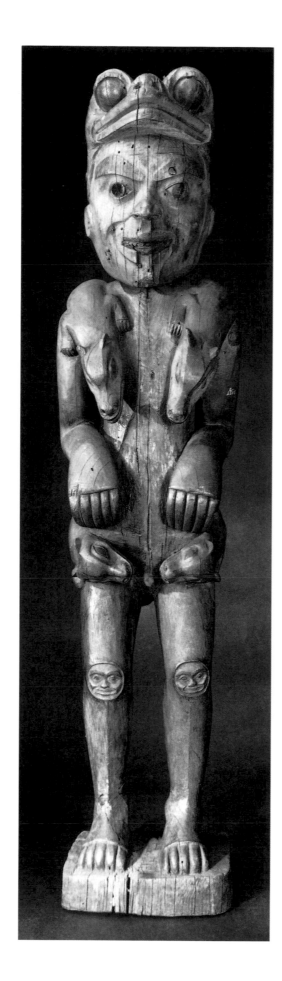

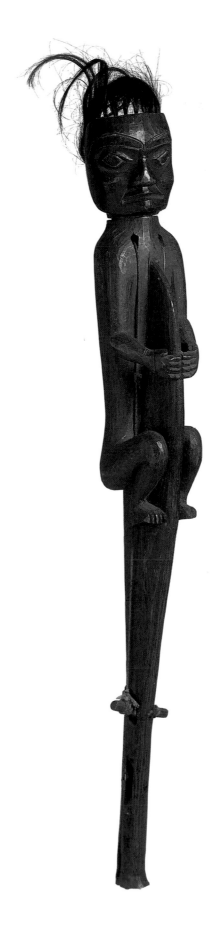

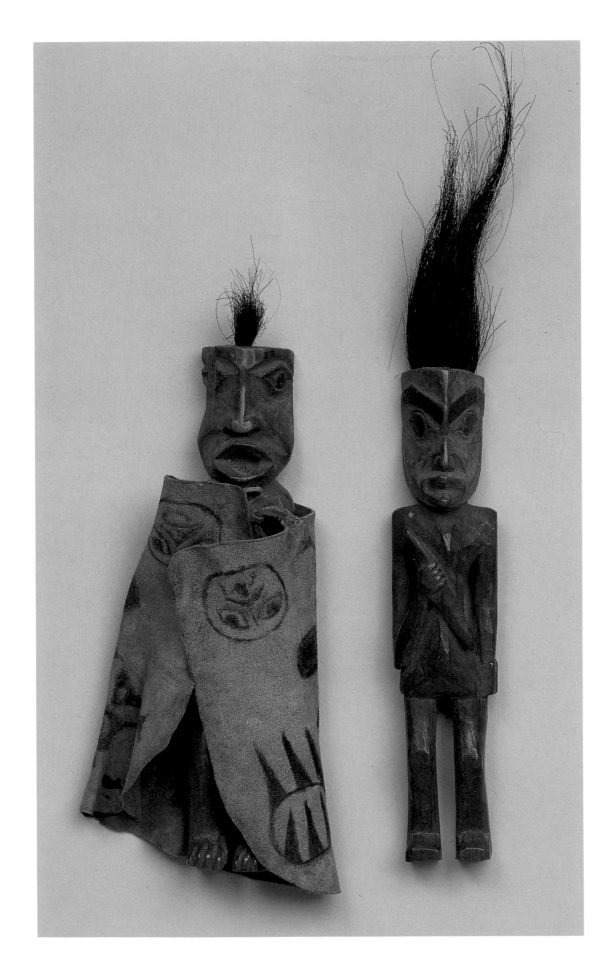

No. 472. *Two Tlingit Figures* (left). Although there are no collection data connecting these figures to shamans, they were undoubtedly used to represent the shamans themselves or their spirit helpers. Collected by Lieutenant T. Dix Bolles. Wood, animal skin, human hair, and red, black, and blue pigment; height 5⅞ and 6 inches (figures only); c. 1840–60. National Museum of Natural History, Smithsonian Institution, Washington, D.C., 73836/7. Given by Bolles, 1885

No. 473. *Tlingit Figure* (opposite, left). Emmons (n.d., Notes, NMAI) describes this as a guardian figure from a headdress that was owned by a Sitka shaman. Collected by him, with nos. 152 and 165, at Sitka. Wood, human hair, abalone, and red, black, and blue pigment; height 5½ inches (figure only); c. 1850–70. National Museum of the American Indian, Smithsonian Institution, Washington, D.C., 9/7890. Purchased from Emmons, 1920

No. 474. *Tsimshian Figure* (opposite, right). Because the back of the head is cut away, it has been suggested that this figure is wearing a mask (Musée de l'Homme, 1969, no. 91). The long hair indicates the depiction of a shaman. Collected by William A. Newcombe at Lakalzap (Greenville), 1905. Wood, human hair, cedar bark, and red and black pigment; height 9½ inches; c. 1840–60. Canadian Museum of Civilization, Ottawa, VII–C–176. Purchased from Newcombe, 1909

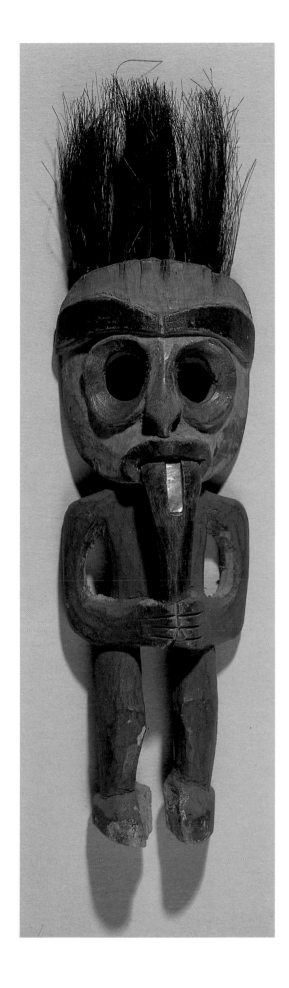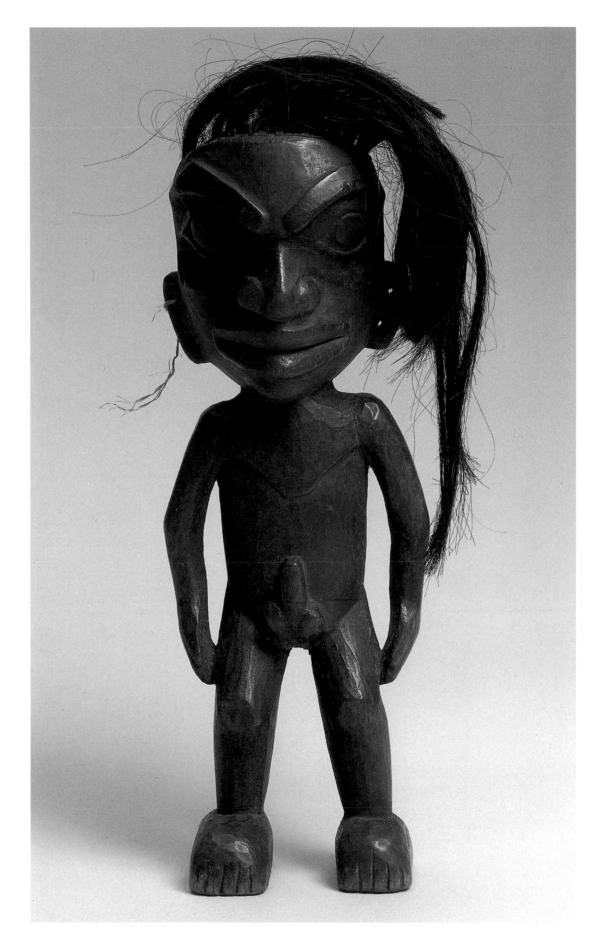

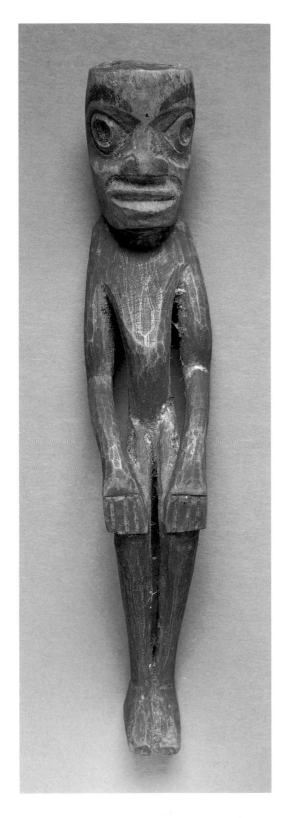

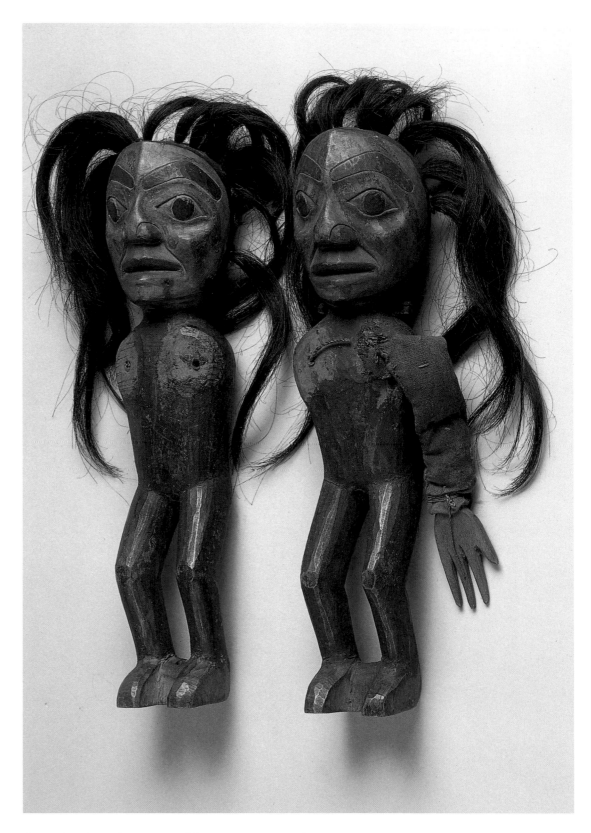

No. 475. Tlingit Figure. Probably a guardian figure from a shaman's headdress. Collected by Captain Edward G. Fast at Sitka, 1867–68. Wood and red, black, and blue-green pigment; height 6 inches; c. 1840–60. Peabody Museum of Archaeology and Ethnology, Harvard University, Cambridge, 69–30–10/1687. Purchased from Fast, 1869

No. 476. Pair of Tsimshian Figures of Shamans. Emmons (n.d., Notes, NMAI) states that both of these figures were carried during dances, one in each hand. Although he gives no indication of shamanic use, the long hair suggests that shamans are represented; the figures were probably puppets, although all but one of the articulated arms are now missing. Collected by Emmons at Aiyansh. Wood, cloth, human hair, and red, black, and blue-green pigment; height 10½ and 10⅞ inches (figures only); c. 1840–60. National Museum of the American Indian, Smithsonian Institution, Washington, D.C., 1/4170. Purchased from Emmons, 1907

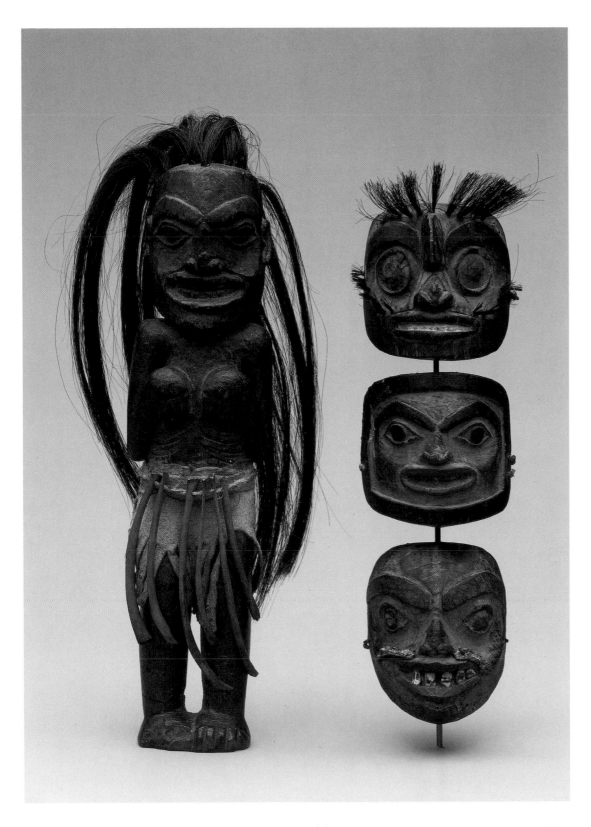

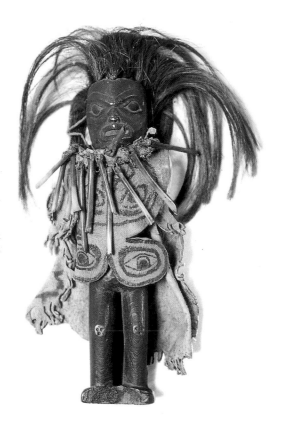

No. 477. Tlingit Figure of a Shaman with Three Miniature Masks. The masks probably are small replicas of those that were used by the shaman owner. Collected by Alton L. Dickerman at Sitka, 1885. Wood, animal hide, bone, human hair, and red, black, and blue pigment; height 7½ inches (figure only); c. 1840–60. Former collection: Colorado Springs Fine Arts Center, 4910. The Eugene V. and Clare E. Thaw Collection, Fenimore House Museum, Cooperstown, New York

No. 478. Tlingit Figure of a Shaman. The long hair, bone necklace, and painted tunic indicate the representation of a shaman. Though said by Emmons (n.d.) to have been given to boys as a toy, it was most probably part of a shaman's kit, and was originally accompanied by a set of miniature masks. Collected by Emmons, 1882–87. Wood, human hair, bird bone, animal hide, and red and black pigment; height 7 inches (figure only); c. 1840–60. American Museum of Natural History, New York, 19/258. Purchased from Emmons, 1888

No. 479. *Tsimshian Puppet* (below). Barbeau (1958, p. 55, no. 67) describes this as a "shaman's statuette." Wood, animal hide, sinew, and human hair; height 20½ inches; c. 1850–70. Former collection: The Reverend George H. Raley. Centennial Museum, Vancouver, AA 675

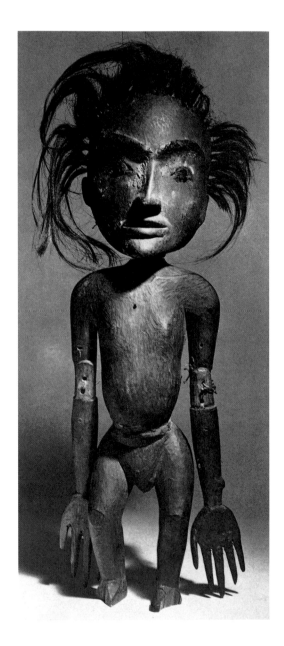

No. 480. *Tlingit Figure* (right). Holm (Vaughan and Holm, 1982, p. 162, no. 137) notes that Captain Edward G. Fast, who collected the figure at Sitka in 1867–68, referred to this as an idol, and suggests that it may have been attached to a shaman's regalia. Wood and red and black pigment; height 5⅞ inches; c. 1840–60. Peabody Museum of Archaeology and Ethnology, Harvard University, Cambridge, 69–30–10/1670. Purchased from Fast, 1869

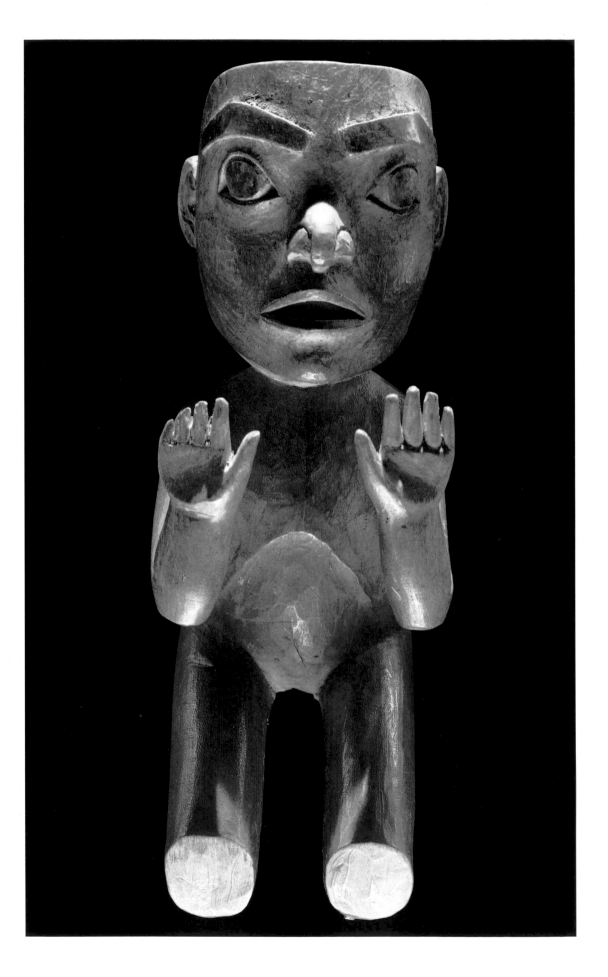

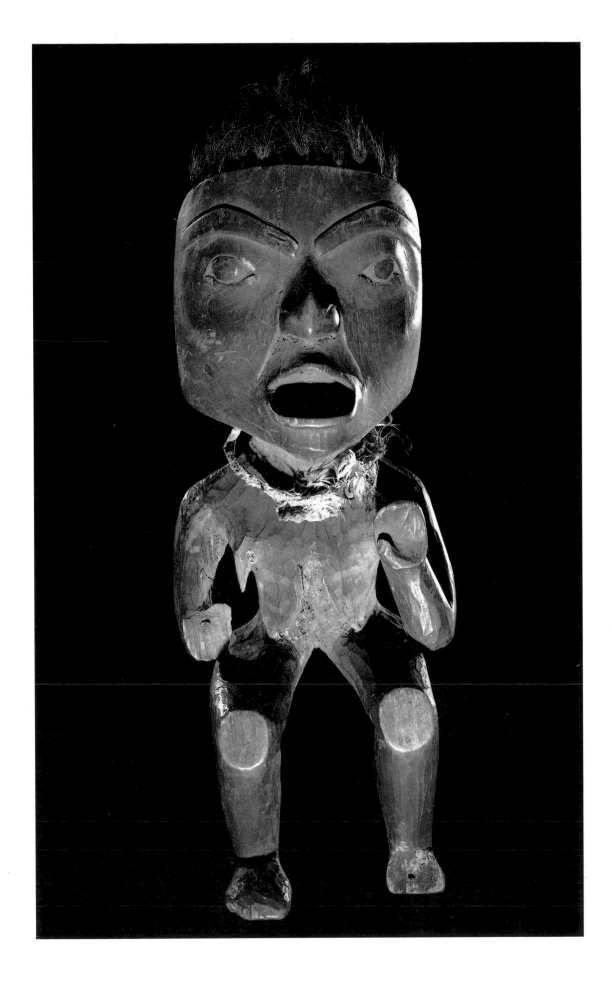

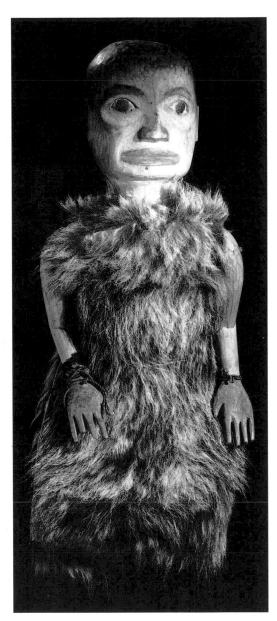

No. 481. *Tsimshian Figure* (left). The labret indicates that a woman is represented. Museum records speculate that this figure was part of the paraphernalia of a shaman named Skedin's. Collected by Charles F. Newcombe at Gitlakdamiks, 1913. Wood, human hair, feathers, bird skin, cedar bark, and red pigment; height 11½ inches; c. 1840–60. Royal British Columbia Museum, Victoria, 1566. Purchased from Newcombe, 1913

No. 482. *Tsimshian Puppet* (above). Tsimshian shamans probably used articulated puppets such as this to re-enact their exploits or to represent their spirit helpers. Collected by Charles F. Newcombe from J. Priestley at Aiyansh. Wood, bearskin, cedar bark, animal hide, and black and red pigment; height 14¾ inches; c. 1850–70. Royal British Columbia Museum, Victoria, 9693. Purchased from Newcombe, 1917

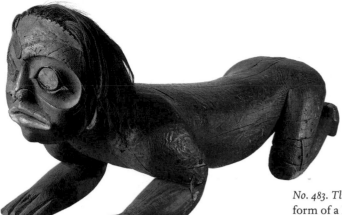

No. 483. Tlingit Canoe Prow. This figurehead in the form of a land otter man decorated the canoe of Jinsatiyi, a Tlingit warrior of the Silver Salmon clan of Sitka. The emblem and the canoe it decorated were given to him to honor his brave deeds (see Collins et al., 1973, p. 231, no. 287; Lovejoy, 1984, pp. 93–98). Collected by Louis Shotridge from the Eagles' Nest House at Sitka, 1918. Wood, abalone, human hair, metal, and black, red, and green pigment; length 39 inches; c. 1840–60. The University Museum, University of Pennsylvania, Philadelphia, NA 8500

No. 484. Tlingit Figure. Emmons (n.d.) states that this figure was held to the fire and, when heated, applied by a shaman to the afflicted parts of a patient to effect a cure. Collected by Emmons from a shaman's grave house at Shakan, 1882–87. Wood, human hair, twine, and red, black, and blue pigment; length 9¼ inches; c. 1840–60. American Museum of Natural History, New York, 19/334. Purchased from Emmons, 1888

No. 485. Tlingit Figure. A figure, perhaps a shaman, reclines on the back of a land otter. A small spirit figure emerges from the abdomen. There are no collection data, but because of the presence of the otter, the figure is assumed to be shamanic. Its use is uncertain, but it is comparable to a Tlingit object described as a "rattle panel" (Sotheby's, 1990, no. 322) that shows a figure on the backs of two otters placed back to back. Wood, abalone, and red and black pigment; length 14½ inches; c. 1860–80. Milwaukee Public Museum, 52825. Accessioned 1943

No. 486. Tlingit Canoe Prow. (below) This figurehead represents the transformation of a human into a land otter man (see Collins et al., 1973, p. 234, no. 290). Canoe prows showing land otter men were sometimes used as crest symbols by the Tlingit, Haida, and Tsimshian to honor an individual's nimbleness and exploits as a human, rather than referring to the supernatural qualities of the animal as used in shamanic art (see Lovejoy, 1984, pp. 93–98). Several examples are included here to illustrate a non-shamanic aspect of the land otter man (see nos. 483, 487). Collected by the Alaska Commercial Company before 1898. Wood, human hair, fox skin, metal, glass, foil, and red, black, and green pigment; height 33⅞ inches; c. 1860–80. Lowie Museum of Anthropology, University of California at Berkeley, 2–4814

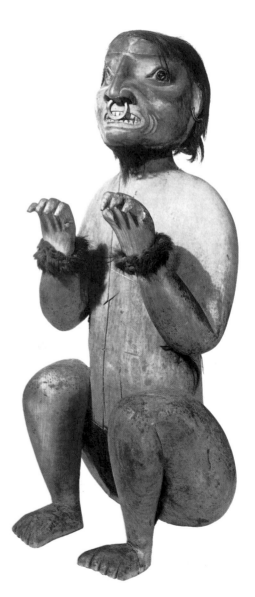

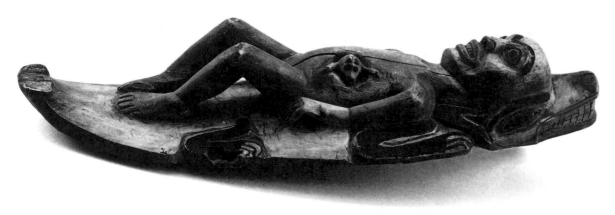

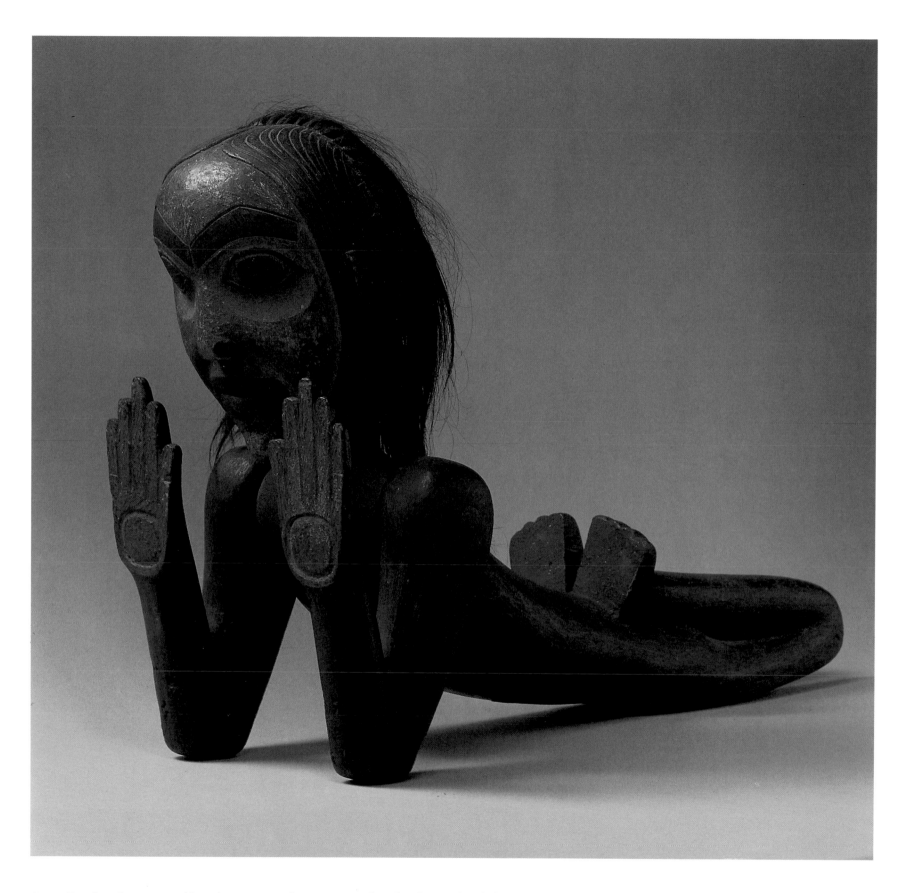

No. 487. Tsimshian Canoe Prow. Although Emmons (n.d., Notes, NMAI) describes this as a female figure, it most likely represents a land otter man. Collected by the Commissioner of Indian Affairs of British Columbia on the Nass River, 1870. Wood, human hair, and red, black, and yellow pigment; length 24 inches; c. 1840–60. National Museum of the American Indian, Smithsonian Institution, Washington, D.C., 3/5010. Purchased from Emmons, 1914

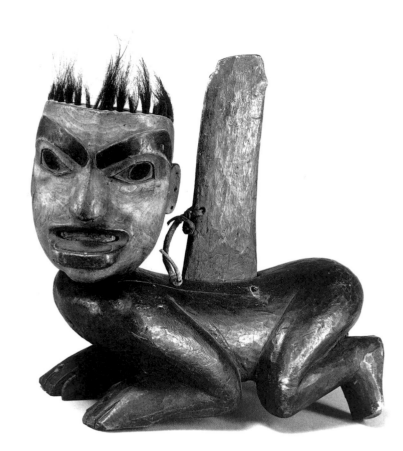

No. 488. *Tlingit Figure.* This figure is related to the water spirits represented by nos. 489 and 490; the labret indicates the depiction of a woman. Traditionally attributed to the Haida. Wood, human hair, rawhide, and red and black pigment; length 11 inches; c. 1840–60. Denver Art Museum, 1935.568ab. Acquired from the Northwest Coast exhibit at the World's Columbian Exposition, Chicago, 1893

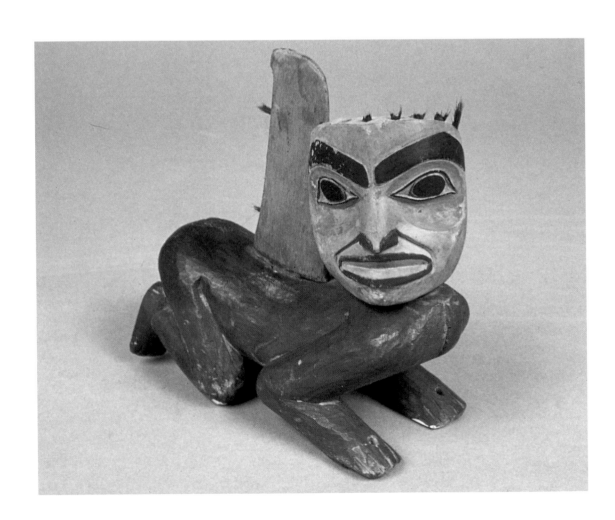

No. 489. *Tlingit Costume Ornament.* One of six figures representing water spirits which decorated a shaman's costume. Collected by Emmons in 1884–93 from the grave house of a Henya shaman near Shakan. Wood and red and black pigment; length 7 inches; c. 1840–60. Former collection: American Museum of Natural History, New York, E 1583. Thomas Burke Memorial, Washington State Museum, Seattle, 2327. Acquired by exchange, 1905

No. 490. *Tlingit Costume Ornaments.* There were origi-
nally nine squatting figures in this set. According
to Emmons (n.d.), they were attached to a skin robe
and represent mythical water spirits. The reclining
figure depicts the first man who saw the spirits. Col-
lected by Emmons in 1884–93 from the grave house
of a Henya shaman at Klawock. Wood, human hair,
and red, orange, black, and blue pigment; height
of standing figure 15½ inches; c. 1840–60. American
Museum of Natural History, New York, E 1584. Pur-
chased from Emmons, 1893

No. 491. *Tlingit Guardian Figure.* Emmons (n.d.) states
that this carving was placed over the door of a sha-
man's dwelling to ward off evil spirits and sickness.
He was told that it represented a whale or a seal,
and suggests that it was inspired by a dream. Boas
(1927, p. 199, fig. 183) identifies it as a sea monster.
Collected by Emmons, 1882–87. Wood, metal, oper-
cula, and red, black, and traces of blue-green pigment;
length 13⅛ inches; c. 1840–60. American Museum
of Natural History, New York, 19/377. Purchased
from Emmons, 1888

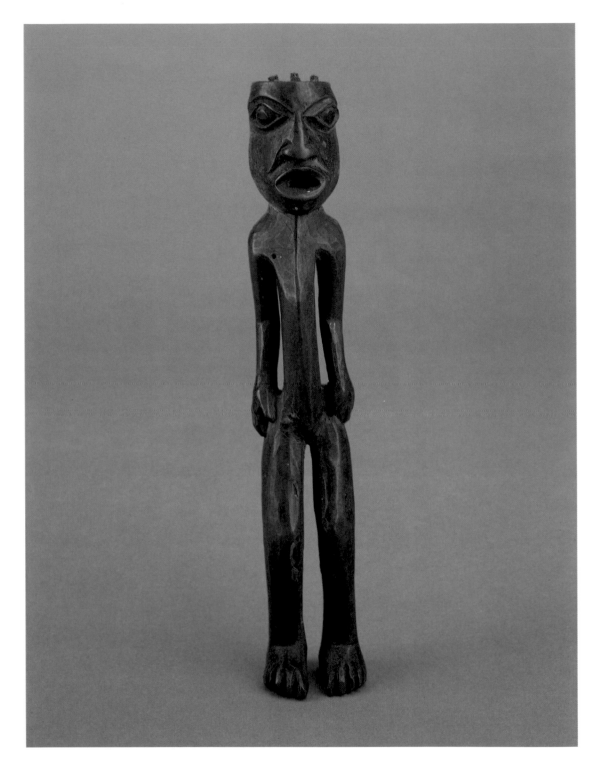

No. 492. *Tlingit Figure.* Emmons (n.d., Notes) writes that this represents a "spirit man" and was worn around the neck by an old Chilkat shaman. Wood and human hair; height 3½ inches; c. 1840–60. Field Museum of Natural History, Chicago, 78226. The Carl Spuhn Collection. Purchased from Emmons, 1902

No. 493. *Tlingit Figure of a Shaman.* Emmons (n.d., Notes) describes this as a headdress ornament of a shaman "in the act of singing a spirit song." Collected from the Chilkat at Lynn Canal. Wood and red and black pigment; height 6¼ inches; c. 1840–60. Field Museum of Natural History, Chicago, 78148. The Carl Spuhn Collection. Purchased from Emmons, 1902

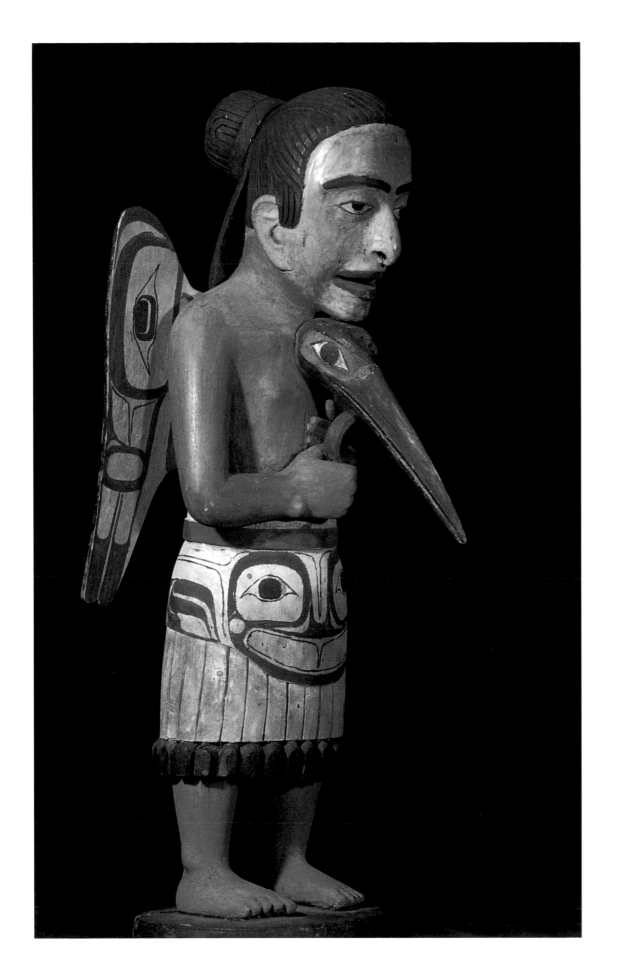

No. 494. *Haida Figure of a Shaman*. Carved by Charles Gwaytihl or Simeon Stilthda of Masset (see nos. 31, 63, 64). The figure was probably made for sale and not for ceremonial purposes. As suggested by Blackman (1990, p. 251, fig. 12e), transformation is represented by showing the bird form emerging from the back and front of the shaman. Collected by Israel W. Powell, 1881. Wood and black, red, orange, yellow, and blue pigment; height 20⅛ inches; c. 1870–80. American Museum of Natural History, New York, 16/397. Heber R. Bishop Collection

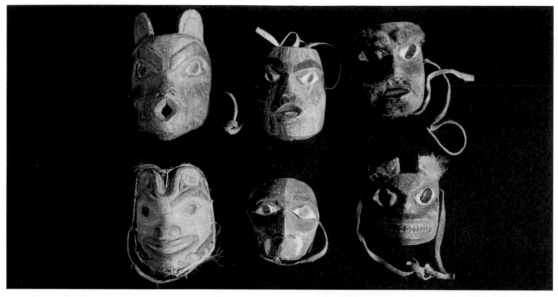

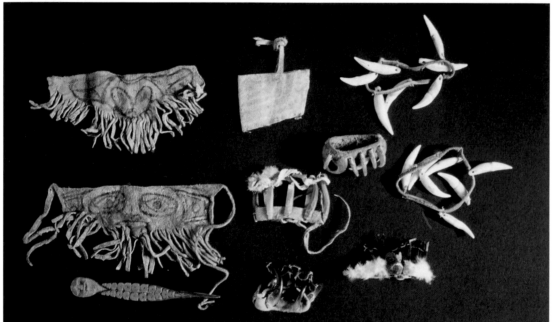

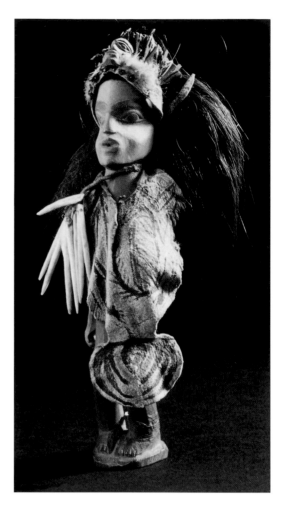

No. 495. Tlingit Figure of a Shaman with a Box and Paraphernalia. The figure, perhaps singing, is wearing a maskette headdress, a skin tunic, and a bone necklace. The painted box contains six masks, a headdress with a maskette, three crowns, two bone necklaces, a hat, a staff in the form of a devilfish, an animal skin tunic, two animal skin aprons, a "shield like object," and a bag (Haberland, 1979, p. 58, no. A–16). Collected by Dr. Beraz, c. 1870. Wood, human hair, brass tacks, animal skin, down, bone, cedar bark, and black, white, red, and blue-green pigment; height approximately 6 inches (figure only); c. 1840–60. Staatliches Museum für Völkerkunde, Munich, 91.142a–k

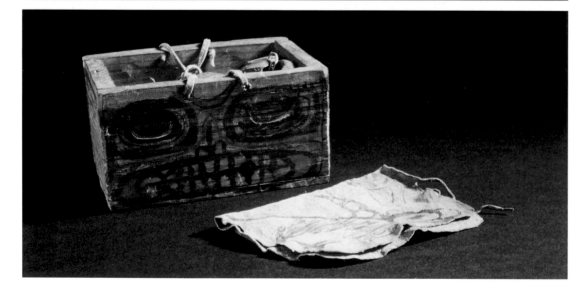

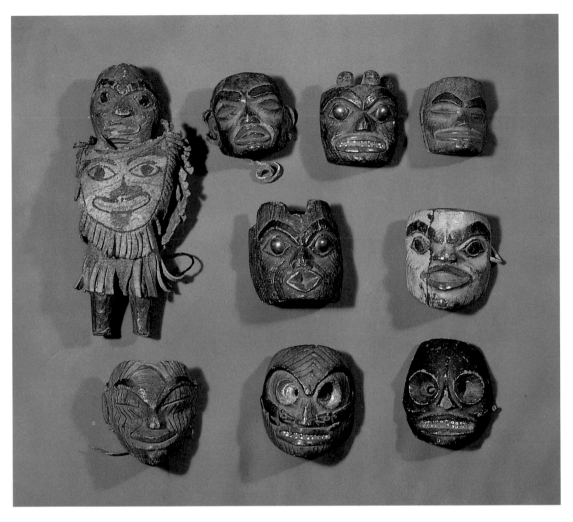

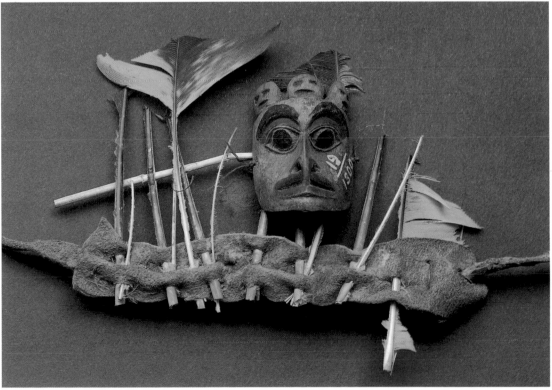

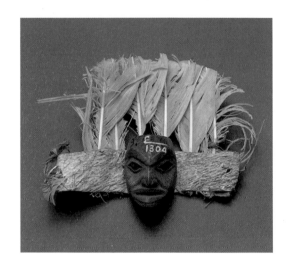

No. 496. Tlingit Figure of a Shaman with Eight Miniature Masks (left). The most powerful shamans acquired eight spirit helpers, which were often represented in their kits by masks that were worn during séances to provide specific types of assistance. Jonaitis (1981a) has analyzed eight such masks from the paraphernalia of a Dry Bay shaman which are now in the Field Museum of Natural History, Chicago. The miniature masks with this figure are probably replicas of full-size masks in the possession of their shaman owner. A number of the miniatures show trance expressions, one is in the form of a death head (see no. 158), and another depicts land otters extracting the secrets of a dead person through its nose (see nos. 41, 114, 115). The figure, accompanied by the appropriate mask, may have been left with the patient a shaman was attempting to cure after he had completed his ceremony. Wood, brass tacks, shell, beads, animal skin, and red, black, and blue-green pigment; height 6⅛ inches (figure only); c. 1830–50. Peabody Essex Institute, Salem, E 36643. Purchased 1958

No. 497. Tlingit Miniature Headdress (above). This headdress originally accompanied a figure (see no. 495). Collected by Emmons, 1882–87. Wood, feathers, bird skin, and red, black, and blue-green pigment; height 2¼ inches; c. 1840–60. American Museum of Natural History, New York, 19 /1304. Purchased from Emmons, 1888

No. 498. Tlingit Miniature Headdress (left). Collected by Emmons, 1882–87. Wood, animal skin, quills, feathers, and red, black, and blue green pigment; height 2¾ inches; c. 1840–60. American Museum of Natural History, New York, 19/1300. Purchased from Emmons, 1888

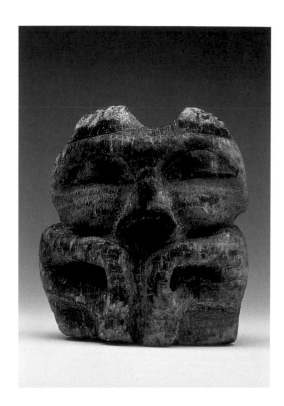

No. 499. *Tlingit Guardian Figure.* Emmons (n.d.) describes the placement of this and several similar tree fungus figures at the head of the body in a shaman's grave house as protection against hostile spirits. He notes that this example is wearing a protective fighting headdress. According to Healey (1993, p. 19), such carved fungi also served to alert the Tlingit to the sacred nature of the burial site. Fourteen examples in various collections are known. Collected by Emmons, 1888–93. Tree fungus and black pigment; height 7⅜ inches; c. 1840–60. American Museum of Natural History, New York, E 1044. Purchased from Emmons, 1893

SALMON BOY
(Tlingit)

There was a Kik-sa-de whose hunting and fishing ground included the head of Nakwasina Bay, Ta khate, where he had a summer house and took and cured his winter supply of salmon.

He had a little boy, who, one day, came to the mother for something to eat. She cut off a piece of dried mouldy salmon and gave it to him. But he threw it away, which angered the Salmon People so that they determined to punish him. Since he never went near the water, they were powerless, until they conspired with the Sea Gull that walked along the shore, eating salmon eggs. He made a snare of the membrane of the spawn and watched the little boy until he stepped into the loop. Then the Sea Gull took the leader in his bill and dragged him into the water. Then the Salmon took him and carried him away to their country, far out to sea.

The following spring, when the sun's heat was felt in the waters, the Salmon People got their canoes ready and set out for their favorite streams. With them was the boy who had now been transformed into a silver salmon, and he was sent up the stream where he had been taken. The mother standing by the water, grieving for her lost son, for whom a death feast had already been given, saw in the clear water at her feet a beautiful salmon, motionless in the pool. She called to her husband who, with his gaff, quickly took the fish and gave it to her to cut up. When she attempted to sever the head with her blue mussel shell knife, she found a copper neck ring which she recognized as the one she had fastened about the neck of her lost son. She called her husband who said, "Yes, our son has been turned into a salmon."

He wrapped the salmon in a cedar-bark mat and laid it away in the outhouse. Returning to their fire, the father and mother seated themselves with heads bowed and buried in their blankets. When night came, the people were aroused by a low "Ah-ah-ah-ah," such as a shaman sounds when practicing. They traced the sound to the bundle in the outhouse. Upon opening it, they saw that the salmon had disappeared. In its place lay a tiny child which grew larger and larger and by morning had become a man with long hair like a shaman. He said that the Salmon People had sent him back as their shaman and named him in their language Ah-ko-tarts, heene "Alive or moving at the bottom of a little lake" or "Frog swimming in a lake."

Calling upon four young men of his family [clan], he went with them to the mountain lake above the waterfall, where they built a sea lion canoe of branches. They embarked in it and floated down to the waterfall. They dove under it and were finally stranded on a rock at the mouth of the stream which is known as Sea Lion Rock, Tawn each. By this act, he established himself as a powerful shaman.

I saw his remains in 1888, when [where] they had been laid on a bed of devil's club stems under a cavelike overhanging rock on the southern shore of Nakwasina Bay. At his side were a bow and two arrows, a rattle, several masks, wands, and charms, all more or less decayed. (Emmons, 1991, p. 388)

Fig. 40. Haida Shaman's Grave Guardians on a Small Point Near Masset (opposite right). Photograph by Charles F. Newcombe, 1899. Field Museum of Natural History, Chicago, 16329

BIBLIOGRAPHY

ABBOTT, 1981
Donald Abbott, ed. *The World as Sharp as a Knife: An Anthology in Honor of Wilson Duff*. Victoria: British Columbia Provincial Museum, 1981.

ADAM, 1936
Leonhard Adam. "North-West American Indian Art and Its Early Chinese Parallels." *Man*, vol. 36 (January 1936), article no. 3, pp. 8–11.

AMOSS, 1984
Pamela Amoss. "A Little More Than Kin, and Less Than Kind: The Ambiguous Northwest Coast Dog." In Miller and Eastman, 1984, pp. 292–305.

ARTSCANADA, 1973–74
"Stone, Bones and Skin: Ritual and Shamanic Art." *Artscanada*, 30th Anniversary Issue, vols. 184–87 (December 1973–January 1974), pp. 31–189.

ARUTIUNOV AND FITZHUGH, 1988
Sergei A. Arutiunov and William W. Fitzhugh. "Prehistory of Siberia and the Bering Sea." In Fitzhugh and Crowell, 1988, pp. 117 29.

BARBEAU, 1953
Marius Barbeau. *Haida Myths Illustrated in Argillite Carvings*. National Museum of Canada Bulletin, no. 127. Anthropological Series, no. 32. Ottawa: National Museum of Canada, 1953.

BARBEAU, 1957
——. *Haida Carvers in Argillite*. National Museum of Canada Bulletin, no. 139. Anthropological Series, no. 38. Ottawa: National Museum of Canada, 1957.

BARBEAU, 1958
——. *Medicine-Men of the North Pacific Coast*. National Museum of Canada Bulletin, no. 152. Anthropological Series, no. 42. Ottawa: Department of Northern Affairs and National Resources, 1958.

BARBEAU, N.D.
——. Collection Notes. Ethnological Department. Canadian Museum of Civilization, Ottawa, n.d.

BENEDICT, 1923
Ruth Fulton Benedict. *The Concept of the Guardian Spirit in North America*. Memoirs of the American Anthropological Association, no. 29. Menasha, Wisconsin: American Anthropological Association, 1923.

BLACKMAN, 1990
Margaret B. Blackman. "Haida: Traditional Culture." In Sturtevant, 1990, pp. 240–60.

BOAS, 1898
Franz Boas. "The Mythology of the Bella Coola Indians." In *Publications of the Jesup North Pacific Expedition*, edited by Franz Boas. Memoirs of the American Museum of Natural History, vol. 2, pt. 1, pp. 25–127. New York: Trustees of the American Museum of Natural History, 1898.

BOAS, 1916
——. "Tsimshian Mythology." *Thirty-First Annual Report of the Bureau of American Ethnology . . . 1909–1910*, pp. 27–1037. Washington, D.C.: Government Printing Office, 1916.

BOAS, 1927
——. *Primitive Art*. Institutet for Sammenlignende Kulturforskning, ser. B, no. 8. Oslo: H. Aschehoug and Co. (W. Nygaard), 1927.

BOAS, 1930
——. *The Religion of the Kwakiutl Indians*. Pt. 2, *Translations*. Columbia University Contributions to Anthropology, vol. 10, 1930. Reprint, New York: AMS Press, 1969.

BOAS, 1935
——. *Kwakiutl Culture as Reflected in Mythology*. Memoirs of the American Folk-Lore Society, vol. 27. New York: The American Folk-Lore Society, 1935.

BOAS, 1966
——. *Kwakiutl Ethnography*. Edited by Helen Codere. Chicago: The University of Chicago Press, 1966.

BOAS, N.D.
——. Catalogue of the Heber R. Bishop Collection. Department of Anthropology, American Museum of Natural History, New York, n.d.

BOAS AND EMMONS, 1907
Franz Boas and George T. Emmons. "The Chilkat Blanket: With Notes on the Blanket Design by Franz Boas." In Memoirs of the American Museum of Natural History, vol. 3, pt. 4, pp. 329–401. New York: Trustees of the American Museum of Natural History, 1907.

BORDEN, 1983
Charles E. Borden. "Prehistoric Art of the Lower Fraser Region." In Carlson, 1983a, pp. 131–65.

BRODZKY, 1973–74
Anne Trueblood Brodzky. "Editorial: A Thirtieth Anniversary Message." In *Artscanada*, 1973–74, p. 31.

BROWN, 1987
Steve Brown. "From Taquan to Klukwan: Tracing the Work of an Early Tlingit Master Artist." In Corey, 1987, pp. 157–75.

CAMPBELL, 1983
Joseph Campbell. *Historical Atlas of World Mythology*. Vol. 1, *The Way of the Animal Powers*. New York: Alfred van der Marck Editions, 1983.

CARLSON, 1983a
Roy L. Carlson, ed. *Indian Art Traditions of the Northwest Coast*. Burnaby, British Columbia: Simon Fraser University, Archaeology Press, 1983.

CARLSON, 1983b
——. "Change and Continuity in Northwest Coast Art." In Carlson, 1983a, pp. 197–205.

CARLSON, 1983c
——. "Prehistoric Art of the Central Coast of British Columbia." In Carlson, 1983a, pp. 121–29.

CARLSON, 1983d
——. "Prehistory of the Northwest Coast." In Carlson, 1983a, pp. 13–32.

CHRISTIE'S, 1976
Christie's, Manson and Woods Ltd., London. *American Indian Art from the James Hooper Collection*. Sale, November 9, 1976.

CINCINNATI ART MUSEUM, 1976
Cincinnati Art Museum. *Art of the First Americans from the Collection of the Cincinnati Art Museum*. Cincinnati: Cincinnati Art Museum, 1976.

CLARK, 1971
Ian C. Clark. *Indian and Eskimo Art of Canada*. Toronto: The Ryerson Press, 1971.

CODERE, 1990
Helen Codere. "Kwakiutl: Traditional Culture." In Sturtevant, 1990, pp. 359–77.

COLE, 1985
Douglas Cole. *Captured Heritage: The Scramble for Northwest Coast Artifacts*. Vancouver: Douglas and McIntyre, 1985.

COLLINS ET AL., 1973
Henry B. Collins, Frederica de Laguna, Edmund Carpenter, and Peter Stone. *The Far North: 200 Years of American Eskimo and Indian Art*. Washington, D.C.: National Gallery of Art, 1973. Exhibition (traveling),

National Gallery of Art, Washington, D.C., March 7–May 15, 1973; Anchorage Historical and Fine Arts Museum, June 10–September 9, 1973; Portland (Oregon) Art Museum, September 23–November 18, 1973; Amon Carter Museum of Western Art, Fort Worth, December 6, 1973–February 3, 1974.

COLLISON, 1915
W. H. Collison. *In the Wake of the War Canoe: A Stirring Record of Five Years' Successful Labour, Peril & Adventure Amongst the Savage Indian Tribes of the Pacific Coast, and the Piratical Head-Hunting Haidas of the Queen Charlotte Islands, B.C.* New York: E. P. Dutton and Company, 1915.

CONN, 1979
Richard Conn. *Native American Art in the Denver Art Museum.* Denver: Denver Art Museum, 1979.

COOK, 1784
James Cook. *A Voyage to the Pacific Ocean, Undertaken by James Cook in the Command of His Majesty for Making Discoveries in the Northern Hemisphere.* 3 vols. Dublin: Lords Commissioners of the Admiralty, H. Chamberlaine et al., 1784.

COREY, 1987
Peter Corey, ed. *Faces, Voices and Dreams: A Celebration of the Centennial of the Sheldon Jackson Museum.* Juneau: Division of Alaska State Museums, 1987.

CROWELL, 1988
Aron Crowell. "Prehistory of Alaska's Pacific Coast." In Fitzhugh and Crowell, 1988, pp. 130–40.

DAUGHERTY AND FRIEDMAN, 1983
Richard Daugherty and Janet Friedman. "An Introduction to Ozette Art. " In Carlson, 1983a, pp. 183–95.

DAVIS, 1949
Robert Tyler Davis. *Native Arts of the Pacific Northwest from the Rasmussen Collection of the Portland Art Museum.* Stanford: Stanford University Press, 1949.

DE LAGUNA, 1954
Frederica de Laguna. "Tlingit Ideas about the Individual." *Southwestern Journal of Anthropology*, vol. 10, no. 2 (Summer 1954), pp. 172–91.

DE LAGUNA, 1972
——. *Under Mount Saint Elias: The History and Culture of the Yakutat Tlingit.* Smithsonian Contributions to Anthropology, vol. 7 (in 3 pts.). Washington, D.C.: Smithsonian Institution Press, 1972.

DE LAGUNA, 1988a
——. "Potlatch Ceremonialism on the Northwest Coast." In Fitzhugh and Crowell, 1988, pp. 271–80.

DE LAGUNA, 1988b
——. "Tlingit: People of the Wolf and Raven." In Fitzhugh and Crowell, 1988, pp. 58–63.

DIXON, 1908
Roland B. Dixon. "Some Aspects of the American Shamans." *Journal of American Folklore*, vol. 21 (1908), pp. 1–12.

DOCKSTADER, 1960
Frederick F. Dockstader. *Indian Art in America.* Greenwich, Connecticut: The New York Graphic Society, 1960.

DRUCKER, 1940
Philip Drucker. "Kwakiutl Dancing Societies." *University of California Anthropological Records*, vol. 2, no. 6 (1940), pp. 201–30.

DRUCKER, 1955
——. *Indians of the Northwest Coast.* Anthropological Handbook, American Museum of Natural History, no. 10. New York: McGraw-Hill, 1955.

DUFF, 1956
Wilson Duff. *Prehistoric Stone Sculpture of the Fraser River and the Gulf of Georgia.* Anthropology in British Columbia, no. 5. Victoria: British Columbia Provincial Museum, 1956.

DUFF, 1975
——. *Images: Stone: B.C. Thirty Centuries of Northwest Coast Indian Sculpture.* Seattle: University of Washington Press, 1975. Exhibition (traveling), Art Gallery of Greater Victoria, British Columbia March 4–April 13, 1975; Vancouver Art Gallery, May 7–June 4, 1975; Royal Ontario Museum, Toronto, June 23–August 24, 1975; National Museum of Man, Ottawa, November 15, 1975–January 11, 1976; Winnipeg Art Gallery, January 27–March 7, 1976.

DUFF, 1981
——. "The World as Sharp as a Knife: Meaning in Northern Northwest Coast Art." In Abbott, 1981, pp. 209–24.

DUFF, HOLM, AND REID, 1967
Wilson Duff, Bill Holm, and Bill Reid. *Arts of the Raven: Masterworks by the Northwest Coast Indian.* Vancouver: Vancouver Art Gallery, 1967. Exhibition, Vancouver Art Gallery, June 15–September 24, 1967.

EDSMAN, 1967
Carl-Martin Edsman. *Studies in Shamanism: Based on Papers Read at the Symposium of Shamanism, Held at Abo on the 6th–8th of September, 1962.* Stockholm: Almqvist and Wiksell, 1967.

ELIADE, 1964
Mircea Eliade. *Shamanism: Archaic Techniques of Ecstasy.* Translated by Willard R. Trask. Bollingen Series, no. 76. New York: Bollingen Foundation, 1964.

EMMONS, 1903
George T. Emmons. *The Basketry of the Tlingit.* Memoirs of the American Museum of Natural History, whole ser., vol. 3, no. 2. New York: The Knickerbocker Press, 1903.

EMMONS, 1908
——. "The Use of the Chilkat Blanket." *American Museum of Natural History Journal*, vol. 8, no. 5 (1908), pp. 65–72.

EMMONS, 1991
——. *The Tlingit Indians.* Edited by Frederica de Laguna. Seattle: University of Washington Press, 1991.

EMMONS, N.D.
——. Collection Notes. Department of Anthropology, American Museum of Natural History, New York, n.d.

EMMONS, N.D., NOTES
——. Collection Notes. Field Museum of Natural History, Chicago, n.d.

EMMONS, N.D., NOTES, NMAI
——. Collection Notes. National Museum of the American Indian, Smithsonian Institution, Washington, D.C., n.d.

EMMONS AND MILES, 1939
George T. Emmons and G. P. Miles. "Shamanistic Charms." *Ethnologia Cranmoriensis*, vol. 4 (1939), pp. 31–35.

FEDER, 1971
Norman Feder. *Two Hundred Years of North American Indian Art.* New York: Praeger, 1971.

FEDER AND MALIN, 1962
Norman Feder and Edward Malin. "Indian Art of the Northwest Coast." *Denver Art Museum Quarterly*, Winter 1962 (entire issue).

FITZHUGH AND CROWELL, 1988
William Fitzhugh and Aron Crowell, eds. *Crossroads of Continents.* Washington, D.C.: Smithsonian Institution Press, 1988.

FLADMARK, 1986
Knut R. Fladmark. *British Columbia Prehistory.* Canadian Prehistory Series. Ottawa: National Museum of Man, National Museums of Canada, 1986.

FRASER, 1966
Douglas Fraser. *The Many Faces of Primitive Art.*
Englewood Cliffs, New Jersey: Prentice Hall, 1966.

FURST, 1973–74
Peter T. Furst. "The Roots and Continuities of Sha-
manism." In *Artscanada*, 1973–74, pp. 33–60.

FURST AND FURST, 1982
Peter T. Furst and Jill Leslie Furst. *North American
Indian Art.* New York: Rizzoli, 1982.

GARFIELD, 1951
Viola E. Garfield. "The Tsimshian and Their Neigh-
bors." In *The Tsimshian: Their Arts and Music*, by Viola
E. Garfield, Paul S. Wingert, and Marius Barbeau,
pp. 1–70. Publications of the American Ethnological
Society, no. 18. New York: American Ethnological
Society, 1951.

GOLDMAN, 1975
Irving Goldman. *The Mouth of Heaven: An Introduction
to Kwakiutl Religious Thought.* New York: John Wiley
and Sons, 1975.

GUÉDON, 1974
Marie-Françoise Guédon. "Chamanisme Tsimshian
et Athapaskan: Un Essai sur la définition des méth-
odes chamaniques" (in French with an English
abstract). In *Proceedings of the First Congress, Canadian
Ethnology Society*, edited by Jerome H. Barkow.
National Museum of Man, Mercury Series. Canadian
Ethnology Service Paper, no. 17, pp. 186–222. Ottawa:
National Museums of Canada, 1974.

GUÉDON, 1984a
——. "An Introduction to Tsimshian Worldview and
Its Practitioners." In Seguin, 1984, pp. 137–59.

GUÉDON, 1984b
——. "Tsimshian Shamanic Images." In Seguin, 1984,
pp. 174–211.

GUNN, 1966
Sisvan Gunn. "Totemic Medicine and Shamanism
among the Northwest Coast American Indians."
Journal of the American Medical Association, vol. 196,
no. 8 (1966), pp. 700–706.

GUNTHER, 1962
Erna Gunther. *Northwest Coast Indian Art.* Seattle: Cen-
tury 21 Exposition, Inc., 1962. Exhibition, Seattle
World's Fair, Fine Arts Pavilion, April 21–October
21, 1962.

GUNTHER, 1966
——. *Art in the Life of the Northwest Coast Indian.
With a Catalog of the Rasmussen Collection of North-
west Indian Art at the Portland Art Museum.* Portland,
Oregon: The Portland Art Museum, 1966.

GUNTHER, 1972
——. *Indian Life on the Northwest Coast of North
America As Seen by the Early Explorers and Fur Traders
During the Last Decades of the Eighteenth Century.*
Chicago: The University of Chicago Press, 1972.

HABERLAND, 1962
Wolfgang Haberland. *American Indian Art from the
Rietberg Museum.* Zurich: Rietberg Museum, 1962.

HABERLAND, 1979
——. *Donnervogel und Raubwal: Indianische Kunst der
Nordwestkuste Nordamericas.* Hamburg: Hamburgische
Museum für Völkerkunde und Christians Verlag, 1979.

HAEBERLIN, 1918
Herman K. Haeberlin. "Principles of Esthetic Form
in the Art of the North Pacific Coast: A Preliminary
Sketch." *American Anthropologist*, n.s., vol. 10, no. 3
(July–September 1918), pp. 258–64.

HALPIN, 1984
Marjorie M. Halpin. "'Seeing' in Stone: Tsimshian
Mask Making and the Twin Stone Masks." In Seguin,
1984, pp. 269–88.

HALPIN, 1988
——. "Review of *Art of the Northern Tlingit*, by Aldona
Jonaitis." *The Art Bulletin*, vol. 70, no. 3 (September
1988), pp. 534–35.

HARNER AND ELSASSER, 1965
Michael J. Harner and Albert B. Elsasser. *Art of the
Northwest Coast.* Berkeley: University of California
Press, 1965. Exhibition, Robert H. Lowie Museum
of Anthropology, The University of California at
Berkeley, March 26–October 17, 1965.

HAWTHORN, 1979
Audrey Hawthorn. *Kwakiutl Art.* Seattle: University
of Washington Press, 1979.

HEALEY, 1993
Jessica Healey. "Sacred Fungus." *Archaeology*, vol. 46,
no. 7 (September–October 1993), p. 19.

HILL AND HILL, 1974
Beth Hill and Ray Hill. *Indian Petroglyphs of the
Pacific Northwest.* Seattle: University of Washington
Press, 1974.

HOLM, 1965
Bill Holm. *Northwest Coast Indian Art: An Analysis of
Form.* Seattle: University of Washington Press, 1965.

HOLM, 1981
——. "Will the Real Charles Edensaw Please Stand
Up? The Problem of Attribution in Northwest
Coast Indian Art." In Abbott, 1981, pp. 175–200.

HOLM, 1983
——. *The Box of Daylight: Northwest Coast Indian Art.*
Seattle: Seattle Art Museum and the University
of Washington Press, 1983. Exhibition, Seattle Art
Museum, September 15, 1983–January 8, 1984.

HOLM, 1987a
——. "The Head Canoe." In Corey, 1987, pp. 143–55.

HOLM, 1987b
——. *Spirit and Ancestor: A Century of Northwest
Coast Indian Art at the Burke Museum.* Seattle: Thomas
Burke Memorial, Washington State Museum, and
the University of Washington Press, 1987.

HOLM, 1988
——. "Art and Culture Change at the Tlingit-Eskimo
Border." In Fitzhugh and Crowell, 1988, pp. 281–93.

HOLM, 1995
——. Personal communication, New York, 1995.

HOLM AND REID, 1975
Bill Holm and William Reid. *Form and Freedom:
A Dialogue on Northwest Coast Art.* Houston: Rice
University, 1975. Exhibition, Rice University, Insti-
tute for the Arts, Houston, 1975.

INVERARITY, 1950
Robert Bruce Inverarity. *Art of the Northwest Coast
Indians.* Berkeley: University of California Press, 1950.

JOHNSON, 1973
Ronald Johnson. *The Art of the Shaman.* Iowa City:
University of Iowa Museum of Art, 1973.

JONAITIS, 1978
Aldona Jonaitis. "Land Otters and Shamans: Some
Interpretations of Tlingit Charms." *American Indian
Art Magazine*, vol. 4, no. 1 (Winter 1978), pp. 62–66.

JONAITIS, 1980
——. "The Devilfish in Tlingit Sacred Art." *American
Indian Art Magazine*, vol. 5, no. 3 (Summer 1980),
pp. 42–47.

JONAITIS, 1981a
——. "Sacred Art and Spiritual Power: An Analysis
of Tlingit Shamans' Masks." In Matthews and Jonaitis,
1981, pp. 119–36.

JONAITIS, 1981b
——. *Tlingit Halibut Hooks: An Analysis of the Visual
Symbols of a Rite of Passage.* Anthropological Papers
of the American Museum of Natural History, vol. 57,
pt. 1. New York: American Museum of Natural
History, 1981.

JONAITIS, 1983
——. "Style and Meaning in the Shamanic Art of the Northern Northwest Coast." In Holm, 1983, pp. 129–31.

JONAITIS, 1986
——. *The Art of the Northern Tlingit*. Seattle: University of Washington Press, 1986.

JONAITIS, 1988
——. *From the Land of the Totem Poles: The Northwest Coast Indian Art Collection at the American Museum of Natural History*. New York: American Museum of Natural History, 1988.

KAPLAN AND BARSNESS, 1986
Susan A. Kaplan and Kristin J. Barsness. *Raven's Journey: The World of Alaska's Native People*. Philadelphia: The University Museum, 1986. Exhibition, The University Museum, University of Pennsylvania, Philadelphia, 1986.

KEITHAHN, 1945
Edward L. Keithahn. *Monuments in Cedar*. Ketchikan, Alaska: Roy Anderson, 1945.

KEITHAHN, 1963
——. *Monuments in Cedar*. Seattle: Superior Publishing Company, 1963.

KING, 1979
J.C.H. King. *Portrait Masks from the Northwest Coast of America*. London: Thames and Hudson, 1979.

KRAUSE, 1956
Aurel Krause. *The Tlingit Indians: Results of a Trip to the Northwest Coast of America and the Bering Straits* [text written in 1885]. Translated by Erna Gunther. Seattle: University of Washington Press, 1956.

LÉVI-STRAUSS, 1963
Claude Lévi-Strauss. "The Sorcerer and His Magic." In Claude Lévi-Strauss, *Structural Anthropology*, vol. 1, pp. 167–85. Translated by Claire Jacobsen and Brooke Grundfest Schoepf. New York: Basic Books, 1963.

LING ROTH, 1923
H. Ling Roth. "American Quillwork: A Possible Clue to Its Origin." *Man*, vol. 23 (August 1923), article no. 72, pp. 113–16.

LOMMEL, 1967
Andreas Lommel. *Shamanism: The Beginnings of Art*. New York: McGraw-Hill, 1967.

LOPATIN, 1945
Ivan A. Lopatin. *Social Life and Religion of the Indians in Kitimat, British Columbia*. The University of Southern California Social Science Series, no. 26. Los Angeles: University of Southern California Press, 1945.

LOVEJOY, 1984
James Lovejoy. "Tlingit Shaman Charms." Master's thesis, Department of Fine Arts, University of British Columbia, Vancouver, 1984.

LUNDY, 1983
Doris Lundy. "Styles of Coastal Rock Art." In Carlson, 1983a, pp. 89–97.

MACDONALD, 1983a
George F. MacDonald. *Haida Monumental Art: Villages of the Queen Charlotte Islands*. Vancouver: University of British Columbia Press, 1983.

MACDONALD, 1983b
——. "Prehistoric Art of the Northern Northwest Coast." In Carlson, 1983a, pp. 99–120.

MACNAIR ET AL., 1980
Peter L. Macnair, Alan L. Hoover, and Kevin Neary. *The Legacy: Continuing Traditions of Canadian Northwest Coast Indian Art*. Victoria: British Columbia Provincial Museum, 1980.

MALIN, 1978
Edward Malin. *A World of Faces: Masks of the Northwest Coast Indians*. Portland, Oregon: Timber Press, 1978.

MATTHEWS AND JONAITIS, 1981
Zena P. Matthews and Aldona Jonaitis, eds. *Native American Art History*. Palo Alto: Peek Publications, 1981.

MAURER, 1977
Evan M. Maurer. *The Native American Heritage: A Survey of North American Indian Art*. Chicago: The Art Institute of Chicago, 1977. Exhibition, The Art Institute of Chicago, July 16–October 30, 1977.

MILLER, 1984
Jay Miller. "Tsimshian Religion in Historical Perspective: Shamans, Prophets and Christ." In Miller and Eastman, 1984, pp. 137–47.

MILLER AND EASTMAN, 1984
Jay Miller and Carol M. Eastman, eds. *The Tsimshian and Their Neighbors of the North Pacific Coast*. Seattle: University of Washington Press, 1984.

MILLER AND MILLER, 1967
Polly Miller and Leon Gordon Miller. *Lost Heritage of Alaska*. New York: Bonanza Books, 1967.

MUSÉE DE L'HOMME, 1969
Chefs-d'œuvre des arts indiens et esquimaux du Canada/Masterpieces of Indian and Eskimo Art from Canada (in English and French). Paris: Société des amis du Musée de l'Homme, 1969. Exhibition (traveling), Musée de l'Homme, Paris, March–September 1969; The National Gallery of Canada, Ottawa, November 1969–January 1970.

NEWCOMBE, N.D.
Charles F. Newcombe. Collection Notes. Department of Anthropology, Field Museum of Natural History, Chicago, n.d.

OLSON, 1961
Ronald L. Olson. "Tlingit Shamanism and Sorcery." *The Kroeber Anthropological Society Papers*, no. 25 (Fall 1961), pp. 207–20.

OLSON, 1967
——. *Social Structure and Social Life of the Tlingit in Alaska*. University of California Publications, Anthropological Records, vol. 26. Berkeley: University of California Press, 1967.

PAALEN, 1943
Wolfgang Paalen. "Totem Art." *Dyn*, vols. 4–5 (December 1943), pp. 7–39.

PARK, 1938
Willard Z. Park. *Shamanism in Western North America: A Study in Cultural Relationships*. Northwestern University Studies in the Social Sciences, no. 2, 1938. Reprint, New York: Cooper Square Publishers, 1975.

PASCO, 1994
Katie Pasco. Personal communication, New York, 1994.

PASZTORY, 1981
Esther Pasztory. "Shamanism and North American Indian Art." In Matthews and Jonaitis, 1981, pp. 7–30.

PENNEY, 1985
David W. Penney. "Continuities of Imagery and Symbolism in the Art of the Woodlands." In *Ancient Art of the American Woodland Indians*, by David S. Brose, James A. Brown, and David W. Penney, pp. 147–98. New York: Harry N. Abrams in association with The Detroit Institute of Arts, 1985. Exhibition (traveling), National Gallery of Art, Washington, D.C., March 17–August 4, 1985; The Detroit Institute of Arts, September 2–November 11, 1985; The Houston Museum of Fine Arts, December 17, 1985–March 2, 1986.

RADIN, 1915
Paul Radin. "Religion of the North American Indians." In *Anthropology in North America*, by Franz Boas et al., pp. 259–305. New York: G. E. Stechert and Co., 1915.

RAUTENSTRAUCH-JOEST-MUSEUM, 1969
Indianer Nordamerikas: Schatze des Museum of the American Indian, Heye Foundation, New York. Cologne: Rautenstrauch-Joest-Museum, 1969. Exhibition, Kunsthalle, Cologne, July 1–October 1, 1969.

ROHNER AND ROHNER, 1970
Ronald P. Rohner and Evelyn C. Rohner. *The Kwakiutl: Indians of British Columbia.* Case Studies in Cultural Anthropology. New York: Holt, Rinehart and Winston, 1970.

ROYAL BRITISH COLUMBIA MUSEUM, N.D., NOTES
Royal British Columbia Museum, Victoria. Photographic Archives, Ethnology Division, n.d.

SAWYER, 1993
Alan Sawyer, Personal communication, Vancouver 1993

SEGUIN, 1984
Margaret Seguin, ed. *The Tsimshian: Images of the Past, Views for the Present.* Vancouver: The University of British Columbia Press, 1984.

SETON-KARR, 1887
H. W. Seton-Karr. *Shores and Alps of Alaska.* London: Sampson Low, Marston, Searle, Rivington, 1887.

SHANE, 1984
Audrey P. M. Shane. "Power in Their Hands: The Gitsontk." In Seguin, 1984, pp. 160–73.

SIEBERT AND FORMAN, 1967
Erna Siebert and Werner Forman. *Indianerkunst der Americanischen Nordwestkuste.* Prague: Artia, 1967.

SOTHEBY'S, 1990
Sotheby's, New York. *Fine American Indian Art.* Sale 6061, September 25–26, 1990.

STRYD, 1983
Arnoud Stryd. "Prehistoric Mobile Art from the Mid-Fraser and Thompson River Areas." In Carlson, 1983a, pp. 167–81.

STURTEVANT, 1990
William C. Sturtevant, ed. *Handbook of North American Indians.* Vol. 7, Northwest Coast. Washington, D.C.: Smithsonian Institution, 1990.

SWANTON, 1905
John Swanton. "Contributions to the Ethnology of the Haida." In *Publications of the Jesup North Pacific Expedition,* edited by Franz Boas. Memoirs of the American Museum of Natural History, vol. 8, pt. 1, pp. 1–300. New York: Trustees of the American Museum of Natural History, 1905. Reprint, New York: AMS Press, 1975.

SWANTON, 1907
——. "Shamans and Priests." In *Handbook of American Indians North of Mexico,* edited by Frederick Webb Hodge, vol. 2, pp. 522–24. Bureau of American Ethnology Bulletin, no. 30. Washington, D.C.: Government Printing Office, 1907.

SWANTON, 1908a
——. *Haida Texts. Publications of the Jesup North Pacific Expedition,* edited by Franz Boas. Memoirs of the American Museum of Natural History, vol. 14, pt. 2. New York: Trustees of the American Museum of Natural History, 1908.

SWANTON, 1908b
——. *Haida Texts and Myths.* Bureau of American Ethnology Bulletin, no. 29. Washington, D.C.: Government Printing Office, 1908.

SWANTON, 1908c
——. "Social Conditions, Beliefs and Linguistic Relationships of the Tlingit Indians." In *Report of the Bureau of American Ethnology for 1904–5,* pp. 391–486. Washington, D.C.: Government Printing Office, 1908.

SWANTON, 1909
——. *Tlingit Myths and Texts.* Bureau of American Ethnology Bulletin, no. 39. Washington, D.C.: Government Printing Office, 1909.

VASTOKAS, 1973–74
Joan M. Vastokas. "The Shamanic Tree of Life." In *Artscanada,* 1973–74, pp. 125–49.

VAUGHAN AND HOLM, 1982
Thomas Vaughan and Bill Holm. *Soft Gold: The Fur Trade and Cultural Exchange on the Northwest Coast of America.* Portland: Oregon Historical Society, 1982. Exhibition, Oregon Historical Society, Portland.

WAITE, 1966
Deborah Waite. "Kwakiutl Transformation Masks." In Fraser, 1966, pp. 264–300.

WARDWELL, 1964
Allen Wardwell. *Yakutat South: Indian Art of the Northwest Coast.* Chicago: The Art Institute of Chicago, 1964. Exhibition, The Art Institute of Chicago, March 13–April 26, 1964.

WARDWELL, 1978
——. *Objects of Bright Pride.* New York: The Center for Inter-American Relations and the American Federation of Arts, 1978. Exhibition (traveling), Cleveland Museum of Art; The Denver Art Museum; Museum of Natural History, Los Angeles; Seattle Art Museum; New Orleans Museum of Art; Center for Inter-American Relations, New York.

WARDWELL, 1993
——. "Some Discoveries in Northwest Coast Indian Art." *American Indian Art,* vol. 18, no. 2 (Spring 1993), pp. 46–55.

WYATT, 1989
Victoria Wyatt. *Images from the Inside Passage: An Alaskan Portrait by Winter and Pond.* Seattle: University of Washington Press, 1989.

SYNONYMY

Some of the diacritical marks needed to spell certain native names of peoples and places used in this book do not exist in the typefaces used. Therefore, the names given in the text are the most common Anglicized forms. In the case of the transcriptions of stories, particularly those from Franz Boas, I have tried to use the orthography of his time. However, these orthographies have undergone several changes since then. The following synonymies are drawn from the work of present-day linguists as presented in Sturtevant, 1990 (pp. 226–27, 258–59, 282–83).

Only those names that appear in the text are listed here. Please note that among the Tlingit, tribes and places have the same names.

PEOPLES

Haida ḥà·ṫe· / ḥà·de· ; *(Alaskan)* ḥa·dé· / ḥa·dá·y
 Haida Tribes
 Kaigani ḱáyḱa·ní·
 Kunghit ʕaŋ.i·d ʕud
 Masset mà·sad
 Skidegate sgi·dəgi·ds
Kwakiutl kʷáguʼł
Tsimshian ċmsyan
 Tsimshian Tribes
 Gitksan kitxsan
 Nishga nisqáʔa
Tlingit li·ngít
 Tlingit Tribes
 Auk ʔá·ḱʷ
 Chilkat ǯiłqá·t
 Chilkoot ǯiłqut
 Gu-nah-ho (Dry Bay) ġuna·xu·
 Henya he·nẏa / hinẏa·
 Hoonah xuna·
 Hutsnuwu xucnu·wú
 Kake qé·x̣ / qí·x̣
 Kalaikh ġałyax̣
 Klawak ławá·k
 Kuiu kuyú
 Sanya sa·nẏa·
 Sitka ši·ṫká
 Stikine štax̣hí·n
 Sumdum ṡawdá·n
 Taku ṫa·qú
 Tongass ta·nṫa / ṫanga·s / ṫanga·š
 Yakutat ya·kʷdá·t
 Tlingit Raven Clans
 Desitan de·ši·ta·n
 Ganaxadi ġa·nax̣ʔádi

 Kiksadi kiksʔádi
 Takdentan ṫaqde·nta·n
 Tlukwaxdi łukʷa·x̣ʔádi
 Xatkaayi x̣aṫkaʔa·ẏí
 Tlingit Wolf Clans
 Daklawedi daqławe·dí
 Kagwantan ka·gwa·nta·n
 Tequedi te·qʷe·dí
 Tluxwedi łux̣ʷe·dí

PLACES

Haida Villages
 Haina xeyna·
 Howkan ʔáwḱya·n.
 Kaisun qəysʔun
 Kasaan gasá·n
 Kiusta ḱyu·sṫa·
 Kung qaŋ
 Masset mà·sad
 Skidegate sgi·dəgi·ds
 Tanu (Kloo) ṫanu·
 Yan ya·n
Tsimshian Villages
 Nishga Tsimshian Villages
 Gitlakdamiks kitlaxtá·miks
 Gitwunksithk kitwinksí·łk
 Gitksan Tsimshian Villages
 Kisgegas kisqaqáʔas
 Kispiox kispayákʷs
 Kitanmaks kitʔanmá·xs
 Kitsegukla kicikúkʷła
 Kitwancool kitwanłkúʔul
 Kitwanga kitwinġáx̣
 Coast Tsimshian Village
 Kitselas kitsalá·sẏ

SHAMANS' NAMES

Most of the shamans' names were Anglicized to such an extent that it is impossible to give their proper synonymy. The exceptions are as follows:

Gutcda Ḡutcda
Kude K!oda -i
Setan Sᴇtᴀn
Skundoo Sx̣anduʔú·
Tekic Teḱ·ʼic

PHOTOGRAPHIC CREDITS

THE CREDITS listed below refer to the photographers, individuals, or institutions that supplied photographs of the plates. Credits for figure illustrations are given in the captions.

American Museum of Natural History, New York. Department of Library Services: Nos. 12, 15, 34, 56, 116, 170, 177, 181, 335, 339, 415, 431, 435, 452, 467 (right), 470, 499

Anonymous: Nos. 35, 198, 235, 455

Joshua Baer & Company, Santa Fe (Tony Vinella): No. 62

British Museum, London: Nos. 64, 126, 243, 258, 262, 276, 295, 388, 398, 399, 413

Brooklyn Museum, New York: Nos. 220, 272, 418

Centennial Museum, Vancouver: No. 479

Christie, Mansion, and Woods, Ltd., London: No. 320

Cincinnati Art Museum, Cincinnati: Nos. 151, 178, 438

Cleveland Art Museum, Cleveland: Nos. 179, 422

Denver Art Museum, Denver: Nos. 199, 200, 316, 349, 401, 436, 488

Addison Doty, Santa Fe: Nos. 80, 144, 281, 390

Field Museum of Natural History, Chicago (Diane Alexander White and Ron Testa): Nos. 6, 7, 17, 20, 22, 32, 51, 66, 70, 73, 84, 93, 106, 120, 162, 240, 244, 327–329, 344, 346, 350, 352, 354, 387, 417, 424, 434, 442, 453, 465, 492, 493

Fogg Art Museum, Harvard University, Cambridge: Nos. 19, 366

Werner Forman Archives, London: Nos. 86, 104, 148, 155, 175, 176, 410, 437, 440

Glenbow Museum, Calgary: No. 113

Bobby Hansson, New York: Nos. 1, 2, 4, 8–11, 16, 18, 24–26, 29, 30, 36–41, 45, 48, 50, 52–55, 57–61, 63, 67–69, 72, 75, 77–79, 81–83, 88–91, 94–97, 99–103, 107, 110, 111, 122–124, 129–132, 134, 135, 137, 139, 140, 160, 161, 163, 164, 166, 171, 172, 180, 183, 184, 186, 187, 190, 192, 193, 195–197, 204, 206, 207, 210–213 (above), 215, 219, 221, 224, 225, 227–230, 232, 236, 239, 241, 245–247, 251–254, 257, 259, 263, 265, 267–269, 278–280, 282–284, 297, 299–303, 306–309, 313, 314, 323–325, 330–332, 337, 338, 340–343, 345, 347, 353, 355, 357–365, 367, 368, 375–377, 379–381, 383, 392, 394, 396, 400, 403–407, 420, 421, 423, 432, 443–446, 449, 450, 457, 458, 461, 462, 464, 466, 468, 471–474, 476, 487, 490, 497, 498

Bill Holm, Seattle: No. 205

Gideon Lewin, New York: No. 460

Lowie Museum of Anthropology, Berkeley: Nos. 254, 287, 486

Diane Maas, New York: No. 231

Paul Macapia, Seattle Art Museum: Nos. 294, 296

Robert Mates, New York: Nos. 46, 47, 173, 201, 248–250, 305, 310, 315, 322, 370, 372–374, 389, 402, 409, 460, 463

Metropolitan Museum of Art, New York: Nos. 43, 112, 157, 216, 255, 266, 397

Milwaukee Public Museum, Milwaukee: Nos. 222 (below) 371, 485

Museum für Völkerkunde, Basel: Nos. 14, 185

Museum für Völkerkunde, Vienna: No. 264

National Museum of the American Indian, Smithsonian Institution, Washington, D.C.: Nos. 165, 213 (below), 233, 234, 274, 277, 290, 333, 447, 448, 456

National Museum of Natural History, Smithsonian Institution, Washington, D.C.: Nos. 150, 194, 208, 494

National Museum of Natural History, Smithsonian Institution, Washington, D.C. "Crossroads of Continents" Exhibition: Nos. 44, 49, 127, 223, 321, 334, 336, 411, 428, 429

Peabody Essex Institute, Salem: No. 496

Peabody Museum, Harvard University, Cambridge. Hillel Berger: Nos. 3, 23, 71, 87, 105, 109, 117, 128, 153, 156, 167, 174, 203, 209, 217, 218, 242, 311, 317–319, 356, 378, 412, 419, 433, 439, 475, 480

Portland Art Museum, Oregon Art Institute, Portland: Nos. 76, 288, 386

Rietberg Museum, Zurich (Wettstein and Kauf): Nos. 42, 142

Royal Albert Memorial Museum, Exeter: No. 261

Royal British Columbia Museum, Victoria: Nos. 13, 27, 65, 214, 271, 273, 275, 286, 293, 326, 348, 369, 385, 430, 481, 482

Royal Ontario Museum, Toronto: No. 238

Saint Joseph Museum, Saint Joseph, Missouri: No. 141

Saint Louis Art Museum, Saint Louis: No. 31

San Diego Museum of Man, San Diego: No. 425

Seattle Art Museum, Seattle: Nos. 33, 108, 114, 118, 119, 133, 143, 146, 158, 159, 168, 169, 188, 189, 285, 312, 391, 395, 396, 414, 469, 484, 491

Sheldon Jackson Museum, Sitka: Nos. 28, 138

Staatliche Museum für Völkerkunde, Munich: No. 495

John Bigelow Taylor: Nos. 21, 147, 477

Thomas Burke Memorial, Washington State Museum, Seattle: Nos. 85, 98, 182, 226, 270, 351, 382, 384, 393, 416, 489

Ubersee Museum, Bremen: No. 427

University of British Columbia Museum, Vancouver: Nos. 298, 459

University of Indiana Art Museum, Bloomington: Nos. 202, 256, 260

University Museum, University of Pennsylvania, Philadelphia: Nos. 5, 121, 149, 291, 408, 426, 451, 454, 483

Allen Wardwell: No. 441

Ben Woods, Chicago: Nos. 74, 92, 124, 125, 145, 152, 154, 191, 222 (above), 237, 289, 292, 304, 364, 467 (left), 478